SURREALISM IN BRITAIN

TO LISA AND NICOLAS

Surrealism in Britain

Michel Remy

ASHGATE

Published by
Ashgate Publishing Limited
Gower House
Croft Road
Aldershot
Hants GU11 3HR
England

Ashgate Publishing Company
Old Post Road
Brookfield
Vermont 05036-9704
USA

British Library Cataloguing-in-Publication data

Remy, Michel
 Surrealism in Britain
 1 Surrealism – Great Britain
 I.Title
 709.4'1'09041

Library of Congress Cataloguing-in-Publication data

Remy, Michel.
 Surrealism in Britain/Michel Remy.
 p. cm.
 Includes bibliographical references and index.
 ISBN 1–85928–282–2 (hb)
 ISBN 0-75460-041-6 (pb)
 1. Surrealism — Great Britain. 2. Art, British. 3. Art, Modern — 20th century — Great Britain. I. Title.
 N6768.5.S87R46 1999
 709'.41'09041 — dc21

98–50874 CIP

Hardback ISBN 1 85928 282 2
Paperback ISBN 0 75460 041 6

Printed on acid-free paper

Typeset in Palatino by Wearset, Boldon, Tyne and Wear. Printed in Singapore.

Contents

List of illustrations 7

Foreword 15

1 Exits and entrances 23

2 The entry of the mediums: the establishment of surrealism in
 Britain 1932–6 35
 Paul Nash and Unit One 36
 Hugh Sykes Davies and David Gascoyne 44
 Len Lye and Humphrey Jennings 49
 British artists in Paris: Penrose, Trevelyan, Agar and Banting 62
 Henry Moore 70
 Publications and meetings 71
 The International Surrealist Exhibition 73

3 Communicating vessels: formation and growth 1936–7 101
 Art and politics 102
 Surrealist Objects and Poems 112
 Axis and *Circle* 123
 David Gascoyne 125
 John Banting 127
 Paul Nash 128
 Henry Moore 131
 Roland Penrose 134
 Julian Trevelyan 136
 Eileen Agar 140

4 Spirit levels, level spirits: the years of definition 1938–40 147
 The Road is Wider than Long 166

Samuel Haile 171
Ceri Richards 176
Eileen Agar 179
Henry Moore 180
Roland Penrose 184
Humphrey Jennings 189
F.E. McWilliam 192
Conroy Maddox and John Melville 196
Ithell Colquhoun 204
Grace Pailthorpe and Reuben Mednikoff 205

5 The eye of the hurricane: the war years 1940–45 209
Division in the ranks 224
Gordon Onslow-Ford and Conroy Maddox 228
Toni del Renzio 241
Ithell Colquhoun, Emmy Bridgwater and Edith Rimmington 244
John Tunnard 256
Grace Pailthorpe and Reuben Mednikoff 261
Apocalypticism 265

6 Watchman, What of the Night?: the *Free Unions* years 1945–51 271
George Melly 275
Activity resumed 276
John Banting and Conroy Maddox 285
Emmy Bridgwater 293
Edith Rimmington 296
Roland Penrose 301
F.E. McWilliam 306
Eileen Agar 306
Samuel Haile 310
Ithell Colquhoun 312
'Scottie' Wilson 316
Desmond Morris 321

Postscript: the search for a fading prospect 327

Notes 345

Select bibliography 358

Index 385

List of illustrations

Every attempt has been made to contact relevant copyright holders and other appropriate sources of information in order to provide the date, ownership and description of each work illustrated here. It is regretted that in a number of instances some of this information could not be established; neither has it been possible to add to the sources already given.

The works illustrated on pp. 133, 135 and 183 are reproduced by permission of the Henry Moore Foundation.

1 John Armstrong, *The Open Door*, 1930, oil on canvas, private coll., 76 × 62 cm (30 × 24.5 in.), © The Artist's Estate

2 Tristram Hillier, *Surrealist Landscape*, *c.* 1932, oil on canvas, private coll., 87 × 75 cm (34.25 × 30 in.), © The Artist's Estate

3 Edward Wadsworth, *Tomorrow Morning*, 1929–44, tempera, private coll., 75 × 62 cm (29.5 × 24.4 in.), © The Artist's Estate

4 Paul Nash, *Northern Adventure*, 1929, oil on canvas, City of Aberdeen Art Gallery and Museums Collections, 67.3 × 101.6 cm (26.5 × 40 in.), © Tate Gallery, London 1999

5 Humphrey Jennings, *Tableau Parisien*, 1938–9, oil on canvas, Peter Nahum at the Leicester Galleries, 51 × 61 cm (20 × 24 in.), © The Artist's Estate

6 Humphrey Jennings, *Armchair with Seal*, *c.* 1935, collage, private coll., 19 × 14 cm (7.5 × 5.5 in.), © The Artist's Estate

7 Humphrey Jennings, *Mountain Inn and Swiss Roll*, *c.* 1936, collage, coll. Jeffrey Sherwin, 15.5 × 22 cm (6.1 × 8.7 in.), © The Artist's Estate

8 Humphrey Jennings, *Portrait of Lord Byron*, *c.* 1936, photograph, coll. Mary-Lou Jennings, 25.5 × 38 cm (10 × 14.8 in.), © The Artist's Estate

9 Humphrey Jennings, *Portrait of Roger Roughton*, *c.* 1937, photograph, private coll., 24 × 37 cm (9.8 × 14.5 in.), © The Artist's Estate

10 Humphrey Jennings, *House in the Woods*, 1936, oil on canvas, Tate Gallery, 30 × 36 cm (12 × 14.1 in.), © The Artist's Estate

11 Len Lye, frames from *Colour Box*, 1935, film, Len Lye Foundation, © The Artist's Estate

12 Len Lye, *Pond People*, 1930, batik on silk, Len Lye Foundation, 98.5 × 143 cm (38.8 × 56.3 in.), © The Artist's Estate

13 Len Lye, *Snowbirds Making Snow*, 1936, oil on hardboard, Len Lye Foundation, 94.3 × 144.8 cm (37.1 × 57 in.), © The Artist's Estate

14 Eileen Agar, *Quadriga*, 1935, oil on canvas, coll. Roland Penrose Estate, 52.1 × 61 cm (20.8 × 24.5 in.), © The Artist's Estate

15 John Banting, *Ten Guitar Faces*, *c.* 1932, gouache, private coll., 47 × 29 cm (18.5 × 11.5 in.), © The Artist's Estate

16 John Banting, *Conversation Piece*, *c.* 1935, gouache, Tate Gallery, 51 × 45 cm (20 × 18 in.), © The Artist's Estate

17 John Banting, *Two Models*, 1935, gouache and watercolour, 107.5 × 66 cm (42.5 × 26 in.), © The Artist's Estate

18 Cover of David Gascoyne's *A Short Survey of Surrealism*, 1935

19 Invitation to the International Surrealist Exhibition, 1936

20 Poster for the International Surrealist Exhibition, 1936

21 E.L.T. Mesens, Roland Penrose, André Breton and Humphrey Jennings, at the International Exhibition of Surrealism in 1936, The Penrose Archive, Scottish National Gallery of Modern Art, © Estate of Claude Cahun

22 Sheila Legge as the Surrealist Phantom in Trafalgar Square, for the International Surrealist Exhibition, 1936

23 Salvador Dalí in a diving suit, with Paul Eluard, Nusch Eluard, E.L.T. Mesens, Rupert Lee, Diana Brinton Lee, 1936

24 Poster for the International Surrealist Exhibition by Max Ernst, 1936

25 Cover of a dinner menu for a gathering of the surrealist group, coll. Professor Christopher Buckland-Wright, design by Graham Sutherland. Photographer: Richard Valencia

26 Merlyn Evans, *Conquest of Time*, 1934, oil on canvas, Tate Gallery, 101.6 × 81.3 cm (40 × 32 in.), © The Artist's Estate

27 Cecil Collins, *The Cells of Night*, 1934, oil on canvas, Tate Gallery, 76 × 63.5 cm (30 × 25 in.), © The Artist's Estate

28 Merlyn Evans, *Tyrannopolis*, 1939, tempera on canvas, coll. Jeffrey Sherwin, 76 × 91 cm (30 × 36 in.), © The Artist's Estate

29 Grace W. Pailthorpe, *Ancestors I*, 1935, ink on paper, Peter Nahum at the Leicester Galleries, 30.5 × 38 cm (12 × 15 in.), © The Artist's Estate

30 Grace W. Pailthorpe, *Ancestors II*, 1935, ink on paper, Peter Nahum at the Leicester Galleries, 30.5 × 38 cm (12 × 15 in.), © The Artist's Estate

31 Reuben Mednikoff, *Stairway to Paradise*, 1936, watercolour on canvas, private coll., 26 × 34.5 cm (10.2 × 13.6 in.), © The Artist's Estate

32 Reuben Mednikoff, *Little Nigger Boys Don't Tell Lies*, 1936, oil on canvas, Coll. The Israel Museum, Jerusalem, gift of Arturo Schwartz, 58 × 40 cm (22.8 × 15.7 in.), © The Artist's Estate

33 Reuben Mednikoff, *Headwaiter*, 1936, drawing, private coll., 25 × 20 cm (10 × 8 in.) © The Artist's Estate

34 Reuben Mednikoff, *drawing*, n.d., pen and ink, coll. James Birch, London, 25 × 20 cm (10 × 8 in.), © The Artist's Estate

35 Reuben Mednikoff, *The Flying Pig*, 1936, oil on board, private coll., 48 × 62 cm (18.9 × 24.4 in.), © The Artist's Estate

36 Grace W. Pailthorpe, *Composition*, 16 Nov. 1937, oil on canvas, Peter Nahum at the Leicester Galleries, 67.5 × 52 cm (27 × 20.1 in.), © The Artist's Estate

37 Cover of Herbert Read's *Surrealism*, 1936. Collage by Roland Penrose

38 'Declaration on Spain', statement from the surrealist group, *Contemporary Poetry and Prose*, 1936

39 Surrealist group manifesto, *We Ask Your Attention*, with a drawing by Henry Moore

40 Cover of catalogue to the Surrealist Objects and Poems exhibition, 1937

41 Eileen Agar, *The Angel of Anarchy*, 1937, 1940, plaster cast covered with mixed media, Tate Gallery, 50.8 × 48 cm (20 × 18.9 in.), © The Artist's Estate

42 Roland Penrose, *The Dew Machine*, 1937. Object destroyed; photograph from the catalogue of the Surrealist Objects and Poems exhibition, 1937, © The Roland Penrose Estate

43 Julian Trevelyan, *Machine for Making Clouds*, 1937. Object lost; photograph from the catalogue of the Surrealist Objects and Poems exhibition, 1937

44 Paul Nash, *The Bark is Worse Than the Bite*, 1937. Object lost, © Tate Gallery, London 1999

45 Roland Penrose, *Guaranteed Fine Weather Suitcase*, 1937. Object lost, © The Roland Penrose Estate

46 Peter Norman Dawson, *British Diplomacy*. Object lost; reproduced from the catalogue of the Surrealist Objects and Poems exhibition, 1937, © The Artist's Estate

47 Geoffrey Graham, *Virgin Washerwoman*. Object lost; reproduced from the catalogue of the Surrealist Objects and Poems exhibition, 1937, © The Artist's Estate

48 Charles Howard, *Inscrutable Object*. Object lost; reproduced from the cata-logue of the Surrealist Objects and Poems exhibition, 1937, © The Artist's Estate

49 Roland Penrose, *Condensation of Games*, 1937, mixed media, object lost, © The Roland Penrose Estate

50 Edith Rimmington, *Family Tree*, 1937 (but inscribed 1938), photo-collage, Private coll., 34.2 × 24.8 cm (13.5 × 9.8 in.), © The Artist's Estate

51 John Banting, *Mutual Congratulations*, c. 1936, oil on canvas, Peter Nahum at the Leicester Galleries, 101.6 × 76 cm (40 × 30 in.), © The Artist's Estate

52 Paul Nash, *Landscape from a Dream*, 1936–8, oil on canvas, Tate Gallery, 67.3 × 101.6 cm (26.5 × 40 in.), © Tate Gallery, London 1999

53 Paul Nash, *Harbour and Room*, 1932–6, oil on canvas, Tate Gallery, 91.4 × 71.1 cm (36 × 28 in.), © Tate Gallery, London 1999

54 Henry Moore, *Four Piece Composition (1934)*, 1934, Cumberland alabaster, Tate Gallery, length 51 cm (20 in.), © Henry Moore Foundation

55 Henry Moore, *Reclining Figure (1936)*, 1936, elmwood, City Art Gallery, Wakefield, length 105 cm (42 in.), © Henry Moore Foundation

56 Henry Moore, *Reclining Figure (1937)*, 1937, Hoptonwood stone, coll. Miss Lois Orswell, length 83 cm (33 in.), © Henry Moore Foundation

57 Roland Penrose, *L'Île Invisible (Seeing is Believing)*, 1937, oil on canvas, coll. M. Lods, 100 × 75 cm (39.3 × 29.8 in.), © The Roland Penrose Estate

58 Julian Trevelyan, *City*, 1936, oil and crayon on board, private coll., 72 × 115 cm (28.3 × 45.2 in.), © The Artist's Estate

59 Julian Trevelyan, *A Symposium*, 1936, oil on canvas, Tate Gallery, 61 × 105 cm (24 × 41.3 in.), © The Artist's Estate

60 Eileen Agar, *David and Jonathan*, 1936, mixed media. Lost; reproduced

from *International Surrealist Bulletin*, September 1936, © The Artist's Estate

61 Eileen Agar, *Mate in Two Moods*, 1936, mixed media, 29 × 23 × 42 cm (11.6 × 9 × 16.8 in.), © The Artist's Estate

62 Eileen Agar, *Fish Circus*, 1939, watercolour and collage, Scottish National Gallery of Modern Art, 26 × 18 cm (10.2 × 7 in.), © The Artist's Estate

63 Photo of Eileen Agar by Lee Miller, 1937, © The Lee Miller Archives, Chiddingly, UK

64 Eileen Agar, *Ladybird*, 1936, photograph with gouache and ink, private coll., 74.5 × 50.8 cm (29.3 × 20 in.), © The Artist's Estate

65 David Gascoyne, *Perseus and Andromeda*, 1936, collage, Tate Gallery, 16 × 24 cm (6.3 × 9.5 in.), © The Artist

66 Poster for the exhibition of *Guernica* in London, 1937

67 Clement Attlee opening the *Guernica* exhibition at the Whitechapel Gallery, 1938, The Penrose Archive, Scottish National Gallery of Modern Art, © Illustrated Press, London

68 Window of Mayor Gallery, London, for an exhibition of works by Roland Penrose and Ithell Colquhoun, 1939

69 F.E. McWilliam, *Mask of Chamberlain*, 1938, papier mâché, carpet felt, paint, private coll., height 19 cm (7.5 in.), © The Artist's Estate

70 Surrealists demonstrating in Chamberlain masks in Hyde Park, 1938

71 Surrealists James Cant, Roland Penrose, Julian Trevelyan and Geoffrey Graham demonstrating in Hyde Park, 1938, The Penrose Archive, Scottish National Gallery of Modern Art

72 Billboards in support of aid for Spanish Republicans, 1939, © Marianne Haile

73 Sam Haile and Ceri Richards, painting billboards in support of aid for Spanish Republicans, 1939, © Marianne Haile

74 Roland Penrose, page from *The Road is Wider than Long*, 1939, © The Roland Penrose Estate

75 Lee Miller, *Portrait of Space*, 1937, photograph, 29 × 27.2 cm (11.9 × 10.9 in.), © Lee Miller Archives, Chiddingly, UK

76 Lee Miller, *Cock Rock* or *The Native*, 1939, photograph, 26.6 × 27.3 cm (10.5 × 10.8 in.), © Lee Miller Archives, Chiddingly, UK

77 Lee Miller, *Eggceptional Achievement*, 1940, photograph, 24.8 × 24.8 cm (9.8 × 9.8 in.), © Lee Miller Archives, Chiddingly, UK

78 Thomas Samuel Haile, *Mandated Territories*, 1938, oil on canvas, 76 × 61 cm (30 × 24 in.), © The Artist's Estate

79 Thomas Samuel Haile, *Brain Operation*, 1939, oil on canvas, coll. Austin/Desmond Fine Art, 61 × 51 cm (24 × 20 in.), © The Artist's Estate

80 Ceri Richards, *Chimera Costerwoman*, 1939, oil on canvas, Coll. Israel Museum, Jerusalem, gift of Arturo Schwartz, 100 × 45 cm (40 × 18 in.), © The Artist's Estate

81 Thomas Samuel Haile, *Woman and Suspended Man*, 1938, oil on canvas, private coll., 51 × 76 cm (20 × 30 in.), © The Artist's Estate

82 Eileen Agar, *Muse of Construction*, 1939, oil on canvas, private coll., on loan to Southampton City Art Gallery, 127 × 127 cm (50 × 50 in.), © The Artist's Estate

83 Eileen Agar, *Possessed*, 1938, assemblage on canvas, private coll., 47 × 36.5 (18.5 × 14.5 in.), © The Artist's Estate

84 Henry Moore, *Bird Basket*, 1939, lignum vitae and string, coll. Ms Mary Moore, length 42 cm (16.5 in.), © Henry Moore Foundation

85 Henry Moore, *Helmet*, 1939–40, lead, Scottish National Gallery of Modern Art, Edinburgh, height 29 cm (11.5 in.), © Henry Moore Foundation

86 Roland Penrose, *Le Grand Jour*, 1938, oil on canvas, Tate Gallery, 76.2 × 101.6 cm (30 × 40 in.), © The Roland Penrose Estate

87 Roland Penrose, *The Real Woman*, 1938, collage, 2 Willow Road, The Ernö Goldfinger Collection (The National Trust), 81 × 106 cm (31.9 × 41.7 in.), © The Roland Penrose Estate (1984)

88 *The Conquest of the Air*, 1938 by Roland Penrose (1900–84), Southampton City Art Gallery, Hampshire, UK/ Bridgeman Art Library, London/New York, oil on canvas, 50.8 × 61.1 cm (20 × 24 in.), © The Roland Penrose Estate

89 *Bien Vise* (*Good Shooting*), 1939 by Roland Penrose (1900–84), Southampton City Art Gallery, Hampshire, UK/ Bridgeman Art Library, London/New York, oil on canvas, 101.6 × 76.2 cm (40 × 30 in.), © The Roland Penrose Estate

90 Roland Penrose, *From the House Tops*, 1939, monotype, Roland Penrose Estate, 37.5 × 50 cm (14.7 × 19.6 in.), © The Roland Penrose Estate

91 Roland Penrose, *Octavia*, 1939, oil on canvas, Ferens Art Gallery, Hull, 77.5 × 63.5 cm (30.5 × 25 in.), © The Roland Penrose Estate

92 Humphrey Jennings, *Horse's Head*, 1937–40, oil on canvas, private coll., 55 5 × 43.2 cm (21.9 × 17 in.), © The Artist's Estate

93 Humphrey Jennings, *Locomotive*, 1936–8, oil on canvas, private coll., 25.5 × 30.5 cm (10 × 12 in.), © The Artist's Estate

94 F.E. McWilliam, *Spanish Head*, 1938–9, Hoptonwood stone, coll. Jeffrey Sherwin, height 130 cm (51 in.), © The Artist's Estate

95 Humphrey Jennings, *Apples*, 1940, oil on canvas, private coll., 25.4 × 31 cm (10 × 12.2 in.), © The Artist's Estate

96 Humphrey Jennings, *Alpine Landscape* or *Mountain and Plum*, 1938, oil on canvas, private coll., 30.5 × 35.5 cm (12 × 14 in.), © The Artist's Estate

97 F.E. McWilliam, *Eye, Nose and Cheek*, 1939, Hoptonwood Stone, Tate Gallery, height 90 cm (35 in.), © The Artist's Estate

98 Conroy Maddox, *The Lesson*, 1938, oil on canvas, coll. Jeffrey Sherwin, 81 × 71 cm (31.8 × 28 in.), © The Artist

99 John Melville, *Seated Woman with Fruit* or *Surrealist Portrait*, 1938, oil on board, private coll., 59.6 × 73 cm (23.5 × 28.7 in.), © The Artist's Estate

100 John Melville, *Concavity of Afternoons*, 1939, oil on canvas, private coll., 55 × 44 cm (21.6 × 17.5 in.), © The Artist's Estate

101 John Melville, *Mushroom-headed Child*, 1939, private coll., 66 × 46 cm (26 × 18.1 in.), © The Artist's Estate

102 John Melville, *The Museum of Natural History of the Child*, 1937, Leeds City Art Gallery, 70 × 100 cm (28 × 39.4 in.), © The Artist's Estate

103 John Melville, *Alice*, c. 1938, drawing, coll. Conroy Maddox, 34 × 43 cm (13.6 × 17.2 in.), © The Artist's Estate

104 Reuben Mednikoff, *The King of the Castle*, 1938, oil on board, coll. James Birch, 42 × 53 cm (16.5 × 20.8 in.), © The Artist's Estate

105 Window of the Zwemmer Gallery for a surrealist exhibition, 1940

106 John Banting, *Janus* or *The Eye of the World*, 1942, watercolour, private coll., 61 × 45 cm (23.6 × 17.7 in.), © The Artist's Estate

107 John Banting, *The Funeral*, 1944, ink, gouache and watercolour, private coll., 51 × 65 cm (20 × 25.5 in.), © The Artist's Estate

108 Birmingham group, *Cadavre Exquis*, c. 1944, private coll., 32 × 23 cm (12 × 9 in.), © The Artists

109 Gordon Onslow-Ford, *Determination of Gender*, 1939, oil on canvas, Tate Gallery, 92 × 72.6 cm (36.3 × 28.5 in.), © The Artist

110 Gordon Onslow-Ford, *Cycloptomania*, 1939, oil on canvas, coll. the artist, 87.5 × 125 cm (35 × 50 in.), © The Artist

111 Conroy Maddox, *The Lily*, 1944, Indian ink on paper, England and Co. Gallery, 36.5 × 25.5 cm (14.3 × 10 in.), © The Artist

112 Conroy Maddox, *The Strange Country*, 1940, collage, Tate Gallery, 41 × 28 cm (16.2 × 11 in.), © The Artist

113 Conroy Maddox, *Propagation of the Species*, 1941, gouache, private coll., 36 × 56 cm (14.1 × 22 in.), © The Artist

114 Conroy Maddox, *Morning Encounter*, 1944, oil on canvas, coll. the artist, 94 × 122 cm (37 × 48 in.), © The Artist

115 Conroy Maddox, *Passage de l'Opéra*, 1940, oil on canvas, Tate Gallery, 136 × 94 cm (53.5 × 37 in.), © The Artist

116 Conroy Maddox, *Rue de Seine (The House of Georges Hugnet)*, 1944, oil on canvas, private coll., 126 × 75 cm (49.7 × 29.5 in.), © The Artist

117 Conroy Maddox, *The Visible Man*, 1941, oil on canvas, private coll., 45 × 60 cm (17.7 × 23.6 in.), © The Artist

118 Conroy Maddox, *Onanistic Typewriter*, 1940, modified ready-made, private coll., 25 × 47 × 33 cm (9.8 × 18.5 × 13 in.), © The Artist

119 Toni del Renzio, *Mon Père Ne Pas Reviens*, 1942, watercolour, private coll., 17.5 × 30 cm (7 × 12 in.), © The Artist

120 Toni del Renzio, *Le Rendez-vous des Moeurs*, 1941, gouache, private coll., 19.5 × 16.5 cm (7.6 × 6.5 in.), © The Artist

121 Ithell Colquhoun, *Dance of the Nine Opals*, 1942, oil on canvas, coll. Jeffrey Sherwin, 51 × 69 cm (22.5 × 28 in.), © The Artist's Estate

122 Ithell Colquhoun, *The Pine Family*, 1941, oil on canvas, Coll. Israel Museum, Jerusalem, gift of Arturo Schwarz, 46 × 50.5 cm (18 × 20 in.), © The Artist's Estate

123 Emmy Bridgwater, *drawing*, c. 1942, Indian ink on paper, private coll., 18 × 21 cm (7.8 × 8.2 in.), © The Artist

124 Emmy Bridgwater, *drawing*, c. 1942, Indian ink on paper, private coll., 18 × 21 cm (7.2 × 8.2 in.), © The Artist

125 Ithell Colquhoun, *A Visitation*, 1944, oil on canvas, private coll., 61 × 51 cm (24 × 20 in.), © The Artist's Estate

126 Emmy Bridgwater, *Remote Cause of Infinite Strife*, 1940, oil on cardboard double face, private coll., 41 × 51 cm (16 × 20 in.), © The Artist

127 Emmy Bridgwater, *Brave Morning*, c. 1942, oil on canvas, coll. Jeffrey Sherwin, 61 × 80 cm (24 × 32 in.), © The Artist

128 Edith Rimmington, *drawing from 'Message from Nowhere'*, 1944, 8 × 11 cm (3.1 × 4.3 in.), © The Artist's Estate

129 Edith Rimmington, *Eight Interpreters of the Dream*, 1940, gouache, private coll., 36 × 54 cm (14.2 × 21.2 in.), © The Artist's Estate

130 Cover of *Fulcrum* by Edith Rimmington, 1944

131 John Tunnard, *Psi*, 1938, oil on canvas, coll. Peggy Guggenheim, 87.5 × 128 cm (34.4 × 50.4 in.), © The Estate of John Tunnard

132 John Tunnard, *Fulcrum*, 1939, oil on canvas, 44.3 × 81.5 cm (17 × 32 in.), © The Estate of John Tunnard

133 John Tunnard, *Composition*, 1939, gouache, private coll., 73.5 × 54.8 cm (29 × 21.6 in.), © The Estate of John Tunnard

134 Grace W. Pailthorpe, *The Blazing Infant*, 1940, oil on board, private coll., 43 × 57.5 cm (16.9 × 22.7 in.), © The Artist's Estate

135 Reuben Mednikoff, *The Little Man*, 1944, oil on canvas, private coll., 50 × 40 cm (19.6 × 15.7 in.), © The Artist's Estate

136 Grace W. Pailthorpe, *The Spotted Ousel*, 1942, oil on cardboard, Coll. Israel Museum, Jerusalem, gift of Arturo Schwarz, 20 × 35 cm (7.8 × 13.8 in.), © The Artist's Estate

137 Cover of *Free Unions Libres*, 1946

138 Edith Rimmington, *drawing from 'Free Unions Libres'*, 1946, private coll., 14.5 × 18 cm (5.7 × 7.1 in.), © The Artist's Estate

139 E.L.T. Mesens, *La Partition Complète Complétée*, 1945, Indian ink and collage on paper, coll. Musées Royaux des Beaux Arts in Brussels, 30 × 46.1 cm (12 × 14 in.), © The Artist's Estate

140 Ithell Colquhoun, *Dreaming Leaps: in homage to Sonia Araquistain*, 1945, oil on paper, private coll., 78 × 54 cm (31 × 21.5 in.), © The Artist's Estate

141 John Banting, *From the Blue Book of Conversation*, c. 1946, 24 × 15 cm (9.6 × 6 in.) © The Artist's Estate

142 Conroy Maddox, *Warehouses of Convulsion*, 1946, oil and collage, painting lost, © The Artist

143 Conroy Maddox, *The Conspiracy of the Child*, 1946, oil on canvas, private coll., 100 × 65 cm (39.3 × 25.6 in.), © The Artist

144 Conroy Maddox, *Dénouement*, 1946, assemblage in box, coll. Jeffrey Sherwin, 21 × 33 × 36 cm (8.2 × 13 × 14.1 in.), © The Artist

145 Conroy Maddox, *Watchman, What of the Night?*, 1981, collage, private coll., 27 × 41 cm (10.6 × 16.2 in.), © The Artist

146 Emmy Bridgwater, *Transplanted*, 1947, oil on paper, coll. Jeffrey Sherwin, 52 × 36 cm (20.5 × 14.3 in.), © The Artist

147 Emmy Bridgwater, *Bursting Song*, 1948, oil on paper, private coll., 53 × 35 cm (20.8 × 13.8 in.), © The Artist

148 Edith Rimmington, *Museum*, 1951, private coll., 64 × 48 cm (25.2 × 18.9 in.), © The Artist's Estate

149 Edith Rimmington, *The Oneiroscopist*, 1947, oil on canvas, Coll. Israel Museum, Jerusalem, gift of Arturo Schwarz, 51 × 41 cm (20 × 16.1 in.), © The Artist's Estate

150 Edith Rimmington, *Mythical Composition*, 1950, pen and ink, watercolour on board, private coll., 53 × 74 cm (20.8 × 29.1 in.), © The Artist's Estate

151 Edith Rimmington, *Polymorphic Interior*, 1950, gouache, Coll. Galeria Nazionale d'Arte Moderna, Rome, 34.3 × 50.8 cm (13.5 × 20 in.), © The Artist's Estate

152 Roland Penrose, *Black Music*, 1940, oil on board, The Roland Penrose Estate, 16 × 45.7 cm (24 × 18 in.), © The Roland Penrose Estate

153 Roland Penrose, *Unsleeping Beauty*, 1946, oil on canvas, coll. Jeffrey Sherwin, 59.8 × 75 cm (23.5 × 29.5 in.), © The Roland Penrose Estate

154 Roland Penrose, *Question and Answer*, 1950, oil on board, private coll., 20.3 × 29.2 cm (8 × 11.5 in.), © The Roland Penrose Estate

155 Roland Penrose, *The Red Seal*, 1949, oil on cardboard, private coll., 35 × 25 cm (13.8 × 9.8 in.), © The Roland Penrose Estate

156 F.E. McWilliam, *Head in Extended Order*, 1948, Hoptonwood stone, private coll., length 60 cm (24 in.), © The Artist's Estate

157 Eileen Agar, *Garden of Time*, 1939/47, oil on paper, private coll., 63 × 47 cm (25 × 18.5 in.), © The Artist's Estate

158 Eileen Agar, *Caliban*, 1945, oil on canvas, private coll., 51.5 × 61.6 cm (20.6 × 24.6 in.), © The Artist's Estate

159 Thomas Samuel Haile, *Couple on a Ladder*, 1941–3, ink, watercolour, collage, private coll., 58 × 46 cm (22.8 × 18.1 in.), © The Artist's Estate

160 Thomas Samuel Haile, *A Children That Has Gone to Cheese*, 1943, watercolour, Leeds City Art Gallery, 33 × 26 cm (13 × 10.2 in.), © The Artist's Estate

161 Ithell Colquhoun, *Guardian Angel*, 1946, tempera, Peter Nahum at the Leicester Galleries, 32 × 36.5 cm (12.5 × 14.4 in.), © The Artist's Estate

162 Ithell Colquhoun, *Dervish*, automatic drawing, *c.* 1952, Indian ink, 44 × 31.25 cm (17.5 × 12.5 in.), © The Artist's Estate

163 'Scottie' Wilson, *Untitled*, early 1950, watercolour on paper, Mayor Gallery, 36.8 × 53.3 cm (14.5 × 21 in.), © The Artist's Estate

164 'Scottie' Wilson, *Greedies II*, 1950s, watercolour on paper, Gimpel Fils Gallery, 45.5 × 32 cm (17.9 × 12.6 in.), © The Artist's Estate

165 Desmond Morris, *Entry to a Landscape*, 1947, oil on board, Peter Nahum at the Leicester Galleries, 50 × 40 cm (20 × 16 in.), © The Artist

166 Desmond Morris, *The Progenitor*, 1950, oil on canvas, coll. Mark Seidenfeld, 30 × 40 cm (12 × 16 in.), © The Artist

167 Desmond Morris, *Endogenous Activities*, 1950, oil on canvas, coll. estate of Mrs Mary Horswell, 52.5 × 77.5 cm (21 × 31 in.), © The Artist

168 Desmond Morris, *Fear of the Past*, 1957, oil on canvas, private coll., 17.5 × 35 cm (7 × 14 in.), © The Artist

169 Cover of *TRANSFORMAcTION*, issue 9, 1979

170 Anthony Earnshaw, *Homage to Jason*, 1985, mixed media, coll. the artist, 36 × 20 × 26 cm (14 × 18 × 10.2 in.), © The Artist

171 John W. Welson, *Interior of Wuthering Heights*, 1977, oil on board, private coll., 23 × 30 cm (9 × 11.8 in.), © The Artist

172 Philip West, *Derailed Sea*, 1987, oil on canvas, Coll. M.R. Mateos, 100 × 73 cm (39.4 × 28.7 in.), © The Artist's Estate

Foreword

No study of twentieth-century art published in any country, even in Britain, has given British surrealism the attention that it deserves. Yet it not only produced an astonishing quantity of poems, sculptures and paintings, but was also a fully grown part of the international surrealist movement, whose dominance in twentieth–century aesthetics is indisputable. It is surprising that British critics and art historians, and most institutions, have found it difficult even to acknowledge this important episode in the history of their own country's art. Either it has too easily and rapidly been dismissed as negligible, or it has been always reduced to the same two or three names: Paul Nash, Henry Moore and, erroneously, Graham Sutherland. The fact that these three have been blessed by the establishment has let critics off giving due consideration to the force of the movement, by either ignoring its other members or by implying that it was ephemeral. Only in exhibitions organized by private galleries or in huge international commemorative exhibitions has British surrealism had a chance, over the past ten years or so, to find a place where it has not been underrepresented.

The obscurity that has shrouded the 40-odd poets and artists taking part at some point in the movement in Britain may well be due to the giant shadow cast by British surrealism's own progenitor, or elder brother, continental surrealism. Its main actors, like Dalí, Ernst, Miró, Tanguy and Masson, have sometimes received critical attention that has been so specific that it has verged on the obsessive – for example, the authors of the many books on Dalí or Magritte have tended towards non-aesthetic preoccupations. However, studies have recently been made of the Dutch, Danish, Swedish and Czech branches of surrealism, which suggests that there is an interest in the specific ways that the issues addressed by surrealism have spread internationally. Generally speaking, these studies refuse to consider French surrealism as a model for surrealism elsewhere, preferring to judge these other movements in their own right.

A systematic reassessment of British surrealism began in 1971 with a wide-ranging show at the Hamet Gallery, with 115 works. There followed a mammoth exhibition, 'Dada and Surrealism Reviewed', at the Hayward Gallery in 1978. This included 52 British surrealist works, but unfortunately ignored half a dozen significant artists. In Paris in 1982, more than 130 surrealist works were shown at the Galerie 1900–2000 and several exhibitions were mounted to commemorate the fiftieth anniversary of the London International Surrealist Exhibition.[1] Original or travelling exhibitions were also staged at the Mayor Gallery in London, in Colchester, Canterbury, Newcastle, Hull, Middlesborough, Swansea, and, of particular note, in Leeds, offering in almost every year some further explorations of the world perceived by the British surrealists.[2] British surrealism has been given attention in several other countries, as evidenced by international shows in Retretti, Finland (1986), Geneva (1987), Milan (1989), Frankfurt (1990), Berkeley (1990) and Canberra (1996).[3]

In many minds, British surrealism nonetheless remains an annex to its French equivalent. The aim of this book is to re-establish the balance so that readers can assess the range of 'visual propositions' specific to British surrealism as well as the difficulties that it encountered in trying to introduce its main principles and questions into pre-war and wartime Britain. We are confident that this work will bring to light and encourage further study of a hidden, obverse side of twentieth-century British art.

Essentially, British surrealism shared and developed the fundamental tenets of French surrealism, laid out as early as 1924 by André Breton in the first *Manifesto of Surrealism* and in successive issues of *La Révolution Surréaliste*. In 1929, these were expanded via the *Second Manifesto of Surrealism*, coincidentally with the launching of the militant magazine *Le Surréalisme au Service de la Révolution*, which lasted until 1933. Within ten years, the foundations had been laid for one of the most genuinely subversive movements in the history of ideas. During this time, the rapid spread of the cross-cultural spirit of surrealism provoked considerable activity, the launch of various magazines and the establishment of formal groups in Yugoslavia (1924), Belgium (1926), Romania (1928), Czechoslovakia and Denmark (1929), the Canary Islands (1932) and Egypt (1934), along with the migration of artists to Paris from Germany, Switzerland, Cuba, Chile and Spain specifically to join the movement between 1925 and 1935.

To understand the historical importance of surrealism, one must realize that above all its appearance in 1924 was as the *coda* to a whole series of aesthetic questionings and counterquestionings. Together these made surrealism not so much another art movement as a state of mind, a 'disposition of the soul' in Patrick Waldberg's words, and an entire mode of knowledge and being.

From impressionism in the 1850s to Dadaism in the early 1920s, Western art placed the nature of reality, and its perceived stability and reliability, increasingly under examination and criticism. Nineteenth-century theories had come to dwell on the composition of light and its effects on striking individual objects. Such ideas refused to consider objects merely as surfaces and determined to see them *beyond* their external appearances, passing to their internal nature as reflected through the vision of the artist, thus reinstating the self as the centre of vision. In this way post-impressionism and fauvism had emphasized the deep organic qualities of things, choosing to paint in 'unrealistic' colours so as to transfigure the object and free it from habitual ways of seeing. By submitting so-called reality not only to the modifying action of light, but also to each subject's unpredictable *intensities*, the artist gives the viewer access to an underlying world that is both chaotic and awe-inspiring, between what is known and what is yet to be discovered. It was left to Cubism to go one step further, fragmenting objects and figures, and making the eyes sneak into the interstices of a work, in celebration of reality's general, irresistible slippage and of the viewer's power of reconstitution.

The turn of the twentieth century might have seen this as the ultimate point that could be reached as doubt transformed itself into a system of disconcerting perspectives. But 1900 was the year when Sigmund Freud published *The Interpretation of the Dreams*, and in 1905 Einstein published studies which were to constitute his theory of relativity. A more fundamental questioning followed a few years later when World War I challenged the arguments of Futurism against humanistic values and its praise of the Machine. More radically, the slaughter of millions of soldiers on both sides in the war prompted most intellectuals and artists to distrust, if not be disgusted by, such hitherto sacrosanct values as flag, fatherland, family and religion. How could any of these vainglorious concepts still be extolled when they had been used to justify such monstrous mass-killings? Indeed, how could one still accept those philosophies and beliefs which failed to condemn it? Consequently around Apollinaire and the review *L'Esprit Nouveau* there gathered a small group of painters and poets, among whom were Juan Gris, Braque, Chagall, Picasso and de Chirico, and poets such as Breton, Soupault and Paul Valéry. From the middle of the war this group grew as a force of change and disruption. It was soon to welcome to its membership Tristan Tzara, the founder in Zurich of the Dada movement, who arrived in Paris in 1919.

From the end of the war, Paris resounded with the iconoclastic provocations of Dada, a movement of fundamental protest which advocated utter doubt and complete demoralization. It was fiercely antidogmatic, denied anyone the right to speak as its leader or representative, recognized no predecessor nor successor, and, whether by plastic, graphic or verbal means, expressed itself with the sole aim of creating confusion. At poetry readings

poems were delivered inaudibly from inside papier mâché masks, in public meetings objects were thrown at the public, and its magazines were disfigured with bewildering typographies and formats. It was from this revolt by Dada against all comfortable systems – and itself – that surrealism was to arise, as a codified, more pragmatic form of deconstruction. In Breton's words the two movements correlate 'like two waves unfurling one over the other'. Dada was a 'decisive effervescence', needed for its anarchistic debunking and effacement of debased values. Thereafter new theories and new 'morals' could emerge, arising from a total independence of thought, and retaining from Dada the concept of poetry as a vital expression of the self, literally an 'activity of the mind'.

In November 1924, André Breton published the first *Surrealist Manifesto*; in December, the first issue of *La Révolution Surréaliste* followed. The former has become the main source of surrealism's principles and programme. Among these the following can be identified as the starting-point for all explorations, whether it be in poetry, painting, the cinema, photography or sculpture:

SURREALISM, noun, masc., pure psychic automatism by which it is intended to express, either verbally or in writing, the true function of thought. Thought dictated in the absence of all control exerted by reason, and outside all aesthetic or moral preoccupations.

ENCYCL. Philos., Surrealism is based in the belief in the superior reality of certain forms of association heretofore neglected, in the omnipotence of the dream, and in the disinterested play of thought. It leads to the permanent destruction of all other psychic mechanisms and to its replacement of them in the selection of the principal problems of life.

Breton then extends this statement:

Surrealism rests upon the belief in the superior reality of forms of associations hitherto neglected, in the almightiness of the dream, in the disinterested play of thought. It tends to ruin definitively all the other psychic mechanisms and to replace them in the resolution of the main problems of life.[4]

This belief directly derives from experiments by André Breton and Philippe Soupault in automatic writing, conducted around October 1919, which they published serially in the review *Littérature*. During these sessions, both writers entered into as passive a state as possible, letting their pens run freely over the page to record whatever passed through their minds without interference from rational or logical control. In that way, it was hoped both poets might manage to capture startling images from the dormant recesses of the mind, as evidence of the mind's fecundity when liberated from the restraint of reason.

During the many sessions they held, countless word-associations emerged, revealing an inner space to which Freud had largely paved the way. It is through the general articulation of this space that each of us can

expand our own awareness, by stepping across to, and joining, an *other* reality, a surreality: 'I believe in the future resolution of those two states, apparently contradictory, dream and reality, into a kind of absolute reality, a surreality, if one may say.'[5]

The *Second Manifesto* was to clarify surrealism's ambition yet further, along with the new function that poetry was to serve: 'There is every reason to believe that there exists a certain point in the mind at which life and death, real and imaginary, past and present, communicable and incommunicable, high and low, cease to be perceived as contradictory.'[6]

Thus, Surrealism is not merely a new aesthetic; it is a mode of knowing, of living. It is only through a constantly renewed attempt to determine the 'supreme point', at which destruction and construction no longer stand in opposition, that one can embrace the socio-political aspect of surrealism. However unfettered the surrealist artist should ideally be, revolt against conventional poetic models calls constantly upon a deep sense of responsibility. Those French and English surrealists who joined the Communist Party for a while, still believing this to be the torchbearer of proletarian revolution, soon realized that it had become the instrument of Stalin's totalitarian policies, including dictatorship over the mind. In 1938, they allied themselves with Trotsky, a process marked by a solemn declaration signed by Breton and Rivera in Mexico to create an International Federation of Revolutionary and Independent Artists. But after Trotsky's assassination in 1940 the surrealist movement refused all labels, merely accepting that its members were free to align either with later Trotskyism or with libertarian movements. In connection with this, André Breton's earlier declaration in Tenerife, in 1935, when asked if art could 'put itself into the service of a definite political idea', is relevant:

It must unreservedly put itself into the service of the idea during the period in which the idea is transformed into action . . . It is indispensable, however, that art regain its independence if the artist wishes to escape serious contradictions objectively harmful even to the idea which he wishes to serve.[7]

In other words, surrealism exemplifies a philosophy of immanence that sees the world of true existence as not being divorced from the world as commonly perceived, but contained within it, waiting to be uncovered.

For this reason, the surrealist artist sees it as his moral and political duty to precipitate revelation by any method, no matter how violent, 'in order to start a vertiginous descent into the hidden territories of the subconscious'. Surrealist works, written or painted, thus seek, in Breton's words, 'the extension of the possible'. Their validity can only be judged by the extent to which they widen the perception of the relationships between things, deepen the understanding of what lies behind the façade of reality and create an end-

less, for ever insoluble, interrogation of not only what one sees but what one is. Because a surrealist image in a poem or on a canvas purports to make the reader or viewer re-examine the whole universe and the way it is constituted, that viewer or reader is unavoidably brought to stand at the origin of relations that he had formerly seen as unthinkable.

Marcel Duchamp claimed that one half of each surrealist work was made by the artist and the other half by the onlooker. To this extent, it should be seen both as the repository and the deliverer of desire. Confronted with a surrealist work, the reader, too, writes the poem, the viewer helps to paint, mentally and imaginatively, the scene he is made to see. In each case, however, he acts on another register – that of his own triggered desires and fears. The work no longer challenges the establishment of a particular meaning; instead it favours the endless creation of meaning in a kind of Brownian agitation.

It follows that no writing, no painting can be analysed only from a purely aesthetic, technical angle. In surrealism there is no technique as such, but only an unbounded series of *strategies*, aimed at destabilizing the gaze and conducted from as many angles as possible, with the object of involving the whole individual. This approach seeks never to dissociate the artist's work from his 'public' involvement. In that sense, no one could conceive of a surrealist being a member of any church or sect, or supporting a political creed based on the repression of the individual's freedom and desires.

Here the critical notion of a group as a self-defined, self-growing, constituted body arises. The surrealist group is, all things considered, the only guarantee of the moral coherence of its members. Indeed, from the very outset, surrealism has necessarily been a collective experience; it is only through the group that the surrealist affirmation can become a *presence*, since the group is the seat of certain shared moral exigencies and issues. In its modes of functioning, the group cannot be dissociated from the surrealist practice as a whole, which makes the surrealist group radically different in concept from any other, whether political or religious. The surrealist group is, in itself, exploration *and* discovery, construction *and* destruction, law *and* transgression of the law, a place of conjunction *and* disjunction. Another group is *always already* present in the group, and it is from within it, and almost in spite of it, that the surrealist proposition keeps building itself and evolving. Accepting all kinds of, by definition, inassimilable individualities, welcoming all kinds of emancipatory strategies, the group, as an entity, acts as a rampart against individual deviation; perceiving the difficult cohabitation of the individual and the collective, it thus vouchsafes its members' endless investigation and requestioning in their work. Thus it is for the leader of the group to affirm himself by denying himself; standing in the eye of the hurricane, it is he who must maintain the pressure to keep surrealism as an ever-

receding object of desire.

British surrealism in some ways exemplified this fluctuating structure superlatively well. It was a source of both unity and disparity, of 'free unions', in the words of the title of one of its magazines – so much so that it can hardly be defined at any moment by any list of members. In its own workings, the British surrealist group unwittingly showed how impossible it was for any such body to have a *definitive* presence. A locus of forces, a forum of spectral voices, it represented in the very fallibility and resistance of its members the difficulty of repeatedly confronting visions that were thought-defeating in their constitutive evanescence and their uniqueness.

In looking at British surrealism one should not underestimate the effect of the lack of sustained interest in collective work or in the defence of common values that is inherent in the British individualistic diffidence towards ideologies and the formation of closely knit groups. A sense of failure is all too apparent even in the most committed members of the group in their groping after such coherence. This is especially so when seeing them from above so to speak; that is from a dualistic point of view. Seen from below, however, from the midst of the surrealist ranks, such failure is the obverse of the many attempts by each and every artist and poet to recuperate the totality of our psychic forces 'to communicate with the unknown', in the words of Maurice Blanchot. (Blanchot also bids us remember that 'to communicate with the unknown requires plurality'.[8])

This book results from twenty or so years of patient research, through museum files, gallery archives and personal memoirs. Interviews – often three or four per artist – were systematically conducted with practically all the members of the surrealist group in England, or its fellow-travellers – those at least who were still alive in the late seventies. This first-hand knowledge, often transmitted by people who had become the author's friends, has proved invaluable in providing anecdotes or personal viewpoints which illumine the more theoretical critical analyses of individual works. The aim has been to recapture, from a viewpoint both interior *and* exterior, the 'living context', essentially socio-political, within which a number of people decided to form their own group to risk going counter to aesthetic fashions and decorum – not a common event in British art history.

My research was helped considerably by the friendly and patient welcome extended to me by many artists and their companions: Eileen Agar, Emmy Bridgwater, Cecil Collins, Ithell Colquhoun, Toni del Renzio, David Gascoyne, S.W. Hayter, Monica Kinley, Conroy Maddox, George Melly, Robert Melville, Desmond Morris, Sir Roland Penrose, Edith Rimmington, Philip Sansom, Marian Torres, Julian Trevelyan and John W. Welson. Help, advice and stimulating remarks I owe to Edouard Jaguer and Anne Ethuin,

Yves Laroque, Lisa Rull, Michael Sweeney, Rui Moreira Leite, Christiane Krauss-Geurts, Kathleen Raine, Isabelle Ewig, Sarah Wilson, Andrew Murray and Ann Simpson.

The Librarian of the Tate Gallery Archives, Andrew Glew and Simon Wilson of the Tate Gallery, the Librarians at the British Library, British Museum and the Librarians at Senate House, University of London were very helpful in research.

Thanks are also due to the Centre de Recherches des Ecritures de Langue Anglaise (C.R.E.L.A.) at the University of Nice and to all those who kindly, and often generously, gave permission to reproduce works: Tony Black, Mrs Frazer, Jean-Pierre Kahn, Arturo Schwarz, Charlotte Jennings, Mary-Lou Jennings, Anthony Penrose, Emmy Bridgwater, Conroy Maddox, Toni del Renzio, Sarah Gretton, Peter Nahum, Mrs Eugene Rosenberg, Jeffrey Sherwin, M. R. Mateos, Anthony Earnshaw, and John W. Welson.

My warmest and most affectionate gratitude and a profound sense of indebtedness go to Monique and the late Dudley Hatch in Maidenhead, Somerset.

Obviously, too, this book would never have seen the light without the venturesome spirit of Nigel Farrow of Ashgate Publishing, Elfriede and Alan Windsor, and my indefatigable editors, Pamela Edwardes and Sue Moore.

Exits and entrances

When the Manet and the Post-Impressionists exhibition, organized by Roger Fry and Clive Bell, ran at the Grafton Galleries from November 1910 to January 1911, no one could conceive of the far-reaching consequences of the 'revolution of the gaze' that it represented. It was destined to bring in one of the most important innovations in twentieth-century art, and the first in a series of challenges to England's insular artistic conservatism.

The influence of the New English Art Club, formed in 1886 in reaction against the Royal Academy by artists such as Sargent and Steer, had previously been overwhelming, but it was now on the wane, due to lack of inspiration and repetitive subject matter, 'the august-site motif, and the smartened-up-young-person motif', in Sickert's words. Its diminishing achievements contrasted greatly with the revision of aesthetic values that had been taking place in France since the 1880s. Within the Club's own ranks, a progressive wing was moving away from total allegiance to impressionist techniques and use of colour; instead it embraced a post-impressionist view of reality, together with a vehement treatment of colour almost independent of the object as such, and an unsophisticated treatment of form no longer intent on representation.

Most critics realised that Fry and Bell's presentation of Manet as a celebrity was a strategy to show the works of certain other artists. Some of these were seen either as mad, like Van Gogh, or bad, like Cézanne, or simply unacceptable by the standards of impressionism which had eventually been accepted by the British public and art world. Many people felt they had been swept along by the rapid changes in French painting, and reacted to the new styles by entrenching themselves behind accusations that the works represented 'horror', 'madness', 'putrescence', 'pornography', 'anarchy' and 'evil'. These terms were later to appear frequently in articles on surrealist art in Britain.

The creation by Frank Rutter, the *Sunday Times* art critic, of the Allied Artists Association in 1908 was inspired by the French Salon des Indépendants, a means of allowing artists to exhibit outside the restrictions of an academic-minded jury. Although part of the New English Art Club, its existence also implied criticism of the Club's narrow-mindedness, and eventually various progressive artists seceded to form the Fitzroy Street group and subsequently the Camden Town Group. Spencer Gore was its president, and its members included Augustus John, Lucien Pissarro, W. Ratcliffe, Sickert and Wyndham Lewis. All were strongly influenced by recent developments in French art, most of them having studied or worked in France. What distinguished them from other members of the New English Art Club was their deliberate choice of, and concern with, low-life subjects and their social and urban treatment of portraits, interiors and scenes from cities and suburbs, almost to the exclusion of rural, sentimental scenes. They largely turned their approach into social activity, one best summed up in an article by Charles Ginner in January 1914, praising 'Neo-Realism', and quoted by Charles Harrison in his *English Art and Modernism*:

Neo-Realism ... must interpret that which to us who are of this earth, ought to lie nearest to our hearts, i.e. life in all its aspects, moods and developments. Realism, loving life, loving its age, interprets its epoch by extracting from it the very essence of all it contains of great or weak, of beautiful or of sordid, according to the individual temperament.[1]

An exhibition at the Grafton Galleries was of key importance, coming as it did towards the end of 1910, between the launching of Rutter's AAA and the founding of the Camden Town group. The new movement became the cause for, or against, which one should now fight. The fierceness of its critics and the ironical comments of art specialists and teachers, currently intent on inculcating fluency of draughtsmanship and sophistication of form, all indicate that the time had come to redefine artistic criteria and codes. Fry and Bell meanwhile were developing a strong interest in primitive art and in establishing links between post-impressionism and, for example, children's art. Consequently, they helped radicalize the debate by centring it upon the necessity to sever the expression of the artist as an individual from the hitherto indisputable objective quality of reality.

The most remarkable feature of this dispute was the powerful influence of the aesthetic upheaval taking place in France, and the subsequent domestic debate about what was called the 'evils of cosmopolitanism'. The conflict repeated itself a year and a half later when in the autumn of 1912 Fry organized the second post-impressionist exhibition, which was mainly devoted to the emergent British avant-garde, notably Wyndham Lewis; and again the following year at the Doré Galleries with an exhibition organized by Frank

Rutter, 'Post-Impressionists and Futurists', in October 1913. The latter show came as an attempt at reconciling the irreconcilable, namely cubism, post-impressionism and futurism: it thus constituted the first solemn gesture of severance from the more insular aspects of Bloomsburyism. Indeed, its object had been to highlight the birth of an avant-garde movement which did not follow Roger Fry's endeavour to produce a British form of post-impression-ism. The stimulus had been given by the Italian Filippo Marinetti on his fre-quent, highly publicized visits to London. Each of these had been marked with exuberant events at which he would read onomatopoeic poems and strident free verse paeans to the greater glory of the machine. Interestingly enough, this tied in with Wyndham Lewis's move away from the con-strained Bloomsbury group and from Roger Fry's belief that 'all the essential quality [of a work] has to do with pure form'. The rift between them started in October 1913 when some obscure accusation of dishonesty was levelled at Fry by Lewis. It became irrevocable after other hard-hitting, abusive public declarations were made by the secessionists, who saw themselves as rebels appointed to subvert the English artistic establishment and celebrate in the most iconoclastic way the dawn of a new aesthetic. Virility, uncompromising energy and liberation from representational subject matter were the main tenets which Frank Rutter's exhibition propounded, through works by people such as Nevinson, Wadsworth, Epstein, Etchells, Hamilton and Lewis.[2]

The exhibition was the occasion for Lewis to discover a close-knit group – David Bomberg joined three months later – and, as a consequence, for him to travel an increasing distance from Marinetti's wild romantic poses and nega-tion of the past, in the same way as he had from Fry's pacific Bloomsbury group and Sickert's uninspiring Camden Town group, with whom he had flirted. Lewis did draft a form of programme; its substance, however, was vague, in that it merely asked for a seriousness of purpose which the Italian futurists did not have, and for the 'realization of the value of colour and form as such independently of what recognizable form it covers and enclos-es'. Such primitivism was bound to meet with Ezra Pound's conception of a whirling force which would attract and synthesize all the most innovatory contemporary techniques and strategies in art, whether poetry, painting or sculpture. The vortex, a motif already used by Lewis in drawings of 1912, and which had haunted Pound's poetry for the preceding five years or so, became the emblem of the new art, whose name 'vorticism' was coined by Pound in the spring of 1914.

Pound had tried to delineate a new approach to poetry, based exclusively on the image. The image was seen as an 'energetic centre', radiating an intrinsic force; it was a circle, free of the limitations of space and time, achieving in itself a balance between the finite and the infinite. It was seen as

a semantic pattern of energies, a whirlwind of mental and physical forces, a means of elevating objects into the sphere of mental, intellectual activity. The term 'imagism' itself was first applied in 1908 by the poet T.E. Hulme in the preface to his own *Complete Works*, and was soon found to be limited by its application solely to writing. Meanwhile Pound inevitably saw in the new movement the enlargement and extension of his own poetical theories. In a made-up interview with F.S. Flint in 1913, Pound had already outlined what he saw as the four main principles of imagism:

1) Direct statement of the 'thing' whether subjective or objective.
2) To use absolutely no word that does not contribute to the presentation.
3) As regards rhythm, to compose in sequence of the musical phrase, not in sequence of a metronome.
4) To conform to the 'doctrine of the image'.[3]

In the preface to the 1915 anthology, *Some Imagist Poets*, these principles are further extended, with an insistence on the need to 'employ always the *exact* word', 'to create new rhythms . . . a new cadence means a new idea', to 'allow absolute freedom in the choice of the subject' and 'to produce a poetry that is hard, clear, never blurred', based on the essential principle of 'concentration'. The similarities between these principles and those of vorticism are obvious. In a way, imagism became the literary section of vorticism and as such, it was absorbed, superseded by vorticism. Both movements shared a passionate radical determination to make a clean slate of it all, driven by the same spirit of revolt that castigated those who defined art in terms of 'Englishness'; and both launched violent diatribes against firmly established aesthetic values.

In March 1914 the Rebel Art Centre was founded, as an insurrectionary stronghold from which forays could be launched into the complacent art world. Non-figurativeness and geometricality were on the agenda, as Lewis, Wadsworth, Nevinson, Etchells, Hamilton met at 38 Great Ormond Street on Saturday afternoons, joined by Pound, Marinetti and Ford Madox Ford as friends and occasional lecturers.

The new movement was to develop in a way that removed it from Marinetti's influence, gradually severing the umbilical cord that had bound it to Futurism. This process was complete when in June 1914 it was announced that the group would henceforth call themselves 'vorticists'. The change was made more obvious by the simultaneous publication of the first issue of *Blast*, which Lewis had been preparing and advertising for some months. This featured a violent 'Manifesto of the Vorticists', and struck the iconoclastic note that was to be inseparable from the movement. Stamping huge letters in bold type across its pages, dividing each page with diagonals and suspending words in varying types from vertical lines, rearticulating

space with monumental slogans and pyrotechnical arrangements of words – making the verbal visual – the publishers blasted England with aphorisms. Members of the establishment were attacked by name as the magazine affirmed its unflinching intention to clean the country of 'the famous English 'humour', the thrilling ascendancy and *idée fixe* of Class, producing the most intense snobbery in the World'.

BLAST
years 1837 to 1900
Curse abysmal inexcusable middle-class
(also Artistocracy and Proletariat)
[. . .]
BLAST
The Post Office Dean Inge
Galsworthy Croce Matthews
C.B. Fry Elgar Lyceum Club
Tagore Beecham

In spite of the war – were they challenging its destructiveness or subconsciously fascinated by its steamrolling machinery? – the group's activities developed unabated. In June 1915, the Doré Galleries organized the first and only vorticist exhibition, with 49 works. The core of the show was formed by Roberts, Lewis, Gaudier-Brzeska, Etchells, Dismorr and Wadsworth. In July that year, the second issue of *Blast* came out. This was more subdued in tone, and revealed a group united by reaffirmation of a belief in the mission to be fulfilled 'on the other side of the World War'. The central tenets were summed up as: 'activity as opposed to the tasteful passivity of Picasso', 'significance as opposed to the dull or anecdotal character to which the Naturalist is condemned' and 'essential movement . . . as opposed to the imitative cinematography, the fuss and hysteria of the Futurists'. It was to be the last public group appearance of the vorticists. 'Long Live the Vortex!', the first *Blast* had proclaimed. Yet, warfare and the artists' subsequent dispersal, the death in the war of Gaudier-Brzeska and T.E. Hulme, the unfavourable reviews of the 1915 exhibition, the treatment of the vorticists' plastic propositions as unintelligible jokes, the way the destructiveness of the war seemed to condemn what the futurists had celebrated – all this tolled the knell of the movement, which proved incapable after 1918 of recovering its momentum. It was soon reduced further by critics such as Clive Bell for 'having become an insipid as any other puddle of provincialism'. Having never been properly understood, the movement fell into oblivion as early as the twenties, with no one except Pound realizing what part vorticists had played in the shaking of a complacent art world out of its conservative beliefs. Vorticism is apt to seem like an anticipation of surrealism's own intransigence, but this is not to say that vorticism – and imagism – were harbingers of surrealism.

There is no such link as might be detected between, say, dadaism and surrealism. Nonetheless, by unilaterally stepping aside from the mainstream, elaborating attacks rather than defences, and flatly refusing to join in the formation of any system, the vorticists did open a breach in the habits of the art world. Indeed, the emphasis was not on the renewal of theoretical thought but on the necessity to subvert and change the process of thinking itself. Exactly as the surrealists were to advocate.

As the heat of the vorticist blast furnaces faded and the 'Primitive Mercenaries in the Modern World', as they called themselves, gradually returned to figuration and representationality – disgusted as they were by the human toll taken during the war by those machines they had once extolled – resistance to the dominant ideology coincidentally shifted ground. Passing into the political field, it was to develop in ways that were sometimes surprisingly drastic. This movement, born out of the perception that a new dawn seemed to rise with the Bolshevik revolution in Russia, was not confined to Britain, but spread throughout Europe. To some extent, it filled the ideological void left by World War I, and in Germany was a response to the ensuing political chaos. Its proposal of new values and reordered system of thought attracted the intelligentsia throughout the West and, particularly in Britain, the undergraduate population – a tendency shown in various magazines of the universities of Oxford and Cambridge, such as *Experiment* in Cambridge, *The Oxford Outlook* and Anthony Blunt and Michael Redgrave's *The Venture* in Oxford.[4]

Of these, *Experiment* started publication in 1929. Though aptly named, it never departed from established intellectual standards in its emphasis on 'a clearing up of beliefs' and the 'building up of a uniform and contemporary artistic attitude'. New literary values had to be discovered, declared Julius Bronowski in his introduction to its manifesto of November 1929, and it was for *Experiment* to lead the way in finding them and to become the *locus* of all propositions. Bronowski struck an unfamiliar note, in his refusal to classify or theorize from the basis of accepted ideas. While the other magazines insistently sought a new unity, *Experiment* advocated a 'suspension of beliefs', a blending of protest with rationalization of that protest. *Experiment* sought to distance itself from all moral codes, ethical beliefs and the definitional labels.

We have lost faith, you see, in this tinkering with the structure of literature: and if you find us labouring it is because we are trying to shift, ever so slightly, its bases. Rather accidentally; because we invented no principles; and now that they have happened to us, they are uncertain and not at all startling. A sense that literature is in need of some new *formal* notation . . . a belief in the *impersonal* unit: a belief, and a disbelief – for it is about this mainly that we are at odds – in *literature* as a singular and different experience, something more than a mere *ordering* of life. You see how haphazard it all is. And its criterion ultimately is only again *Experiment*.[5]

Contributors including Julian Trevelyan, Hugh Sykes Davies and Humphrey Jennings all gave expression to this desire to de-axiomatize literature and the arts. 'Let us gladly shout: To dream is TO CREATE,' wrote Julian Trevelyan. It was in the pages of *Experiment* that literary activity was first transformed into an area of unorganized expectation.

Simultaneous with these three 'literary' magazines, Oxford and Cambridge came to the fore of the political scene with avowedly left-wing publications from 1931 onwards. For example, *The Outpost* was the first step to the left with articles on the economics of unemployment, on the proletarian revolution, and on the necessity to release culture from the hands of the elite. The *Student Vanguard* – one of the most militant of the magazines – went further, and sought the concealed place where a wedge could be hammered into the dominant ideology.[6]

The intellectuals' and the artists' political militancy culminated in the publication of two seminal anthologies of poetry in 1932 and 1933, edited by Michael Roberts. The evolution, within one year, from the former, *New Signatures* to the latter, *New Country* symptomatically testifies to the artist's growing involvement in social issues.[7] It is the function and duty of the poet – the witness of the collapse of all *absolutes* – as Michael Roberts writes in his preface to *New Signatures*, to cultivate an impersonal form of poetry, not out of detachment but out of feeling of 'solidarity with others'. He then radicalizes this view in the preface to *New Country*, strongly advocating the artist's alliance with revolutionary forces and a renunciation of aesthetics based on the class system:

If our sympathies turn towards revolutionary change it is not because of our pity for the unemployed and the underpaid, but because we see at last our interests are theirs ... If [the Marxist doctrine] seems inelastic and fails to understand a temper which is not merely bourgeois but inherently English, it is for us to prepare the way for an English Lenin, by modifying and developing that doctrine.

The *Transatlantic Review*, published from January to December 1924, was the first magazine to help the passage of surrealism from France to Britain.[8] Though it only used the word 'surrealism' once, it referred many times to the main protagonists of the movement. The magazine was bilingual, edited in Paris by Ford Madox Ford, notwithstanding that Ford's permanent base was London; the Paris correspondent was the former Dadaist Philippe Soupault, André Breton's companion in the first hours of surrealism. Among the contributors, Jacques Baron and René Crevel published notes and reviews, and called for 'a total re-evaluation of the literary assets of Anglo-Saxondom'. They also drew attention to the originality of contemporary French poetry, the 'Vers-Libristes, Symbolistes, dadaises'. Tristan Tzara's poems and the work of Brancusi, Picasso, Aragon, Eluard and Breton delineated the new and vital scene opening in the world of French arts and letters.

After one year, the *Transatlantic Review* had to stop for lack of readership – circulation was about 1500 copies, 150 of which were sold in England. Its place was taken by *transition*, another avant-garde review, which built a strong cultural bridge between France and Britain, but from a more intransigent angle.[9] It militated for a new language and new visions, adopting as its slogan Rimbaud's 'hallucination of the word'. Its manifesto 'Revolution of the Word', published in June 1929, demanded the artist's right to 'disintegrate the primal matter of words imposed on him by textbooks and dictionaries', and 'disregard existing grammatical and syntactical laws'. Understandably, no surrealist signed this declaration, since the hallucination of the word can only be seen by surrealism as a stage, not as an end in itself; surrealists never aimed at stepping outside the laws of language; on the contrary, they aimed at trapping language from the inside. Yet, *transition*'s declaration also partakes of the same desire for subversion and of the belief in the possibility of expressing through a renewed language the various strata of human conscience: 'I believe in [the creator's] right to audaciously split the infinitive ... It is necessary that grammar become a-logical again. I believe in the dynamics of an inner grammar.'[10]

The guiding spirit of *transition* was Eugene Jolas, an American expatriate in Paris. Jolas never flagged in advocating 'the refusal of the mathematical logic of language', in his investigation of language as the voice of the irrational, nor in seeking the 'reality of the universal word'. His quest came to border on the mystical. Indeed, in 1933, in proclaiming the 'twilight of the horizontal age' and the new 'Vertigral Age', which would 'lead the emotions of the sunken, telluric depths upward toward the illumination of a collective reality and a totalistic universe', Jolas called for creation of 'a primitive grammar, the stammering that approaches the language of God'.[11] Subversion stops where theological abstraction begins, and Jolas never had unmitigated support from the surrealist movement.

What emerges from this is what might have brought *transition* and the surrealists together – the idea of a savage eye and mind and the vast iconoclastic enterprise of demoralization – as well as what might have separated them, namely the lack of a clearly expressed political standpoint, and a singular *Rousseauistic* nostalgia for a golden age of language. The review constituted a formidable attempt at finding the primeval chthonic energy along with modes of writing to express that energy. Altogether, it published 24 surrealist poems, translated into English by Jolas, Beckett and Stuart Gilbert, and the scenario of Dulac and Artaud's *The Seashell and the Clergyman*, and reproduced no less than 49 surrealist works. Furthermore, *transition* published such seminal texts as Breton's 'Introduction to a Discourse on the Dearth of Reality', extracts from *Mad Love* and *Nadja* and, in 1927, 'Hands Off Love', a manifesto in defence of Charlie Chaplin, then under attack by several

American papers. The link between surrealism in England and France was also furthered by *transition* with its publication in June 1930 of 30 pages given over to the Experiment group. Under the title 'Experiment – A Manifest', it featured texts by Julius Bronowski, Julian Trevelyan, Humphrey Jennings, Kathleen Raine, Hugh Sykes Davies and George Reavey, most of whom were to be members of the surrealist movement in Britain.

The first review to show surrealism as the making of a collective body of artists was *This Quarter*, edited in Paris by Edward W. Titus and widely circulated in Britain.[12] Under the editorial responsibility of André Breton, its September 1932 issue was devoted entirely to surrealism, which thus appeared for the first time as a constituted force, an organized movement which 'must be taken as it stands, measurable as it is by no standard that we know', as Edward W. Titus wrote. In his preamble, 'Surrealism Yesterday, Today and Tomorrow', Breton salutes the English ancestors of surrealism – Young, Radcliffe ('surrealist in landscape'), Swift ('surrealist in malice'), Monk Lewis ('surrealist in beauty of evil'), Maturin ('surrealist in despair'), Lewis Carroll ('surrealist in nonsense') – thus redefining and deepening the perspective of the movement. Seventeen poems, several explanatory, theoretical texts by Crevel, Dalí, Eluard, the screenplay of *Un Chien Andalou* and drawings by de Chirico, Ernst, Tanguy, all helped readers to take stock of surrealism as a coherent activity.

Experiment, transition and *This Quarter* were available from Anton Zwemmer's bookshop in Charing Cross Road, the rallying point of most intellectuals and artists in the early thirties interested by the latest trends in continental art. The aesthetic and philosophical propositions of surrealism could no longer be ignored. Within the five or six years which preceded the 1936 International Surrealist Exhibition in London, references to surrealism proliferated, among which was a manifesto-like article entitled 'The New Reality', written in 1929 by Edouard Roditi, a young Oxford student just back from France.[13] In lyrical terms, Roditi announces the advent of a 'new reality, the reality of the night, ... the reality of symbols before they have proved to be symbols'.

Some writers, as in articles from T.S. Eliot's *Criterion*, made surrealism a constant butt of criticism. Described as 'a ludicrous prolongation of the Romantic revival',[14] surrealism was taxed with charlatanism and with servility to the workings of the subconscious, as well as to communism – a reductive interpretation destined to plague it in Britain from then on. It was as a contrast to many such attacks that in 1932, in F.R. Leavis and L.C. Knights's *Scrutiny*, Henri Fluchère, a French don, published a remarkably clear and balanced synthesis of the tenets of the movement, perceiving the surrealists as the 'artisans of a new spiritual progress ... conscious of all the potentialities of human nature'.[15]

In October 1933, at the age of seventeen, David Gascoyne published 'And the Seventh Dream is the Dream of Isis', the first surrealist poem written in English:

> white curtains of infinite fatigue
> dominating the starborn heritage of the colonies of St Francis
> white curtains of tortured destinies
> inheriting the calamities of the plagues of the desert
> encourage the waistlines of women to expand
> and the eyes of men to enlarge like pocket-cameras
> teach children to sin at the age of five
> to cut out the eyes of their sisters with nail scissors
> to run into the streets and offer themselves to unfrocked priests
> teach insects to invade the deathbeds of rich spinsters
>
> . . .
>
> for the year is open the year is complete
> the year is full of unforeseen happenings
> and the time of earthquakes is at hand[16]

Gascoyne's text appeared in *New Verse*, which had been founded in January of the same year by Geoffrey Grigson. The poem heralds a litany-like 'branching out' of words or images, leading to an almost irresistible transgression of meaning. The curtains open, not on the outside, but on the inside, on an inner scene whose premonitory violence is literally extraordinary. *New Verse* was the first publication to open the door into Britain to surrealist writing: in December 1933, it published Charles Madge's 'Surrealism for the English', the first thoroughgoing article on the specificity of English surrealism. Ruling out mere imitation of Parisian surrealism, Madge asserted that close analysis was compatible with a British perspective that could be developed from French standpoints. This article was regularly followed in *New Verse* by surrealist texts translated by David Gascoyne, and by reviews of related books.[17]

In France, surrealism had appeared as a rebel, tangential to all other movements and publications. Its emergence in Britain, however, took place in university magazines, in texts written by dons or students (with the exception of Gascoyne, who had dropped out of school at fifteen). Nowhere in these writings does the desire for total rupture and 'derangement of the senses' strongly assert itself. Nor from this initial period is there any evident attempt at forming a group, at making a collective effort to concentrate surrealism's message of universal anticonformism.

As a conduit for the values of surrealism, the cinema too was valuable. The creation of the London Film Society, in December 1925, opened a loophole in the censorship laws as well as the laws of commercial cinema. Here, films previously unavailable in Britain could now be seen. These included Henri

Chomette and Man Ray's film *A Quoi Rêvent les Jeunes Filles?*, a celebration of pure cinematography based on Man Ray's 'cine-portraits', René Clair's *Entr'Acte,* Léger and Murphy's *Ballet Mécanique*, Man Ray's *The Starfish*, and Germaine Dulac and Antonin Artaud's *The Seashell and the Clergyman*, formerly dismissed by the censors as 'so cryptic that it is meaningless and even if it had sense, it would have to be rejected'.[18]

Paradoxically, the slump of the early thirties helped British cinema to escape its former dependence on Hollywood companies, which were suffering, and to develop its own values. Experiment was encouraged by this newly regained independence. In 1933 the British Film Institute was created; though a state-run organization, the BFI signalled an effort to stimulate an independent British film industry. But the determining factor in the rebirth of British film was the emergence of documentary cinema. The starting point here was John Grierson's film *Drifters* (1929), whose formidable success was due to its technique. The style was based on filming outside, in wind and rain; the technique, marked by quick editing and a vast symphonic structure, owed much to Soviet cinema, especially in its use to achieve social comment.

Within four years, more than a hundred comparable films had been made, all 'dramas of the doorstep' in Grierson's words, and all created by 'the desire to bring the citizen's eye in from the ends of the earth to the story, his own story, of what was happening under his nose'. In 1933, the creation of the GPO Film Unit enabled documentarists to experiment freely on the relations between image and sound only four years after the introduction of the soundtrack in films.

Scandal and uproar were meanwhile let loose by London's first significant encounter with paintings from the surrealist movement, notably those of Miró, Ernst and Dalí. Having been closed for a time the Mayor Gallery reopened in 1933 with an exhibition of works by Arp, Miró, Ernst, Picabia and future British surrealists like Paul Nash and Henry Moore. The reactions of the press were strong. Most of the works, wrote P.G. Konody in the *Observer*, 'can but be taken as practical jokes, abortive from the aesthetic point of view, owing to the substitution of conceptive or craftsmanly freakishness, or both, for sincerity and dignity – the cornerstone of abstract art'.[19] The exhibition was followed in June 1933 by another, of Ernst's collages, gouaches and paintings, which provoked the same kind of reaction. Defended only by Paul Nash in the *Week End Review* and by Herbert Read in the *Listener*, Ernst was criticized for 'the expression of his personality, . . . for recording what he thinks and not what he sees', and for the fact that 'without a catalogue, his exhibition is incomprehensible'.[20] Kenneth Clark, in the *New Statesman*, confessed that 'before Herr Max Ernst's pictures, [he felt] nothing whatsoever except a mild distaste for their shapes and colours', probably, he ventured to say, because Ernst had not 'felt his symbols

strongly enough' so that they remain 'too personal' and 'especially insult our senses by the mode of delivery'.[21] In spite of the furore of the critics, the exhibition had to be extended a fortnight on account of the pressing crowds of visitors. Immediately after, the Mayor Gallery once again showed work by Miró; once again, the critics declared themselves unimpressed. Some saw them as 'sentimentalized and imperfectly assimilated Freud', or even the works of 'one of these gentlemen with third-rate minds and limited intentions arrogating themselves the title "Surréaliste" ',[22] while others stressed that 'by ingenious combinations and contrasts Mr Miró has produced some entertaining decorations.'[23] The *Scotsman*, however, stated that the works 'restored a vital rhythm'; its critic also realized the necessity, already emphasized by Read in the *Listener*, of replacing the discursive mode of appreciation by an intuitive one.[24]

The Zwemmer Gallery was another venue prepared to be bold in its choice of exhibits. In 1934 Salvador Dalí's fried eggs created another stir among the London public on being exhibited there along with his illustrations of Lautréamont's *Les Chants de Maldoror*. These were generally seen as excellent drawings, but shocking in their subject. David Gascoyne hailed them as a successful expression of the 'horrors of the subconscious', while Kenneth Clark, in the *New Statesman*, judged them as 'vulgar trash intended ... to take in the would-be smart and up-to-date', as 'having the feebleness of a tenth-rate Meissonier ... and being bad jokes and bad drawing'.[25] By contrast, the prudence and hesitancy of most of the other critics is summed up by Anthony Blunt's remarks in the *Spectator*:

Not only are his paintings the expressions of his sexual disturbances, but these disturbances are recorded merely in diagrammatic form, plotted according to personal coordinates. The idiom is so personal that even those to whom the matter is sympathetic will find satisfaction hard to obtain.[26]

The introduction of surrealist painting into England thus met with a deep misunderstanding, due either to a public lack of interest in, or difficulty in finding, any central exposés of the movement's principles. Uniquely, surrealism offered the critics an experience of the powerlessness of words, the untranslatable quality of the images, the overriding elusiveness at work in every one of them. In this way, like quicksilver running through the fingers, was surrealism seen to enter the artistic scene of Britain in the early thirties.

The entry of the mediums:
the establishment of surrealism in Britain 1932–6

The actual word 'surrealism' took some time to enter English vocabulary. The history of its introduction into Britain parallels the difficulty the surrealist movement experienced in establishing itself. 'Surrealism' does not occur in an English dictionary before 1933, where the reference is to a quotation of 1927. In the *Transatlantic Review,* published throughout 1924, there are two mentions of the word coined in March 1917 by Apollinaire and Pierre-Albert Birot in relation to the ballet *Parade;* it was used officially for the first time later that year in the subtitle to *Les Mamelles de Tiresias.* Thereafter its fortune in English varied with its spelling. Either the French word was used, as in *Criterion, transition* and some university magazines, or with aberrant spellings such as 'surréalism', 'surealisme' or 'sur-realism'. This hesitation between languages sometimes created strange couplings, as in an article by Julian Trevelyan in 1930: 'The Surréalistes, into whom one may read (one may read very much what one likes into Surrealism) . . .'.[1] The disparity was tentatively solved by Herbert Read's attempt in 1933 to draw a difference between 'surréalisme' and 'super-realism'. Read saw the former as an ideology, precisely situated in history; and the latter as a 'wider phenomenon, . . . a continuation of the romantic tradition of subjectivism, but drawing new inspiration from the Freudian analysis of the subconscious'.[2] Three years later, Read himself dropped this distinction in a letter to *The Times Literary Supplement* about David Gascoyne's recently published *Short Survey of Surrealism,* and advocated the use of 'superrealism':

On the analogy of such correspondences as surnaturel-supernatural, surhumain-superhuman surhomme-superman, 'superrealism' is surely the commonsense equivalent of surréalisme. It has the advantage of immediately explaining itself, and of being perfectly easy to pronounce. Most of those I have heard using the word 'surrealism' might be suspected of attempting to pronounce the French word 'surréalisme'.[3]

However, no other critic followed Read's example, nor did the public, and he confessed his failure in his introduction to *Surrealism*, saying that he 'has been defeated by that obscure instinct which determines word-formation in the life of a language'. He also remarked that probably 'the public wanted a strange and not too intelligible word for a strange and not too intelligible thing', an ambiguous explanation if any, which surprisingly excuses insular resistance not only to the word but also to the concept. Read then returned to his proposed distinction between an historically inscribed 'surrealism' and a more general, a-historical 'superrealism'.[4]

Anglicized or not, the word's varying form signalled that the idea had an irreducible power, an intrinsic resistance to integration. Nor had any critic except Read attempted to explain its theoretical basis. The suggestion is that the word, and the movement, required testing and proving, before they could feel at home as a part of British culture.

Paul Nash and Unit One

Among the harbingers of surrealism in Britain who worked in imaginative figuration, some were to continue in its margins, others resolutely joined its ranks. Among the former can be counted John Armstrong, John Selby Bigge, Tristram Hillier and Edward Wadsworth, as representatives of what has become known as 'magic realism', while John Banting, John Melville and Paul Nash are among the latter.

It is significant that, along with Nash, the first four artists were all members of Unit One. This group epitomized the efforts made in Britain to break away from traditional categorizations and become a mirror of modernism, linking – Nash was definite on this – figuration and non-figuration, surrealists and abstractionists. From 1928 to 1933 Nash was turning away from the post-impressionism and cubism that dominated British galleries; he had visited Paris in 1930 with Edward Burra to take stock of new trends and had helped organize an exhibition at Tooth's in October 1931 entitled Recent Developments in British Painting, six of whose artists were to form 'Unit One': Armstrong, Burra, Nicholson, Nash himself, Bigge and Wadsworth. In January 1933, Nash suggested to Henry Moore that a group should be formed, which, he proposed, should be called the 'English Contemporary Group'. When this name was not approved by the others, it was replaced, again at Nash's instigation, with the cryptic Unit One.

Further members included the architect Wells Coates, Barbara Hepworth, who had met Moore two years before, and Frances Hodgkins, who resigned soon after joining and was replaced by Tristram Hillier. Fred Mayor, the buoyant director of the Mayor Gallery, and proponent of new art forms,

offered to lend his premises as the group's headquarters. In the spring of 1933, Moore introduced to the group a neighbour from the same street as himself in Hampstead, the poet and critic Herbert Read, who soon became their staunch ally. On 2 June 1933, Nash, taking advantage of a debate on 'Art and Nature' in the readers' column of *The Times*, sent a letter that he intended to be the official birth certificate of Unit One:

The challenging statements made by your Art Critic which provoked the lengthy correspondence upon 'Nature and Art' and which are still the subject of discussion in the 'art world', are also, by chance, so pertinent to a recent event that, perhaps, its announcement and explanation may interest your readers. I refer to the composition of a new society of painters, sculptors and architects under the name of UNIT ONE.

... There is nothing naive about Unit One ... There is a quality of mind, of spirit perhaps, which unites the work of these artists, a relevance apparent enough to any intelligent perception. It cannot be said that these artists practice 'abstract' art, or that they are all interested in an architectonic quality principally ... More exactly, Unit One may be said to stand for the expression of a truly contemporary spirit, for that thing which is recognised as peculiarly of to-day in painting, sculpture and architecture. ...

The formation of Unit One is a method of concentrating certain individual forces, a hard defence, a compact wall against the tide, behind which development can proceed and experiment continue.

But for the ivory-tower implications of the wall metaphor, these lines might well describe the formation of the surrealist group three years later. Unit One sought a new synthesis between aesthetics, materials and purpose, a new coherence free from the dogma of fidelity to Nature, and an emphasis on structural and formal research. Its theoretical tenets were so vague ('lack of reverence for Nature as such', 'engrossment with imagination, explored apart from literature and metaphysics', ...)[5] and the stylistic development of each artist so rapid, that a split soon took place between what one might call the 'figurationists', and the pure abstractionists. In October 1935, Ben Nicholson, Barbara Hepworth, Henry Moore and Len Lye exhibited with the predominantly abstract group The Seven and Five Society, and in the same year Paul Nash openly distanced himself from 'the immaculate monotony' of such abstractionist art as in Myfanwy Evans's *Axis*.[6]

After their one exhibition at the Mayor Gallery in April 1934, followed by a tour of six other venues – Liverpool, Manchester, Henley, Derby, Swansea and Belfast – Unit One broke up. Yet it was to leave an indelible mark on the history of art in Britain. No other group had been formed to confront the dominant taste so rooted in feelings of insularity. In a time of aesthetic disorientation it contributed to a debate between modernity and tradition, between politically committed art and abstract art – which the main art schools were endeavouring to ignore, especially in terms of its social implications. It was in its readiness to take new initiatives that Unit One paved the

way for surrealism: the part played by the figurative artists of the group, Armstrong, Bigge, Hillier and Wadsworth, cannot possibly be underestimated. What they shared was a fascination with the lines and forms of nature, whether mineral, animal or vegetable, and with the intrinsic force of growth that these suggested. Expanded and hypertrophied, this or that leaf, corolla or seashell is given a presence, which, made overwhelming, endows the object with an oneiric quality, a pulsating hesitancy, and casts doubt on how one can judge the reality of what one sees.

John Armstrong's development throws much light on this new aesthetic approach. He went to few art classes and was, like many English surrealists, largely self-taught. Although he was enrolled at St John's Wood School of Art in 1913 and 1914 and briefly after the war, his attendance was extremely irregular. He rarely went to France and had no contact with any French surrealist. Mainly through exhibitions he saw in London, and the art magazines he read, he developed a style inspired by de Chirico and Pierre Roy, founded on shifts of scale, incongruities and thoroughness of detail. Surrealist imagery became for him a strategy to express his detestation of pure abstraction. It also gave form to his own left-wing ideas against the dominant political ideology, yet another reason for which he took part in the formation of Unit One under the aegis of Paul Nash.[7]

Almost symbolically, if one goes by the title, Armstrong's *The Open Door* (1930) (Pl. 1) centres on a pure surrealist gesture of irruption, whose end is in itself. A door is opened in the vestiges of a wall, whose very existence seems to be justified by the opening in it; the door gives onto a deserted, vaguely hilly landscape. In a break from prevailing cubist or realist techniques, objects are deprived of any function. The spectator stands at an edge. Later, *The Philosopher* (1938) and *Dreaming Head* (1938) were to retreat from such an extreme position, through satire in the case of the former – where the plaster head of a Greek philosopher is unaware of its own fragmentation – or poeticism in the case of the latter – a huge feminine plaster head leaning against a hill dreaming an irrefutably real landscape. In these, there is no radical questioning of habitual reasoning, no radical displacement. What Armstrong took from de Chirico and Roy was technique, enhanced by the studied use of egg tempera. His paintings are metaphors.

With Armstrong one could associate John Selby Bigge, a talented artist who departed further than Armstrong from figuration, stepping into a world of unidentifiable shapes, vaguely reminiscent of vegetal or sometimes human organs. Strangely enough, the treatment of his subjects with bright and glazed colours gives his canvases a kind of varnished, sleek aspect which renders them primarily decorative and blunts their disquieting and disruptive quality. Though he was to be included in the 1936 exhibition, Bigge could in no way be seen as belonging to the ranks of surrealism.

Tristram Hillier also represents a break with dominant aesthetics. He became a student at the Slade in 1925, went the next year to Paris where he worked at the Grande Chaumière, attended André Lhote's atelier and met Picasso, Matisse and André Breton. He exhibited at the Lefèvre Gallery in 1931, 1934 and 1935, as well as at the Mayor Gallery with Unit One. Through a slightly exaggerated use of perspective, stressed by elongated shadows,

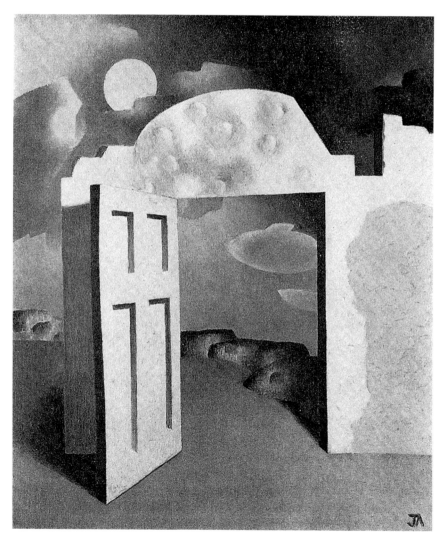

1 John Armstrong, *The Open Door*, 1930, 76 × 62 cm (30 × 24.5 in.)

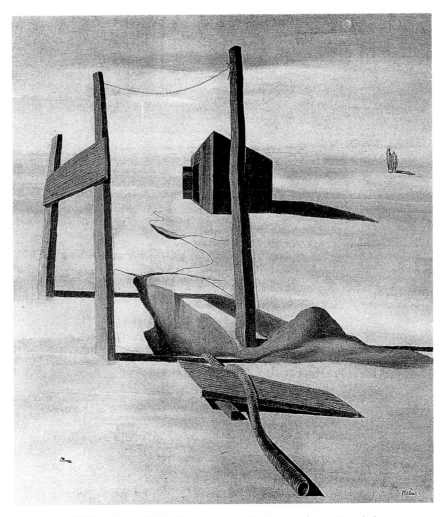

2 Tristram Hillier, *Surrealist Landscape, c.* 1932, 87 × 75 cm (34.25 × 30 in.)

Hillier brings out the ominousness intrinsic in his flat, Tanguy-like expanses of land, which are deserted except perhaps for a couple of pylons, purposeless wooden poles and a half-open wooden shed. Those desolate settings are made more unsettling by the monstrous presence of an anchor, or a snake-like pipe coming out of a crevice in the parched, cracked ground (*Surrealist Landscape, c.* 1932: Pl. 2), or a rope left on a heap of earth under a notice which reads 'Danger' (*Pylons,* 1935). Hillier displaces and re-situates objects through almost inconsistent associations. Unlike Dalí and Tanguy, his objects are not unlikely and his landscapes not improbable. In this, he falls short of being a surrealist but his cracking of the surface of reality contributes nonetheless to

paving the way for the movement in Britain. His absence from the 1936 exhibition was maybe to appear less justifiable than Collins's presence; whatever its reason, Hillier constantly remained independent of any group.

Asked by Herbert Read to make a statement on his own painting for publication in *Unit One*, Edward Wadsworth declared that 'a picture is primarily the animation of an inert plane surface by a spatial rhythm of forms and colours'. Initially an engineering student, he attended the Bradford School of Art, where he won a scholarship to the Slade in 1907 and contributed to a number of important exhibitions presenting new artistic currents: post-impressionism, futurism, vorticism and cubism. Basic to his approach was a deep belief in the mutability of objects' identities, and in their internal rhythm and life, almost independently of their utility value. When Wadsworth passed to figuration, he found himself at the edge of what was about to become surrealist territory. All his marine paintings from the late twenties and early thirties – technically helped by his expertise with tempera – present maritime objects in their irreducible otherness. True, his gathering together of items from the nautical world is excessive. But these objects are focused and emphasized and accumulated in an uncommon way, and are so devoid of human presence – yet they communicate the feeling that someone *must* have arranged them there – that they lose their normal identities. The space in Wadsworth's paintings is an intermediate zone between earth and sea; it is a dramatic space of jetties, pontoons and wharfs that holds our gaze almost hypnotically. *Tomorrow Morning* (1929–44) (Pl. 3) is supremely uncanny, with its dissolution of perspective *within the objects*, the excess of reality, the disproportion, especially with the foregrounding of the seaweed, the absence of reason for such arrangements, and the leaps which the eye is obliged to make from one object to another. It is exactly here, where objects seem to obey some mysterious law, that surrealism starts, at the limit between the inorganic and the mental, and in the absence of finality in each encounter.

In the area of perception opened by Armstrong, Hillier, Bigge and Wadsworth, there emerged a principle by which the stability of reality is irretrievably threatened. In that sense their works testified to the spreading influence of surrealism, even though none of them was to become a member of the group.

The artist Paul Nash was sensitive to every new possibility. By the thirties, he was famous for his drawings and paintings of the Somme battlefields rent open by bomb craters and covered with smashed, splintered trees, 'landscapes of catastrophe'. His attempt, through art, to pit the forces of imagination against the forces of destruction, his deep belief in the potential of nature to renew itself and renew the vision one might have of it, his interest

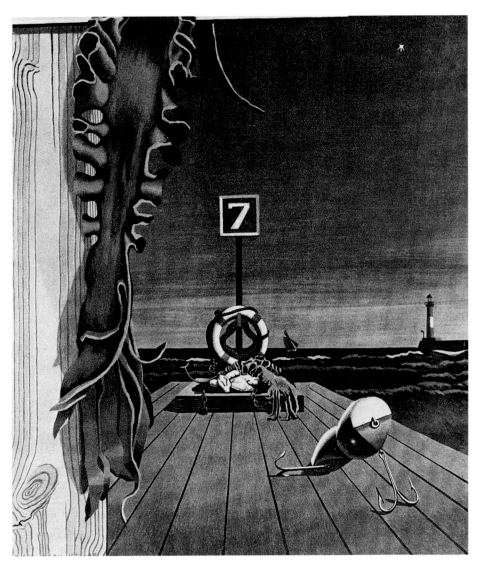

3 Edward Wadsworth, *Tomorrow Morning*, 1929–44, 75 × 62 cm (29.5 × 24.4 in.)

in the eerie forms liberated by chance and in the associative powers of clumps of trees, groups of hills and clusters of stones, continued unabated. He started with watercolours, drew in the vorticist fashion, worked with wood engraving in the early twenties and veered towards geometric and abstract compositions; he then experimented with cubist motifs in the late twenties and early thirties, took to photography in 1931 and settled for a blending of abstraction and surrealism around 1935. During that period, he

travelled extensively in France and seems to have visited almost every stone circle in the South of England.[8]

Almost from the start, the emptiness of his settings, made aggressive by the sharp and straight edges of walls and steps – as in the tension between the harshly angular and precise lines in his paintings and drawings of Dymchurch in the twenties – lend to his work a sense of foreboding, of imminence and timelessness. Its perspectives entrap the eye almost theatrically. Nash made a step towards this form of dramatization in 1928, with the repeated creation of tensions between irregular objects meeting on flat fields or, amidst undulating hills, with the flow of forms into forms, indicating Nash's fundamentally analogical approach.

This conjunction of geometric formalism and imaginativeness was typical of his later work, exemplified by *Northern Adventure* (1929) (Pl. 4). Here scaffolding, based on some seen in front of St Pancras Station from the window of his wife's London flat, is made to reverberate through the painting, at the back as well as in an uptilted window. The perspective of the painting leads us into the station, in a progressively ascending movement, inviting us to risk being adventurous: the scaffolding has no sure basis whatever.

Paul Nash's determination to investigate beyond the surface of reality couldn't be made clearer than in the countless photographs which he started to take in 1931 after Margaret, his wife, gave him a pocket camera when she sailed for the United States to join the jury of the Carnegie International Award in Pittsburgh. The pictures he took between 1931 and 1935 echo his preoccupations with the still, secret life of objects after they have been waived aside by the hand of man, as if they were regaining a genuine presence. On the trip to New York, he took pictures on shipboard – rope entwining the rails and contrasting with their metallic stiffness, the meshes of a net playing with the verticality of funnels, erect masts and empty riggings clashing with the gaping mouths of air shafts. In another series of seashore and farmhouse photographs, the everyday reality of a barn besieged by a pile of leaning logs (*Woodstack and Barn*, 1932), or of a doorway flanked with two animal skins (*Doorway, Spain*, 1934), seem to recede and almost dissolve. Our vision is precipitated into the object, thus renewing its presence.

Writing in the *Listener* in 1931, Nash declared that de Chirico 'had the extraordinary power to make something happen in his paintings ... with all the astonishing quality of the visionary or oneiric event'.[9] This is where Nash's own nascent surrealism lay, in the re-evaluation of the event, the suspension of the so-called objectivity of things seen, and in their dramatization. Whatever the limitations of this approach, it was one from which he would never depart. Meanwhile, in the early thirties, Nash was opening a new world of correspondences, weaving a fabric between the manifest and the latent, the physical and the metaphysical.

Hugh Sykes Davies and David Gascoyne

In a limited way, what took place in painting in the early thirties also happened in literature, where David Gascoyne and Hugh Sykes Davies were protagonists of surrealist disruption.

As the first surrealist poem published in English, David Gascoyne's 'And the Seventh Dream is the Dream of Isis' refers appropriately enough to the goddess of the mysteries of creation and the reconstitution of fragmented bodies. Its initial scene multiplies, opening onto other scenes, in a catalogue of unconnected 'vignettes':

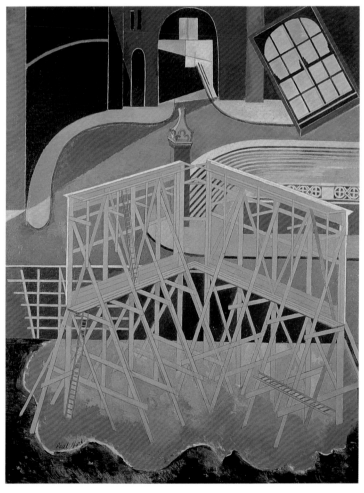

4 Paul Nash, *Northern Adventure*, 1929, 67.3 × 101.6 cm (26.5 × 40 in.)

> Today is the day when the streets are full of hearses
> and when women cover their ring fingers with pieces of silk
> when the doors fall off their hinges in ruined cathedrals
> when hosts of white birds fly across the ocean from america
> and make their nests in the trees of public gardens
> the pavements of cities are covered with needles
> the reservoirs are full of human hair

Images of destruction, desecration and death tumble out, undercutting any process of referenciation or attempt to establish meaning:

> the trunks of trees burst open to release streams of milk
> little girls stick photographs of genitals on the windows of their home
> prayerbooks in churches open themselves at death service
> and virgins cover their parents' beds with tealeaves
> there is an extraordinary epidemic of tuberculosis in Yorkshire

Gascoyne's text remains threaded along each word-to-come, as if its meaning were constantly about to be made clear, thus sending the text constantly back to itself and its own process of reflection. The last lines of the poem summarize this play of the words:

> whereupon the whole place was stifled with vast clouds of smoke
> and with theatre and eggshells and droppings of eagles
> and the drums of the hospitals were broken like glass
> and glass were the faces in the last looking-glass.

Even if these lines echo the poetry of Breton and Péret, the use of the litany as a structure and the ever-widening scope of the images make this text profoundly original. Although so young, Gascoyne had already published a collection of symbolist poems, *Roman Balcony*, in 1932, and an autobiographical novel, *Opening Day*, the next year, and the irruptive kind of writing which he developed through his contact with the surrealists culminated in the publication in early 1936 of *Man's Life is This Meat*, a gathering of twenty poems.[10] Characteristic of the whole volume is his placing of the process of signification at the centre of its concerns:

> Yes you have said enough for the time being
> There will be plenty of lace later on
> Plenty of electric wool
> And you will forget the eglantine
> Growing around the edge of the green lake
> (And if you forget the colour of my hands
> You will remember the wheels of the chair
> In which the wax figure resembling you sat).
>
> Several men are standing on the pier
> Unloading the sea
> The device on the trolley says MOTHER'S MEAT
> Which means *Until the end*.

A year before the publication of *Man's Life is This Meat*, the surrealist sun had already shone on a strange undefinable text, *Petron*, by Hugh Sykes Davies, a Cambridge don.[11] *Petron* is a unique novel; it constantly alters its course and its logic, although its central character is unaffected by all the bizarre and haphazard events around him, even though his presence pro-vokes them. The principle behind the book is semantic subversion working from within the most rigid logical categories.

From a glade in the midst of a thick forest emerges Petron, 'our hero, our you and me, our me and you, or, if you will, our them, our mutual friend', a universal double. After disturbing the signposts of a road to the great dis-may of a hedgekeeper who protests by dividing each of Petron's fingers with a pruning bill and passing a string through his head and drawing it through the nostrils, he winds his way round a landscape which proves to be the mouth of a giant, escapes death at the hands of bandits but seems to retrace his steps back to their hiding place, receives a sackful of butterflies from a tree stoned by children, and eventually reaches a town in commotion on account of an awful crime. Before entering, he sculpts his face with a mallet and chisel to change his features. He helps investigate the crime and reveals to the amazed population the whole story of the deed and the identity of the culprit – himself! The citizens, smitten with reverence and awe, let him go and he disappears into oneiric visions which arise in front of him as he crosses a mountain crowned with a magnificent setting sun. Evidently, the apparent gratuitousness of the sequence is a cover for the series of precipita-tions at work.

The narrative exemplifies the displacement and compression found in dreams. The subject is made to face himself and the eternal return of his desire, as in a mirror. He also confronts the desire which unites language and fact in the alchemy of creation. These points are strikingly exemplified in a key passage:

As a means of seizing the scale of these matters, and placing them against a familiar background, I suggest that you should hire a milch cow, in colours as striking as possible, and that you take her to the shore below some cliff of considerable height. There, having tethered her to a boulder, contemplate her until the image is firmly embedded in your mind: so firmly embedded that not even a considerable shock will dislodge it. For it is precisely to such a shock that you must subject the image. Pass another twist of the rope round the rock, to make all secure, and then ascend to the top of the cliff. Stand at the edge for a few minutes, concentrating your mind on the image of the cow, and occasionally verifying it by a glance at the real cow below. Then, when you feel quite sure of it, cast yourself over the precipice head foremost lest your body should impede your view. For you must note as you fall the impression which you have of the cow, outlined upon the rocks where you will so shortly be dashed: note how the cow might be considered to have been so dashed already: note its exact size above all. For that is the size of these adventures of Petron. That is exactly the scale on which we are working.[12]

Petron is a linear and vertical text, a text which displaces its own centre over and over again, in a way which is the key to surrealist aesthetics. Petron is – as we are – at the meeting point of image and text, dream and reality, the possible and the impossible. Reviewing this extraordinary non-novel in December 1935, David Gascoyne summed it up thus:

One cannot help wondering whether *Petron* is an 'interior' hero, a projection of genuine obsessions and inner conflicts, or whether he is merely an ingeniously manipulated puppet, made to dance to a fantastic tune that Mr Davies once heard in a library.[13]

True, there are definite echoes of the Bible, Eugène Sue's *Mysteries of Paris*, Ariosto's *Orlando Furioso* and Edgar Allan Poe's tales, but these references serve to denounce the rules of novel writing.

Davies published only two poems, one in *Contemporary Poetry and Prose*, the other in *London Bulletin*, but these texts are probably among the most powerful of British surrealism.[14] They share the litany-like style of Gascoyne's texts – and, before, those of Breton and Péret – but their singular force comes from an ascending, almost spiralling movement which is hypnotic in its effect. Both texts are organized around a blank centre, a neutral core which remains unidentifiable and unnameable. Meaning builds itself up only to collapse, so that all that remains is the pure energy that underlies the process of writing:

> It doesn't look like a finger it looks like a feather of broken glass
> It doesn't look like something to eat it looks like something
> eaten
> It doesn't look like an empty chair it looks like an old woman
> searching in a heap of
> stones
> It doesn't look like a heap of stones it looks like an estuary
> where the drifting filth is swept to and fro on
> the tide
> It doesn't look like a finger it looks like a feather with broken
> teeth
> The spaces between the stones are made of stone
> It doesn't look like a revolver it looks like a convolvulus
> It doesn't look like a living convolvulus it looks like a dead one
> KEEP YOUR FILTHY HANDS OFF MY FRIENDS USE
> THEM ON YOUR BITCHES OR
> YOURSELVES BUT KEEP THEM OFF MY FRIENDS
> The faces between the stones are made of bone
> It doesn't look like an eye it looks like a bowl of rotten fruit
> It doesn't look like my mother in the garden it looks like my
> father when he came up from the sea covered with shells
> and tangle
> It doesn't look like a feather it looks like a finger with broken
> wings

It doesn't look like the old woman's mouth it looks like a
 handful of broken feathers or a revolver buried in cinders
The faces beneath the stones are made of stone
It doesn't look like a broken cup it looks like a cut lip
It doesn't look like yours it looks like mine
BUT IT IS YOURS NOW
SOON IT WILL LOOK LIKE YOURS
AND ANYTHING YOU SEE WILL BE USED AGAINST
 YOU

The text focuses on the search for what kind of object the recurrent, incantatory 'It' represents, and develops through a succession of densely entangled, criss-crossing lines, an almost impenetrable network of phonetic and semantic echoes and paronomasias. It is haunted by the notion of resemblance and dissimilitude, but the logic that it tries to establish is soon suspended and destroyed by contradictory statements, in such a way that as the text seems to approach the object in question, it actually edges away from it. 'It' is at the centre of ever-widening concentric circles, and becomes the locus of all attempts to find certainty and presence – but in vain. Like the shelf in the grocer's shop in *Through the Looking Glass*, 'it' is always empty of its totality. But there is more, since the link is clearly established between the identity of 'it' and its appearance. 'Look like' are the key words, and the power of the eye is definitely at stake. The last three lines are clear about this: the eye is for ever barred from reaching the core of the object. 'It' will remain unseen, untouched, subverting the goal of writing – at least in our classical conception that a signifier should make sense – by positing no reference centre whatever. What 'it' is, can never be approached logically, by exhausting all possibilities; 'it' is irrevocably cut from its self, from anyone's self.

Davies's other text, like its fellow simply entitled 'Poem', is in the form of a psalmodic injunction against letting a hand go down into a hole in the stump of an old tree in which some rank, brackish water stagnates. Clearly, the descent is into the forbidden zone of desire, as obscure and unreachable as it is irresistibly attractive. Each stanza is an almost faithful repetition of the previous one with just a few words changing places, and as the unidentified subject quivers at the limit between what is allowed and what is not, as he gropes for the ultimate reality of what is 'in the stumps of old trees', as he expresses a desire to see with his hands, he is constantly subjected to a solemn interdict. As in 'It doesn't look like ...', seeing turns against the one who sees, making him bleed and barring him from 'eating'. The whole text celebrates the nature of being tantalized. The poem unfolds as if one could reach the object of desire, but stops short and raises from itself the barrier of Law and Censorship. Like other surrealist writing the poem is the site of an endless process of self-differentiation.

Len Lye and Humphrey Jennings

With Len Lye it has to be asked if he was a surrealist. And then if he was a British surrealist. These questions need to be raised because Lye was born in Christchurch, New Zealand, only staying in England from 1926 to 1940, and because he is often labelled 'abstract'. But this is to ignore the part he played within the surrealist group, whose activities he participated in while in England. And in 1930, upon the suggestion of Laura Riding, who ran a small publishing house in Majorca where she was living with Robert Graves, he published *No Trouble*, a fascinating series of twenty short 'letters' and texts which foreshadowed the importance of poetic prose – rather than verse forms – in British surrealist writing.[15]

In *No Trouble*, the reader is directly involved in the warp and weft of a text in the making, a text no longer guided by syntactic codes but based on phonetic echoes, spelling similarities and transparent effects:

Ye yea you gentle South E breeze flow far from me waft no take me to Poneke shore and to the friends no fried eggs and friends I loved so well in days of yore yoke or gone by – which started from breeze which started from a friend saying how are your knees and things – and I – oh not knocking and not flapping ever so lazily in the breeze.[16]

Lines of words cross and criss-cross each other to reveal the very process of formulation. 'E' sounds reverberate through an inchoate text; we are hovering between 'fried' and 'friend', 'knees' and 'breeze', waiting for the egg to burst out, for the text to *start* – a recurrent word here. When Len Lye wrote: 'O yess I used to know someone her name started with a J and she used to twist around the door . . . Her name was Juniper, that was watercress for celery'[17] the phrase is a pulse, always starting to spell the poem's title ('Yes By Jesus No') over and over again, a movement before meaning is actually made, a kind of voyage to the centre of writing. Another recurrent word in Len Lye's letters is 'core', which means not a simple point but a gathering of centres, a central zone, towards which all mental and linguistic energies are strained. In the image of the following sentence, words work both ways, backward and forward. The act of writing is dramatized, the text vibrating at its own limit of emergence or disappearance:

. . . as I write in grim determination, I feel the domination of that uncompleted and unstarted now bats mats cats ha ha nothing like a madman I writhe under my domination Dominion construction waying weighing wheying and no curds, Kurds, curds, turds, birds what are they to me . . . as I write in grim determination I feel the status what is that ha ha . . .[18]

Words stumble on each other, 'spitting in the eye of domination', informing a surreality – which Len Lye never names as such since his whole writing

spells the absence of an ultimate word. Len Lye's writing is like a Moebius strip, turning and twisting, always on the other side of itself.

In the cinema, the years immediately preceding 1936 were marked by the rise of the documentary, a development in which Len Lye figured in the vanguard, along with Humphrey Jennings. The new concept had developed around one man, John Grierson and one institution, the Empire Marketing Board, from 1927 until 1933 when it became the GPO Film Unit. Grierson's enterprise was greatly aided by the creation of the British Film Institute, the 'memory' of the British cinema, the same year. Within a few months, a team of directors and artists, sharing the same preference for showing scenes from everyday life so as to reach a large public and speak directly to them, formed a group around Grierson; they produced more than a hundred films within four years, covering the whole aesthetic range from films on trawlers (*Drifters*, dir. Grierson, 1929) and postmen's work on night trains (*Night Mail*, dir. Basil Wright and Harry Watt, 1936) to the first film made without a camera (*Colour Box*, dir. Len Lye, 1935). The team secured the close collaboration of W.H. Auden for texts, Benjamin Britten for music and William Coldstream for settings. As filmmakers, Humphrey Jennings and Len Lye devised a radical and ironical treatment of reality that clearly heralded their participation in surrealist activities two years later. Grierson's leitmotif in his various writings was 'creative' and 'poetical': the documentarist's task is to make a new kind of poetry, to reveal the intrinsic life of objects and men alike, especially through the use of close-up, framing and editing. The realism of such films was not concerned with the surface of things but with their depths. For example, in *Night Mail*, the work of postmen sorting out the mail on the London–Edinburgh night train was dramatized and redefined by Auden's text and by the original treatment of the soundtrack, contrapuntal with the human voice, which raised the individual to the level of the collective.[19]

Humphrey Jennings had been active in Cambridge, building a cultural bridge between England and France through his many trips to Provence. As one of the few in Cambridge who painted, he had played a central role in the *Experiment* circle, introducing its members to French contemporary art and *Cahiers d'Art*. Such was his enthusiasm for modern art that his most usual criticism of a friend's painting was 'that picture of yours hasn't got 1931ness.' His articles in *Experiment* show his fascination with the potential visionary links between the past and the present, as exemplified for him in some newly discovered rock paintings by South African bushmen. When a job as a temporary teacher in Salisbury came to an end in July 1931, he went to Paris to work for a month on designs for Cresta Silks, returning there the year after on a small legacy and going on to the South of France to stay with Gerald Noxon, who had been the editor of *Experiment*. In 1933, he was back

in Cambridge, more strengthened than ever against 'this country and its ludicrous inhabitants', as he wrote in a letter to Trevelyan in April 1933. Paris had been the place where he first read Rimbaud and studied Baudelaire, whose shadow, as in *Tableau Parisien* (1938–9) (Pl. 5) was to haunt some of his most perceptive paintings.[20]

Jennings came late, however, to the cinema and apart from one short film only started directing films for the GPO Film Unit in 1938. However, he had other involvement in film-making before this. In 1934 he had appeared in, and had charge of the setting for, *Pett and Pott*, which was directed by Alberto Cavalcanti. The film was the GPO Film Unit's first sound movie, and was edited in such a way that, for example, a woman's scream would become an engine's siren, a voice off was used to replace the sound of train wheels on the track, and a pipe and drum band would be heard to coincide with the argument between a husband and wife on screen. Every attempt was made to estrange the spectator from figurative reality. Jennings would draw from this technique in his own films, especially in *Birth of a Robot*, made with Len Lye in 1935, as well as in his celebration of the courage of Londoners during the Blitz. Within his use of documentary, reality both depended on, and initiated, new relationships between 'text' and spectator.

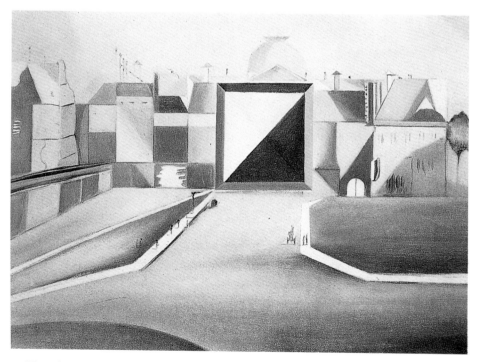

5 Humphrey Jennings, *Tableau Parisien*, 1938–9, 51 × 61 cm (20 × 24 in.)

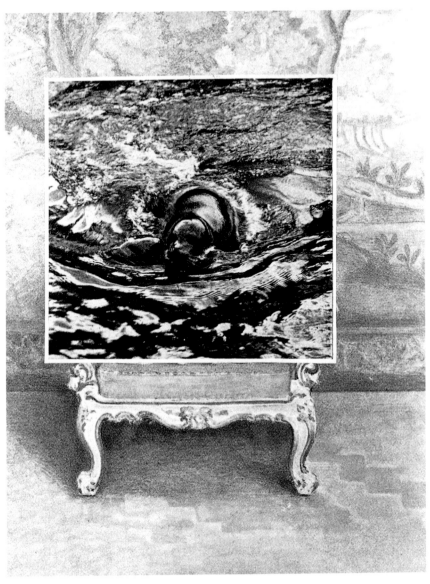

6 Humphrey Jennings, *Armchair with Seal*, c. 1935, 19 × 14 cm (7.5 × 5.5 in.)

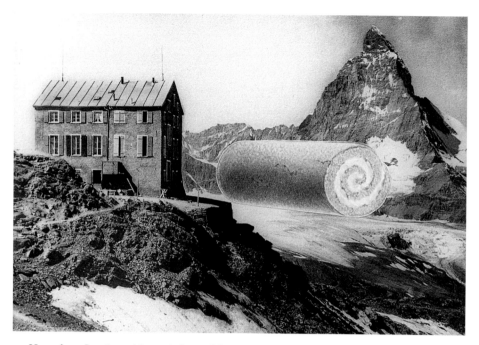

7 Humphrey Jennings, *Mountain Inn and Swiss Roll, c.* 1936, 15.5 × 22 cm
(6.1 × 8.7 in.)

Collage is an excellent way of probing the fundamental nature of relation-
ships in what we take for reality. Humphrey Jennings used it to highlight
simple dualisms such as support our most solidly acquired beliefs, which he
irretrievably refuted. From late 1934 onwards, he developed a very personal
way of making collage to confront these dualisms *minimally*. The settings
where these confrontations take place are identifiable and familiar. They all
are photographs, most banal, and always taken in a straightforward way.
The disruptive element is provided by another photograph, totally displaced
from where it belongs *and* from where it is now; the more remote the two
photos are from each other, the deeper the level of the rapport. Most of the
disruptive elements refer to food, as if the key to the collages was the fusion
of the organic and the inorganic. In *Hospice de la Bernina with Shelf and
Sugarbowl* (*c.* 1935), two domestic objects almost float in the Alpine land-
scape, depriving the setting of its majestic sharpness. In *Armchair with Seal*
(*c.* 1935) (Pl. 6), the framed photograph of a seal swimming in a rough sea,
looking at us, displaces the baroque armchair on which it has been placed, as
well as the bucolic wallpaper at the back.

Among the dozens of collages which Jennings produced, *Mountain Inn and Swiss Roll* (c. 1936) (Pl. 7) is one of the most humorous: the impressive reality of the Matterhorn and the Bernina setting is first radically challenged by the 'pleasure' of seeing a giant Swiss roll lying between an inn and a snow-covered peak, then by appreciation of the pun, which indicates that the roll is perfectly in place here since this is Switzerland. Some time later, Jennings took a photo of the collage which he had stood up on a shelf with a clothes' brush in front. This new juxtaposition redoubles the previous tension, as if the first collage contained umpteen other combinations through the sheer force of its disruption of reality. To these, one could also add the collage of a mansion or manor whose corner is a salt shaker the same height as the house (*Collage*, 1935). The originality of these collages resides in the fact that Jennings lays all his cards on the table for the viewer to see, hiding none up his sleeve, but tricking the viewer with banal and inoffensive appearances.

The many photographs which Jennings took deal with the same issues of chance and choice. His interest in photography had emerged in the late twenties and early thirties. At nine years of age he went to the Perse School in Cambridge, a school famous for its avant-garde teaching and the importance it gave to the theatre. In 1926, he went to Pembroke College, Cambridge where he designed the settings of many plays, including Honegger's opera *King David*. After working briefly at the Cambridge Theatre Festival in 1933, he started to work with Grierson in the GPO Film Unit. All this helps to explain the very peculiar theatrical quality in his photographs – even more than in the collages. In *Portrait of Lord Byron* (c. 1936) (Pl. 8) and *Woman's Head and Fireplace* (c. 1937) there is a sense of deliberate installation, but superseded by the drama apparently taking place. The portrait of Byron is one object among others, but is also constituted by a photograph of a horse's head almost upside down on the paper on the left, and that of a railway tunnel under construction. In the other photograph, the face of a woman is echoed by the face seen in the burning coals in the fire – their relative placing 'dynamizes' both items, linking the erotic position of the woman and the fire. In the *Portrait of Roger Roughton* (c. 1937) (Pl. 9), printing in negative gives a surreal dimension – as in Man Ray's photographs – while a white shadow projected on the wall introduces a dramatic turn to the reality of what we are supposed to see.

The principle of collage also shaped Jennings's writing. He published several 'Reports' in *Contemporary Poetry and Prose*, which were composed according to the technique of collage. They were close enough to logic to unhinge the categories of time and space, often by varying the tenses. Thus he plunges us into a liminal territory, between the instant and the permanent:

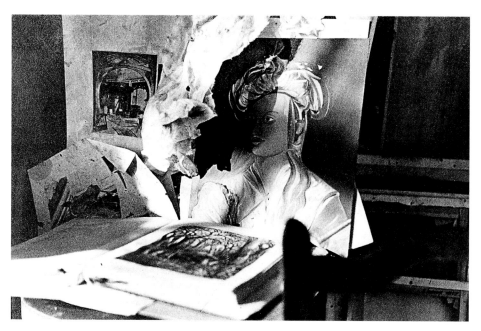

8 Humphrey Jennings, *Portrait of Lord Byron*, c. 1936, 25.5 × 38 cm (10 × 14.8 in.)

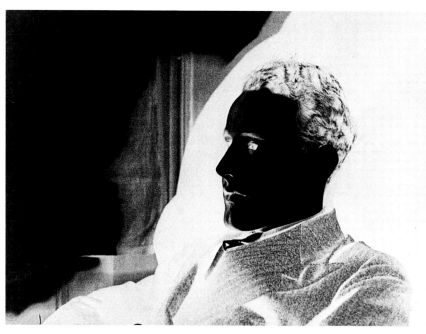

9 Humphrey Jennings, *Portrait of Roger Roughton*, c. 1937, 24 × 37 cm (9.8 × 14.5 in.)

The conditions for this race, the most important, of the Classic races for three-year-old fillies, were ideal, for the weather was fine and cool. About one o'clock the Aurora again appeared over the hills in a south direction presenting a brilliant mass of light. Once again Captain Allison made a perfect start, for the field was sent away well for the first time that they approached the tapes. It was always evident that the most attenuated light of the Aurora sensibly dimmed the stars, like a thin veil drawn over them. We frequently listened for any sound proceeding from this phenomenon, but never heard any.[21]

Jennings's 'Reports' are places of arrival and departure. In 'The Boyhood of Byron', which throws light on *The Portrait of Byron*, he crosses time and space, from Latin America to ancient, and modern, Greece, asks us to stop awhile to admire the Latino-American horses which 'feed on an eternal spring', speaks of Oedipus' Greece, explains Byron's morbidity with his physical defects and his mother's stifling affection, describes the difficulty of rearing a horse and takes a train from Livadia to Delphi. At no moment does the text stop limping.

For Jennings, an object existed essentially in relation to a kind of internal drama. Hence his probing deeper into that drama, to come up with one of the most productive ideas of British surrealism, the imaginary link between the form of one given object and the form of others. The two objects he grew especially interested in were the railway engine – which he never ceased to link with the horse – and, in the late forties, the plough and its shadow, and their echo in the guitar. In his poem *La Charrue*, apparently addressed to Breton or to Eluard, he insisted that 'the plough is the English guitar'. In other words, his quest is for a transhistoric, synthetic vision, or rather *angle* of vision. His fascination for the shadows of objects and people, noticeable in the photographs but also in his films, is thus further evidence of his dealing with objects at the point of boundaries. *House in the Woods* (1936) (Pl. 10) exemplifies the way forms recede in favour of a secret, fluid, mythopoeic intensity. It shows the encroachment of nature upon human construction, and a fusion of the energy contained in both. The house and the forest around it seem to have exchanged their melting *essences*. This was to be deepened and sharpened when he delved into the world of machines for The Impact of Machines, an exhibition organized by the London Gallery in 1938.

Less concrete and figurative than Jennings, Len Lye's experiments, whether in the cinema, writing or painting, could in no way be made to fit existing aesthetic traditions. His work linked with Australian and Maori tribal art and can only be appreciated at the junction of ethnography, mythology, scientific discoveries in genetics and biology, and of personal preoccupations with the reawakening of man's relation to nature and to his deepest, most secret roots. At the age of nineteen, Lye started working on kinetic

constructions based on artistic and choreographic creations by Australian and Oceanian aborigines. In 1921, he studied animation, then spent two years in Samoa painting and sculpting. Working his passage as a stoker from Sydney to England, he settled in London in 1926 in a barge on the Thames, 'the Ark', loaned to him by the painters Alan Herbert and Eric Kennington, off Durham Wharf where Julian Trevelyan lived. Kennington introduced him to Robert Graves and Ben Nicholson that year and he started to exhibit with the Seven and Five Society.

In 1928, Lye completed *Tusalava*, a film which took him two years to make. When *Tusalava* was denied a certificate by the censors on account of its obscurity of meaning, Lye sent the following note in explanation: 'The picture represents a self-shape annihilating an antagonistic element.'[22] The film is obsessed with the origin of movement, and denies the opposition of beginning and end, interior and exterior, line and point. Together with the specific treatment of sound effects it is effectively a precursor of surrealism. Editing is pushed to extremes, featuring collage and frottage, and leaves each sequence, each one of the 9500 separate drawings, almost each dot, autonomous, as if expressing an interior necessity. Lye describes the film as 'a grub dance' and as 'life among the macrobes'; subsequently he regarded it as the intuitive vision of 'antibodies and microphages' of later medical discoveries.[23] Both primitive and modern, material and abstract, *Tusalava* shows affinities with surrealist qualities apparent in works by Miró, Klee or Desmond Morris.

Lye continued to paint, developing a free-wheeling style, and six years elapsed before he made another film, *Quicksilver*, a short with a text written by Laura Riding. It was commissioned by various cinema societies, in response to an appeal from *Close-Up*, the avant-garde film review, in June 1933. Oswell Blakeston described the film as 'forms being spun out of eddies of forces'.[24] In 1935, Lye made *Colour Box*, a film without a camera, without any team or assistant, a 'direct' film, painted straight onto the celluloid (Pl. 11). Here, Lye reached a peak of inventiveness, not so much in what he produced as in the paths he opened with this technique. He attempted to capture the vibrations inherent in forms by the use of popular music, played by Ray Baretto, especially the creole music of Cuba, with an energetic beat that evoked tribal dance. Grierson was deeply interested in Lye's films, but the Unit promoted the film only when Lye accepted the addition of a few advertising slogans. To counter the disastrous effects these might have had on the hypnotic rhythm of the film, he randomly varied the colour, texture and distribution on the screen of the letters composing the slogans.

As a close collaborator with Humphrey Jennings and a faithful member of the surrealist group before the war, Lye went further than the others in tapping the primitive brain by developing a personal theory parallel to current

biological and genetic discoveries. The film *Tusalava* was his initial state-ment, and it was followed by a series of paintings and drawings, all obsessed with signs. Like his written work, for example *No Trouble*, Len Lye's graphic work is hieroglyphic. The cover he designed for *No Trouble* showed cells, genes and spermatozoa dancing around before meeting, before making meaning. His subsequent work was to aim at being aboriginal, ceaselessly exploring the retrieval of precognitive imagery.

To understand Lye's aesthetics, essentially based on an intuitive and instinctual knowledge of man's relationship to the world of nature, it is cru-cial to consider what he declared in his characteristically winding, shimmer-ing sentences, to Andrew Bogle in an interview in New York in 1979:

The kind of myth that is going to make a one-world possible in terms of each of us feeling a relationship to one another and a unity in that relationship in our values and in relation to nature is a myth that we deduce out of our genetic information and general instructions, and my work shows a hint, a very vague hint, but nevertheless it's there, that there is such a possibility that artists with a particular temperamental leaning towards expression of their very intensest feelings of self in terms of myth, can develop the old brain propensity for reading or transposing or divining the genetic truths that are in their own make-up and, when those truths are symbolized, the magic of the whole business will be conveyed and we'll have access to intense feelings that relate to everybody else and to nature.[25]

As a consequence of this belief, Lye's imagery is both abstract and natural-istic; it probes deep into such refined, almost sublimated forms as will take us back to the space where our roots lie. In this attempt to find oneness with nature, Lye almost unwittingly blended Freud's and Jung's propositions with the scientific data of genetics. He maintained that to short-circuit the reason and logic, man has no other choice but block out his propensity to explain and interpret, and plunge directly into what Lye called the 'old brain' – the area of the brain that developed first in the course of human evo-lution. In contrast, the new brain acts as the power that censors and reorien-tates material provided by the old brain. But Lye goes further than this. For him the old brain also stores images and information dating from time immemorial. As Gerhard Brauer described, 'it is a repository for information about forms and structures, processes and events, which range from the sub-atomic through the cellular to the cosmic'.[26] This world, Lye insisted, lies within our reach, so long as we make the necessary mental effort to establish contact with it, just as children do. Hence, he made a systematic exploration of 'doodles': out of the entanglement of lines and motifs, the artist is likely to capture non-cognitive information from his old brain.

This links up with the surrealist theory of automatism. Of all the surrealist painters, Lye most admired Miró, the only one, he said, to have 'a real "Old Brain" attitude of divining imagery'.[27] It is quite probable that he was

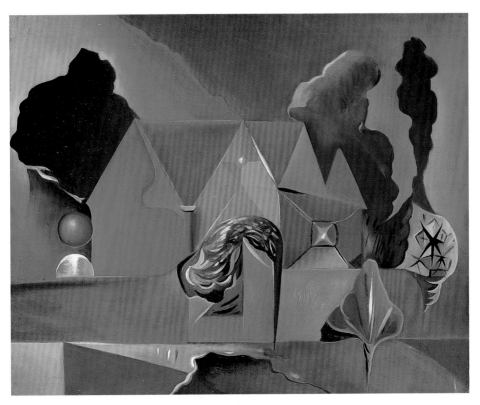

10 Humphrey Jennings, *House in the Woods*, 1936, 30 × 36 cm (12 × 14.1 in.)

11 Len Lye, frames from *Colour Box*

confirmed in this theory when he saw Miró's work for the first time in London at the home of H.S. ('Jim') Ede, a collector friend of the Seven and Five Society artists. His own work furnishes many examples of premonitory imagery. According to Gerhard Brauer, discoveries in deep-sea biology were anticipated with Lye's image of 'small bubbles as conveyors of food for deep sea protozoa'. So too were discoveries in high-energy physics, with 'horizontal lightning associated with volcano'; also in cell biology with the discovery in 1976 of the 'pin-wheel cells', all images detectable in Lye's work. Lye's intuition was remarkable, but more so was his faculty for reaching down to the lower depths of the subconscious. At the 1936 exhibition, he showed a photogram of *Tusalava*, which he entitled *Marks and Spencer in a Japanese Garden*. This was initially a photo plan from the third section of the film; it was then turned into a batik on silk, entitled *Pond People* (1930) (Pl. 12), and then was exhibited as a photogram, made by pressing plasticine onto unexposed photographic paper before exposing and developing it. Two foetus-like figures, one decidedly masculine, the other feminine, stare at each other from the sides of a huge uterine pocket. From the masculine figure another pocket full of egg-like cells has grown, each one in the squares of a grid; and from the feminine figure there falls a shower of egg- and worm-like cells. Both a lake and a stomacal pouch, a pond and a uterus, the 'setting' is a place of liquidity and fertility. Ovules, Fallopian tubes, nuclei and cells on the verge of mitosis, are the traces of a space-to-come, involved in a circular, endless movement. *Marks and Spencer* has been simplified, and keeps the two figures in an arrested confrontation, where nothing has yet happened.

The same interest in original sites is manifested in an exuberant, subtle work, *Snowbirds Making Snow* (Pl. 13), which is reminiscent of cave paintings, such as those Lye used to copy from displays at the Victoria and Albert Museum soon after he arrived in London. This work takes its inspiration from a different source for Lye. No longer are there any biomorphic shapes or cells; instead lines are drawn automatically, black lines vying with white lines, in an ever-renewed 'making'. The title is doubly 'creative': it is tautological and, in the echo of the first word of the title in the last, implies birth. But it is also an interpretation of the name of these birds, properly *Junco hiemalis*, which are said to appear when the snow comes, so that they are birds actually creating snow. The birds make the snow which makes the birds. The calligraphic, almost ideogrammatic, quality of the lines opens a new territory: hieroglyphs.

Two avant-garde film magazines played an important role in the attempt to break with visual conventions in the cinema. *Close-Up* and *Film Art* were both concerned with film as an ideological force.[28] From its first issue in July 1924, *Close-Up* printed articles by Buñuel, Man Ray, Bruguière and Walt

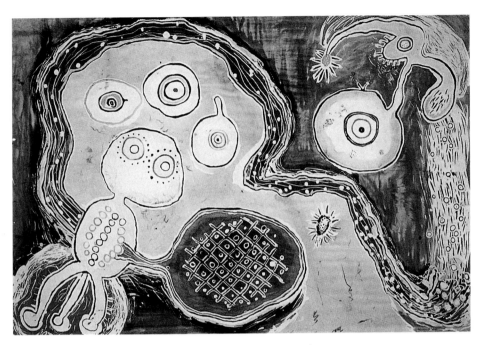

12 Len Lye, *Pond People*, 1930, 98.5 × 143 cm (38.8 × 56.3 in.)

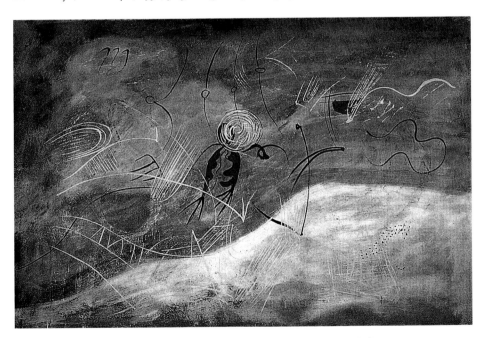

13 Len Lye, *Snowbirds Making Snow*, 1936, 94.3 × 144.8 cm (37.1 × 57 in.)

Disney ('Mickey Mouse mocks terrestrial laws and prolongs to the infinite the resources of the real'). In a report exhorting the London Film Society to give the British public a chance to see *Un Chien Andalou* in 1930 Oswell Blakeston, the magazine's Paris correspondent and a friend of Len Lye and Humphrey Jennings, used the word 'surrealist' for the first time in this magazine. *Film Art* was more technical and theoretical in its preoccupations, especially on the links between the cinema and proletarian revolution, and carried articles on Eisenstein's fade and dissolve techniques, on Pudovkin and on Len Lye's innovations. Though Cocteau's *Le Sang d'un Poète* was not intended as a surrealist film, a review in the first issue, in spring 1933, examines it for its use of 'superimpositions, negative projections, dissolves, ... in the presentation of surrealistic emotions'. The leader in the winter 1934 issue makes no bones about the review's goal: 'There is the man for whom we should fight. The man who starves, the outcast, the unemployed, the unwanted, the wasted humanity.'[29]

Both periodicals echoed one of the principles of the documentary movement, the revitalization of the cinema through a new visual language.

British artists in Paris: Penrose, Trevelyan, Agar and Banting

The year 1935 witnessed a gradual coming together of the influences that were to 'make' surrealism in Britain, including a number of artists who were to return from France between late 1934 and early 1936.

The central role in the passage of surrealism from France to England was played by Roland Penrose, who had left England in 1922 to escape the influence of his Quaker family and Georgian respectability. Penrose decided to study art in Paris. There he was given the addresses he needed by Roger Fry, with whom he had made friends in Cambridge. A chance friendship with Yanko Varda, a Greek painter, introduced Penrose to modern French culture from Rimbaud to Jarry and Picasso; he met Braque at Galanis's, a wood engraver; he attended sessions at the Académie Lhote, and he immersed himself in the heterosexual life of Montparnasse, where he got acquainted with Man Ray, Kisling and Pascin: all of this served to liberate him from his puritanical background. The following summer was spent in Cassis with Varda, entertaining friends from Paris and London; there, Penrose fell under the enigmatic spell of Valentine Boué, whom he met when she knocked at his door to enquire about someone else living at their villa. At this time Penrose also encountered the writings of Breton, an influence that was furthered by a friendship with Max Ernst, whom Penrose had met when looking for a studio. There followed a trip to India, after which Penrose came back to Paris in 1928, the year of his first one-man exhibition in the rue de

Seine. He left in 1935 for health reasons and because Valentine had gone back to India. After his parents left him and his brothers a substantial sum of money, he started buying works and helping friends in need, particularly Paul Eluard. Among other projects at that time, he worked with Robert Bresson on his first film, had a part in Buñuel's second film, *L'Age d'Or*, and helped in the publication of Max Ernst's *Semaine de Bonté*. A particularly significant meeting took place in the rue de Tournon, with Eluard and other surrealists, who introduced him to his young fellow Englishman, David Gascoyne. 'It was the encounter of two explorers who had discovered independently the same glittering treasure,' is how Penrose described this event, crucial in the history of surrealism. David Gascoyne had exclaimed: 'Why do we know nothing of this in England?', and both men had decided to 'do something' in their own country, a resolve that was to lead eventually to the International Surrealist Exhibition.[30]

David Gascoyne had arrived in Paris in autumn 1933 with the money he had received from Cobden Sanderson as royalties for *Opening Day*; his mind was full of the art magazines he had bought at Zwemmer's, including *transition* and *La Révolution Surréaliste*, and he was currently reading Herbert Read's *Art Now*. Through George Reavey, he was introduced to Julian Trevelyan, who was then studying engraving. Trevelyan gave him the address of S.W. Hayter's Atelier 17, a contact point for many young British artists in Paris for the first time, and there Gascoyne encountered Zadkine, Hélion, Dalí, Max Ernst and Pavel Tchelitchew. He stayed in Paris throughout that winter, during which time he read Tzara's, Eluard's and Breton's poetry. On his return to London, he met Roger Roughton at the Parton Street Bookshop. Roughton was a poet of the same age as Gascoyne, and was as enthusiastic as he for modern art and modern writing. With a commission from Cobden Sanderson, Gascoyne went back to Paris in 1935 to work on his book, *A Short Survey of Surrealism*, which was published the same year.

Among the self-exiled friends of Penrose and Gascoyne's, Julian Trevelyan had come to Paris having been a prominent figure in the Cambridge of the late twenties, where he had contributed to Bronowski's *Experiment*, as well as subscribing to *transition*. In 1931, disenchanted with what he saw as the artificiality of Cambridge, he settled in Montparnasse amid the cosmopolitan crowd of the Dôme, the Coupole and the Rotonde. He shared a studio with George Reavey at the Villa Brune, a kind of residence for artists – Alexander Calder was staying there at the time, making electric mobiles – and attended Léger and Ozenfant's Académie Moderne, then the Grande Chaumière; he also studied etching and engraving at Hayter's Atelier 17, where he met Miró, Ernst, Giacometti and Picasso. Returning to London, he settled by the Thames at Durham Wharf, next to Len Lye's barge-studio. This became a regular meeting point for friends from Paris as well as new London

acquaintances such as Ceri Richards and Ivon Hitchens; among them was Yanko Varda, who had settled in England at the time of World War I, and whom Trevelyan would join every so often for the summer at his house in Cassis in the south of France.

For Eileen Agar, Paris was where she came to terms with both the potentialities of abstract construction and the need to give free vent to the lyrical aspect of the imagination. Following a brief sojourn at the Byam Shaw Art School, a year spent at Leon Underwood's Brook Green School at Hammersmith, where she met Gertrude Hermes and Henry Moore, and time at the Slade, she came to Paris in 1927, escaping from an early marriage and divorce. She brought with her an introduction to Marcoussis from Ezra Pound, a friend of Joseph Bard's, who was to become her second husband. In Paris, she worked under the guidance of the Czech Cubist artist, Frantisek Foltyn, through a recommendation from another friend of Joseph Bard's, the Viennese architect Adolf Loos. She visited Brancusi and met some of the French surrealists, striking a durable and intimate friendship with the poet Paul Eluard. Back in England, in 1935, she was introduced to Paul Nash, in Swanage, by a mutual friend, the poster designer Ashley Havinden. Another long and intimate friendship ensued, through which Eileen Agar could be said to have been 'discovered' as a surrealist a year or so later, by Herbert Read and Roland Penrose.

The return to elementary images and forms links Len Lye not only to Humphrey Jennings but also to Eileen Agar. The strategy is different; the depth of vision too. But they all share the same *playful* fascination with what given forms may reveal, when reduced to essentials. Before 1936, Agar had in fact been immersed both in cubism and abstraction: in the 'rarefaction' of reality. But, if she had learnt the importance of the principles of construction in painting, especially abstract construction, she had also become convinced of nature's fundamental role as a source of inspiration. In 1931 she contributed an article, and a few abstract and cubist-inspired woodcuts, to Joseph Bard's review, *The Island*. In the first issue, she wrote:

In Europe, the importance of the unconscious in all forms of Literature and Art establishes the dominance of a feminine type of imagination over the classical and more masculine order. Apart from rampant and hysterical militarism, there is no male element left in Europe, for the intellectual and rational conception of life has given way to a more miraculous creative interpretation, and artistic and imaginative life is under the sway of womb-magic.[31]

Her development towards a more imaginative and spontaneous vision than was provided by formalism is marked in *The Autobiography of an Embryo* (1933–4). This huge work is divided into four panels, each tracing the process of birth from the womb to parturition, via forms emerging from nature as the process develops: birds, vegetal shapes, leaves, fishes, seashells, Greek,

Egyptian and Sumerian figures, each echoing the other from one cell to the next. All are the inhabitants of circles and egg-shapes; and all these circular motifs are like eyes playfully, almost facetiously, staring at us. The work is an invitation to share in the eternal return of the moment of birth. Her aesthetic evolution was deepened from 1935 onwards by friendship with Paul Nash. His imagery, both solid and fluid, helped confirm her perception of such natural and accidental forms as rocks, pebbles and driftwood as expressions of fertility.

Quadriga (1935) (Pl. 14) was one of four paintings of hers chosen by Read and Penrose for the 1936 International Exhibition. Divided into four parts, this work challenges the Western way of reading from left to right, by 'un-stopping' such a process. As explained in Agar's autobiography, she started from a photograph of a stone horse's head from the Acropolis. First she linked it imaginatively with the Muses' sacred fountain, the Helicon, which gushed when Pegasus struck the ground with his hooves; secondly it evokes Selene, who was given horses to drive across the sky. All this, together with

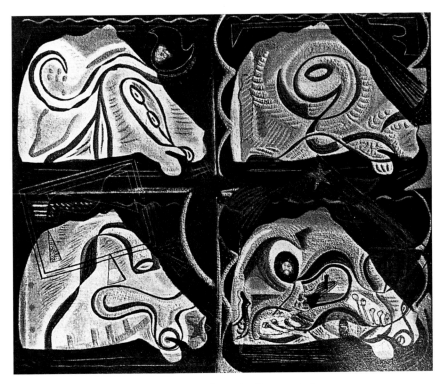

14 Eileen Agar, *Quadriga*, 1935, 52.1 × 61 cm (20.8 × 24.5 in.)

childhood memories of riding sessions, combines and multiplies into a multi-layered vision of a mythical 'arch-horse'. Each square seems a starting-point, leading to the next along overlapping lines and forms and reining us in wherever the eyes alight, in a frenzied, unbridled race through space and time. Technically this is reinforced by Eileen Agar's unique use of exuberant colours, expressive of the energy of creation. Like the rainbow, they connect earth and heaven, combining the materiality of their physical substance with the immateriality of the exaltation they provoke.

While other expatriates living in Paris at that time enjoyed private incomes, John Banting's financial situation seems to have been almost permanently dire. Determined to become a painter, he had studied in London and Paris in the early twenties, before getting a job as a bank clerk and attending life classes at the Westminster College of Art under Bernard Meninsky. When he returned to Paris, in 1922, he encountered Peggy Guggenheim, Nina Hamnett, Brancusi and Man Ray. Throughout the next ten years he travelled between London, Paris and the Riviera, living a life of impecunious leisure and staying in Nice, Cannes and La Napoule, often with Brian Howard and Nancy Cunard, whom he had met at a party in London. The *enfant terrible* of the famous steamliner family, Nancy Cunard had broken with her class and family to take part in racial, social and political struggles. Through her, Banting made friends with Louis Aragon, the composer Georges Antheil, and a number of French surrealists, revising his style from that of a kind of Neue Sachlichkeit, as practised by Otto Dix, to a more pronounced surreal-ism. Politically on the side of those repressed by capitalism and colonialism, he designed banners used by Nancy Cunard in demonstrations in support of the Scottsboro Boys, and accompanied her to New York to collect material and contributions for a prospective *Negro Anthology*, a huge celebration of black culture to which he contributed an article on 'The Dancing of Harlem'.[32] Meanwhile growing friendships with Duchamp and Beckett, forged during visits to Nancy Cunard at the Hours Press in La Chapelle Réanville in Normandy or in her Paris office, further strengthened Banting's links with surrealism.

Well acquainted as Banting was with continental surrealism, it was rela-tively early, in 1930, that he can be said to have painted his first surrealist works. They were to follow two paths: one inspired by music, the other denouncing the emptiness and artificiality of man's life. In the former paint-ings, represented by such works as *Ten Guitar Faces* (c. 1932) (Pl. 15) or the *Siamese Triplets* (1932–3) series, dominated by the accordion, forms are play-fully placed in an inexhaustible rhythm. In *Ten Guitar Faces*, the itinerary the eye is enticed to follow like the footsteps of a tango dancer. The gouache is built on two columns each of five drawings; each column reproduces the

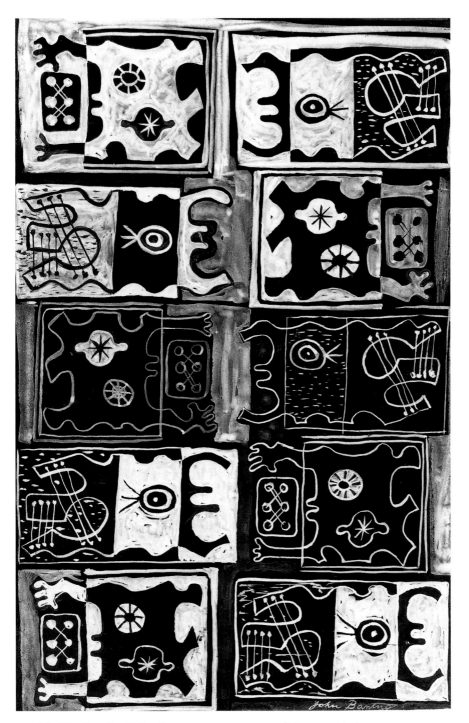

15 John Banting, *Ten Guitar Faces, c.* 1932, 47 × 29 cm (18.5 × 11.5 in.)

same basic drawings varied two by two. The eye is kept circulating between the light- and the dark-coloured drawings and between the left-hand column and the right. The faces are the shape of guitars, and their limbs linked by strings; stars and other patterns build complex visual echoes and create ruptures out of whose labyrinth harmony seems to emerge as the eye zigzags over its surface. Through their repetition, these organic-musical creatures, both fluid and solid, invite us to join their music. But if music is a relief and an expression of human creativity, it is dramatically threatened in Banting's work by man's self-destructive impulses.

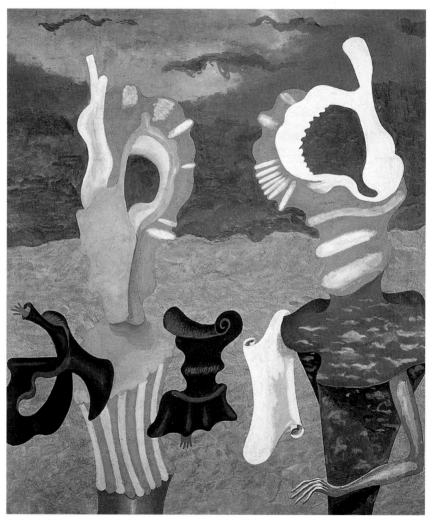

16 John Banting, *Conversation Piece*, c. 1935, 51 × 45 cm (20 × 18 in.)

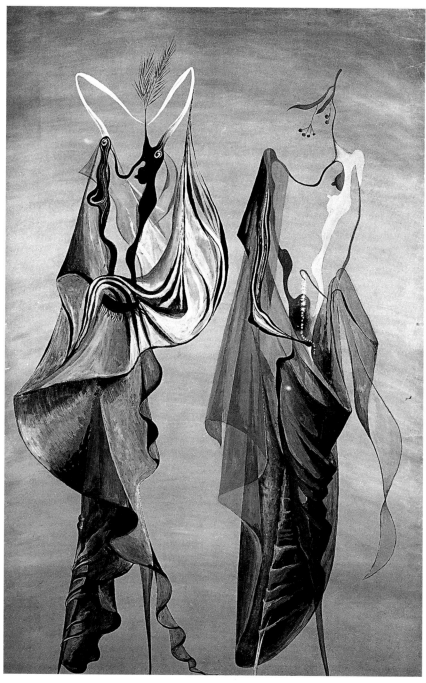

17 John Banting, *Two Models*, 1935, 107.5 × 66 cm (42.5 × 26 in.)

A creator of forms, Banting pierces and hollows them out to show their ultimate vacuity. Indeed, for him, forms embody conventions and codes, and so must be suspended if the mind is to be emancipated. An obsession with the body's submission to formality, with the 'too too sullied [or solid] flesh' of *Hamlet* was never to leave him. *Two Models* (1935) (Pl. 17) and *Conversation Piece* (*c.* 1935) (Pl. 16) show the undoing of appearances; only the general form and attitude of the figures recall the human, which is almost negated by the heterogeneity of what the forms 'contain'. In the former, the heads have been replaced, one by a flimsy palm-like leaf, the other by the frail twig of a lime-tree, both of which are reminiscent of hat decorations. The bodies have dissolved under transparent flowing robes and gossamer-like dresses, which hardly cover their spindly legs, and scarcely is there any trace of the one or two tiny breasts, along crudely drawn oesophagi. In *Conversation Piece*, the heads are two distorted hollowed-out bone structures, the arms are furled scrolls, part of an ancient armchair, glued so to speak to the chests, one as a truncated Greek column, the other as an upturned tree trunk. The principle is that of collage, yet one cannot wholly recognize the parts. Given the titles, this emptiness and insubstantiality are evidently of a social nature; social order, the etiquette these figures stand for, being violently nullified.

In 1932, with his friend Brian Howard, Banting organized one of the most sensational hoaxes which London's intelligentsia had seen. They set up an exhibition of works by a certain German artist by the name of Bruno Hat at Bryan Guinness's house in Buckingham Street. Of course, Bruno Hat was entirely fictitious. The idea was initially Brian Howard's, and Banting painted the works, while Tom Mitford, Nancy's brother, impersonated the non-existent artist. Evelyn Waugh wrote a 'preface' to the catalogue, entitled 'Approach to Hat', and Lytton Strachey bought a painting . . .

Henry Moore

Among the artists affected by French influences in the years up to the inauguration of the surrealist group in Britain was Henry Moore. In Paris, from 1923, he came under the influence of Brancusi, Arp and Picasso's paintings of heads and bathers. This aspect of French surrealism, with Picasso's motif of the human figure broken up and imaginatively remade, helped develop the treatment of form in Moore's sculpture from 1931 to 1939, especially his bone shapes, which echo surrealism's found and altered objects.

It has been said that among the first influences on his sculpture, the most significant was his discovery of Egyptian, Etruscan, Mexican and African sculpture in the early twenties; from then on he would be intent on expressing the archaic and the primitive. The inspiration he received from cubism in

1927 and 1929 reinforced this, and his fascination for pebbles, which he started to collect in 1929, made him evolve towards biomorphism rather than pure abstraction, rather like Brancusi. A sign of this was his decision to start working outdoors in 1934, when he moved into a country house with a large garden in Kingston near Canterbury. Even when he made solid, square sculptures which may look abstract, like *Carving* (1936), the surface is incised with linear designs which break the abstraction of the piece with their unexpectedness and their hints of primitive and Aztec art. 'The violent quarrel between the Abstractionists and the Surrealists seems to me quite unnecessary'[33] certainly qualifies his surrealism in 1936, and, in a sense, he was proved right, when Mesens, three years later, first combined Abstract artists with surrealists in his exhibitions. In any case, Moore felt closer to surrealism than constructivism, and his later 'return' to the human figure is evidence of this. In early 1936, he visited the cave paintings in the Pyrenees and in Altamira and, the year after, started on his first stringed figures in wood.[34]

Publications and meetings

The year 1935 was also marked by the publication of key texts in surrealism's introduction into Britain. Typically of British surrealism's difficulty in defining its own identity, the *First Manifesto of English Surrealism*, written in London in May 1935, was published in France and in French by David Gascoyne in *Cahiers d'Art*.[35] All of Breton's principles are referred to, and Gascoyne proposes a strongly independent political standpoint, especially in relation to the Marxist Writers' International. He pledges allegiance to dialectical materialism, the proletarian revolution and to the fight against fascism, and expresses the hope 'that a vast field of poetic, artistic and philosophic action may open in England'. Thereafter no mention of the text was heard, however, in Britain or France.

Six months later Gascoyne published his *A Short Survey of Surrealism* (Pl. 18), written between July and September 1935, and the translation of Breton's seminal text, *What is Surrealism?* The former is a chronological summary of the main phases of surrealism in France, followed by the translation of texts by Breton, Char, Dalí, Hugnet, Eluard and Péret, and the reproduction of works by Arp, de Chirico, Dalí, Ernst, Giacometti, Magritte, Miró, Man Ray, Picasso, Tanguy and Valentine Hugo, and clips from *Un Chien Andalou*. It was the first collection of statutory surrealist texts, published with the aim of proving their indissociable unity. Almost all surrealist publications are mentioned and fully explained; as are the political dilemma raised by the Aragon Affair, and the various aesthetic 'techniques' such as collage, frottage and Dalí's paranoia-criticism. Insistence is laid on surrealism's

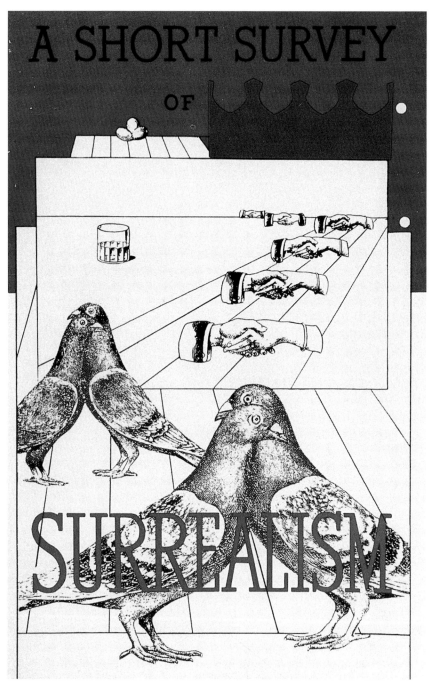

18 Cover of David Gascoyne's *A Short Survey of Surrealism*, 1935

central aim of decategorizing thought so that it may recover its emancipatory force; and the *Survey* ends on the possibility of surrealism flourishing on British soil.

In any analysis of French surrealist activity, much has been written on the role of cafés, a social feature whose absence is said to explain much of the looseness of the English group. However, a centre was provided by the Parton Street Bookshop, which became in 1934 a gathering place for those poets who wanted to escape the influence of Bloomsbury. David Archer, a rich young man, and a poet himself, had opened the shop along similar lines to Shakespeare & Co. in Paris or Harold Munro's Bookshop. Above the shop were the premises of a small publishing firm, the Parton Press, and a room or two where poet and artist friends could stay in London overnight. A largely bohemian clientele frequented the shop of this always impeccably smart young man, who openly admitted his homosexuality, something not done at that time. Also, across the road, at 1 Parton Street, was the Arts Café where Roger Roughton's *Contemporary Poetry and Prose* was edited, a place frequented by George Reavey (who as a Cambridge student was a member of the *Experiment* team and a pivotal figure in the opening of England to Russian literature), Dylan Thomas, George Barker, David Gascoyne, John Cornford, Esmond Romilly, the indefatigable Marxist A.L. Lloyd (translator of Garcia Lorca and one of the main critics on *Left Review*) and Julian Trevelyan. Here too the first sympathies with surrealism found expression, and a poetry was born, half way between social protest and neo-romanti-cism, which was to engender the new apocalypse movement. At 2 Parton Street was the office of the left-wing publishing house Lawrence and Wishart, who published Nancy Cunard's *Negro Anthology* in 1934, and the headquarters of the Workers' Theatre Movement as well as of the Student Labour Federation; in April 1936, the *Left Review* also opened its office there. David Archer's address also became that of the Artists' International Association's headquarters. In this milieu the Parton Street Bookshop was 'the mecca of the radical artistic and poetic young', a centre for new ideas during the thirties.

The International Surrealist Exhibition

In the first days of 1936, André Breton and Paul Eluard planned to visit London to discuss a prospective international exhibition. At the instigation of Roland Penrose and Herbert Read, an organizing committee was set up, and the first of eight meetings took place on Monday, 6 April 1936 in Penrose's home at 21 Downshire Hill, with Rupert Lee in the chair. Present

INTERNATIONAL SURREALIST EXHIBITION

NEW BURLINGTON GALLERIES
BURLINGTON GARDENS

The Committee have the honour to announce that

M. ANDRÉ BRETON
WILL OPEN THE EXHIBITION
on THURSDAY, JUNE 11th

MM. HANS ARP, SALVADOR DALI, MAX ERNST, MAN RAY, and other distinguished members of the Surrealist Movement abroad will be present

The Committee hope to have the pleasure of your company at 3 p.m.

19 Invitation to the International Surrealist Exhibition, 1936

were Herbert Read, Paul Nash, Henry Moore and Hugh Sykes Davies. From the fourth meeting, Man Ray, Humphrey Jennings, David Gascoyne, Sheila Legge and occasionally S.W. Hayter and McKnight Kauffer, also attended. The main point under discussion initially was how to attract as many sponsors as possible. The London Film Society was to be approached by Jennings to supply films; publicity strategies were defined and the magazines to be contacted were identified; articles – later dropped – were chosen for the catalogue; Kenneth Clark in Cambridge was to be asked by Hugh Sykes Davies to lend ethnological objects, and the form of the opening ceremony was agreed. It was even planned that Paul Nash should try to provoke a controversy in *The Times* – as he had done three years before for Unit One – and Davies suggested that in the interest of publicity they all should ring up Selfridge's and ask what surrealism was. Contact was made with Georges Hugnet, Paul Eluard and André Breton in France, E.L.T. Mesens in Belgium and Bjerke-Petersen in Denmark, so as to get works from other countries. Hanging was arranged for Monday and Tuesday, June 8 and 9; an Objects sub-committee was created with Nash, Davies and Moore; and Fred Mayor of the Mayor Gallery was to be asked to lend his private view list.

Two days before the private view, E.L.T. Mesens arrived from Brussels and disagreed with the hanging. He redesigned the exhibition, alternating

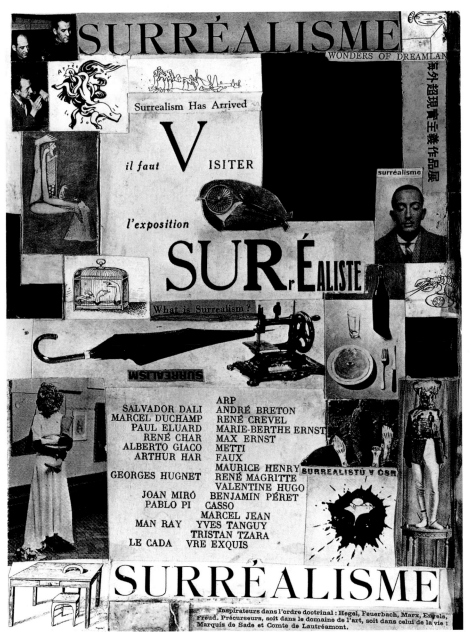

20 Poster for the International Surrealist Exhibition, 1936

large and small paintings, so that the visitor was obliged to step forward and then backward, thus encountering each picture individually.

On 11 June 1936, 1150 persons crowded into the New Burlington Galleries. Publicity had been well organized in the press. The *Daily Telegraph* published extracts from André Breton's statements, the *Star* gave tantalizing details of several works; the *Sunday Express* described strange compositions including a fur cup and saucer, and spoke of the promised appearance of a surrealist phantom; the *Manchester Evening News* railed against 'the meaninglessness for the sake of meaninglessness. A travesty of everything that's decent', and the *Sunday Dispatch* announced a storm over London and spoke of madness.[36]

André Breton, clothed in green, opened the exhibition with a declaration – also used as a preface to the catalogue – asserting that a revolution in the relationships between perception and representation was taking place 'around the visitors'. Meanwhile the 'surrealist phantom', Sheila Legge (Pl. 22), made her way through the crowd in a long white satin dress with coral-coloured belt and shoes, her face completely covered with roses. In one hand she held a pork chop, in the other an artificial leg, but the pork chop had to be abandoned on account of the heat. Dylan Thomas was going round with teacups full of boiled string, politely enquiring, 'Do you like it weak or strong?' at the same time that a lecture was being held that was being constantly interrupted by an electric bell. Surrealism was put to the test when a herring was pinned to one of Miró's objects – apparently by the composer

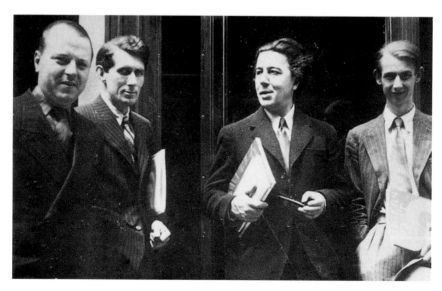

21 From left to right: E.L.T. Mesens, Roland Penrose, André Breton and Humphrey Jennings, at the International Exhibition of Surrealism in 1936

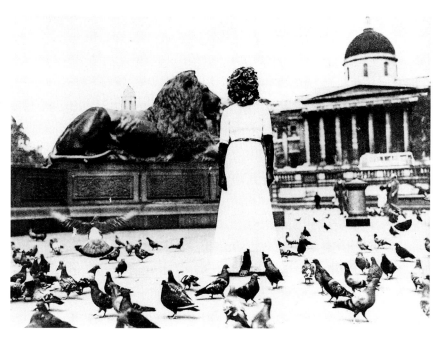

22 Sheila Legge as the Surrealist Phantom in Trafalgar Square, for the International Surrealist Exhibition, 1936

William Walton – and had to be taken away by Nash on account of the smell. A dispute broke out between Mrs Tait, a successful miniature painter, and Humphrey Jennings, who had used one of her miniatures in a satirical collage of Lord Kitchener (*Le Minotaure*). Jennings brushed the complaint aside by saying that, from a surrealist point of view, as far as he knew, the collage was not properly *his*.[37]

Dalí and Buñuel's *Un Chien Andalou* was shown, and several lectures were given: by André Breton on 'Limits Not Frontiers of Surrealism', and by Herbert Read who lectured on 'Art and the Unconscious', standing on a spring sofa. Paul Eluard spoke about surrealist poetry, and Hugh Sykes Davies lectured on 'Biology and Surrealism'.

An audience was also shocked by Salvador Dalí with a lecture on 'Authentic Paranoiac Phantoms', about a philosophy student who had eaten a mirror wardrobe over six months. Dalí appeared dressed in a deep-sea diving suit (Pl. 23), holding two borzoi on the leash in one hand and a billiard cue in the other. A bejewelled sword hung at his side. Edward James, a close friend, sat at the front and helped by translating Dalí's almost inaudible words. After Dalí had been speaking for a few minutes from inside the diver's helmet, he started to suffocate, and Gala, his wife, and Edward James

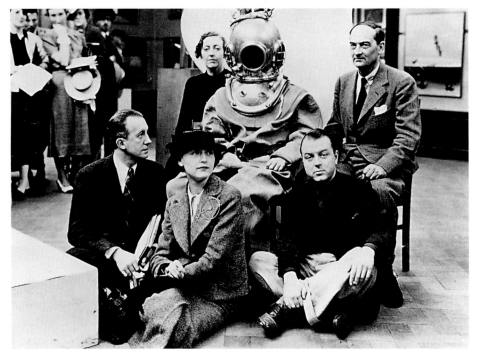

23 Salvador Dalí in a diving suit with, clockwise from left: Paul Eluard, Nusch
Eluard, E.L.T. Mesens, Rupert Lee, Diana Brinton Lee, 1936

had to unscrew the helmet. Then Dalí showed slides in any order and mostly
upside down; every so often, he would claim they showed Greta Garbo in
various staged attitudes, or protecting herself from journalists.

There was also a poetry reading. Eluard read texts by Lautréamont, Jarry,
Baudelaire, Rimbaud, Breton, Mesens, Péret, Picasso and himself, and David
Gascoyne, Humphrey Jennings and George Reavey read their translations as
well as some of their own poems.

Altogether, about 23 000 visitors attended. There were 360 collages, paint-
ings and sculptures exhibited, 30 African and Oceanian objects, two walking
sticks and several *objets trouvés* by Eileen Agar, André Breton, Max Ernst,
Herbert Read, Roland Penrose; there were children's drawings, and surreal-
ist objects by John Banting, Eileen Agar, Gala Dalí, Hugh Sykes Davies,
David Gascoyne, Rupert Lee, Sheila Legge, Roger Roughton, E.L.T. Mesens
and Tanguy. Sixty-nine artists, representing fourteen nationalities, were
exhibited, 27 of them British. Scandinavian surrealism was given pride of
place with the special publication of a 20-page catalogue entitled *The Art of
the Surrealists in Denmark and Sweden*, with a preface by Carl V. Petersen, the
director of the Hirschsprung collection. The exhibition's only setback was the
seizing by customs of the Danish consignment on the grounds of indecency;

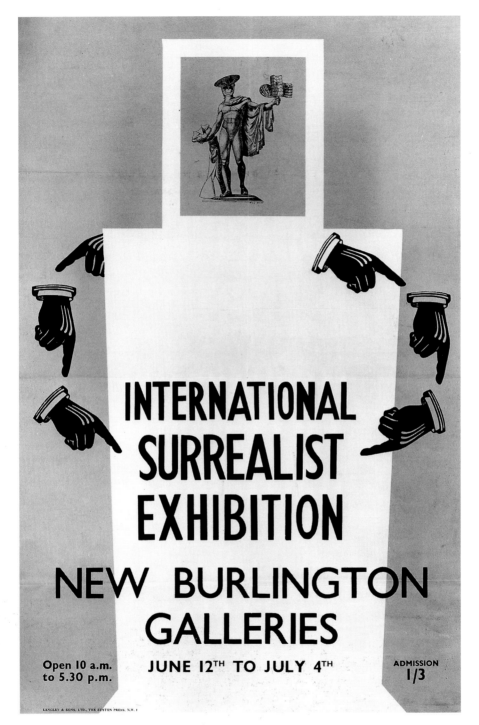

24 Poster for the International Surrealist Exhibition by Max Ernst, 1936

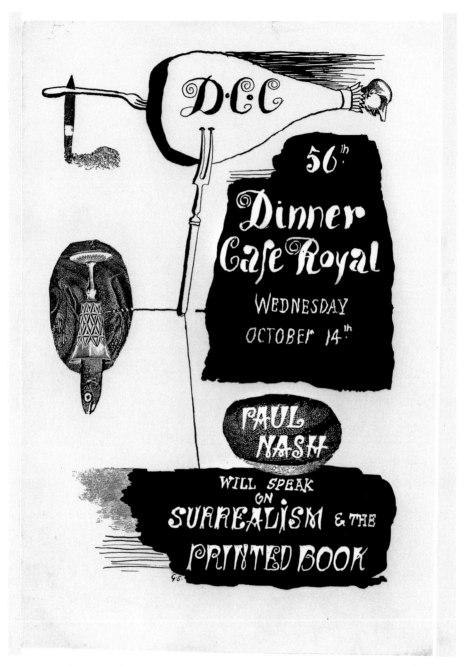

25 Cover of a dinner menu for a gathering of the surrealist group, coll. Professor
Christopher Buckland-Wright, design by Graham Sutherland. Photographer: Richard
Valencia

it contained seven works by Wilhelm Freddie, one of which was *Psychophotographic Phenomenon: Those Fallen in the First World War*, a monstrous figure displaying masculine and feminine sexual attributes and atrociously wounded and bleeding. A decision was taken to burn them and Rupert Lee could only persuade the authorities to send them back. Reaching London by other means, two of these drawings were exhibited, and one was reproduced in Read's *Surrealism*.

Since no British surrealist group existed prior to the exhibition, Penrose and Read's task in choosing artists was bound not to be easy. Not only did no group format exist, but no British exhibition had yet been related in any way to surrealism. Yet, by the late twenties and early thirties, a number of artists were turning towards the Parisian scene, currently dominated by the surrealists. To account for some of the contrasting choices Read and Penrose consequently made, including 'hasty' ones, will help chart the development of surrealism in Britain.[38]

One example is two greatly contrasting works; Merlyn Evans's *Conquest of Time* (1934) (Pl. 26) and Cecil Collins's *Cells of the Night* (1934) (Pl. 27). Within their differences in style and inspiration, they can be seen to represent the two extremes within which Read and Penrose made their choices for the 1936 exhibition.

Merlyn Evans was undoubtedly closer to surrealism than Cecil Collins. Having studied at the Glasgow School of Art from 1927 to 1930, and visited Germany and Denmark, he then went to Paris, where for a while he frequented the studios of Mondrian, Max Ernst and S.W. Hayter. His links with the surrealists were then strengthened by friendships with F.E. McWilliam and Charles Howard, by his growing sense of the futility of reality, by his political radicalism (although he belonged to no party), and by his interest in Freudian and Jungian investigation. His pictorial work increasingly involved subconscious imagery. In *Tyrannopolis* (Pl. 28), one of his first works painted in 1939 after he left for South Africa in revulsion at cultural and political life in Britain, a chaos of pyramidal forms and aggressive angles struggles, in its midst, with organic traces of mouths, teeth, limbs and skeletal forms, suggesting nocturnal rituals and parades of monsters, as in some of André Masson's works.

However, the main characteristic of *Conquest of Time*, painted in 1935, is geometric formalism. It cannot but deny any connection with surrealism. This picture combines the many successive movements and positions of a kingfisher plunging its beak into a river. Read and Penrose may have chosen it as a surrealist work because of its process of derivation from natural observation, the underlying presence of the bird, its blending of the natural and the mechanical, and its combination of the intellectual and the emotional, through the tension between the angles at the top and the curved lines which

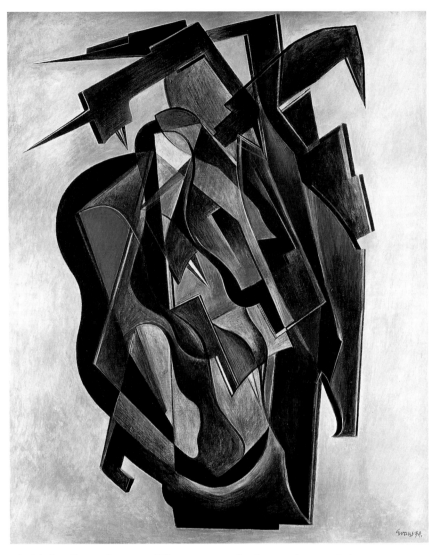

26 Merlyn Evans, *Conquest of Time*, 1934, 101.6 × 81.3 cm (40 × 32 in.)

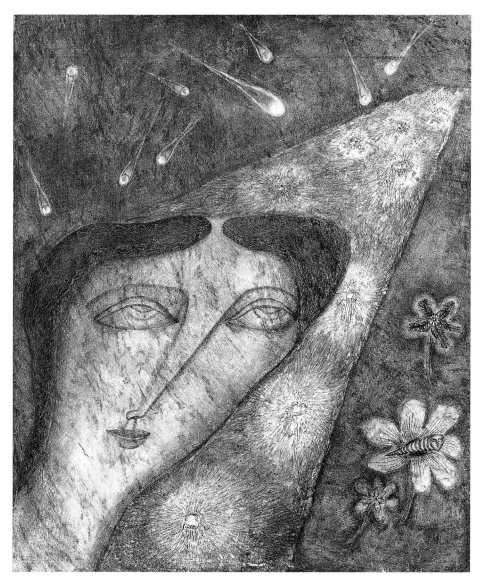

27 Cecil Collins, *The Cells of Night*, 1934, 76 × 63.5 cm (30 × 25 in.)

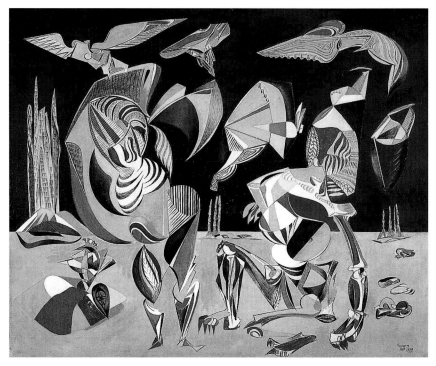

28 Merlyn Evans, *Tyrannopolis*, 1939, 76 × 91 cm (30 × 36 in.)

circulate beneath them. However, the entanglement of planes and intersect-
ing lines definitely link the picture, however belatedly, to cubism and vorti-
cism.

 Cecil Collins, by contrast, had never felt in sympathy with the main tenets
of surrealism. It is true that, independent as Collins was of any contempor-
ary school or trend, he had developed a very personal style, both naive and
symbolic; it is also true that his paintings intimate the passage into another
world, the realm of night, and that his images have a liminal quality,
between dream and reality, as in *Virgin Images in the Magical Processes of Time*
(1935), or the half nocturnal, half diurnal atmosphere of *The Cells of Night*,
with the leitmotif of a cellular womb, chrysalis and flower seeds. All these
point to the process of origination, central to surrealism. But the works are
also marked by the repetition of fixed symbols, figures borrowed from
Byzantine and Biblical mythologies, a pilgrim motif, eleven repetitions of the
word 'resurrection' in one of the shapes in *Virgin Images*, angelic figures in
flowing robes, a subtext from *Paradise Regained*, and Collins's stated intention

to recreate formally the spiritual unity of mankind, all of which irrevocably estrange him from the surrealists and their permanent self-questioning.

Among those included in the exhibition, John Selby Bigge, previously a member of Unit One, would never join the group in any declaration or activity, Edward Burra always denied being a surrealist, although he was dragged into a few surrealist shows, Robert Medley was more of an abstract artist and never took part in any activity of the group, and Graham Sutherland's independent turn of mind and religious involvement were out of keeping with any surrealist position. Read and Penrose also took a risk in selecting Grace Pailthorpe and Reuben Mednikoff, who were then by no means established artists – they had been working together for only a year and had never exhibited. On the other hand, they rejected Francis Bacon 'for not being surreal'. In both these cases, they proved right.

The work of Grace Pailthorpe and Reuben Mednikoff, two intriguing figures in British surrealism, was a major revelation for André Breton at the exhibition. Others within the group found them controversial; certainly they seem to have been the haunting conscience of British surrealism in the sense that they explored the unconscious in the most thorough, tenacious and uncompromising way.[39]

Prefaces to the catalogues published on the rare occasions of exhibitions of their works have related the circumstances of their first encounter, at a party given by Grace Pailthorpe at her flat in Dorset Square in London in February 1935. Each was interested in the other's profession and, in spite of a considerable age difference – Mednikoff was 28 and Pailthorpe was 52 – they embarked on a collective project of psychological cross-analyses which lasted over thirty years, with fascinating aesthetic results.

After having studied medicine in London and been a surgeon in Western Australia during World War I, Grace Pailthorpe travelled extensively, returning to England in 1922, when she became involved in Freudian psychoanalysis. This decided her to start studying criminal psychology in 1923. The result of her research on the limits of normality is given in *Studies in the Psychology of Delinquency*, published in 1932, followed by *What We Put in Prison and in Preventive and Rescue Homes*. Within the profession these books created something of a scandal, since Pailthorpe suggested treatments that avoided any kind of repressive attitude toward the criminal. She was convinced that the man in the street had much to learn from children, madmen and 'delinquents'. In 1928, she founded the Institute for the Scientific Treatment of Delinquency, later named the Portman Clinic, the first of its kind in the world. Its aims were radical.

The Clinic's subscription appeal starts provocatively with a quotation from a criminal: 'The only way to stop us is to find out who and what we are, and what we're good for.' This, and not a system of thought or a precon-

ceived theory, is the starting-point for the Institute's whole approach. It intended to exploit 'all known methods of scientific treatment' and to 'investigate and treat cases of children and young adults, first offenders who come under the attention of the police', so that 'our prisons ... should empty ... and potential criminals will be useful citizens'. Pailthorpe, tacitly referring to the terms of the report she had prepared at the request of the Medical Research Council, proposed psychotherapeutic clinics, re-education centres and permanent protection without loss of freedom – except for anti-social mental defections – convinced as she was that the application of her theories would 'serve humanity in the raising of the whole human status'. The creation of such an institute, she added, was the responsibility of society.

The most prestigious figures in psychological research supported the project, and among the Institute's vice-presidents there were Alfred Adler, Havelock Ellis, Sigmund Freud, Ernest Jones, C.G. Jung, John Masefield – the Poet Laureate – Otto Rank and H.G. Wells. The guiding light of Pailthorpe's ideas was the double notion of therapy and freedom. This was a combination which she never abandoned and applied repeatedly when working with, and on, Reuben Mednikoff, her special patient, from the moment they started to live together.

Reuben Mednikoff had studied at St Martin's School of Arts and had specialized in drawing for advertising from 1925 onwards. In the early thirties, he became interested in psychoanalysis and soon realized what use could be made of it, especially in confronting one's personal problems. His relations with his father were problematic, which in turn created tensions with his sister. It was no wonder that when he met Grace Pailthorpe they should strike a stable professional friendship. From being her assistant, he soon became her disciple and then her husband. Each complemented his or her own talent and knowledge by absorbing the other's abilities: Grace Pailthorpe drew and painted, Reuben Mednikoff joined her in conducting analyses, each one on the other, as if a two-way mirror were placed between them permanently. The automatic paintings and drawings which they then explored count among the most astonishing testimonies of the fauna and flora of the depths of the subconscious. Regardless of classical principles either in art or medical practice, and obsessed by the search for scientific and human truth, they produced an enormous output of drawings, gouaches and oils, though never cashing in on the reputation that these gained for them.

Three days after their first meeting, Mednikoff visited Pailthorpe to discuss helping with her patients. The following month, on 20 March 1935, Pailthorpe visited Mednikoff's flat in Belsize Square to see his works, and they hit upon the key idea behind what would be their shared investigation: to find, and explore, 'freedom in writing similar to freedom in painting'. Mednikoff produced his first oil 'unconsciously' on 1 April; he painted a

second three days later. Such was their radically clinical approach that thenceforth they never omitted to give the exact date and time of each session or identify each work completed, and drafted at the back of every gouache and drawing its psychoanalytical interpretation, thrashing out all the possible implications of the work. As soon as this joint venture started, Mednikoff decided to leave his job.

Grace Pailthorpe left London for Devon and Cornwall at the end of April 1935, going to Polperro, then Foscot, then Trebetherick and eventually Garrick, in July. Mednikoff joined her and they started to cross-analyse each other immediately, covering page upon page of notebooks. The following two extracts are examples. On 16 April, after Mednikoff sketched two pen-and-ink drawings, Pailthorpe interprets them:

He had been astounded at the previous interpretation I had given him and the way he had responded, in eagerness to follow on, had greatly helped me on to form my own plan of research. I felt that there must be somewhere a quicker way to the deep layers of the unconscious than by the long drawn out couch method and I had a feeling that it was through art. At any rate it should be used in conjunction.[40]

This elated feeling apparently never flagged. In August, she wrote:

We are doing a piece of research work which is so amazing to us in its development that we feel, if we can bring it to a finish and if it shall be in the smallest way understood, the results of our findings will metamorphose the whole of the pseudo-civilisation in which we live.

The mother–child relationship that formed between Pailthorpe and Mednikoff, with its considerable age difference, greatly simplified things, and consequently clarified the terms of the research, helping both to reach straight to the essence of the problems. Mednikoff, the one under study, plunged headlong into his fantasies, fears and obsessions, conjuring them up through drawings in an attempt to unveil the feelings of guilt he felt and question a castration complex he had had for some time.

During the sessions that Mednikoff underwent throughout 1935, strange situations emerged in which Pailthorpe made him confess to things, and in turn rewarded and punished him. It became apparent that the six-month-or-so relationship with Pailthorpe helped him re-enact his previous situation as a child with his elder sister, who was always presented as being much superior to him. That way, all the facets of the phantasmatic *knot* at the core of Mednikoff's subconscious were lengthily explored, his network of obsessional images of beasts, fanged jaws, snakes, breasts, penises, his own childhood memories, the image of Pailthorpe, his breathing problems, ... But more important is the idea he gives about his paintings:

I have always been anxious to prove to Dr P. and to find opportunities of proving to myself that I was as capable as she – as capable of giving to the world (mother) by

reason of my intelligence, a creation that would be admired. It would seem also that my wish to paint beautiful works is based upon a similar unconscious idea. If my pictures are really beautiful, mother (the world) will accept them as well as those of my sister's, or even in place of them.

This strong relation of dependence upon Pailthorpe was felt by Mednikoff to be absolutely necessary. It also explains the rapidity with which the relationship was formed between them, and the key role played by painting – an *a posteriori* justification needed by Mednikoff, and for Pailthorpe a new field of investigation. Most of Mednikoff's fundamentally creative anguish also appears in poems he wrote at the time:

> Some who sang hovered round the mulberried head
> The others, singing, swung their corpses round and fled . . .
> all dead . . . all dead . . .
> Sing soft, sing low lest they who are dead
> should rise and fling the world
> into the red and bloody bed . . .
> and who lies there . . . all dead . . . all dead!

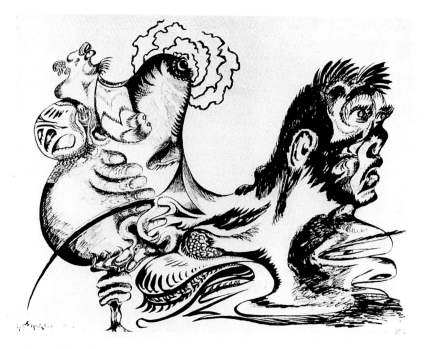

29 Grace W. Pailthorpe, *Ancestors I*, 1935, 30.5 × 38 cm (12 × 15 in.

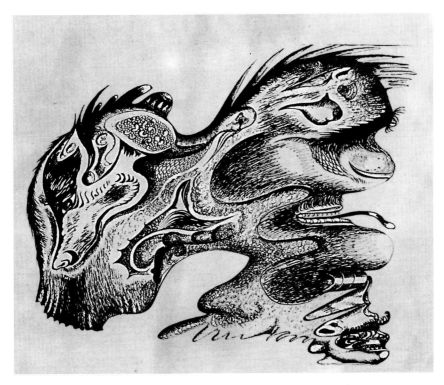

30 Grace W. Pailthorpe, *Ancestors II*, 1935, 30.5 × 38 cm (12 × 15 in.)

Mednikoff subsequently re-read the notes and poems made by him in 1935 and 1936; and though they were never corrected or modified, he was to augment them with further comments and interpretations in October 1937, after returning from London to Cornwall. These constitute a double commentary on the experience of creation and prove the unflinching spirit of continuity of his joint undertaking with Pailthorpe.

Pailthorpe's drawings at the 1936 International Exhibition and Mednikoff's oils and drawings are the best examples of psychoanalytical examination becoming a means of liberation, based on a spontaneous outpouring of feelings, design and colour. In Pailthorpe's *Ancestors I* and *II* (1935) (Pls 29 and 30), a figure with a monstrous, hairy masculine face, and a breast-shaped hump on its back, a womb-like pouch and multiple wriggling forms rise from the depths of the mind at the mere thought of fathers. Mednikoff's *Headwaiter* (1936) (Pl. 33) is no less monstrous, with horns, trunk and a hairy excrescence counterbalanced by ear-shaped and circular orifices, one of them garnished with pointed teeth. An eye stares at us, the other is a gaping cavity from which there wriggles out an elephant's trunk. The

portrait is that of a head-waiter – another father figure modified by death wishes, and a title which indicates that we have to read the drawing as a pun. The head is waiting and making us wait, a kind of double agent who welcomes us at the table of the subconscious – Mednikoff's as well as ours. The analytical descriptions on the back are made carefully, though some-what ramblingly, as with an untitled drawing made in 1936 (Pl. 34):

If I am without the child (my child) I am not able to feel that possessiveness which indicates my ability with possession of a penis. Of a penis that can do things. This brings back my sister conflict. 'Doing things' means possessing F.'s penis. If the child (egg) is taken back by M. I feel that I too must be swallowed with it. Without this egg I am useless – a nothing. And yet I apparently am not allowing M. to have the egg. I have lodged it between her teeth. She cannot possibly swallow it. This drawing indicates the anxiety state I am in.

The *Stairway to Paradise* (20 March 1936) (Pl. 31), presented at the 1936 exhibition, tells a similar story of unresolved tension. At the centre of a womb-like space, itself a place of tension between a solid, bony structure and a blue liquid tongue, a little stairway, fragile as a paper accordion, leads up to a box. It comes out the other side as a pink hosepipe which reaches towards a – genital? – hole situated just below where the tongue forks. The whole design plunges the viewer, especially with its soft and non-aggressive colours, into a kind of hesitation between protection and hostility, tension and release, inwardness and outwardness.

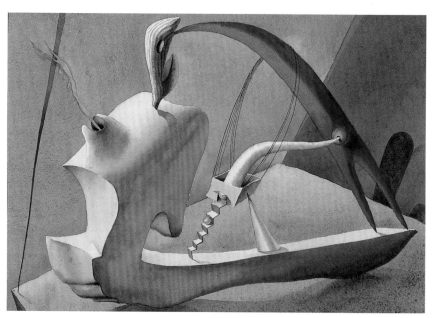

31 Reuben Mednikoff, *Stairway to Paradise*, 1936, 26 × 34.5 cm (10.2 × 13.6 in.)

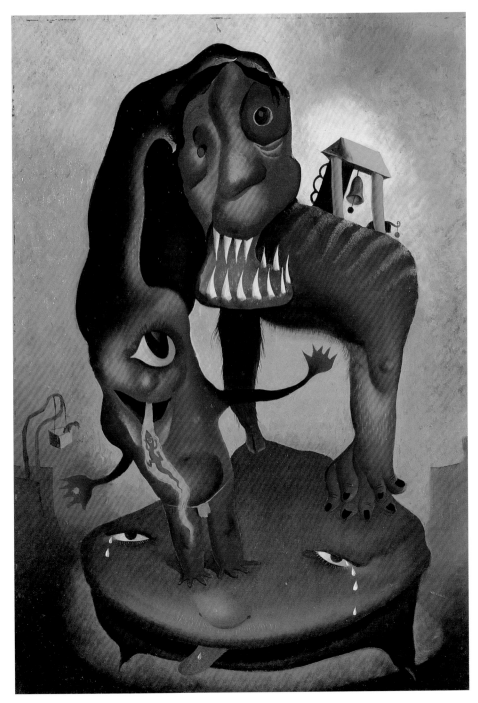

32 Reuben Mednikoff, *Little Nigger Boys Don't Tell Lies*, 1936, 58 × 40 cm
(22.8 × 15.7 in.)

33 Right: Reuben Mednikoff, *Head-waiter*, 1936, 25 × 20 cm (10 × 8 in.)

34 Below: Reuben Mednikoff, *drawing*, 1936, 25 × 20 cm (10 × 8 in.)

Two other no less astonishing oils by Mednikoff were to retrace this regression to its origins in order to tell its story again – a story in which the human interplays with the animal. *Little Nigger Boys Don't Tell Lies* (September 1936) (Pl. 32) and *The Flying Pig* (10–14 September 1936) (Pl. 35) open out onto the conflict of the interior and the exterior, hence the importance of fluxes in the paintings, as indicated by the proliferation of mouths, ears, anal and genital orifices. In *The Flying Pig*, a trickling flow of excrement, blood and sperm threatens the bodily organs and firm bodily forms with fluidity. A wolf's head turns into a breast, the space between the legs is both a cow's udder and a fish's head. All places of origin are made double; even the solidity of the whole composition rests upon no sure basis. Indeed, in *Little Nigger Boys*, a polymorphic, multi-headed monster – the blending and summary of all secret fears, the little nigger boys being the dark imps visiting the child in his bed at night, the embodiment of the threatening father – rests upon a little child's crushed head; similarly, the flying pig seems to float above the smoke coming out of some Aladdin's lamp, although its apparent concreteness likens it to some sort of shoe. Mednikoff's and Pailthorpe's worlds are intermediate and amphibious, articulating a double vision: the homunculus, in the wolf's head in *The Flying Pig*, is given two breasts and a penis, as the masculine and the feminine join in the aggression directed at the child, so that the child's paradoxical efforts to regress to a protective womb – which refuses it – and to have access to a sexual identity copied from its father's, are defeated.

Pailthorpe's paintings are, on the whole, more sedate and joyful than her companion's. Her being his surrogate mother appears in the themes of protection, feeding and warmth. All the same, they are not devoid of tension or threat. Indeed, the shadow of traumatic birth looms large. In *The Abandoned Pig* (1936), a baby-like pig stares, imploring and bewildered, at an apparently indifferent masculine face, and in *Composition* (16 November 1937) (Pl. 36), foetus-like arthropods, finding protection in the hollow of the mother's armpit, cling to the eggs from which they have just emerged. Here the vegetal and the human put the viewer in an area of shifting boundaries, with dramatic overtones hinted at by spots of blood.

The paradox at the heart of every work produced by Pailthorpe and Mednikoff is the abundance of detailed explanations. Each work aims at being exhaustive in order to be fully therapeutic; this, no less obviously, contrasts with the uncanny, ineffable force of the entangled design, and the colours which defeat sense. However fully explicative it might wish to be, every work unwittingly challenges any closure and opens vistas onto a world teeming with the artist's, and the viewer's, deeply buried memories. Because both artists defy totality of vision and *comprehension*, their works keep a consistently enigmatic quality, due to the irremediable fragmentation

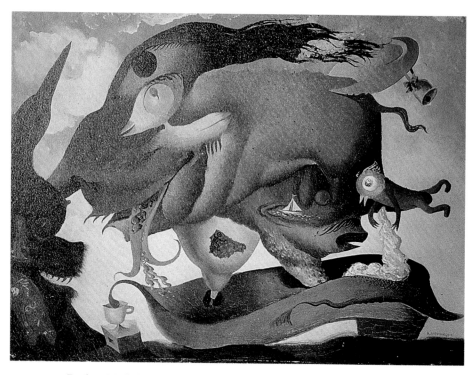

35 Reuben Mednikoff, *The Flying Pig*, 1936, 48 × 62 cm (18.9 × 24.4 in.)

of the subject and the unimpeded, discontinuous surfacing· of conflicting images. Consequently, these are not the transcription of a set of images lying dormant and supposedly present elsewhere. They are the expression of a psychic energy which runs *between* the conscious and the subconscious, informing both uninterruptedly; in this emerging process, these images find themselves constituted as a protection against ... themselves. In 1939, Samuel Haile was to stress the far-reaching importance of Pailthorpe and Mednikoff's achievement when he wrote in his personal diary: 'The extraordinary freedom of colour and drawing achieved by Dr Grace Pailthorpe and R. Mednikoff, whilst interpreting their subconscious childhood memories, throws a strong light on the inhibiting handicaps in the way of a more universal flowering of aesthetic potentiality.'[41]

The catalogue of the International Exhibition – whose cover was designed by Max Ernst – featured André Breton's text on the dialectical interaction of perception and representation. It also had an introduction by Herbert Read, who maintained the distinction between superrealism in general, with its

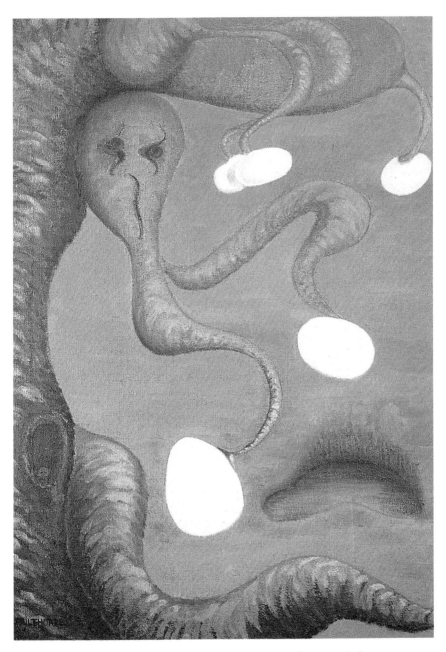

36 Grace W. Pailthorpe, *Composition*, 1937, 67.5 × 52 cm (27 × 20.1 in.)

romantic principle of sensitivity, and superrealism in particular, that is all kinds of 'outsider' art and any art produced 'on the basis of ... the scientific knowledge of the psychological processes involved in the creation of a work of art'. Read concluded, 'Do not judge this movement kindly. It is not just another amusing stunt. It is defiant.'

The fourth *Bulletin of Surrealism*, published in September 1936 by Anton Zwemmer under the signature of 'the surrealist group in England', contained a summary of Read's open letter to the Artists' International Association, a lecture by Hugh Sykes Davies on 'Biology and Surrealism' and a selection of press comments, together with the reproduction of works by Penrose, Jennings, Nash, Pailthorpe, Burra, Evans, Rupert Lee and Eileen Agar. Indeed, on the whole, it is the political, revolutionary dimension of the movement based on Marxism and psychoanalysis which is stressed more than the aesthetic one, together with the necessity of collective action to combat individualism and unrestricted capitalism.

Press reactions to the exhibition were violent; only a few writers understood surrealism. The *Daily Mirror* and the *Daily Herald* dismissed the movement, while the *Daily Telegraph* described it as 'poor jokes, pointless indelicacies and relics of an outworn romanticism'. The *Sunday Dispatch* and the *Daily Express* ('Blotches on the face of space are surreal') were humorous, while the *Evening News* was fierce in its denunciation: 'Frankly, I don't see why a sense of world despair should make you want to construct a cup, saucer and spoon of rabbit fur ... It is not worth looking at. I don't mind its being meaningless, but it is horribly clumsy as well.'[42] Sensational reports on André Breton's green pipes, on Jacqueline Breton's green eyes and nails, Salvador Dalí's deep-sea diving suit and Sheila Legge's pork chop were accompanied by jocular headlines, and criticism dismissing the new images altogether. In contrast, however, an article by Cyril Connolly in *The Bystander* stressed that anyone can exercise the right to decide that a piece of rock may be shaped like the *Queen Mary* or like a prime minister, and to exhibit it as such, and claims that the surrealists 'stretch a hand to anyone who in answer to reason's peevish "Why?" returns, instead of a lame "Because" an arrogant "Why not?".' One other, anonymous, article in the *Sunday Referee* criticized the British artists exhibited for not having evolved beyond the aesthetic tenets of Unit One,[43] and these tenets were apparently at the back of the critics' minds, threatening to reduce and blur what was different about surrealism.

The impact of the International Exhibition was felt long after the closing of the doors of the New Burlington Galleries. In a subsequent series of attempts to explain and redefine the movement, two tendencies come to light: Read and Davies's approach, which aims at making surrealism 'acceptable' and part of English tradition, and Jennings and Madge's approach, which warns

people against reducing surrealism to simple formulas and stresses its break with the past.

A prime example of the former approach is a thick volume of essays entitled *Surrealism* (Pl. 37), edited by Herbert Read, which includes texts by himself, André Breton, Paul Eluard, Hugh Sykes Davies and Georges Hugnet, which came out in September 1936 in an attempt at a definitive assessment of British surrealism.[44] Unfortunately, it did more harm than good. In their attempt to familiarize the public with the principles of surrealism, Read and Davies overdid it in stressing the natural links between, say, Wordsworth, Coleridge, Lewis Carroll, Edward Lear and surrealism, even forgetting in their own list of ancestors Swift and Young, whose names were hailed by Breton in the 1924 manifesto. This selection of canonical, fully accepted works of English romantic and Victorian literature marks a fundamental misunderstanding about surrealism. When Read writes that 'by the dialectical method we can explain the development of art in the past and justify a revolutionary art at the present time', he may be right, but the two verbs imply an attempt at exhausting the meaning of surrealism.

In the same way, Davies, in his 'Surrealism at this Time and Place', compares Magritte's *Red Model* with Wordsworth's hallucination in *The Prelude*, when he is out one night in a small boat which he has stolen. Davies seems to ignore that the *perspectives* of these works are poles apart, and this misunderstanding can be best summed up by these lines at the end of his text: 'To become a Surrealist no violent act of conversion is necessary. It is enough to examine and understand the historical facts and to accept their implications.'[45] This type of statement amounts to a defusing of any revolutionary force in the movement, no matter what attack on bourgeois culture preceded it. Indeed, the founding texts of surrealism in Britain appear to scarcely acknowledge its radical challenge of reason and logic. Humphrey Jennings fully realized this when he stood up against his own comrades' short-sightedness:

How can one open this book, so expensive, so well produced, so conformistly printed, . . . containing so protesting a number of English statements and so stiffly pathetic a presentation of French ones, and compare it a moment with the passion, terror and excitement, dictated by absolute integrity . . . which emanated from *La Révolution Surréaliste* and *Le Surréalisme au Service de la Révolution*. . . .

The elevation of definite 'universal truths of romanticism' in place of the 'universal truths' of classicism is not only a shortsighted horror, but immediately corroborates really grave doubts already existent about the use of surrealism in this country.[46]

To be fair, Read had also stressed that 'surrealism has no respect whatever for academic traditions', and Davies had anathematized bourgeois culture and bourgeois marriage ('the vilest of all prostitutions'). Yet, the difference between Davies's and Read's explanatory comments and Breton's and

37 Cover of Herbert Read's *Surrealism*, 1936. Collage by Ronald Penrose

Hugnet's texts in defence of desire and anti-aestheticism reveals the weakness identified by Jennings, especially when he added that 'Mr Davies's article becomes a lecture on Coleridge, and Mr Read's a defence of Romanticism'. As a prelude to this, back in 1933 Charles Madge's articles had already declared a necessity to "indigenize" the movement. Surrealism, he had written, 'is not best served if English writers imitate the work of the French ones'; it has to be seen not as personal objective, but as a process involving the whole of English language and literature.

If this controversy had been pursued, it would greatly have helped to refocus the group's position. Instead, much of its energy was soon to be directed elsewhere, into a long public debate with the Marxist-inspired parties, represented by the *Left Review*.

Mention must be made of the supporting role played in surrealism by Edward James, who had walked through the exhibition with a billiard cue in his hand. His position might seem ambiguous, given that he enjoyed great wealth.[47] On the face of it, his passion for surrealism might seem akin to aristocratic dilettantism. But he avoided any simplistic interpretation of what it meant and truly rejected the values of his class. Fascinated by the world of the theatre and fashion, he organized his life and the places where he lived as one would stage a play and plan stage sets. Over three years, he befriended Coco Chanel, John Betjeman, Serge Lifar, Georges Auric, Christian Bérard, Balanchine, and Pavel Tchelitchew, and Marie-Laure de Noailles, who introduced him to surrealism after they met and became lovers in 1932. In 1934, James started a long relationship with Salvador Dalí, whom he met at Dalí's first London exhibition at the Zwemmer Gallery. On signing a contract with Dalí that would last from 1935–9, James became one of surrealism's only patrons in Britain; he marked the occasion by sending Dalí a stuffed polar bear. He also commissioned Paul Nash to design a bathroom, and published three poems in *Minotaure*, together with an ironic article on the political, aesthetic and culinary significance of hats worn by the people compared with those worn by the queen.[48] In 1937 he asked Magritte to decorate his house and modelled for him; he also asked Dalí to design furniture and decorate one of his homes. It was James who ordered the famous lobster telephone as well as the transformation of a sofa into the lips of Mae West.

Whether in Monkton House, a residence built next to West Dean, in West Sussex, or at 35 Wimpole Street, James played ceaselessly with the parallel world of the imagination. He did so not only with *trompe-l'oeil* effects, but through a paranoia-inspired detachment of the object from itself: a pawprinted staircase carpet, which replaced Tilly Losch's footprints before their catastrophic divorce, a shaving mirror in the shape of the globe, chairs with actual arms and hands carved in wood, and, outside, bamboo drainpipes, pilasters the shape of large unfurling ferns, fake doors, plaster draperies

under windows like sheets hung out to dry, a clock face on a stalk telling not the hours but the days of the week, the tips of chimneys giving the appearance of huge eyes, a loudspeaker on the roof, and the planned, but not achieved, conversion of a dining-room into 'the breathing stomach of a rather ill dog' (the room was to be lined with flock-sprayed sheet rubber concealing compressed air ducting to ensure that the walls expanded and contracted unevenly, in the words of Hugh Casson, who was in charge of the project). An aesthete in the tradition of Oscar Wilde, James was playing at the edge of space and time in perfect accord with Dalí's own regressive impulses, and fighting against the inhibitions of his own internal paradoxes: being immensely rich and refusing to be part of the upper classes; being latently homosexual and desiring female conquests. As poet and critic he was preoccupied with the stimulation of the vegetal and organic through the deviation of specific objects and interactive exchanges between the inside and the outside. In surrealism, he found the perfect conditions for making such concerns concrete.

Edward James travelled widely in the quest to make his dreams real. In 1939 he joined Dalí in a mad project for the New York World Fair, 'The Dream of Venus', which was to have a tank full of water with girls swimming about in the nude recreating Botticelli's famous *The Birth of Venus*. After an unrequited passion for Charles-Henri Ford's sister, he moved to California in search of spiritual relief with the Vedanta movement and the mysticism of Aldous Huxley. Severely disappointed, he went in 1946 to Mexico and bought 2500 acres of jungle where he built a series of fantastic vegetal-like follies in concrete and steel. The figure he had cut in the 1936 International Exhibition with his billiard cue had indeed been emblematic, representing an alliance with play and playing, which involved the whole person, and which turned Edward James into a liminal creature, the living ghost of British surrealism.

Communicating vessels:
formation and growth 1936–7

Alongside the 1936 exhibition, and in its wake, there were various tentative events. Roger Roughton devoted a double number of *Contemporary Poetry and Prose* to surrealist verse, containing some 40 works by British and French poets.[1] It opened with Paul Eluard's statement that 'the poet is he who inspires far more than he who is inspired', a phrase which gainsays Read's and Davies's insistence on the link between romanticism and surrealism. British surrealism was represented by Gascoyne, Kenneth Allott, Roger Roughton, and Humphrey Jennings's strange prose poems in collage form.

The press briefly echoed the new spirit in various ways, for the most part reductively. The most responsive area was the fashion world, which hailed the arrival of surrealism in England as a source of new ideas and fresh images. Amidst reproductions by Pierre Roy and Rupert Lee, *Vogue* wrote:

White butterflies on the head are absurd, white birds in the bosom even more absurd; but we like them. The world has been starved of fantasy, and the surrealists supply it . . . Why not tap this fourth dimension of the mind, this rich country of the imagination? ask the surrealists. Why be bounded by the vision of the physical eye?[2]

The *Sunday Referee* published a declaration by Schiaparelli, on whose creations Dalí regularly collaborated from 1936 onwards, in wording that contributed to level down surrealist ambitions:

Surrealism has crept into fashion. Three models, after designs by my friend Salvador, are in my winter collection . . . Why are these models such a success? Because they are neat. Simplicity itself. Just the clear, stark lines of modernism. Good, practical suits. . . . So, if surrealists can give us practical ideas, why not?[3]

An article in *Harper's Bazaar*, entitled 'Sur-réalisation' in August 1936, hailed creations by Aage Thaarup:[4] black felt caps with seashells, white hands holding grapes, and sharp and flat signs with lips all over them. An advertisement for Jaeger's hunting outfits showed a gun which became a

train out of whose billowing smoke there emerged a goat's head.

In all this there was a danger of turning surrealism into a body of mere recipes and tricks. When the *Architectural Review* organized a photographic competition entitled 'Holiday Surrealism', Paul Nash, who with Roland Penrose was one of the judges, wrote a simplistic introduction:

> . . . all [art] that is not primarily or exclusively preoccupied with aesthetic form or with the mere reproduction of the bald external appearance of logical reality, may legitimately be termed surrealist in the widest sense of the word.[5]

The competition required that participants should send in their entry with 'brief explanations indicating where lay the surrealist significance of the photograph'. First prizes went to works by Luke Summers and Bill Brandt, both staging encounters of natural forms and objects deemed by the two judges to be 'naturally . . . the most current presentation of surrealism'.[6]

Art and politics

Towards the end of 1936, an essentially sociological activity developed, which for a while could be seen as surrealism's ally. While Mass Observation cannot be seen as an offshoot of surrealism, its founding members included several British surrealists.

By the autumn of 1936, Humphrey Jennings, Stuart Legg the film-maker, David Gascoyne and Charles Madge, were already agreed on the need for a group which would evolve an 'anthropology of our people'. In a letter to the *New Statesman* in January 1937, Humphrey Jennings, Charles Madge, calling himself 'Poet and communist', and the ethnologist Tom Harrisson, stated the aims of the organisation.[7] It was to be an independent, scientific and fact-finding body, with a team of trained, full-time investigators helped in their task by a nationwide panel of voluntary observers.[8] The aim was to document the daily life of people and the processes of social change and of political trends, of public and private opinion, in a series of books, bulletins, broadcasts and articles. Mass Observation met perfectly with Humphrey Jennings's vision of the cotton workers of Bolton – the town chosen for investigation, renamed Worktown – as the descendants of Stephenson and Watt, the dwellers among Blake's dark satanic mills reborn into a world of greyhound racing and Marks and Spencer. The investigation, running halfway between the ghosts of Marx and Freud, included a survey of fears and dominant images, female taboos about eating, bathroom behaviour, the aspidistra cult or the private life of midwives, as well as the anthropology of football pools and the people's behaviour on Coronation Day.

The enthusiasm created by the movement at the end of 1936 and early

1937 helped Tom Harrisson to attract several brilliant artists to it. Some of them believed in the necessity to work for the people in a world threatened by the rise of fascism, others in the possibility of making a better world by furthering a sense of community and sharing. Sir William Coldstream, Julian Trevelyan, Graham Bell and Robert Medley were all appointed to paint scenes from Worktown. For Julian Trevelyan, this resulted in developing his collage technique into ironical and satirical plastic statements, for example glueing torn shreds of pictures of the Coronation crowds to make the cobble-stones of Worktown. When he then went to the Potteries, he found that a return to oil on canvas corresponded better to his new involvement – one which took him down the pit and along the seams with Tom Harrisson in the Ashington colliery. Humphrey Spender, who was then working as a documentary photographer for the *Daily Mirror*, was appointed to take photographs of the interior of working-class houses, William Empson made reports on the contents of shop windows, Humphrey Jennings took photographs and painted in Bolton and Blackheath, and Robert Melville, then a clerk in Birmingham, lent a hand in sorting out the hundreds of reports sent to Charles Madge.

Mass Observation could have provided surrealism with concrete anchorage in British society's everyday life. But Tom Harrisson's purely ethnological viewpoint and his unwillingness to take sides politically distanced his undertaking from the main surrealist propositions. Whatever the destiny of MO in the forties and its evolution towards a governmental marketing body, it must be remembered first 'as a movement which aimed at giving working-class and middle-class people a chance to speak for themselves, about themselves'. For a short while, however, it was attuned unambiguously to surrealist preoccupations with the mass expression of a collective unconscious.

Two political tendencies appeared within British surrealism during the eighteen months or so following the International Exhibition, which both attempted to clarify the movement's orientation. One was the mildly *engagé* defence of surrealism as the continuation of romanticism, represented by Herbert Read and Hugh Sykes Davies, the other, more militant, was based on the hope of seeing one day the victory of the proletariat via the necessarily revolutionary qualities of surrealism. The international scene had become very disordered as, gradually, through the first half of the thirties, a united front of workers, artists and intellectuals confronted the rise of fascism in Germany, Spain, Italy and throughout Europe in general. The Artists' International Association, whose membership was becoming formidable, had exchanged its initial exclusivity for an opening of ranks to an ever-widening circle of members, fellow travellers and comrades, so that all, it was hoped, could share in the struggle for Peace, Culture and Democracy, the watchwords of those years.

Spain was at the centre of most preoccupations: it had become the battle-field of progressivism and obscurantism, democracy and fascism. Among the many initiatives, fund-raising events and marches organized by parties of the Left, the British surrealists signed and published a virulent 'Declaration on Spain' in Roger Roughton's *Contemporary Poetry and Prose* (Pl. 38). This denounced the British government for its non-intervention pol-icy and accused it of 'duplicity and anti-democratic intrigue'.[9] Reactionary forces in Spain had proved they were not ready to accept the constitutionally elected Republic; fascism was an obvious threat for the whole of Europe; and the government had it in its power to impede Franco's influence. Accordingly the surrealists asked the authorities to change policy and 'send arms to the people of Spain'. At home, support for the Republicans went together with the many demonstrations against Mosley and his Blackshirts, as in the 'They Shall Not Pass' demonstration of 4 October 1936, organized by the Labour Party, the Independent Labour Party and the Communists in the streets of the East End against the gathering there of 3 000 Fascists.[10]

Seeking to define their political position and to make that position active, the surrealists collaborated with the parties of the Left in various political and artistic ventures. They simultaneously opened a strongly worded debate with them, in the pages of the *Left Review*.[11] This debate lasted over two years, during which there took place one of the most fruitful discussions on political engagement at a critical moment in the Western world. Led by Read, against Randall Swingler, T.A. Jackson and A.L. Lloyd, it echoed the central artistic preoccupations of the thirties: what is the function of art in a society conscious of the exploitation of its workers? To what extent can art serve the proletariat's struggle? As a consequence, asked theorists of the Left, what kind of political consciousness does surrealism have, and where does it stand in relation to realism and especially Jdanov's principles of socialist realism?

In his book, *Illusion and Reality*, Christopher Caudwell made it clear that a new voice was needed to create new artistic perceptions. Speaking about the 'anarchists, nihilists and *surréalistes*', he wrote:

Man becomes free not by realising himself in opposition to society, but by realising himself through society ... But because the surréaliste is a bourgeois and has lost control of his social relationships, he believes freedom to consist in revolting against these forms whereby freedom has been realised in the past. Social activity, the means of freedom, is – because its products are appropriated more completely by individuals the more social the activity becomes – opposed by a resolutely non-social activity which is felt to constitute freedom because its products are useless to society and therefore cannot be appropriated by individuals.[12]

More specifically, Caudwell saw surrealism as 'escape from the social ego', a technique 'where freedom, in true bourgeois style, is the unconsciousness

DECLARATION on SPAIN

Against the appalling mental and physical suffering that the Spanish Civil War is involving, we can already offset certain gains to humanity which will remain whether the Government of the People conquers or not; gains of knowledge which have been purchased far too dearly, but which for that very reason have an imperative claim on our attention. They are these:

1. No one can continue to believe that, if a People's Government is elected constitutionally, Capitalism will be content to oppose it only by constitutional means.

2. No one can continue to believe that violence is the special weapon of the proletariat, while Capitalism is invariably peaceful in its methods.

3. No one can continue to believe that Fascism is a merely national phenomenon. It is now abundantly clear that in a crisis the Fascist countries emerge as parts of an international whole, the International of Capital. German and Italian arms are killing the people of Spain.

4. No one can continue to believe that Fascism cares for or respects what is best in humanity. In Garcia Lorca, the foremost modern poet of Spain, they have assassinated a human life which was especially valuable. Meanwhile the People's Government have made Picasso director of the Prado, hoping to widen still further the scope of his work for humanity.

5. No one can continue to believe that our National Government has any right to speak in the name of democracy. It has assisted in the crime of non-intervention; it has refused to allow the export of arms to a Government democratically constituted, and has regarded with equanimity the assistance given by Fascist powers to the rebels. There

can be no more conclusive proof of its real sympathies than its conduct towards Portugal. Portugal is a British financial colony, and depends on British arms for the protection of its overseas possessions. A word from our Foreign Office would have secured her immediate adherence to the pact of non-intervention. Evidently that word has not been given. The National Government has permitted the Portuguese dictatorship to assist the rebels in complete freedom; at every stage of the campaign the rebel armies have been based on the Portuguese frontier.

If these things are clear, we are the gainers in so far as we know *inescapably* where we stand with regard to Fascism, to the People's Government, and to the National Government of Britain. And in the light of this knowledge we support the popular demand that the ban on the export of arms to the Spanish Government be lifted. We accuse our National Government of duplicity and anti-democratic intrigue, and call upon it to make at once the only possible reparation

A R M S
for the People of Spain

Hugh Sykes Davies, David Gascoyne, Humphrey Jennings, Diana Brinton Lee, Rupert Lee, Henry Moore, Paul Nash, Roland Penrose, Valentine Penrose, Herbert Read, Roger Roughton.

ISSUED BY THE SURREALIST GROUP IN ENGLAND.

38 'Declaration on Spain', statement from the surrealist group, *Contemporary Poetry and Prose*, 1936

of necessity, i.e. the ignorance of the affective organisation which determines the flow of imagery'. In that sense, surrealism is identical with anarchism, 'so disgusted with the development of bourgeois society that he asserts the bourgeois creed in the most essential way: complete "personal" freedom, complete destruction of all social relations'. Other critics, writing in *Left Review*, denounced the surrealists as bourgeois intellectuals who might sympathize with the workers but remained bogged down in idealism, and even mysticism, above the daily preoccupations of the proletariat. Anthony Blunt saw surrealism as a rational movement based on the scientific exploration of the subconscious, but too much centred on the interior. Alick West asked surrealists 'to remain true to their negation of bourgeois society' and cross over; T.A. Jackson accused surrealism of being almost synonymous with pragmatism, and prioritizing 'subjective interests'. A.L. Lloyd, while paying homage to the surrealists for having published their 'Declaration on Spain' and demonstrated against fascism, stigmatized automatic writing and the belief in chance, which would never 'make the proletariat conscious of its social and revolutionary responsibilities'. In a subsequent attack, Randall Swingler continued these exhortations: surrealists should look outside, and not gaze at their own entrails.[13]

What cannot be denied Read and Davies, for all their levelling-down statements in *Surrealism*, is an affirmation of surrealism's position as an intermediary between social involvement and aesthetic preoccupations. The Left felt that surrealism was thwarting their own artistic objectives, by the terms on which it was conjoining art and politics. Not only was surrealism questioning, but it was escaping any strongly codified system. An excellent summary of this standpoint, between alignment and independence, is provided by the various declarations made by Roger Roughton, a thoroughgoing surrealist and a militant member of the CP, who walked this ideological tightrope in his successive editorials in *Contemporary Poetry and Prose*.

In Roger Roughton's poems, given his affiliation to the Communist Party, and his militancy, it is no wonder that this protest at the existing social order should be voiced so vibrantly:

> To-morrow the palmist will lunch on his crystal
> To-morrow REVOLT will be written in human hair
> To-morrow the hangman's rope will tie itself in a bow
> To-morrow virginia creeper will strangle the clergy
> To-morrow the witness will tickle the judge
> To-morrow this page will be found in a womb
> To-morrow the lovers will answer the palace
> To-morrow Karl Marx will descend in a fire-balloon
> To-morrow the word that you lost will ask you home
> To-morrow the virgin will fall down a magnified well
> To-morrow the news will be broadcast in dialect

To-morrow the beautiful girl will attend
To-morrow a cloud will follow the bankers
To-morrow a child will rechristen our London as LONDON
To-morrow a tree will grow into a hand
Yes listen
To-morrow the clocks will chime like voices
To-morrow a train will set out for the sky

National papers please reprint[14]

Each line, which sounds as if uttered from the proletariat's pulpit, shares the same derision of laws and conventions; some stigmatize various forms of power, the hangman, the judge, the clergy, the banker, even a palmist, while others celebrate hope, the lovers, the virgin, news broadcast in dialect. The enumerative process which takes stock of the transformations to come finds its apotheosis in London's recovery of its genuine name – the same but made other, just as today will be transformed into tomorrow; Roughton's revolt is inextricably linguistic and political. His other texts, published in his own *Contemporary Poetry and Prose*, are a series of tableaux which deviate from semantic logic and satirize the established powers; in 'The Largest Imaginary Ballroom in the World: A Date at the Kremlin', he writes of 'policemen disguised as burglars [who] were waiting outside night clubs for burglars disguised as peers of the royal Blood (even their best friends won't tell them)'.[15] What is being celebrated at this ball at the Kremlin is the dance of the real in the arms of the imaginary on the rubble of decorum and the establishment.

This marriage of word and action was felt by Roughton to hold much promise. When it failed under the pressure of events, Roughton, one of the most thoroughgoing surrealists, realized that a United Front could never be achieved, that surrealism and communism could never ally; having by then become a pacifist, he was to leave London on the eve of war for Dublin, where in 1941 he gassed himself.

In September 1936, Roughton declared that 'surrealist work, while not calling directly for revolutionary intervention, can be classed as revolutionary insofar as it can break down irrational bourgeois-taught prejudices, thus preparing mental ground for positive revolutionary thought and action'. He went on to say that 'as long as the surrealists will help to establish a broad United Front (and not delude themselves, as one member did, into imagining that there is any revolutionary part to be played *outside* the United Front . . .) there is no reason why there should be any quarrel between surrealism and communism'.[16]

In the course of a subsequent reply to Ezra Pound, who charged the Surrealists with being 'intellectually timid', Roughton criticized Breton for having published an attack on the Moscow Trials and the Soviet Union at a time when democracy was fighting against fascism. He insisted that the

Communist Party was the only party which fought for a society where 'they and everyone will be able to work under the most favorable possible conditions'. This led him, as a militant, to issue a warning: 'While surrealism is intrinsically a revolutionary element of limited but certain importance, an overdose of Freudianism may lead, and has led, some surrealists to an individualistic, anarchic trotskyism'.[17]

It is here that a crucial rift in the ranks of the Left appears: as in the streets of Barcelona, Stalinism and Trotskyism were literally fighting each other. In 1938, the British surrealist group mainly threw its allegiance in with Trotskyism, and Roger Roughton, seeing the basic incompatibility of surrealism and communism, drifted away from the group. This marginal position also explains why many surrealists, either personally or collectively, were to join the activities of the Artists' International Association.

When in 1935 the AIA changed from being an organ of communist propaganda and opened its ranks to as many artists as possible, it made a decisive move towards a possible Popular Front Against Fascism, continuing an alliance struck the year before between the Independent Labour Party and the CP.[18] In its commitment to a specifically communist programme, the AIA had perceived artists only in connection with the needs of the working class. Now, a new turn had been taken, and a spate of exhibitions and lectures were organized. Herbert Read spoke for example on 'Abstract Art'. The first exhibition, opened by Aldous Huxley, was 'Artists Against Fascism and War', and was attended by over 6000 visitors. In 1935 the first AIA book was published. This was 5 On Revolutionary Art, whose contributors included Herbert Read ('What is Revolutionary Art?'), Alick West, F.G. Klingender and A.L. Lloyd.[19]

With the outbreak of the war in Spain, the activities of the AIA redoubled. Some of its members, including John Banting, who was accompanied by Nancy Cunard, went to Spain, whether or not to join the International Brigades. The first British woman to be killed in action, in August 1936, while helping a wounded colleague, was Felicia Browne, one of the AIA's most prominent members. Republican Spain was calling for help. Reports of the war reached Roland Penrose as he was staying with Paul and Nusch Eluard, Picasso and Dora Maar, and Christian and Yvonne Zervos, the editor of Cahiers d'Art, in the Hotel Vaste Horizon in Mougins above Cannes. Penrose and Zervos decided to go and see for themselves. They obtained an invitation from the Propaganda Minister, Mirravitles, to collect material about works recently discovered in churches, cathedrals and the houses of exiled or executed fascists. The idea was to write a book showing the world that 'in spite of revolutionary acts of violence, the monuments had been revered and protected, in some cases more efficiently by the Republican regime than by the church, which had often either neglected or sold its

treasures'.[20] Penrose invited David Gascoyne to join them, and secured letters of introduction from Fenner Brockway of the Independent Labour Party; when passing through Paris, they were given a list of names and addresses of friends in Spain by Paul Eluard. In Spain, David Gascoyne worked for Radio Catalonia, translating news bulletins and broadcasting them to the rest of Europe, and accompanied Penrose and Zervos on visits to Gerona, where old tapestries of the Apocalypse had been discovered. Gascoyne came back to London at the end of November, delivering a huge bundle of posters for an exhibition at the Whitechapel Gallery in aid of supplies for Spain. Penrose returned a little later, bringing with him photographs from the front taken by Robert Capa.

In Britain, a campaign in support of the Republican cause was launched, mostly centred on exhibitions. In September 1936 an exhibition of Felicia Browne's works helped to collect £260 for the Spanish Medical Aid Committee; in December 1936 'Artists Help Spain', with the participation of Paul Nash, Ben Nicholson, Moholy-Nagy and Pissarro, raised funds for a field kitchen for the International Column. Additionally, at the beginning of 1937, the decision was taken to set up the First British Artists' Congress organized by Nan Youngman, Quentin Bell and Viscount Hastings. Its primary aim was to establish the terms for an across-the-board art policy in Britain, including art education in schools and the formation of artists' trade unions. The participation of surrealists in these various initiatives was far from negligible, and Henry Moore and Herbert Read were among the main supporters of the Congress. Parallel to the Congress, an exhibition was mounted by the AIA in April and May 1937; rooms were devoted to the various artistic tendencies and styles, and one of them was assigned to surrealism. Three separate juries were appointed, one for surrealism, one for abstraction and one for the rest, among which was a Working Men's Group. Out of almost one thousand works, 118 were surrealist, out of which 43 were by British artists.[21]

The 'spirit' of this enormous exhibition was that it would be a mass demonstration by and a gathering of everyone engaged in the political struggle against the suppression of culture. Hepworth, Wadsworth, Medley and Coldstream were on the list of supporters, together with Banting, Moore, Read and Nash. There were many new names in the list of British surrealists, most of whom would never be heard of thereafter, some of whom are critical figures in the history of the movement in England: John Tunnard, Samuel Haile, F.E. McWilliam and, to a lesser extent , the Australian James Cant, and Geoffrey Graham. The surrealist group issued a broadsheet printed on both sides with a long text, overprinted with a design by Henry Moore and entitled *'We Ask Your Attention'* (Pl. 39). The text is a landmark in the evolution of the attitude of the group, and beyond the group, towards pacifism: not only does it criticize the government's non-intervention policy, but it also

On the occasion of the Artists' International Congress and Exhibition

WE ASK YOUR ATTENTION

NON-INTERVENTION is not merely a political expedient in the Spanish situation, nor the alleged policy of a certain international committee. It is something much more than that; it is the typical and inevitable product of a way of thinking and behaving, the prevailing political attitude of **educated and conscious** people since the war.

This attitude has been pure NON-INTERVENTION. Politics were looked upon as a dirty and stupid game of little real importance. Politicians were paid off to play it on their own, recognised knaves and professional liars, but not too sharply questioned as long as things went not too outrageously, and above all as long as the intellectuals were left safely with their books, their arts and intellectual interests. Their aim was **to localise politics**, to confine it to a few people, to treat is as a possibly contagious, certainly disgusting disease.

This attitude has been modified in one direction only. Memories of the last war, and the obviously growing dangers of another, have produced widespread pacifism. For the pacifist tries to deal with war as an isolated disaster, apart from its wider causes and connections; he tries to look upon it as the embodiment of an abstract principle of VIOLENCE, and he will try to oppose it by the equally abstract principle of REASON. He will not examine the actual social and economic circumstances which produce violence, and above all he will not seek to oppose it by actual political means; he will not meet it on its own ground. He remains NON-INTERVENTIONIST.

In a similar way the London Non-Intervention Committee was designed to apply this policy in the situation created by the international Fascist coup in Spain. Political expedience and political justice were ignored; all social and political circumstances were disregarded, in favour of a single object: to localise the conflict, to confine within limits as narrow as possible this outbreak of VIOLENCE.

In this way the London Committee has a significance far beyond its own immediate aims. It is a practical test, a crucial experiment upon the attitudes which we have adopted. Is it possible to remain blind any longer to the results of this experiment?

The facts, the events, are not in dispute. The Fascist countries Italy, Germany and Portugal, have assisted Franco freely with materials of war and barely disguised divisions of their regular armies. They have condescended to cloak their actions to some extent under promises, agreements, denials and counter-charges. But behind this fog of words, Fascist intervention has proceeded unhampered save by the magnificent courage of the armies of THE SPANISH PEOPLE.

Is there any reason to suppose that Non-Intervention at future times and in other places may succeed better? Has Fascist militarism announced any limit to its hopes of conquest? Has it shown signs of a moral regeneration, of a greater respect for agreements and conventions? The opinion of the politicians at least is clear. Since the Fascist outbreak in Spain every European country

has hastened and enlarged its plans of re-armament. Only a few pacifists continue to believe in Non-Intervention. By doing so, they can only assist the forces of war, by yielding one strategic point after another to the militarist dictators, they make VIOLENCE more certain and infinitely more disastrous in its effects.

One thing, then, is clear. With all respect for the motives of **pacifism,** for the sincerity and courage of pacifists, this form of Non-Intervention is completely discredited **in practice** by the Spanish experiment.

But more depends on the experiment than this. Not only pacifism has been on trial, but our whole attitude of Non-Intervention in politics. How have our paid knaves and liars conducted themselves?

Unfortunately, like paid knaves and liars. If, conceivably, six months ago NON-INTERVENTION was defensible, it was, only remotely justifiable as long as there was a fair fight between the parties in Spain. The German and Italian invasions removed even these remote justifications. At the very least we might have expected unequivocal protests against the Fascist aggressors, but even these have been lacking.

Unfortunately, this is not all. Our Government has in various ways intervened actually on behalf of the Fascist aggressors. Several weeks before the international ban on volunteers, it dug up a century-old Act on Foreign Enlistment, and indicated its intention to harass British volunteers gratuitously by this antiquated instrument. It has repeatedly refused to admit representatives of THE SPANISH PEOPLE, and their

39 Surrealist group manifesto, *We Ask Your Attention*, with a drawing by Henry Moore

explains why the pacifists' approach is ostrich-like and why it becomes effectively the ally of fascism. It concludes on the urgent need for radical action based on unity and increased activity within the various organizations and the parties of the United Front. The last call is 'Intervene as poets, artists and intellectuals by violent or subtle subversion and by stimulating desire.' It is obvious that the surrealists wanted to appear at least as engaged as the AIA. Was this 'politically naive and aimlessly sensational'?[22] Perhaps, but the surrealists were proving their political maturity and seriousness of purpose and were in no way lagging behind the AIA's newly adopted unitary positions, while at the same time they had to follow André Breton's plea for radical independence.

That summer, links were indeed strengthened between the members of the group and some of the French surrealists, following a visit by Penrose to Paris in July. At a fancy dress party given by Madame Rochas he met Lee Miller, Man Ray's favourite model, and fell in love with her at first sight. Back in London, where Max Ernst joined him a little later on the occasion of his exhibition at the Mayor Gallery, he decided to issue a wide invitation to friends to come and spend the summer in Cornwall at his brother's house – a 'sudden surrealist invasion'. Eluard and Nusch arrived first and then Herbert Read, Eileen Agar, Joseph Bard, E.L.T. Mesens, Max Ernst and Leonora Carrington, whom Ernst had just met and fallen in love with when in London, Man Ray and Lee Miller. Spirits were high and at Penrose's instigation, Eileen Agar reports in her autobiography, they all exchanged partners. Eluard suggested then they could all meet again at the Hotel Vaste Horizon in Mougins in September. There, Eileen Agar recalls that not only did they exchange partners again, but also identities. 'Eileen Agar became Dora Agar, Pablo Picasso became Don José Picasso, Joseph Bard became Pablo Bard, Man Ray became Roland Ray and if one forgot one's new name, one was fined one or two francs.'[23] That summer, too, Picasso was painting *Guernica*, Paul Eluard was writing his vibrant poem 'La Victoire de Guernica', Penrose was discovering a completely new process of collage by cutting out and juxtaposing picture postcards in such a way that the original reality represented by the card was totally transformed, Herbert Read published *Art and Society*, Jennings and Trevelyan were busy reporting and painting for Mass Observation, and Len Lye made three films, among which was *Trade Tattoo* – a film expressing the energy of trade and made from black and white cuts from GPO Film Unit documentaries, coloured by Lye and augmented with animated words and designs. It was a year of active and productive friendship, a year of lyrical militancy.[24]

Surrealist Objects and Poems

The Surrealist Objects and Poems exhibition, organized at the end of 1937, was another opportunity for the surrealists to test their coherence and re-affirm their principles. It was opened by Herbert Read at the London Gallery 'on the thirteenth stroke of midnight' on 24 November. Groping his way through the crowd was Julian Trevelyan, dressed up as a blind explorer and leaning on a white stick, and thus making concrete the issues of vision and visuality in surrealism. The catalogue (Pl. 40) contained texts by Philip O'Connor, Herbert Read, Mesens, Pailthorpe, Mednikoff, A.C. Sewter, Arthur Sale and David Gascoyne. The foreword by Herbert Read was short and simply claimed that 'surrealism may be regarded as a return to the ani-mism of our savage ancestors'. 'Imagine', he continued, 'that you have for a moment shed the neuroses and psychoses of civilization: enter and contem-plate with wonder the objects which civilization has rejected, but which the savage and the surrealist still worship.'

Altogether 138 items were exhibited, 88 of them by British artists. All were precisely classified into surrealist objects, found objects, found objects inter-preted, object collages, oneiric objects, interpreted objects, objects for everyday use, objects by a schizophrenic lunatic, mobile objects, poem objects, perturbed objects, ethnological objects, constructed objects, collages and photocollages. Though not all exhibitors can be defined as surrealist, this exhibition made the London Gallery the place where the surrealist current would circulate.

Hardly any exhibit has survived from the exhibition; for most of them, only photographs can testify to their extraordinary inventiveness and high degree of inspiration. The most striking epitomize the process of prolifera-tion of meanings in surrealism; the object is made to belong *naturally* to two worlds, the world of external reality and the world of mental reality.

Eileen Agar's *The Angel of Anarchy* (1937:1940) (Pl. 41) owes its existence to the very process of addition twice repeated, since the Angel we now see is the second version of a head bearing the same title, exhibited at the Surrealist Objects and Poems exhibition in London in November 1937. Eileen Agar had had it made as a bust of Joseph Bard, but she had not been pleased with the result and had put it aside. Then, chancing upon it one day, she decided to transform it by attaching fragments of doilies and fur; only the lips were painted. Such was *The Angel of Anarchy*'s first version. Subsequently it was sent to the International Surrealist Exhibition in Amsterdam in 1938 but got lost on the way back. As it happened, two casts of the head had mistakenly been sent back to Eileen Agar. So she brought out the second bust and started the operation again, covering it elaborately with ostrich feathers for hair, a piece of dark cloth round the neck, African beads at the back, and a diamanté nose. Then, she blindfolded it, as if stress-

Surrealist
Objects & Poems

LONDON GALLERY, LTD.

40 Cover of catalogue to the Surrealist Objects and Poems exhibition, 1937

41 Eileen Agar, *The Angel of Anarchy*, 1937, 1940, 50.8 × 48 cm (20 × 18.9 in.)

45 Roland Penrose, *Guaranteed Fine Weather Suitcase*, 1937

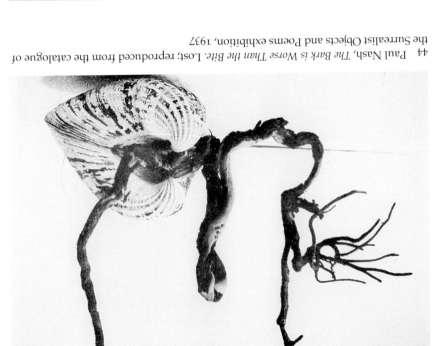

44 Paul Nash, *The Bark is Worse Than the Bite*. Lost; reproduced from the catalogue of
the Surrealist Objects and Poems exhibition, 1937

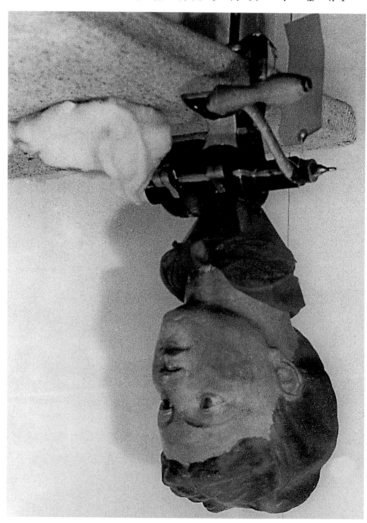

43 Julian Trevelyan, *Machine for Making Clouds*, 1937

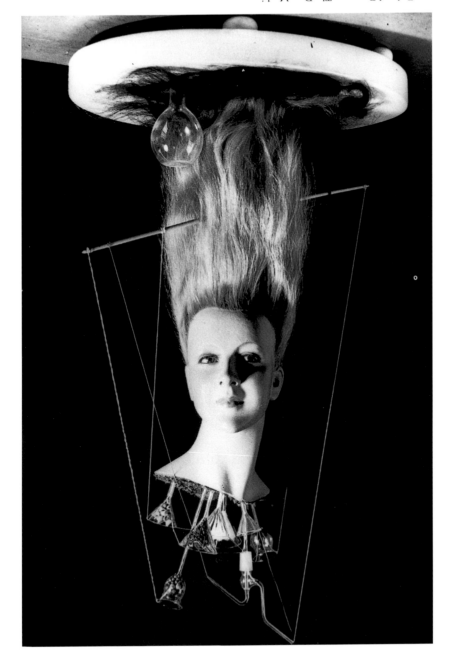

ing the impossibility of total vision. All this is deeply connected with her anarchist sympathies, and the rejection of any final authority. The title given to the completed head was influenced by Herbert Read, who a few months later was to publish *Poetry and Anarchism*, and by carpenters working outside Eileen Agar's studio and talking about 'Archangel pine'.

Reality was likewise liquidated by Penrose's *The Dew Machine* (Pl. 42). This 'object for everyday use', as he ironically called it, claimed to be scientific and mechanical, but the complex geometrical installation meant to support the structure was overwhelmed by the high erotic charge of the upturned head and its free-flowing hair. The 'dew' which this machine produced was a constantly renewed flux of desire which ran along the wires, penetrated the hair, and roamed around the face and the neck. Penrose's machine was explained by some reviewers to have been made 'for moisturing stale air of clubs, offices, banks, waiting rooms'. The same ambivalence could be attributed to Julian Trevelyan's *Machine for Making Clouds* (Pl. 43): a woman's head fixed at the top of a mincer which seemed to produce a white cotton-like mass. The machine corners the viewer's logic: the impossibility of actually making clouds is radically contradicted by the machine and vice versa.

From the display of *objets trouvés*, Paul Nash's *Lon-gom-pa* stood out, a five-branch root named after a Tibetan runner famous at the time – the object's new exotic identity epitomizing its change of reality. A 'found object interpreted', Nash's *The Bark is Worse Than the Bite* (Pl. 44) sought to exemplify the random, energetic action of nature: a dead branch, found on a Dorset beach, was held prisoner in the fold of a seashell and seemed to be struggling to tear itself away. The pun on 'bark' and its relation with 'bite' precipitated the object further into an intermediate space, between the animal and the vegetal. Roland Penrose's *The Survivor* also stood in that space, a piece of flotsam into which nails had been driven in the shape of an eye; a plumb-line had been added to remind the onlooker of gravity dragging drowned bodies to the bottom of the sea. Another of Penrose's objects, also classified as 'for everyday use', was his *Guaranteed Fine Weather Suitcase* (Pl. 45). This contained the uncontainable: the sides of a large suitcase had been painted over with a few white clouds drifting across a beautiful blue sky. Thus in a humorous leap from the concrete and material to the immaterial, the object guaranteed by mere imagination the perfection of its environment when used.

The exhibit which shocked the public most and nearly had to be withdrawn was Peter Norman Dawson's *British Diplomacy* (Pl. 46), a wooden fish pegged onto a piece of wood, onto whose back a syringe, a hook and a little doll were fixed. 'The salmon has caught the angler', remarked the *Daily Sketch*.

Two works stood out which had been made by artists marginal to British

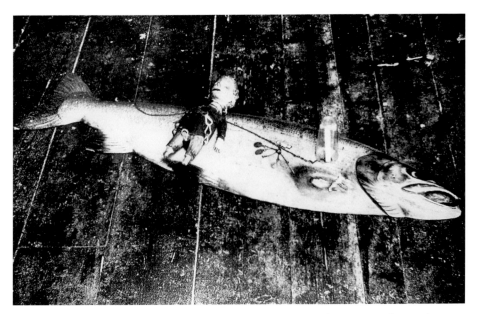

46 Peter Norman Dawson, *British Diplomacy*. Lost; reproduced from the catalogue of
the Surrealist Objects and Poems exhibition, 1937

surrealism; both dealt with the eye as an organ, raising the issues of seeing
and the visual in surrealism. In Geoffrey Graham's *Virgin Washerwoman*
(Pl. 47) the little trap door at the base of an old-fashioned flat iron was open
to reveal that the burning embers used to keep the iron hot had been
replaced by a pair of staring eyes, burning with all the tension that they
introduce, between the organic and the inorganic. The object loses its flat,
stable identity, a loss that comes from *inside* the object. Our eyes are thrown
into a liminal space open to various connotations. The iron has flattened
itself out, opened itself and is losing its thingness. Central to the surrealist
occupation with vision was the visual *violation* of identities, and Graham
here collapsed the disruptive process at work both in the object and in the
viewer's own eyes. The same disruption is celebrated in Charles Howard's
Inscrutable Object (Pl. 48), a work which we *can* see, but which asserts that it
cannot be seen, acting as a summation of surrealist visuality. Howard
peremptorily affirms that the object of our vision will for ever remain foreign
to us, since the object is neither more nor less than the repository of our most
secret desires. The animism mentioned by Read in his foreword to the cata-
logue, the savageness he claimed we were returning to in this exhibition, the
'world of steel swans and tender glaciers' to which we are transported on
'the thirteenth stroke of midnight' – all these were intended to be taking
shape under our very eyes through and beyond the shapes of given reality.
Roland Penrose's *Condensation of Games* (Pl. 49) provides the last word:
objects are baits for our desires, our eyes are hooked by objects although

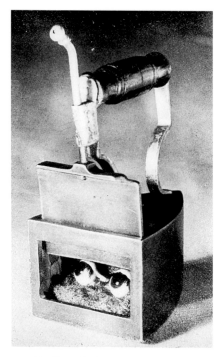
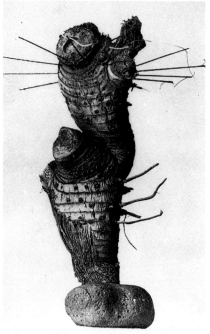

47 Geoffrey Graham, *Virgin Washerwoman*. Lost; reproduced from the catalogue of the Surrealist Objects and Poems exhibition, 1937

48 Charles Howard, *Inscrutable Object*. Lost; reproduced from the catalogue of the Surrealist Objects and Poems exhibition, 1937

never caught, in a ceaseless process of condensation. The humour implicit in every object is revealed as one of the most serious games which British surrealism asks us to play.

The surrealist section of the AIA Exhibition, and the Surrealist Objects and Poems exhibition, were occasions for the group to welcome new artists to its ranks. The former introduced F.E. McWilliam, Samuel Haile, Robert Baxter, John Tunnard, James Cant and Geoffrey Graham, the last two of whom accompanied the group for the next two years before returning to Australia. The Surrealist Objects and Poems exhibition confirmed the membership of these newcomers and introduced to the group Leicester-born Edith Rimmington, married to Robert Baxter, who showed a photo-collage of a huge steel chain seen in a foreshortened perspective, with a snake coiling round two of its links (Pl. 50); the title, *Family Tree*, is a mind-provoking blending of the Biblical and the Darwinian, mythological and scientific.[25] Each surrealist exhibition was thus not only an occasion for stocktaking, but also offered a moment of redefinition and an extension of the scope for action.

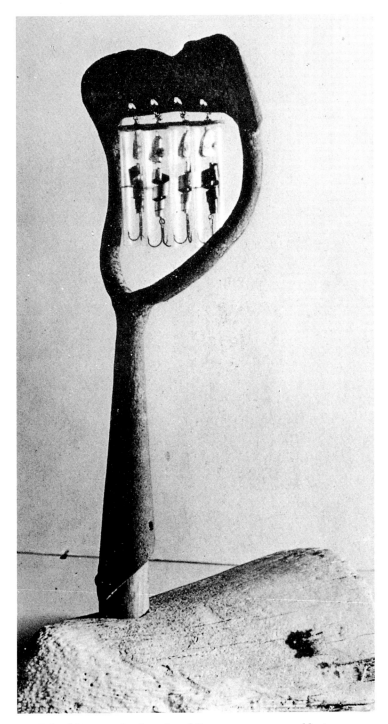

49 Roland Penrose, *Condensation of Games*, 1937, presumed lost.
Reproduced from Roland Penrose's *Scrapbook* (1981)

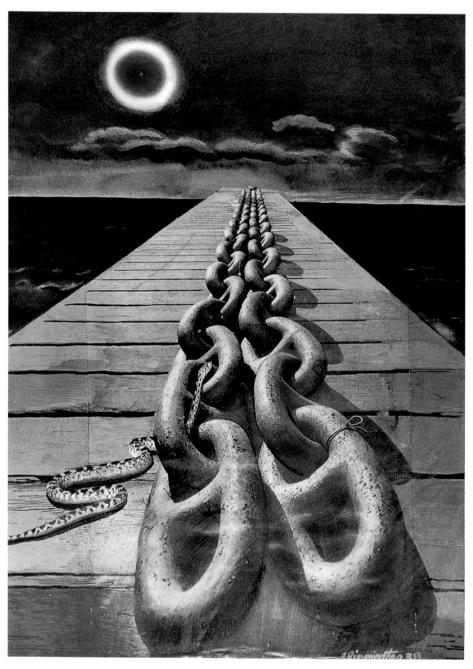

50 Edith Rimmington, *Family Tree*, 1937, 34.2 × 24.8 cm (13.5 × 9.8 in.)

Axis **and** *Circle*

Surrealism in Britain was thus defined not so much through agreed texts and declarations, as through internal controversy. If the incompatibility between the group's two political viewpoints found no solution, at least it proved and reinforced surrealism's own independence. The same could be said of its aesthetic position in the British context.

Following upon the Unit One exhibition in 1934, another exhibition held in 1936, Abstract and Concrete, had confirmed the split of the Unit One group into two tendencies; one was to grow into the British 'branch' of surrealism, the other would be entirely devoted to abstract art, leaving political issues aside. The latter movement, far from being theoretically isolated in Europe, was centred on the creation of forms, insofar as these 'repeated in their appropriate materials and on their appropriate scale certain proportions and rhythms which are inherent in the structure of the universe and which govern organic growth'. The archetypal, nothing but the archetypal . . .

A number of exhibitions attempted to consolidate both this movement and its theory. The Swiss Thèse, Antithèse, Synthèse exhibition at the Luzern Kunsthalle in 1935, the enormous Cubism and Abstract Art at the Museum of Modern Art in New York in 1936, and Constructivism at the Basel Kunsthalle in 1937, were epoch-making international events. In Britain, the Seven and Five Society, founded in 1920, changed its name to the Seven and Five Abstract Group in 1934 under the influence of Ben Nicholson. This led to the Abstract and Concrete show, the most important artistic event that took place between February and June 1936 in England. Organized by Nicolette Gray, it travelled to Oxford, Liverpool, Cambridge and London. It included not only Gabo, Hepworth, Léger, Moholy-Nagy, Mondrian and Nicholson, but also Moore, Piper, Calder and Miró: a fascinating juxtaposition – on equal terms – of British and Continental artists, which could otherwise only be found in a surrealist exhibition. In addition, 'Abstract Art in Contemporary Settings' in the showrooms of Duncan Miller Ltd in London in 1936, the Abstract section of the AIA exhibition in 1937, and the London Gallery exhibition of Constructive Art in January and February 1937, with works by Gabo, Moholy-Nagy and others, testified to activity which was as 'avant-garde' and 'progressive' as surrealism.

In this context, the magazine *Axis* represented an attempt to bridge the gap, although its sympathies were on the side of abstraction, and the first issues tried to define and emphasize the function of abstraction in the contemporary world. *Axis* was launched by Myfanwy Evans, with the help of John Piper – later on her husband – at the instigation of the French abstract artist, Hélion. The idea, which arose in 1934 on one of Myfanwy Evans's trips to Paris, was to publish an art magazine in England which would echo

Abstraction–Création in France. *Axis* had eight issues from January 1935 to the winter of 1937. In the first, H.S. Ede struck a defining note when he stressed that the physical aspects of any object, just like those of a work of art, are 'but the clothing of its real life'. As a consequence:

Art should not compete with the physical aspects of life ... the statue of a man with the man himself ... It can never accomplish this and must find expressions within its own laws, suggestive if it will, of these things but using them to convey the life of the spirit.[26]

Almost as a counterbalance, Paul Nash's article in the same issue states his diffidence towards pure abstraction:

I discern among natural phenomena a thousand forms which might, with advantage, be dissolved in the crucible of abstract transfiguration; but the hard cold stone, the rasping grass, the intricate architecture of trees and waves, or the brittle sculpture of a dead leaf – I cannot translate altogether beyond their own image, without suffering in spirit.[27]

Grigson, Read, Nash and Anatole Jakovski – the founder, with André Breton and Jean Dubuffet, of the Art Brut Company after World War II – were all contributors to the first issue. They not only impressed the readership – however small – with the high quality of its commentary and questioning, but also unwittingly opened the magazine to a non-abstract viewpoint. Its essential preoccupation was, however, constructivism, with successive issues devoted to Ben Nicholson and Hélion, while one issue was devoted to contemporary sculpture with articles on Moore, Hepworth, Brancusi and Calder. As well as by Nash and Read, surrealism was represented by Roland Penrose, who sent two short articles: one, in November 1935 was a report on the Surrealist Objects Exhibition at the Galerie Charles Ratton in Paris, and the other, in Spring 1936, discussed the recently published *Short Survey of Surrealism* by David Gascoyne. Penrose also had works reproduced, along with Nash and F.E. McWilliam.

In its catholic taste and policy, *Axis* showed faithfulness to its initial intentions, to be an axis about which the body of contemporary art would rotate. Similarly Myfanwy Evans, in late 1937, edited a volume of essays, *The Painter's Object*, which featured studies of and declarations by abstract and surrealist artists; among the latter were Nash and Moore, who were both deeply committed to surrealism at that time.

Shortly before *Axis* ceased publication, J.L. Martin, Ben Nicholson and Naum Gabo edited a series of essays and declarations under the title *Circle*, 'an international survey of constructive art'.[28] *Circle* was both a manifesto and a forum of ideas; the purpose was to confront painting, sculpture, engineering, choreography, architecture, urban planning and art education, and see how deeply they contributed to human progress. In this last flourish of

constructivism as a movement, there ran a streak of idealism and purism, as if in Western Europe in 1938 the Bauhaus and its generous humanitarian ideas were still the order of the day. Only Moore and Read contributed, Moore with two brief quotations, and Read with a middle-of-the-way, almost ecumenical assessment of abstract and surrealist art, 'The Quality of Abstraction', proving once more, if need be, that he was, as he later reminisced, 'in the position of a circus rider with his feet planted astride two horses'.[29]

Between June 1936 and the end of 1937, surrealism thus established itself in Britain along four main aesthetic issues: the questioning of logic and logical reasoning, the questioning of natural form, the openness to myth and the systematic probing of the unconscious, all of these obviously overlapping. They may all be seen to define the specificity of surrealism in Britain.

David Gascoyne

The questioning of logic was expressed in particular in writing. David Gascoyne's *Man's Life is This Meat* was followed by several texts, most of them published in *Contemporary Poetry and Prose*.[30] They were intended to form a sequence entitled 'The Symptomatic World', but this could not be completed on account of drastic changes and personal disturbances which occurred in Gascoyne's life and inspiration in the course of 1937. More and more the subject of ideological doubt and deep suffering due to solitude, gloom and poverty, whether in London or Paris, he started to demand so much of his writing that he constantly threatened himself with the inability to put words on paper. Moreover, the political and spiritual crossroads which the surrealists had just reached had left him totally powerless. He was in a way rescued by his own – free – empathetic translation of Hölderlin's poems (*Hölderlin's Madness*, 1937), to which he added a few personal texts; this was the occasion for him to plumb the depths of despair, as Hölderlin had done, and try to find new poetic directions. He was then able to reorientate himself towards a poetic that sought for its own spirituality by a combination of influences: the poetry of Pierre Jean Jouve, which he had just discovered, that of German romantics, and Benjamin Fondane's book on Rimbaud, which introduced him to the existentialism of Leon Chestov. Gascoyne's poetry became an unrelenting epidermic search for its own essence, for a prophetic quality, religious in the widest sense of the word, a quest for a synthesis that would mean spiritual revolution. This is in no way remote from the surrealist quest for the 'supreme point', but with totally opposite means; and for surrealism, the end does not justify the means.

In his surrealist quest for the philosopher's stone, David Gascoyne left behind splinters of lexical brilliance and mental vertigo which turn language into a place where words are simultaneously dug into, and made to soar up.

> Following an arrow
> To the boundaries of sense confusion
> Like the crooked flight of a bird
> The glass-lidded coffins are full of light
> They displace the earth like the weight of stones[31]

Surrealist writing implies the loss of direction, the installation of a disseminating space, at the limit of light and darkness. The key to Gascoyne's writing is to understand that the process of writing *says itself*, as is apparent in the following lines, where verbs and adjectives used not only tell stories or describe, but unmistakably 'tell' and 'describe' the very process of disruptive writing at work:

> The pinecone falls from the sailor's sleeve
> The latchkey turns in the lock
> And the light is broken
> By the angry shadow of the knave of spades
> Kneeling to dig in the sand with his coal-black hands
> His hair is a kite to fly in the dangerous winds
> That come from the central sea
> He is searching for buried anvils
> For the lost lamps of Syracuse[32]

The text is a place of falling, turning, locking, breaking, digging, flying away, searching; a place of constant loss. Throughout, it turns back on itself, summing itself up so to speak, to create a reading both linear and spatial. There is no centre, except a spiralling one, as the poem glides away from any completion, yielding to a secret internal law, that of the intensity of desire which refuses to obey reason, that of automatism:

> And behind him stands
> The spectre whose lips are frozen
> Unwinding the threads of her heart
> From their luminous spool
> She is stone and mortar
> And tar and feather
> Her errand is often obscure
> But she comes to sit down in the glow of the rocks
> She comes with a star in her mouth
> And her words
> Are rock crystal molten by thunder
> Meteors crushed by the birds[33]

Writing is ceding to a silent voice behind the words, the automatic dialogue of words. A game may well be played, of finding strings of phonetically

and semantically echoing words: spectre-frozen-stone, stone-mortar-tar-feather, obscure-glow, glow-star, obscure-star, mouths-words, glow-molten, molten-mortar, thunder-rock-meteors-birds. Infinite interlacings, uselessly called back to reason by a few phrases like 'which is why', 'for' and 'because', create a metamorphic world, devoid of any origin, inviting us to attend repeatedly the ritual of its immaculate conception in ever-receding perspectives:

> This is my world this is your garden gate
> Our vistas stretch a thousand leagues from here
> As far as forests full of moving trees
> As far as fingers holding tigers' skins
> As far as bushes on the window sill
> As far as castles with unlicensed towers
> As far as caskets full of human hair
> As far as clouds on fire and dying swans
> On lakes that swallow beds as fast as tigers swallow hands.[34]

John Banting

The piercing through the surface, or rather the superficiality, of so-called reality, is probably one of the main strategies developed by British surrealists. This was especially true of John Banting and Paul Nash, however contrasting their approach and 'philosophy of life'.

In the year of the International Exhibition, Banting collaborated with Len Lye on the film *The Birth of the Robot* as its art director and maker of the constructions used in the film – a stop-frame animation using puppets and models and on a promotion film for Shell-Mex and BP Ltd[35]. Humphrey Jennings was *The Birth of the Robot*'s colour director, the music was Holst's *Planets* and the film was another of the GPO Unit productions. In September and October 1936 Banting made the décor and the costumes for *Prometheus*, a ballet choreographed to Beethoven's music by Ninette de Valois. Parallel to this, he went on making cover illustrations for book-jackets, before embarking on a mural for John Lehmann, the publisher of *New Writing*, which he completed in 1938 – a work full of the anguish of civilized man witnessing the crumbling of his own civilization.

John Banting continually satirized both forms and formality at their source. The two figures in *Conversation Piece* (1935), whom he named Lady Turquoise Tuckroe and Lady Diamond Lit, have identities that are no more than the objects they wear. They are purely formal and emptied of any content. Three canvases painted in 1937 have a similarly scathing force: *Discussing Dress*, *Woman Passing between Two Musicians* and *Mutual Congratulations*. In *Discussing Dress*, the ectoplasmic forms hardly recall

human bodies: 'discussing dress' – a definitely misogynist title – has deprived them of their common humanity. In *Woman Passing between Two Musicians*, Banting seemingly liquidates both the woman and the musicians. The sophistication of the woman's huge standing figure and its reduction to an unstable column of scrolls of paper looking like Swiss rolls, and the flimsiness and feebleness of the thin, transparent bodies of the musicians, are typical of Banting's surrealism. His dedication to music joins here with his misogyny: the presence of an overdone fashionable belle sailing by is enough to cancel the action of music and the being of the musicians.

In *Mutual Congratulations* (*c.* 1936) (Pl. 51), socialites are shown as irremediably ossified. Two skeletons, that of an upper jaw and that of a skull (a rabbit's?), one vaguely masculine, the other vaguely feminine, are engaged in a conversation which, even if it were a real one, would be no more meaningful than the silent one now taking place. Forms and beings are hollow like death, empty like congratulations which no longer signify because they are mutual and thus annul each other. The artifices of high society and of its dead politeness are agents of death, the death of man as a living being, not only to the world, but also to himself. Banting's obsessional representation of skeletal forms is a cry of revolt against man's self-destruction, an attempt to bar the way to the 'dusty death' of the spirit.

Paul Nash

By contrast with Banting's work, Paul Nash's paintings, although intent on the disruption and dislocation of objects, are attempts to show the thriving life beneath not only living creatures but also apparently inanimate objects. In his manipulation of natural forms, Nash projects to the fore the underlying process of metamorphosis, which is made to rise from inside and *inform* the design. In that sense, he partakes of the surrealist quest for the *locus* where all the sources of creation are concentrated. Even if his control over the material, his sense of balance, proportion and rhythm, the obvious thinking and organization at the back of all his works, tend to water down the force of revolt – there is no doubt about this – still, he exemplifies one crucial aspect of surrealism: the interacting and constantly requestioned relationship of the imaginative powers with the world around.

In summer 1936, Nash had left Dorset to live in Eldon Grove, Hampstead, in the same neighbourhood as Nicholson, Moore and Hepworth, the main reason being poor health. Apart from writing several articles related to 'seaside surrealism', he made many collages and assemblages, set about writing his autobiography, prepared a large one-man show at the Redfern Gallery for April 1937 and, in the summer of that year, visited the Uffington White

Horse, the gigantic 'drawing' on the slope of a hill in Berkshire. In this, Nash saw not just the action of man, nor only the overpowering action of nature, but the encounter of both: the geometric form of the horse links up with magical, ritualistic, prehistoric practices whose driving force needed to be rediscovered. This is what he tried to convey in his famous *Landscape from a Dream* (Pl. 52), painted between the summer of 1936 and early 1939, and hailed by Breton as a masterpiece. It is a complex picture and the repository of personal dream images and symbols and universal archetypes.

At the centre of the painting, a falcon is perched on the bottom rim of the last panel of a folding screen which occupies the right half of the picture; it looks at itself in a mirror placed behind the panel to the left. The sky in the painting is blue and the sky in the mirror is that of a beautiful summer evening; but the suffused glow from the sun affects the sky but not the landscape in the mirror. Next to the falcon is a huge ochre ball reminiscent for Nash of tumbleweed; the ball is reflected three times in the mirror. Here lies the crux of the visual enigma: the mirror as an *other* world. Indeed the reflection of the three balls, supposedly in suspension this side of the mirror, creates such a depth that the landscape in the mirror is endowed with a life and rules of its own, so that we may well doubt that it is a reflection. The process at work here is actually expressed in the painting itself: our vision is folding up on its double; in the same way that the falcon is hypnotized by its double, the viewer's eye is repeatedly split as it stares at the different parts, trying to dovetail the interior and the exterior, the near and the far, the same and the other. It is impossible not to see the falcon as representation of Horus, the sun god in ancient Egypt, especially as Nash is said to have owned such a statuette. Indeed, Egyptian mythology saw the sky as a divine falcon, whose two eyes are the sun and the moon, and the hieroglyph which represented the idea of 'god' was a falcon on its perch.

The mirror, a threshold towards otherness, is central to Paul Nash's work. *Harbour and Room* (1932–6) (Pl. 53) was famously inspired by an experience Nash had in a hotel by Toulon harbour in 1931: in the large mirror above the mantelpiece of his bedroom, he saw a ship sailing in the harbour, exactly as if it were sailing into the room. The painting is doubly articulated and blends interior and exterior perfectly – the continuation of the two being achieved by colour echoes between the ship and its chimney, tiles and roofs, vertical lines in wallpaper, a half-open door, the flagmast. The geometrical is in the service of the imaginary, a relationship which he explored when painting the Avebury standing stones, *translating*, so to speak, their cosmogonic, disruptive energy into rectangular or cylindrical volumes through a process of analogy.

Nash occupies a place inside the circle of surrealism but not far from its outer rim. His way of tapping the subconscious, and drifting away from

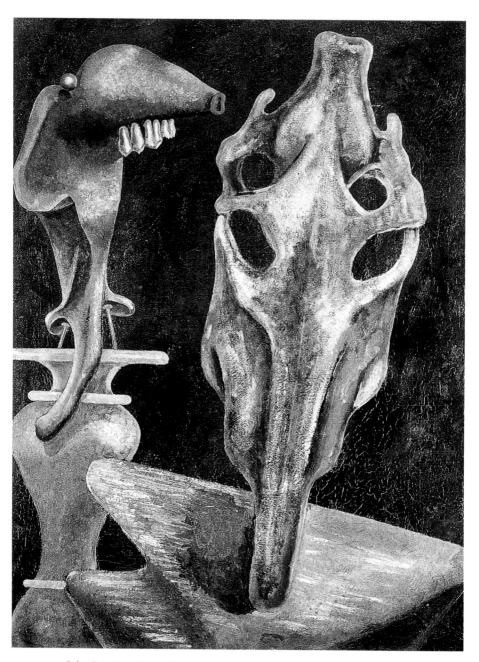

51 John Banting, *Mutual Congratulations, c.* 1936, 101.6 × 76 cm (40 × 30 in.)

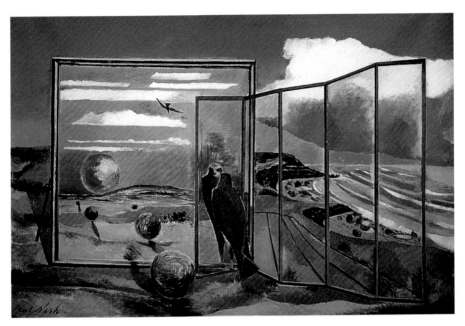

52 Paul Nash, *Landscape from a Dream*, 1936–9, 67.3 × 101.6 cm (26.5 × 40 in.)

external reality into a world of active forms, elicits a perfect balance between spontaneity and organization, between deep instinctive communication with hidden forces and rational, cerebral analysis. Roland Penrose celebrated Nash's opening of perspectives within natural objects when he wrote in the *London Bulletin*:

One reality leads into another with the assurance that both exist simultaneously and in the same place . . . Paul Nash with admirable subtlety, blends and muses . . . melting down elements so that they become transparent, and in that transparency constructs the new life, the new world behind the mirror.[36]

This, as Penrose wrote, ensures 'a mutual understanding' between Paul Nash and surrealism. Nash holds a mirror; others will roam behind it.

Henry Moore

The comparison between Paul Nash and Henry Moore, legitimized by their 'surrendering' to nature, brings out the deeply committed surrealism of the latter in the three years following the International Exhibition.

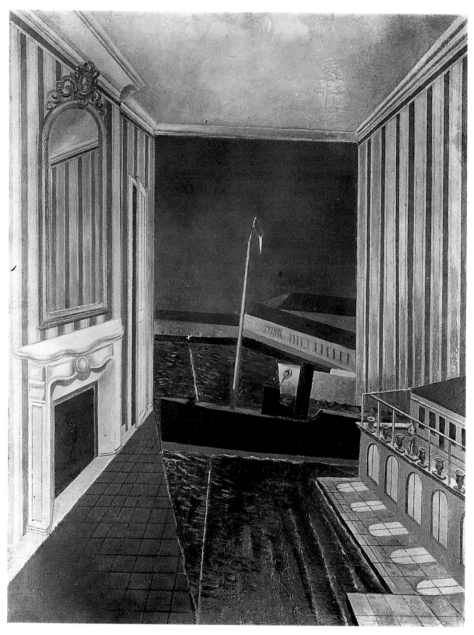

53 Paul Nash, *Harbour and Room*, 1932–6, 91.4 × 71.1 cm (36 × 28 in.)

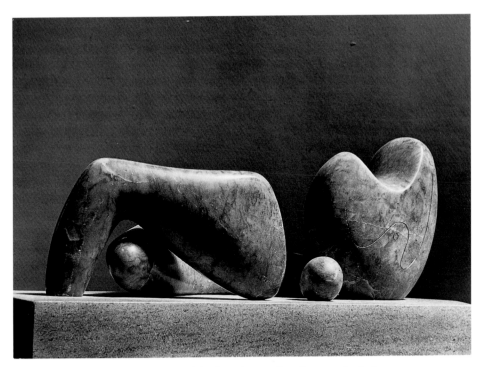

54 Henry Moore, *Four Piece Composition (1934)*, 1934, length 51 cm (20 in.)

Moore's fundamental obsession was with digging into forms, the slow, gradual opening out of matter *from within*. His approach actually begins at the point where Brancusi left off. Brancusi had purified sculpture by doing away with surface excrescences and bringing a sculpture to a more rarefied shape; but, as Moore pointed out, 'it may no longer be necessary to close down and restrict sculpture to the single static form unit. We can now begin to open out, to relate and combine together several forms of varied sizes, sections and directions into one organic whole.'[37] The last words are crucial: organicity means life, birth and tension, and it was natural that after exploring that life-principle in the abstract, i.e. by working on matter unreferentially, he should go on to investigate the human form. Supporting this was a fascination for *objets trouvés*, imbuing his sculpture with a powerful lyricism.

When he sculpted his *Four Piece Composition* (Pl. 54) in 1934, Moore had been playing with the accidental and the accumulative rather than the fragmented. More than in any other work, the viewer is obliged to change his place, height and angle of vision to see and construct the piece. There is no finality to cling to; the viewer is plunged into an infinite movement of inclusion and exclusion, as the eye goes round. This process is made even more

active in his *Reclining Figure* of 1936 and 1937, whose surfaces are hollowed out and pierced through; when he bore his first hole into matter in 1932 – in a found stone which erosion had already considerably hollowed out – Moore had felt that he was repeating the work of nature. His sensation was that of approaching a primeval, almost aboriginal image: that of the cavern, dramatically dark and light, the cavern of the mind and imagination, but also the interior of a woman's body. As David Sylvester pointed out: 'The image of the cavernous reclining figure subsumes that of the mother and the child.'[38] This is why the surrealist period of Moore's sculpture is so important: it forms the nucleus of his later development and of his imagination.

In the 1936 *Reclining Figure* (Pl. 55), holes are both the hollow formed by folded arms *and* the breasts; they thus create a space that is empty but invested with libidinal intensity. The statue is a figure in the making, leading the viewer on progressively into the holes and hollows of the torso, between the legs, into secret places. Matter, be it wood or stone, becomes a place of passage and transition between its own presence and its own absence, inseparable from the shadow which our eyes are gradually entering, as they slip onto the other side.

The seeming softness of these figures recalls the undulations of hills, and it is true that Moore has always compared the female body and landscapes, interested as he was in the properties shared by human beings and nature. Their common energy is dramatically expressed in the movement of *Reclining Figure* of 1937 (Pl. 56). Contrary to the others we have looked at, here there is no hole; matter is absolutely solid. But the forms swelling at its surface, like blisters on the skin or bubbles on the surface of hot springs, and the angle of the piece, invest it with a tremendous ascending tension.

Roland Penrose

Displaced forms, subsequently condensed: these are the central matter of Roland Penrose's work. Most of his early paintings before 1936, for example *The Jockey* – reproduced in Herbert Read's *Surrealism*, but now lost – attempt to put some of the lessons of cubism at the service of the destabilization of vision, a strategy to which Penrose was to revert in the early forties with great poetic force. Angular, geometric shapes are use as *elements* from which fluid shapes unfold, as if we were attending some birth, some new creation out of the primeval chaos. In the meantime, Penrose's source of inspiration veered towards a very personal use of figuration and an almost Magrittian treatment of visuality. The starting point seems to have been the object he made for the 1936 exhibition, *Captain Cook's Last Voyage*. The reference provided by the title – invented by the artist after completion of the work –

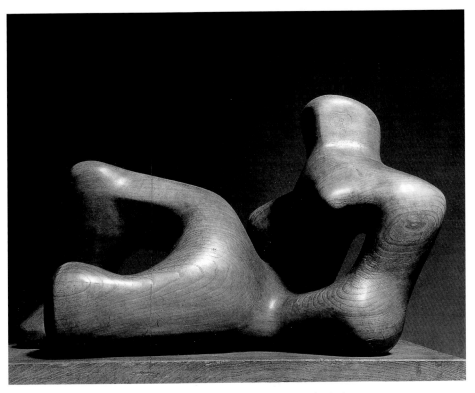

55 Henry Moore, *Reclining Figure (1936)*, 1936, length 105 cm (42 in.)

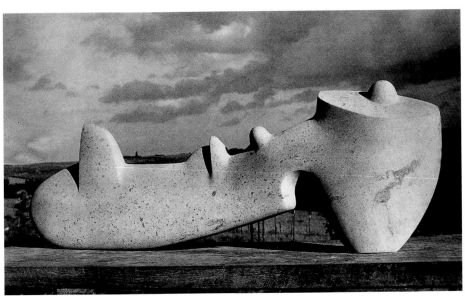

56 Henry Moore, *Reclining Figure (1937)*, 1937, length 83 cm (33 in.)

helps us read the object as the absorption of Cook on one of his voyages around the world into the dark world of death, into the earth which is represented here by a wire globe which Penrose ordered from a bicycle repairer in London. A white plastic nude torso inside it, headless and armless, is inseparable from a deathly sawhandle; it also links up with the death of Captain Cook, and his time-transcending return to the Mother Earth, to the womb. Penrose's work at this time – when Valentine was drifting away and Lee Miller was his obsession – is evidently haunted by the female face. This takes the form of a *universal* face both absent *and* present, crystallizing desire and frustration, revelation and hindrance, in the shadow of the castration complex, implied in recurrent beheadings and amputation of limbs.

L'Île Invisible (Pl. 57) was completed in 1937. For all its distinctness and clarity of line, it is a most disturbing work. An inverted face implies both an extension and a suspension of the viewer's vision in an intermediate space. In the same way as this severed head is dangling mid-air between the sky – defined by dark clouds – and the surface of the earth, an island is seen caught between presence and absence, as if threatened by disappearance. Correspondingly, a double hand in the foreground creates a distance between here and there, now and then, to suggest the presence of a third party, so that the viewer is faced with a timeless scene. Mythological references come to mind, first to cities in ancient Greece protected by goddesses linked to the moon – as suggested by Norbert Lynton in his preface to the catalogue of Penrose's retrospective in 1980[39] – but also to the town of Ys. According to Breton mythology, this town was covered by the tide, on account of the king's daughter's immorality, while the beautiful but dissolute girl, pledged to the gods of the sea, drowned in the waves to become the 'Morgane' – in Breton language a mermaid. All these layers of meaning build a network of visibility so complex that one can scarcely help being blinded to any meaning the painting may hold. This much is implied by the title: the isle is eventually invisible, while the second title, *Seeing Is Believing*, insists that there is no disbelieving a dream image, however inaccessible.

By reaching deep, surrealism in Britain not only questioned the existing forms of reality, whether social reality, nature, or the actual act of seeing, but also opened onto another more primitive mode of knowing the world. This in turn necessitated avoiding given forms.

Julian Trevelyan

As participants in setting up Mass Observation, Len Lye, Julian Trevelyan and Humphrey Jennings shared a fascination with mythopoeic thought, although their media differed.

Trevelyan, who wrote that 'to dream is to create',[40] was to launch himself into the charting of the archetypal city of his infancy and childhood. In 1933 he painted *Underground*, a succession of sketchily drawn house fronts, all similar – a triangle on top of a square – and most of them harbouring a black keyhole. Under a line, probably the level of the ground, the 'cellars' of the houses are occupied with anatomic organs, cells with filaments, and a heart with arteries and veins, which is placed in the axis of a crane that is about to continue building the city. The heart is beating. In *City* (1936) (Pl.58), broken lines define planes that are dependent on the forces exerted by them and create a balance, putting the activation of the surface to the fore by revealing how this is achieved. Trevelyan's lines, angles and curves enact various of Klee's propositions, especially those regarding the creation of an animated space. The lines of force in the work, as well as in the city, are established by the keyholes in *Underground*, by diamond shapes, stars and circles in *City*. The apparition of five letters floating next to floating circles in the sky indicates a playful space which conjures up childhood artefacts. The aim is to recover a pristine vision of creation, through new, spontaneously raised urban symbols. This means that the new myth is not to be dug up, but found, through renewal of vision.

A *Symposium* (1936) (Pl. 59) is another example of the circuits which produce energy. It is a dense network of shafts, wheels, pulleys and cogs mixed with rectangles and triangles instead of houses, chimney flues, and pipes; as a humorous gesture, the centre is occupied by the schematic drawing of a muscle, which seems to be the mechanism's throbbing centre.

At that time, the Maudsley Hospital in London was engaged in research into the curative effect of drugs on cases of acute schizophrenia. Trevelyan took part in experiments using Mescalin: painters were though to be 'better' at describing their experiences than the ordinary man in the street. The experience furthered Trevelyan's search into the deep self.

Trevelyan's paintings expound a mythology, both personal and collective. But rather than a city or a mythology waiting somewhere to be discovered, he describes a city that will be made to exist through ceaseless construction, a city of which we are invited to be the builders and the inhabitants:

Today there is the same city to paint; but it has become a World City, more all-inclusive yet less precise in its geographic connotation. Mingling in its streets and among its labyrinthine galleries are the mass desires and individual experiences of its innumerable inhabitants . . . There can be no limit to its vistas, panoramas, and airplans.[41]

He achieved this especially in collages he produced from newspaper cuttings – a symbol of community relationships and communication. Usually, the paper is cut in the shape of houses and fields. When participating in Mass Observation, he 'transformed' photographs of the crowds attending

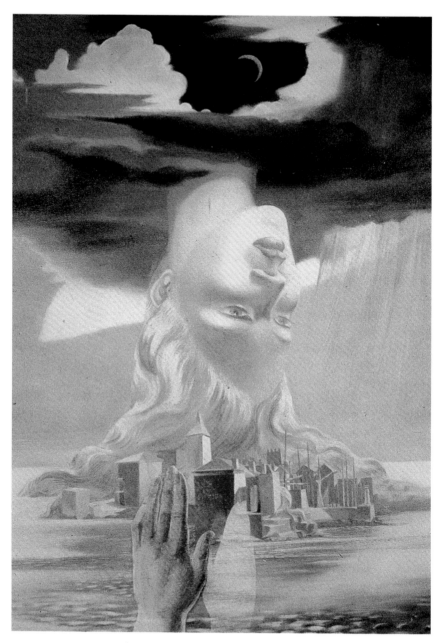

57 Roland Penrose, *L'Île Invisible* (*Seeing is Believing*), 1937, 100 × 75 cm
(39.3 × 29.8 in.)

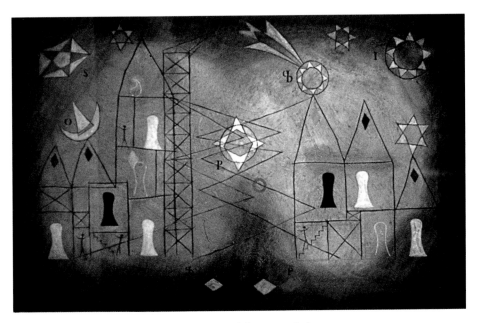

58 Julian Trevelyan, *City*, 1936, 72 × 115 cm (28.3 × 45.2 in.)

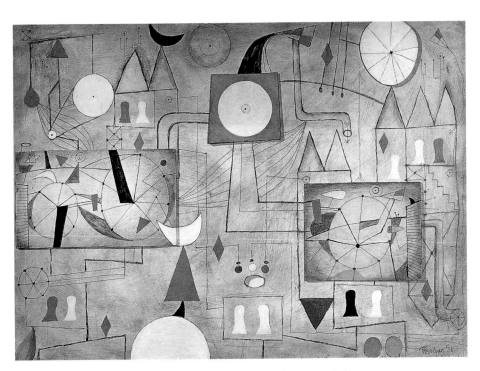

59 Julian Trevelyan, *A Symposium*, 1936, 61 × 105 cm (24 × 41.3 in.)

the Coronation (taken from *Picture Post*) into cobblestones, as a metaphor for his protest against a ceremony so endowed with mythical quality and so indifferent to the people's real needs. The myth had to be changed, and a new myth developed, one more firmly anchored in the reality of ordinary people's lives. In these collages the ethereal city of his earlier paintings was now made concrete.

Eileen Agar

Eileen Agar's work shows a fascination with marine objects as an element in her exploration of the way images are born. Her *Mate in Two Moods* (1936) (Pl. 61), a playful reference to chess playing, shows a table surmounted by the plaster cast of a hand, a fishbone ('the diagonal of the bishop'), a little Tanagra head ('the queen'), an unidentified 'prickly object' and a sunfish. She specified that it was to be placed against a wall so as to play with its own shadow, thus increasing its doubleness. Another object, *David and Jonathan* (1936) (Pl. 60), suggests the inseparability of components. The Biblical story of undying friendship turns here into a closed circuit of relationships. Beyond their heterogeneity, the two objects are similar in their capacity to challenge identification and excite the imagination. The same process of rediscovery of the object is conveyed in her collages, such as *Precious Stones* (1936), *Woman Reading* (1936), *Food of Love* (1936) or *Fish Circus* (1939) (Pl. 62). She never tries to cover up the successive layers of the material used, and the 'harmonious tension' between the upper and lower layers creates, through the collapsing of fully identifiable but exotic objects one against the other, an all-embracing rhythm, a musicality.

When holidaying in Brittany with Joseph Bard in 1936, Eileen Agar was struck by the famous marine rock formations in Perros-Guirec and Ploumanach – mineral monsters emerging not so much from the sea as from prehistoric times. Both dashed to Brest to buy a camera, and photography became another way of nourishing Agar's fascination with the unrecognized, alien side of things whenever she and Bard went to the seaside. Her photographs rate at the same poetic level as Nash's or Jennings's – indeed, one of the Ploumanach rocks was even used by Nash in a work of his own.[42] One encounters here the same paradox of the object displaced in its own context, through the same choice and 'framing' of the artist's eye. One of the means used by Agar is to play on the angle and on the relative proportion of objects in order to unhinge our faith in our own knowledge of sizes, as in *Figure-head and Ship's Wheel, Cornwall* (1938), where the huge size of the two objects of the title contrasts with a door and wall against which they have been made to lean, so precipitating earth and sea, house

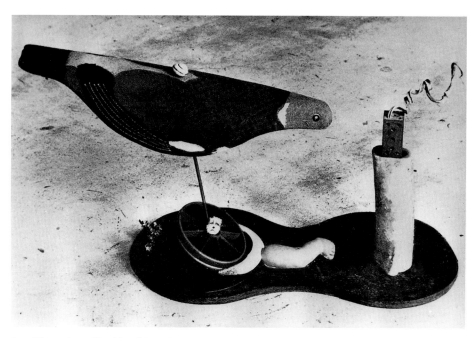

60 Eileen Agar, *David and Jonathan*, 1936. Lost; reproduced from *International Surrealist Bulletin*, 4 (September 1936)

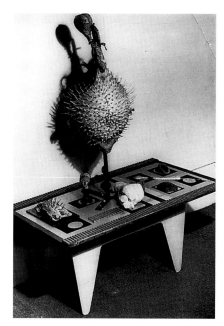

61 Eileen Agar, *Mate in Two Moods*, 1936, 29 × 23 × 42 cm (11.6 × 9 × 16.8 in.)

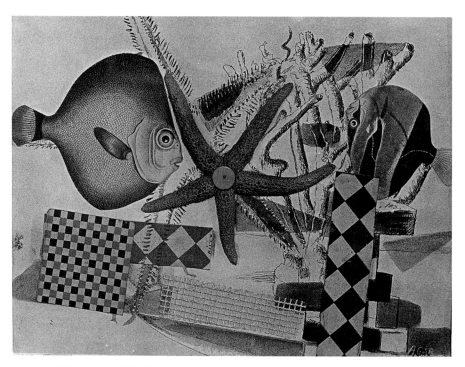

62 Eileen Agar, *Fish Circus*, 1939, 26 × 18 cm (10.2 × 7 in.)

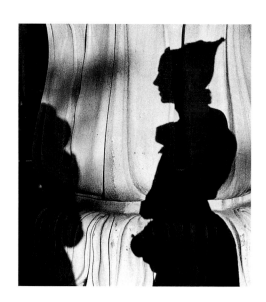

63 Photo of Eileen Agar by Lee Miller, 1937

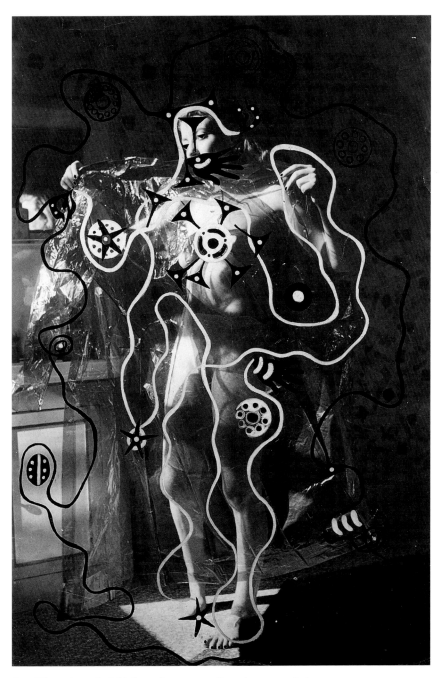

64 Eileen Agar, *Ladybird*, 1936, 74.5 × 50.8 cm (29.3 × 20 in.)

and ship, the puniness of man and the vastness of the sea world against, or rather into, each other.

Agar's photo of herself as *Ladybird* (Pl. 64), in which she appears dancing naked, covered only with a veil of transparent plastic, can be read as a commentary on her technique.[43] This is especially so in that the photo has been painted over with swirling black and white lines, circular motifs and star shapes. The eroticism of the body, veiled or unveiled, is seen as from behind a fuzzy window pane, and the effect is like a solarization which reveals the lines of the object in all its magic. This effect is similar to that of a photo by Lee Miller of Agar's shadow projected on part of a column the shape of an urn (Pl. 63). The shadow, deformed by the undulation of the column, reveals a non-existent pregnancy, while the excrescence at the level of the abdomen, the shadow of part of the camera she was carrying, is a no less non-existent penis.[44] Deformation, elongation, condensing of the human form, turn Eileen Agar into a magician or benevolent witch, especially as she wore a pointed hat. And it is true that there was always something intrinsically supernatural in that unabated freshness of inspiration which never left her.

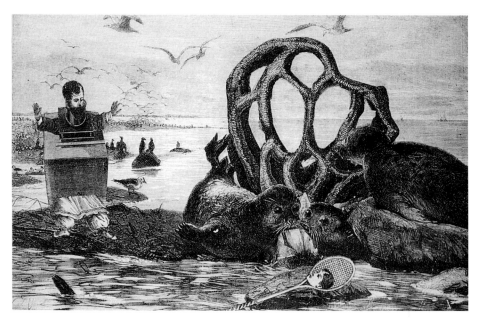

65 David Gascoyne, *Perseus and Andromeda*, 1936, 16 × 24 cm (6.3 × 9.5 in.)

Such were the paths opened by surrealism in Britain. To these works one should add the works, collages and objects made by poets on special occasions, such as the International Exhibition or the Surrealist Objects and Poems exhibition. They are equally valid and express the same urgency as any other collage or object made by someone normally working as an artist. The objects now lost that were made by Herbert Read, Hugh Sykes Davies, Sheila Legge and Roger Roughton also contributed to the breach by surrealism of preconceived categories and easy classifications. One of the most striking is David Gascoyne's collage *Perseus and Andromeda* (Pl. 65), in which Arctic seals are surrounded by an enormous madrepore, a masculine body imprisoned in an incubator or hot air bath and wearing a woman's pantaloons, and a badminton racket with a man's head in place of a shuttlecock. The division at work in each item of the collage implies the establishment of new relationships, however monstrous, like that between the man's face on the left and the head on the racket, both exchanging looks as one would look at the shuttlecock. Links are established by the lines of vision, but they open onto *blind spots* from which the monster of the mythological story indicated by the title, lying in wait somewhere below, is ready to leap up and devour the sacrificed maiden. Who is who in Gascoyne's collage? Who is Perseus? Andromeda? Who is the monster? The answer is an unfulfilled desire to find an answer, and is therefore entirely up to the viewer.

EXHIBITION *of*

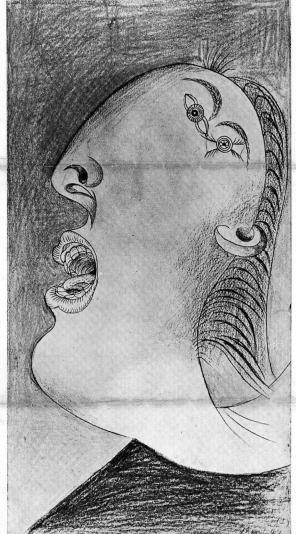

P I C A S S O S'

Clichés 'Cabiers d' Art'

'GUERNICA'

66 Poster for an exhibition of *Guernica* in London, 1937

Spirit levels, level spirits:
the years of definition 1938–40

In the years immediately before World War II, British surrealism needed to gather its forces. For various exhibitions, a number of 'fellow travellers' had convened around the initial group. This was especially so at the Surrealist Objects and Poems exhibition in November 1937, where more than two thirds of the participants were just guests or 'temporary members'. Consequently, both the pressure of outside political events, and a certain theoretical laxity, now threatened the unity of the group. While it was crucial that surrealism should be able to rally as many supporters as possible, as part of the process of formalization, this needed to be counterbalanced by a degree of recentring. When Penrose drafted the list of the members of the group on 14 July 1938, they numbered 38. A third of these, including Dylan Thomas, Edward Burra, Ceri Richards's wife Frances Clayton, Elizabeth McWilliam, Eric J. Smith, Onion S. Playfair and one Dr James B. Coltman, were far from deeply committed. British surrealism was in need of a basis and a firm centre. Herbert Read could not be relied on to provide this, on account of his flirtation with officialdom and his jumping from communism to anarchism and Trotskyism, and back again.

Other influences were at work, however. During 1937 E.L.T. Mesens stayed in London increasingly often, eventually settling in Downshire Hill in the early days of 1938. In April, he took over the management of the London Gallery and launched the *London Gallery Bulletin*. This was decisive in the reorganization of surrealist activities in Britain. The London Gallery had been founded in October 1936 by Mrs Clifford Norton and Mrs Cunningham Strettell at 28 Cork Street, where it had been active in promoting modern art, but without any specific policy. One-man exhibitions had been presented there of work by Munch, Moholy-Nagy, Bayer, Léger, Schlemmer, Gabo and David Low, as well as collective exhibitions of children's drawings, Young Belgian Artists, and the 1937 Surrealist Objects and Poems exhibition. It also

offered the services of a lending library, and access to various journals and magazines.

In a letter to Roland Penrose in January 1938, in which he outlined difficulties to be overcome in order to take over the gallery, especially its outstanding debts, Mesens defined the gallery's policy: to exhibit young surrealists on the first floor, and on the second, younger painters from fauvists to abstractionists. The primary goal would not be to reflect existing tendencies, but to try to attract well-known artists from Britain and other countries, so that the second floor should not be run at too great a loss. This policy was to be adhered to and pursued until the very last days of the gallery, in 1951.[1]

Two months later, notwithstanding problems in obtaining his resident's permit and leaving his job at the Palais des Beaux-Arts in Brussels, Mesens settled in London. Another letter to Penrose described a sober decoration scheme for the gallery – white walls, with a subtle shade of blue and green in places – and outlined the exhibitions to come: Magritte, Piper, Braque, Gris, Agar, de Chirico, in that order. Mesens also confirmed that he had bought the whole studio of Paul Delvaux, for which Penrose agreed to pay half. He also proposed to employ Sybil Stephenson, a former employee of the gallery and ex-wife of Cecil Stephenson, an abstract painter, to look after the sales. Sybil Stephenson was to become Mrs Mesens not long after.

In April 1938, the fortnightly *London Gallery Bulletin* – the title was to be shortened to *London Bulletin* from the second issue onwards – was launched. At the same time a huge exhibition, The Impact of the Machines opened at the gallery, and an exhibition of *Guernica* was planned. In the meantime, Roland Penrose's purchase of the entire collection owned by the French poet Paul Eluard made it possible for the gallery to bring to public view a list of surrealist art that reads like a collector's dream: six de Chiricos, ten Picassos, eight Mirós, four Magrittes, three Dalís, about 40 Ernsts, plus works by Giacometti, Brauner, Arp, Picabia and others, as well as several African and Oceanian masks and figures. With these 121 items and the 50 paintings and drawings acquired by Mesens, together with the René Gaffé collection, which Penrose had bought in 1936, the London Gallery could fulfil the role Mesens had assigned to it.

Under Mesens's direction, the gallery became the centre of resistance against obscurantism, making surrealism a pivot of living, avant-garde art. Indeed, in view of the political situation in the months before the outbreak of the war, the London Gallery and the *Bulletin* chose to become the rallying point for all progressive forces in art and culture, rather than concentrate exclusively on surrealism. The gallery's selection of exhibitions and the choice of articles for the *Bulletin* should be seen therefore as a collection of defiant gestures, each one nevertheless in total accordance with the surrealist

principle in that it always raised the issue of representationality.

In the two years that preceded the war, no less than eighteen exhibitions were organized by, or with the participation of, the London Gallery. Ten of them helped reinforce links with the continent especially with French, Belgian and Danish surrealists. The first was an exhibition of 46 works by Magritte, most of which came from Mesens, from a collection of about 150 that he had bought in 1931 at a price very much reduced by the Depression. The press reacted violently to this inaugural exhibition, the *Sunday Times* declared that Magritte's 'lack of inventiveness as a painter [is] painfully obvious', the *Daily Telegraph* found that 'the quality of the painting is of a bleak, photographic kind', and the *Observer* that it was 'a kind of pictorial and intellectual facetiousness'; while the *Scotsman*'s critic declared that it was 'quite wonderfully disgusting' and 'almost persuaded [him] to be a Nazi'. 'Goebbels, at any rate, will not tolerate such stuff.'[2] During the next month, the London Gallery showed drawings, *papiers collés* and collages by Picasso and, in June, seventeen oils and watercolours by Paul Delvaux, together with an exhibition of works by de Chirico, Ernst, Klee, Léger, Magritte, Paalen and Picasso. In October, eighteen works by de Chirico were shown, and in December 51 by Max Ernst. These were immediately followed in 1939 by 95 works by Man Ray, the presentation in March of Paul Klee's watercolours and oils, and in April of Marcoussis's twenty Cubist works together with nineteen paintings by Miró. Picasso was once again shown in May and June with 52 paintings and drawings from English collections, mostly Penrose's; so successful was this exhibition that the closing date had to be postponed by a fortnight. The *London Bulletin* meanwhile gave ample publicity to exhibitions both at the Mayor Gallery, ten houses away in Cork Street, of Miró and Léger, for example, and at Guggenheim Jeune Gallery, next door, where Rita Kerrn-Larsen, Geer van Velde, Tanguy, Paalen and Henghes were on display.

It is in the light of this effort to shake people out of aesthetic conservatism, with its obvious political implications, that the large exhibition devoted to Picasso's *Guernica* must be seen. The horror of the bombing of Guernica was echoed in the painting's entanglement of lines and forms, and in its tortured and screaming animal and human bodies, in a way that shocks the spectator into both aesthetic and political awareness. On 3 October 1938, a private view of the huge mural, together with 67 preparatory drawings, was held at the New Burlington Galleries. Through his close friendship with Picasso, Penrose had arranged for the painting to be lent after it had been exhibited at the Spanish Republic Pavilion at the Paris World Fair in August 1937. Since Penrose was away in the Balkans, Mesens was in charge of exhibiting it. Setting up a committee with Herbert Read as vice-chairman, he gathered such different patrons as Douglas Cooper, Bonamy Dobree, E.M. Forster,

Naomi Mitchison, Harry Pollitt (chairman of the Communist Party) and Virginia Woolf. Though Picasso's painting became the occasion for a rather mixed gathering of politicians, writers, art lovers and realists and surrealists alike, the aim of the exhibition, widely publicized, was the raising of funds in aid of the National Joint Committee for Spanish Relief. It must be admitted that most of those who agreed to be patrons were more interested in the political meaning of the work than in the aesthetic challenge it posed.

The controversy that developed around the painting was fierce, but it was also stimulating from a surrealist point of view. When Anthony Blunt reported on the Paris World Fair for the *Spectator* in October 1937, it was the opinions of the communist and Left Realists to which he gave voice. In particular, he stressed the 'disillusioning quality' of the work, which gave 'no evidence that Picasso has realised the political significance of Guernica', the etchings, he said, 'cannot reach more than the limited coterie of aesthetes'. A little later, in January 1938, Picasso's etchings came under further attack, in a report published by the AIA *Newssheet* of the Second American Congress of Artists. This spoke of 'the bad influence of Expressionism, Surrealism, Futurism and Abstraction', and maintained that Picasso's painting *The Dreams and Lies of General Franco* was 'far less comprehensible than Goya's work in the denunciation of war'. Such statements proved wrong, however, when the painting came to be shown publicly in England, in October 1938. With about 3000 visitors the exhibition achieved only mild success in London at first, but it gained a larger public when it travelled to Leeds and Oxford, and a still greater number of visitors when it returned to London, to be shown no longer in the West End but in the East End, at the Whitechapel Gallery from 4 to 29 October under the aegis of the Labour Party and the Trade Unions. The exhibition was officially opened by Clement Attlee, Leader of the Opposition (Pl. 67), and about 12 000 visitors were recorded, in addition to attendances at accompanying lectures.[3]

The role of art as part of a collective effort against a growing militarist and utilitarian spirit was further emphasized by Living Art in England, an exhibition which Mesens put on at the London Gallery. This ran from 18 January to 10 February 1939, during which time it presented 49 paintings by 36 artists, eighteen of whom were surrealists or allied to surrealism, the others being largely constructivists. Mesens's main object was to highlight the presence of refugee artists from the Continent who couldn't but provide a leaven for British art. Works by Eileen Agar, Grace Pailthorpe and Roland Penrose, as well as newcomers like Ithell Colquhoun and Conroy Maddox, were exhibited alongside those by Mondrian, Kokoshka, Gabo and Heartfield. Mesens was thus able to show how British surrealism stood at the head of progressive cultural forces against fascism, without adulterating its own voice. London had become a place of refuge and consequently an

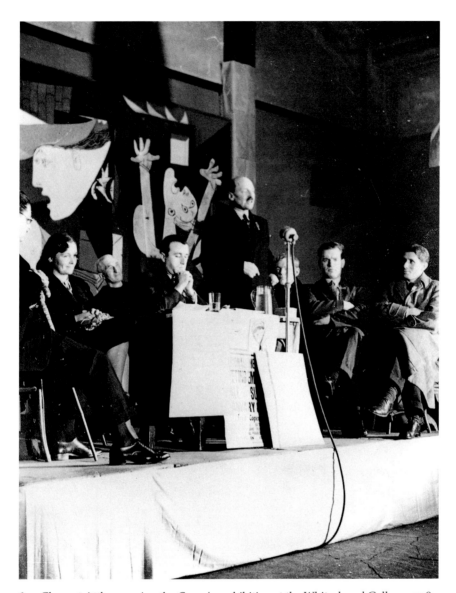

67 Clement Attlee opening the *Guernica* exhibition at the Whitechapel Gallery, 1938; sitting to the right, Roland Penrose

international art centre – more than Paris, since the French government had just issued restrictions, known as the Saraut decrees, on political immigrants and foreigners living in France.

In his preface to the exhibition, reprinted in the *London Bulletin*, Read insisted that the exiled artists and the voluntary exiles 'even from Paris' contributed a new ferment to the complacent atmosphere of London. The tone is nonetheless gloomy. 'Let us give up, as the most childish of illusions, that art – our art – can ever recover its social relevance.' Even Russia had discarded the two politicians who had shown 'any glimmering of an understanding of the social significance of art, Trotsky and Bukharin'. Although retaining its variety, art must 'enter into its individual phase – even its hermetic phase'. He considered that what was at stake was human consciousness, man's awareness of his potentialities, and it was precisely this kind of gathering which would prevent the soul of humanity from shrinking. Nevertheless, however relevant his analysis, nowhere does Read meanwhile include issues from the world at large; his aesthete's isolationism marks his own drift away from a truly surrealist commitment.[4]

British surrealism was also exhibited outside London and indeed outside Britain. In May 1938 an exhibition was put on at the Guildhall, Gloucester, under the confusing title Realism and Surrealism, as a form of sequel to the AIA debate two months before. In October and November, the 64th Autumn Exhibition in Liverpool counted no less than 32 works by seventeen British surrealists. In July and August the following year, ten surrealists showed works, alongside with a dozen abstractionists, at the Art Gallery of Northampton. The catalogue has a brief foreword on surrealism, in the form of an extract from Read's *Art Now* which recalls the two planes of mental life, the conscious and the subconscious and, using the image of the iceberg, the need to explore one's 'submerged being'.

Abroad, eight British surrealists were invited to the international exhibition 'Surrealism' organized by Shuzo Takiguchi in Tokyo in June 1937, and another eight to the Exposition Internationale du Surréalisme at Galerie des Beaux-Arts in Paris in January 1938; the Amsterdam Exposition Internationale from March to June 1938 invited five; and the Surrealist Exhibition in São Paulo eight. The latter was organized with the help of Flavio de Carvalho, a pioneer of avant-garde art in Brazil; he had met Herbert Read when in London in February 1935 and had kept in touch with the group. The Salo de Maio, held in June 1938 at the Esplanada Hotel in São Paulo, included twenty British surrealist works. More consequential was the British participation in the Canadian National Exhibition which took place in Toronto from 26 July to 10 September. Out of 39 British artists invited to show, no less than 21 were surrealists or belonged to the movement's immediate margins. Sixty works were hung, and nearly all the important surrealist

publications were on display. Part of a huge annual event devoted to the arts, the exhibition was a unique opportunity for Canadians to see what was being done abroad. In the genteel atmosphere of Toronto it was rated as an 'upheaval', especially because of the disconcerting power of the surrealist paintings. This was the first surrealist exhibition in Canada, and Read's forceful introduction, heavily indebted to Breton's preface to the 1936 exhibition catalogue, calls for 'a new vision of reality' and 'a new dimension to be given to creative activity'. Reactions in the press were divided, but the public flocked to the exhibition. The impetus it gave to the development of automatism was to affect Canadian art for several decades, and as Britain was still the country to which Canadian culture referred, the Toronto show became a step in the development of Canadian artistic identity.[6]

Activity at the London Gallery centred mainly on exhibitions of young British surrealists: Humphrey Jennings in October and November 1938, and in March 1939 21 sculptures and 25 monoprint drawings by McWilliam. Publicity was given to Grace Pailthorpe and Reuben Mednikoff's exhibition of 69 works at Guggenheim Jeune in January 1939, and to Roland Penrose's and Ithell Colquhoun's paintings and objects at the Mayor Gallery in June 1939. These purely surrealist exhibitions demonstrated the London Gallery's prime interest and turned Cork Street into a magnetic centre. At the same

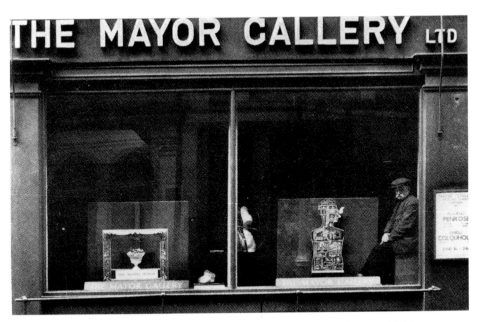

68 Window of Mayor Gallery, London, with tramp in the window, for an exhibition of works by Roland Penrose and Ithell Colquhoun, 1939

time, London Gallery Editions was launched, demonstrating surrealism's determination to develop in all fields. Five titles were published in the Editions' first two years of existence: Herbert Read's *Edvard Munch*, Siegfried Giedion's *Moholy Nagy*, A. Dorner's *Herbert Bayer*, the catalogue of the Surrealist Objects and Poems exhibition, including eight poems (this was the gallery's first publication), and Roland Penrose's *The Road is Wider than Long*. This last work, an image diary from the Balkans, printed in coloured type, established a landmark in the history of the Editions (see pp.166–9). But it was the *London Bulletin* that remained the outstanding publication, the reflection of the gallery's preoccupations, although it would disappoint anyone seeking manifestos, dream narratives or resounding surrealist declarations. The *Bulletin* was, in fact, an introduction to, and a presentation of, avant-garde art, mostly surrealist, but also including abstraction and constructivism.

Nevertheless, the *Bulletin*'s policy was under the full direction of surrealist poets and painters. Mesens's three successive assistant editors were Humphrey Jennings, Roland Penrose and George Reavey, and the last issue, a triple one published in June 1940, was co-edited by Penrose and Gordon Onslow-Ford. This ensured coherence and unity in the material published; but what is noticeable above all is an awareness of anything, however trivial, which might contribute to the emancipation of the mind. This awareness took the form of notes, photographs, short articles, letters to the editor, and reports and reviews on subjects as various as fashion, folklore, the theatre, psychoanalysis or even machines. In the first issue, two dresses by the fashion designer Norine, embroidered with motifs from surrealist paintings, were shown between photographs of two models by Dalí and Ernst; issue number 7 celebrated the vitality of the left-wing Unity Theatre and its Rebel Players' performances, and number 8–9 devoted two pages to folk dances from Bali and Romania, stressing their role in initiation rituals. Public interest in the values of surrealism was further developed by a controversy about psychoanalysis that originated in the *London Bulletin*.

The starting-point was a lengthy article in number 7, by Grace Pailthorpe, on 'The Scientific Aspects of Surrealism'. The goals of surrealism and those of psychoanalysis, she declared, were similar in that both aimed at the liberation of people from internal conflicts, 'so that he or she may function freely', and led to 'a greater understanding of the world around and within us'. This is why 'the harmonization, the coming to terms of the individual with his own internal world has to be explored, if not totally achieved'. This view provoked criticism from poets and critics, such as Parker Tyler in New York and another psychoanalyst, Werner von Alvensleben, in London. To the latter, Pailthorpe answered undaunted in the June 1939 issue that it is only when 'fantasy is freed from infantile fears which compel to repeat it ad

infinitum' that it will 'enter into creative art and creativity to a degree previously unknown'.[7]

Another aspect of British surrealism's scientific preoccupations was expressed in the curious exhibition The Impact of the Machines, organized by Mesens, Humphrey Jennings and Arthur Elton, as well as in several accompanying articles in the *London Bulletin* of June 1938. As Jennings emphasized in his article 'The Iron Horse', 'machines are animals created by man', and 'every machine has a latent human content'.[8] A blurring of categories – mineral, animal and human – was intended in the exhibition of 87 drawings, paintings, woodcuts, photographs, lithographs and collages, belonging to different periods of history, and all giving humorous, scientific, poetic or naive views of machinery, or cross-sections of machines. In this way, the machine was, so to speak, suspended in timelessness; the technical differences which had made the machine evolve were largely neutralized in favour of its symbolic content and the echoes it sounded in man's subconscious. Evidence of this 'redistribution' of the rational and the irrational – a cornerstone of surrealism – was provided in the same issue of the *London Bulletin* by Jennings's publication of a collage of extracts from poems, reports, diaries, letters, novels and essays, written by authors such as Blake, Ruskin, Engels, and Fanny Kemble. All these texts, later gathered by Charles Madge into a volume entitled *Pandemonium*, showed how man and the machine have entered by degrees into dialectical relationships.[9] Further abetted by the reprinting of Breton's article on Duchamp's *Lighthouse of the Bride*, the exhibition and magazine established the principle of imaginative materialism that was a distinctive feature of surrealism in Britain.

Meanwhile British surrealism strengthened its links with its continental equivalent. From number 6 onwards, the *Bulletin* added to its cover and title page Paris, Brussels, Amsterdam and New York, with the names of its representatives overseas, Georges Hugnet, P.G. Van Hecke and Charles-Henri Ford. This extension across national borders was followed by the publication of several texts in French, with or without translation. Breton, Eluard, Magritte, Nougé, Chavée, Hugnet, Tanguy, Péret and Lecomte thus formed an 'international front' with Davies, Penrose, Mesens, Read, Colquhoun, Maddox, Jennings and Melville. This close collaboration was affirmed in every issue, the best example being the publication of Breton and Rivera's Declaration in *London Bulletin* 6, to be followed by a translation in the next issue. The magazine's network of international reciprocation also resulted in the publication of poems by Eluard for Jennings, Ernst, Tanguy and Miró, a poem by Charles-Henri Ford for Eluard, poems by Péret for Ernst, Ruthven Todd for John Piper and Miró, Eluard's poem and Read's text for *Guernica*, Magritte and Nougé's analysis of Penrose's postcard collages, and a repeated welcome extended to Rita Kerrn-Larsen. Among the forces working freely in

European art and aesthetics, the *Bulletin* now occupied a prominent position.

Mesens effectively had sole charge of the gallery and, as a consequence, of any surrealist group activity. Roland Penrose was largely absent, leaving England at the end of June 1938 for Paris, going on to Athens to join Lee Miller, whence they set out in Lee's Packard on an expedition through the Balkans, via Delphi and the Meteora monasteries, and Bulgaria. In Bucharest they met up with Harry Brauner, an ethnologist, and Victor Brauner's brother, who helped with the trip, advising them on traditional festivals. Meanwhile, Mesens encountered problems in the management of the gallery, and the Impact of Machines exhibition was poorly attended in spite of resounding press coverage. Subsequent financial difficulties forced him to sell one of Penrose's Picassos, while between the opening of the gallery and the war it was difficult to find opportunities for the group discussions and exchanges, outside of exhibitions.

However, Mesens's unabating energy and dedication to surrealism, and his many contacts abroad, reinforced by those of Penrose in Britain, succeeded in maintaining a solid surrealist presence in London, constantly manifested by efforts to link both the political and the artistic.

The lack of strict political allegiance could be seen as evidence of uncertainty as to what course British surrealism sought to follow. But the reverse can be argued: like *Minotaure*, which never declared a political allegiance, the *London Bulletin* shows the new direction taken by the surrealists after the controversy with *Left Review* and the group's decision not to align itself with any party policy.

The drift of British surrealism away from Stalinist Marxism towards Trotskyism was given voice in Breton and Trotsky's declaration, 'Towards an Independent Revolutionary Art'. There was however no specific orientation given to the group, indeed, political indifference was tolerated in some members, as well as Banting's and Davies's Stalinism and Read's leanings towards anarchism. The group as such made no reply, therefore, to a strongly worded letter from André Breton, 'To Our Friends in London', sent in October 1938, which stated that the British group must define its position towards Trotskyism:

At the moment we expected to hear of the constitution of the English section of the FIARI [Fédération Internationale de l'Art Révolutionnaire Indépendant], Penrose informs us that you have not been able to agree on a plan of action. The question which seems to worry you most is what attitude to adopt towards the USSR.[10]

Acknowledging the group's 'fear that a polemic launched by us against Russia ... would play into the hands of the Fascists', especially after the Munich agreement, Breton drives home again the argument that 'if the leaders of the proletariat had not committed errors, there would never have been

fascism either in Italy or in Germany'. As a consequence, 'not to react when faced by the faults of the Third International would be tantamount to acceptance of the responsibility for its errors and its crimes'.

We feel sure, and we have regret to have to remind you of this, that what remains of the October conquests can only be saved, consolidated and increased with the support of the international proletariat. The defence of the USSR, according to your conception, will be in opposition to that view. We refuse to admit the identification of the Soviet proletariat with its present leaders.

In a previous exchange of letters, Penrose had evidently defended an alliance with the USSR, or the Communist Party, for tactical reasons, to prevent any isolation in the fight against fascism. Breton replied, however, from the perspective of long-term strategy, which was to achieve the unity, at any cost, of 'all the creative forces of man by all critical and effective means'. The issue, for Breton, was crucial:

Certain surrealists in London, it appears, hesitate. We hope that this letter will help them to dispel their fears. If this is not the case, it is obvious that they will only be surrealists in name. We are not deceived by words or labels, no more by the label 'surrealist' than by the label 'communist' or USSR.

A reply from Read is printed alongside others in the first issue of *Clé*:

Dear friend,
Today Mesens has shown me your letter and the manifesto. I hasten to say I completely agree. I have already expressed myself in that sense. Certain pages of my recent book *Poetry and Anarchism* are almost word for word those of the manifesto.
 Needless to say that I am ready to adhere to the Federation which you are now forming
 Affectionately yours,
 Herbert Read[11]

In the second number of *Clé*, Read affirms his support of the FIARI and reiterates its essential principle, that it is not a political, or aesthetic, school. Instead it is a way of 'ozonizing the atmosphere in which the artists have to breathe and create', since 'independent creation in this period of convulsive reaction . . . cannot but be revolutionary in its very spirit'.

If Breton hoped for other replies from England, he did not get any. However, his analysis was based on the situation in France, where the Popular Front had failed, having conducted a reformist programme. The consequence of this was that the influence of the working class had been greatly reduced – the more so since Stalin and Litvinoff's policy reduced, if not severed, all links between the Soviet proletariat and their comrades abroad. The situation in Britain was technically different, and Mesens was acting in sympathy with Breton's wish for an international and cultural front – but through a specific strategy based on union with the Artists' International Association.

Indeed, a vacuum was created in Britain by the failure of left-wing parties to form a Popular Front that would change Britain's social and political choices, as well as by the need that many intellectuals felt to offset the influence of Stalinism without giving way to reactionary ideologies. Such a vacuum was one which the apparently neutral AIA was ideally placed to fill. This ecumenical approach might have been censured by Breton on the grounds of causing rampant confusion, but because of the personal relationships of James Cant, Sam Haile, John Banting and Roland Penrose with members of the Independent Labour Party and the Communist Party, as well as the variety of political choices within the group, it was impossible for anyone to propose, let alone dictate, a line to the group. The alliance with the AIA corresponded to both historical and local necessity.

Penrose said as much in a letter to Herbert Read on 27 January 1939, written aboard the *Marietta Pasha* on his way to Egypt. He had just seen Hugnet, Eluard and Ernst in Paris, and the letter echoes his friends' own conclusions:

The idea of a united international surrealist activity is now a thing of the past . . . my feeling is that we should do well to soft pedal on all issues which might enfeeble even further revolutionary tendencies, some sort of unity must be attained and self-criticism which prevents this looks like a kind of neurosis, a self-destructive force.[12]

He goes on to advocate publication of a manifesto – one different from the FIARI platform – which would 'help English intellectuals to clarify their own position' and build 'a group of revolutionary anarchist intellectuals with a very definite programme behind it'. It was understandable that the disorientation felt by artists such as Penrose prompted them to avoid enslavement to party politics by joining forces with the AIA.

By the last few pre-war months, the AIA had moved from a strictly Marxist policy towards advocating a more comprehensive fight for peace against fascism. It retained special relationships with the Communist Party, but it was no longer at the service of a small group of militant artists, campaigning to recruit from intellectuals and from art teachers and students. Simultaneously, the CP of Great Britain had converted to the idea of a United Front, first at the Congress of Peace and Friendship with the USSR in December 1935, and then at its own 14th Congress in May 1937. In March 1938, the editor of *Reynold's News*, Sidney Elliott, published an appeal for a united alliance under the leadership of the Labour Party for the defeat of Chamberlain. The appeal was addressed to the Labour Party, the Liberals, the ILP and the Communist Party. The chairman of the Communist Party, Harry Pollitt, greeted this as a victory and an expression of support for the Congress's decision, even saying that it was in keeping with 'the whole theory and practice of Leninism, the need for seeking allies to carry forward the struggle as a whole'. Whatever the gulf between principles and practice, the surrealists saw their own collaboration with the AIA as part of their strategy.

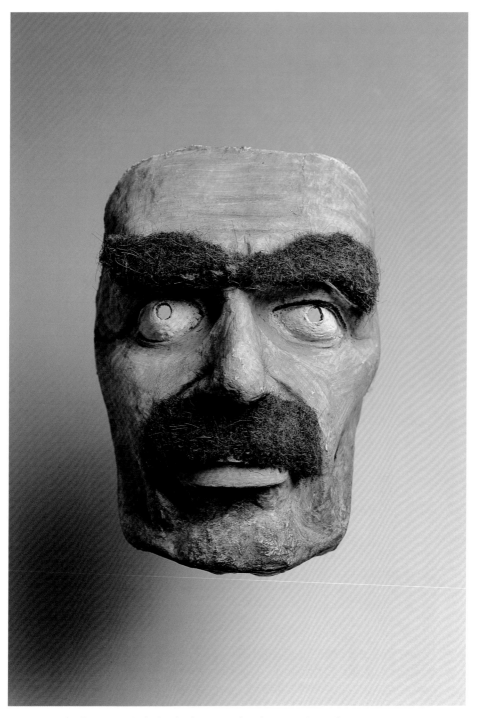

69 F.E. McWilliam, *Mask of Chamberlain*, 1938, height 19 cm (7.5 in.)

Politically British surrealism's involvement at this time was too low-key to take the form of direct statements or open attack, and only once did the group publish a 'call to arms'. This took the form of a broadsheet similar to the 'Declaration on Spain' in the November 1936 issue of *Contemporary Poetry and Prose*. It was headed 'To the Workers of England' and was printed in varying types. Signed 'issued by the Surrealist Group in London', it stated:

The Government is asking you/to carry out its/Re-armament programme/For what purpose?/Are your efforts to be to help fascism?/Power is in your hands/Unite and use it/Make your conditions, insist on a/democratic foreign policy and/arms for the Spanish people/UNITE! Dictate your terms.

Five other texts, mostly from foreign sources, help define the group politically: a brief article by André Breton warning of the danger run by Freud in Nazified Vienna; a series of texts about Lorca's death and the bombing of Guernica; Breton and Rivera's manifesto; a diatribe from Magritte and Scutenaire against bourgeois values; and Herbert Read's text against 'the exultant forces of philistinism' and 'the abandonment of artists by state and public alike'.

Twice, at least, Trotskyism found public favour; a review by Parker Tyler, the New York correspondent of the *Bulletin*, proclaims that 'Stalinism is not the inevitable or logical result of Leninism', and S. John Woods, who exhibited at the Living Art Exhibition as an 'independent', denounced 'realism as a flight from reality', along with any naive trust in the blending of art and action. He contended that 'the artist cannot move to the masses and must wait until the masses move to him (and do everything in his power to make the masses make that move)'. Despite its deviation from surrealist principles, Mesens agreed to the publication of the article.[13]

Magritte and Scutenaire's article in the next issue of the *Bulletin* complemented Woods's declaration, by stressing the artist's role in contemporary politics. In no way, they say, should the artist retreat into an ivory tower.[14] As 'the actor of the future' he can only preserve his individual freedom (and fulfil his function) by refusing to be celebrated as an artist. Capitalist hypocrisy, they emphasize, bestows on art the characteristics of a superior activity, 'with no resemblance whatever with any ordinary activity of men', thus isolating the artist from society. 'The artist's efforts', they conclude, 'like any working man's, are necessary to the dialectical development of the world.' Although written by two foreign surrealists, the text can be seen as conveying the voice of the British group in its blending of pure aesthetic protest and Marxist politics. According to this synthesis, political involvement and exhibitions should be viewed as having the same practical value. However, the AIA *Newssheet* of January 1938, in stigmatizing 'the bad influence of ... surrealism' and the incomprehensibility of Picasso's work,

claimed there was a limit to this collaboration. The surrealists' reaction was immediate and violent; their reply, in the following issue of the *Newssheet*, and signed among others by Eileen Agar, James Cant, Sam Haile, Ceri Richards, Henry Moore, F.E. McWilliam, Penrose and Trevelyan, threatened their withdrawal from the AIA if that was its official attitude. The AIA apologized, saying that they recognized the surrealists' 'efficacy' and undeniable sympathy for the supporters of peace and democracy.

On 16 March 1938, the AIA sponsored another public debate between 'surrealists and realists' at the Group Theatre Rooms, taking as the bone of contention twelve contemporary paintings. As Herbert Read reported in the *London Bulletin*, he and Trevelyan attacked socialist realism, and Penrose stressed the development of extra-retinal vision and Jennings the importance of automatism. They stigmatized their opponents Robert Medley, Anthony Blunt, Graham Bell, William Coldstream and Peter Peri as 'the effete and bastard offspring of the Bloomsbury School of Needlework', who kept avoiding the political issues lurking behind realist aesthetics. Randall Swingler, writing in the *Left Review*, and Anthony Blunt in the *Spectator*, pointed out the 'vociferation' of the surrealists and acknowledged the realists' difficulty in finding an artist who could be opposed to Picasso. Blunt remarked that 'to the system of shocks, incongruities with which the superrealists work, Coldstream opposes the quality of honesty', and Swingler opposes 'the pretentious flourish of the surrealists' and 'the humility and honesty' of the realists.[15]

It should be remembered that Britain's attitude towards the two main issues in Europe, the Spanish Civil War and the rise of fascism, was still one of compromise and expectancy, as Chamberlain's coalition government kept on sheltering behind policies of non-intervention and peace at all cost. The *Guernica* exhibition, widely publicized by the AIA, has to be seen in this context. Equally important was a retrospective of Max Ernst's works held at the London Gallery in December 1938 in aid of the Czech and Jewish refugees in London, which was opened by Herbert Read and a Labour MP Vernon Bartlett in an explicit display of politics siding with aesthetics.

The surrealists made a display of political unity with their participation in an enormous parade on May Day 1938 in Hyde Park organized by all the left-wing parties. They hired a van on which they installed a loudspeaker that played Spanish Republican songs as well as the 'Internationale'. Trevelyan recalled in his memoirs, 'Inside was a cage in which hung a skeleton. Next came an ice-cream tricycle on to which we had rigged a superstructure of wire-netting culminating in a great horse's head. Inside the wire-netting were coloured balloons. Finally, McWilliam had made four masks of Chamberlain, ·and four of us were dressed up as four Chamberlains, complete with top hats and umbrellas.'[16] Thus attired, Roland

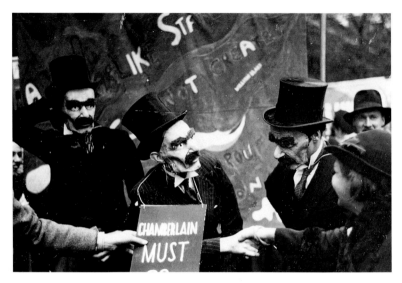

70 Surrealists demonstrating in Chamberlain masks in Hyde Park, 1938

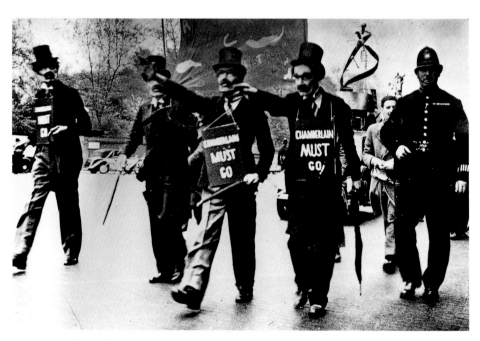

71 Surrealists demonstrating in Hyde Park, 1938. Left to right: James Cant, Roland Penrose, Julian Trevelyan, Geoffrey Graham

Penrose, James Cant, Geoffrey Graham and Julian Trevelyan marched along (Pl. 70), shouting 'Chamberlain must go!', and making the Nazi salute.

By late 1938 the fighting in Spain had produced large-scale destruction and slaughter, while the Republican forces were losing ground. Hitler had annexed Austria in March 1938, and the Munich agreement in September 1938 opened the way to German hegemony in Europe. The various campaigns of the time tended to radicalize in response. Within the art world, the determination of the surrealists as well as of the AIA to sever all links between progressive artistic activities and the conservative West End art establishment led to an increase in travelling exhibitions, giving provincial cities a greater opportunity of seeing contemporary art. In February 1939, a few weeks before the fall of the Spanish Republic, a group of 80 AIA members, including Sam Haile, Ceri Richards and John Banting, undertook to paint a number of billboards with giant pictures and slogans asking for food to be sent to Spain (Pl. 72). British art was getting involved in current issues by moving out into a world beyond that of museums and galleries. Its artists also exerted themselves to raise money in response to the widening European crisis. Another United Front exhibition was held at the Whitechapel Gallery in February and March 1939 under the theme 'Unity of Artists for Peace, Democracy and Cultural Development', otherwise 'Art for the People'. The money raised was to go to the Artists' Refugee Committee.

Three months earlier, in November 1938, an appeal had been sent to influential artists and art critics in Britain, among whom were Epstein, Rothenstein, Paul Nash, Herbert Read and Roland Penrose, by a group of German artists from Berlin who had taken temporary refuge in Czechoslovakia. These called themselves the Kokoshkabund – Kokoshka being among the best-known artists who had recently taken refuge in Britain. Through Penrose's efforts, a committee was formed, essentially from members of the AIA, to raise funds for the immediate maintenance of the refugees and to find the employment and host families required before an entry visa would be issued to them. A subcommittee was also constituted to give assistance to Spanish refugee artists.

The committee mounted the United Front exhibition with a selection of 300 works. In London alone, it attracted 40 000 visitors. Its intention was also to bring art to the people, by demystifying the concept of exhibitions, and divesting them of their West End mystique. An unemployed worker was selected at random from the street to open the exhibition officially and polls were held to decide the popularity of the paintings being shown. Surprisingly enough, realism did not score too well. The organizers made a point of asking the artists to be present as much as they could, meanwhile seeking to make the show as eclectic as possible – it featured work by Duncan Grant, Ben Nicholson, Coldstream, Moynihan, Graham Bell,

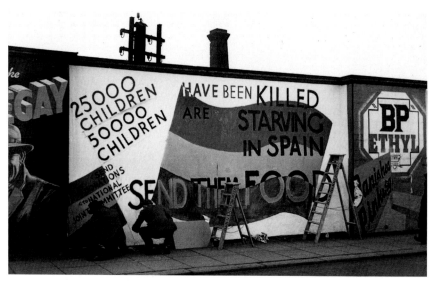

72 Billboards in support of aid for Spanish Republicans, 1939

Trevelyan, Eileen Agar, Moore, James Cant, Roland Penrose and F.E. McWilliam. The exhibition went on to tour thirteen English towns, in schools, colleges and rural and urban communities; its destinations included Southport, York, Bradford (where 32 500 visitors are said to have attended), Kidderminster and Carlisle. The tour was to continue until autumn 1940, when it had to stop on account of wartime travel restrictions.

In contrast with the political tolerance that British surrealism had accepted by the summer of 1939, a feud broke out that June between Mesens and Herbert Read. Although it was short-lived, it was indicative of the moral intransigence that Mesens tried to instil into the group

Peggy Guggenheim intended to create a Museum of Modern Art in London with Read as its director. In spite of her friendly links with the surrealists, who in view of her wealth were not always uninterested, and despite their previous collaboration with the Guggenheim Jeune Gallery and the part played by Read, Mesens saw Peggy Guggenheim's proposal merely as a means of legislating over the world of art for mercenary ends. Mesens accordingly saw Read as 'a weakling, a coward, a renegade, who put himself at the service of what is base'. Penrose was being pressed by Guggenheim and Read to join them with his recently acquired collection, and on 29 July, Mesens wrote to him in Antibes where he was with Eluard, and tried to convince him not to have anything to do with Peggy Guggenheim's plans. By way of 'retaliation', Mesens set out detailed plans for his own Museum of

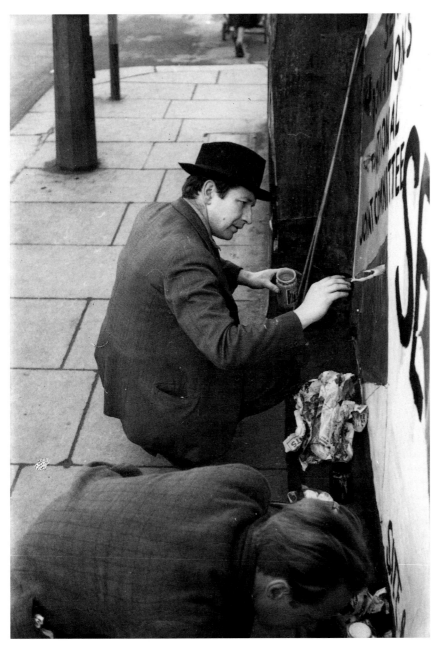

73 Ceri Richards and Sam Haile painting billboards in support of aid for Spanish
Republicans, 1939

Modern Art, convinced as he was of support from a great number of friends: not only Paul Nash, Moore, Davies, Jennings and F.E McWilliam, but also Cavalcanti, Edward James, Charles Laughton, Zwemmer, J.M. Keynes, Freddie Mayor and Sybil Thorndike. Begging Penrose to refuse involvement with 'la Guggenheim', Mesens also asked him to try and persuade Picasso to be one of *his* trustees, leaving Peggy Guggenheim with Kenneth Clark (who had been fiercely attacked in the *Bulletin)*, Augustus John, Stanley Spencer, Ben Nicholson and William Coldstream. Another letter from Mesens dated 18 August listed a series of harsh criticisms of Read by Nash, Jennings. Eileen Agar, Joseph Bard and Ernö Goldfinger, and reproached Penrose with hesitating and listening too much to 'Read the Vicar'. Penrose, in his reply, fully accepted Mesens's arguments. Penrose welcomed the project of a counter-Museum – and dispelled any clouds in their relationship. What this feud shows is Mesens's profoundly moral standpoint, his friendship with Penrose and his intellectual rigour.[17]

Meanwhile, inspired by the AIA's policy of travelling exhibitions, Mesens had visited Dartington Hall in Devon in July 1939, where he was greatly impressed by the work of Hein Heckroth, although he found it much influenced by Grosz, and by that of Cecil Collins, 'except that he believes that he is the reincarnation of Blake'. An exhibition was then decided on and planned for the summer of 1939.

In August, Mesens was mobilized and had to go back to Brussels. After sorting out his situation with the Belgian Army, he obtained a visa with the help of the British Council through Penrose,[18] and returned in early 1940.

The Road is Wider than Long

This span of two years before the outbreak of war was undeniably the most prolific period in the history of British surrealism. The earlier exploratory years had been stimulating, but this more radical period of investigation was when the field of surrealism expanded across borders and categories.

In literature the key work of this period is Roland Penrose's *The Road is Wider than Long* (1939) (Pl. 74). In this book, poetry, photography and typography are telescoped in a kind of visual prism celebrating an unbounded love, a dovetailing of love *for* creation and created things, and a love attained *through* creation. Was Penrose seeking images that would liberate violent visions of his own, or which would capture authentically the life of the Balkan peasantry, or was he pursuing Lee Miller, his beloved will-o'-the-wisp? Whatever the complexities of his pursuit, it left passionate traces in the book.

The title epitomizes the general spirit of the surrealist quest, its widening,

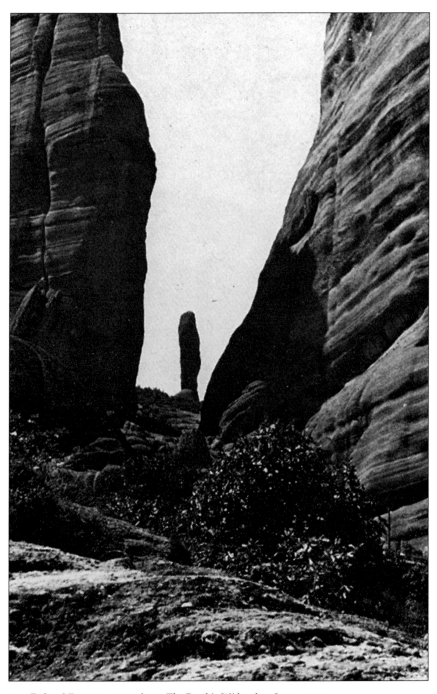

74 Roland Penrose, page from *The Road is Wider than Long*, 1939

as opposed to its deepening. In its reverberating interplay of type, small and large, italic and bold, of coloured letters and of words distributed over the page, between, under, above and around photographs, *The Road is Wider than Long* creates a sense of ever-widening space, as if the words were also opening up and moving their letters away from any set meaning. However, a reviewer in the *Times Literary Supplement* declared: 'the verse, despite all the varieties of type, red and black, is too inconsequent to leave any clear impression'.

In the book words turn into images, and images are a function of words. The whole of *The Road* is, indeed, a celebration of 'inconsequence', of absolute nomadism; the poet, the photographer, the text, whether written or photographic, cannot be located in relation to a definite aim or meaning. They occupy the constantly decentred centre of a process of accretion and growth:

> When the journeys alone that fill
> the world become fertile
> in each lover on each headland
> as the frontier is passed
> lovers watching for the red train
> have grown into each other's eyes.

This indefinite wandering, breaking through time and space, cannot be satisfied with any single representation, and can only be narrated through the successive layers of a plurality of representations. Indeed, the typography and the juxtaposition of text and image oblige the eye to adopt several focuses. There is no limit to cross, no authority; the text bounces from facts to visions and vice-versa, shifting our field of vision onto simultaneously varying planes.

Inaccessible love and desire are the subtext of the journey, not only the love which sent Penrose dashing to Athens to join Lee Miller, but also the love of desire, beyond time and space, between life and death, inspired by

> the little girl
> whose breasts begin to break the plain
> whose sisters lie clothed in crops
> their valleys fertile
> their spring sacred.

Our gaze, changing focus from one type to the other and made to follow the alternation of verticals and horizontals from page to page, becomes a nomad, torn between the four cardinal points of the page. Penrose never actually kept a diary, but wrote *The Road* after he had to come back to London, piecing together whatever emerged from his memory, guided by rekindled desire. The last photo, a statue wrapped up in a tarpaulin, cuts us off from any visual certitude, thus epitomizing the ambivalence of the whole photographic/poetical composition.

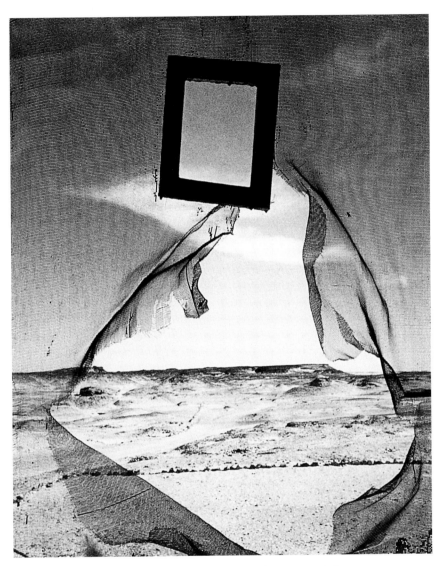

75 Lee Miller, *Portrait of Space*, 1937, 29 × 27.2 cm (11.9 × 10.9 in.)

Lee Miller's role in the book was fundamental, especially as much of the impact is achieved by her photographs: it is the camera lens which explores the width of the road. A studied visual rhythm in the geometrical structure of successive shots parallels and redoubles the internal rhythm of the words. Mountains, village scenes, people's faces, horizonless skies, truncated columns, cloud formations, animals, panoramic and close-up shots ... every photograph lends density to ordinary subjects. Lee Miller's photos, an

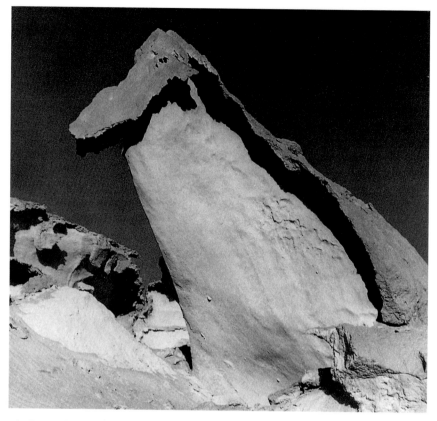

76 Lee Miller, *Cock Rock* or *The Native*, 1939, 26.6 × 27.3 cm (10.5 × 10.8 in.)

integral part of surrealism in Britain, question the concept of space as three-dimensional, and the very identity of given objects. Through the angle of shot, all her photographs convey an imminent, or accomplished, tearing open of space; it is as if she made one eye precipitate into the void and the other stop on the threshold of straightforward representation. Two photographs reproduced in the *London Bulletin*, *Portrait of Space* (1937) and *Cock Rock* (1939) overcome the eye by the tensions at work within them. In *Portrait of Space* (Pl. 75), the flat unreflecting surface of a hanging mirror has no depth and is offset by a perspective opening through a hole in a net. Space, as the title implies, is inseparably flat and deep, vertical and horizontal, framed and escaping all frames, and the mirror is its eternal double. In the second, *Cock Rock* – also called *The Native* (Pl. 76), – the interplay of light and shade, bright snow and dark mountain rocks, divides our gaze as it attempts unsuccessfully

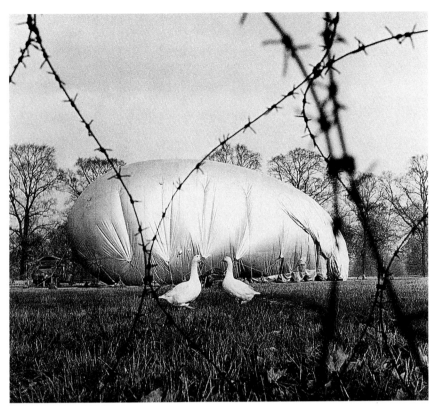

77 Lee Miller, *Eggceptional Achievement*, 1940, 24.8 × 24.8 cm (9.8 × 9.8 in.)

to grasp the whole, and seizes upon a face hidden in the natural forms, a face which can only be that of the native of the alternative title.[19]

Lee Miller's photographs, as in the humorous chance encounter in *Eggceptional Achievement* (1940) (Pl. 77), are an essential expression of the ceaseless wandering described in *The Road*, and, beyond, of the visual issues addressed by British surrealism, which, in 1938–9 is itself made in the image of this wandering: an open movement, never fully *satisfied* with itself.

Samuel Haile

Samuel Haile went through the most active phase of his surrealist work in 1938 and 1939. A Londoner, he had left school at sixteen and worked in a shipping office, following evening art classes and painting at night. Having won a scholarship, he had gone to the Royal College of Art. When he joined

the surrealist group in mid-1937, he was still teaching part-time at the Kingston and Hammersmith schools of art, had just married Marianne de Trey, a brilliant potter, and was much involved in AIA activities, serving as one of the links between the surrealists and the association. In these two years, he exhibited at the London Gallery and at the Arts and Crafts Society, and participated in international exhibitions in Paris, Stockholm and Toronto; he showed pottery but also produced about half his paintings and drawings, including some of his most remarkable ones. On the declaration of war in September 1939, the Hailes, who were on holiday in France, decided it would be unwise to return to Britain. Sam Haile's anti-imperialism and pacifism made him refuse to feel involved in the war at all, much less be conscripted. They crossed into Switzerland where they obtained visas for the United States, reaching New York in December 1939.[20] A similar exile was sought by Breton and most French surrealists a year later, Haile's own is explained in his notes:

It is not for himself that [the artist] seeks to warn his contemporaries when he sees their spiritual gropings. Provided he can keep enough freedom to continue his craft, it matters little if the people wish to cut each other's throats.[21]

The artist must resist any submission to values imposed on him by such abstract entities as Flag, Fatherland or Freedom, and refuse to 'serve an end which cannot be reconciled with poetic truth'.

This gesture, at odds with prevailing morals, explains why Haile's aesthetics developed in two ways: a continuing fight against fascism and a protest against British jingoism, and a systematic denunciation of man's abdication of his creative forces and his abandonment to fragmentation. His imagery, rooted in an obsession with suffering, is aimed at reawakening the poetic sense in man, so that he can hope to survive the agonies he experiences. Beneath and beyond the pessimistic strain which haunts his works, there is paradoxically a force which counteracts and denies it, a belief in the underlying 'life of the imagination'. Throughout the paintings, heads are elongated and hardly linked to bodies, eyes protrude at the end of long, winding stalks or drift about, nerves and muscular tissues are laid bare, wounded bodies are suspended from trees, and severed feet spring up from waste lands in supplication.

In *Mandated Territories* (1938) (Pl. 78), Haile confronts man with his exploitation of other populations and of nature, and with the realization that he, too, is a victim of self-imposed codes. In this, as in *Colonial Administrators*, exhibited in 1937 at the AIA exhibition, accusations are levelled at the usurpers of land and identity. Long tentacular stems, terminated by accusing eyeballs, trip and squeeze a female figure who is down on all fours. Uncoiling natural forces, standing up against the mandating authorities,

fight for the territory which belongs to them, displaying a savagery which reflects back on the title and invests it with its hidden significance. Breton's sentence 'the eye exists in a savage state' could find no better illustration. Any deterritorialization has to be countered by reinstating a 'savage' eye, an instinctive original eye. Haile's other works of this period, metaphorical, yet very physical, likewise point out the necessity to do away with the old cramping vision. In *Clinical Examination, Brain Operation, Surgical Ward* and *Torso with Severed Mamma*, an obsessive cutting and tearing apart leads to other fields of vision; indeed, Haile's fascination with surgery and dismemberment forces the eye to cut itself free of its moorings in what is usually called 'reality'. In *Brain Operation* (1939) (Pl. 79), the eye hesitates, like the scissors in the canvas, between the inception and the completion of the operation, between the bright-coloured upper part of the painting and the dark lower part, between white and black operating hands, left and right, yellow and black threads, round and square shapes. To cut is to be cut, and to be cut is to hasten the change of forms and their relationships; the brain operation leads to an eye operation and the brain operated upon is eventually that of the spectator. A similar suspension of the eye haunts *Surgical Ward* and *Clinical Examination*. In the former, gouged out eyes look along graph-like lines, as well as from stems towards a central 'box'; a surgeon tramples a tree-like mass of nerves and veins. The operating theatre becomes the place where analytical vision is laid out flat, like a dissected body. Vision is confronted with its own disembodiment, and the use of bare, simplified lines questions radically the stability of the onlooker's gaze.

In Haile's work, we are asked to reorganize, as best we can, the fragments given to us. This we can do by turning the thought process back on itself. In *Woman and Suspended Man* (1938) (Pl. 81), the need for reconnection is pointed out. The male is left helpless, hanging on a washing line and reduced to impotence by the all-pervading presence of a woman. The eye is torn away from any unity, either of the couple or of the body. As elsewhere, the two-dimensionality of the drawing, the winding lines and the simplification of forms reduce bodies and organs to mere artefacts open to manipulation.

Haile's contribution to British surrealism argues against all clipping of man's wings, and aims at flaying and tearing surfaces to help vision become primary again. He asks the spectator to find and follow the lines of force which carry the eye to 'another plane of existence', an 'extra-state', where man is freed from dualities. In the course of notes accumulated abundantly between 1938 and the end of World War II, he explained his standpoint with a penetration which places him as a theoretician of surrealism above Herbert Read and Hugh Sykes Davies. The cornerstone of his theory is what he calls 'the dimension K', which transforms 'an aesthetic object or image' into 'a work of art', it is, 'the expression of the amount of human passion (as distinct

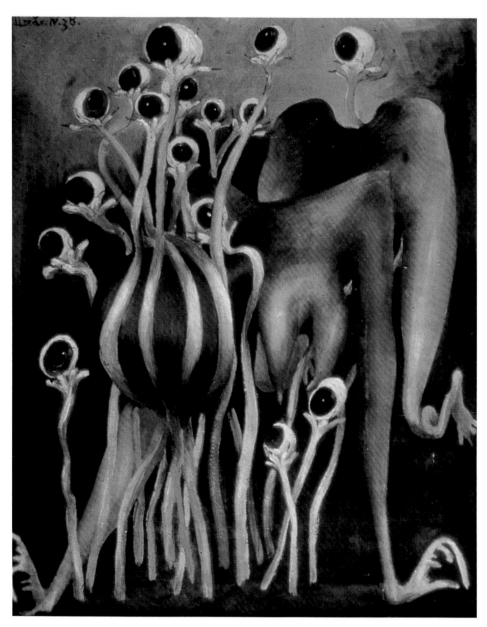

78 Thomas Samuel Haile, *Mandated Territories*, 1938, 76 × 61 cm (30 × 24 in.)

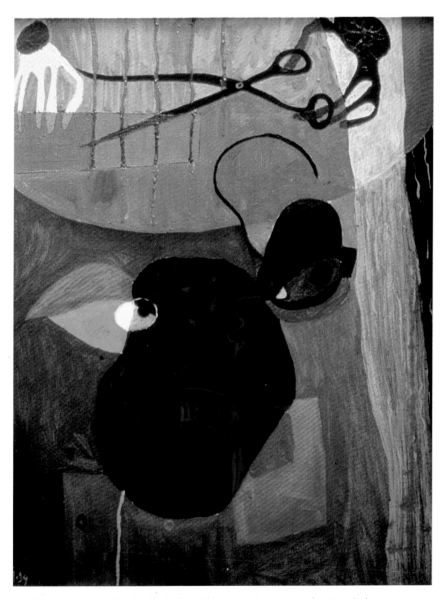

79 Thomas Samuel Haile, *Brain Operation*, 1939, 61 × 51 cm (24 × 20 in.)

from individual, often conditioned emotions, such as fear, joy, eroticism . . .) which has accompanied the conception and execution of the rendering in either of the other (first, second or third) dimensions'. Hence the use of intruding squares and rectangles, and of intersecting, overlapping lines and colours, which raise images above their natural categories. The distance between the spectator and the work is removed, making room for vigorous dialectical interaction.

The three-dimensional aspect of matter is not the whole of reality. As is demonstrated by the metaphor of a source of light, the medium by which the beam travels, and by which it receives back its reflected light from the object, must be taken into account as an additional aspect of reality. So then must the medium in which the mind perceives an object and receives back a reflection of itself . . . Thus, every object must have this other aspect of reality, this additional physical state linking it with the human consciousness, apart from the connection established through the senses by its other aspects.[22]

Haile shrewdly understood how there should be a mutual relationship between the spectator and the painting, how vicarious the role of the artist is, and how inseparable surrealism is from ceaseless exploration and the instability of meaning:

Surrealism is only a beginning, albeit an exciting one. It does not expect to remain stationary and endlessly to repeat its discoveries. By its very nature it is adapted to changing conditions, and as the discoveries of surrealism react on our world, so will the ensuing reality react on surrealism. Surrealism was, and is, inevitable.

Ceri Richards

A similar double purpose to Haile's, aesthetic and political, informs Ceri Richards's adherence to surrealism. His close two-year association with the group began at the AIA exhibition For Peace, Democracy and Cultural Progress in April 1937, at which his name appeared as a surrealist. The connection was natural; a close friend of Trevelyan's, with whom he used to play duets for oboe and piano, Richards lived in Hammersmith and taught at the Chelsea College of Art, counting among his colleagues Henry Moore and Graham Sutherland. Also in 1937, Trevelyan brought Hans Arp to Richards's studio, where Arp expressed admiration at Richards's reliefs and constructions. Around the same time, Richards became closely involved in political action; he joined the AIA and took part in 1939 with Banting and Haile in the designing and painting of billboards to draw attention to starving children in what was left of Republican Spain.

Richards has been introduced to modern art after a scholarship enabled him to attend Randolph Schwabe's classes at the Royal College of Art.

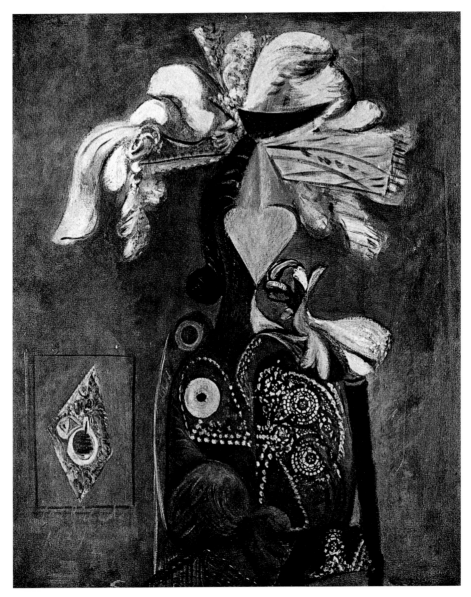

80 Ceri Richards, *Chimera Costerwoman*, 1939, 100 × 45 cm (40 × 18 in.)

Apollinaire's *Les Peintres Cubistes* and Kandinsky's *The Spiritual in Art* influenced him enormously, especially in his study of Picasso, Braque and Matisse. Parallel with this, a fascination with his own Celtic roots led him to befriend such artists as David Jones, and to praise the latest monumentality in his works, as if they proceeded from a totemic inspiration and a wish to return to the primitive manifestations of nature. The link between these archetypal roots and the geometricality of his own special form of cubism

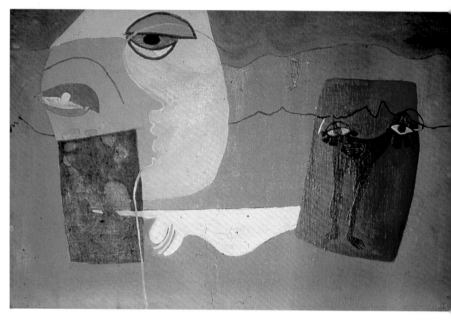

81 Thomas Samuel Haile, *Woman and Suspended Man*, 1938, 51 × 76 cm (20 × 30 in.)

found full expression in the first relief constructions and collages he pro-
duced, in 1933. In the words of Bryan Robertson, Richards's reliefs stand
exactly opposite to Ben Nicholson's in that they 'burrow inward, and make
his forms even more pictorial by turning his compositions into a kind of
theatre . . . in which shapes play out their own drama . . . as if they were on a
kind of proscenium'.

Each relief is a plot the onlooker has to unravel, in which shapes expand,
possessed with a life of their own. What we see proliferates. In its juxtaposi-
tion and overlapping of biomorphic shapes, for example, *Two Females*
(1937–8) shows a couple of *representatives* of the principles of femininity.
Beyond them, we see the engendering of forms, both geometrical and organ-
ic, at work, each included in the other, a principle which finds its eventual
materialization in relief-making. These pieces are where circular, rectangu-
lar, organic and inorganic forms, traces of breasts, eyes, legs and mouths are
being born. In *The Female Contains All Qualities* (1938) and *Chimera
Costerwoman* (1939) (Pl. 80), the blending of shapes goes further, and figures
emerge organically from a whirl of tentacles, leaves, vegetal tongues, and
flowing viscerae. In all these works the underlying figures are curves, semi-
circles and circles; they are often sensuous, and always free and variable,
evocations of the ceaselessly active womb.

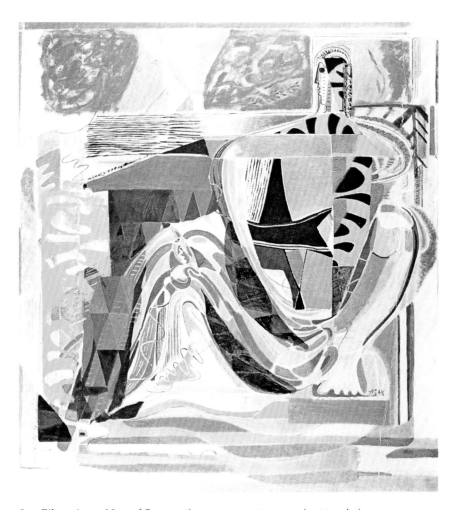

82 Eileen Agar, *Muse of Construction*, 1939, 127 × 127 cm (50 × 50 in.)

Eileen Agar

A fascination with the generation of forms and the consequent assault on the stability of given reality also featured in the works of Eileen Agar, Henry Moore and Roland Penrose, whose output reached a peak between 1937 and 1940.

In 1939, Eileen Agar summed up her main aesthetic preoccupations in *Muse of Construction* (Pl. 82), a hymn to the birth of the image. Triangles, lozenges and rectangles, along with human forms – a leg, a foot, a face –

emerge from an entanglement of lines and colours, making the observer witness the birth of a human figure out of angular and fluid lines. In this somewhat monstrous reflexivity lies the pure process of construction – further emphasized by the liberation of more and more vivid colours as the eye looks from the centre outwards. The eye roams over the lines and coloured shapes in an effort to integrate them all, yet finds no place to rest. There is no building any totality, the Muse seems to say. This concept reappears in *Bacchus and Ariadne* in a multi-layered, playful way: firstly, the two parts of this painting – symmetrical no matter how different, one a concentration of bodily fragments, the other a shattering and splintering of forms – are connected by a form of umbilical cord. Secondly, a sheet of tin has been used as the support, and various paints applied to it, as well as materials that include plaster and molten lead, another way of refusing the eye any stability; thirdly, when exhibited in January 1939 it was given the title *The Light Years* – a hint at its latent disintegration – and in June 1940 the title *Battle Years, a Bullet-proof Painting*, as an implied description of its forms struggling with each other and deciding on their own construction or destruction.

The limit between certainty and uncertainty is blurred in Agar's many collages by an obsession with facial profiles, shadows and the contour of objects. In *Possessed* (Pl. 83), an assemblage made in 1938, the eyes, nose and laughing mouth of a round face are also hands, body and legs. Forms haunt forms, and the whole work is in turn permeated with snake-like shapes and Mexican motifs: a haunting spirit which stares at us mockingly rises out of Quetzalcoatl's altar. Who is possessed? The priest, the emerging shapes, or the spectator?

Henry Moore

Moore's quest for the 'spirit of matter', by piercing holes in his sculptures, started at the end of the twenties, and developed a particularly dramatic quality in 1938 and 1939. Concentrating on small sculptures in lead, reclining figures in stone and stringed figures in lead and wood, he worked on the separation of the figure from itself. Increasingly, holes are used for, and in, themselves, with hardly any link with naturalism, so that the spectator's perceptions become poised at the limit of matter. In the 1939 *Reclining Figure*, holes, tunnels and cavities seem to be aligned and invite the penetration of matter – so much so that the holes become the sculpture's main subject, and the shadows which inhabit them offer the only traces of the wood or stone used by the sculptor. This constituted a drastic break with the tradition of sculpture which rests upon reliefs and works in the round, including those with origins in African and Mexican art.

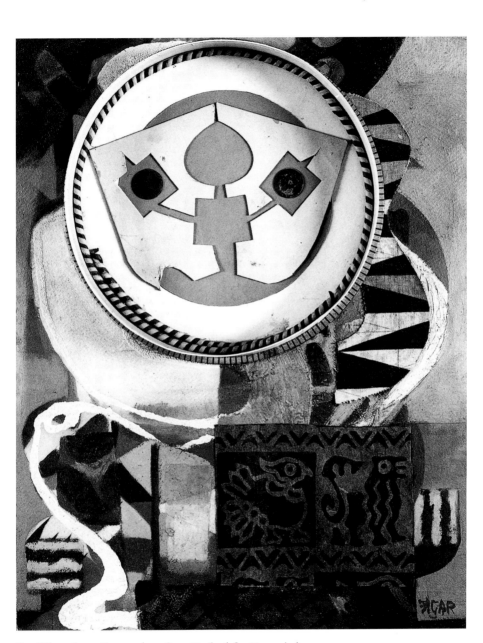

83 Eileen Agar, *Possessed*, 1938, 47 × 36.5 (18.5 × 14.5 in.)

Moore's surrealist inspiration is pushed further still with the use of strings from 1937 onwards, a plastic 'strategy' which he developed from his observation of mathematical constructions and machines in London's Science Museum while a student at the Royal College of Art. Among the most striking pieces are figures made in 1938–9 whose strings delimit the interior of the sculpture, but in the twofold meaning not only of limiting it but of opening it by revealing its innerness. In *Bird Basket* (1939) (Pl. 84), geometric lines create tensions with the curves in the lead or the stone and redouble the tension between interior and exterior with a further tension between the visible and the invisible, the open and the closed. The hole is both protected and made more fragile by a transparent screen which intensifies the drama between weightlessness and density along these irruptive lines of force. David Sylvester understood this infusion of spiritual quality into matter when he wrote that 'it establishes a barrier between the space enclosed by the sculpture's mass and the space which surrounds the sculpture', adding:

only a barrier, which, being a cage and not a wall, can contain the space on its open side while allowing it to remain visible. Above all, the string provokes movement of the spectator's eye along its length and thereby increases his awareness of the space within the sculpture, especially when, as in the *Bird Basket* of 1939, one set of taut strings can be seen through another, so creating a counterpoint of movement which brings to life the space around and within which the strings operate.[23]

This concept of awareness is crucial. Moore proclaimed here the ephemeral quality of forms, a position which he was to renounce a few years later. Forms are endowed with a vibrating quality, and strings make the eye pause at the entrance to them, just as when following the curves it is made to hesitate between keeping to and leaving the surface. Forms are negated as such; they are submitted to constant reinvention and revision, and made insecure at the boundaries. They reveal the infinite potentialities of matter, so long as the viewer consents to be aware of the libidinal intensities thus unleashed. Moore often recalled the mysterious attraction he felt for caves in hillsides and cliffs as the erotic trace of a regressive desire for the mother's womb. It was a prefiguration of the less problematic 'mother and child' figures which he was to produce later, when no longer a surrealist but an official war artist.

The tension between strength and fragility, regression and exploration, is at work in Moore's series of *Helmets* (Pl. 85), made in 1939 and 1940, and to which he was to return in the fifties. They crystallize the interplay of sheltered forms and external ones, in a situation again reminiscent of the child before its birth. To this pure pregnancy of forms is added the phallic quality of most of the internal shapes. A phantasmatic network undermines these figures, which are now places of contained energy and desire. In harmony with surrealist principles, Moore was teaching the eye how to find renewed visionary power by burrowing through matter, Alice-like.

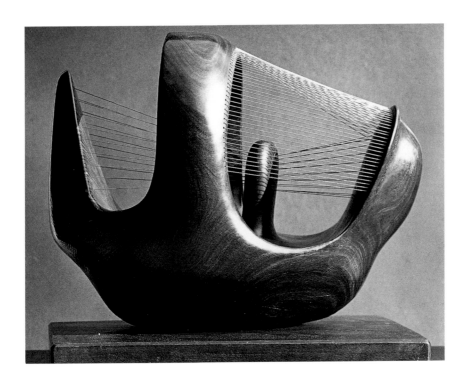

84 Above: Henry Moore, *Bird Basket*,
1939, length 42 cm (16.5 in.)

85 Right: Henry Moore, *Helmet*,
1939–40, height 29 cm (11.5 in.)

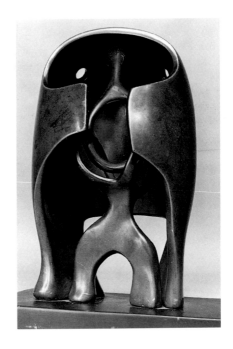

Roland Penrose

Roland Penrose's already considerable contribution to British surrealism was augmented in 1938 by his extensive production of a new, particularly original, kind of collage based on colour postcards. This technique was described by Magritte and Nougé in the *London Bulletin* as an experiment which took the collage even beyond the limits Ernst might have attained.[24] Compelled by that particular British – as opposed, say, to Latin – sensitivity to light effects, Penrose juxtaposed and overlapped ordinary picture post-cards in fan and butterfly shapes, triangles and rectangles, so that the actual image on the card was made to recede by the colours. In *Magnetic Moths*, 'the structure imposed on the image [i.e. the postcards] has transformed its very nature'. The Eiffel Tower, because it is repeated sideways, loses its weight. Habitual forms shrink back, opening onto new sequences of lines and colours. Colours emerge in a 'purified' state and make us see the Invisible beyond structures and categories. In *The Real Woman* (1938) (Pl. 87), rocks become feathers, a line of statues becomes the contour of a bird's breast, and the postcard of a sunset turned on its side becomes a woman's pudenda. Every item calls for a double vision so that what comes out as real is the double nature of woman; the emergence of her double, the bird, is insep-arable from her own sexuality, and from the inexhaustible variety of the forms she brings about, as implied by the umbilical cord linking them con-trary to natural laws.

All Penrose's paintings from the months before World War II are based on the same kind of displacement. In *Le Grand Jour* (1938) (Pl. 86), centres of vision proliferate, from each of which lines radiate out, which in turn beget the most heterogeneous objects in a chain reaction gone mad. It becomes apparent to the viewer that this repetition originates in a chemical still in full activity; indeed, six identical couples dancing in the furnace of the still seem to generate the process of repetition, as indicated by three sunsets in the still's neck. On the memorable day of the title, each object is invested with the alchemical power to redistribute reality. *Good Shooting* (1939) (Pl. 89), also shows how surfaces can be opened, as could be done by a hand in the right-hand side of *Le Grand Jour*: the violence of death and rape depicted in the for-mer has not ended in the void we might expect; the shooting has not revealed the blank surface of a wall, and a heavy chain at the side is now hanging loose. The lethal force of the shooting has been converted into a new power of release; the victim has been given the power to open her arms, in other words the capacity to break the wall and liberate the tranquil world of trees, grass and water. In the same way, *The Conquest of the Air* (1938) (Pl. 88) stresses both man's propensity to curb and control his flights of fancy, and his immense reserve of liberating energy. The life of man is shown as lying

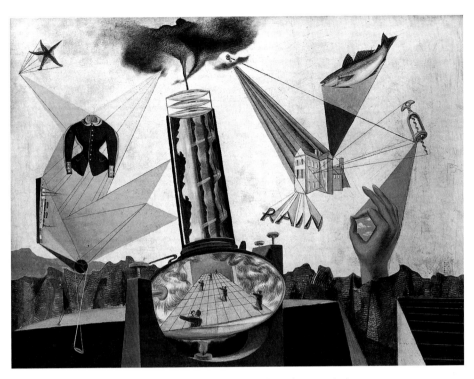

86 Roland Penrose, *Le Grand Jour*, 1938, 76.2 × 101.6 cm (30 × 40 in.)

beneath the surface of his skull, behind the dead façade of his face, a life which may well mean rapacious destruction.

In *Octavia* (1939) (Pl. 91), erotic and morbid undertones vie with each other, and the eye is obliged to invert itself and revolve around an intrusive black bar. Even if one accepts psychoanalytical interpretations – the castration complex, sadism, masochism and anal fixation – one nonetheless cannot read a definitive meaning into the painting with certainty. This is because of the ambivalence of the woman's arms, which can also be seen as a man's legs, the head then taking on a sexual meaning linked to the phallic spikes on the crenellated body. The thick black bar cuts across the visual world, reminding us of the shot in Buñuel's film *Un Chien Andalou* when a razor cuts through the middle of an eye. Any spectator is literally prevented from achieving unity and completeness.

The extent to which Penrose was willing to provoke the viewer comes out blatantly in *Portrait*, a work refused by the Royal Academy at the United Artists' Exhibition at the end of 1939 on account of words such as 'sex' and 'arse' written on the canvas. Penrose sent another painting, *From the House*

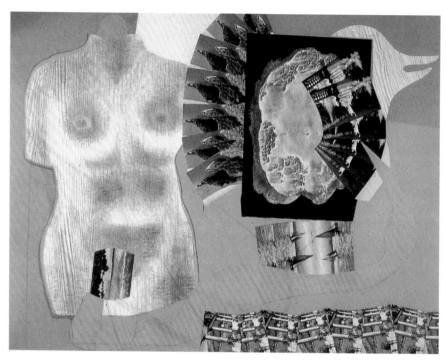

87 Roland Penrose, *The Real Woman*, 1938, 81 × 106 cm (31.9 × 41.7 in.)

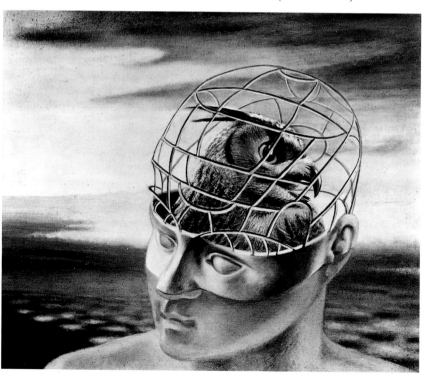

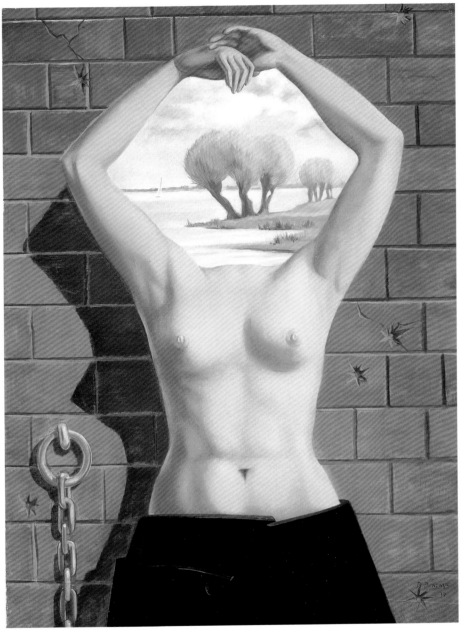

89 Roland Penrose, *Bien Vise* (*Good Shooting*), 1939, 101.6 × 76.2 cm (40 × 30 in.)

88 Left: Roland Penrose, *The Conquest of the Air*, 1938, 50.8 × 61.1 cm (20 × 24 in.)

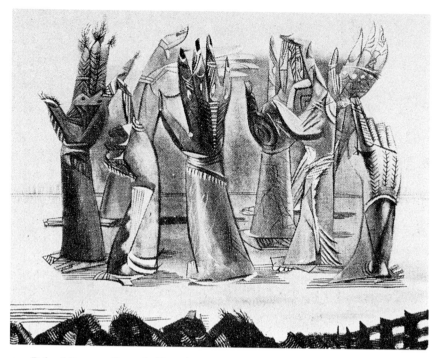

90 Roland Penrose, *From the House Tops*, 1939, 37.5 × 50 cm (14.7 × 19.6 in.)

Tops (1939) (Pl. 90), which was readily accepted (and then stolen in 1943), but William Hickey (then Tom Driberg) of the *Evening Standard* revealed that, if read in deaf and dumb language, the painting's four pairs of gloved hands that rise from the ground spell a very unseemly S.H.I.T.[25]

Penrose was travelling widely at this time; in Egypt he made numerous frottages of intertwining palm leaves, minarets and ibises' beaks, and a magnificent oil, *Egypt* (1939). He visited France, not only as an envoy of British surrealism but as a close friend of French artists and poets. He frequently stayed with Picasso and Dora Maar at Antibes and Mougins, and visited Max Ernst and Leonora Carrington in an old farmhouse recently acquired by Ernst at Saint Martin d'Ardèche, where they were often joined by Man Ray. In addition to his own other works – drawings, frottages and paintings – he brought back a photographic record made with Lee Miller of sculptures which Ernst had added to the outside walls of his farmhouse.

Humphrey Jennings

Humphrey Jennings's exhibition at the London Gallery in October 1938 presented him as another destabilizer of our firmest visual habits. This he did by juxtaposing in each of his collages and paintings just two items carefully selected to achieve a highly ironic effect. In late 1937 he had parted with Mass Observation, stating that he was not interested in the essentially scientific and analytical nature of its reports that had developed under Tom Harrisson's influence. In the meantime, he gave radio talks on poetry and the poet's relationships with the public – once he talked about 'The disappearance of ghosts' – and worked on a series, 'The Poet and the Public', discussing issues with poets Cecil Day Lewis, Herbert Read, Patience Strong and others. With no specific end in mind and without any idealization or dramatization, he also went on photographing the living conditions of workers in industrial towns such as Bolton. In 1938, with Mesens and Arthur Elton he organized the Impact of Machines exhibition, summarizing his search for the primitive source of organic energy which runs through mind and matter when he wrote that 'every machine [had] a latent human content'.

Accordingly, one should examine *Horse's Head* (1937–40) (Pl. 92) and *Locomotive* (1936–8) (Pl. 93) simultaneously; the former explains the latter, and both show an identical process of transformation at work. In about 1936, the horse started to fascinate Jennings, coinciding with his desire to retrieve the machine from a purely materialist conception. In *Horse's Head*, the blending of the mechanical and the animal through the very angular, almost vorticistic features of the head, brings out the same powerful underlying energy that is conveyed in *Locomotive* by the soft curves and fluid shapes of an engine. In both, a double displacement reshapes reality, that of nature and that of the machine, beyond time and space.

In a text published in October 1938, Jennings drew a map of words and concepts which he links with dotted lines, inviting us to chart our unconscious reactions. At the centre of the constellation is the word 'prism', from which other words derive; these, in turn, become centres for other relationships, a concatenation of objects and words, each of them seen as a source of pure creation.[26] The visual and mental structure of this conceptual chart is close to that of Roland Penrose's *Le Grand Jour*. Here, as in his collages, Jennings walks the tightrope which separates the real and the imaginary, by staging a direct confrontation of two remote elements: all laws are suspended, whether those of gravity or of optics. What remains are 'the fleeting hues of reality', a 'chaos of elemental and artificial' lights, colours and objects, to quote his poem 'The Origin of Colour', itself a report on the constitutive changeability of light.

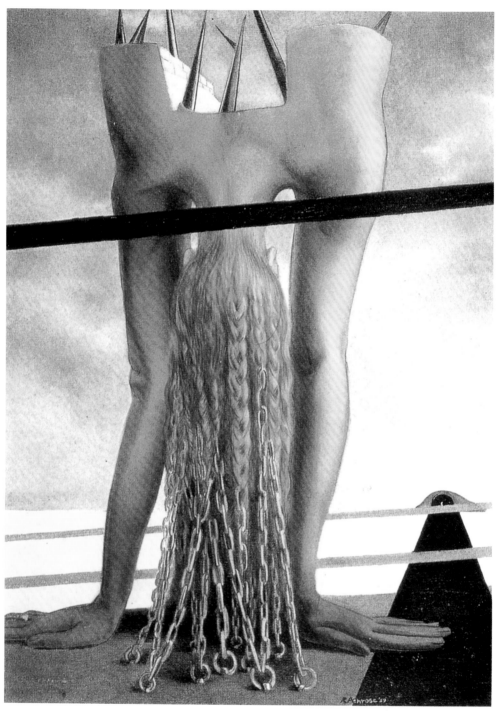

91 Roland Penrose, *Octavia*, 1939, 77.5 × 63.5 cm (30.5 × 25 in.)

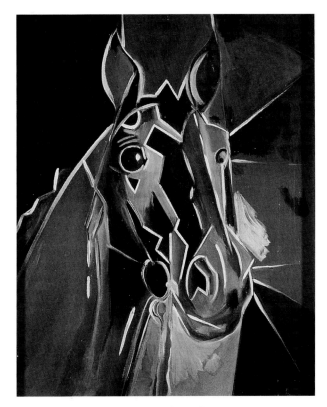

92 Humphrey Jennings, *Horse's Head*, 1937–40,
55.5 × 43.2 cm (21.9 × 17 in.)

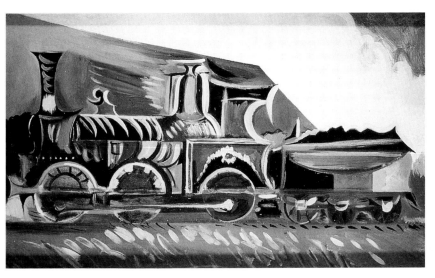

93 Humphrey Jennings, *Locomotive*, 1936–8, 25.5 × 30.5 cm (10 × 12 in.)

Alpine Landscape, or *Mountain and Plum* (1938) (Pl. 96) – the choice of title depends on whether one prefers to be descriptive or ironic – is based on this same disorganizing principle. Here, the intrusion of a plum into the middle of a glacial valley doubles the centre of vision, defies the physical laws which condition our mundane vision of the most ordinary scenes, and lends itself to various questions and interpretations, including Freudian ones. Similarly, in *Apples* (Pl. 95) a striking blend of the material, the visual and the spiritual, establishes, in the intrusiveness of three apples, a daring link between a natural Alpine landscape and the geometrical materialization of light into prisms. In one and the same glance, Newton's experiments in gravitational physics and optical phenomena are thrown together and fused.

Jennings's films made at the time convey the same kind of challenge. *Penny Journey,* for example, follows a postcard through the post, and is a series of images of the internal as well as external time and space of the spectator.[27] The epitome of this is given in a short poem published in the *London Bulletin*:

> As we journey up the valley
> Of the Connecticut
> The swift thought of the locomotive
> Recovers the old footprints.[28]

F.E. McWilliam

In the same spirit as Jennings's work, F.E. McWilliam's surrealist sculptures also challenged the laws of physics, anatomy and vision. McWilliam's first one-man exhibition at the London Gallery, in March 1939, showed that, after working under the influence of Brancusi (as in his works of 1936 and 1937), he had evolved from minimalizing forms to questioning them, having by 1939 rejected Brancusi's belief in purity and primordiality. In contrast to Henry Moore, McWilliam does not let forms have their own way or yield to the elemental sense of life so as to leave the eye wandering loosely. McWilliam detaches forms from their context, gives them back their freedom and lets them create their own space from, not with, the material. He chose to do this with the human face and body because he knew that subverting their organic unity would most efficiently lead to the destabilizing of reality. McWilliam refused what is complete and organically entire. By isolating some fragments and excluding others, he rejected the notion of functionality itself. *Spanish Head* (1938–9) (Pl. 94) is a perfect example: it conjures up what must have existed in the past (just before the artist broke in) by showing what has been salvaged. To see it is not only to see the fragment given to us, but also the empty space around, with which it seems to be struggling. This

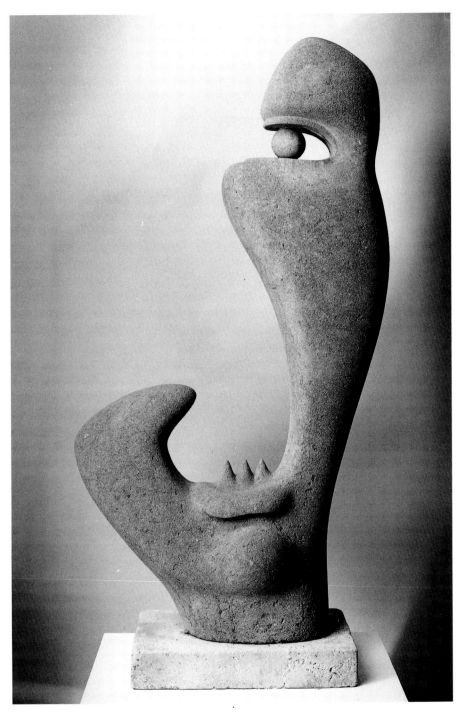

94 F.E. McWilliam, *Spanish Head*, 1938–9, height 130 cm (51 in.)

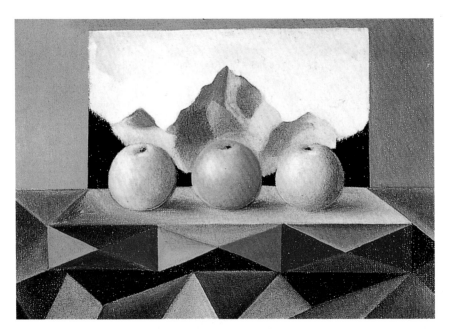

95 Humphrey Jennings, *Apples*, 1940, 25.4 × 31 cm (10 × 12.2 in.)

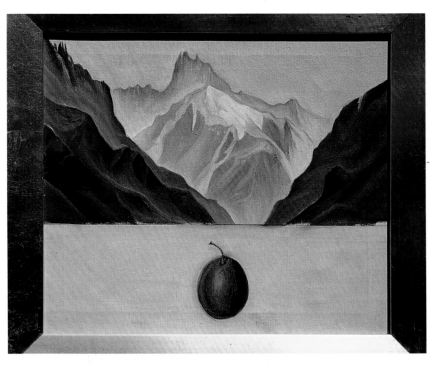

96 Humphrey Jennings, *Alpine Landscape* or *Mountain and Plum*, 1938, 30.5 × 35.5 cm (12 × 14 in.)

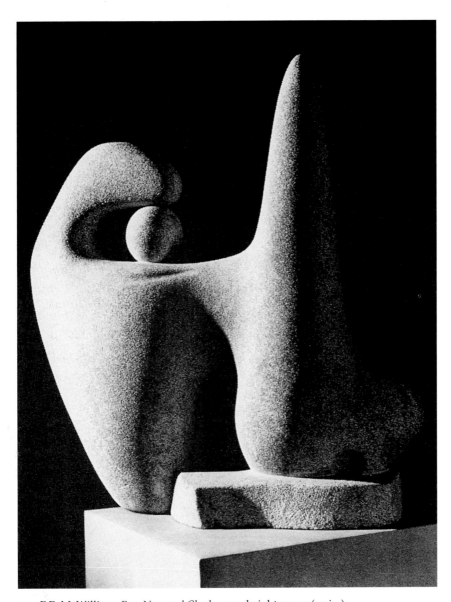

97 F.E. McWilliam, *Eye, Nose and Cheek*, 1939, height 90 cm (35 in.)

almost predatory violence is reminiscent of Goya's screaming heads and reinforces the political meaning of the work. *Eye, Nose and Cheek* (1939) (Pl. 97) also presents different parts of the face, scarcely attached to each other, and made both darkly vulnerable in their monstrous displacement and isolation and ironically powerful in the way they provoke normal order. McWilliam's sculptures, in his own words, 'concern the play of solid and void, the solid element being the sculpture itself while the "missing" part inhabits the space around the sculpture'. But, of course, one is irresistibly tempted to reconstruct the human face by supplying the missing parts, so that these become essential. The snag is that they will always remain missing, except in our minds. In other words, mind turns into matter, and the fragments we are supplied with, an eye, a nose, a cheek, are situated *between* our perception of them and the perception of what is absent but necessary to make them *mean*, to make them functional in a human face. As happens with Moore's sculptures, the distinction between inside and outside, presence and absence, is abolished, but, far from creating a lyrical, almost spiritual revelation, it provokes a devastating foundering of reason. McWilliam's sculptures are intellectual statements of a most scathing anti-intellectualism: just enough reason is left to the spectator for him to sense, and feel, the splitting of his own rational faculties. As Paul Nash pointed out in the *London Bulletin*, 'human attributes are implied, rather than openly confessed', hence, 'the magic of the primitive's object is inseparable from them', the magic which comes from the 'evidence of growth'.[29] When asked about his work on one occasion by Merlyn Evans, McWilliam quoted Lewis Carroll's *Through the Looking Glass:* 'I believe in the words of the Queen of Hearts; she said it takes all the running you can do to keep in the same place.'[30] As such, McWilliam is the sculptor of the complete fragment.

Conroy Maddox and John Melville

Among the newcomers, Conroy Maddox and John Melville probably did most to develop the surrealist proposition, by introducing visual distortion as a basic principle. Both had brought themselves to the notice of the art world on the occasion of the 1936 exhibition when they refused to participate because too many artists had been included who had no claim to be called surrealists. Shunning the London art scene, they joined the group only when it took a new turn under Mesens's direction.

From the summer of 1937, Conroy Maddox, who was working as a designer for a Birmingham firm specializing in exhibition stands, spent time intermittently in Paris. Through the French poet and erotic collagist Georges Hugnet, he was introduced to the other French surrealists. He also attended

a few classes at the Académie Grande Chaumière and visited Man Ray and Marcel Duchamp. Having joined the surrealists' meetings at various cafés, particularly the Café du Dôme, Maddox found himself 'accommodated and motivated by the Parisians', while 'somewhat marginalized by his English fellow surrealists'. He renewed links with Mesens in October 1938 when he visited London to see the Guernica exhibition, joined the group a little later, and was represented as a surrealist at the exhibition Living Art in England, in January 1939. It was a new start in a life that was dedicated to surrealist investigation through all possible media, a life marked by unflinching purpose and acerbic humour. In late 1938, he discovered and developed a semi-automatic technique, which he called 'écrémage', 'a skimming process without any conscious control that would lend itself to interpretation either in oil or gouache'. This is how Maddox describes the idea he had one day:

In a large tray I added about one inch of water on which I dropped splashes of diluted oil colours which floated on the water's surface. By dragging across the surface a piece of stiffish paper, the oil paint adhered to the surface leaving a strange configuration that emulated a trance-like pattern that merely needed the intervention of conscious control to complete what I could interpret in the shapes confronting me.

This combination of unconscious expression and the conscious organizing faculty lay at the basis of Maddox's exploration of the world of objects, and would continually haunt it. Indeed, in his collages and paintings, man appears 'thunderstruck' by the objects whirling around him; landmarks are still noticeable, but lost in the midst of a general short-circuiting of relationships. As an example, *The Lesson* (1938) (Pl. 98), an impressive early work, is structured on the repetition of the same experience: one does not find any meaning because one does not want to see, or simply does not see. Phallic icicles threaten a woman who is leaning dangerously out of a window; a naked phantasmatic eyeball presses at her back; as an erotic prelude to love-making, a couple dance and hold an immaculate white sheet in the bottom left window; a table waits to be laid. These scenes are intriguing invitations to visual and verbal punning, confronting us with impulses of fear and desire. They are the visual expression of something unnameable, symbolized by the missing word on a blackboard in the last window. The schoolmistress is only prepared to inscribe the key-word when a young man lifts his arm, opens his eyes and is ready to learn how to spin a thread from one window to the next, filling the gaps between them with his own unacknowledged desire. Our gaze is drawn to the son's refusal to cross the solid bar on the ground and contemplate the secret stories in the house of the mind, between the pressure of the law and the fluidity of desire.

A friend of Conroy Maddox's since the early thirties – they lived for a time in the same Birmingham neighbourhood – John Melville kept away from the London art scene throughout his life after that initial refusal to participate in

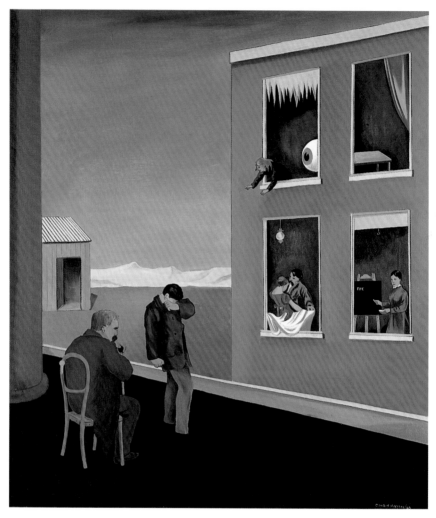

98 Conroy Maddox, *The Lesson*, 1938, 81 × 71 cm (31.8 × 28 in.)

the 1936 London exhibition. He was to help form the Birmingham group, which included painters such as Maddox, and writers including Walter Allen and the poet Henry Reed, and the sculptor Gordon Herrickx. From 1934 onwards, he was supported by the art collector Enoch Lockett, a customs and excise official who paid him a monthly salary for the right to choose every so often from his works.[31] One great influence was Max Ernst's *Semaine de Bonté*, not because of its technique as collage, so much as the oneiric, if not nightmarish, fascination it created. Another was Picasso and

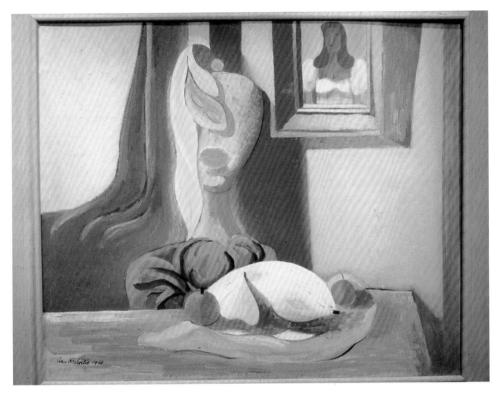

99 John Melville, *Seated Woman with Fruit* or *Surrealist Portrait*, 1938, 59.6 × 73 cm
(23.5 × 28.7 in.)

his current form of cubism. In May 1938, Melville joined the surrealist group
on the occasion of the Realism and Surrealism exhibition in Gloucester and
took part in Living Art in England at the London Gallery six months later.
Shortly before this six of his paintings had been excluded from an exhibition
organized by the Birmingham group at Birmingham Art Gallery in March
1938, on the grounds that they risked being 'detrimental to public sensibili-
ty', especially that of Sunday afternoon visitors.[32] Melville defended his case
in the *Birmingham Post*, saying that his nudes, largely Picasso-like in the
deformation of their contours, could not be seen as nudes in the commonly
accepted sense, since 'they are formalized to serve a decorative purpose, and
in many instances, are not easily to be seen'.

Seated Woman with Fruit (1938) (Pl. 99), painted a year later, also plunges
the viewer into a process of deformation. Not only is the woman's face frag-
menting as she even loses parts of herself – not unlike what is suggested in
F.E. McWilliam's sculptures – but she is losing her human substance and

turning into a vegetable. The greenness of some curtains in the painting – whose hanging folds could well be the woman's falling hair – has pervaded the woman's face. Level with her full rounded breasts in a scarlet dress are their equivalents in the forms of halved fruits on the dish. A mask falls from her eyes, as at the revelation of a new reality. On the wall, the frame of a painting within the painting ironically emphasizes the discrepancy between the stereotyped attitude of 'classical' academic portraits and the painting of an actual process, of the drama of forms actuated by a vegetative sexuality.

In 1937, Melville, the only British surrealist to have made a drawing of Lewis Carroll's Alice (Pl. 103), produced one of the key paintings of British surrealism *The Museum of Natural History of the Child* (Pl. 102). A spiralling movement structures the painting and gives it two visual sources, confronting the spectator with a whirling indeterminate space. From the genitals of a woman, open-legged in a Balthus-like position, covered in proliferating leaves and vegetal glands, rises a semi-circular movement of insects, flower seeds, leaves, sepals, petals, stamens and half-open pistils. Another spiral starts from a child's bent head, moving around his back and that of a chair. This joins a line issuing from the woman at the level of an apple out of which an obviously phallic worm is wriggling. A link is thus established between the boy's head and the woman's open sex, which both externalizes and materializes the fantasy world of the child, the museum of his subconscious.

This is further exploited in *Concavity of Afternoons* (Pl. 100) and *Mushroom-headed Child* (Pl. 101). Painted in what was for Melville the very active year of 1939, both paintings are based on what might be called a desubstantiation ritual (in contrast to a transubstantiation ritual). The former tentatively constructs a narrative from a woman's head shrieking at having been cut from a body that has been replaced by an upturned waste-paper basket, and two pigeons which seem to have escaped from a cage-like basket. Drops of blood, the traces of a loss, are central to the drama in the painting and also in the viewer's perception. *Mushroom-headed Child*, painted in the tradition of the most realistic of family portraits, is a site of divisions, graftings and hybridization. The child's head, a mushroom, and its mother's head, a snail's shell, both derive from water and thus participate in the liquifaction of the body. This itself originates in a centrally placed pond in the mother's lap, teeming with seashells. These natural references indicate an ambiguous origination – the mushroom has no root, the snail is hermaphrodite. The scene is one of pure transformation, and the painting's other title, *The Font*, signals the ritual at work: instead of sanctifying a human identity, a normality, the water has given blessing to monstrosity in imaginary bodies.

Melville identifies the genesis of malformation, an indefinite metamorphosis, through bodies which assert their power of growth by severance from themselves. The time in Melville's paintings is the moment of disruption.

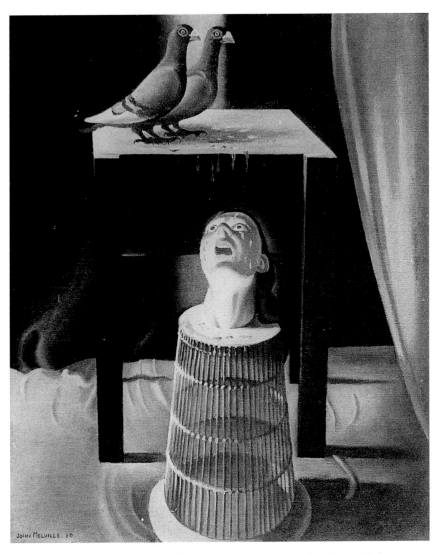

100 John Melville, *Concavity of Afternoons*, 1939, 55 × 44 cm (21.6 × 17.5 in.)

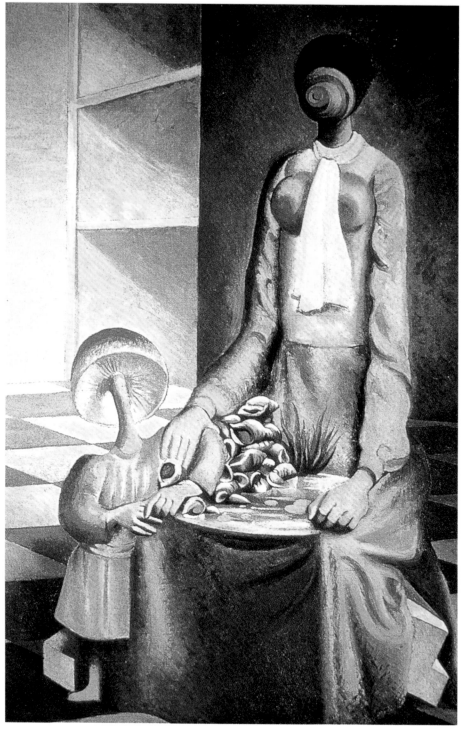

101 John Melville, *Mushroom-headed Child*, 1939, 66 × 46 cm (26 × 18.1 in.)

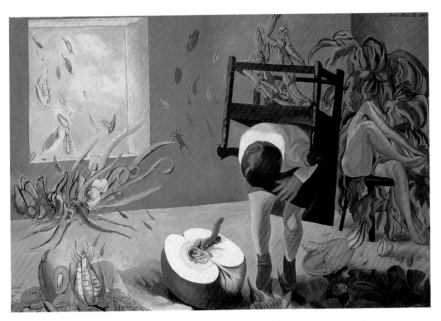

102 John Melville, *The Museum of Natural History of the Child*, 1937, 70 × 100 cm (28 × 39.4 in.)

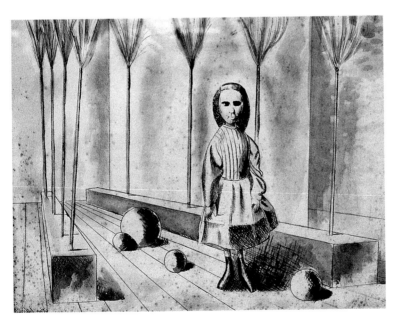

103 John Melville, *Alice*, drawing, 1938, 34 × 43 cm (13.6 × 17.2 in.)

Ithell Colquhoun

Before actually joining the surrealist group in late 1939, Ithell Colquhoun had already developed a style similar to surrealism's questioning of reality. At the Slade, she painted portraits, exotic plants and flowers in a vein of magic realism, using superimposed glazes of colour and choosing to draw hypertrophied forms, leaves, stems, corollas or plain objects such as rails or anchors. The selection of flowers is in itself revealing. Clematis, anthuriums, arums, magnolia, hibiscus and pomegranate flowers all indicate her fascination for elaborate shapes, and hint at fantastic worlds inaccessible to rational man. The subtle delicacy of the colours, a certain slickness in the design and the sharp irruptiveness of the objects which occupy the whole canvas prefigure erotic undertones that are to be prominent in her later works.

In 1931, when she was 25, Colquhoun briefly lived in Paris, where her first contact with surrealism was through Peter Neagoe's little book, *What is Surrealism?*. In frequent visits to surrealist exhibitions, she was particularly impressed by Salvador Dalí's work, which confirmed and furthered her own development away from the classical themes taught at the Slade. Back in England, she was converted to surrealism when she visited the 1936 International Surrealist exhibition and attended Dalí's lecture delivered from inside a deep-sea diving suit. Through Eileen Agar and Peter Norman Dawson, whom she met when she joined the London Group, she approached Mesens and was invited to take part under the 'Independent' label in the Living Art in England exhibition in January 1939. That summer she met André Breton and Jacqueline Lamba in their flat in rue Fontaine in Paris, who introduced her to 'psychomorphology', as developed by Matta and Gordon Onslow-Ford at the time, 'a new automatic strategy of intensification of imaginary powers through decalcomania, dripping and the use of coloured, non-geometric, organic forms'. Decalomania, a technique to be used by other surrealists, is a way of producing strange mottled effects by pressing a sheet of paper onto another one that has been covered with gouache. The results are determined by the pressure exerted and the way the sheet is lifted off.

Scylla (1939) and *Rivières Tièdes* (1939) are Ithell Colquhoun's two key works of this pre-war period. They are marked with a radical unsettling of concrete reality. *Rivières Tièdes* manifests the secret tension between the interior and the exterior of an object, between the origin and the process of origination. Four snake-like rivulets of different colours flow from under the four doors of a rectilinear Spanish-looking church. A secret is clearly lurking inside the hermetically closed church, so that we are barred from a purpose and meaning for ever contained there and lost to sight. In *Scylla* the eye is precipitated into a yawning gap. Our gaze is snagged on the sharp point of a

boat's prow, which appears through a hole dug in rocks – or is this a gap between two rocks that have subsequently been joined? Ithell Colquhoun confirmed this ambiguity: 'It was suggested by what I could see of myself in a bath – this with the change of scale due to "alienation of sensation" became rocks and seaweed.' The painting is thus a pictorial pun, the result not of a dream, but of a dream-like state. The two rocks, marked with veins and wrinkles, unmistakably become penises meeting at the top of the painting, and the gap transforms the setting into an open vulva. The boat's prow thus becomes a penis which penetrates the gaping aperture. When the painting is looked at upside down, the tuft of grass becomes pubic hair. The vulva is thus the hidden opening of the penis, one containing and implying the other, a double focus reminiscent of Dalí's paranoia-critical method. Between what is erect and what is supine, between present unfulfilment and hoped-for consummation, the fascinated eye is confronted with its own desire, deposited at the very tip of the boat, between the male and the female, perhaps as an androgynous fantasy.

Unobtrusively, Colquhoun makes us pass over to the far side of perception. In short texts such as 'The Echoing Bruise', she looks into the heart of man and things alike, where 'below the proud surf lie images of the perpetual terror of earth and sea'. In a strong, young boatsman's heart, she shows his vision of 'the twelve men he saw frozen stiff in the stranded lifeboat . . . the brothers from Lumio drowned in each other's clasp . . . and the corpses he had seen half eaten by worms at the cemetery'. In another text, 'The Volcano', she creates the symbolic confrontation of a 'pharos', whose message is not 'a message of reassurance', with the 'seething underground cauldron' of a volcano whose 'last eruption . . . flung millions of pieces of money into the air'.[33] The reality in Colquhoun's works is essentially eruptive.

Grace Pailthorpe and Reuben Mednikoff

For Grace Pailthorpe and Reuben Mednikoff, the crowning of their four years' psychoanalytical research was a display of 69 works in January 1939 at the Guggenheim Jeune Gallery. In October 1938, they had shown at the Walker Art Gallery in Liverpool with other British surrealists, and they took part in the 'Living Art' exhibition in London in January 1939. To coincide with this, the result of a protracted joint exploration of the territories of the subconscious, Pailthorpe published 'The Scientific Aspects of Surrealism' in the *London Bulletin*. According to this, 'the final goal of surrealism and psychoanalysis is the same – the liberation of man [from internal conflict]' and although 'the approach to this end is by different paths', the point was to 'create a well-organized external world' by harmonizing 'the internal mental

world'. In the accompanying discussion of five paintings and oils, Pailthorpe elaborates a form of grammar of the subconscious, based on the assumption that every mark, shape and colour is intended by the subconscious and has a specific meaning.

Such a reduction of the aims of surrealism was a misunderstanding, if not betrayal, of its basic principles, which never implied that individual freedom meant harmonious socialization and perfect integration into the outside world. Paradoxically, every painting or drawing made by Pailthorpe and Mednikoff is the site of an infinite slippage, a constantly renewed problematization of the gaze. The challenging vitality of their work, almost feeding upon itself, the striking variety and evocative power of the details, the profoundly clear and enigmatic quality of what is raised up to the light, either in the painting or in the spectator, contrast sharply with the artists' clarity of intention and scientific logic, and maintain their work in a liminal, if not subliminal region.

Mednikoff's *The King of the Castle* (1938) (Pl. 104) is a case in point. It

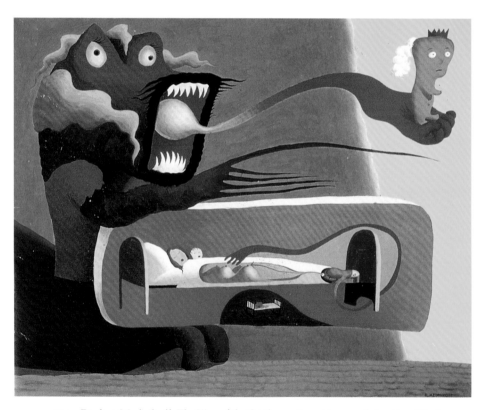

104 Reuben Mednikoff, *The King of the Castle*, 1938, 42 × 53 cm (16.5 × 20.8 in.)

represents the child's phantasmatic hesitation between leaving the mother's womb or bed, and staying inside it. The imagery is simple: a sharp-toothed mouth draws a huge tongue with the crowned child-king at its very tip – the bad mother who has released the child too early – while the belly displays a bed with a mother and child clasping each other and a little cot occupied by a baby safely hidden away under the mother's bed – the good, protective mother. The insoluble question is raised: shall I stay in or go out, and where does my real power lie? The painting's strong primitive colours – deep navy blue, bright yellow and red – and the tactile quality of the forms create a dynamism which eludes any scientific analysis.

In Pailthorpe's *Surrealist Fantasy* (1938), subconscious tension is turned into a happy relationship, that of an intimate embrace: an umbilical cord curves up towards, and encircles, a breast, stroked and firmly held by the five fingers of a hand, a metaphor for a greedy baby. The cord and the fingers are the strong, assertive links with the happy memories of the pregnant mother's womb, top left, and indicate the baby's possession of the mother. A pattern of recurrent circles, echoing the 8-shape of the design, together with a background of organic, cell- and egg-like forms, and the subtle balance achieved by the colours, lend to the composition an Eden-like harmony and a quality that is almost hieratic.

Horror and pleasure are the key to these works. For Pailthorpe and Mednikoff, man's fantasies have to be freed from sterile repetition and be allowed to become creative. In a violent attack on Pailthorpe's article in the *London Bulletin*, Werner von Alvensleben, a psychoanalyst who also went in for painting, doubted the liberating power of these works and stressed the absence of any external object which might induce phantasmatic associations in the spectator, which, according to him, happens in all truly surrealist works. However, Alvensleben did not realize that the 'literal representation' with which he charged Pailthorpe itself constitutes an opening for the spectator's phantasmatic processes. In the obfuscation of Pailthorpe's pedagogical rationalizing, he did not fully see that, deep down, these images come *before* meaning. It is not incidental that most works by Pailthorpe and Mednikoff were given no title. For all the positive message they wanted their works to impart, we are kept hovering on the brink between nameability and namelessness, for the problem of naming – i.e. naming the father? naming one's desire? – is the central point of their visual enigmas. However literal and legible they meant their works to appear, in the violence of the colours, the grave, almost sick humour and the overall unarrestable fluidity, there remains nonetheless an irreducible element of illegibility, an incandescent residue, which eventually short-circuits whatever authority they were aiming at.

*

The anticipation of war in the late thirties, and then the declaration of war on 3 September 1939 inspired the surrealists to stay utterly committed to the emancipation of the imaginative powers and to their own political beliefs. After the war began most of them joined civil defence work or paramilitary activities, and the group as such remained only loosely constituted. However, developments of the previous two full, fertile years undoubtedly shaped the future of surrealism in Britain and gave it a singular resilience throughout the war.

The eye of the hurricane:
the war years 1940–45

On Thursday, 11 April 1940, E.L.T. Mesens called a meeting at the Barcelona restaurant in Soho's Beak Street of all surrealists currently living in London. The idea was that, in the ideological and material confusion prevailing in these first months of war, surrealists should define their stance both as individuals and as a group. With the advantage of being an outsider, Mesens lay down a number of guidelines for surrealist action, which, he believed, was in especial need of reaffirmation, in response to the difficulty of several artists, sometimes critical, with simply surviving. The date is a landmark in the history of surrealism in Britain, signifying as it does the only public attempt to define surrealism *in situ*.

Earlier in the month, Mednikoff, at almost no notice, had convened the same group of surrealists to discuss their position in, and towards, the art world. The conclusion, which was strongly supported by Ithell Colquhoun and Eileen Agar and seems to have rallied most of those present, was that the artist should be left free in his choice of venues where to show his work, the British Art Centre being certainly one of them. Mesens had not been invited and the gathering at the Barcelona restaurant can undoubtedly be seen as a countermeeting.[1]

In the text that he drafted for his speech at the meeting, Mesens stressed his intention to 'see as many people as possible ... participating in a strong surrealist activity in this country', yet 'participating not as phantoms but as men supremely conscious of the weapons that they wield'. At the start of the meeting he acknowledged that 'one cannot reproach anyone for covering himself materially, that is to say for undertaking certain work without special significance but satisfying his immediate necessities'. Yet, he implies, there are limits which 'some [of us] have gone beyond'.[2]

The main issue apparently concerned the British Art Centre. This project had been launched the year before by Peggy Guggenheim and Herbert Read,

who were trying to talk certain surrealist artists into joining (see p.164). 'Why certain persons among us . . . rather than others' was a key question for Mesens who saw any link with 'artists of different false academic, bourgeois or independent traditions' as betrayal:

I assert that all flirting with the art world is the most crucial outrage against all the perspectives the surrealist movement has had in view since its advent . . . I accord a very precise value to the cultural patrimony of humanity but I think it is your duty to consider history (and particularly the history of art and thought) only in its dialectic movement where you yourselves can be inscribed . . . From history we have kept only the fire and not the frothy irruptions of parasites of all times.

Rather than see Mesens as a dictator, it is important to understand the premisses behind such declarations, based as they were on the role of surrealism in the development of art. It is in this way that the questions he addressed can be justified:

In order to give all the force necessary to a surrealist activity, are you prepared to renounce all participation in group exhibitions springing from an artistic bourgeois spirit? Are you prepared to withdraw your name from the membership list of organisations of the kind of the AIA, the London Group, the British Art Centre . . . etc . . . ?

Furthermore, he declared it incompatible with the spirit of surrealism for a surrealist writer or a poet to be associated with such professional activities as being on the editorial board of a non-surrealist publication or publishing firm. Nor should a surrealist write anything which is not written in a surrealist light; or contribute to non-surrealist or anti-surrealist reviews. What Mesens stigmatizes is 'to defend surrealism in surrealist organs, and at the same time constructivism in its organs . . . to consider educational problems touching on the arts according to views of conventional educationalists and to apply non-surrealist critical methods'. The third question he puts to the meeting is this:

Are you determined that all the articles and criticisms that you write in the future shall be in agreement with the views of the surrealist movement? Are you determined to refuse all collaboration – with the exception of texts defending points of view strictly surrealist – with literary or artistic non-surrealist magazines?

Other issues were raised, such as the adherence to the proletarian revolution and the association with secret societies, but the main issue was the intransigent quality of the surrealist spirit.

Apparently the meeting was well attended; those present included Buckland-Wright, who was in the chair, Herbert Read, who must have felt he was being attacked when the British Art Centre was mentioned, Roland Penrose, Humphrey Jennings, J.B. Brunius, Ithell Colquhoun, Eileen Agar, Edith Rimmington, S.W. Hayter, A.C. Sewter, Reuben Mednikoff and Grace

Pailthorpe, John Banting, Gordon Onslow-Ford and Charles Howard. Ithell Colquhoun, who had been with the group for a little more than a year and had only just started investigating the occult, could not agree with all these points, nor could Eileen Agar and Henry Moore, who regularly exhibited with the London group. Mednikoff and Pailthorpe refused to agree to the clause which asked them not to exhibit or publish except under surrealist auspices, and they were never again to be associated with the group. Eileen Agar and Herbert Read were accepted back later, the former being allowed to exhibit with the London group, the latter 'in friendly association with the group', probably on account of his sympathies with anarchism.[3]

The issue raised by Mesens was that of what purpose one should assign to any form of surrealist activity. A surrealist work of art should in no way submit to, or compromise with, the belief that it is an end in itself. The surrealist spirit, Mesens implied, rested in the refusal to align oneself, or comply, with closed systems of thought.

The revitalization of the group quickly produced an exhibition at the Zwemmer Gallery, which opened on 13 June for three weeks. The exhibition included works by S.W. Hayter, who had left Paris at the outbreak of the war and stayed in London for a short while before leaving for the United States in 1940, and works by Gordon Onslow-Ford, who had returned to London before also going to the States the same year. Paul Nash, Lee Miller, John Tunnard, Matta, Esteban Frances, Rita Kerrn-Larsen, Tanguy, Elisabeth Onslow-Ford, Briery Russell and Werner von Alvensleben were guests of the group. The window display in the gallery, which had been designed by Eileen Agar and Roland Penrose, featured a miniature bed with rumpled sheets transfixed by a dagger (Pl. 105). Next to it there was an armchair – an antique found in Chelsea by Eileen Agar – turned into a fat Negro woman, with her wide lap forming the seat, her white-cuffed hands the arms, and her grinning head surmounting the back. Most of the press agreed to the 'premonitory' value of all the works on show, especially *The Studio*:

Clearly the movement must, from the beginning, have been something more than an outbreak of Parisian futility . . . one cannot help wondering whether the surrealists did not instinctively sense whither the European society in which they lived was tending and whether their movement was not, in fact, a criticism of that society.[4]

Although the article reduces the works on display to being mere mirrors of 'our frightening . . . terrible world of today', it still acknowledges the vitality and the uncanny, mind-provoking quality of the movement. This view was not shared by Jan Gordon of the *Observer* ('[Surrealism] gives no hint of the great human response to horror, ignores the heroism and nobility of the human soul'), nor by Eric Newton in the *Sunday Times* ('Shocking bad taste . . . I itch to deliver a hearty physical kick in the parts to the artist who has

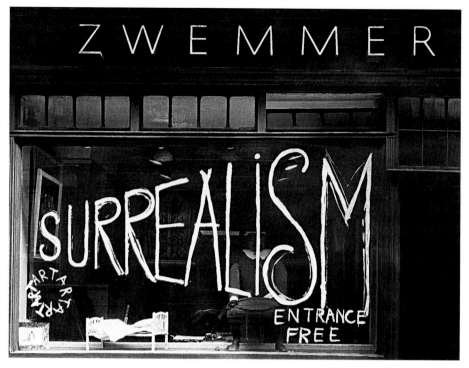

105 Window of the Zwemmer Gallery surrealist exhibition, 1940

nothing better to do than trip up my tattered emotions'), nor the *Manchester Guardian* ('At a moment like this surrealism seems unnecessary ... surrealism can be a good psychological cocktail, but cocktail time is over').[5]

The month in which the exhibition opened saw the one uncompromisingly surrealist issue – actually a triple issue – of the *London Bulletin*, no doubt the result of Mesens's ultimatum at the Barcelona restaurant meeting. Onslow-Ford had financed most of it, together with Roland Penrose, and both are presented as co-editors with E.L.T. Mesens. There were 28 contributors, sixteen of whom were British. De Chirico's *The War* was reproduced on the cover; the first page bore a declaration that 'the enemies of desire and hope have risen in violence' and that Hitler's ideology had to be fought 'wherever it appears'.

Poems by Breton, Mesens, Eluard, Len Lye, Benjamin Péret, articles by John Banting, Robert Melville, Conroy Maddox, Onslow-Ford, photographs by Lee Miller and reproduction of works by Eileen Agar, Conroy Maddox, McWilliam, Moore, John Melville, Esteban Frances, Brauner, Edith Rimmington, Penrose, Banting, Lye, Tunnard, Hayter, Tanguy, Onslow-

Ford, de Chirico, Delvaux and Buckland-Wright made this a landmark issue and an operational platform for further surrealist activity. The articles practically declare a full programme of future work: Banting's social protest, Melville's extensive use of psychoanalysis to assess de Chirico's paintings, and Onslow-Ford's claim that, to destroy the rational world as it is, one should probe scientifically into the morphology of the mind, together with an announcement that a bureau of analytical research will be founded to coordinate all branches of science.[6] But the most perceptive and circumstantial article is Conroy Maddox's 'The Object in Surrealism'. Here, Maddox sees the object as completely discrediting the world of immediate reality, and as a source of demoralization and, as a consequence, of extension of the concrete traces of the marvellous. When read today, this article has lost nothing of its edge.[7]

Simultaneously with the exhibition and the publication of the *London Bulletin*, the London Gallery Editions published twenty surrealist postcards, by Eileen Agar, J. Buckland-Wright, de Chirico, Matta, Esteban Frances, Len Lye, Mesens, Moore, Onslow-Ford, Penrose, Man Ray and Tanguy – an idea that was to be taken up again after the war.

In spite of the war – the first Blitz struck London in September 1940 – the activities of the group continued. In September, Mesens organized a surrealist exhibition at the Oxford University Art Society. Pursuing his project of an arts centre in Dartington, South Devon, he had talks on future collaboration with the college, including publishing the *London Bulletin* from there with the help of Hein Heckroth and the financial support of Mr and Mrs Elmhirst. Eventually only a series of shows was held and some lectures given in December 1940 by Mesens, who traced the development of fauvism, cubism, dadaism and surrealism. Mesens had also organized a lecture tour with Penrose in Birmingham and Hereford in the last week of July.

However, this burst of activity was short-lived, and soon everyone was caught up by the war. While in late 1940 Breton, Ernst, Masson and Péret were inventing the 'Jeu de Marseille', a new game with cards bearing the figures of great poets, visionaries and explorers of the mind, and preparing for emigration to the States, the British surrealists, busy with adjusting to their new war occupations, went through a period of silence that lasted almost a year.

Mesens was given a job at the BBC on the Belgian radio in exile – he is said to be the inventor of the French slogan against the German-occupied radio station of Paris, 'Radio Paris ment, Radio Paris ment, Radio Paris est allemand', still remembered all over France. Among other things, he used his talent for music – which he had abandoned in the twenties – to devise tunes for BBC programmes, including a collage of the 'Marseillaise' and the 'Internationale', which became a call to arms! He was soon joined by J.B.

Brunius, working for the BBC Free French radio; both of them could not only offer their knowledge of surrealism and French culture, but also felt uninvolved enough to steer the surrealist boat, in its ramshackle form, through the tempestuous spate of nationalistic feelings.

Penrose stayed in London throughout the war; his home in Downshire Hill became a 'centre' frequented not only by surrealist friends from France and elsewhere, but also by a host of journalists, politicians, poets and scientists. Penrose was first appointed a warden on night duty, then was employed as War Office instructor in camouflage to the Home Guard. In 1941, he wrote the *Home Guard Manual of Camouflage*. As he recalls, he was simply 'applying the principles of cubism to the optical disruption of forms obtained by covering a surface with patterns'. One of the main themes was 'how to disappear into a landscape', from which he went into problems arising from shadows, movement, the shine of certain surfaces and the layout of defences. He went on lecture tours in England and Wales, and was eventually given the command of the Eastern Command Camouflage School. In the spring of 1944, he was sent to Italy to study the use of camouflage in modern warfare.

Indeed, several artists were entrusted with devising camouflage. S.W. Hayter had arrived from Paris in September 1939 with Helen Phillips, whom he had just married, and at his instigation, and Penrose's, the Industrial Camouflage Research Unit was created. As well as these two, it employed Julian Trevelyan and John Buckland-Wright. They found premises for their office in the house of the architect Ernö Goldfinger, who had participated as a surrealist in the 1937 and 1938 AIA exhibitions. After the fall of France and the reorganization of war activities they met again in a six-week training course at Farnham Castle. To the teaching of camouflage techniques, such as counter-shadowing and animal protective coloration, the Unit added the invention of fake objects, including plaster trees, dummies, pillboxes camouflaged as houses-on-wheels, houses in ruins, Gothic lodges, thatched cottages, haystacks, and wayside cafés.[8] Subsequently posted in Devon, Trevelyan visited John Tunnard, who was an auxiliary coastguard at Cadgwith, Adrian Stokes in St Ives and Cecil Collins at Dartington Hall. Trevelyan went on making crazier and crazier camouflage, such as garages complete with petrol pumps or Cornish cottages with lace curtains; he also lectured on the use of paint in relation to the environment. In February 1942 he was sent to the Middle East for two years. In the meantime, S.W. Hayter left England in 1940 for the USA where he set up Atelier 17 at the New School for Social Research in New York.

Like Penrose, Trevelyan and Tunnard, F.E. McWilliam was called up. He joined the Royal Air Force, and was especially engaged in aerial reconnaissance photography; he then was sent to India, where he stayed from 1944 to

1946, serving as a soldier and a teacher of life drawing.

In the USA Samuel Haile was eventually offered a teaching post at Alfred University, then went on to teach in Ann Arbor. He joined the US Army as a non-combatant, and was assigned to the Dental Corps. Transferred to the British Army, he got into the Education Corps and stayed through to 1946 at Bulmer, in Suffolk, making slipware in a brick kiln he had built in a pottery attached to a nearby brickyard. His inventiveness as an artist and his exploratory spirit never flagged.

Similarly, John Banting's fierce social comments did not abate. Staying in London – he had failed his army medical – he worked as an air raid warden as well as making documentaries and official films for the Ministry of Information. In 1941, he became a member of the People's Convention, a Marxist, semi-communist organization, and editor as well as art director of *Our Time*, a leftist monthly magazine, which published many of his violently satiric drawings as well as articles.[9] One of the films he made was *Balloon Site 586*, which he co-directed with Banting and Dylan Thomas.

The comments passed by John Banting on the condition of man – social as well as psychological – in wartime Britain, are sharply and metaphorically illustrated in two works, *Janus* (1942) (Pl. 106) and *The Funeral* (1944) (Pl. 107). Janus, the two-faced divinity of war and peace, is a monument to indifference. War and peace form a double bind, an inextricably entangled skeleton, in which the world is trapped by the forces of destruction. The bony structure glaringly shows a lack of flesh and spirit, which separates the world from itself and reduces it to a lifeless eye. In *The Funeral*, the attending figures, convened for the ceremony, are all dead themselves; an unsteady column of charcoal, hollow tree-trunks, shoulder blades and jaws are the tottering debris of life, its fossilization. On the left, a tiny human figure drags an empty coffin, his own; on the pavement, a glove on its stand was supposed to bar the street, but has been put to the side, just like a notice reading 'closed'. The way to the void is wide open. On the wall is an obscene graffito, the paltry, final trace of life: man's world is haunted by devitalized, disembodied dry forms, man has betrayed himself, and the perspective of his streets end on the blank buildings of death. The impressiveness of *The Funeral* lies in the desperate solemnity of its warning, screaming silently.

Several places in London served as meeting places or headquarters for painters and poets. In Soho a number of pubs acted as a focus for young intellectuals, whether or not on leave from the army: the York Minster, the Helvetia, the Fitzroy, and the Horseshoe, together with the Barcelona restaurant, these latter two the haunts of the surrealists. The International Arts Centre, at 22 St Petersburgh Place in Bayswater, whose patrons included Stephen Spender, John Lehmann and John Piper, was also frequented by left-wing and anarchist artists, who organized poetry readings and exhibitions.

In February 1942, its annual exhibition broke with tradition by inviting art students to exhibit; it was also suggested that the works on show should be judged, and that artists should be asked whether they preferred to be judged by 'a composite jury or a jury only consisting in Abstracts and Surrealists'. Zwemmer's Bookshop in Charing Cross Road, where the poet and historian Ruthven Todd was Randolph Friedmann's assistant, continued to welcome artists. Another place for the exchange of new ideas was Toni del Renzio and Ithell Colquhoun's flat at 45a Fairfax Road. The Modern Art Gallery opened in Baker Street in October 1941, founded and run by Jack Bilbo and his wife. Of German origin, Bilbo had fled Germany in 1933 for France, then Spain, and settled in London in 1936, where he painted and sculpted – his second one-man exhibition in 1940 was at the Zwemmer Gallery. After being released from internment on the Isle of Man in 1940 and taking various jobs, he decided to open a place 'to give the modern artist a free and unbiased platform' and create 'for the people an oasis of sanity and construction in a world of false values, believing in the necessity for an intellectual fight against Hitlerism and all it stands for'. This, the Modern Art Gallery, occupied part of a very small house, whose first floor was the bedroom, and in whose basement, the 'Cave', he would entertain friends, among whom were Schwitters. Hein Heckroth, Jankel Adler, and other refugees; it was the setting for talks, poetry readings and exhibitions. The World of Imagination, devoted to objects made only out of rubbish, and Emmy Bridgwater's first one-woman exhibition,[10] were among these. Bilbo also published books concerned with art, and collections of his own stories. However, due to the precarious and insecure conditions in which Londoners lived, there was no focus, no one centre of British surrealism in wartime.

Bearing this in mind, for all that Mesens might have said, it was of paramount importance for everyone to secure their 'means of existence' at a time when the whole nation's efforts were geared towards survival. It is therefore unfair that Humphrey Jennings should have been blamed by some people for agreeing to make propaganda films for the government. In contrast with Banting and others, Jennings rarely introduced obviously surrealist elements into his professional work. From 1939 onwards, his reputation in the cinema and his considerable film output took him away from involvement with surrealism – unsurprisingly in light of the lack of surrealist activity in Blitz-hit London. However, tribute should be paid to the way he raised the most ordinary-looking images of his films, however overtly or subtly propagandist they may have been, to a poetical, almost mythopoeic level. It is undeniable that his wartime films contributed to a strongly patriotic consciousness, but it was a consciousness vividly aware of its roots and foundations, and one promoted in his films by a search for its community basis. Jennings's preoccupation with showing how Britain could survive made him investigate,

in the wake of both surrealism and Mass Observation, the deep reflexes and subconscious preoccupations of his fellow countrymen. *London Can Take It* (1940), describing life in the capital, and its complement *Heart of Britain* (1940), based on life in the countryside, present us with such scenes as 'WVS girls serving hot drinks to firemen and people, all secretly delighted with the privilege of holding up Hitler'. Lessons in courage, fortitude and unselfishness, they also try to grasp the contrasting forces of humour and tragedy at work: *Fires Were Started* (1943) goes a step further into 'understanding people and not just looking at them and lecturing or portraying them'. The strong social feelings Jennings had shown throughout the thirties grew in his war films through his contact with the people. It is in this that one may detect the enduring spirit of surrealism: in the use of images not for themselves but for the combinations they enter into with other images.

Jennings's *Pandemonium* book project – a collection of pieces from across the centuries centred on the making and function of machines – reveals his surrealist fascination for the passage of being from one object to another, the violent transformation of matter into machines and the slow transformation of machines into other machines through history. Like his films, his poems from this time attempt to grasp this transformation, the dark concentrated nucleus from which creation emerges:

> I see London
> I see the dome of Saint Paul's like the forehead of Darwin
> [...]
> I see London at night
> I look up in the moon and see the visible moving vapour trails
> of invisible night fliers
>
> I see a luminous glow beyond Covent Garden
> I see in the mind's eye the statue of Charles the First riding in double
> darkness of night and corrugated iron
>
> ... And at last at the end of Gerrard Street, I see the white helmeted day,
> like a rescue man, searching out of the bottomless dust the secrets of
> another life.[11]

Jennings was a re-inventor of history, at the meeting point of chance and deliberation, surrendering himself both to the concept of the *objet trouvé* and a conscious, scientific assessment of historical progress. He celebrated the detection of productive forces through an intertextual web, enabling him to make his way towards the transcendental in the object. This growing idealism may have been what estranged him from surrealism. So too may the displacement at work in his objects, which resulted in poetic populism and near-communist propaganda:

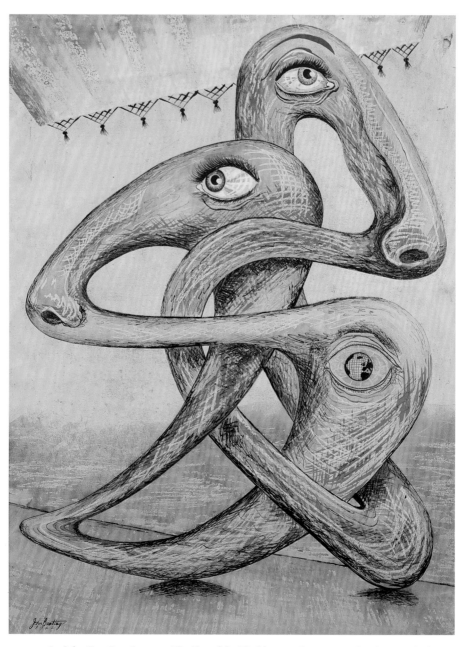

106 John Banting, *Janus* or *The Eye of the World*, 1942, 61 × 45 cm (23.6 × 17.7 in.)

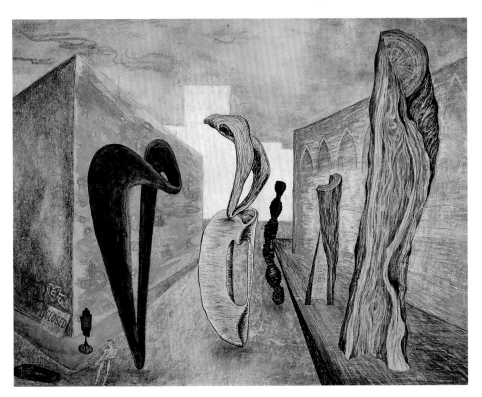

107 John Banting, *The Funeral*, 1944, 51 × 65 cm (20 × 25.5 in.)

I saw Harlequin peeping in the foxholes in Kharkov
[...]
I saw Harlequin marching to the Curzon line
Raise your head high in the light love
And his name was the Red Army
Open your eyes and cry[12]

In 1943, when he accompanied British commandos on the first attack on Sicily, he saw them as 'artist warriors', agents of the recovery of the nation's wholeness. Correspondingly, the pictures he started to paint were reaching towards plenitude and away from tension. Any latent violence was cancelled in his post-cubist, pastel-coloured landscapes that seemed to float in space. As a result of this reorientation in 1947 Mesens confirmed that he was officially excluded from the group.

It was outside London that surrealist activity developed most during the war, as if in response to the practical difficulties met by London artists in finding the materials for expressing themselves. In Birmingham, an informal group of Robert Melville, Conroy Maddox, John Melville and a few non-surrealist friends came together, and in 1941 started organizing lectures and debates. In early 1940, they had been joined by Emmy Bridgwater. Born in Edgbaston, Emmy Bridgwater had studied art under Fleetwood Walker at Birmingham Art School between 1922 and 1925, then continued part-time studies in Oxford. Following her visit to the 1936 Surrealist Exhibition in London, she attended Ian McNab's classes at the Grosvenor School of Modern Art, returning regularly to Birmingham. In the late thirties she responded to an advertisement placed by the Birmingham Group of Artists and started attending their meetings. Through them, she joined the surrealist group in London and became a close friend of Edith Rimmington's, strengthening the links between the London and Birmingham groups.

The formation of the Birmingham group was partly a form of reaction to what it saw as the city's parochial nature and the conservatism of its official art organization. Although it was 'an amorphous body that ebbed and flowed with members', the group maintained a spirit of artistic rebellion.[13] Meetings were usually at Conroy Maddox's home in Edgbaston; as well as lecturing, Maddox was employed by the Ministry of Defence to study and design parts for film projectors to be used for the soldiers' entertainment. John Melville, who was working as a civil servant for the Ministry of Food, lived close to him, as did Emmy Bridgwater; Robert Melville had settled in London. The group also included Philip Toynbee and Henry Reed. They wrote jokey poems about each other and several 'cadavres exquis' (Pl. 108) testify to their working together fairly regularly. Although no text, declaration or manifesto was published, the existence of the Birmingham a group ensured a good level of debate and interrogation.

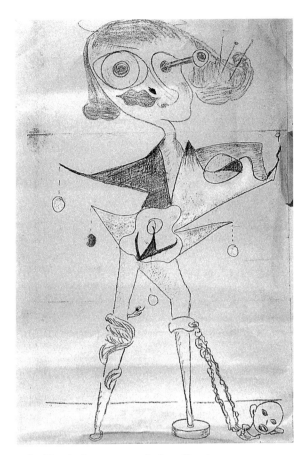

108 Birmingham group, *Cadavre Exquis, c.* 1944,
32 × 23 cm (12 × 9 in.)

Nonetheless the large-scale dispersion of the surrealists prevented, or at least, rendered terribly difficult, any attempt at regrouping or at hitting upon some common undertaking. Nor could the previous alliance with the AIA be re-established. Certainly Mesens would have opposed it strongly on political and moral grounds.

Indeed, politically speaking, any alternative political alliances for the group were negligible. On the one hand, the pacifists had lost all credibility. The launching and campaigning of the Peace Pledge Union under the highly respected George Lansbury in 1937 had gathered considerable popular support. But its peace-at-all-costs demands were brutally made redundant once war was declared, especially as their only demand had been the constitution of a government ready to sign an armistice with Hitler and demand a world

conference on economy. This, they insisted, along with acceptance of most of Hitler's demands, would save the peace. Despite the hopelessness of their cause the Peace Pledge Union went so far as to publish brochures eulogizing Hitler, and in January 1941, the *Peace News* leader's column declared that 'National Socialism compared to any other form of society, is a good thing'.

Political disarray on the Left was total. After the Nazi-Soviet Pact of 23 August 1940, in which Germany and the Soviet Union pledged neutrality towards each other, the British communists twice had to change policies and slogans, steering as best they could under varying instructions coming from Moscow. At first they held the belief that the governments of Germany and of the USSR had made enormous efforts to return to peace against the greedy, bellicose instincts of France and England. Thereafter they moved to the proposition that 'German fascism had been compelled by the strength of the Soviet Union to retreat from its anti-Soviet world' and that 'the conflict [is now] between British imperialism and world socialism'. The Communist Party then asked for the 'immediate ending of the war and the calling of a peace conference' – which, they said, had been rejected by the British and French ruling classes in order to 'establish their reactionary domination and prepare for the final assault on the Soviet Union'. In January 1941, the People's Convention – a sort of united left-wing front, created in August 1940, held its first meeting. Its object was to broaden the base of the anti-war appeal and create a movement in support of Soviet policy in the interests of a 'defence of democratic rights'.

On 21 January 1941, the government banned the publication of the *Daily Worker* – evidence, for the communists, of the British authorities' siding with the fascists. Six months later the ban was withdrawn when Hitler invaded the Soviet Union and the Communist Party dropped its pacifist policy. The United Front now stood for freedom from Nazi occupation. After two years of heavy anti-war campaigning, the new line somewhat bewildered Communist Party members. General secretary Harry Pollitt made fervent exhortations to the party admitting a mistake in the understanding of the situation and calling for their total support for the war and the government – an extraordinary ideological right-about-turn. In a by-election in Cardiff in 1942, the CP supported the Tory candidate against the Independent Labour Party candidate – Fenner Brockway of all men, its leader!

AIA policy followed suit – at a distance. Indeed, the AIA had long opposed the National Government; neither had it allied with, nor supported, the Labour Party, charging it with the failure to create a popular front in Britain. With the outbreak of war, such an intransigently independent position became impossible, and the AIA joined the war effort despite the many dissenting voices in its midst. Its aim rapidly evolved towards maintaining the independence of culture and art, 'both as a creative activity and as a cultural

amenity', as well as providing artists with the chance to exhibit, and to go on working, and selling their works. An important programme of exhibitions and lectures was developed and maintained throughout the war, showing particular inventiveness in its choice of sites and themes. In February 1941, an exhibition of 71 paintings visited no less than nine cities, in canteens, schools and RAF stations; in October it used the booking hall of Charing Cross Underground station. After Hitler's troops swept into Russia, in June 1941, an Artists Aid to Russia exhibition was held at Hertford House, in which artists donated half the selling price of their works to Mrs Churchill's Aid to Russia Fund. The AIA developed regional groups, to compensate for the dominance of London, and to support the work of artists sent around the provinces to carry out commissions such as murals in canteens and drill halls. Julian Trevelyan and John Tunnard were regular contributors.

The left-wing magazine *Our Time* also continued to hold a place on the margins of surrealism, maintaining its role as a sounding board for the people's preoccupations in wartime Britain, and have people writing about the jobs they did. Among contributors, leading representatives of the theatre, graphic arts, music, architecture and literature dominated. The object was that 'the essentials to human living' could be 'restored', as the announcement of the first issue declared. Banting was one of the editors, together with Beatrix Lehmann, Ben Frankel and Randall Swingler, all from the defunct *Left Review* circle. In one article on 'War Posters', Banting demanded a revival of poster art, along the lines of those produced during the Civil War in Spain; he contended that those being produced in England were too similar to 'reproductions of bad Royal Academy paintings' and did not link with ordinary people. Writing elsewhere on Picasso, he quoted André Breton and explained that 'surrealism may be defined as caricatures when in its more direct and popular form'.[14] Banting's artistic presence was forcefully asserted by his regular drawings in the first eleven issues, up to June 1942. These were all scathingly satiric of the upper classes, depicting society women drinking champagne in the ruins of London's working-class districts. His bony, skeletal figures, almost completely devoid of humanity, wear evening dress and hold cocktail glasses, or even demonstrate with banners reading 'Blue Bloods of the World, Unite!', 'Unfair to Debutantes!' or 'Polo Players' Union'. The caricatures challenge nationalistic slogans and the silence of the opposition parties, self-imposed in the name of national unity. Mary Wykeham, a brief member of the surrealist group at the end of the war and after, F.J. Brown, a contributor to *Free Unions Libres* in 1946 (see p.272), Julian Trevelyan who wrote on Picasso, and Hugh Sykes Davies, who reviewed books by Huxley, Auden and Orwell, not forgetting Jennings on 'Cleaned Pictures' at the National Gallery, all contributed to *Our Time* during and after the war, thus tacitly placing the magazine in the left margin, but

only the margin, of surrealism – certainly more than the doctrinaire *Daily Worker*, which Penrose tried to renew links with when it resumed publication in 1942.

The only instance of actual collaboration between surrealists and Marxists during these two years is a little volume of drawings and poems entitled *Salvo for Russia*. It was published in support of the Comforts Fund for Women and Children in Soviet Russia, created just after Hitler's surprise invasion of the Soviet Union in June 1941. It consisted of four poems by Cecily Mackworth, James Law Forsyth, J.F. Hendry and Nancy Cunard, and nine engravings by John Banting, Ithell Colquhoun, Roland Penrose, Wolf Rieser, C. Salisbury, Mary Wykeham, John Piper, John Buckland-Wright and Julian Trevelyan.

Division in the ranks

A central part in maintaining British surrealism throughout the war was played by Toni del Renzio who arrived in London from France early in 1940. Born in Russia, del Renzio spent his youth in Italy before escaping from fascism – he was about to be sent to join the fighting in Abyssinia – and crossing North Africa to Spain. During the Spanish Civil War, he fought in the ranks of the POUM, but had to cross the Pyrenees back to Paris when the Republic fell. In Paris, he became acquainted with the surrealists, especially Matta, but, being a foreigner and a staunch anti-fascist, when war broke out he was unable to stay. In England, he linked up with Mesens's group and attended some of the Barcelona restaurant meetings. When force of circumstance dispersed the group, del Renzio set out to create a forum of ideas redefining the part to be played by surrealists in wartime.

After talking it over with Mesens in London, he got in touch with Conroy Maddox and the Birmingham surrealists, and started to collect texts. In spite of such technical difficulties as finding paper and good typesetters and printers, *Arson* came out in March 1942, with the financial help of Kenneth Clark: 'a spectral review . . . a surrealist review, testimony of a vital life lived among the ruins not only of bombed houses but of exploited people'. It opened with a dedication to surrealists in several parts of the world: New York, Mexico, Marseille, Guadaloupe, Belgium, Cairo, Paris – and E.L.T. Mesens in London. Despite this last acknowledgement, *Arson* marks the beginning of a feud between Mesens and del Renzio that led to a two-year split within the ranks of British surrealism.

Given the absence of any text or illustration by Mesens, the mention of his name in the dedication has to be seen as an attempt to assert unity when it was at its most fragile. With the agreement of Mesens and Brunius, del

Renzio had launched the idea of an inquiry 'to take stock of who is with us and who against', and in 1942 wrote to Conroy Maddox saying how surprised he was to have no news from Mesens. He was at the same time putting the finishing touch to the surrealist section in Alex Comfort and John Bayliss's *New Road 1943*, with texts by Maddox, Ithell Colquhoun, Robert Melville and himself, together with contributions from several foreign and overseas surrealists – André Breton, Nicholas Calas, Benjamin Péret, Georges Henein, Aimé Césaire, Leonora Carrington, Kurt Seligman and André Masson. On publication of this review, *Horizon* published a strongly worded letter signed by Mesens, Brunius and Penrose. Del Renzio was charged with being an arriviste, and with having published texts unauthorized. He was called 'a spam-brained intellectual' who 'institutes himself the Barnum of Surrealism', 'a buffoon [who] has smuggled himself into the surrealist waggon', and who has profited by the dispersed surrealists' ignorance of him 'to involve them in his grotesque manifestation'.[15]

In fact, Toni del Renzio's adherence to the moral principles of surrealism could not be fairly doubted. In March 1942, having seen a galley proof of an essay by Herbert Read to be published in *Horizon* on an exhibition at the London Museum, he wrote to Conroy Maddox saying how shocked he was by Read's defence of Eluard and Dalí, and by his attack on Breton, 'the Grand Instigator [who] landed from a refugee boat' and his praise of the abstractionists. Del Renzio consequently stressed the necessity to 'adopt a completely unequivocal position, without compromise, without thoughts of oneself as an artist'. In November 1942, he sent the typescript of the anthology he had put together for *New Road* to Robert Melville and Conroy Maddox for approval, and he wrote to the latter:

to succeed we must risk all, create our freedom. It is essential to obtain a unified view of the world, a monist but multipolar view. To that end, we must study Marx, Engels, Lenin, Freud, Trotsky, the Alchemists, Hegel, Magie, anthropology. Let us reject nothing out of hand. Let us value it carefully, before casting it into the flames.[16]

In April 1943, he wrote: 'let us by all means get together, define an attitude, issue a manifesto and oppose everything that exists to forbid freedom'.

In his own article in *New Road*, del Renzio stressed the importance of collective undertaking:

this has led Calas to define the initiative value of collective surrealist activity, adding to the creation of an unconscious reality in the group's personality. It is this that differentiates our group from all others. . . The dialectical relationship between the unconscious reality and the consciousness of life determines precisely the solidarity of the Surrealist Group.

In contrast to most British surrealists, del Renzio was acutely aware of the ideological functioning of surrealism and the dialectical tensions between

the individual and the collective. By taking the initiative with surrealist activity in Britain he raised the issue of authority within the group. Surrealism could *only* exist through a concerted programme, between 1940 and 1943, but Mesens had failed to organize any such collaboration. Inasmuch as Mesens's fallibility as a leader had been exposed, it is understandable that he should have wrongly perceived del Renzio as a young upstart. There was, however, another cause of the rift between the two men.

In early 1942, del Renzio had seen Ithell Colquhoun's paintings at the AIA exhibition. His first judgment was negative. He wrote in *Arson*: 'Miss Colquhoun has finally damned herself publicly with her admission of endeavouring to do in painting what the "New Apoplexy' is doing in literature.'[17] A month later, he wrote to Conroy Maddox that he found Ithell Colquhoun 'essentially a mystic, therefore individualist, conscious of being an artist, anxious to exhibit'. However, in July 1942, from another letter it appears that they were living together, and a little later they got married.[18] Now, it has to be remembered that Colquhoun had refused to adhere to Mesens's conditions presented in 1940 to the members of the group, on the grounds she wanted to be free to exhibit wherever she wanted and to investigate occult matters if she liked. It was to be expected, then, that relations between del Renzio and Mesens – strained as they were – could only deteriorate further.

Behind this growing rift, there also loomed the shadow of Paul Eluard, whose poetry was increasingly yielding to the propaganda demands of the Resistance. In a reply published in the following issue of *Horizon*, to Mesens's letter, del Renzio accused Mesens, Brunius and Penrose – who were translating, and about to publish *Poésie et Vérité 1942* – of having 'compromised themselves with the moribund versification of that dismal renegade, Eluard', and of having 'skulked in silence, sitting as a deadweight upon a movement that is alive and has demanded a voice'. In private correspondence with Maddox, he deplored that Mesens and Brunius should 'foist the wretched contortions of Eluard upon the public as a surrealist'.[19]

In answer to this, Mesens and Brunius published privately a leaflet, *Idolatry and Confusion*.[20] The points of contention between them could be deemed negligible, if they had not offered a pretext for violent argument, since no one could fail to agree that it was right to reject propagandist, *engagé* poetry.

Del Renzio retaliated with the six pages of *Incendiary Innocence*, a manifesto where he reiterated the principles of surrealism and proposed to add new names to Breton's list of 'predecessors', such as those of the alchemists and occultists of the past.[21] The whole text was a cry of anger, haunted by the desire to burn down in order to start afresh. Beginning with the realization that poetry was being alienated and lacked nerve – 'Eluard, long ago

abandoned by the surrealists pitiably drags image after image from his for-
mer glory to make some eighty five lines of nothing new on liberty' – del
Renzio placed surrealism in a 'process of occultation'. He saw the solution to
the conflict between Eros and the death instinct as implying a 'genuine ...
intervention into mythic life'. He went on to ask solemnly for a 'hermetic
immersion in metaphysics', for 'the alchemy of the word' as a counter-attack
against the intellectual collapse which resided, he said in reference to Breton,
in 'the separation of the sign from the signified thing'. Del Renzio's was a
precise, argumentative, programmatic text, an act of total allegiance to
Breton, an affirmation of the truth of surrealism, an appeal for a return to
basic principles. The implication was that those principles had been ignored
by 'those in charge'.

In early spring 1944, there were scenes of uproar at a poetry reading
organized by del Renzio and Ithell Colquhoun at the International Arts
Centre and attended by a number of British, Belgian and French surrealists.
The reading was interrupted almost as soon as it began by Mesens and his
friends when Ithell Colquhoun, 'the charwoman of the meeting', according
to Ken Hawkes's report in Mesens's *Message from Nowhere*, refused to read a
letter of protest from one of the surrealists there.

These hostilities continued when, on 14 July 1944, Toni del Renzio pub-
lished 'Surrealism or else ...', an article in *Tribune* which attacked Eluard's
Poésie et Vérité 1942 and Mesens's *Third Front*, both published by London
Gallery Editions, as a poetry which can only come from 'the author's bath-
room and toilets'. It also praised Aimé Césaire's poetry, recently discovered
by Breton, and André Breton's speech to the students of Yale. A counter-
attack in a subsequent issue of *Tribune* from Alec Smith, S.W. Taylor and J.B.
Brunius followed, questioning why *Tribune* entrusted the criticism of surreal-
ist publications to a revengeful self-appointed surrealist like del Renzio, who
only sought to fawn upon Breton.

At this point, all hopes of regrouping British surrealists had to be aban-
doned for the time being, and Feyyaz Fergar's publication of *Fulcrum* in July
1944, which collected texts and drawings by Mesens, Brunius, Maddox,
Banting, Taylor and Edith Rimmington together with 'Apocalyptic' poets
like Henry Treece, James Kirkup and John Atkins, could in no way be seen
as an attempt at regrouping the dispersed artists. However, with the stead-
fast support of Penrose and Brunius, Mesens gathered enough surrealist
texts, poems and drawings by British and foreign surrealists to publish an
issue of *Message from Nowhere* in November 1944.[22] This opened with
Breton's speech to the Yale students, a rebuff to del Renzio's act of allegiance
in *Incendiary Innocence*. There followed poems by Mesens, Penrose, Brunius,
S.W. Taylor, an article by Banting stigmatizing Moore, Nash and Sutherland
and letters from supporters, among whom were Read, Treece, Forster and

Osbert Sitwell, all in relation to *Idolatry and Confusion* and all constituting a regular thrashing of del Renzio. It was the ultimate stage in a feud whose true issue had been a crisis of authority.

To reinforce that newly reaffirmed authority, that of a group, S.W. Taylor started making plans in late December 1944 to publish a series of texts which would sum up the position of the surrealists. To coincide with it, Mesens was to set up an exhibition, a re-assembling of surrealist forces at the end of the war. These two events, the latter in late 1945, the former in the summer of 1946, were attempts at re-starting surrealist activity. The wars were over, the World War and the civil war of the surrealists, and the surrealist vision, making the most of its own earth tremor, now had to be refocused.

Gordon Onslow-Ford and Conroy Maddox

For individual surrealists, the war years were predominantly marked by the exploration of uncharted territory at the margins of automatism. The strength of this inspiration is apparent in Len Lye and Gordon Onslow-Ford's work in the *London Bulletin* 18–20, the arrival in the group of Emmy Bridgwater, the allegiance to it of John Tunnard and, last but not least, the development of psychological landscapes by Conroy Maddox.

Gordon Onslow-Ford became a painter when he left the Navy in 1937. He took a studio in the rue de la Tour in the Paris suburb of Passy, and became a regular visitor to Fernand Léger's atelier. One of his first acquaintances was Roberto Matta, the Chilean surrealist. Soon, Onslow-Ford was working in close collaboration with Matta, whose freedom of line, explosive colour, suffusion of astral light through the canvas, dancing amorphous organisms and elemental forms, made a permanent impression on him. In 1938, he invented 'coulage', a technique which linked up with a 'reading' of the subconscious by means of spontaneous gestures, achieved by pouring Ripolin enamel over the canvas. This constituted a crucial development away from 'figurative', dream-inspired imagery, and was subsequently to evolve into so-called 'abstract surrealism' and 'lyrical abstraction'. Also in 1938 Onslow-Ford met André Breton and joined the surrealist group in Paris, where he became a close friend of Yves Tanguy, Kay Sage, Esteban Frances and Pierre Mabille. With Matta and Esteban Frances, he investigated what he called 'psychological morphology'. In late 1939 he settled briefly in London, bringing editorial and financial backing to the *London Bulletin* triple issue of June 1940 and the Zwemmer exhibition. What Onslow-Ford's work reveals is an extremely original imagery informed by a radical freedom of expression. This itself is based on a ritualistic gestural approach which produces a rarefied, almost stellar atmosphere. It was to be further developed only a few years later by Jackson Pollock.

The gates opened by Gordon Onslow-Ford's work give onto a world beneath the world of dreams. They show a form of archaic text, an Ur-text, fraught with lines of force that lead towards centres, and centres that issue lines of force. His paintings are places of proliferation for spawning stars, overlapping planes and false concentricities. In *Determination of Gender* (1939) (Pl. 109), a multiplication of focal points indicates the refusal and eventual loss of the concept itself of centre, and seems to deprive vision of any fixed source. Straight, angular lines vie with uncontainable, wriggling and twisting forms for possession of space. In the brief notes which Onslow-Ford wrote on Matta and Esteban Frances in the *London Bulletin*, and which apply to his own approach, he stressed Frances's division of space into several compartments, each communicating its own energy and influence to the next, and Matta's singular tension between 'the lines-of-force shadows and the floating thought-objects'.[23] Both are echoes of his own attempt, conducted so cogently in *Cycloptomania* (1939) (Pl. 110), at transcribing the moment of the passage from the psychic world to the physical one.

Conroy Maddox's own friendship with Matta likewise helped him in developing a sense of automatic production. His 'écrémages' had already shown an approach to the secret life of the subconscious. Without seeking to imitate the work of Matta and Frances, Maddox directed his efforts at landscapes. He drew a series of fascinating 'anthropomorphological landscapes', most of them intended as illustrations for Stefan Schimanski's *Knight and Devil* (1942). Here, perspective is crushed and collapsed; the ground rises into gigantic monsters, half human, half animal, which emerge from the mountains and hills, *and* simultaneously create those mountains and hills. Legs are tree trunks, complete with roots and gnarled branch stumps; and arms extend outwards to fuse with, or actually create, hillocks, bridges or other tree trunks in a bewildering concatenation. The eye is caught between emergence and absorption, in a process that flattens the perspective without denying it in the least. In *The Lily* (Pl. 111), for example, parts of the background relief actually constitute the pelvis of a figure in the foreground while a flat-topped outlier becomes its thigh, with the result that it is almost impossible to differentiate the fore-, middle- and backgrounds. The animal or human figures on the one hand, and the landscape elements on the other, are revealed as the indissociable, asymmetrical halves of an impossible whole. In 'Infiltrations of the Marvellous', an article he wrote for the apocalyptic magazine *Kingdom Come*, Conroy Maddox defined his technique as the creation of poetical images outside any kind of *scale*; consequently they can be seen as the revelation of 'new mythologies of desire'.[24]

This approach was developed by Maddox in 1939 by extending the potential of decalcomania through the technique of écrémage. This found a yet wider application in gouaches he produced profusely from 1940 onwards.

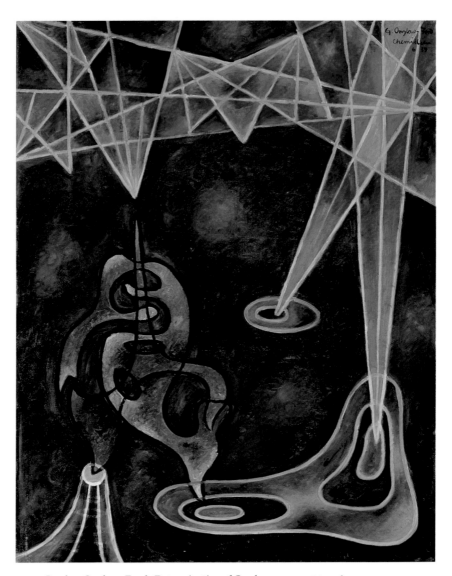

109 Gordon Onslow-Ford, *Determination of Gender*, 1939, 92 × 72.6 cm
(36.3 × 28.5 in.)

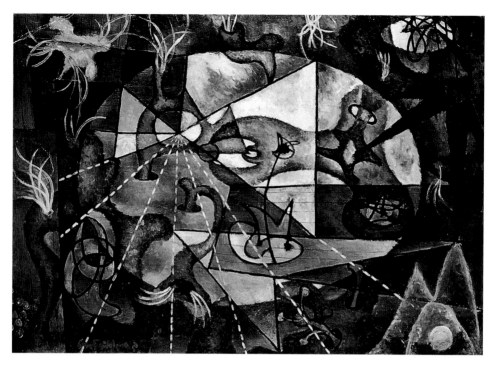

110 Gordon Onslow-Ford, *Cycloptomania*, 1939, 87.5 × 125 cm (35 × 50 in.)

Due to a shortage of canvas and oil paint, they were painted on small-format sheets of drawing paper. A majority of forms in the gouaches are non-figurative; they are 'pure forms', 'pure signifiers'. Every one of them is a parade of geometrical and biomorphic figures, sometimes standing in the midst of criss-cross patterns of straight and broken lines, sometimes dancing on the crest of waves or hills. They comprise monstrous arrangements of pipes, tubes, shafts, pouches, furniture, boilers and various instruments, hardly identifiable on the spot, but all *vaguely* reminiscent. The colours are usually bright and stand out all the more since the backgrounds are either liquid, translucent, or mottled and darkly nebulous decalcomania. They belong to the same protohistoric species as 'the erring creatures', the 'spectres', that Breton saw in Tanguy's paintings.

In that they both tempt the spectator to try to reach the mystery of creation and participate joyfully in it, Maddox's gouaches cannot be separated from his canvases. Certainly in *Morning Encounter* (1944) (Pl. 114), the limits of the material and the immaterial that are investigated in the gouaches are similarly 'tested'. In this painting the parts of an unidentifiable mechanism, seen from the front, speak of material production; pipes, a fire, a brick-built kiln

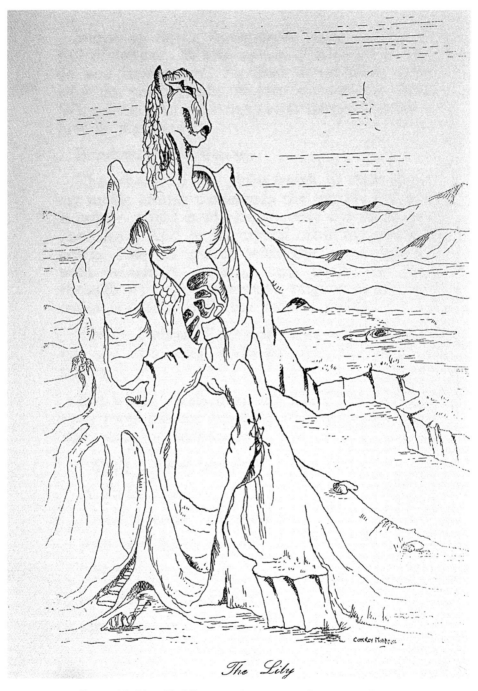

111 Conroy Maddox, *The Lily*, 1944, 36.5 × 25.5 cm (14.3 × 10 in.)

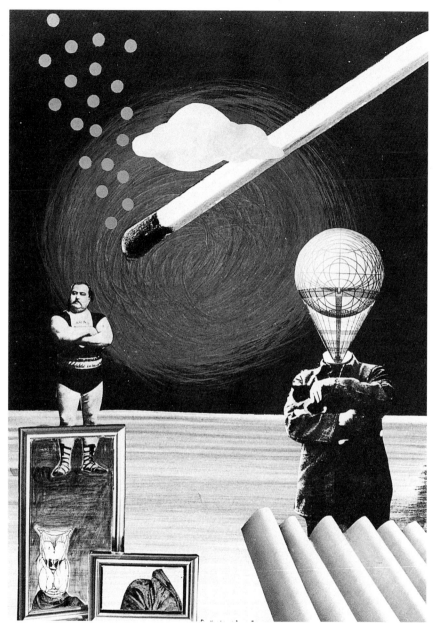

112 Conroy Maddox, *The Strange Country*, 1940, 41 × 28 cm (16.2 × 11 in.)

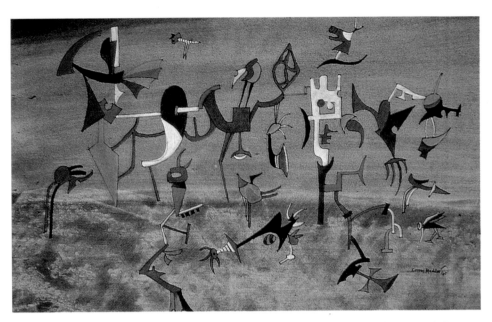

113 Conroy Maddox, *Propagation of the Species*, 1941, 36 × 56 cm (14.1 × 22 in.)

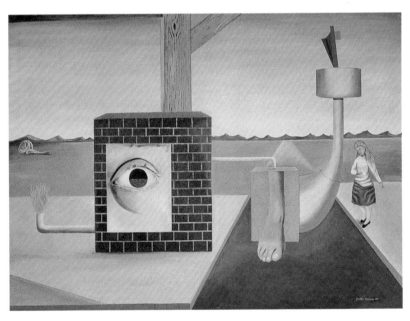

114 Conroy Maddox, *Morning Encounter*, 1944, 94 × 122 cm (37 × 48 in.)

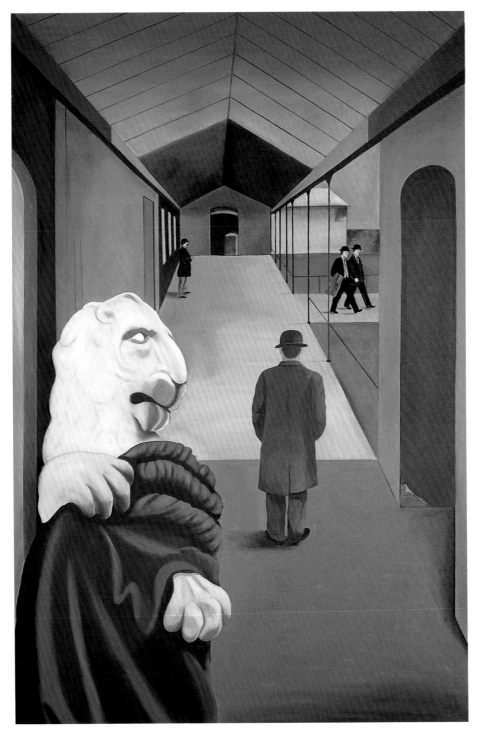

115 Conroy Maddox, *Passage de l'Opéra*, 1940, 136 × 94 cm (53.5 × 37 in.)

in the middle and a surge-tank on the right, point to some machine that is ready to function. Yet, three elements create an organic disruption: a large eye, a foot which comes out of the tank and is apparently 'fuelled' by a pipe, and a little girl, who witnesses this strange mechanistic encounter. Energy originates in the disjunctive contiguity of objects, as is echoed in a beam supposed to support some roof – but no one can ever see it – and in a shapeless object on the left, placed there, Maddox said, outside any reference.

Collage seems to be the principle behind Maddox's way of painting, whether he uses gouache or oil. Indeed, central to collage, as he pointed out, is the separation of the image 'from its original function, withdrawn from its utilitarian use' and the recuperation by the object of its 'power to operate in the field of possibilities directed only by the needs and necessities of the artist'.[25] The technique rests upon a double focus approach; 'the original identity of the pictorial element remains intact, irrespective of the function it may be given in the completed work'. *The Strange Country* (1940) (Pl. 112), the first collage he made during the war, is based on images wrenched from their contexts and made to enter into new relations so that the eye is asked to both assemble and separate. Here, a double reading of the collage, encouraged by the parallel attitudes of the two figures in it and the disproportionate sizes of objects, is prompted by the balloon-head of the figure on its right and the visual uncertainty raised by the wrestler on its left, which poses the question: if the frame is pushed aside, what will happen to his feet?

This radical approach, which 'refuses to recognise pictorial frontiers', is also that of Conroy Maddox's paintings from the late thirties onwards, especially those built on the subversive use of perspective. The title of *Passage de l'Opéra* (1940) (Pl. 115) refers to an arcade famous as a haunt of Paris prostitutes, and is also the title of Aragon's piece in *Paris Peasant*. This, the first significant work of its kind, was painted at the same time as the gouaches. The painting's space is emphatically *transitive* and centres on a blank asking to be filled up. But once filled up, it is to be emptied again, as is indicated by two men departing on the right and two more expecting to move from where they stand. But there is more. On the threshold of the passage, there prevails a singular ambivalence; a lion, a modern Cerberus, an Ernst-like keeper of an *other* world, a monument of power, is standing guard. It evokes the concierge of the actual passage who used to lock it every night in Aragon's text, but is also reminiscent, especially in the way it is draped, of the prostitutes who gave the passage its reputation. The lion is a symbolic guardian, both ancient and modern, masculine and feminine, dovetailing law and desire, a tension which pervades the whole space and plunges it into expectancy and imminence.

In *Rue de Seine (The House of Georges Hugnet)* (1944) (Pl. 116) the perspective is blocked and the spectator is stared at and invited in. But the street is

guarded; behind two figures whose masculinity is emphasized by their clothes, a horned head and a truncated column, the street is lined with scenes of violence and disowning. Meanwhile, the eye, rebounding from a thick forest at the back, has no choice but to *look*, over and over again. The key to these scenes (rue de *scènes* – Maddox's knowledge of French is sufficient to entitle us to take it as a pun) is the body of the woman lying on her back on an altar in the foreground. It reproduces exactly one of the famous photographs of hysterical women taken by Charcot's assistants and published in the 1928 issue of *La Révolution Surréaliste* to mark the fiftieth anniversary of his researches into hysteria. Indeed, there are many examples of convulsion: two men forcing a woman, a man throwing himself out of the window, a woman hiding her eyes from a man embracing a huge column, a hand holding a card showing a hand holding a huge nail; these scenes spread from the woman at the entrance of the street to the whole street. Perspective produces the ideal site for an imaginary body of impulses and desires to take shape. This projection of the mechanisms of the subconscious, their liberation so to speak, triggers an inexhaustible sequence of subversive images.

Conroy Maddox's fascination with hysteria never abated. A great impression was left on him by seeing a hysterical woman when younger, and he subsequently became interested in Charcot and in the surrealists' celebration of hysteria. Above all, he saw poetic potentiality in the hysterical state. All these explain why his paintings, gouaches and collages – as well as the few objects he made – seem to encapsulate convulsive turmoil. He summed this up in 1940 in his text, 'The Playgrounds of Salpêtrière', the name of the hospital in which Charcot 'discovered' and studied hysteria:

In the rancid hearts of tropical forests are the long neglected playgrounds of Salpêtrière, the illustrated journals of your childhood, the horizon of your difficult reality and human sentiments, where the light of the paraffin lamp only occasionally penetrates the hour that determines your presence and illuminates the miraculous invisible obstacles of your incertitude. An image of exquisite anonymity, of imperturbable contradictions, an image so uncertain that it seems to forever tremble between the believable and the unbelievable and phantom-like questions the validity of all that surrounds you.[26]

More sedate, but no less cogent, *The Visible Man* (1941) (Pl. 117) recalls us to the process of condensation at work behind all the juxtapositions we have seen so far. (Condensation, in Freudian terms, is the process which combines and telescopes waking images into composite dream images, overruling any contradiction which might arise.) Here, the gaze hinges on a half-demolished wall, half-open drawers, the tension between this and that side of the wall and the figure of a man both detached from, and melting into, the wall. The relevance of this to the whole of Maddox's work and to surrealism in general

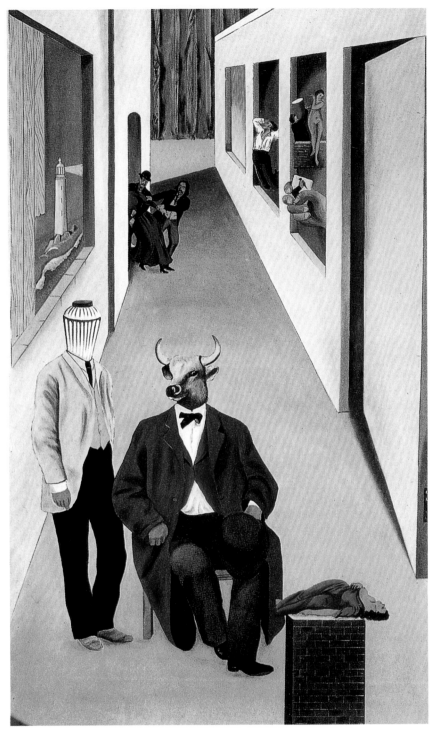

116 Conroy Maddox, *Rue de Seine (The House of Georges Hugnet)*, 1944, 126 × 75 cm
(49.7 × 29.5 in.)

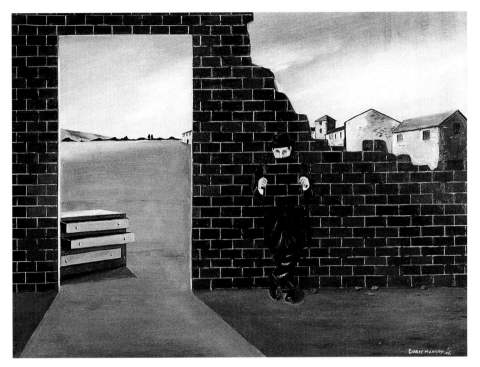

117 Conroy Maddox, *The Visible Man*, 1941, 45 × 60 cm (17.7 × 23.6 in.)

lies in the question: what is it to be visible? To what extent is the man *seen*, or simply visible? To what extent does the representation of a man, or any object, coincide with his visibility? Facing the wall of hard reality, its opening and its crumbling, we are made to waver at the limit of visibility and invisibility, exactly where the hidden secrets of things lie, as in a set of drawers. The fact that the man is in a way holding his own visibility in his hands indicates that there will always be another reality inside and outside us, behind anything else thought to be real.

This radical approach is made even more concrete in a construction by Maddox, *Onanistic Typewriter* (1940) (Pl. 118), an extreme example of André Breton's forecast, in 1935, of a forthcoming 'fundamental crisis of the object'. On each key, a sharp tack has been fixed upside down; on the platen, from under the paper bail, a rivulet of blood appears. As with all surrealist objects, the viewer is forced to revise the 'normal' relation to the ordinary object, and open himself to secret fears and desires, halfway between attraction and repulsion. But here, another issue is raised in this revolution of appearances: the illogical, irrational link between the act of typing on the tacks – why not

118 Conroy Maddox, *Onanistic Typewriter*, 1940, 25 × 47 × 33 cm
(9.8 × 18.5 × 13 in.)

dare? – and the trickle of blood on the roller. The typewriter is wrenched
from its banality and truthfulness, and projected into a world where deep
erotic conflicts take place between the pleasure principle and the reality prin-
ciple: only the pain self-inflicted by the typist can bring about the emission of
blood, through a special osmosis of subject and object.

One of Conroy Maddox's poems from this time exemplifies the process of
dissemination at work behind the deconstruction of reality:

> I seek only the gestures of a lonely ruthless quest
> To resurrect if only for a day the marvellous
> dressed corpse of my desire.
> Larvae, moths, necrophors.
> To perpetuate the cemetery, to plaster you with sea-weed,
> to open up a gap and produce a breakdown.
> Everything that goes up comes down.
> . . . If I fail to stab you in the back
> it is because the dancing woman is irritating.[27]

Toni del Renzio

Essentially a man of ideas, provocative and persistent, 'a true Lenin of the arts', as the critic Derek Stanford called him,[28] Toni del Renzio worked at the barrier of meaning-making, fully knowing that it had to be breached and ready to show how to achieve it. The vast stretches opening ahead of him have hardly any horizon left that is not hazy or cloudy. Barring access to them, splintered fragments of wooden planks nailed together hang improbably in the air or come up from no one knows where, to remind us of previous obstacles. Among such works *Mon Père Ne Pas Reviens* (1942) (Pl. 119) instils a deep sense of loss with a torn piece of cloth, a bone taken from a skeleton – a shoulderblade or a pelvis? – and an eye squeezed in the angle formed by two planks. A paper left on the ground at the level of the opening into the fence contains a sentence in French which became the title of the work. This was a sentence which del Renzio saw in a dream – complete with the grammatical mistake, which he did not want to correct. The symbol of authority and law is rejected, just like the grammatical rules. In *Le Rendez-vous des Moeurs* (1941) (Pl. 120), a hand rising from an egg and holding a twig approaches a wooden trellised structure. Inside this hangs a blue ball, attached by a thread to another wooden pole from which a rag is suspended. On a piece of paper, floating beneath the rag, an eye, the colour of the ball, the shape of the half-closed fingers, seems the last, fragile remnant of any authority.

Del Renzio's approach as a painter may become clearer when his poetry is looked into: here, the liberation of desire is inseparable from the elimination of the father. In *Can You Change a Shilling?*, which he published in *View* in 1943, the self is struggling with what perturbs and splits it, the eternal return of the image of the father.[29]

> Who dares to drop the pin destruction of our silence
> Who intrudes his shadow across our parallel paths
> Who throws his paper wrappings in the wind of our faces
> Who is this travel stained person
>
> Why do you ask those questions
> Why do you resent him in the landscape
>
> That man is the image of your father

The evocation of the self's double is almost intolerable. To escape it, the self takes refuge in narcissism, but this attempt at replacing an image with another is doomed to failure:

> I am the key to all my problems
> I am the lord of my desires
> I am the prince of pleasures
> I am the hunting hound that is chased by the hare

119 Toni del Renzio, *Mon Père Ne Pas Reviens*, 1942, 17.5 × 30 cm (7 × 12 in.)

As in several of Maddox's paintings, the onlooker is in turn looked at and the 'I' does not exist except in the constant change of his validity, in the permanent re-forming of his desire.

The same ambivalence between the reality principle and the pleasure principle gives its structure to another text, 'These Pennies were Well Spent', written in 1942 for Emmy Bridgwater. The text first conjures up the past to liquidate it and help the self to affirm itself in reaction:

> The beams of the headlamps penetrate the darkest caves
> My flaming beacon of your delight reveals the crevices
> The rhythms of jazz are good to hear
> [. . .]
> The secrets of my father are at my fingertips
> The love that lavished on a wooden box is mine
> That love that lay forbidden behind the bars of gold
> Those terrible divisions of my father's music
> That love is still lavished in the shadows of a tree
> But it is not lavished by that flaming sword my father wielded

The liberation of the phallus is concomitant with the liquidation of the father. From then on, time dissolves ('Today is the first wednesday of the month/Yesterday was the first sunday/And tomorrow the first easter'). Eventually, however, one faces oneself again because the mirror-like effect of love has in turn revealed that the relationship with the other can only be a struggle with oneself. Indeed, after the act of love, after the separation with

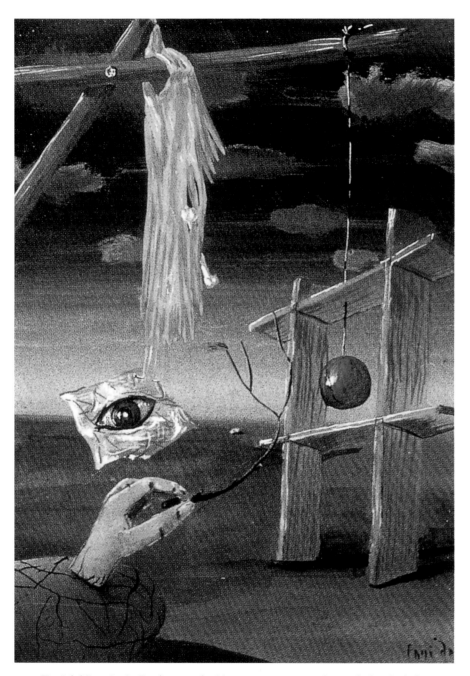

120 Toni del Renzio, *Le Rendez-vous des Moeurs*, 1941, 19.5 × 16.5 cm (7.6 × 6.5 in.)

the father and the encounter with the other, we are like strangers to our-selves – a process of disidentification:

> My image is my own eye
> It is in your eyes and they are in mine

Ithell Colquhoun, Emmy Bridgwater and Edith Rimmington

Three women artists were to leave a considerable mark on the wartime phase of surrealism in Britain, with an unprecedented surge of aboriginal images, linked to the radical process of transformation of thought and imagin-ation into concrete images. Edith Rimmington had joined the group in 1937 and Emmy Bridgwater in 1940, while Ithell Colquhoun had been close to the surrealists as early as 1939, albeit as an independent. She had decided to dis-tance herself from Mesens just after the Barcelona restaurant meeting (see p.209), yet was undeniably a genuine surrealist spirit.

Colquhoun's history as an artist is intriguing, in that the strongly affirmed independence of her views isolated her from groups, but her challenging of morals and established values and her interest in the secret lores lost deep in alchemical books, hermetic traditions and the subterranean layers of Cornish legend anticipated the surrealists' preoccupations with arcane lore and Celtic as well as Gallic art. In *Dance of the Nine Opals* (1942) (Pl. 121) she establishes imaginary links between the Merry Maidens – a magic circle of nineteen stones which she frequently visited near Penzance, and the deep telluric energy and forces of Celtic lore. A beam of light issues from the centre of the Earth spreading out to link the stones, rearranged as nine opals – Colquhoun's birthnumber and birthstone – by visionary powers abetted and multiplied by such chthonic contact.

Throughout the war, as first the companion, then wife, of Toni del Renzio, she explored the outer reaches of physicality and furthered her investigation into the technical and spiritual relationships between automatism and occultism. In *The Pine Family* (1941) (Pl. 122), one of the most striking and complex works of British surrealism, while not yet exploring fully the me-anders of esotericism, she confronted the onlooker with the monstrousness of dismemberment, in a painting in which body fragments are made to build another type of sequence of imaginative relations. The juxtaposition and plastic similarities of three truncated bodies, one masculine, one feminine, the third hermaphrodite, create a vertiginous movement of repetition and differentiation. The three bodies are similar in that they have been ampu-tated – the section of the cut limb is insistently identical – the hermaphrodite being a paradoxical summary of what happened to the other two. As they

share certain features, being members of the same family, the eye is thus made to waver between the bodies' identity and non-identity.

Ithell Colquhoun gives a French name to each of these bodies. 'Celle qui Boîte' refers to her interest in the symbolism of limping, whether mythological, like Hephaistos and Wayland Smith, or literary, like the Limping Devil and Captain Ahab; the name may also be meant to remind one of Sarah Bernhardt. 'L'Hermaphrodite Circoncis', assembled from what man and woman, each of them, lacks, was the ironical nickname given by the French surrealists to the nineteenth-century realist writer George Sand – a woman who had rejected her maiden name altogether and had given herself a man's name vaguely inspired by her husband's. This labelling is literal. The implications of the third label are more complex. Atthis, sometimes spelt Atis or Atys, was a Phrygian divinity, the equivalent of Adonis, who was loved by Cybele. Having been unfaithful to her, he was struck mad by the goddess and, in a fit, castrated himself. Restored to sanity, he was going to commit suicide when the goddess intervened and transformed him into a pine tree. Atthis himself was born from the genitalia, fallen on the ground, of a hermaphrodite creature, itself born out of Zeus' seed and eventually castrated by the gods, a fact which casts light on the central issues of the painting: this is the tragedy of a doomed family.

A strange family, indeed, irretrievably barred from procreation, since the phallus is ostensibly, alarmingly absent. Colquhoun's family has cut itself from all creation and is now pining for its missing parts, or for the children it will never beget. This could lend itself to feminist criticism, and one might conclude that it constitutes 'a parody of the great surrealist myths of love' and 'an alienation from the surrealist cult of desire'. However, to stop at this would be superficial and reductive. One thing it ignores is that the labels planted on the thighs are written in French and in perfect French handwriting. Ithell Colquhoun knew French well, and it is no coincidence that 'pine' is one of the many slang words in French for 'penis'. The title thus refers to what is lacking, the family is united by what they all want, and made by what unmakes. The onlooker is plunged into the gaping void where words and bodies play limpingly together, where Eros plays with Thanatos and both proclaim the absence of the ultimate object of desire.

Short texts Colquhoun wrote under the title 'Experiments', some of them published in the surrealist section of *New Road 1943*, probe deep into the secret life of natural forms. One describes her experience of scrambling over rocks into 'a wide fissure slanting down towards the centre of the earth', to discover 'a cave with water the colour of crysolite' and 'fish-like flowers growing directly from the stone without leaves'. Another time, she wanders onto a rough piece of land between Oxford Street and Piccadilly where she finds gigantic flowers, and is fascinated by their petals 'full to the brim with

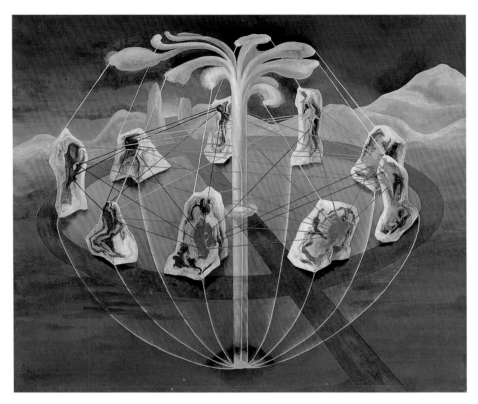

121 Ithell Colquhoun, *Dance of the Nine Opals*, 1942, 51 × 69 cm (22.5 × 28 in.)

dark water', from which strange living creatures of various jewel colours crawl and cling to the side of the pool, inviting her to touch them. Another of her 'experiments' tells of her visit to a house to let, whose back garden slopes down 'to a pebbly shore and, beyond, the crash and smother of Atlantic waves, breaking ceaselessly and without tide'.[30]

A Visitation (1944) (Pl. 125) exploits automatic techniques such as decalcomania more basically than the other paintings. From two nuclei, one red in a blue shell, the other blue in a red shell, there trickle up two other nuclei, as from alchemical stills. Their extensions meet in a luminous organism suspended in the air above. The whole structure is symmetrical and forms a double lozenge; the lower one gives birth to the upper one as well as to its own intestinal forms, which invite us to read into each of them, celebrating the resurgence of phantasmic realities. One understands why, at the time this work was produced, occultism was opening other doors to Colquhoun.

There is a definite similitude between Ithell Colquhoun's organic apparitions and Emmy Bridgwater's metamorphoses. Both take place in the

landscape of the mind. However, Emmy Bridgwater's are more embedded within a process of birth, death and rebirth. In her paintings between 1940 and 1945, she created spaces of circulating energies; in each of these the countless curves, spirals and wriggling lines seem to point to a centre, which escapes as soon as it is posited. With diffusion and dilution, geological upheaval, her visions celebrate the unyielding resistance of matter as well as its limits: folds and mounds, hills and ravines are bowels; lianas and larvae are nerves and arteries winding their way through an amniotic realm in search of cells, limbs and bodies. In *Remote Cause of Infinite Strife* (1940) (Pl. 126), two long ropes, indicative of an undiscovered link, emerge from behind a ridge of mountains in turmoil, one of them untwists its strands as if to emphasize the general process of *unfurling*. In front of the ridge, flowers spring up from the soft phallic curves of the earth, evoking, if one goes by the title, a pristine state, a hidden reference to the abolished Garden of Eden, where indeed 'eternal strife' originated. We are confronted with the entrails of the earth at the moment when matter breaks through its limits and

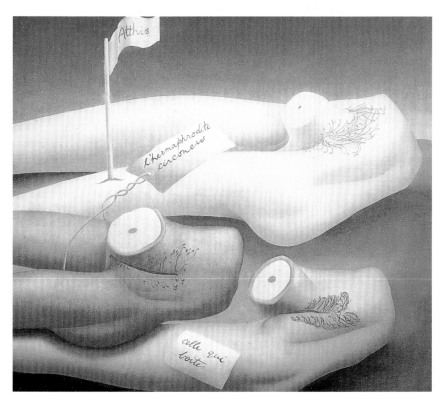

122 Ithell Colquhoun, *The Pine Family*, 1941, 46 × 50.5 cm (18 × 20 in.)

delivers itself. Snakes, worms, bird-like animals, star-shaped flowers seem to have just been created, and attend the earth's spasms.

Toni del Renzio wrote enthusiastically about Bridgwater in *Arson*:

> In the liquid atmosphere of these lunar landscapes rare creatures encounter one another in the sensuous curves of animal innocence. These bewildered shell-less crustacea peer across the contours of the marches seeking dark caverns in which to immerse themselves . . .

> Earth, Sky, Fire and Water, the four elements of the ancients, are inextricably mixed. Yet, each is clearly recognisable and the antipathies do not cancel each other but rather heighten the effect. This very ultra-clarity of recognition itself adds to our confusion, preventing our seeing the real nature of the fundamental tragi-comedy played out before us.

> We do not see these pictures. We hear their cries and are moved by them. Our own entrails are drawn painfully from us and twisted into the pictures whose significance we do not want to realise.[31]

Del Renzio has grasped the ascending and burying movement in Emmy Bridgwater's works. Indeed, the same movement of production contains both the forces of life and the forces of death: any form, once drawn out and extracted, can only grow and die. This in a way explains why, a couple of years later, a recurrent theme in Emmy Bridgwater's poetry was that of a crypt as a closed space that opens out.

In 1942, Emmy Bridgwater's inspiration changed. Birth became associated with death, an association directly dramatized in figurative terms and focusing on birds as the agents of the new form of creation. In *Brave Morning* (c. 1942) (Pl. 127). a typical work of this period, the circular structure of the painting is made up of everyday objects often in strange conjunctions: a bunch of flowers in a vase, a dog with an upturned flower on its head, a head with a top hat, a bird, a girl's face and a broken window frame. The circularity of the structure is set off by the diagonal flight of a bird, apparently let loose by the girl, and dashing towards the bunch of flowers. It is a scene of aggression, destruction and chaos, pivoting around the explosively red bird, halfway between the horrified girl and the deadly pale face of a father figure. The man, wearing an undertaker's hat (unless it is a bank clerk's, in reference to Bridgwater's father, who was a banker), is metaphorically 'barred', decapitated by the bird, as if the girl had unleashed the forces of death. Balancing this cancellation of a phallic reference, the flower bouquet on the left is an affirmation of life in its striking resemblance to an 'ovary about to pop out an egg', an interpretation reinforced by an ovary-like form, 'similar to a fertilized egg', which has grafted itself onto the hat. The painting thus precipitates the forces of birth against the forces of death, and the central eye, symmetrical with, and inseparable from, the liberated egg, holds the promise of a brave, regenerative morning/mourning.[32]

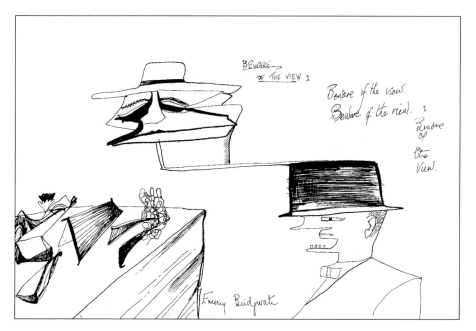

123 Emmy Bridgwater, *drawing*, c. 1942, 18 × 21 cm (7.8 × 8.2 in.)

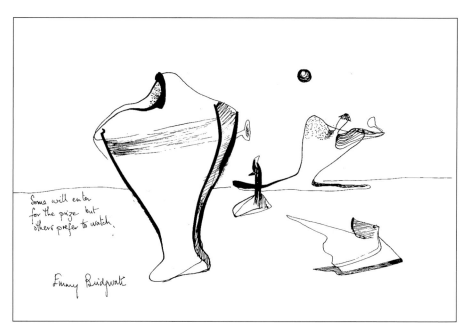

124 Emmy Bridgwater, *drawing*, c. 1942, 18 × 21 cm (7.2 × 8.2 in.)

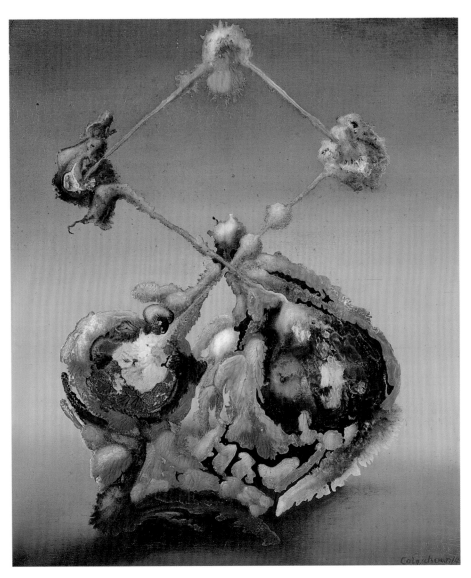

125 Ithell Colquhoun, *A Visitation*, 1944, 61 × 51 cm (24 × 20 in.)

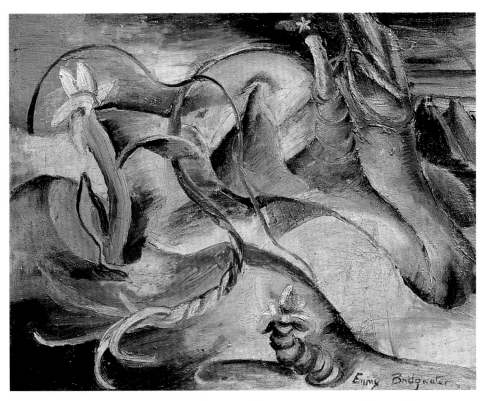

126 Emmy Bridgwater, *Remote Cause of Infinite Strife*, 1940, 41 × 51 cm (16 × 20 in.)

Wartime was a fertile period for Bridgwater's writing. Her – as yet unpublished – poems complement her painting in the sense that they articulate the whirling processes of emergence and transformation. *Closing Time* places itself at the origin of creation, which can only take place in an in between space, at the point where one can only *repeat* creation, like the famous mythological dragon or snake, the ouroboros:

> So comes the flame out of the serpent's mouth
> So plucks the bloom, the red-tipped fingered hand
> So, as the clock goes round and round and round
> So turns again the record of the sound.
>
> Repeat the space where the swallows try their turns
> Reveal the place where ants begin to crawl
> Remove the time when rain begins to drip
> Re-seal it all.

The hauntingly, repeatedly circular movement attempts to abolish chronological time by emphasizing both what is inchoate and renewed beginnings ('comes out of', 'repeat', 'try', 'begin', 'begins'). Opening and closing vie with each other within linear time, and eventually evade linear time for cyclical time. Bridgwater's interest in Tennyson's poetry is perhaps out of this deep sense of timelessness. Similarly, *Back to the First Bar* is a blending of the human and the vegetal, of the deathly and the erotic, in the face of Time's eternal return, seen here in the territory of libido:

> After ten thousand years I will repeat my claim
>
> Repeat it in the grey garden in the morning when the clouds are swinging and the raindrops are singing and the ground is moist and the worms are turning, are turning the earth that is me.
>
> little brown bird you will hear
>
> You will take no heed of the insistent whispers, again you will turn to pecking your insect with the striped black body and the blue eyes of a Mona Lisa.
>
> Creeps the penetrating grass over the unvirgin soil, brown as the dried spilt blood.
>
> And again, after the insect,
>
> You will sing.

The erotic charge of these lines, contained in the spaces between the words, released by a few pregnant terms, locates the poem in an intermediate space.

In the course of the war years Emmy Bridgwater also made automatic drawings, of which the key pieces are jointly entitled *Beware the View*. In keeping with the issues of visuality in the works we have so far analysed,

she plays with angles of perspectives and vanishing lines, but always to crush the perspective and often to amplify an apparently remote object. The unfinished quality of the drawings brings her close to Breton's definition of automatism as 'the direct expression of the thought', i.e. before it is put into words. Her technique is in itself fascinating: she would be slow to start with, waiting for the energy to gather momentum, and then the work would suddenly precipitate as if it had found its space and stages.

As tranquil-seeming and as uncompromisingly violent as Emmy Bridgwater, and with the same earthly forces, Edith Rimmington introduces a land of collective monsters, stressing, at the same instant, the insufficiency of the human eye. Her collage, *Family Tree*, shown at the Surrealist Objects and Poems exhibition in November 1937, and two automatic drawings exhibited at the Zwemmer show in June 1940, pave the way to her paintings. These are automatic, not in their making but in their content, in the way heterogeneous animal and vegetal elements are grafted onto each other. The violence which prevails in them is exerted against the viewer *and* against the drawing itself, which seems to tear itself apart, almost sending the viewer back to the time before the drawing. In a drawing in *Fulcrum*, for example, a tree trunk stretches rapacious claws towards a vaginal orifice near the ground (Pl. 130); in *Message from Nowhere* (1944) (Pl. 128), a tree branch ends not with a bud, but with an open toothless mouth sticking out a huge phallic tongue, while two side branches ending in claws turn upon the mouth in a gesture of self-mutilation. The implication is that automatism can only renew itself through the self-destruction of the monsters it begets.

Rimmington's paintings offer no exceptions to this kind of reading. In *Eight Interpreters of the Dream* (1940) (Pl. 129), disruption is created by the mere presence of eight deep-sea diving suits left to dry in the arches of a quiet cloister, especially as the stretched-out limbs are reminiscent of a cross, but an inverted one – a double inversion of the meaning of the place. Eight sheep's heads, repeating the number of diving suits, create an unavoidable logic: the sheep's heads must belong to the headless, helmetless diving suits. However, in both series, something is missing, and what is missing in one is provided by the other. The eye is thus suspended, in the gaping interval between the bodies and the heads, one cut off from the other, as the diagonal path in the middle seems to imply. The fact that four heads are still in the shade on the foreground, and the other four heads have passed by the diving suits, seems to intimate a movement, an ellipse, which links the two series. Noteworthy, too, is the title: by stating that there are eight interpreters, it signifies the bringing together of the heads and the bodies. The eventual re-heading of the bodies, however, or the re-bodying of the heads, is unthinkable: ultimate unity is again unreachable, just as interpreters of dreams will always be torn between displaced elements.[33]

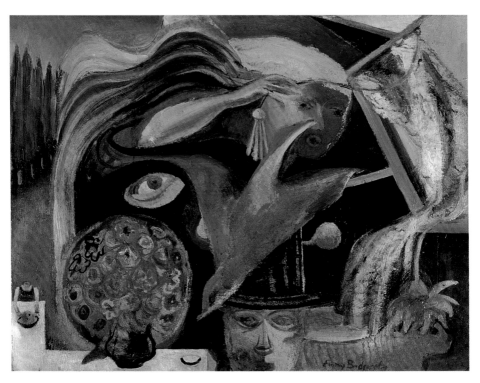

127 Emmy Bridgwater, *Brave Morning, c.* 1942, 61 × 80 cm (24 × 32 in.)

128 Edith Rimmington, *drawing from 'Message from Nowhere'*, 1944, 8 × 11 cm
(3.1 × 4.3 in.)

129 Edith Rimmington, *Eight Interpreters of the Dream*, 1940, 36 × 54 cm
(14.2 × 21.2 in.)

In common with other artists, Rimmington found it difficult to paint during the war. In one letter, for example, she complained her secretarial job at Stephen Lief's health farm in Sussex got in the way. Apart from automatic drawings and very few gouaches, however, she did explore automatic writing extensively. Among her many texts, 'Time-table' and 'Leucotomy' are remarkable in their cyclical movement, spiralling upwards as if the centre of unity and vision couldn't but keep moving.

Death is alive in rhythm at the screech of the siren like a calm box pouring out music, projecting a lifetime through endless rooms ... In the dark tunnel above two musical boxes fight to be heard, heart against hub. On the ground the death chimneys vomit and always there is birth. When the music dies down life runs on wheels of search, probing for the last thought even though it is dead. After the silence of relaxation, the flower buds open, exhausted, only to die from rhythm eaten roots. As death moves slowly oh the torture of waiting for a new rhythm.[34]

The same circular movements, centrifugal and centripetal, are repeated indefatigably. Life and death are no longer contradictory, and this non-opposition, created by syntactic rhythms, in turn creates the rhythmic alternation of sameness and otherness, as if these two terms were entering a dance of concepts. The two musical boxes are fighting 'heart against hub', 'heard' and 'heart' are conjured up one by the other, just as 'vomit' and 'birth', 'search' and 'probing', 'thought' and 'though'. Automatism beats the time here in a subtle game of variation and difference. 'Leucotomy', a text which is perhaps more radical, is marked by recurrent hiatuses, echoing each other, every eight words or so:

When the music of the touch hangs well then the oasis, the hair and the gasp as the tall chimneys shatteringly deliver death. The hair waves break on the shore of white picked bones, reluctantly returning to the dun of tomorrow, empty of the fury of yesterday. The starfish is dead in the empty box and the prone logs dream go astray until the glare cuts short their sojourn and return-shocks them to the drag a chain.

Like waves unfurling upon shores covered with bones, phrases deliver fragments of meanings which break upon words. Paradigms of the sea, which might institute a structure, as could the clearly marked temporality, are undermined by an estrangement from meaning and from any hint of meaning, which the final phrase emphasizes.

John Tunnard

On a different plane but in a no less puzzling way, the struggle was pursued by John Tunnard at the boundary between the mental and the physical, the abstract and the concrete. In the March 1939 issue of the *London Bulletin*, Julian Trevelyan reported:

fulcrum

edited by Feyyaz Fergar

130 Cover of _Fulcrum_ by Edith Rimmington, 1944

First Tunnard walks along the seashore till he spots an old ship's-timber, a cast-off ironing board, a washed-up chart, an unfinished lavatory seat. To see him returning from one of these expeditions is to mistake him for a submarine junk shop. Next he turns his spiders to work on them. Delicate webs are spun, while the slug ambles around, leaving his silvery trail behind him. Now it is the turn of the shipworms and the weevil who scour the surface into the most intriguing patinations, while the beetles lay globular eggs in appropriate positions. Any other delicacies that you may notice in the finished product are probably the work of the exotic caterpillars . . .[35]

John Tunnard's inspiration is both technological and vegetal. Hardly a painting does not have parts of machines or instruments and natural elements, so far detached from where they are supposed to belong that they fuse into each other. This is understandable in that Tunnard shared his time from very early on between ornithology, geology, botany, civil engineering and architectural design. From 1930 he lived among fishermen in the Cornish fishing village of Cadgwith. He had been a wildfowler in Lincolnshire, where he was also lay rector of the parish of Frampton and used to handle a small boat among the sandbanks of the Wash. Subsequently he was an art adviser to the carpet manufacturer H and M, then a selector of woven printed fabrics for John Lewis in London. He became a part-time teacher of design at the Central School of Arts and Crafts, living in Bedford Park in London. His restive personality led him to stay for long periods in Cornwall where he gave up commercial work and became first a painter of farm and coastal scenes and then set up a form of hand-blocked silk industry with his wife. Probably because of the potential of this technique and his meeting with other artists, after he joined the London Group in 1934 his works became less representational. The story has it that his 'conversion' to surrealism took place when he discovered Klee and Miró at almost the same time, and when too his wife gave him Herbert Read's *Surrealism*. Not a year later, he was included in the surrealist section of the AIA exhibition at the Grosvenor Gallery, in March 1937. For the next three years he kept up a connection with the group and exhibited with them at the Zwemmer Gallery in 1940.

The war was an extremely prolific period for Tunnard, who was hailed by Moore as a leading artist. Looking back on his works in 1944, he insisted on the 'geometrically dramatic content' of the landscape:

by that I mean the dramatic movement of roads, of ruts sweeping into farm yards, of the lines of telegraph poles or the sweep of railings, and these found myself exaggerating to get the geometrically dramatic. Of course, I got to the stage when, confronted with a landscape, I felt that I could not be bound by the things that I saw, and naturally the only thing to do was to invent.[36]

In *Psi* (1938) (Pl. 131), which was Peggy Guggenheim's favourite painting of Tunnard's, a large rudder shape, similar in appearance to an anvil, seems

131 John Tunnard, *Psi*, 1938, 87.5 × 128 cm (34.4 × 50.4 in.)

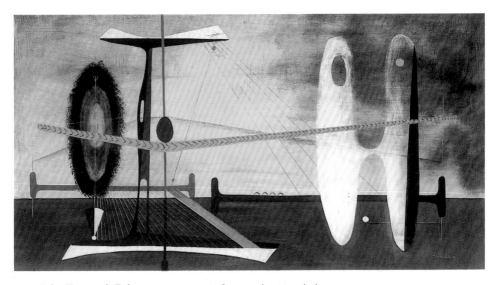

132 John Tunnard, *Fulcrum*, 1939, 44.3 × 81.5 cm (17 × 32 in.)

to orchestrate a ballet of lines, circles and other forms to a wavy musical score. Here and there, the Greek letter Ψ, the shape of a tuning fork, creates a rhythm which reinforces the general rhythm of lines and the more or less geometrical shapes. *Fulcrum* (1939) (Pl. 132) ironically disrupts 'normal' vision to welcome visionary personages. Two figures, apparently one the part of a rudder, the other a toothed wheel, stand in perfect equilibrium, as is implied by an egg between them. But looking at the egg carefully, one notices a strange use of perspective based on a totally illusory flattening of distance; this makes it almost impossible to link objects according to the laws of optics or to accept the reality of the apparent equilibrium achieved here. The balance of dark colours on the left and the light colours on the right keeps the viewer in a state of uncertainty, poised at the interaction of lines, between the egg and a second one, one solid, the other one as empty as a hole. *Composition* (1939) (Pl. 133), evidently painted half consciously, half automatically, opens what seems to have been the corner of a room. Lines forming musical scores create a substructure, the perfect condition for playing with the depth of the painting's space – semblances of objects actually retreat and come forward, flatten on the background and come back to the front through a white line, a brown frame or a shape changing colour at one of the intersections; all these items meanwhile force a change of focus.

Undeniably, these paintings may be seen as building a bridge between abstraction and surrealism, but they are essentially inner landscapes. They do not 'represent' nature, but retrace its formative principle, with 'a grasp which enables the artist to create forms that are analogous to those in nature ... That which is formed is straightaway transformed again, and if we would to some degree arrive at a living intuition of nature, we must on our part remain forever mobile and plastic, according to her own example.' This statement, from an article by Herbert Read on 'The world of John Tunnard' emphasizes the two main features of Tunnard's approach: mobility and plasticity, two qualities probably increased by his wartime occupation as an auxiliary coastguard accustomed to scanning for hidden objects.[37]

After John Tunnard had shown at the New Movements in Art exhibition at the London Museum in 1942 with Eileen Agar, he was never again to appear with any surrealists. He had never joined the group formally, and in January 1939 had exhibited at the Living Art in England exhibition under the label 'abstract'. Two months later, he showed at the exhibition Abstract Paintings by Nine British Artists at the Alex Reid and Lefèvre Gallery; while in July and August 1939 he joined the surrealists in the Northampton British Surrealist and Abstract Painting exhibition and at the Zwemmer Gallery in June 1940. Being marginal to surrealism, it is most clearly through his 'prefigurative images', to take up Wolfgang Paalen's words, that he shows surrealism's desire to measure the unmeasurable inner space. The importance of

Tunnard in his relation, at a distance, with surrealism is in the transforma-
tion of the vestiges of a world we think we know into the harbingers of a
novel vision. It is in that sense that such traces have something totemic about
them, their solid transparency situating them halfway between the material
and the immaterial, the solid and the ephemeral, the living and the monu-
mental. Tunnard's contribution to surrealism in Britain, even if it lasted only
until around 1945, was instrumental in investigating the poetic fusion
between constructivist and surrealist principles.

Grace Pailthorpe and Reuben Mednikoff

Although having bid farewell to Mesens's group, Grace Pailthorpe and
Reuben Mednikoff continued determinedly to explore the precipices of the
subconscious abyss. They first retreated to Cornwall and then left England
altogether for New York in July 1940, probably on Peggy Guggenheim's
advice. From New York they went on to California and, in the summer of
1942, to Vancouver, a city whose tranquillity might have attracted them in
the pursuit of their research. Pailthorpe was employed at the Provincial
Mental Hospital, and there they formed the Association for the Scientific
Treatment of Delinquency. Jack MacDonald, one of the rare Canadian sur-
realists at the time, has described the reputation that preceded the couple.
Pailthorpe was, he said, 'the person who liberated the prisoners from their
prison and studied the brain of the cannibals in New Guinea'. They were to
stay in Vancouver for four years.

Between April and July 1944, Grace Pailthorpe gave three talks on surreal-
ism, an exceptional event in Vancouver at the time – in fact, anywhere in
puritanical Canada, which was unused to hearing about such provocative art
forms as surrealism, especially in its Freudian form. The first, organized by
the Vancouver Ladies' Auxiliary, took place at the Vancouver Art Gallery,
with a slide show; the second was on the occasion of a joint exhibition of
Pailthorpe and Mednikoff's works; and the third was broadcast by the
Canadian Broadcasting Corporation.[38]

The radio talk was centred on the investigation into what Pailthorpe called
the 'hieroglyphic inscriptions of memories', which manifest the activity of
the subconscious. According to her, it was precisely this that interested the
early Parisian surrealists. But Breton being no psychoanalyst, the undertak-
ing was too ambitious for him, and he diverted the line of exploration thus
started towards revolutionary social action. To illustrate her argument she
used his example, the scribbling done at random with a pencil when on the
phone. She ended her explanation of the workings and function of the sub-
conscious by saying that 'surrealism has opened the aesthetic horizon by

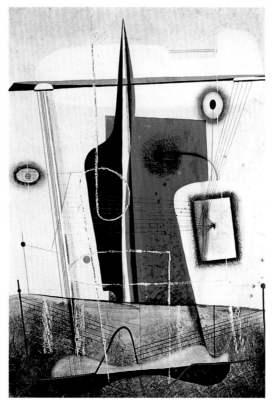

133 John Tunnard, *Composition*, 1939, 73.5 ×
54.8 cm (29 × 21.6 in.)

establishing a new conception of art' based on the marvellous and 'the
beauty of irrational thought and creation'. She invited all her listeners to
'accept the fact that fantasizing is a universal and legitimate activity every-
one is entitled to draw pleasure from', concluding:

> The works of surrealism will go on, for the liberation of man is an emotional urge in
> each of us . . . As we become more and more emotionally and creatively conscious, we
> bring the day of our deliverance nearer. The creative urge is within each of us. It is
> part of the biological rhythm, and therefore, it becomes a biological necessity that it
> should find full expression. Only to the extent that that creative urge within us is
> liberated, shall we experience individual freedom.

This was on a programme called 'Mirror for Women', which was usually
devoted to personal memories or experiences! Few surrealists would have
attacked such a committed position, however simple and proselytizing it
may sound. The press response to her was favourable. The *Vancouver Sun*
and the *News Herald* both praised the joint exhibition of Pailthorpe and

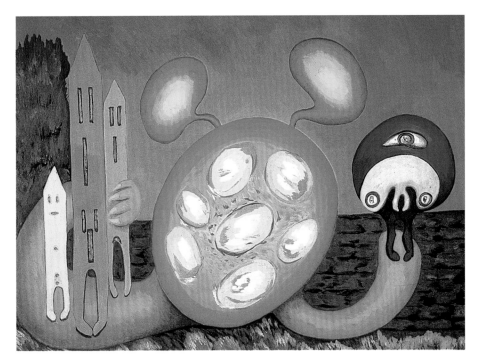

134 Grace W. Pailthorpe, *The Blazing Infant*, 1940, 43 × 57.5 cm (16.9 × 22.7 in.)

Mednikoff's work; the papers had already alerted their readers two weeks before it opened, and on the day people queued in the rain. Not everyone could get in to hear her lecture about automatism as 'the real process of thought, the expression of the subconscious', as the papers reported the next day; meanwhile, the impact of the 80 works exhibited was enormous. The *Vancouver Sun* emphasized the complex entanglement of 'the bizarre, the fantastic, the humorous, the grotesque, the fantasmatic, the nightmarish and the beautiful'. The stature, and the scientific and artistic background of Pailthorpe, the fact too that she and Mednikoff were British, influenced avant-garde circles in the rest of Canada. When Pailthorpe and Mednikoff returned to Britain in March 1946 surrealism had taken root in West Canadian art, and the message they left, that artistic activity should stop whenever the conscious seems to be dominant again, had been noted.[39]

Four works made at that time bear witness to the uncompromising purposefulness of Pailthorpe and Mednikoff's investigations. Pailthorpe's *Blazing Infant* (1940) (Pl. 134) forces the viewer, with a singular aggression conveyed by garish colours and their primary contrasts, into the deepest recesses of the body, laying bare its organs of reproduction. A wall, dark-

green grass, and trees insist on the externalization of the organic; a lush gar-den-like space, which contrasts with the solidity of the brown brick wall, emphasizes the tension between closure and opening, between law and desire. Maternal fantasy is exposed by a gaping womb between leg-like ten-tacles, one holding a uterine pouch, the other phallic claws. The ovaries, floating in mid-air at the top, the eggs floating inside the womb-like circle, the frontal presentation of male and female elements, point to desire barred from realization. The vision Pailthorpe obliges us – and herself – to accept is that of a wishful process, the temptation, and the eventual impossibility, of giving birth. The infant-to-come is ablaze with the force of censored desire.

The same fantasy, that of the impossible return to a unity made meaning-ful, is encapsulated in the more serene and thoughtful *Spotted Ousel* (1942) (Pl. 136); indeed, there is a confrontation here, between two birds astounded at each other's sight, and yet linked by a winding thread. What exactly links, or separates, them? What makes them differ? If one follows the purely emblematic umbilical cord – a zoological lie! – the spotted ousel appears to have been begotten by the bigger bird and is now being fed by its 'mother'. The birds' surprise comes the sudden realization of the difference in the colour of their plumage – the grey ousel has given birth to a spotted one! That birth, any birth, Pailthorpe would say, is the emergence of the astonish-ingly, irretrievably different. The origin of Pailthorpe's representations of her own fantasies lies in the realization of a gap which threatens identity.

Almost in answer to this, Mednikoff produced a powerful example of dis-semination and self-fragmentation. *The Little Man* (1944) (Pl. 135) is a haunt-ing monster condensing basic phantasmic fears and desires. The nose of a large face, which occupies the whole picture, grows into a ghostly half child, half hand-puppet figure. Three human beings form the base of this aerial image: one a human body lying down, the next a grinning eyeless person-age, and, at the base of the large face, a sleeping child's head formed by the projected shadows. The latter is no doubt a representation of the dreamer who sees the little man in a dream which has conjured up tutelary father fig-ures. A nocturnal emission let out on the right hand side of the face is the sign of the growing of the child into a man. In that respect, the title has to be understood at several levels. Indeed, if the boy is jocularly called 'a little man', posing as the figure on the right hand side, he also has all the qualities of a man, and the title may also refer, by a common nickname, to his penis, which he is so proud of and shows as one would a puppet. Finally, the two eyes are strikingly similar to two breasts: the little man is proud to show his penis to his mother, who is now reduced to two eyes feeding his manhood.

Defeating these literal interpretations, as confirmed by Pailthorpe and Mednikoff's notes, there is, as noticed, a singular force in the ceaseless circu-lation of the gaze, suspending itself, so to speak, in this space.

Apocalypticism

Among the few attempts at redefining man's prospect in such troubled times, and refocusing man's social, philosophical and aesthetic principles, one movement avowedly tried to 'overtake' surrealism and go further into the exploration of the mind's hidden powers. This was apocalypticism, an informal gathering of poets and artists formed on the eve of World War II, whose platform was the publication of *The New Apocalypse*.[40] The first anthology of the new movement, 'prose and verse of the new apocalypse', this was edited by the poets and essayists J.F. Hendry and Henry Treece and published by Routledge. It had black and white illustrations and a colour frontispiece by Matta. In 1946, Henry Treece published *How I See Apocalypse*, a series of essays on Tennyson, Joyce, Hopkins, Dylan Thomas, Herbert Read's poetry, and other topics that included the image and the romantic revival.[41] Between these two publications, roughly marking the beginning and the end of the movement, a number of short-lived magazines – wartime restrictions on book production were expectedly drastic – spread awareness of the new values: *Kingdom Come*, *Counterpart*, *Life and Letters Today* and *Transformation* were among the most important. Apocalypticism was presented in these various magazines as a strongly programmatic form of what has come down as 'neo-romanticism'. In the arts, the neo-romantic imagination was essentially expressed through a deliberate intertwining of the past and the future, almost above and beyond the present. In these times of moral and social hardship, the need was felt to tap the roots of the 'English soul' through English art. The immediate reality of bombed-out houses, cities in ruins and bewildered faces, provided inspiration for the movement's paintings, often commissioned by such governmental bodies as the Ministry of Information; but the purpose of neo-romanticism was to conjure up 'the spirit of the place' in a transcendentalization of the grim, Blitzed reality.

Among the most significant artists of the new apocalypse, several were friends or fellow travellers of surrealism, or merely sympathizers with it. Cecil Collins developed a mystical preoccupation with the progress of the soul in monastic, austere paintings, as in the *Fool* series, full of the naive elation elicited through contemplation; John Piper, as early as 1939, embarked on an expressionist, almost Gothic-inspired cataloguing of the monuments and architectural treasures of Britain. John Craxton conveyed a bucolic and sylvan vision of a Golden Age Britain, and David Jones invoked the Celto-Christian Great Mother of the Earth in settings inspired by Arthurian legends as well as Greek temples: both could be linked, almost by permeation, with Graham Sutherland's monstrous landscapes, his trees as spiky as crowns of thorns, all of these the representatives of a Blakean urge to find, and cling to, the traces of innocence in a world of dire experience. Equally

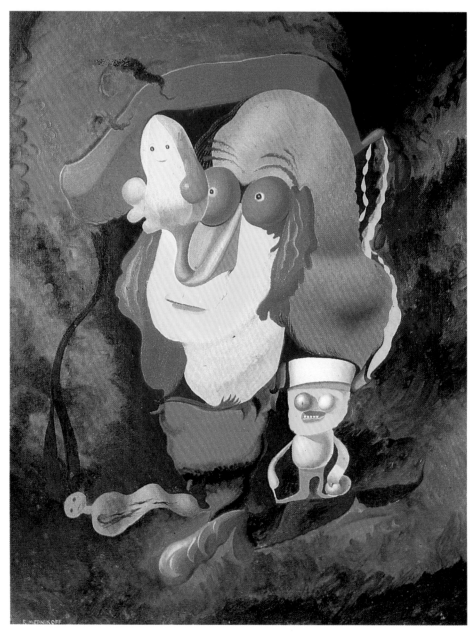

135 Reuben Mednikoff, *The Little Man*, 1944, 50 × 40 cm (19.6 × 15.7 in.)

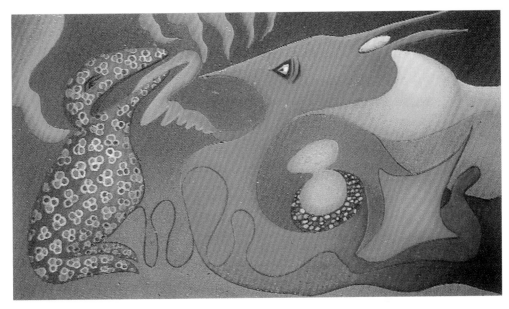

136 Grace W. Pailthorpe, *The Spotted Ousel*, 1942, 20 × 35 cm (7.8 × 13.8 in.)

important are the agonized works by Michael Ayrton showing Greek-like distorted bodies and macabre visions of a sin-ridden, decaying humanity; John Minton's metropolitan wilderness in which innocent youths wander aimlessly; and Bill Brandt's photographs of Britain under fire, and of pastoral Britain, which make two inseparable fields of vision. These artists created the neo-romantic myth as an organic endeavour, both sensual and spiritual, to drag man out of the restrictions of his temporality into a primeval, archaic past, not as escapism but as an attempt at reorigination.[42]

The differences with surrealism are obvious: the return to the origin is the return to a given vision, although lost sight of; it is vital for man, according to the neo-romantics, to retain it, to re-connect. To surrealists, every attempt should be made to go beyond given forms. Their mistrust of anything which might smack of mysticism was, in this case, justified.

In the very words of his analysis of the movement, G.S. Fraser, one of the main proponents of the new apocalypse, draws the line between it and surrealism:

The New Apocalypse, in a sense, derives from Surrealism, and one might even call it a dialectical development of it . . . It embodies what is positive in Surrealism, 'the effort', in Herbert Read's phrase, 'to realize some of the dimensions and characteristics of man's submerged being'. It denies what is negative – Surrealism's own denial of man's right to exercise conscious control, either of his political and social destinies, or of the material offered to him as an artist, by his subconscious mind.[43]

The positioning of the apocalyptics is clearly at the margin of surrealism, before tension and the principle of contradiction gather full force. The permanence of the challenge and questioning inherent in surrealist activities was underestimated by Fraser. This led him to retain from surrealism only what he termed its 'mechanical' conception of freedom, 'in which the subconscious feeds out a constant stream of discrete images, like parcels pouring down a chute.' In other words, the apocalyptics aim at helping man recover the completeness and wholeness of his existence – two recurrent terms in Fraser's text.

To this teleological concept of an eventual coherence and completeness should be added the apocalyptics' 'scepticism about political thought', expressed in a rather fuzzy belief in 'the human' and man's 'freedom and responsibility'. Their indebtedness to D.H. Lawrence and his 'Apocalypse' makes their standpoint even clearer. In the movement's anthology, *The White Horseman*, J.F. Hendry, a poet and essayist, based an article on myth on the necessity to link as closely as possible the collective desire for earthly myth and that for economic change.[44] According to this, the social 'myth' perverted by fascism and capitalism will be renewed and Economic Man will join Spiritual Man into a Whole Man. In his retrospective account of the war years, *How I See Apocalypse*, Henry Treece, dealing with the failure of English critics to understand the movement, would try to spin together the various threads of Fraser and Hendry's theoretical writings in a series of statements, most of them not at all remote from surrealist orthodoxy. Indeed, he declared that apocalypse resolutely sides with anarchism, 'an antidote to left-wing Audenism as much as to right wing Squirearchy', 'a mode of living in which equity replaces justice ... and natural law takes over from man-made law'. Yet, accusing the surrealists once more of placing madness before anything else, he writes:

Apocalyptic writing ... is the obverse of paranoia, since its movement is in the direction not of domination, but of the freedom from domination ... the Surrealist who made his eggs twang like a banjo was paranoiac, for he insisted on remaking the world in an arbitrary, casual and erratic image of himself as lunatic ... No human activity can be profitable, or even possible, in a world where watches melt down the waistcoat front, and where showers take place only *under* the umbrella! ... The Apocalyptic writer is far too serious to be merely mad. He wishes to create not a mad new world, but to look bravely on the bad old one, in the hope of seeing it a new and better way ...[45]

Throughout his recapitulory article, Treece's insistence on 'man's sanity', 'commonsense', the need to teach man 'to aspire towards wholeness' and 'to reach to the totality of experience' is clearly a reinstatement of the imperialist rationale. Surrealists could not side with such a self-limiting position, its shortcomings evidenced by the limited poetical inspiration of apocalyptic

poets, who tried in vain to drag Dylan Thomas into their midst. Only Henry Treece, Vernon Watkins, Tom Scott, Nicholas Moore and Norman McCaig can be seen as seriously sharing and attempting to develop the apocalyptic vision.

The only tangential points between apocalypticism and surrealism are found in three publications, Stefan Schimanski's review *Transformation*, Treece's magazine *Kingdom Come*, and, by dint of contributions from Robert Melville and Conroy Maddox, Schimanski's volume of prose poems, *Knight and Devil*. Melville had already contributed to the *White Horseman* an article on 'Apocalypse in Painting', in which he explored the revelatory, and organically agonistic nature of de Chirico's, Matta's and Onslow-Ford's paintings, all of them indicative of a necessary, regenerative metamorphosis. In like manner, Melville's analyses of Picasso's work had been greeted as eminently 'apocalyptic'.

Impressed by Conroy Maddox's 'anthropological landscapes', Stefan Schimanski decided to use them for his little volume of visionary scenes, *Knight and Devil*. This was published in 1942 by Grey Walls Press, whose proprietor, Wrey Gardiner, although not a supporter of surrealist writing, had always been a defender of new poetry.[45] Maddox's vertiginous drawings stole the limelight, the first publication in which his 'landscapes' were ever included.

Kingdom Come had started publication in Oxford in November 1939 under the editorship of John Waller and Kenneth Harris. From the beginning, in spite of the religious overtones of its title, it was wide open to progressive writing and surrealism. Poems by Breton, Eluard (both translated by G.S. Fraser), Charles Madge, David Gascoyne and Georges Hugnet (translated by Nicholas Moore) were included, along with articles on Mass Observation by Tom Harrisson and on current poetry by Geoffrey Grigson. When Treece and Schimanski took over the editorship in November 1941, the magazine became openly the voice of apocalypticism. Its four numbers, from November 1941 to Autumn 1943, included poems by Hendry, Jouve, Alex Comfort, Read, Heath-Stubbs, de la Mare and Sidney Keyes. However, only Robert Melville's article on Picasso's 'Minotauromachy' and Maddox's article on 'Infiltrations of the Marvellous' – an account of the function of surprise and accident in surrealist technical processes – constituted a bridge with surrealism.

Likewise, Schimanski's *Transformation* – four issues from 1943 to 1946 – grew from the attempt at a fully philosophical approach – 'personalism' – in its own right, thus linking up with the existentialist ideas of Emmanuel Mounier and Jean Paulhan in France. The general line of the review was one of benign humanism, as expressed in articles about 'the future of education', 'reflections on modern architecture', Jacques Maritain, and Nicolas

Berdyaev. Edith Sitwell, Stephen Spender, A.S. Neill, Herbert Read, Cecil Collins and Henry Miller were among the contributors to what was an ecumenical endeavour to cover all cultural fields in Britain at the end of the war.

In this series of collaborations, cross-influences, dissensions and regroupings, both the strength and the weakness of surrealism in Britain are apparent. The weakness seems intrinsic to the movement, and also part of its originality; it lies in a form of centrifugal impulse inherent in British artists, all fundamentally distrustful of any idea of group – except, possibly, Conroy Maddox. The dispersal forced upon them by the war was perhaps in keeping with their natural tendencies. Correspondingly, the two remaining years of the official existence of the group, until 1947 – at least until a short-lived reformation in the sixties – were to see a gradual dilution of surrealism's basic principles. Balancing this, the strength of surrealism in Britain showed itself in the resilience with which it found expression for itself despite adversity, officialdom and easy compromises and alliances. It emerged through magazines, manifestos, declarations, poetry writing and painting, all from the midst of war, unconnected with any frontier-scanning nationalism.

Watchman, What of the Night?:
the *Free Unions* years 1945–51

On 12 December 1944 Scotland Yard raided the premises of Freedom Press, an anarchist printing house. The police were hoping to find documents hostile to the nation or that threatened its security and gave evidence of spying activities. Among the papers that the security forces seized, were the proofs of *Free Unions Libres*, which Simon Watson Taylor had just printed. The poems, drawings and articles ready for this new surrealist review were soon declared to be coded messages and as such not to be released.

Letters of protest were sent to *Tribune*, signed by T.S. Eliot, Alex Comfort, E.M. Forster, Herbert Read, Stephen Spender, Julian Symons, the Libertarian Discussion Group and others. The authorities responded with embarrassed silence. Whereupon Herbert Read sent another letter to *Tribune*, announcing the formation of a Defence Committee, with himself as president, 'to defend the four anarchists in jail, to protest against such all too frequent police actions, and to create an Aid Fund'.[1] On 27 April 1945 three of the four who had been arrested during the raid were condemned at the Old Bailey to nine months' imprisonment for revolutionary activities, among whom was the prominent anarchist Philip Sansom, a member of the surrealist group since 1944 and a contributor to *Free Unions Libres*. On 4 May Herbert Read, in a virulent letter to *Tribune*, warned England against 'its Gestapo', and called upon the readers' generosity to contribute to the fund. In the same issue, a letter signed by George Barker, Alex Comfort, Dylan Thomas, George Orwell, Paul Potts and Nicholas Moore protested against the verdict, which it claimed actually condemned 'the teachings of Jesus, the philosophy of Kropotkin, the political theories of Tom Paine, the poetry of Blake and the painting of Van Gogh'. On 31 August Read announced that the Defence Committee's activities were to be enlarged and would henceforth include campaigning for an amnesty on behalf of those who had broken such laws as were specific to wartime, and had no other validity outside of it. When

eventually they were released and the nature of the documents cleared, it is said that the police officer who brought them back to S.W. Taylor asked how he could join the surrealist group.

The idea for the redefinition of a platform had come to Taylor in the summer of 1944, almost in order to dissipate officially all the clouds that had gathered over the group throughout the war years. On 2 August 1944, Taylor shared his plans with Conroy Maddox, then in Birmingham:

The revue will be nominally under my editorship (for purely practical reasons, I am English, free from the Labour Exchange and therefore able to accept all responsibility for contents, and I intend to finance the production of the review), but the aim is for a collective editorship. Those taking part will be J.B. Brunius, Jean Vidal, Feyyaz Fergar, and some French friends, whom you will not know.[2]

It was implied that Mesens could not actually be the editor and that Taylor was acting in the name of a group, with Mesens's blessing – a precaution not taken by del Renzio two years before. Another letter to Maddox defined the spirit of the review:

As we do not constitute at the moment a real surrealist group, it seems necessary to make some declaration of sympathy for those ideas as from a number of individuals whose interest in surrealism has brought them together. We want to avoid anything in the nature of a 'programme', the idea is to make clear the affinities and commonly held beliefs of the contributors.

The review can be seen as a manifesto, produced in a communal spirit, and gathering anarchists (most of Taylor's friends, such as F.J. Brown and Philip Sansom) together with Trotskyists (Benjamin Péret, for example), so that it should constitute a conduit for surrealist tenets. In its combination of French and English, the title is the epitome of this gathering, just as the review aimed to help re-link the group in London, the Birmingham group and the French surrealists. *Free Unions Libres* came out in the summer of 1946, with one of Conroy Maddox's 'écrémages' as its enigmatically volcanic cover (Pl. 137).

The editorial, probably written by Mesens and Taylor, called for such new organic unity as a real dialectical movement warranted between the group and the individual. It also insisted on a radical re-definition of freedom:

The concept of unity has today come to imply an antithesis to that of freedom. It is this antithesis in politics, morality, art and society that denies life, that renders fruitless and invalid so much activity and effort on all these planes, that permits an unscrupulous distortion of these words out of all meaning and recognition; and it is this antithesis that some of us, in the following pages, have determined to resolve.[3]

Any renewed surrealist activity evidently entailed a reminder of fundamental principles; *Free Unions Libres* was no forum for discussing ideas. Its inaugural text centred on a quotation from Breton's Yale speech which

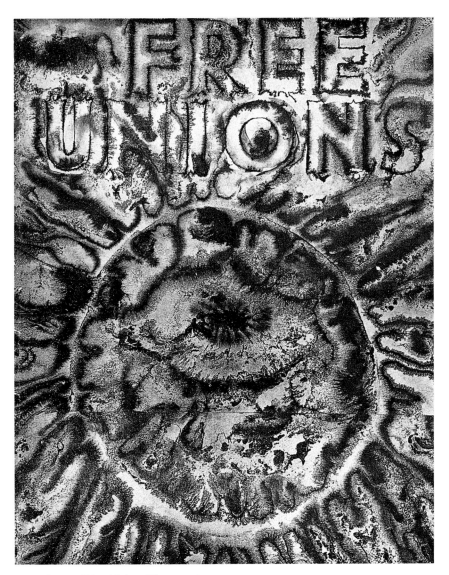

137 Cover of *Free Unions Libres*, 1946

summarized surrealism's strong belief in automatism, objective chance, black humour and practical intervention in the individual's mythical life – all basic *'mots d'ordre'* – and saw itself as 'the evidence of a creative, organic existence ... amid fossilized conceptions of life ... and the putrescence of war'. A drawing by Edith Rimmington strikingly epitomized the principles just laid out. From a truncated tree branch blossom out a bunch of four bird of prey's claws and four stems ending in huge eyes complete with eyelids and eyelashes. All that enables vision and grasping is assembled here, all that is violence and softness, activity and passivity, outward-oriented (hands, fingers, claws) and inward-oriented (the immobile eye). It is a bouquet of opposites.

The review strikes a strangely unachieved, unfinished note. Most of the material was gathered in 1944 and this may well have restricted those regrouped. It may also explain why British surrealism is strongly represented, with Conroy Maddox, S.W. Taylor, Edith Rimmington, E.L.T. Mesens, Emmy Bridgwater, J.B. Brunius and a newcomer, George Melly. The drawings are all but one by surrealists, Robert Baxter, John Banting, Emmy

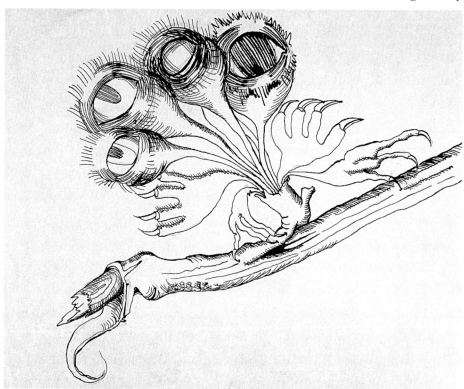

138 Edith Rimmington, *drawing from 'Free Unions Libres'*, 1946, 14.5 × 18 cm (5.7 × 7.1 in.)

Bridgwater, Conroy Maddox, Mesens, Edith Rimmington, Roland Penrose, Philip Sansom. The exception is by Lucian Freud, a satirical depiction of a straw chair with a box in which an owl with a walrus's tusks is roosting. Its ironic title, 'A Room in West Sussex', echoes the strong discrepancy between name and content.

George Melly

George Melly almost literally knocked at the door of surrealism in the late days of 1945. He had enlisted in the Royal Navy, as his brother and father had before him, but, probably through his passion for jazz and his fascination for the paintings of Blake and Fuseli, he drifted towards anarchism, avidly reading the Freedom Press pamphlets. He discovered surrealism when he chanced upon Herbert Read's 1936 *Surrealism,* which connected vividly with his own contempt for religion and bourgeois values. He subsequently wrote to the London Gallery and sent some of his poems to Mesens, a veritable cult-figure for him then. Simon Watson Taylor replied, Melly went up to London when the war ended, and started to attend the surrealist meetings at the Barcelona restaurant. Encouraged by Mesens to read his own texts aloud and dramatically, he started one day to recite a poem which contained the lines:

> You are advised to take an umbrella
> in case it should rain knives and forks

At that very moment, he grabbed the restaurant's cutlery and hurled it all into the air, to the owner's utter dismay and anger.

The two texts he published in *Free Unions Libres* encapsulate this ironical boisterousness, proving writing 'an engineer/Hoist with his own petard':

> If your brains
> were wool
> *You could not knit a sock*
> If your brains
> were thread
> *You could not manipulate a sewing machine*
> If your brains
> were dynamite
> *You could not blow off the top of your head*

When the London Gallery resumed its activities, Melly was given the job of secretary for a while. Since then, he has never ceased to give voice to the permanence of the surrealist spirit, emerging from his indefatigable jazz singing sessions to open an exhibition, write a preface, or testify to the gleam

of hope which surrealism represented for him. However disillusioned and somewhat diluted his surrealist principles may sometimes appear, he keeps the flame alive in his own prankish, unorthodox way. Melly is a surrealist *at the border*.[4]

Activity resumed

It was in *Free Unions Libres* that Mesens published the only work which he did immediately after the war, and his only collage since the early thirties. *La Partition Complète Complétée* is a complex work, begun in 1943 and completed two years later; a collage twice completed, then, as the humorous title indicates. To understand the work one must bear in mind that Mesens had started by being a musician. At the age of sixteen he met Eric Satie; in 1921, he put Philippe Soupault's poem, *Garage*, to music and he gave piano lessons to René Magritte's younger brother, Paul; then in 1923 he abruptly abandoned all interest in music.

In the light of this, the collage takes on ironical dimension, a perfect example of the desacralization of music and musical scores. A score is written to be played; here Mesens goes to the extremity of logic and plays *with* it. The first collage, *La Partition Complète*, mocked musical writing by including a flower, a feather, a razor, and various nonsensical signs as if they were notes. The score was complete because it had been *completed* with the artist's own vividly contrived notes. Yet, in that same sense, it could always be further completed. The 1945 score (Pl. 139) reaches an extreme by having its lines widened and verticalized; apart from a few fragments of staves, inverted clefs, quavers and natural signs turning into little flags, the 'music' of the score is rendered with angels in flight, lips, broken fragments of trumpets, trombones, cymbals and bugles, phrases written in odd spaces, and two hands under one of which a caption reads: 'One recognizes the author's hand'. The derisiveness of the collage originates in the deflating proliferation of intrusive images, the repeated musicalization and remusicalization of the score. Every item is the source of a specific kind of music, one jarring with the other but all of them irremediably jeopardizing the assertiveness of the title – a corrosive, self-mocking humour.

At the end of the war, Mesens took the initiative in asserting the continuity of surrealism and organizing an exhibition. Despite problems with venue – the London Gallery had been partly damaged by bombs – and the difficulty of obtaining works, 21 artists were represented with 25 works at the Arcade Gallery in Bond Street from 4 to 30 October. Paul Wengraf, the owner of the gallery, was also the editor of a series of art books and had published Robert Melville's *Picasso's Treatment of the Head*. British surrealism was represented

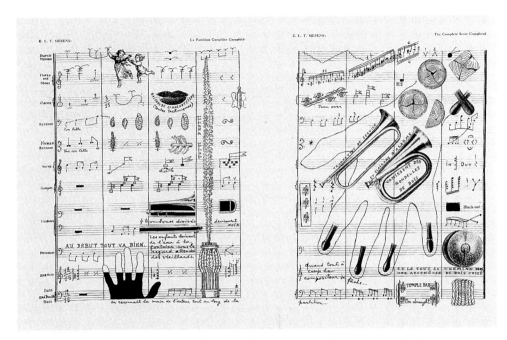

139 E.L.T. Mesens, *La Partition Complète Complétée*, 1945, 30 × 46.1 cm (12 × 14 in.)

only by Baxter, McWilliam, Penrose, Onslow-Ford and Edith Rimmington. But a well-produced small catalogue carried extracts from the writings of Breton, Read and E.L.T. Mesens, all asserting the need for a new synthesis, an inner coherence that would accommodate divergent aspirations. As Mesens pointed out, 'in the present chaos, the most individual expressions ... are the only light'. Likewise Breton, in his Yale address, had already claimed that surrealism was at a crossroads, in the expectation of a still more emancipatory movement. Better then to call upon the individual rather than the collective, upon personal invention rather than style.

This fact was reflected in Mesens's title for the Arcade Gallery show, Surrealist Diversity. It also conveyed the promise of *Free Unions Libres*, halfway between group activity and the part played by the individual. One example of this promise was Mesens's chance discovery of the 'outsider' work of 'Scottie' Wilson. With the help of Roland Penrose, Mesens put together an exhibition of 30 works by Wilson simultaneously with the Surrealist Diversity show, from 18 October to 3 November. It was almost at that same time that Breton, together with Dubuffet, was starting to see art such as 'Scottie' Wilson's as another manifestation of surrealism's free-wheeling spirit – a view which lead to the foundation of the 'Compagnie de l'Art Brut', which welcomed Wilson in its ranks from the outset.

It was a death in bizarre circumstances which kindled Toni del Renzio's hope of re-launching some form of surrealist activity. On 4 September 1945, the London dailies published the news of the suicide of Sonia Araquistain, the daughter of the ex-Spanish Republic's ambassador to Berlin and Paris, Luis Araquistain. He was a prominent member of the Committee for the Liberation of Spain, a gathering of various Spanish Republican political groups that had been based in London. Sonia Araquistain, aged 23, a painter, was staying in her father's Bayswater house. On 3 September, she went down from her room to make a phone call from the concierge's flat, even though, according to all the newspapers, her room had its own phone. Quite suddenly, after putting down the receiver, she dashed up the stairs, taking off her clothes as she went. On reaching the top of the house, she threw herself naked into the street, some eighty feet below. The peculiar link between the phone call and her own undressing, the explosive combination of Eros and Thanatos that it represented, could only intrigue someone like Toni del Renzio who was intent on breaching the laws of modesty. A few days later the papers started to debate the girl's 'perverse reading habits'. Her gesture of despair was attributed to an interest in Freud and psychoanalysis, the obvious source, they said, of her mental deviation. According to the judge's report, her fascination with dreams, which she noted down carefully, testified to her 'morbid curiosity and lack of mental balance'. Her father then revealed that she claimed 'she was the missing link between man and animal', 'had supernatural powers', and 'would give birth to a new race of immortal beings'. The judge's verdict was that it was 'a field that suits no one and that no one should wish to explore'.[5]

Toni del Renzio reacted against this condemnation of someone else's inner life. He proposed the publication of a collection of poems and illustrations in defence of Sonia Araquistain's memory, following the example of the French surrealists, who rallied in 1933 to the defence of Violette Nozières, condemned for killing her father. Del Renzio's scheme never came to fruition, but it did provoke him, and Georges Henein in Cairo, to write poems and Ithell Colquhoun to paint one of her most inspired works, *Dreaming Leaps: in homage to Sonia Araquistain* (1945) (Pl. 140).

The painting is hypnotic; the movement of the fall seems to have been suddenly arrested and eternalized at its climax. Filaments of colour, garish and sombre garlands, fragments of comets, unfolding masses of decalcomania, entanglements of intestinal ribbons of sharply contrasting colours, are suspended, like improbable peelings of a twilight sky, before they emerge into a dark brown mass. Out of this, other forms emerge and rise up, both identical to, and different from, those which were seen falling, creating a circular movement: the eternal return of the Same as Different. Fragmented by the unknowable, forms are reborn as in the alchemical process, an operation

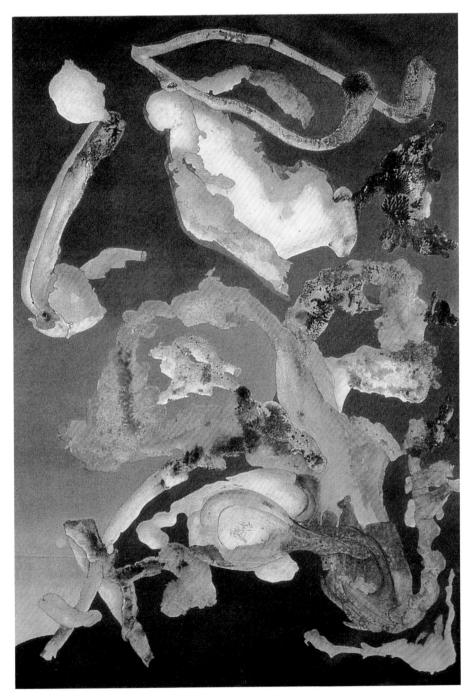

140 Ithell Colquhoun, *Dreaming Leaps: in homage to Sonia Araquistain*, 1945,
78 × 54 cm (31 × 21.5 in.)

which becomes apparent as the painting's central motif. The last three stages of the alchemical operation – exaltation, multiplication and projection – are recalled in the way the *terra nigra* in the lower part liberates brighter and brighter colour chippings from its earthiness in an ascending movement. The dovetailing of the fall of forms and the ascension of colours, of the body's descent and the rising of essences, detaches death from its finality and plunges the viewer into pure otherness. Reversing Sonia Araquistain's physical descent, it enlarges her gesture into a movement towards her own transformation; stripped of all its trappings, the subject faces its own subversion, which in reality had been denounced as a perversion by the judges, who could not realize they were giving the suicide a solemnly defiant dimension. Furthermore, the subject faces its own reversal and its dilution, its own leap into another space, a dreamscape, away from, but still in sight of, the lunar landscape in the background. *Dreaming Leaps* is a homage to the growth of the subject out of himself, which is intrinsic to the most radical surrealist gesture.

Surrealism's post-war disorientation, as revealed in the tentativeness of *Message From Nowhere* and the inconclusiveness of *Free Unions Libres*, is revealed in the gap in which English surrealism repeatedly situated itself, between constitution and self-effacement. Symptomatically, Brunius wrote two letters to Mesens, in February and March 1945, despairing at surrealism's situation in Britain and at Mesens's apparent laxity in accepting members into the group.[6] The meetings now resumed at the Barcelona restaurant, he maintained, were mere gatherings of friends rather than a base for a unified platform. To this, Mesens replied that he had never asked to be the 'leader of *nos petits amis*'; in his opinion, there had never been a surrealist group proper in England, but only a group of 'philosurrealists'. Letters between various members reveal a fundamental reticence to accept the systematic existence of a group, even as others argued that this would be the only guarantee against adulterating the movement's basic working principles. What eventually came out of the doubts expressed by Brunius, Mesens and Taylor was the necessity to reaffirm the resilience of the surrealist spirit through dialectical and even contradictory tests and trials. Surrealism was in search of a new language, one which would once again join the individual and the collective together.

The group's meetings were resumed just after the May 1945 armistice, at the Horseshoe Pub in Tottenham Court Road. On 30 August it was decided that the official name of the 'Surrealist Group in England' would be reactivated; membership would cost 2s. 6d. a month and meetings would be held every Wednesday at the Barcelona restaurant. On 12 September, Robert Baxter, Emmy Bridgwater, J.B. Brunius, Sadi Cherkeshi, Feyyaz Fergar, Mesens and his wife Sybil, Antonio Pedro, Edith Rimmington and S.W.

Taylor and his wife Sonia decided to hold public debates and resume exhibitions when the London Gallery reopened at 23 Brook Street. However, due to the slackness of the authorities, and of the building trade, only a small section of the gallery was ready on 5 November 1946, for the first exhibition in England, twenty drawings altogether, of Wifredo Lam's works.[7]

By selling some inherited property, Penrose was able to act as the guarantor of the London Gallery until the company – since this was the gallery's official status – could be properly financed. After two years' operations, in June 1948, the accumulated losses of the gallery since the reopening amounted to £4500; two years later, the lease was put up for sale. In 1951 the gallery closed, one reason being the bank overdraft, another Penrose's thorough involvement by then in the constitution of the ICA.[8]

At the end of 1946, the group mobilized itself in anticipation of the International Surrealist Exhibition in Paris. By the following April, however, Breton was expressing discontent at the British group's apathy. He was emphatic in his demand for English contributors to the exhibition:

I consider it essential that the International Exhibition of Surrealism which opens about June 20th at the Galerie Maeght, should include the work of our English friends. I beg your urgently to invite on my behalf, or re-invite:
 Roland Penrose
 John Banting
 Edith Rimmington
 Conroy Maddox
 F.E. McWilliam.[9]

With the group's manifesto required for the catalogue, Taylor's report of their hesitations shows its constitutional looseness, as well as the determination of individual members like himself or Maddox:

If Mesens in any way opposes the preparation of the manifesto I think I should consider myself free to take any independent action in the matter I thought necessary – this I have already mentioned to Brunius and Robert. I am not anxious that the English surrealists should give some sign of life on this occasion above all and I am very weary of our procrastinations and bickerings of the last few years (from which you have been blessedly free). In the last resort I shall prepare and sign a manifesto myself and circulate it to all our friends for their endorsement.[10]

When eventually written, the text, drafted essentially by Mesens and Brunius, must be seen as the last public appearance of the British surrealists as a group. Paradoxically, it is worded in peremptorily firm terms, but its signatories disbanded immediately afterwards. The manifesto began by describing the obstacles in British culture to any genuine surrealist activity. These included 'tendencies to irrationality', 'the absence in the main currents of English thought and even in everyday life of a coercitive logic' and the

'very peculiar kind of Christian moral oppression' manifested by Protest-antism and deprived of the definite contours of Catholicism. In other words, the need to form a group was felt less urgently in Britain than anywhere else. The only shared attitude, it seemed, was the refusal of any compromise with officialdom. Consequently Henry Moore, David Gascoyne and Humphrey Jennings are pilloried by the manifesto for having respectively lapsed into sculpting Madonna figures, yielding to religious iconology and accepting the OBE. The manifesto concluded by strongly reaffirming an allegiance to Breton and to the idea of the proletarian revolution. Surrealism in Britain was, in other words, adopting a predominantly defensive attitude.

The group, as an entity, was in disarray. While Conroy Maddox and Desmond Morris, another newcomer, were very much active in Birmingham, the situation in London was 'lamentable', in Taylor's words:

Apart from Mesens and Brunius, both absorbed in their different spheres, I can only rely on Feyyaz Fergar. Characters such as George Melly are, I fear, to be considered strictly as callow exhibitionists; Robert, whom I consider a brilliant and astringent critical spirit, has I believe decided to make a name for himself in the world, and I am reluctant to approach him for collaboration in an activity which would be far from lending added prestige to his triumphant progress across the intellectual world. Roland Penrose, for whom I have warm regards as an individual and an artist, seems hopelessly compromised by his fantastic manifestations of political somnambulism, waltzing with the shades of Aragon and Eluard for instance . . .

The main threat to the group, in other words, was its members' surrender to external activities. Mesens, too, admitted defeat when he wrote:

I must say . . . that I think that a rebirth of surrealist activity is not the answer. Surrealism has played a most important historical role between the wars, and produced incidentally several great painters and poets, but the new, and if anything more disgusting, psychological condition of today demands a new solution.[11]

But at the same time as this growing disorientation, over three years or so from the end of 1945, no less than 48 exhibitions were held at the London Gallery. In keeping with Mesens's spirit of exploration, it was a period of sustained revelation. Two exhibitions were landmarks in the gallery's post-war history and were symbolic of its eclecticism. In March 1947, 57 works celebrated The Cubist Spirit in Its Time; in February 1948, Three Types of Automatism collected the works of 'Scottie' Wilson, Paul Paun and Ernst Martin, to open another perspective in Mesens's exploration of the multi-form margins of surrealism.

In Mesens's introduction to the former exhibition's catalogue, it is evident that this is not some 'harmonious', comfortable retrospective. Instead, Cubism is revealed not as a 'school' or a 'style' but as the yielding to the marvellous; not an 'aesthetic' but a resistance against rationalization. Through the choice of painters, Mesens presented Cubism as endowed with

'a radiating power', 'an unsurpassed radicalism', an unencompassable variety, which should 'discourage those scholars and art historians who like to explain everything in the light of tradition'. In other words, Cubism was here seen from a surrealist point of view – as expressing frustration and outrage by those used to the faithful reproduction of familiar objects or scenes. From such an original position, it was perceived as 'the weapon to attack every aspect of conformism', which 'provided the field of reflections and researches from which sprang the automatism of the surrealists'.[12]

It was also to Mesens's credit that he organized a great number of 'first exhibitions in England'. Among these were shows of the works of the Polish Alexander Zyw, the Australian James Gleeson, the Columbian Pedro Restrepo and the Swiss Oskar Dalvit. The gallery's first one-man exhibitions included Edith Rimmington, Stephen Gilbert, Desmond Morris and Cyril Hamersma and the newly discovered Austin Cooper. Also, in addition to the one-man shows of Kurt Schwitters, Mary Wykeham, Peter Rose Pulham, Lucian Freud and Roland Penrose, was the presentation of recent works by Masson, Ernst, Miró, Picasso, Craxton and Esteban Frances. It was a formidably pioneering programme, equivalent to the earlier trail-blazing of gallery owners like Kahnweiler. Ironically, the London Gallery could also boast of not having sold a single painting or sculpture to a public art gallery in Great Britain – only to museums and private collections in Europe and the USA.

A small eight-page leaflet, an 'occasional newspaper', was circulated among the patrons and friends of the gallery, the *London Gallery News* (December 1946) and the *London Gallery Express* (March–April 1947). The latter briefly reported on a private reading of Picasso's *Desire Caught by the Tail*, an interesting gathering at the margin of surrealism, on Friday, 21 February 1947. Among the readers were Mary Wykeham, S.W. Taylor, John Banting, Julian Trevelyan, Sybil Mesens, Robert Melville and his daughter, Roberta. Musical effects were supervised by Gigi Richter – Hans Richter was still in London at the time – and the production was by Roland Penrose, who had translated the text from the French. Also, Kurt Schwitters gave two recitals of Merz poetry on 5 and 7 March, introduced by E.L.T. Mesens and Robert Melville.

In 1946, the group voiced their individual and collective fears and desires in the answers to a questionnaire drafted by René Magritte for *Le Savoir Vivre*, a publication from Le Miroir Infidèle in Brussels. The questions were these:

What are the things you hate most?
What are the things you like most?
What are the things you want most?
What are the things you fear most?

Sixty-seven answers were printed, including ones by John Banting, Emmy Bridgwater, F.J. Brown, J.B. Brunius, Ithell Colquhoun, del Renzio, Conroy

Maddox, Robert Melville, Edith Rimmington, Philip Sansom and Simon Watson Taylor. In these, a general cry rises for freedom, for the liberation from all kinds of tyranny, especially that of religion, and for the liberation of the imagination; underlying all this was a somewhat cynical belief in anarchism. E.L.T. Mesens epitomized this when, to the third question, he answered that 'six years [before he] would have replied without any hesitation: "Proletarian World Revolution"'. Contradicting what he would declare to be vital in the 1947 manifesto, he continued: 'I shall not be hypocritical enough to simulate the slightest hope in Proletarian Revolution. It is a little too late for the world. The proletariat and its leaders dialectically resemble their oppressors and their leaders.'

It is understandable that, during the post-war years, surrealists in England were preoccupied with politics. The landslide victory of the Labour Party at the General Election of 1945 ended years of Tory domination, and the social changes immediately implemented fulfilled what was materially at the centre of surrealism's social preoccupations and hopes. But, beyond this, the ordeal of the war and the collapse of cherished hopes for proletarian revolution confirmed the leanings of some group members towards anarchism or Trotskyism. In 1945, Brunius was trying to set up a Trotskyist group in London, albeit while reaffirming surrealism's independence of any constituted group or party as such. Maddox, Bridgwater, Rimmington and Melly all developed a definitely libertarian attitude as an expression of indifference to the pettifogging activities of politicians and art merchants.[13]

The Birmingham group around Conroy Maddox emerged as more dynamic than the surrealists in London. It consisted of seven regular members, Emmy Bridgwater, Conroy Maddox, John Melville, Desmond Morris, Oscar Mellor, Eric Malthouse and William Gear. The meetings were still held at Maddox's home, and most of the group regularly exhibited either at Birmingham Artists' Committee or at the Coventry Art Circle, though each of their participations was the butt of provincial prejudices. John Melville was already developing towards cubist abstraction; Oscar Mellor, on the other hand, who had arrived in Birmingham just before the war, was a convinced surrealist. The Dalí-like landscapes he painted, vast and bare, are the sites of erotic encounters and pruriently phantasmatic liberations, monuments to our physical desires. Among the members who were not strictly speaking surrealists, William Gear is probably the most famous representative, with Stephen Gilbert, of the Cobra movement. Founded in November 1948 by Christian Dotremont, a Belgian painter and poet, and Asger Jorn, a Danish artist, the Cobra movement emerged almost parallel to surrealism in its radical investigation of spontaneous and automatic gestures in painting and its stand against any kind of conformism. Its predilection for the art of the self-taught and outsider artist, for primitive Celtic and Scandinavian art, also

made it an ally of surrealism; in effect the Birmingham group duplicated the coexistence of the two main trends in French and European art at that time, surrealism and abstract expressionism.[14]

One of the first of several public appearances by the group was an exhibition by Conroy Maddox in February 1946 at the Warwick Galleries in Edgbaston. The local press was diffident, merely mentioning that Conroy Maddox was 'recording his nightmares on canvas', and that there was 'a breath of originality', though 'one man's dream may be another man's nightmare'.[15] In May and November 1947, the Coventry Art Circle, 'a group going forward', organized its 25th and 26th exhibitions. The latter was opened by Oscar Mellor and reviewed in the *Coventry Standard* with special mention of Conroy Maddox, Emmy Bridgwater and John Melville.[16] In response to both shows, letters of protest appeared in the local press; in response, Oscar Mellor and Conroy Maddox denounced the city's 'artistic ostrichism'. In February 1949 both artists showed at the annual exhibition of the Birmingham Artists' Committee which, the press declared, 'broke away from the monotonous conventionality of too many Birmingham exhibitions'. They also took part in the 29th Coventry Art Circle exhibition, again dominated by abstract and surrealist works; the latter were especially 'notable for their stark clarity of colour, but far from being readily understandable and lacking rhythm in construction,' according to the *Birmingham Post*.[17] Whatever the reaction of reviewers, the effect of controversy was bound to strengthen and underline the presence of surrealism.

John Banting and Conroy Maddox

In spite of the group's difficulties and contradictions in the first five post-war years, the written and plastic production of English surrealists reached a peak at the time, almost comparable to the achievements of the fertile years just before the war. Inspiration was undergoing a radical renewal, not only through the developing, deepening visions of Emmy Bridgwater and Ithell Colquhoun, but also through new blood that painters like 'Scottie' Wilson and Desmond Morris were infusing into the surrealist 'exquisite corpse'. Banting, Agar, Maddox and Penrose meanwhile continued with their established personal projects or concerns.

In 1946, John Banting collected various satirical drawings he had been making since the early thirties into a book, *The Blue Book of Conversation* (Pl. 141).[18] To these he added the most vitriolic dialogue imaginable between socialites, snobs and aristocrats at dinner and cocktail parties. His target is indisputably English high society, especially those who stayed at home and profited from the war. Formally dressed carcases crowd to empty glasses of

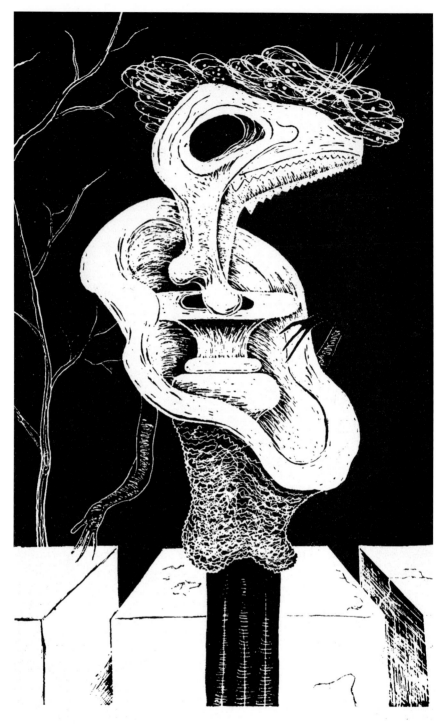

141 John Banting, *From the Blue Book of Conversation, c.* 1946, 24 × 15 cm (9.6 × 6 in.)

champagne as they kill time in vacant conversations. Texts and drawings are both printed in blue, not only to justify the humour of the title, but also to stress the cold cadaverousness of the figures. Heads are reduced to jaws and indiscriminate, pelvis-like bones; skulls have fangs and teeth; postures are rendered ridiculously affected by the inversion of forms; limbs are as thin as ropes and twigs, most of them evoking objects such as armchairs, vases or three-legged tables. Furniture is thus made to speak the words the reader sees on each facing page; alternatively high society figures are turned into decorative furnishing pieces with no more soul and no more life. Their improbable names indicate things rather than beings, transforming their bearers into people from a no man's land: Lady Crevice Raikes-Bagge, Mr Lapelle-Patel-Bullshire, Valda Prouffington, Mrs Fuchsia-Stingwing, who complains about her health ('My congested cestodes have nodules and yellow larva with vaso-motor pressure on the fins . . . '), the old Baroness Orr ('monotonous hag is allowed extremely far snorffling hungrily, marvellous Bone-flowering') and Lady Turquoise Tuckroe. Words, uttered in short, sparse, lethal statements, shape the speakers' faces and bodies into the forms of scavenging birds – vultures or jackdaws. Banting's two prefaces to the book are self-explanatory. The first of the following statements was written in 1935, the second in 1944:

Let us enjoy the spectacle of the dead burying themselves, denying with laughter our needed help as an arm pushes up the earth to collect more earth upon itself . . . At last, tuck in any left-out twisted arm, or it will rot and stink at you with love and kisses for ever.

None of the types in this book are imaginary, but none of the individuals represent any one person. The vistas unfolded are pre-war, pre-time and, no doubt, post-war.

Meanwhile, Conroy Maddox had embarked on a long exploration of the plastic equivalent of hysteria. His collage-painting of 1946, *Warehouses of Convulsion* (Pl. 142), in *Free Unions Libres* was a symptomatic work which throws light retrospectively on his previous paintings. It shows an accumulation of coffin-like rectangular boxes, inside which he has arranged photos of naked women in diverse positions, their faces showing fear and panic. These bodies, or bodily fragments, seem to rise, left to right, as if liberated from their boxes. The collage seems to indicate the creation of a convulsive space in which bodies are tensed between law and desire.

The act of looking as something reciprocal also structures *The Conspiracy of the Child* (1946) (Pl. 143). Two little girls, evidently twins – the inverted images of each other in colour, hair and skirts – are standing symmetrically at the same distance from a crazy, fanged contraption. One is halfway up a stairway, the other in a door she has just opened. Their likeness compels the viewer to try to bring them together, were there no trap in between, where

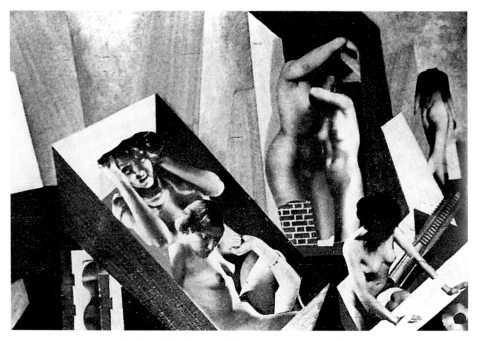

142 Conroy Maddox, *Warehouses of Convulsion*, 1946, now lost

the gaze founders. The undermining of natural order and logic is completed by the inexplicable billowing of an absurd, useless curtain on the wall, and the maimed perspective of the landing at the top of the stairs. Above all, owing to the extraordinary similitude of the trap's phallic prongs and the folds in the girls' skirts the three 'protagonists' coalesce into one paradoxical image: the child conspires against itself, as it conspires against any other person who might enter through one of the doors only to fall into the trap, as the two little girls anticipate. Meanwhile, a wind of unresolved desire swells the curtain, blowing also for the spectator in his quest for meaning.

In these instances, the Same is *convulsively* separated from itself: in the backyard of our minds, one is divested of oneself, a witness of one's own fragmentation. Convulsion is the expression of the deep desire to reach the Other in the hope of reaching and meeting up with . . . oneself. The doubling and multiplication of the gaze's object is precisely that flight of the onlooker which Maddox mentioned in 'The Playgrounds of Salpêtrière', 'your flight [which] was thought to be the riddle of the birds' migration, since it was you who fashioned freedom, who dreamed exclusively of yourself dreaming'.[19]

Maybe this is the reason why Conroy Maddox used a female pseudonym to sign two of his texts, as a kind of distancing through which to realize not only oneself, but one's otherness. One of these, *Aesthetic Dissection*, is indeed

a clinical text which, through the stylistic form of the litany, multiplies the body of a child, denying its supposed unity:

> My child whose body is clay pigeon
> > whose face is shorthand typist
> > whose mouth is a folio of psilothron
>
> My child with grass in her eyes
> > with padlocks in her hair
> > with her back to the wall
>
> My child who is quicksilver
> > who is crazy spectre
> > who is the Eve of St Agnes
> > who lives in the open air market of St Malo.

The second text, *Uncertainty of the Day*, splits words and reshapes reality into an uncertain combination of abstract and concrete. The last line ironically judges the whole text:

> Blood is uniformly spread out over the staircase
> the curtain is holding a dagger
> each breast is unarmed and detached from the body
> each breast is the same shade of gas light
> [...]
> a marble lion recumbent has the face of a sham magician
> it is fast approaching the incredible[20]

Maddox's pseudonym here echoes this general convulsiveness. 'Jeanne Santerre' is not only the feminization of the name of the dispossessed king, but it comments on its author's absent territories: no land means no body. The French-sounding name may also be read as an almost nonsensical 'Jeanne s'enterre', i.e. Jeanne buries herself, disappears into the ground, in an inward movement towards the centre of self.

Dénouement (Pl. 144), a remarkable object made by Maddox in 1946, is just as symptomatic of his post-war work as *Onanistic Typewriter* was of the pre-war period. The *knots* of meaning created in the title are inextricable. Inside the lid of a wooden box, a dagger pierces the shreds of some white garment; a breast can be glimpsed through one of its holes. A piece of clothing hangs from a hook; next to it are two eggs and, further away, three more eggs, all in egg cups ... Life and death, Eros and Thanatos, are echoed in the box itself with a photo of Conroy Maddox assaulting a nun, a phallic finger pierced with a pin, a small crucifix, and a newspaper cutting about 'jailed monks'. Is the top part the outcome of the assault shown below or vice-versa? Seen as a whole, the object is somewhat Gothic, pointing up the violent activity of a repressed mind at the moment that it celebrates the liberation of its fantasies.

From about the same period comes Maddox's staging of an 'entertainment' about a nun. First he had her drink from a beer bottle, then smoke a

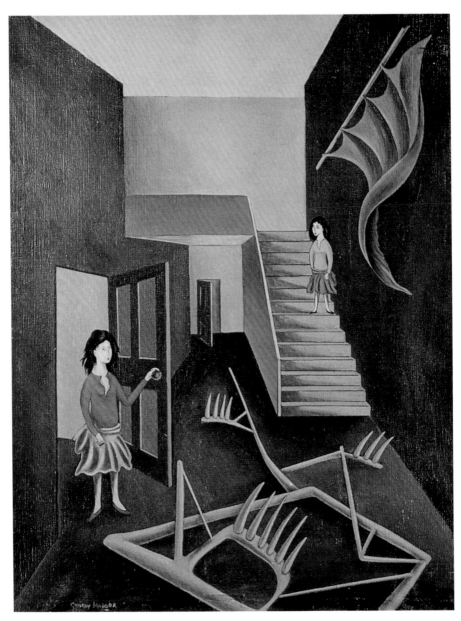

143 Conroy Maddox, *The Conspiracy of the Child*, 1946, 100 × 65 cm (39.3 × 25.6 in.)

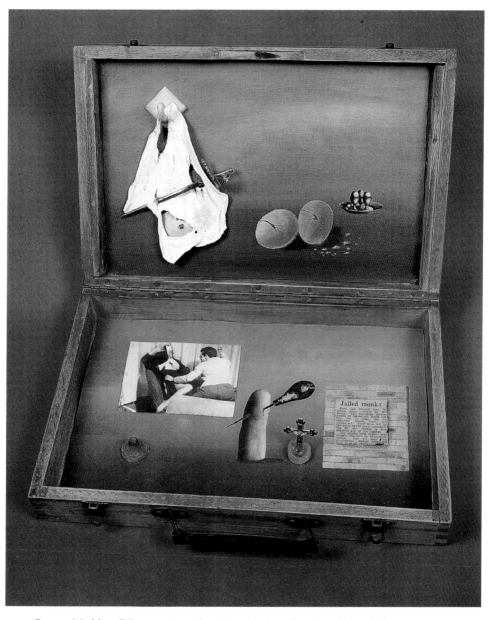

144 Conroy Maddox, *Dénouement*, 1946, 21 × 33 × 36 cm (8.2 × 13 × 14.1 in.)

cigarette; then he struck, strangled and stabbed her, but only after she had bared a leg. It was also at this time that he published 'Notes on the Christian Myth', in *Free Unions Libres*; its repeated argument against the 'scatological and masochistic symbolism' of religion is summed up in this statement:

Only on the basis of an attitude that renounces once and for all the monstrous values of Christian development will it be possible for man to achieve the fullest consciousness . . . The history of Christianity is the history of a creeping sickness, for submission and obedience before the fear-imagery of priestcraft humanity is offered the dubious honour of being clasped to its filthy bosom.[21]

Aphorisms on art, psychoanalysis, poet-painters and poetry are interspersed among these violent attacks. All militate for 'the liberation of the image no longer impeded by the mechanism of that which is within us, any more than that which is outside of us', 'mechanism' being what links the forces of repression.

Of all Conroy Maddox's formidable output in this period, especially his many collages, one of the most interesting is *Watchman, What of the Night?* (1981) (Pl. 145). This work centres on the return of bodies to the place where they originate in the dark night of desire; technically, it represents an extension of the double focusing at work in the paintings.

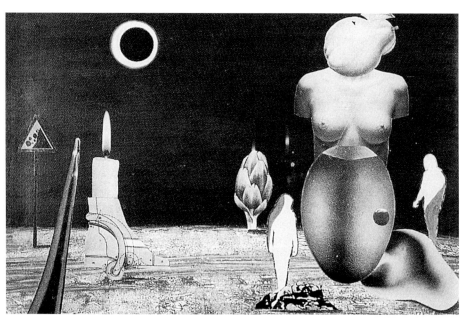

145 Conroy Maddox, *Watchman, What of the Night?*, 1981, 27 × 41 cm (10.6 × 16.2 in.)

Emmy Bridgwater

In Birmingham, Emmy Bridgwater spent the post-war years charting the territories of origination and death. Her fascination with the intertwining symbolism of the bird, the egg and the eye reaches a climax in the paintings she did between 1945 and the mid-fifties. All are haunted by the demise of the body.

In her paintings of the early forties space is where nothing really holds, and everything circulates, having been deprived of any origin; it spirals and diffuses. This developed into an insistence on the joint presence of the opposing forces of life and death. Bridgwater's paintings become an acknowledgement of bereavement as a force which precipitates man to the brink of himself. *Transplanted* (1947) (Pl. 146) is an example of her investigation into the detachment of the body from itself. A face slipping away from itself and the dovetailing of human, animal and vegetal parts create an opening inwards; the image is being displaced from itself. It becomes the place of its own transplantation towards its own depths. The plural meaning of some green ear-drops – fruit, seedbags *and* earrings – the similarity in shape of leaves and eyes, the changing of a sharp nose into a bird's beak prepare us to see the opening of the mouth and the penetration into the face as devoid of stability: indeed, the face is even slipping away from the neck to which it was attached. The general process of decentring will recur in Bridgwater's work as the means of disturbing both the eye and the mind.

Bursting Song (1948) (Pl. 147) explores the intermediary in a complex way, through the superimposition of an eye on a huge egg, supported by wooden stays. Two birds, whose egg has outgrown them, are walking among the debris of its shell, either reconstructing it or bent on its destruction. The power of this painting comes from the feeling that Bridgwater is taking us to the very source of the process of origination, between what is already made and what is about to be made. The egg and the eye are both places of inception, of opening and closing, of strength and fragility. The bird itself condenses this double force: its lightness and apparent vulnerability contrast with the phallic sharpness of beak and claws. A text Emmy Bridgwater wrote in *Free Unions Libres* in 1946 is a precise allegory of this. 'The Birds' is divided into three paragraphs; in the first, birds are flying at a window, trying to get into a king's palace; in the second, they fly at a girl's lips, attracted by their redness; the third paragraph brings together the little girl and the birds:

'Sing a song for the King. Come on, now. Sing!' The child was shy to start, but her mother, standing behind her, gave her a little push which startled her into opening her mouth and she began, 'Wasn't that a dirty dish to set before the king.' 'Begin again dear,' whispered her mother, 'at the first line.' 'O.K. ma,' and she chanted, 'Four

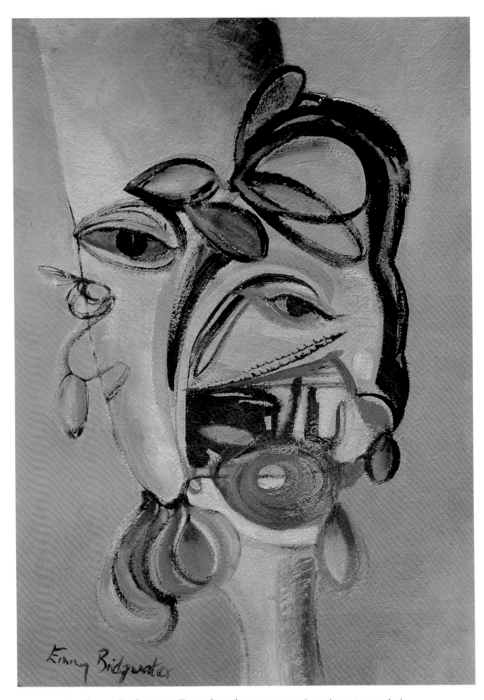

146 Emmy Bridgwater, *Transplanted*, 1947, 52 × 36 cm (20.5 × 14.3 in.)

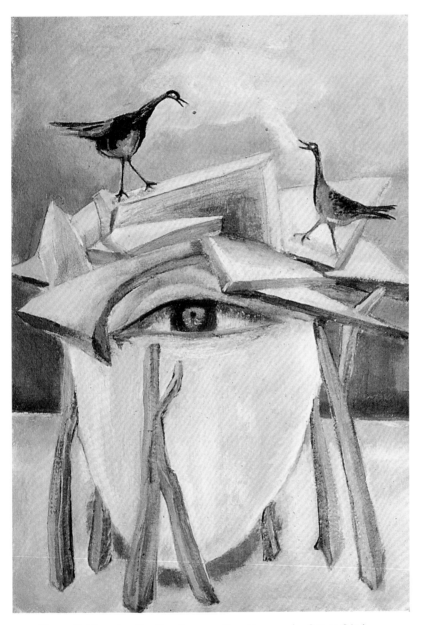

147 Emmy Bridgwater, *Bursting Song*, 1948, 53 × 35 cm (20.8 × 13.8 in.)

and twenty Black . . . oooH' for a peacock had walked in front of her and spread out its tail and croaked 'Frico. Frico.' The little girl went very white. 'Frico. Frico,' she said. The birds, who had been sitting on the cornice as part of the decoration, flew down into the court and circled about the heads of the King and Courtiers, fluttering as close as possible. All the people flapped their hands helplessly. Suddenly the little girl pointed at the King. 'You must get out of here,' she said in a grown-up voice. 'This is their Palace.'[22]

The subtle tension between innocence and experience, female and male, the erotic and the lethal, the fragile and the powerful, birth and death, liberates the mind, in surrealist terms, from all sorts of dualism. Bridgwater's birds are allegorical agents of the original fracture, to be re-enacted over and over again, of the walls of authority, whether sexual, social or political.

Edith Rimmington

Together with Emmy Bridgwater, Edith Rimmington helped re-launch the surrealist vision, by not fearing to tread the margins of life and death. She was an outstandingly powerful visionary *provocateur* whose images, once seen, can hardly be forgotten: there is about them something beyond dispute and subliminal.

The Oneiroscopist (1947) (Pl. 149) is one of the icons of British surrealism. Through its network of incompatibilities and evidence, the spectator evolves a vision by which he endeavours to see everything *except* what is presented to his eyes. A bird-like creature on a jetty lives a strangely liminal life, between having already plunged into the sea and having not yet plunged into it. A ladder epitomizes these two possibilities, immersion and emergence. The rest of the painting is inextricably double: the left and the right sides of the floor are different; the bird is between firm earth and water, above and below the clouds, between solidity and liquidity, just as it is double in itself; indeed, one foot is a bird's skeletal claw, the other wears a diver's heavy shoe. A hosepipe and helmet have been prepared for the impossible: never will the creature's beak fit into the helmet, however open the little window may be. Being an oneiroscopist, i.e. an observer of dreams, the bird cannot but plunge into the water; that is its function. But it won't, because it can't! Its body is arrested, suspended between the possible and the impossible, and the cloak it wears may well cover a full body or hide total emptiness. Plunging into the sea is superseded by plunging into oneself.

What, then, does the eye really see? What is the actual object of vision? No answer can be given, since perception is necessarily fragmented by its object – that is the lesson of *The Oneiroscopist*. *Museum* (1951) (Pl. 148) is another work that recounts the eye's loss of power. The head of a Greek or Roman

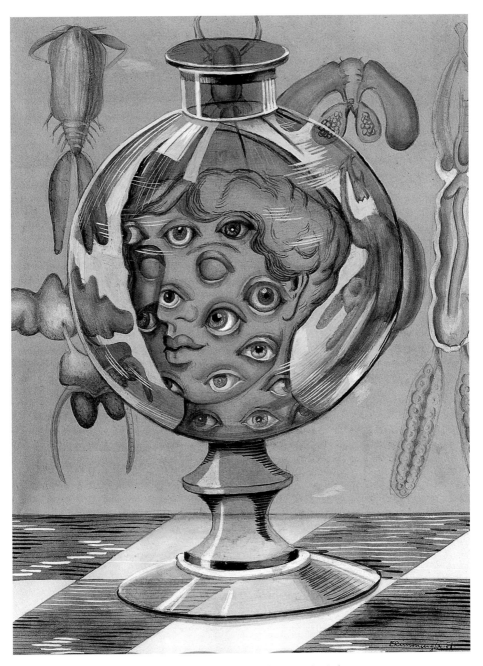

148 Edith Rimmington, *Museum*, 1951, 64 × 48 cm (25.2 × 18.9 in.)

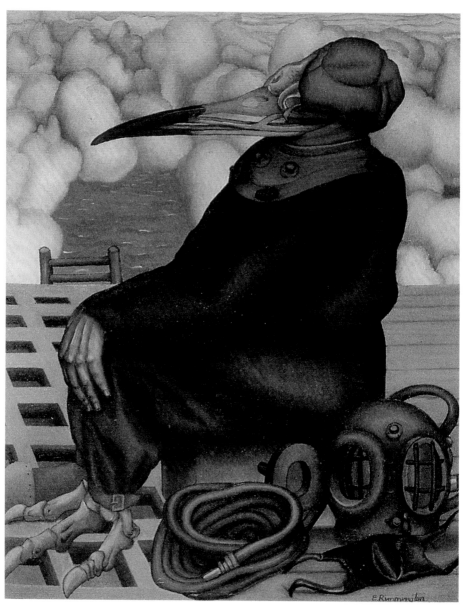

149 Edith Rimmington, *The Oneiroscopist*, 1947, 51 × 41 cm (20 × 16.1 in.)

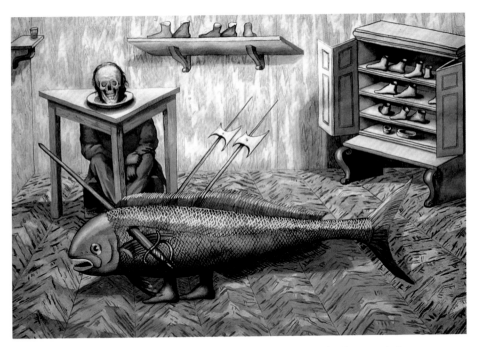

150 Edith Rimmington, *Mythical Composition*, 1950, 53 × 74 cm (20.8 × 29.1 in.)

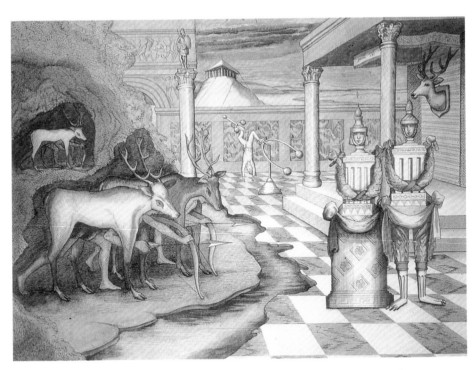

151 Edith Rimmington, *Polymorphic Interior*, 1950, 34.3 × 50.8 cm (13.5 × 20 in.)

statue has been placed in a glass bowl; all around, animal and vegetable fragments looking like larvae, insects and the sexual organs of plants hover, as it were. Twelve open living eyes float on the head, contrasting with its own blind, dead eyes. The organic fragmentation is inseparable from the multiplication of eyes, the infinite division of the gaze. This is increased by the paradoxical placing of the statue's head inside the bowl, whose narrow opening at the top suggests this is impossible, like in three-masted ships built from matches inside a bottle. The eye is confronted with a material impossibility and its endeavour is of no avail: it will always be incomplete, and it will never see its object completely, just as it is incapable of grasping the *reason* for what it sees – the price to be paid for remaining free. From the closed, constituted body of the museum, living, primitive natural forms, independent of all bodies, will always escape.

Two earlier paintings by Edith Rimmington address themselves to the question of vision in a very complex and cogent way – *Mythical Composition* and *Polymorphic Interior*, both produced in 1950. What articulates *Mythical Composition* (Pl. 150) is the tension between the forces of natural life and those of a stifling, artificial power. On the right-hand side, a King and a Queen are mere pawns on a chessboard, dead bodies in an interrupted game. They have become indifferent to the revolt, both animal and human, on the left-hand side, and the trophy they have hung above their thrones has come back to life, from beyond death, from beyond the river of Hades. Stags on the left hide the hunters who have killed them and covered themselves with their skins; they advance towards, and aim their arrows at, the royal figures, prisoners of their squares. The myth of Actaeon comes to mind; he was killed by Diana's dogs when he happened to see her bathing naked. She changed him into a stag and had his dogs turn against him. In this work, the myth is reinterpreted as Actaeon's rebellion. Bodies are disguised, emptied, made double, by contrast with artificial bodies made of stone, wood or flesh. Emblematic of this sidestepping of law and order, an acrobat in the background is held by the feet in a contraption which spins him round, just as our eyes are propelled from one item to the other. At the very centre of the space, he sums up the various games played by the eye when looking carefully at the painting: hunting, chessplaying and a strange game of torture. Bodies lose their powers and their very nature.

Such violence where bodies are the authors of their own fragmentation reaches its logical conclusion in *Polymorphic Interior* (1950) (Pl. 151). They originate in the emergence of what overcomes their organized unity, in the libidinal, the deathly, the perverted. In this painting, the corner of a room is open onto the inside of a cupboard full of shoemaker's lasts, as if upon the letting out of ungraspable secrets. A fish's body signifies both lack and excess: lack of its natural element, water – derisorily hinted at in a blue

square painted on the floor – and excess through its having feet and 'walking' even though pierced with spears and halberds. This twofold tension is echoed in a skull placed on a plate, like John the Baptist's, while its body under the table is in no way that of a dead person. Within this perturbed, cryptic interior, the body has no sustained existence; it no longer *takes place*; and anyone wanting to find a meaning is undermined.

Roland Penrose

By the late forties, Roland Penrose had become a prominent public figure, as founder and head of the Institute of Contemporary Arts. Just before the war, the idea had occurred to various artists and critics, such as Herbert Read, Peter Watson, J.B. Brunius and E.L.T. Mesens, of creating a centre that would bring progressive poets, writers, musicians, actors, scientists and painters together with as large a public as possible. The reopening of the London Gallery in November 1946 revived this idea, with the hope that 'a closer bond would be established with a resuscitated surrealist movement in Paris'. In 1947, helped by a small group of avant-garde artists and other supporters, Penrose managed to launch the Institute of Contemporary Arts. Its first exhibition was held in the basement of the Academy Cinema in Oxford Street – a haunt of the British surrealists before the war. With a degree of help from the Arts Council, the ICA became a largely independent preserve of exclusively modern art, an achievement entirely due to Penrose's determination. Its first important exhibition in 1948 was Forty Years of Modern Art, followed a year later by Forty Thousand Years of Modern Art, a critique of established rules and conventional good taste, which attracted both considerable crowds and academic indignation. But despite Penrose's unceasing opposition to insular indifference he soon had to give up control of the Institute in order to save it from financial difficulties that arose from its deliberate isolation.

Penrose's paintings in the forties take a turn away from imaginative figurativeness in favour of the angular shapes of the early thirties. Thick expressionistic brushwork and a Picassian treatment of the human figure redefine the subject as a place of passage and a moment of transformation, as in *Black Music* (Pl. 152), painted in 1940. Against a dark background, we see a confused entanglement of sharp lines, curved wing-like shapes, transparent planes and sharply defined forms emerging from various spots. On this there appears to rest a guitar with two huge clefs, the top of its handle turning into floating hair. The eye roams through evocations of birds, fire, animal organs and geometric constructions, along an upward movement that has been brought to a momentary halt. In this perfectly balanced construction, every line, however incidental it may seem, is effective, oxymoronically

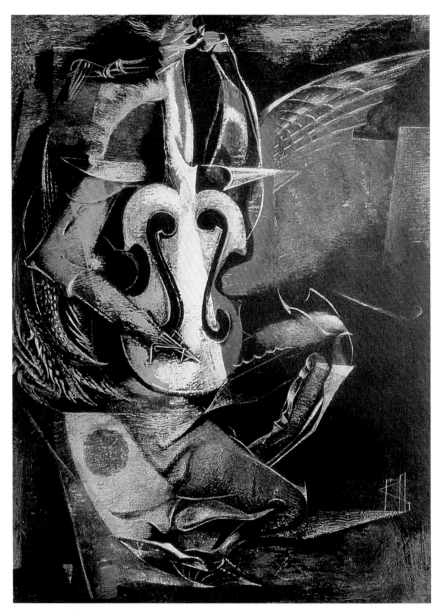

152 Roland Penrose, *Black Music*, 1940, 61 × 45.7 cm (24 × 18 in.)

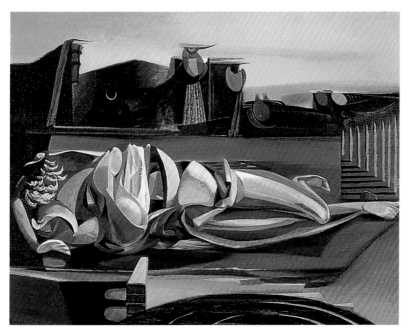

153 Roland Penrose, *Unsleeping Beauty*, 1946, 59.8 × 75 cm (23.5 × 29.5 in.)

linking sharpness and softness, heaviness and lightness. Music attempts to disentangle itself, so to speak, from a mass of darkness, staring at us through the clefs of the guitar. The darkness prevailing here, as in other works of the same period like *Night Orchestra* and *The Dance*, is not only that of the Blitz black-outs, but of one's descent into the underground territories inhabited by the mind's regenerative forces. Music is central to darkness, both as conveyed by the instruments in the picture, and by the rhythmical interplay of its lines. Penrose's paintings of the time are nocturnes, testifying to a deep, resistant energy reminiscent of the concerts given by the pianist Myra Hess in London to a silent, serene audience while German aircrafts droned overhead.

In contrast, the bright colours of most of Penrose's end-of-war and post-war paintings coexist with splinters of hard reality. *Unsleeping Beauty* (Pl. 153) was painted in 1946 when Penrose accompanied Lee Miller, shortly before their marriage, to Arizona, where she went to see her publisher. Among the friends they visited was Max Ernst in Sedona near Phoenix, where he was living with Dorothea Tanning. Ernst had become acquainted with the Hopi Indians and the visit to their reservation was a revelation to Penrose of the deep connection between art and magic. There are evidences

of his trip in the striking *Unsleeping Beauty*, especially in the landscape with its background mountain range, but also in the mountains' inclusion of an Ernst-like female figure. This sleeping body is fragmented into horn-like parts, suggesting an awakening to a new life in the arcane regions of the mind. Breasts, hair, clothes, face, arms and legs, each living a life of its own, are taken by surprise at the moment of separating from the whole, above a blue square that serves as a couch from which they rise. The picture implies a movement from left to right, as if the wind blowing over the wide plains from the totem-like mountains was buffeting the figure, as though it were part of the landscape beyond.

Penrose's artistic activity after the war was both varied and intense. Overall, it achieved a synthesis of his previous inspirations and 'styles', with the difference that he was now guided by an interior *poetic* necessity. *First View* (1947) is a lyrical blue and gold homage to Lee Miller while she was expecting their son, Antony, who was to be born on 9 September 1947. In it, the fruit and the vegetal connotations in the breasts of a body, and the transparence of a womb seem to have drawn in to them all the body's softness. *The Red Seal* (1949) (Pl. 155) is built on a tension between interior and exterior, left and right, upper and lower parts, apparently concentrated in the eponymous round seal. But a rising shape on the right seems to be that of a seal, in the other meaning of the word, playing with a leafless twig. A crescent moon at the top of the painting liberates lines of force which, precisely, go through the two seals, linking them to draw out the pun. *Question and Answer* (1950) (Pl. 154) is a humorous confrontation of two hollow 'faces', one free of expression, the other endowed with aggressive spikes. The impossibility of identifying the question and the answer is the key to an infinite visual and mental exchange between them. Penrose also produced numerous gouaches and collages, mostly from postcards, at the time. In addition he made two small terracottas as homage to the fertile plastic possibilities of clay. All reveal the range of his essentially surrealist motives, in his effort to recombine the motifs and colours, but especially the light, of his previous works in oneiric and abstract compositions.

This is the spirit encountered in the few poems by Penrose. One, a fragment published in *Message from Nowhere* in 1944, blends fantasy and squalor to achieve a vision of futurity, in a world 'blocked with the bones of history' but where 'coral each morning will flower from dusty windows'. It ends:

> Youth has been dissolved
> Youth clothed in governmental dung
> Is used to stir the craters of the future
> Unique piebald universal the blood
> That hammers the tune of its new masters
> New masters still crowned with the vultures they love.[23]

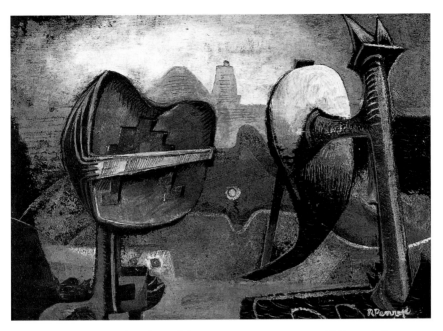

154 Roland Penrose, *Question and Answer*, 1950, 20.3 × 29.2 cm (8 × 11.5 in.)

Although the English group was disbanding, Penrose sustained a link between them and the French surrealists. Two years after marrying Lee in the spring of 1947, and after his son's birth, he bought a Georgian farmhouse in Sussex. It became a haunt of friends of modern art in Britain and beyond. F.E. McWilliam proposed redesigning the garden to include all the sculptures Penrose had accumulated; and among the many visitors were Jean Dubuffet, Georges Limbour, Max Ernst, Bill Copley, Man Ray, Picasso, Dorothea Tanning and Henry Moore, who all at one time or another praised Penrose for his loyal friendship. In 1958, Penrose published *Picasso, His Life and Work*, a book based on interviews conducted on his various visits to Picasso and Jacqueline; it was followed by books on Man Ray (1975) and on Tapies (1978). In 1956, Penrose was appointed Fine Arts Officer at the British Council in Paris for three years, which helped him renew links with Miró, Le Corbusier, Matta, Michel Leiris, Oscar Dominguez and Zadkine. As a final contribution, in 1967, he helped to organize a surrealist exhibition as part of a Festival of Modern Arts set up in Exeter by John Lyle, Conroy Maddox, E.L.T. Mesens and J.B. Brunius, which for a short while succeeded in launching new surrealist activities. By then, his responsibilities at the ICA had already started to estrange him from any genuine surrealist involvement. The conscience of British surrealism, Penrose was also a luminary of modern art in Britain, who believed in the essential *aristocratic democracy* of art.

F.E. McWilliam

Upon his return from India, where he taught life drawing in New Delhi while serving in the army, F.E. McWilliam still attended some of the meetings at the Barcelona restaurant, but surrealism as an organized movement was too restricting for him and he no longer found it attractive. Before changing the point of departure for his sculpture from the idea, as before the war, to the actual media – soon to be wire armatures and bronze – McWilliam made several stone carvings from 1948 to 1949 which take up and, to a certain extent, enlarge upon, his pre-war theme of the 'fragmented head' and 'missing limb'. One of them, *Head in Extended Order* (1948), (Pl. 156), is a major work, which looks towards Magritte's splitting of a female nude in the painting *La Vérité Eternelle*; McWilliam's piece juxtaposes an eye, an ear, a nose with an eye attached to it, and a pair of lips, in a satire on 'the time-honoured practice in art schools of presenting sculpture students with cast fragments of Michael Angelo's *David* for copying'.[24] It is interesting to note that, after a period of more straightforwardly representational work, McWilliam, 'an inventor of styles', in Roland Penrose's words, will return in the late seventies to the surrealist principle of making a demand on the viewer to reconstruct an image, both visually and mentally, thus playing with both the humorous and the mysterious qualities of paradoxes.

Eileen Agar

Eileen Agar did not paint much during the war, largely due to shortage of materials and the instability of everyday life. She served first as a fire-watcher on night duty, and then worked in a canteen in Savile Row. It was only towards the end of the war that she resumed painting full time, encouraged by the success of a one-woman show at the Redfern Gallery in Cork Street in 1942 and a few group exhibitions in London and other cities. These included New Movements in Art in 1942, with Nash, Tunnard, Ithell Colquhoun and Henry Moore.

The painting fundamental to the end of this period is entitled *Caliban* (1945) (Pl. 158), an ironical comment on the civilization the war had brought to the brink of hell. In a reassessment of the Shakespearian character, Agar endows Caliban with the chthonic forces of vegetation and growth. He is turned into an emblem by the dominant green and brown of the earth, a dovetailing of vegetable and organic forms within his head, and a blending of heaviness and lightness, of materiality and essence. Agar plays with the substance of things as she plays with colours to intimate a suspension of

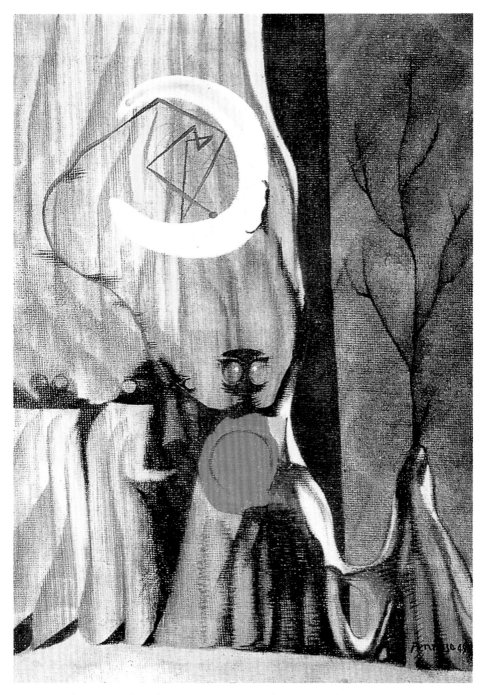

155 Roland Penrose, *The Red Seal*, 1949, 35 × 25 cm (13.8 × 9.8 in.)

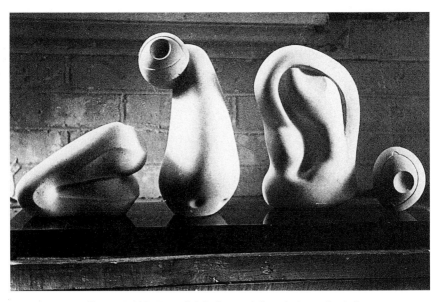

156 F.E. McWilliam, *Head in Extended Order*, 1948, length 60 cm (24 in.)

time and becoming. In *Garden of Time* (1947) (Pl. 157) a similar tension under-
lies an ascending, majestic spiralling upwards of fragments. As a *hortus con-
clusus* – indicated as such by an oblique line on the left – it is a scene of joyful
confusion. Two femora and the skeleton of a hand begin unfolding towards
fern leaves, an opening corncob and a huge waterlily leaf. Their motion
embraces animal traces – those of a lizard or chameleon, and a cat's skull. In
this cyclical movement, the eye is arrested by two evocative geometrical
shapes, one a spiral, the other one the letter 'x', linked by a fern leaf. We pass
from vertebrates to invertebrates, from zoology to botany, from life to death.
The surface of the garden comes back on itself and on its own mystery,
through two inorganic, apparently symbolic signs. One is musical, the other
mathematical, but both are visually and formally linked to the general
unfolding at work, to a slow opening outwards.

Agar's compositions, whether collages, objects or paintings, all derive
from the forms of the natural world. These she redistributes, reidentifies and
renews on backgrounds which recall both the mould-soil of forests and the
proliferating bottom of seas and oceans. She swims between two worlds, the
material and the mythical, the conscious and the unconscious, the present
and the past, in an eternal present.[25]

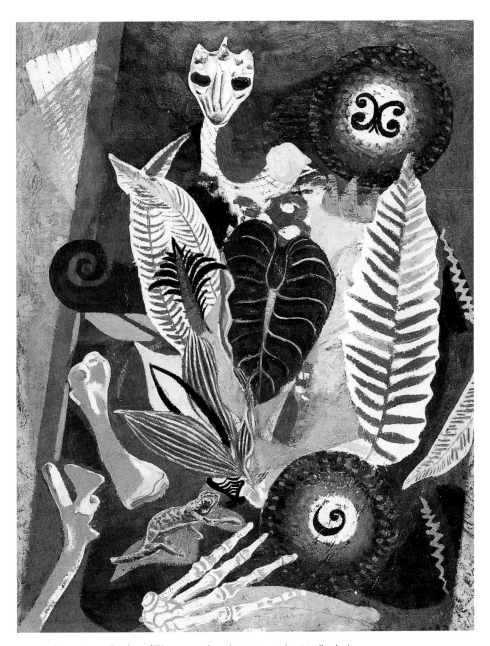

157　Eileen Agar, *Garden of Time*, 1939/47, 63 × 47 cm (25 × 18.5 in.)

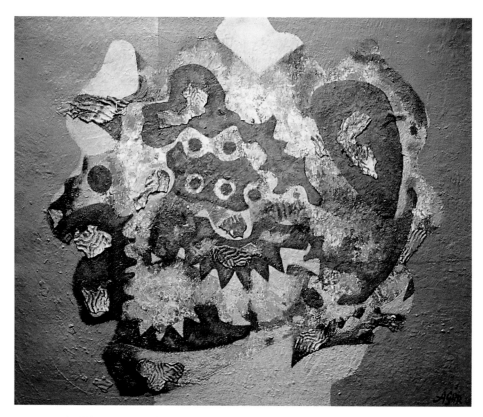

158 Eileen Agar, *Caliban*, 1945, 51.5 × 61.6 cm (20.6 × 24.6 in.)

Samuel Haile

In Devon and Cornwall respectively (but with no connection between them) Samuel Haile and Ithell Colquhoun both worked unceasingly to keep alive the inspiration which had brought them into the surrealist group before the war.

Haile had been demobilized from the Education Corps late in 1945 after being concussed in a motorcycle accident. In 1947, he moved from Bulmer in Suffolk to a house and workshop in Devon which had been left vacant by his fellow potter and teacher, Bernard Leach. He was planning to make salt-glazed pots. At the same time, he was also earning a living by 'working for the Rural Industries Bureau, to whom he was attached as pottery consultant, visiting small workshops and helping them to adapt to the post-war market'.[26] Returning from a visit to one of these, he was killed in a road accident in 1948.

In Suffolk, Haile renewed contacts with Mesens and often went to London,

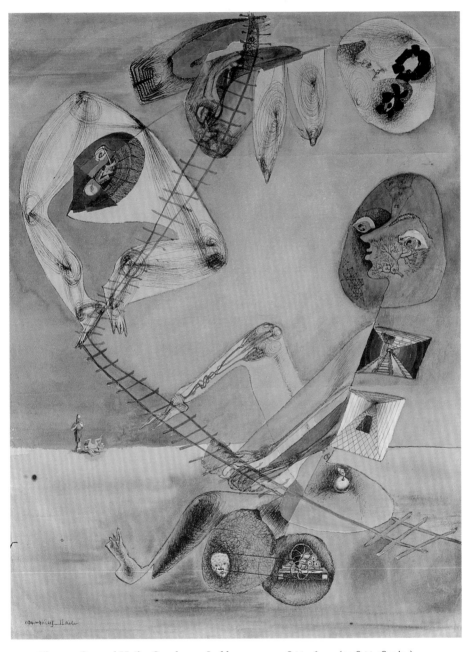

159 Thomas Samuel Haile, *Couple on a Ladder*, 1941–3, 58 × 46 cm (22.8 × 18.1 in.)

staying at Edith Rimmington's and meeting with Sybil and Edouard Mesens; he also exhibited a number of gouaches at the re-opened London Gallery. Nonetheless, he felt that group activity, especially in London, kept him from the work that most engaged him. *Couple on a Ladder* (1941–3) (Pl. 159) and *A Children That Has Gone to Cheese* (1943) (Pl. 160) are two typical works, full of strong, wry humour. In the former the two sides of a ladder are flanked by male and female fragments – testicles, breasts, eyes, genitals, buttocks – caught at the exact moment when they detach themselves from their bodies, distorting and revealing some form of diabolical internal machinery. The eye has no choice but to fold like the ladder and dissipate itself like the bodies, on the brink of falling into, onto and away from, each other. Similarly, *A Children . . .* shows bodies changing totally, woman into man, man into woman, their substance liquefying into empty shapes and ghostly contours. The title comes from *Finnegans Wake* and is in itself a challenge to grammar and sense. Within the title's words, meanings are interchangeable, children given the breast will turn to cheese, in the same way as milk turns into cheese once absorbed by children – or should we also read 'chaldron'? The couple's 'unnatural' condition prevents conception and negates their very function, pointing to impotence in the male and sterility in the female. Though a recurrent theme in Haile's work, in no way is it misogynist or phallocratic; it simply sings a lament over the loss of balance between male and female principles and the subsequent helplessness of reason.

In Haile's war-time and post-war works, the eye is made to circulate through a superabundance of shapes and meanings; indeed he designed his painted and graphic work much as he did his pottery. Largely inspired by the pre-Columbian and Mexican art he encountered during the war at Ann Arbor, Michigan, lines wind their way into contemporary aesthetic preoccupations with the suspension of meaning. In the same way, Haile's pottery stands between the mythical past, exemplified by his use of medieval shapes, and contemporary interrogations, as if to uncover the secrets of creation through telescoping historical forms together with timeless designs. He will remain the lost child of English surrealism.

Ithell Colquhoun

Ithell Colquhoun was a special case in that the nature of the surrealist group could be defined precisely by her distance from it. Never reintegrated into the group she nonetheless pursued a determined research into the subconscious. Because of the British surrealists' failure to regroup properly after the war, Colquhoun can still be seen as a genuinely surrealist spirit, whatever her growing interest in occultism, (comparable to Breton's at the time). As a

possible expression of the link between surrealism and interest in the occult, her membership of cultish groups such as the David Order, the Breton Gorsedd and Aubin Pasque's Fantasmagie group in Brussels, with whom she exhibited from 1959 onwards, was preceded by a spate of drawings based on techniques which all explored the hidden potential of automatism.

From 1947, Colquhoun investigated visions brought about by such technical strategies as decalcomania – she had started using this in the early forties – superautomatism, fumage, parsemage – in this, the surface of the water is covered with tiny coloured particles of chalk – stillomanay – 'an offshoot of decalcomania produced by a splash of ink, or paint on paper or canvas then folded down the middle' – frottage and entoptic graphomania. All were attempts at reproducing the dark, secret, flowing voice of the subconscious. In an article, 'The Mantic Stain', written in 1947, she sees in these 'techniques' the quest for the always elusive primeval image.[27]

What the angel reveals in *Guardian Angel* (1946) (Pl. 161) in anticipation of these explorations is an inner emptiness which turns out to be either the entrance to a grotto, the gateway into another world, a huge mouth with an enormous uvula, or two rounded transparent buttocks – or could it be the opening of a woman's genitals gaping wide apart. The eye slides between one meaning and another, dividing itself in the image of a huge ocular hole that comprises two gaping sockets. The eye and the mind are thrust towards a new threshold of perception, where they encounter the Gorgon – the title of a very similar work done at that time – and her petrifying stare.

This confrontation with the sources of creative forces was entirely in keeping with Colquhoun's occult investigations. Much later, in 1977, she exhibited a series of designs for a Tarot pack, 'both personal and traditional', under the name 'The Tarot as Colour'. It was accompanied by the following text, which incidentally pays homage to the pre-war work of Gordon Onslow-Ford and Esteban Frances:

This design renders the essence of each card by the non-figurative means of pure colour, applied automatically in the manner of the Psycho-morphological movement in surrealism. The pack is traditional in following instructions drawn from the texts of the Hermetic Order of the Golden Dawn. It is, however, distinct from the figurative pack evolved in the early days by MacGregor Mathers and his wife Moina for the use of their students.[28]

A technical description of the hierarchies in the cards follows, extending down, or up?, from the Aces or Roots of power, together with an account of the attractions between the words. Colquhoun eventually links this with cosmic phenomena:

After I had completed the pack, I saw some slides showing nebulae in outer space and the birth of stars. These recalled my designs and confirmed my conviction of their cosmographic function.

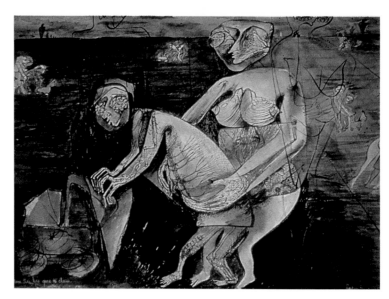

160 Thomas Samuel Haile, *A Children That Has Gone to Cheese*, 1943, 33 × 26 cm (13 × 10.2 in.)

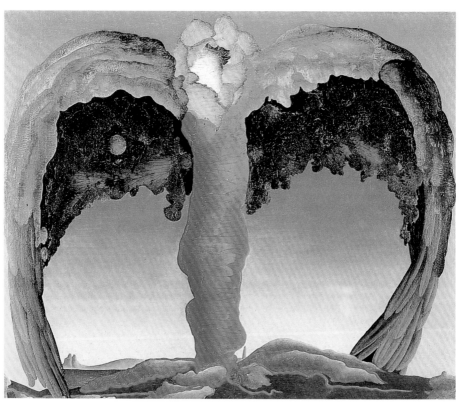

161 Ithell Colquhoun, *Guardian Angel*, 1946, 32 × 36.5 cm (12.5 × 14.4 in.)

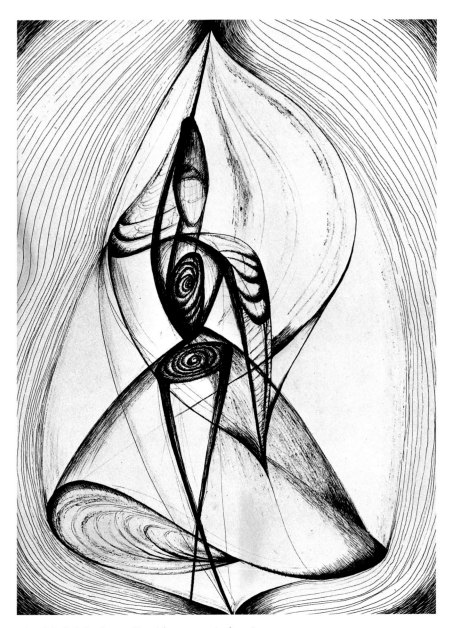

162 Ithell Colquhoun, *Dervish*, automatic drawing, *c*. 1952, 44 × 31.25 cm
(17.5 × 12.5 in.)

In *Grimoire of the Entangled Thicket* (1973), a sequence of poems and draw-ings, she published 'a set of tree-month poems in which the Gaelic tree-alphabet is associated with the lunar months, a most ancient system revealing the heightened faith of our early ancestors in the natural triad of the moon'.

Ithell Colquhoun fully realized where the mainspring of her visionary inspiration was situated: half way between the chthonic and the cosmic, the material and the spiritual. However, she showed a tendency towards ready-made interpretations of the world, towards the mystical, not to say religious, reading of natural phenomena. This tendency, which she acknowledged, was sufficient to bar her from being a surrealist, in the sense of having an exclusive commitment to the emancipation of the mind and the freeing of the imagination from any closed system. However, her use of the technical strat-egies of surrealism, such as decalcomania or automatism, corresponds to its concern with means in its insatiable quest for superior knowledge. Ithell Colquhoun is the alchemist of English surrealism. At a lecture for the mem-bers of the AIA in 1948, after dismissing all contemporary painting in England as valueless, she predicted that the future lay only with 'automatic marks and stains'.

'Scottie' Wilson

Almost at the moment when the war ended, the surrealist territory was expanded by the arrival in London of 'Scottie' Wilson. The first fifty years or so of his life, as documented by George Melly, are as extraordinary as any adventure story.[29] He was born in Glasgow, or possibly in the East End of London, as he once confided to his doctor. His family had received the name of Freeman from an immigration officer who couldn't pronounce their real name when, some time in the last 25 years of the nineteenth century, they landed in Hull from Lithuania. His father had been a taxidermist's assistant, or a furrier, or both, and 'Scottie' Wilson had left school at the age of nine; thereafter he worked as a newspaper boy, then became a street trader. At eighteen, he joined the army. When war broke out he was apparently sent to Ireland with the Black and Tans, but deserted after refusing to follow orders. Changing his name, he went to Canada where, after working as a tradesman selling tinned meat and jam, he settled in Toronto with a stock of scent bot-tles and old fountain pens that he had accumulated.

In his small shop cluttered with junk, waiting for unlikely customers, he would fall to drawing almost at random on a large piece of cardboard on the desk in front of him. It became an obsession, and between about 1928 and 1934 his doodlings developed into designs and pictures. Enthusiastically

taken up by a Mr Douglas Duncan, and Professor Norman Endicott of the University of Toronto, he compulsively covered dozens of sheets of paper with the now characteristic fine parallel strokes, making cones, faces and objects which floated in the air or were arranged in organic shapes. In the late thirties he exhibited in various small galleries, was included in the National Exhibition at the Toronto Art Gallery in 1941, and also showed in Montreal and Vancouver. Rather than choosing conventional galleries and selling his works, his practice was to hold 'silver collections to pay for the costs and buy new material'.

No particular reason is known for his return to Britain but he arrived in London in late 1945. He soon became acquainted with Mesens, probably through Penrose, who quite by chance had walked into a deserted wallpaper shop on the sea front at Scarborough which 'Scottie' Wilson was using for a self-promoted exhibition. Mesens immediately set up an exhibition of 30 works, parallel to the Arcade Gallery show in October 1945 (see p.276), and Penrose bought up entire bundles of drawings. Travelling exhibitions followed, set up by Wilson himself: visiting Aberdeen, Cardiff, Blackpool and Devon in a little van at the back of which he would place a gramophone and a loud speaker, pin up a few of his drawings and put a plate on a small chair or table so that people could give money in exchange for one or two drawings – none of them framed.

In December 1946, Mesens organized another exhibition at the Barcelona restaurant and on one of his trips to Paris he showed Breton some of Wilson's works. Wilson was then included in the Galerie Maeght International Surrealist Exhibition in June 1947 and was subsequently introduced to Dubuffet.

In the first text in Britain on Wilson's works, a leaflet issued for the Arcade Gallery show, E.L.T. Mesens quotes Wilson himself: 'My work is a life's dream', and adds:

A dream in which constantly meet, intersect or are born the memory of a fountain in Glasgow, elements from North American Indian totemism, flower spirits and fish spirits: things seen and things felt.

Mesens's words are a fair summary of what can be read in these works. In an article for *Horizon* six months later he stressed Wilson's *primordiality*:

A man who has refused to be a slave of our chain-civilisation; a very simple man, indeed, and who has achieved his own liberation. Not with the light of the spirit nor with a clever interpretation of materialism, but with the discovery, for himself and through his own means, of drawing.[30]

That year, no fewer than 350 of Wilson's works were on show in Newborough and Scarborough; in February and March 1948, Mesens's Three Types of Automatism exhibition at the London Gallery presented 46 works

by Wilson, and by the following year he had become much sought after, showing at the Gimpel Fils Gallery and others. Yet he steadfastly maintained his independence, never hesitating to sell his drawings for sixpence or so outside a gallery that was showing his works at a conventional price. Throughout his life he unflinchingly sustained a deliberate, total disregard for the art establishment.

The fascination of Wilson's works springs from the sensation of a compulsive organic process of growth working tirelessly behind the entanglement of forms, even behind each little stroke. The hypnotic arrangement of motifs makes his creatures seem to emerge from a trance which directly communicates with the viewer. We are confronted with the uncanny expression of a liberated unconscious, a spontaneous yielding to the automatic voice in total innocence of what it *might* mean.

What the hundreds of tiny strokes of the pen attest to is a gnawing desire to exhaust the source of inspiration. The energy behind this process is what materializes in each form. It soon becomes evident that these forms are in no way predetermined, and that a fish or a bird is not in fact being deliberately represented. It is rather that the strokes follow some inclination of their own, so that they happen to build a particular form, which is only then identified

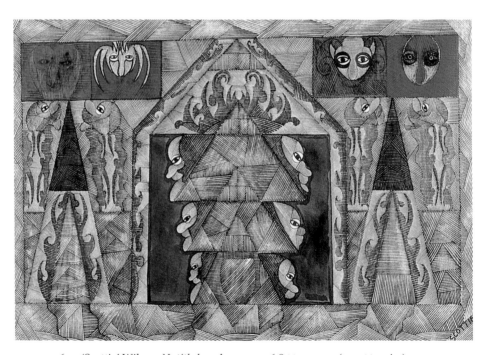

163 'Scottie' Wilson, *Untitled*, early 1950s, 36.8 × 53.3 cm (14.5 × 21 in.)

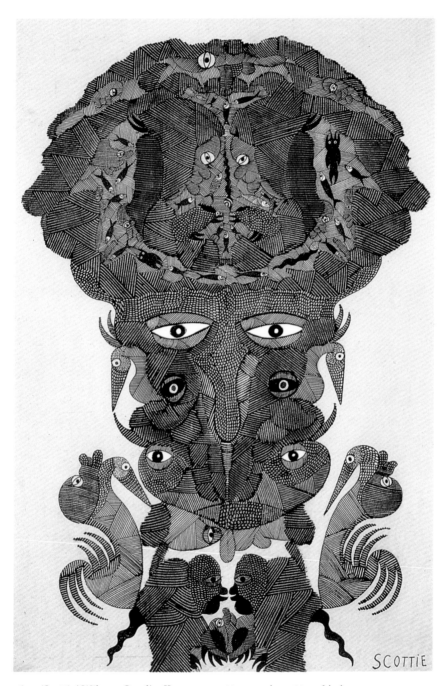

164 'Scottie' Wilson, *Greedies II*, 1950, 45.5 × 32 cm (17.9 × 12.6 in.)

as a bird or a fish. Our vision is inverted in that the eye rises from the inside of the jostling strokes to the 'outer', contoured identity of the forms, many of which cannot be linked to existing objects, animals or plants, but only exist by themselves. The forms in Wilson's drawings are all dependent upon variations of pressure, on the tiredness felt by the wrist as the image emerges, helped by the gradual slackening of attention. In *Greedies II* (1950) (Pl. 164) and *Untitled* (Pl. 163), a work of the early fifties, the same strokes give birth, almost unwittingly, to birds, fishes, flowers and faces. Eyes lend themselves, as provisional organs, to this or that bird, where they are likely to become also the eyes of a human face containing, or contained in, the bird's body . . . There is something obsessional in the solemn, hieratic symmetry of all his characters, in all these fishes, birds, trees, and faces with enormous noses staring at us – seen as a recurrent, ever-repeated self-portrait. The eye is led 'away from the familiar to a new world whose "spatial" limitations do not correspond to its actual vitality',[31] limitations indeed which are exceeded by that very vitality. We are more specifically led to a world of legends, myths, children's tales, between an Edenic world and a hellish, infernal one, a world which comes to the surface every night, haunting our sleep . . .

A battle is going on here. Among those drawings made from 1945 to the fifties, it was clear that 'Scottie' Wilson was fighting against what he felt to be forces that threatened peace and serenity. The use of black ink increases in the early fifties and as the fight intensifies between the sinister-looking Greedies and the angel-like, happy-go-lucky clowns. Little is known of Wilson's private life, even less of his own mental and spiritual preoccupations, so that his work cannot rightly be examined in relation to biography. His pictures constitute a record of personal secrets which, like hieroglyphs, require deciphering, calling us into the gaps between individual strokes and the resulting figures. Each drawing rises from an interior space halfway between the individual subconscious and the collective unconscious, in an effort to exorcize the forces of evil and their grotesque apparitions. Wilson's mind is the battleground for a struggle with itself, clinging to its self-fabricated archetypes while seeking an idyllic, Edenic scene.

Critics have noted the striking resemblance of Wilson's drawings to the Indian totem poles he had seen in Vancouver Park; in the same way, 'his extraordinary imaginary flowers have been equated with those he may have seen in South Africa, his buildings compared with the architecture of India where he served during his early army years'. We may indeed accept this, but, as he himself remarked: 'Yes, that's true, but the totem poles are *my* totem poles.'[32] One should remember that totems, far from representing anything specific, were believed to guard and protect an interior space from trespass and violation. In practically all the drawings, an obsessively phallus-haunted face reappears. Could this be a hint of the secret with which

Wilson ceaselessly struggled? The only answer is in his own joking comment on his works: 'A Chinaman does them for me.'

Desmond Morris

In contrast to 'Scottie' Wilson's fellow-traveller status, Desmond Morris was probably the only important newcomer to surrealism in Britain during the late forties, and he infused the movement with a new inspirational force. His official entrance into surrealism was a joint exhibition with Cyril Hamersma and Joan Miró, organized by Mesens at the London Gallery in February 1950. Regrettably, the group's dispersal obliged Mesens to close the gallery in early 1951, depriving Morris of a place to make himself known. It is therefore due to his own dedication and perseverance that Morris's impressive pictorial production has to be seen.

At the time of the London Gallery exhibition, Morris was 22 and studying zoology at the University of Birmingham. He was already attending meetings held at Conroy Maddox's home. His passion for painting appeared at the same time as an interest in the observation of animal life. Realizing that the subtleties of living organisms, even of a simple feather, could never be recreated in painting, he turned towards 'all the painters who refused to be slaves to the so-called objective representation of the external world, such as Paul Nash, Henry Moore and Graham Sutherland'.[33] Without any technical advice or training, he completed 150 pictures, eventually destroying a quarter of them, within three years, working in a greenhouse he had converted into a studio in his parents' garden. In January 1948, he showed his works to the public for the first time at the Swindon Arts Centre. Apart from Mervyn Levy's comments on his 'visionary powers', the critics were hostile. Nevertheless, Morris showed his 'fanatical monstrosities' again in August 1948, when one reader of the local paper pleaded for the paintings 'to be burnt in a furnace'.[34] In February 1949, he exhibited with Maddox, Emmy Bridgwater, John Melville and others, under the aegis of the Birmingham Artists' Committee. He was soon introduced to Mesens, who was impressed by him and invited him to take part in an exhibition he was mounting for the Belgian Summer Festival in 1951 at Knokke-le-Zoute. In the spring of 1952, having moved his studio from Swindon to Oxford, he exhibited alongside 'Scottie' Wilson at the Ashmolean Museum, showing a film he had just made, *Time Flower.*[35]

From the very beginning, Morris's work has been iconoclastic. His reaction against academicism and representational painting found expression in disrupted 'portraits' and human figures, reminiscent of Picasso's face distortions and the hypertrophy of selected details. But seeing this work as too derivative, he subsequently destroyed many of these paintings. In 1947, he

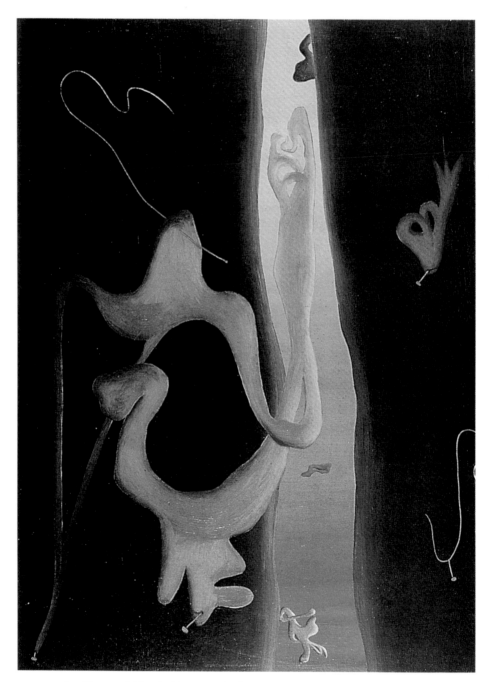

165 Desmond Morris, *Entry to a Landscape*, 1947, 50 × 40 cm (20 × 16 in.)

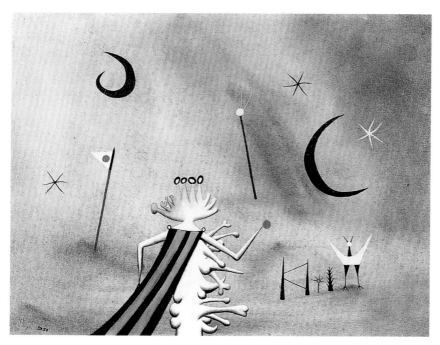

166 Desmond Morris, *The Progenitor*, 1950, 30 × 40 cm (12 × 16 in.)

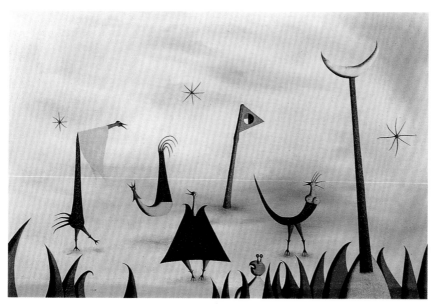

167 Desmond Morris, *Endogenous Activities*, 1950, 52.5 × 77.5 cm (21 × 31 in.)

completed an oil, symbolically entitled *Entry to a Landscape* (Pl. 165), which became the starting point of an exclusive exploration into the world of bio-morphs. On its way out of a world of darkness, a slimy tentacular shape is detaching itself from a wall, as other shapes have apparently already done, and moves away into a clear horizonless territory through a vulva-like inter-stice that 'bars', or 'opens', the whole surface of the painting vertically, split-ting it into two. This work liberated Morris's inspiration and opened the path towards the deeply buried, ancient past, not only a personal one, but also that of mankind at large – a collective biological unconscious. *The Progenitor* (1950) (Pl. 166) marks a further step into the elaboration of an 'archetypal' landscape. A kingly, mammary-encumbered figure in the fore-ground appears to orchestrate the dance of moon-crescents, stars and sticks in a horizonless space, with the appearance in front of him of a bird and geo-metrical 'plants'.

By 1951 Desmond Morris had succeeded in opening a new pictorial space akin to the space revealed by automatism. The links with objective reality had been severed, and if erotic bodily fragments, such as eyes, breasts, mouths and sexual organs, still appeared in his work, underlying his compos-itions was the play with lines and directions of vision as well as the staging of strange half-animal, half-human encounters. Morris's mind became not a *diss*ecting table but a *res*ecting table, where perfectly identifiable parts of ani-mals and humans are grafted onto imaginary bodies, each form being thus suspended in an intermediate space between zoological, biological reality and mythopoeic re-creation. In *Endogenous Activities* (1950) (Pl. 167), a non-chalant movement refers to secret and faraway stories, a paleontology of the mind. *Fear of the Past* (1957) (Pl. 168) confronts us with a radical prehistory, with cephalopods aghast at a six-legged dinosaur-like creature which passes between the legs of an eyeless, faceless body. These scarcely identifiable creatures, with their evidently ritualistic quality, have to be seen as stages in their own imaginary history, and also as stages in the child's pictorial elabo-ration of human and animal likeness. Both, one echoing the other beyond time, are made to coincide, especially in the propitiatory poses of their pro-tagonists. The work expresses the hope of rediscovering the fundamental, magical signs of creation, the secret of the artistic gesture. References to cave-painting, through simple contour lines and the use of decalcomania for brown-greenish backgrounds, evoke a return to origins, the emergence of images and mirages from the point of separation from chaos.

For Desmond Morris, the act of painting makes the painter *and* the onlook-er move back towards a protohistoric, pre-language state. When Joan Miró visited him in 1964, after he was appointed Curator of Mammals at the London Zoological Society, Morris had a huge python coil around his visi-tor. This encounter with the living image of the primordial – for what animal

is more elemental than the snake? – exemplifies the interpenetration of the scientific and the aesthetic, which has been at the core of Morris's surrealist painting since its earliest days. Morris's surrealism is also characterized by a yielding to his inner voices, a total surrender to one hemisphere of the brain and the concomitant blocking-out of the other which ensures his refusal to compromise. Nothing is allowed to reduce his desire to retrieve the meiotic moment, when the self is caught at the centre of a web of dissimilation. Zoology recast in various totemic figures is here turned into fantasy.

This is what his poem, *Exotic Heads* (c. 1949) seems to say in its sustained disruption of the relationships between objects:

> Exotic heads and unhappy unicorns
> trample the antlers of the polar saucers
> in the husband's library.
> The fiddle on the floor is sitting
> in front of the fire
> without noticing the flower
> in the chimney
> and outside the air is crowded with boulders.
> Squares of hairs are singing
> in parallel
> with no particular aim in view
> and the suicides
> on the edge of the interminable armchairs
> are feeling bored.

To regain pure active vision visual codes have to be suspended. One way to achieve this is to start by separating the object which is seen from the subject that sees it. Thus the former soon recovers its inner energy, severed from the mimetic tendency of the average person's way of perception. In Desmond Morris's world, the present yields to a temporality born of the concrete images surging up from the hidden places of the mind and passing, to quote Breton, through a 'resolutely wild' eye.

What is remarkable about surrealism in Britain in the late forties and early fifties was that it remained active and attractive in spite of confusion and disorientation. Without doubt the movement boasted in the London Gallery a magnetic centre, which drew to itself a host of young artists. Whatever the quality of their commitment, which depended a great deal on Mesens's own conviction at the time, they kept surrealism going; in due course, it was to resurface once a structure had been provided. That was to be in 1967 when Mesens, Brunius, Maddox and a newcomer, John Lyle, decided to reconvene old friends and welcome younger artists, on the occasion of a surrealist exhibition and the launching of a surrealist magazine with the eminently programmatic title of *TRANSFORMAcTION*.

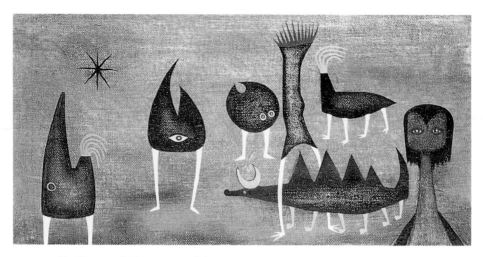

168 Desmond Morris, *Fear of the Past*, 1957, 17.5 × 35 cm (7 × 14 in.)

Postscript:
the search for a fading prospect

The desire to explore the marvellous, to delineate a new area of awareness, was explicit in the title of an exhibition which took place in Exeter in April and May 1967, The Enchanted Domain.[1] As well as E.L.T. Mesens, J.B. Brunius, who had settled in Britain after the war, and Conroy Maddox, now a Londoner, its organizers included a newcomer to the group, John Lyle, a bookseller on Deanery Place, Exeter, and a figure who was about to inspire British surrealists to return to the art scene for the next ten years or so.[2]

The exhibition, to which was appended a show of paintings by the so-called insane, was the centrepiece of a huge festival of modern arts, featuring lectures, filmshows, discussions, plays, teach-ins and readings, all connected with surrealism, and enjoying the participation of some of the most prominent post-war French surrealists. The festival opened with a lecture by Roland Penrose on 'Picasso and Surrealism'; this was followed by the private view of the exhibition, opened by E.L.T. Mesens, with informal speeches by Robert Benayoun, Conroy Maddox, George Melly and Penrose. Over the following days, talks were given on such subjects as 'Accident in Painting', 'Surrealism, Liberty and Art' and 'Eroticism in Art'. Film screenings included Buñuel's *Viridiana*, short features by Roman Polanski, Walerian Borowczyk, Jean Vigo, and W.C. Fields, and art films on Magritte, Delvaux and Molinier. Performances were given of Arrabal's *The Labyrinth* and Obaldia's *The Grand Vizier*, and there were poetry readings by Alan Burns, Ian Breakwell, Ken Smith and Charles Olson. In the preface to the catalogue, whose cover was designed by Maddox, the critic, musician and artist George Melly pointed out that, in spite of Breton's recent death and the subsequent incoherence and disbanding of the group, surrealism was not 'confined to its own time', and was able 'to place itself historically and recognize its own ancestors',

some obscure, some famous: some conscious of their aims, others unaware of what they were doing; but all obsessed in exteriorizing their vision of a counter-reality based on our 'inscape', our dreams, our real nature. By establishing its past, by stressing the existence of surrealism before 'Surrealism', it pointed to the continuance of surrealism after 'Surrealism'.

He saw surrealism as being at the hinge of time and space, constituting a kind of axis between the past and the future, the known and the unknown. This, however, does not exclude a certain disillusionment in his words:

> The pictures were the banner of a small band of courageous brigands who attempted to storm the castle of human misery and release its prisoners from the dungeons. They failed, but the banners still exist to remind us of their intentions.

Taking up these banners, John Lyle was to publish several radical texts by Brunius, Mesens, Benayoun, Breakwell, Maddox, Ken Smith, Alan Burns and himself, undated, under the title *Transformation*. This became *TRANSFORMAcTION* 2 in 1968 with texts by Scutenaire, Melly, Ken Smith, Burns, Earnshaw, and Maddox. Throughout the ten numbers that it launched, its critical and theoretical articles, retrospective studies, declarations, aphorisms, poems, short stories and various reports declare a politically radical position, tending mainly towards anarchism.

The second issue, published in May 1968 at the moment of the student uprising in France, included a manifesto under the title 'We Need You Cohn-Bendit', in reference to the French students' leader, which was 'issued on behalf of the British People by the Surrealist Group'. The signatories were Breakwell, Burns, John Lyle, Maddox, Melly, Rupert Cracknell, Peter Rider, Sophie Kemp and John Rudlin, some of whom were not to be heard of again. British surrealism is the history of the knotting and almost immediate unknotting of energies.

TRANSFORMAcTION provided a platform on which Anthony Earnshaw, Philip West, Paul Hammond, Patrick Hughes, Ian Breakwell and Tony Blundell appeared regularly, the first three of whom remained close to the group's core. It was also the unflinching voice of protest against all forms of ossification, striving to map a world based on *mutuality*: 'We repudiate every power which tries to dictate relationships and to obstruct openness and availability: all closed systems, and imposed disciplines and deprivations.'[3]

TRANSFORMAcTION's task was to refute whatever it saw as the expression of linearity and hierarchization. Its targets were the institutionalization of a once dynamic Marxism; a view of reality and mankind centred on the ego; the labelling of the individual; and such separation from other individuals into artificial units as was encouraged by 'Freud, Stalin, your schoolteacher and your priest'. In almost every issue, Lyle's singularly keen eye reviewed books and current exhibitions related to surrealism, while he set

TRANSFOR MAcTION

9

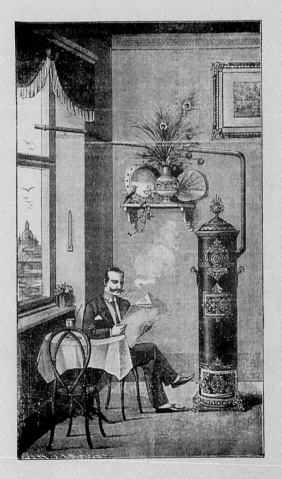

THIS IS NOT A MAGRITTE

169 Cover of *TRANSFORMAcTION*, issue 9, 1979

out to explore and redefine general philosophical standpoints – Hegelianism, Marxism, current political issues, censorship, state education, subsidized art – from a strictly surrealist point of view.

Lyle's articles and editorials also contained a growing number of references to oriental philosophies, the *Bhagavad Gita* and Mahayanism, which he wielded in his attacks on the dictatorship of the self and the overruling power of reality. He went so far indeed as to interpret Breton's famous definition of the supreme point, 'where life and death, the real and the imaginary, the communicable and the incommunicable, the high and the low, cease to be perceived as contradictory' in the light of the commentaries on the nature of karma by Phrin-la-pa. As revealed by a series of letters to Lyle, Maddox took exception to this, and, personal reasons also intervening, stopped contributing to *TRANSFORMAcTION*. Lyle's approach, as it appeared in his own articles, changed afterwards, but the rift between Exeter and London was insuperable. After an international homage to E.L.T. Mesens in October 1979, taking up a whole issue, the magazine ceased publication, for reasons that may have included John Lyle's personal and financial problems.

An attempt to re-centre activities in London was later made by Conroy Maddox and John Welson, who issued an eight-page pamphlet entitled *Surrealism – The Hinge of History*. This claimed a 'refashioning of the human understanding', and attempted to redefine the 'surrealist proposition', as John Welson's article was entitled:

The surrealist belief is not only in the creation of a single class, a 'true democracy' as Lenin put it 'through the initiative of the masses', but also a single class whose desire is to embrace the 'true functioning of thought', in such a way as to live a life which is emancipatory in nature and action.
 Through the belief in the surrealist revolution the human predicament will not be one of a forced alignment with social oppression and mental isolation but, rather, to the emancipation of the poetic dimension of reality, the latent qualities of materialism . . . The primacy of matter will be commensurate with the basic principle of human liberation.[4]

To this assertion the poet and essayist Roger Cardinal added a plea to celebrate the 'giddy marriage of imagination and perception'; and George Melly contributed an analysis of relations between surrealism and anarchism, which, he declared, Breton had understood too late. In the same vein, Paul Hammond demanded a 'dialectical negation' of most of surrealism's achievements so far.

A year later, in early 1979, a group was formed under the name of Melmoth – the compulsive, eternal wanderer, aware of the need to fulfil ethical obligations although conscious of the impossibility of reaching a definitive destination. *Melmoth* was also the title of the two numbers of a review published by the group. John Welson, Tony Pusey, Michael Richardson,

Francis Wright and Haifa Zangana were the main contributors, all newcomers to surrealism, and all possessed with the desire to make 'surrealism ... now move back out of itself into the domain of real life', and 'provide new horizons for surrealist endeavours'. Before it ceased publication in 1981, *Melmoth* had effectively taken stock of the surrealist forces in Britain and printed contributions from groups abroad. Apart from Maddox's and Melly's texts, its outstanding contributions to surrealist inspiration are John Welson's drawings, Haifa Zangana's texts and collages, Michael Richardson's perceptive criticism, and Tony Pusey's protests and eroticomechanistic drawings. All made *Melmoth* a forum of ideas, a platform which briefly held much promise.

Exhibitions were another meeting place for the more committed adherents of surrealism. Dada and Surrealism Reviewed, organized at the Hayward Gallery from January to March 1978 by David Sylvester and Dawn Ades, was enormous, but still ignored flamboyant figures such as Grace Pailthorpe, Reuben Mednikoff, Edith Rimmington and Emmy Bridgwater. It was, however, counterbalanced by Surrealism Unlimited, an exhibition mounted at the Camden Arts Centre by Conroy Maddox, in collaboration with the French surrealists of the Phases movement and running in parallel with a retrospective of his own works. John Welson, Paul Hammond, John Digby, Haifa Zangana, Oscar Mellor and Desmond Morris were among the most committed British surrealists invited. A few weeks earlier, in December 1977, The Terrain of the Dream, an enormous exhibition organized by John Welson, opened in Worcester. A bull's head – an ambivalent, ironical tribute to English stubbornness – was the pivot of the exhibition; two pictures were physically attacked and Welson's lecture on the necessity of surrealism created a commotion.[5]

The least that can be said of British surrealism in recent decades is that its various manifestations have all endeavoured to 'open' the walls to new propositions, and welcomed many artists committed to the surrealist demands of the imagination. They have been years in which, however, follow-up has been inversely proportional to the amount of energy initially present.

Common cause was apparently made with Trotskyism when in 1979 its 88th number of *Socialist Challenge* published a supplement of four pages entitled 'Surrealist Challenge', written and financed by 'the surrealists in England at this moment regrouping and reactivating'. In his introduction, Franklin Rosemont, the leader of the Surrealist Group in America, proclaimed automatism to be 'the means to destroy the network of miserabilist abstractions (God, family, fatherland) used by the ruling class to divert the miserable from their misery'. Automatic and dream texts supported this statement, and the supplement closed on a reprint of Breton and Trotsky's

1938 *Declaration towards an Independent Revolutionary Art.*

This accord aborted, however. The editorial board of *Socialist Challenge* was 'besieged' by a group of determined feminists protesting against one of the dream texts' alleged celebration of rape and male domination; the board apologized for its inclusion. The surrealist group replied with a broadsheet, *'And Onan Cried over His Spilt Milk . . .'*, signed by 'the Sara Emmanuele de Maupers Faction of the Surrealist Group in England'. This described feminism as a movement 'reformist by nature' and threatened with being 'absorbed' and 'contained' by capitalism, which thus sought to ensure 'its own smooth functioning'. To this, they joined a criticism of Trotskyism, 'now firmly and legally embedded in the political apparatus of the modern capitalist state'. Thus was the separation sealed in Britain of surrealism from 'pusillanimous' Trotskyism.

Shortly thereafter, the group issued a two-page declaration, entitled *Trajectory of Passion*. This claimed that 'an authentic poem . . . is not reducible to a mediocre cause', and stigmatized 'fellow-travelling artists who coyly sport their political badge as a variant on the foppish flower of aestheticism'. Its signatories declared themselves fully aware that 'revolt [had] become spectacle' and was permanently threatened with recuperation, and advocated the invention of a new language which would 'take its place on the revolutionary calendar' – a position as yet unmodified:

Thus the poetry we seek cannot but be anarchist. It spells the formidable collapse of the structures which determine our present mentality . . . The poet, writes Péret, is the integral non-conformist.

It is obviously impossible to assess fully the contribution of each individual artist to the 'surrealist proposition'. But among those who, at one moment or other, jumped on the surrealist train – sometimes to get off at the next station for various reasons – a few artists have maintained their participation and their works can be seen as landmarks in the history of post-Mesens surrealism.

As a form of self-criticism, derision and sarcasm are inseparable from the work of Anthony Earnshaw and John Welson, while the work of Tony Pusey, Paul Hammond and Philip West is dominated by renewed questioning of the *place* of reality.

A writer, or *composer* of aphorisms, proverbs and insults, a painter and, above all, a maker of boxed objects, Earnshaw started to paint pictures at the age of 21. He had been led into surrealism through a passion for jazz and the music of New Orleans and through a fascination with Rimbaud's poetry; the influences on him also included David Gascoyne's *Short Survey of Surrealism* and Read's *Surrealism*, two almost inevitable works of initiation in the sixties. Towards the end of that decade, he wrote and illustrated two novels, *Musrum* and *Wintersol* with the collaboration of a long-standing friend Eric

Thacker.[6] He also produced a strip cartoon, featuring Wokker, a 'mercurial hero', in Earnshaw's own words, who embodies the seemingly contradictory characteristics of a mischief maker and an innocent abroad, 'dismayed by the prospect of existence'. Indeed, what attracted Earnshaw in surrealism was the way it 'upset the applecart to upset Western culture with all its pretensions and arrogance', a fundamentally anarchist approach which informs each of his drawings and assemblages and cocks a snook at our most elementary, ordinary beliefs in the *place* and *use* of objects. With Earnshaw, slide callipers are made to measure the petals of a buttercup and two mousetraps are made to enter a dialogue one with the other. *Homage to Jason* (1985) (Pl. 170) pays its respects to the simplest of materials: paper, with which a child's paper boat has been made, and a ball of string. The ball has been fixed to a stand and made to look like the globe of the earth; the paper boat rests on a white plate, attached to the white string. Both trivial objects are lifted from their substance and poeticized, even mythologized, if the title is considered. A deflating homage to Jason, the Argonaut, the assemblage makes fun of the hero's obsession with finding the Golden Fleece, which is reduced here to a ball of string. This material mutation goes even further with the eight versions of the secret alphabet designed by Earnshaw, in which letters are also objects, natural scenes or events. A is a mountain in front of which a jetplane is leaving its white trace; it is also a woman with

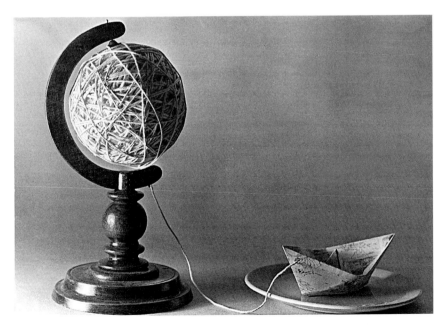

170 Anthony Earnshaw, *Homage to Jason*, 1985, 36 × 20 × 26 cm (14 × 18 × 10.2 in.)

high-heeled shoes, bending forward with her back to us and totally naked, except for her frilly pants halfway down her legs; W is two books next to each other, open in their middle and flying in the air; V is the two arms stretched to the sky of someone almost completely buried in quicksand; N is a man urinating onto the base of a parking meter; M two men facing each other and urinating; T is a dove perched at the tip of a finger with its wings open for balance ... The principle of Earnshaw's humour is that of a duality impossible to divide and separate; it is no mild humour, but aggressive in that the onlooker gradually realizes he has been betrayed by what he thought was the reality of objects.

Paul Hammond and Tony Pusey were both instrumental in the relaunching of surrealist activity at the time of *Melmoth*. However tenuous their collaboration became after ten years or so – Hammond went to live in Barcelona, Pusey in Sweden where he helped develop the Swedish group – for a time they successfully maintained pressure on the group. Pusey, born in 1953, edited *Melmoth* I in 1980, and produced some of the most eccentric hybridizations of the organic and the inorganic, situated between Konrad Klapheck's unpredictable machines and Brauner's mythopoeic apparitions. His creatures, endowed with eyes, noses, mouths, legs and hands, are also never devoid of well-pronounced sexual parts, as if they were emerging from a mechanical life, surprised at the way they grow. Paul Hammond, born in 1947, a student at Leeds Art College and the Slade between 1965 and 1973, set out to question reality by celebrating visual puns. A close companion of Conroy Maddox and John Welson in the *Melmoth* venture, he has given the pun a force which obliges the spectator to re-examine his universe. A key whose ring constitutes the first letter of the word Oedipus is entitled 'the Man with the Swollen Foot' ...

The two figures who emerge as steadfast holders of the surrealist banner throughout recent years are John Welson and Philip West. Although chance was such that they did not meet before the late eighties, both had been working at what appears a subversive and dramatically powerful trial of representation. John Welson was born in 1953 and produced his first surrealist paintings at the age of fourteen. He met Conroy Maddox in 1973, a decisive moment since when he has always been associated with the surrealist movement, contributing to practically all publications and exhibitions of present-day surrealism in Britain, and dozens of exhibitions abroad. He co-edited *Surrealism – The Hinge of History* with Maddox and Hammond in 1979. In December 1977, he organized the Terrain of the Dream exhibition in Worcester.

The violence of Welson's paintings is not gratuitous or simply idiosyncratic. He walks, one might say, on the serrated edges of the knives and carvers of dreams, turning all objects into the jagged fragments of windowpanes through which he wants the spectator to see the other side of things.

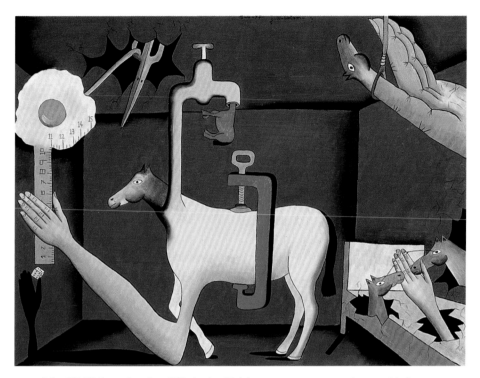

171 John W. Welson, *Interior of Wuthering Heights*, 1977, 23 × 30 cm (9 × 11.8 in.)

His work is a form of controlled automatism in which 'every image is in a continual process of metamorphosis', so that each canvas 'offers an ever-expanding circle of possible meanings like a never-ending *cadavre exquis*'.[7] Welson's paintings throw the animate and the inanimate together only for them to feast on each other: thus a fried egg can become a ruler. Objects painted naively, even awkwardly, are made to prove that what they retain of their conventionality is inseparable from their destruction; in other words, the childish obviousness of the object is concomitant with its having to be torn apart. Only in this way do they ensure what Welson calls the 'permanent state of lucidity' or, in Cardinal's words, 'the giddy marriage of imagination and perception'. In *Interior of Wuthering Heights* (1977) (Pl. 171), one of his most cogent works, the status of matter itself is questioned by an intrinsic, self-generated force – the internal logic of desire, which turns Welson's paintings into Procrustean beds of love. Matter is dialecticized, indissolubly merging with desire. One understands why Welson places his investigation in the light of Hegel's dialectics and the propositions put forward by Lenin. To Hegel and Lenin should be added Heraclitus, who believed in the ceaseless flux of things into things . . .

Where Welson materializes desire and fluidifies matter, Philip West holds desire in check on the brink of dream precipices. Merely juxtaposing *tableaux* and scenes, he challenges the spectator to transpose these on his inner stage, at the risk of sensory derangement. West, who was born in 1949, collaborated with John Lyle's *TRANSFORMAcTION* group, then moved to Caracas, Venezuela, before settling down in Saragoza, in Spain, where he died at an early age. His impressive production of drawings and oils, often in series of interacting canvases, celebrates the workings of the imagination carried to unprecedented extremes. It is in this respect that West stands close to Welson in the radical renewal of the surrealist vision in Britain after 1967.

Each of our two eyes, in contemplating one of West's paintings, is transformed into a cell engaged in endless mitosis. In the same way as cells have to divide in order to multiply, our eyes enter a mad race with themselves, against the logic of each compartmentalized image, towards the superior, complex logic – if any – of the whole. Confronted with any of West's works, for example *Derailed Sea* (1987) (Pl. 172), we fight against the forces of claustrophobia, with only limited success, by probing into the proliferation of centres, articulations and moments of vision. The labyrinth of images proves to be an internal one, as we meander through our own deeply rooted fears and fantasies. By degrees the mind is plunged irresistibly into a visionary state akin, no doubt, to that experienced by medieval man before one of those Boschian or Grunewaldian triptychs or polyptychs erected as altarpieces but with a fascination with devils, ghouls and monsters.

British surrealism has in several ways redirected and reshaped the history of art in Britain. Through its shocks and ruptures modern art has been relieved of several deadweights and has undergone a massive re-evaluation of ideals.

English art's traditional predilection for landscape painting and a holistic conception of nature was not simply scorned by surrealists. Rather, it was resituated within a dialectical movement which gave equal importance to the object and the subject, and subverted the established status of both. Heir to a long tradition of belief in nature's power and beneficence, British surrealism nonetheless rebelled against this romantic legacy, embarking on a radical deconstruction of the concept of nature.

'Surrealism', said Breton, 'is the tail, but a most prehensile tail, of Romanticism.' If so, nature can no longer be seen simply as a unifying and synthesizing force, bringing harmoniously together man and his world, human feelings and external objects. Hugh Sykes Davies, in his contribution to Herbert Read's *Surrealism*, compares William Wordsworth's hallucinatory experience in *The Prelude* ('One Summer evening (led by her)/I found a little boat ...') to René Magritte's painting *The Red Model* – the famous pair of shoes turning into toes. But in so doing he apparently ignores Wordsworth's

monotheism, along with his fundamental conservatism. For surrealism, the images that make up human awareness are in no way imposed by an outside force; instead they arise from within, from a self fashioned out of its own desires and fears. Surrealism is not a philosophy of nature, but of language; it is not a form of pantheism, but is lodged in the space between the heart of men and the heart of things. Throughout its history – more so than, say, its French and Belgian counterparts, probably given the strong tradition it was heir to – British surrealism constantly brought Nature into the dock.

In Davies's prose poem *Petron*, or his poem 'It doesn't look like a finger, it looks like a feather of broken glass', natural laws and the logic of identity are parodied; his verse offers deflating contradictions, creating a vacuum. Ithell Colquhoun's texts in praise of 'Living Stones' and of the fusion of chthonic and mental forces open a gash in the harmony of nature. Likewise, in his 'Reports', Humphrey Jennings hypnotizes the reader by opening cracks in the smooth surface of given reality, cracks which he almost imperceptibly turns into unbridgeable gaps. This too is the focus of Paul Nash's collages and photographs, and Eileen Agar's construction-collages and photographs of rocks. Nash's articles about Swanage and 'seaside surrealism', or 'nests of wild stones' found on the Sussex Downs, all pay homage to the reciprocal influences of nature and the imagination. Nash may well be seen – historically speaking – as the continuation of the romantic school of British landscape painting, but his importance lies in the excesses he introduced into it, to the point of nullifying the school's main tenets for a while. In other words, natural elements in the works of Banting, Melville, Nash, Agar, Emmy Bridgwater, Edith Rimmington, Ithell Colquhoun and Conroy Maddox are stolen from where they apparently belong, to be invested with our ever-shifting, ever-desiring gaze and projected back to a primordial level. The appearance of natural objects is made to recede; nature is no longer what is, but what is being made, in an endless process of disqualification and requalification. Nature is no longer a 'reality', opposed to the 'unreality' of the imagination: the identity of natural objects can only be grasped convulsively. Nature is primitivized; the surrealists have preferred Prometheus to Pan.

It follows that, politically, British surrealism is rooted in the same Promethean spirit – in the determination not to yield to any doctrine. The British surrealists have thus confronted a question which, however unpopular, has been fundamental to twentieth-century politics: how to preserve one's freedom. The issue was first raised by André Breton, in 1935 when, in an interview with the Canary Island paper *Indice* he demanded that, for a surrealist, aesthetic and political involvement should stop once his moral independence was threatened. Having initially joined forces with the Communist Party, the British surrealists did indeed turn from it, to Trotskyism. Given the approach of World War II, this too was a merely

tactical allegiance; on the whole the group's most enduring commitment has been to libertarianism. This was not a reaction against Marxist Stalinist totalitarianism – the orthodox Communist Party in Britain was diminutive, and devoid of influence. Rather, despite the vestigial amount of theoretical writing produced by surrealists in Britain, these anarchist sympathies seem almost intuitive. It is as if their adherents had swiftly but firmly grasped the essence of surrealism without having to go through any harsh experience. Its principles unite nature and politics, in defiance to constituted systems, and hope in the artist's constant self-requestioning.

Self-questioning also governs British surrealism in the way that women found, and exerted, their full independence – *from within* its ranks. There has been a lot of mistaken comment on the male surrealists' 'use' or 'misuse' of their women companions, as 'serving muses', 'child muses', 'objects of their own dream of femininity', 'models', 'dolls', or 'praying mantises'. However, the histories of Eileen Agar, Edith Rimmington, Emmy Bridgwater, Ithell Colquhoun and Lee Miller reveal not only an absence of exploitation or submission to male desire, they also demonstrate as clear an exercise of freedom in their works, in their bodies and in their minds by these artists, as can be found in any male surrealist.[8]

While Eileen Agar's autobiography, *A Look at my Life*, does humorously hint at the chauvinistic pretensions of some of her male colleagues, she minces no words as regards her 'double' relationships with Paul Nash and Paul Eluard, at the same time as being deeply in love and living with Joseph Bard, whom she was to marry at the outbreak of war. Agar was to maintain her freedom of expression as a participant in surrealist activities, while Bard kept at a distance, interfering with none of her decisions.

Ithell Colquhoun's assertion of freedom was more overt yet; while resisting Mesens's call to order, she dedicated herself intransigently to the surrealist exploration of the occult, anticipating by more than ten years Breton's own interest in the arcane. One should perceive Colquhoun's nude body lying on a beach in Corsica in a different light from the half-nude bodies of Nusch Eluard and Man Ray's girlfriend – a photograph taken by Lee Miller in Mougins in 1937 and published in the *London Bulletin*.[9] Colquhoun is seen on her own, unprotected by any male arm, undetected by any male gaze; moreover, the photograph is one of four, which illustrate an article entitled 'What Do I Need to Paint?'. It both protests her aesthetic freedom and affirms her liberty as an individual.

Lee Miller countered male passions and discourses with a personal nomadism. From Poughkeepsie in New York state, where she was born, to Paris, London, Cairo and the Balkans, from Greenwich Village to Montparnasse and Hampstead, from Man Ray to Eluard, Picasso and Penrose, from modelling for *Vogue* to being one of the sharpest-sighted war

172 Philip West, *Derailed Sea*, 1987, 100 × 73 cm (39.4 × 28.7 in.)

correspondents of World War II, she proved that one could be both a 'muse' and an independent-minded professional. It was as the latter that she left England, with David Sherman, an American war photographer, and stayed with him and the US army as a reporter in Germany in 1944 and 1945. Lee Miller's life and work conveys a sense of belonging nowhere and to no one, not even to her own body. This is manifested in the way she had, when posing for a photograph, of keeping at a distance, offering her profile so as to avert the camera's eye. Only in this sense could she never betray a sense of *extreme* liberty.

More subdued, but no less assertive, was Emmy Bridgwater's choice of an independent if financially precarious life, spent mostly tending her crippled sister while living on a small income that was partly inherited and partly derived from random secretarial work. The tranquil upheavals taking place in her canvases bear witness to rigorous perseverance. In all her works there transpires a supremely clear-sighted exploration of the process of origination, through dramatizing the processes of deformation, and through images of life and loss. Nowhere in this do we see an 'obliteration' of female subjectivity; instead there is an affirmation of femininity which, in the face of life's hardships, celebrates itself as the locus of apparent contradictions.

Edith Rimmington made a form of protest against a life managed by men by drifting away from, and eventually leaving, her husband, Robert Baxter, painter and design master at Manchester University. Rimmington was attracted to London's cultural life, but Baxter could not leave Manchester. In work as in her life, she showed an inalienable independence of mind, especially through her paintings' totally non-derivative iconography. All show how central to surrealism is the eye which cuts into, and tears apart, a jealously guarded reality.

Grace Pailthorpe's independence is equally self-evident. From the moment of her encounter with Reuben Mednikoff in February 1935 until the very last day of her life, it was she who managed, inspired and directed their joint production of images. Mednikoff's psychological unbalance, and his need for support entirely justified such a female-dominated relationship, but here too an aggressively feminist interpretation fails. Nowhere could we say of these women artists, and least of all of Pailthorpe, that their rebellion was 'diverted to the purposes of the male surrealists' revolt', or that 'they functioned within the discourse defined by the male surrealists'. Here too, surrealism – especially in Britain – gives the lie to arguments that attempt to frame it.

In contrast with French surrealism, a distinctive feature of the British movement is its almost exclusively *visual* quality. Little writing has been published by British surrealists, when compared to the amount of painting done, not to mention the vast production of collages and objects. It is true that

most of what was written dates from the war, at a time of paper shortage and when little presses had exceptionally limited finances, and even today a great number of texts remain unpublished in archives. But what is meant here by 'visuality' is that the majority of British surrealist paintings place the visual process at the very centre of their statements, in a metatextual comment upon their own creation. The overwhelming presence of eyes, *qua* images, displaces the centre of visuality from the flat surface of the work, into the gap between the eyes in the painting and those of the onlooker. In T.S. Haile's works – among others, *Mandated Territories* and *Brain Operation* – the separation of the onlooker's eye from the body liberates lines from objects. Forms are no longer held up by their contours and the spectator's eye is in turn detached from the body and all its certainties. In Edith Rimmington's works, images are splintered as we look at them. Emmy Bridgwater condenses the poetics of surrealist visuality by identifying the eye and the egg, giving the former the latter's role as a place of origination. To these should be added Geoffrey Graham's object, *Virgin Washerwoman*, Charles Howard's *Inscrutable Object*, Roland Penrose's strategies of retinal inversions (*The Dew Machine, Seeing is Believing, Octavia*), and Conroy Maddox's figures staring us in the face. In all these, eyes – those in the painting and those of the onlooker – meet in a liminal space where roles and places are exchanged. The eyes, whose images we see, send us back inevitably to our own eyes, provoking and dislocating the processes of recognition and awareness. A surrealist object, or work, will always be inscrutable, because it is the repository of unfulfilled desire, and evidence that the reign of totality is over. It is the supreme achievement of British surrealism to have re-situated the poetics of the eye at the centre of surrealist issues.[10]

Outside the surrealist group, others have also hoped to capture the poetics of visuality. But, once past the initial aesthetic shock, their works lack the intensity, audacity and regularity of statement necessary to create an unending circulation of the gaze; above all, they are rarely *constitutively incomplete*. Raymond Myerscough-Walker, Augustus Lunn, Colin Middleton, Hugh Blair-Stanton, John Buckland-Wright, John Lake, Humphrey Spender, Victor Reinganum have all been included in recent exhibitions as an attempt to 'reveal' other British surrealists. They offer brilliant examples of 'applied surrealism', but from outside any concerted, collective action. They also represent the spread of surrealism's questioning, and its disturbing visuality, but also its dilution. In such cases, surrealism becomes a mere reservoir of techniques. The virtuosity of these artists is thus associated with stylistic versatility, decorativeness and variable inspiration, turning their visionary or oneiric constructions into frozen fantasies. However, notwithstanding these artists' refusal of the core group's intransigent morals, and their reduction of

surrealism to technique, they testify, by contrast, to the movement's radicalism and fecundity. Also, they do comprise part of the 'collective invention', a key surrealist concept encompassing all those who *more or less* surrender to the powers of the imagination.

Right from its beginnings, in spite of internal conflicts and the occasional dispersal of its members, surrealism has constantly transformed itself organically, taking risks at every stage and testing its resistance to simplification and reductionism. In its many, geographically diverse, appearances, the forms taken by its activities have been constantly varying, from one moment to the next, from one country to another. It is essential to surrealism, which critics have declared dead at almost every large show since 1938, that it should go through 'periods of occultation' before re-emerging elsewhere, probably in other shapes. In Britain groups have appeared while others disappeared elsewhere, or resurrected themselves – moments of void and disorientation, moments of plenitude and action, they all mark the jagged 'trajectory of passion' of surrealism in Britain.

In its own way, British surrealism has opened territories alien to our personal worlds, yet close to our most intimate selves. This is not surprising, for the images liberated by Eileen Agar, Humphrey Jennings, Conroy Maddox, Emmy Bridgwater, Edith Rimmington, John Welson, Philip West, John Banting, Reuben Mednikoff, Grace Pailthorpe, and many others, have only one demiurge: desire – our desire, which each one of these artists has aimed at *opening* and *expanding*. It was to be expected that this source should be tapped by unscrupulous minds in search of ready-made instruments, keen on making use of signs separated from what they signify: certain artistic manifestations, images in films, devices used in painting or sculpture, certain treatments of the object in advertising or manipulations of matter which might well echo or evoke the surrealist approach, but only as debased imitations. The true influence of surrealism – to speak of its *legacy* would imply that it was dead and buried – has to be sought elsewhere, and shows in the more widely accepted forms of emancipation enabled by the liberation of libidinal intensity.

In writing as in painting, the exigencies of surrealism lie in the continuous accretion of images, whose validity is measured by their disruptive force and their renewal of the process of questioning. The *Goon Show* is a case in point. This radio series, whose scripts were published in 1975, revealed unexpected perspectives of devastating humour. In his illuminating article published in André Breton's *Le Surréalisme Même* in the spring of 1957, J.B. Brunius emphasized the Goons' capacity to turn whatever might seem arbitrary into an absolute necessity.[11] One and the same object may change meaning completely according to the pressure exerted on it. No longer do objects have

any reliable substance. Brunius cites the 'piano on which Napoleon played at Waterloo, which the Goons steal from Le Louvre and is made to sail on the Channel'. In another programme, a wall, once bestridden by the Goons, starts moving in a loud discharge of cracking, backfiring sounds; a blank wall, in fact the same one, becomes a blank cheque filled in with bricks. If someone knocks at the door, Brunius goes on, 'they answer the phone, a butler comes in and says: "There's a pyramid in the hall wants to speak with you, Sir. It's coming from Egypt." ' The link with the surrealist spirit is clear: it is an opening onto extreme consequences which involve the whole being. The Goons' punning was not an end in itself, because it always broke through spatial and temporal categories: the noise which prevents them from going to sleep in the Sahara comes from a neighbour taking off his shoes in the upstairs tent. Harry Secombe, Peter Sellars and Spike Milligan based their challenge to traditional expectations not only on the complete rejection of radio drama conventions, but also in the use of such verbal collages as would 'revitalise statements through relocation and through disrupting conditioned affective reactions'. They led the listener where he thought he would be safe only to abruptly displace him, in a strategy which they took to extremes in order to debunk all complacent moral values. In 'The Affair of the Lone Banana', 'our heroes' are dug in around a lone banana tree, 'the last symbol of waning British prestige in South America' as Peter Sellers' commentary goes, to the tune of the Harry Lime theme, in a mock celebration of British imperialism.

Contrary to all appearances, the Goons' plots are not centred on facts, but on the unending, irrepressible slippage of language. This mistrust in the capacity of language to communicate and the corresponding surrender to the power of play, constitutes the true subversion of the Goons, who carry Lewis Carroll's teasing of the logic of language to a point of no return. The severance of words from the thought they are supposed to convey suspends and redirects the very process of thinking.

The issue of what defines a surrealist was faced squarely by the photographer, writer and art lecturer at Newport, Ian Walker, in organizing the large Contrariwise exhibition in autumn 1986.[12] In the preface to the catalogue, Walker explained how he had divided the 155 works by 69 artists into four sections. Two concentrated on work by artists directly associated with the movement, of which one featured 'historical' figures like Burra, Nash, Moore, Penrose, and the other, the younger surrealists, such as Welson, Earnshaw, Breakwell. In the third section were represented artists who produced works from about 1945 to 1970 and 'seem to be influenced by, or have affinities with, surrealist art and ideas' – Bill Brandt, Angus McBean, Eduardo Paolozzi, Graham Sutherland – while in the fourth section appeared very recent artists; for example Glen Baxter, Barry Flanagan, Susan

Hiller, Alan Miller. 'But it would be foolish', said Walker, 'to try to crudely label [their] work as surrealist.' This cautious explanation identifies the working principle of the exhibition, together with a crystallization of the contradictions, tensions, dead ends, risks and hopes which define post-war British surrealism. It is a lesson in surrealist aesthetics.

In the same way, the critic and scholar J.H. Matthews in his extremely enlightening introductory text to the catalogue, emphasized the new nature and function of the spirit of surrealism, created by changing historical and cultural conditions. He first extends a warning to those who would use the name 'surrealist' as a convenient label, 'would-be hangers-on and frauds' who want to use it as 'a serviceable identification tag' or see it 'as a sort of good conduct medal' after making all the efforts they could to earn approval from the surrealist movement:

> Whatever shape is assumed by surrealist art, its leaven is the aspiration embodied in that art, the viewpoint it betokens, the spirit in which it is executed ... Removal of restraints is seen as a necessary liberative procedure. Surrealists are committed to it by the mood of enquiry which is the exciting cause of all their activity. Hence, the creations of surrealism are unambiguous testimony to a revolutionary posture, rather than works of art meant to be admired, criticized, or even reviled, for that matter ... In the surrealists' estimation, the created work is viable to the degree that it projects the spirit of enquiry without contamination by retarding aesthetic considerations.[13]

Eventually, only surrealism provides the means by which to judge a surrealist work. Maybe it is in the endurance of this spirit of enquiry that the 'influence' or 'legacy' of surrealism can be detected. But more than anywhere else, it lies in a sustained movement of interchange and interaction which overtakes itself constantly. It is hoped that it is now clear that the 'actors' of surrealism in Britain who have come under close scrutiny here, all participated, at one moment or other, in that radical, liberating process. The road of surrealism is wider than long, to use the title of Penrose's photographic and poetic work, it is a road which turns signs into signposts, full stops into question marks, a road now contracting, now widening, but ever expanding.

Notes

Foreword

1. Britain's Contribution to Surrealism of the '30s and '40s, London, Hamet Gallery (3–27 November 1971); Dada and Surrealism Reviewed, organized by David Sylvester and Dawn Ades, London, Hayward Gallery (11 January–27 March 1978); Les Enfants d'Alice – La Peinture Surréaliste Anglaise 1930–1960, organized by Edouard Jaguer and Michel Remy, Paris, Galerie Marcel Fleiss 1900–2000 (14 May–30 June 1982).

2. A Salute to British Surrealism 1930–1950, organized by James Birch, Colchester, The Minories (6 April–5 May 1985); British Surrealism Fifty Years On, London, Mayor Gallery (March–April 1986); Surrealism in England, 1936 and After, organized by Duncan Scott and Toni del Renzio, Canterbury, Canterbury College of Art (19–31 May 1986); Surrealism in Britain in the Thirties, Angels of Anarchy and Machine for Making Clouds, Leeds, Leeds City Art Gallery (10 October–7 December 1986).

3. Surrealism, Retretti (Finland), Retretti Art Centre (16 May–13 September 1987); La Femme et le Surréalisme, Genève, Musée Cantonal des Beaux-Arts (November 1987–February 1988); I Surrealisti, organized by Arturo Schwarz, Milan, Palazzo Reale e Arengario (8 June–10 September 1988); Die Surrealisten, Frankfurt, Schirn Kunsthalle (8 December 1989–18 February 1990); Anxious Visions, organized by Sidra Stich, Berkeley, University Art Museum (3 October–30 December 1990); Surrealism, Revolution by Night, Canberra, National Gallery of Australia (13 March–2 May 1993), then Brisbane, Queensland Art Gallery (21 May–11 July 1993), then Sydney, Art Gallery of New South Wales (30 July–19 September 1993).

4. André Breton, *Manifeste du Surréalisme*, Paris, Gallimard (1924). In Patrick Waldberg *Surrealism*, London, Thames and Hudson (1965), p.72.

5. *ibid.*, p.70.

6. André Breton, *Second Manifesto of Surrealism*, Paris, Gallimard (1929). In Patrick Waldberg, *Surrealism, ibid.*, p.76.

7. André Breton, *Interview with 'Indice'*, Tenerife, Canary Islands (1935), In *What is Surrealism?*, ed. Franklin Rosemont, New York, Monad Press and Pathfinder Press (1978), p.146.

8. Maurice Blanchot, 'Le Demain Joueur', in 'André Breton et le Mouvement Surréaliste', *La Nouvelle Revue Française*, 15, 172 (1 April 1967), pp.866–7.

1 Exits and entrances

1. Charles Harrison, *English Art and Modernism 1900–1939*, London, Allen Lane/Indiana University Press (1981), 41. For detailed and stimulating analysis of the period, see Harrison's book, Part 1, pp.13–141.

2. See *Vorticism and its Allies*, catalogue of the exhibition organized by the Arts Council of Great Britain at the Hayward Gallery (27 March–2 June 1974); introduction by Richard Cork. Contemporary with *Blast* were also published *The New Freewoman* (June–December 1913) and *The Egoist* (January 1914–January 1919), both edited by Dora Marsden; they set for themselves 'the task

... not to create thoughts but to set free life impulses' (Dora Marsden in *The New Freewoman*, 1, editorial).

3. For detailed analyses of literary vorticism and imagism, see William C. Wees, *Vorticism and the English Avant-Garde*, Toronto, University of Toronto Press (1972), Timothy Materer, *Vortex, Pound, Eliot and Lewis*, London and Ithaca, Cornell University Press (1979) and Glenn Hughes, *Imagism*, Stanford, Stanford University Press (1931).

4. *Experiment, a magazine of poetry and prose*, ed. G.F. Noxon, for Experiment at Trinity College, Cambridge, 1 (November 1929) to 7 (Spring 1931); *The Oxford Outlook*, ed. R. Beechman and Beverley Nichols, 1, 1 (May 1919) to 10, 53 (November 1930); *The Venture*, ed. Anthony Blunt, H. Romilly Felden and Michael Redgrave, 1 (October 1928) to 6 (June 1930).

5. 'Experiment: A Manifest', publ. in *transition*, 19–20, spring–summer number (June 1930), pp.106–38.

6. *The Outpost*, I, 1 (February 1932) – 3 (June 1932); *The Student Vanguard*, I, 1 (November 1932) – I, 6 (June–July 1933).

7. Michael Roberts (ed.), *New Signatures*, London, Hogarth Press (1932); *New Country*, London, Hogarth Press (1933).

8. *The Transatlantic Review*, ed. Ford Madox Ford, Paris, I, 1 (January 1924) to II, 6 (December 1924).

9. *transition*, ed. Eugene Jolas, 1 (April 1927) to 27 (April–May 1938). Published in Paris, except 21–4 (The Hague) and 25 and 26 (New York). 'No more than 4000 copies of any issue were ever printed and paid subscription never exceeded 1000 ... there was often a deficit which the Jolases had to make up themselves with occasional help from friends'; see Dougald McMillan, *Transition 1927–38, The History of a Literary Era*, London, Calder and Boyars (1975).

10. Eugene Jolas, 'The Revolution of Language and the New Grammar', *transition*, 22 (February 1933).

11. Eugene Jolas, 'Twilight of the Horizontal Age', *ibid.*, 22 (February 1933), p.6.

12. *This Quarter*, ed. Edward W. Titus, Paris, I (1925) to 5, 2 (1932). Facsimile reprint published by the *New York Times* (1969). In his preface, E.W. Titus adds an interesting note of thanks to Breton, further evidence of the difficulties encountered by surrealism in entering Britain: 'We made it clear [to Breton] that we should not mind in the least what he might say in his exposé of surrealism, nor what material he would give us to print in this issue, *so long as he eschewed politics and such other topics as might not be in honeyed accord with Anglo-American censorship usages*, although entirely permissible in France. He generously agreed, but his happiness was not complete. Nostra culpa' (italics added).

13. Edouard Roditi, 'The New Reality', *The Oxford Outlook*, 10, 49 (summer number, 1929), pp.295–300.

14. See *The New Criterion*, 'Note from Paris' (April 1925); also Matthew Josephson, 'Surréalisme' (October 1926) and 'Books of the Quarter' (January 1930 and January 1934).

15. Henri Fluchère, 'Surréalisme', *Scrutiny*, I, 3 (December 1932), pp.219–33.

16. David Gascoyne, 'And the Seventh Dream is the Dream of Isis', *New Verse*, 5 (October 1933).

17. *New Verse*, ed. Geoffrey Grigson, 1 (January 1933) to 31–2 (autumn 1938).

18. Henri Chomette's film was actually the very first film shown by the London Film Society, on 20 December 1925. The comment on Dulac and Artaud's film comes from the *Film Society Programme* on 16 March 1930. Two film magazines supported avant-garde and surrealist cinema: *Close-Up* (I, 1 July 1927 – III, 4, summer 1935) printed declarations by Man Ray, Buñuel and Len Lye, and *Film Art* (I, Spring 1933–9, Autumn 1936) which printed an article by John Banting on 'Blacks and the Cinema'. See chapter II.

19. P.G. Konody, 'Art and Artists – The Mayor Gallery', *Observer*, 23 April 1933.

20. See respectively, Paul Nash, 'Art and the English Press', *Week End Review* (17 June 1933), Herbert Read, 'Max Ernst', *The Listener* (7 June 1933) and anon., 'Recent Art Exhibitions', *The Blackfriars* (August 1933).

21. Kenneth Clark, 'Art', *New Statesman and Nation* (24 June 1933).

22. Edward Crankshaw, 'Art', *Week End Review* (22 July 1933).

23. Anon., 'Miró', *The Times* (14 July 1933).

24. *The Scotsman*, 18 July 1933.

25. David Gascoyne, 'Salvador Dali', *New English Weekly* (24 May 1934); Kenneth Clark, 'The Zwemmer Gallery', *New Statesman and Nation* (22 December 1934).

26. Anthony Blunt, 'Art – The Beaver and the Silk-worm', *Spectator* (2 November 1934).

2 The entry of the mediums

1. Julian Trevelyan, 'Statement in Painting', *Experiment*, 6 (October 1930), pp.37–8.

2. Herbert Read, 'Superrealism', in *Art Now*, London, Faber and Faber (1933).

3. Letter to the *Times Literary Supplement* (11 January 1936).

4. Herbert Read, 'Introduction', in *Surrealism*, London, Faber and Faber (1936), pp.21–2.

5. Anon., *Country Life*, 73 (17 June 1933).

6. Paul Nash, 'For, but not with', *Axis*, 1 (January 1935), pp.24–6.

7. For further detail, see *John Armstrong (1893–1973)*, London, Arts Council Publication (1973). Introduction by Mark Glazebrook.

8. The bibliography on Paul Nash is vast. Prominent works include Eric Newton's text for the exhibition *Paul Nash – A Memorial*, London, Arts Council (1948), Andrew Causey's *Paul Nash's Photographs*, London, Tate Gallery Publications (1973), Margot Eates's *Paul Nash, The Master of the Image*, London, John Murray (1973) and Roger Cardinal's *The Landscape Vision of Paul Nash*, London, Reaktion Books (1989).

9. Paul Nash, 'De Chirico', *The Listener*, 5, 120 (29 April 1931), 720–21.

10. David Gascoyne, *Roman Balcony*, London, Lincoln (1932); *Opening Day*, London, Cobden Sanderson (1932); *Man's Life is This Meat*, London, Parton Press (1936). The title of the latter was found quite by chance when thumbing through typographical sheets on which fragments of phrases are printed in various types. 'Man's life' was at the bottom of one of them, 'this meat' was at the top of the next.

11. Hugh Sykes Davies, *Petron*, London, Dent (1935). It was published in the 'New Poetry' series. Chapter 3 of Part I had been previously published in *Criterion*.

12. *Petron, ibid.*, ch. 8, pp.27–8.

13. David Gascoyne, '*Petron*', *New Verse*, 18 (December 1935).

14. Hugh Sykes Davies, 'Poem' ('In the stump of the old tree'), *Contemporary Poetry and Prose*, 7 (November 1936), p.129; 'Poem' (It doesn't look like'), *London Bulletin*, 2 (May 1938), p.7.

15. Len Lye, *No Trouble*, Deya (Majorca), Seizin Press (1930); 200 copies were printed.

16. 'Fried Eggs and Friends', *ibid.*, p.2.

17. 'Yes By Jesus No', *ibid.*, p.5.

18. 'In Grim Determination', *ibid.*, p.22.

19. For documentary in the thirties, see Paul Rotha, *Documentary Films*, London, Faber and Faber (1936); John Grierson, *John Grierson on Documentary*, London, Faber and Faber (1966).

20. For further details on Humphrey Jennings, see John Grierson, Kathleen Raine, Basil Wright, Dilys Powell, Ian Dalrymple and John Greenwood, *Humphrey Jennings, a Tribute*, London, The Humphrey Jennings Memorial Fund Committee (n.d.); Alan Lovell, *Humphrey Jennings*, London, British Film Institute (1969); Robert Vas, *Heart of Britain; full transcripts of interviews used for the television documentary on Humphrey Jennings*, London, British Film Institute (1969); Mary-Lou Jennings (ed.), *Humphrey Jennings, Filmmaker, Painter, Poet*, London, British Film Institute in association with Riverside Studios (1982).

21 Humphrey Jennings, 'Report', *Contemporary Poetry and Prose*, 2 (June 1936), p.39.

22. Reported by D. Knowles, *Censorship 1900–34*, London, Allen and Unwin (1934). Tusalava is a Samoan word which means 'in the end everything is just the same'. Traces of Aboriginal and Samoan art and mythology can easily be detected in Lye's films as well as his paintings.

23. Quoted by Roger Horrocks, 'Len Lye's Films', in *Len Lye, a Personal Mythology*, Auckland, New Zealand, Auckland City Art Gallery (1980).

24. Oswell Blakeston, 'Quicksilver', *Close-Up*, 10, 2 (June 1933), p.199.

25. Andrew Bogle, 'Len Lye's Paintings', in *Len Lye, a Personal Mythology*, *ibid.*, p.20.

26. Gerhard W. Brauer, 'Len Lye: the Science behind the Old Brain', *ibid.*, pp.21–4, passim.

27. Quoted by Anne Kirker, 'The Early Years in London', in *Art New Zealand*, 17 (1980), p.50. This was a special number devoted to Len Lye just after his death.

28. *Close-Up*, I, 1 (July 1927) to 10, 4 (December 1933); *Film*, ed. Vivian Braun, 1 (Spring 1933), then *Film Art*, 1 (Summer 1933) to 9 (Autumn 1936).

29. *Film Art*, 5 (winter 1934), p.5.

30. Most of these details come from Roland Penrose, *Scrapbook*, London, Thames and Hudson (1981).

31. Eileen Agar, 'Religion and the Artistic Imagination', *The Island*, 1 (June 1931), p.102.

32. Nancy Cunard (ed.), *Negro Anthology*, London, Wishart and Co. (1934). About 1000 copies were printed; the New York publisher Frederick Unger Publishing Co. reprinted it in 1970 with an introduction by Hugh Ford. Nancy Cunard secured the collaboration of 150 writers, essayists and critics, among whom were William Carlos Williams, Theodore Dreiser, George Antheil, Langston Hughes, William Plomer and Louis Zukofsky. Also included was a vehement denunciation of colonialism and imperialism, 'Murderous Humanism', signed by the Surrealist group in Paris and translated by Samuel Beckett.

33. Quoted by David Sylvester in *Henry Moore*, catalogue of an exhibition at the Tate Gallery (17 July–22 September 1968), p.2. For further information, see also John Russell, *Henry Moore*, Harmondsworth, Penguin Books (1975); Robert Melville, *Henry Moore, Sculpture and Drawings*, London, Thames and Hudson (1970).

34. To explain how the links between English artists and French surrealism gradually developed, it is interesting to note that in 1931, F.E. McWilliam, who was to join the surrealist group in London in the late thirties, visited Zadkine's studio in Paris and met Arp and Brancusi, who had a lasting influence on him. An interesting sideline is that it is in Paris, too, that McWilliam first met Ithell Colquhoun, who was staying there with a painter friend, Roger Hilton.

35. David Gascoyne, 'Premier Manifeste Anglais du Surréalisme (fragment)', *Cahiers d'Art*, 10 (1935), p.106.

36. *Daily Telegraph*, 11 June 1936; *Star*, 10 June 1936; *Manchester Evening News*, 5 June 1936; *Sunday Express*, 7 June 1936; *Sunday Dispatch*, 7 June 1936.

37. The *Daily Mirror* of 20 June 1936 reported the incident.

38. For full information see *Sluicegates of the Mind: The Collaborative Work of Grace Pailthorpe and Reuben Mednikoff*, Leeds, Leeds City Art Gallery (14 January–15 March 1998). Catalogue with articles by Andrew Wilson, Michel Remy and Andrew Maclagan.

39. By the early thirties, Herbert Read (1893–1968) had become one of the most influential critics and essayists writing in defence of new movements in art and avant-garde aesthetics. He gradually paved his own way towards surrealist commitment not only with several articles, but also with *The Green Child* (Billericay, Grey Walls Press, 1935) a 'frontier novel' about the metaphoric journey of a man led by a naiad to his death through the reliving and rediscovery of his own past life. Another landmark was a provocative and very perceptive article 'Why the English Have No Taste', which was published in the French surrealist magazine *Minotaure* 7, (June 1935, pp.67–8); Read sees the source of the paralysis of English taste in the subtle interaction of puritanism and capitalism and its subsequent celebration of individualism. The resulting passion for normality, the belief in 'common sense' and the simultaneous emergence of the English sense of humour led to the separation of spiritual and material values, the development of the British taste for convention and uniformity, and the consequent repression of sexuality. In his advocacy of a 'communal life' which would re-establish links between the individual and the collective, Read definitely shares a common ground with the surrealists. At the same time, however, Read was editor of the *Burlington Magazine*, an extremely conservative art periodical, which never mentioned surrealism at all.

40. All notes by Pailthorpe and Mednikoff come from documents held in the Tate Gallery Archives.

41. Samuel T. Haile, notebook (1938–44), unpublished.

42. 'Needed Pork Chop – To Complete Dress', *Daily Mirror*, 12 June 1936; 'Here Are Marx Brothers of Art', *Daily Herald*, 12 June 1936; 'Surrealism in Art', *Daily Telegraph*, 12 June 1936; 'Surrealism, Or Not So Realism', *Sunday Dispatch*, 7 June 1936; 'Blotches on the Face of Space Are Surreal', *Daily Express*, 2 July 1936; 'Surrealist Art is Clumsy as Well as Meaningless', *Evening News*, 12 June 1936.

43. Cyril Connolly, 'They Paint Dreams', *The Bystander*, 12 June 1936; *Sunday Referee*, 4 June 1936.

44. Herbert Read (ed.), *Surrealism*, London, Faber and Faber (1936).

45. Herbert Read (ed.), *ibid.*, p.167.

46. Humphrey Jennings, 'Surrealism', *Contemporary Poetry and Prose*, 8 (December 1936), p.167.

47. For full information, see Philip Purser, *Where is He Now? The Extraordinary Worlds of Edward James*,

London, Quartet Books (1978) and Didier Girard, *Les Soleils d'Edward James*, Paris, Université de Paris IV (1988), thesis with transitional poems. Born into an extremely wealthy family with countless timber and mining interests, to which had been added a massive investment in the American railroad system, James lived all his life on a private income, and was thus able to indulge in socializing, amassing art treasures, writing a novel, *The Gardener Who Saw God* (1937), publishing his own verse and converting a house on the West Dean family estate into a surrealist home.

48. Edward James, 'Les Chapeaux du Peuple et les Chapeaux de la Reine', *Minotaure*, 9, Third Year, 2nd series (October 1936).

3 Communicating vessels

1. *Contemporary Poetry and Prose*, 2 (June 1936). About 40 poems were printed; those in French were translated by David Gascoyne, Humphrey Jennings, A.L. Lloyd, Ruthven Todd, George Reavey and Jean Jacquot.

2. 'Surrealism in London', *Vogue*, (10 June 1936), pp.88, 110.

3. Elsa Schiaparelli, 'Surrealism Gets into Our Clothes', *Sunday Referee*, 9 (August 1936), p.9.

4. Herbert Read, 'Surrealism', *Harper's Bazaar*, 14, 5 (August 1936), p.57.

5. 'Holiday Surrealism – A Competition', *Architectural Review*, 80 (July 1936), p.80. The results were published in the November issue.

6. The process of dilution of surrealism as a total commitment – and not as the mere reproduction of techniques, however dislocating they may be – was also made manifest in *New Verse*'s publication of texts supposedly written by 'an ex-regular soldier'. One of them read: 'After three hours' sail ... the mate and part of the crew went to the foretop to play cricket, but a heavy squall striking her in the starboard coal hole, it was found that she had sprung a leak in her jibboom. The captain threw his watch overboard to lighten the ship, but to no avail, for she struck against a lucifer box and became a total wreck ... the Young Man saved his life by clinging to a nutmeg grater that floated by him ... he was cast ashore on an uninhabited island, where he opened a butcher's shop' (An ex-regular soldier, 'Found, the Young Man!', *New Verse*, 23, October–November 1936).

7. The story of how contact was made with Tom Harrisson is worth telling. When coming across the expression 'anthropology of the people' used in a letter to *The Times* by one Geoffrey Pike, Charles Madge sent a reply to the paper describing the way he saw the new science. Next to Madge's letter, chance had it that there was a poem about cannibals, signed Tom Harrisson. The link was thus established rather surrealistically.

8. At one point, there were 500 'observers'. Charles Madge saw the reports as a hitherto untapped spring of new forms of expression, issuing from pubs, dog tracks, dance halls and public toilets, hoping that poetic overtones would be found to casual words.

9. 'Declaration on Spain', *Contemporary Poetry and Prose*, 7 (November 1936).

10. An Anti-Fascist procession was also organized to Alexandra Park on 14 October 1936. David Gascoyne, who had recently joined the Communist Party – and was soon to leave it – carried the banner of the Twickenham branch. The involvement of surrealists in the marches was not insignificant.

11. *Left Review* had launched the debate with a supplement in its July 1936 issue, entirely devoted to surrealism.

12. Christopher Caudwell, *Illusion and Reality*, London, Macmillan (1937); Lawrence and Wishart (1940), pp.126–7.

13. See Anthony Blunt, 'Rationalist and Anti-rationalist Art', in 'Surrealism', in *Left Review*, 2, 10 (July 1936), IV–VI; Alick West, 'Surréalisme and Literature', *ibid.*, VI–VIII; T.A. Jackson, 'Marxism: Pragmatism: Surrealism – A comment for Herbert Read', *Left Review*, 2, 11 (August 1936), pp.565–7; A.L. Lloyd, 'Surrealism and Revolution', *ibid.*, 2, 16 (January 1937).

14. Roger Roughton, 'Animal Crackers in Your Croup', *Contemporary Poetry and Prose*, 2 (June 1936), p.36.

15. Roger Roughton, 'The Largest Imaginary Ballroom in the World – A Date at the Kremlin', *Contemporary Poetry and Prose*, 10 (autumn 1937), pp.33–9.

16. Roger Roughton, 'Surrealism and Communism', *Contemporary Poetry and Prose*, 4 (August–September 1936), pp.74–5.

17. Roger Roughton, 'Eyewash, Do You?: A Reply to Mr Pound', *Contemporary Poetry and Prose*, 7 (November 1936), pp.137–8. Pound's article, 'The Coward Surrealists', sent from Rapallo, was printed in the same issue (p.136); it accused surrealism of being 'SUB-realism' and of being 'no more revolutionary than the dim ditherings of the aesthetes in 1888'. 'The intellectual timidity of the pseudolutionists gives me a pain in the neck,' he ended. Among other retorts, Roughton replied that 'the pseudolutionists are rather to be found among the expatriate admirers of fascism and capitalist quackery'.

18. See Lynda Morris and Robert Radford (eds), *AIA: The Story of the Artists International Association 1933–1953*, Oxford, Museum of Modern Art (1983). Also Hugo Dewar, *Communist Politics in Britain: the C.P.G.B. from its Origins to the Second World War*, London, Pluto Press (1976).

19. Rea, Betty (ed.), *5 On Revolutionary Art*, London, Wishart and Co (1935).

20. Roland Penrose, *Scrapbook*, London, Thames and Hudson (1982). See pp.84–5.

21. First British Artists' Congress and AIA exhibition Unity of Artists for Peace, for Democracy, for Cultural Progress, London, Grosvenor Square (March–April 1937).

22. *AIA: The Story, ibid.*, 41. The comment was made in 1983 by the editors of the catalogue of an exhibition devoted to the story of the AIA.

23. Information drawn both from Roland Penrose, *Scrapbook, ibid.*, and Eileen Agar, *A Look at My Life* (in collaboration with Andrew Lambirth), London, Thames and Hudson (1990). Also quoted in Judith Young Mallin, 'Eileen Agar', in Mary Ann Caws, Rudolf Kuenzli and Gwen Raaberg (eds.), *Surrealism and Women*, Cambridge, Mass., the MIT Press (1991), pp.213–27.

24. Other contributions may be quoted in this context. In Birmingham, Conroy Maddox made small wooden disks silkscreened 'No Pasaran' to which a calendar was attached; these were sold at the end of 1936 and through 1937; he also designed big sheets of drawings for floats on the occasion of demonstrations (interview of April 1998). In Cambridge, Hugh Sykes Davies, who could not go to Spain because of a developing tuberculosis, made it a point to play the Spanish Republican hymn every morning, as loudly as possible, with all the windows open.

25. Edith Rimmington, *Family Tree*, photo-collage, 34 cm × 29 cm (1937). Although it was exhibited with the Surrealist Objects in November 1937 and features in the catalogue, it bears the date 1938, which is obviously a later addition.

26. H.S. Ede, 'Modern Art', *Axis*, 1 (January 1935), pp.21–3.

27. Paul Nash, 'For, but not with', *Axis*, 1 (January 1935), pp.24–6.

28. J.L. Martin, Ben Nicholson, N. Gabo (eds), *Circle, an international survey of constructive art*, London, Faber and Faber (1937; reprinted 1971).

29. Henry Moore, 'Quotations', *Circle, ibid.*, p.118; Herbert Read, 'The Faculty of Abstraction', *ibid.*, pp.61–6.

30. David Gascoyne, fragments from 'The Symptomatic World', *Janus*, I, 1 (January 1936), p.17; *Contemporary Poetry and Prose*, 6 (October 1936), pp.113–15; *ibid.*, 7 (November 1936), p.135.

31. David Gascoyne, fragments from 'The Symptomatic World', *ibid.*, p.113.

32. David Gascoyne, *ibid.*, p.114.

33. David Gascoyne, *ibid.*, p.114.

34. David Gascoyne, *ibid.*, p.114.

35. *The Birth of the Robot* (in collaboration with Humphrey Jennings), produced by Shell-Mex and BP Ltd (1935–6), 6 min.

36. Roland Penrose, 'On Paul Nash', *London Bulletin*, 2 (May 1938), p.24.

37. Henry Moore quoted by John Russell in *Henry Moore*, Harmondsworth, Penguin Books (1968; Pelican, 1973), from Philip James (ed.), *Henry Moore on Sculpture*, London, Macdonald (1966).

38. David Sylvester, 'Holes and Hollows', in *Henry Moore*, London, Arts Council of Great Britain (1968), p.71.

39. Norbert Lynton, 'Introduction', *Roland Penrose*, catalogue of the retrospective exhibition at the Institute of Contemporary Arts, London, Arts Council of Great Britain (1980).

40. Julian Trevelyan, 'Dreams', in 'Experiment', *transition*, 19–20 (June 1930), pp.121–3.

41. Julian Trevelyan, 'Mythos', in *The Painter's Object* (ed. Myfanwy Evans), London, Gerald Howe Ltd (1937), pp.59–60.

42. Almost fifty years later, Eileen Agar returned imaginatively to the rocks in Ploumanach. She had never seen them again since 1937, but using her photographs she made a series of starkly coloured paintings which were exhibited from 29 November 1985 to 11 January 1986 at the New Art Centre, London.

43. Eileen Agar, *Ladybird*, photograph with gouache and ink (1936).

44. Lee Miller, *Eileen Agar*, photograph of Eileen Agar's shadow on a column in Brighton (1937).

4 Spirit levels, level spirits

1. Details concerning the relationships between Roland Penrose and E.L.T. Mesens come from their private correspondence, now deposited at the National Gallery of Scotland in Edinburgh.

2. All these statements are ironically reported in 'Sidelights on the Magritte exhibition', *London Bulletin*, 2 (May 1938), pp.18 and 23.

3. On the first day alone, £100 was raised for the East End Food Ship Fund, and coinciding with this, the *Bulletin* published texts by Read and Eluard on the painting, and announced that Picasso had donated 300 000 francs for the Children of the Spanish Republic.

4. Herbert Read, 'In What Sense "Living"?', *London Bulletin*, 8–9 (January–February 1939), pp.5–7.

5. Thanks are due to Ruy Moreira Leite, of São Paulo, who provided the details of this side episode in the history of surrealism.

6. Thanks are due to Yves Laroque, whose thesis – as yet unpublished – on surrealism in English-speaking Canada throws illuminating information on this episode.

7. Grace W. Pailthorpe, 'The Scientific Aspects of Surrealism', *London Bulletin*, 7 (December 1938–January 1939), pp.10–16.

8. Humphrey Jennings, 'The Iron Horse', *London Bulletin*, 3 (June 1938), pp.22 and 27–8. For the catalogue of the exhibition, see *London Bulletin*, 4–5 (July 1938).

9. Humphrey Jennings, *Pandemonium: The coming of the machine as seen by contemporary observers*, Mary-Lou Jennings and Charles Madge (eds), London, André Deutsch (1985).

10. Letter communicated by Conroy Maddox; also in this translation in Roland Penrose's archives, National Gallery of Scotland in Edinburgh.

11. Herbert Read, in *Clé, bulletin mensuel de la FIARI*, 1 (January 1939), pp.4–5.

12. Unpublished letter to Herbert Read, Roland Penrose's archives.

13. Parker Tyler, 'American Letter', *London Bulletin*, 11 (March 1939), pp.18–19, 23; S. John Woods, 'Who's Been Frightened by the Big Bang?', *London Bulletin*, ibid., pp.13–15.

14. René Magritte and Jean Scutenaire, 'L'Art Bourgeois', *London Bulletin*, 12 (15 March 1939), pp.13–14.

15. Randall Swingler, 'What is the Artist's Job?', *Left Review*, 3, 15 (April 1938), pp.930–32 and Anthony Blunt, review of the Euston Road exhibition, *Spectator* (25 March 1938).

16. As reported in Julian Trevelyan, *Indigo Days*, London, McGibbon and Kee (1957), pp.79–80.

17. All these details are gathered from Penrose's archives, especially Mesens's letters to him.

18. An interesting anecdote is that, after a chance encounter in a bar in St Malo in France, Julian Trevelyan and Roland Penrose boarded the last boat to England before the declaration of the war, unaware that Conroy Maddox was also on board (from interviews with the artists).

19. Antony Penrose, *The Lives of Lee Miller*, London, Thames and Hudson (1985).

20. About Sam Haile, see Barry Hepton (ed.), *Sam Haile, Potter and Painter 1909–1948*, catalogue of an exhibition of Haile's works, Cleveland, Cleveland County Council in collaboration with Bellew Publishing (1993). Texts by Victor Margrie, Paul Rice, Marianne Haile and Eugene Dana. Also Michel Remy, 'Samuel Haile's pursuit of theory, or the hidden face of British Surrealism', a preface to a catalogue of an exhibition of Haile's works, London, Birch and Conran Gallery (14 October–6 November 1987). Upon their arrival in the United States, Marianne and Sam Haile lived with Marianne's brother in New York. When eventually Sam's pots arrived from England and were exhibited on Madison Avenue, Charles Harder, then the Design Professor at Alfred University, managed to secure a teaching job for him (from Marianne Haile, 'Recollections', in Barry Hepton (ed.), *ibid.*, pp.57–63).

21. Samuel Haile, unpublished notes.

22. Samuel Haile, *ibid.*

23. David Sylvester, quoted by John Russell, *Henry Moore*, Harmondsworth, Penguin Books (1975), p.90.

24. René Magritte and Paul Nougé, 'Colour-colours, An Experiment by Roland Penrose', *London Bulletin*, 17 (15 June 1939), pp.9–10.

25. Roland Penrose, *Scrapbook*, London, Thames and Hudson (1981), p.126.

26. See Mary-Lou Jennings (ed.), *Humphrey Jennings, Film-Maker, Painter, Poet*, London, British Film Institute in association with Riverside Studios (1982), p.20. On this chart, Jennings wrote that it is clearly 'a problem just how far these "common sense" relationships differ from or overlap the relationships (between "prism" and "fir-tree" for example) established in a painting or dictated by "unconscious fantasy" ' ('Who Does That Remind You Of?', *London Bulletin*, 6, October 1938), pp.21–2.

27. *Penny Journey*, GPO Film Unit (1938), 8 min.

28. 'Two American Poems', *London Bulletin*, 11 (1 March 1939), p.19.

29. Paul Nash, 'F.E. McWilliam', *London Bulletin*, 11 (1 March 1939), pp.11–12.

30. For information on Melville, see Theo Melville, intro. to the catalogue *John Melville: a memorial exhibition*, London, Gothick Dream Fine Art Ltd (1987), and Theo Melville, intro. to the catalogue of an exhibition of John Melville's works, London, Westbourne Gallery (22 May–9 June 1996).

31. Merlyn Evans, 'Recent Sculptures: McWilliam', Hanover Gallery (11 October–5 November 1949).

32. See *Birmingham Mail* of 8 March 1938.

33. Ithell Colquhoun, 'The Volcano', 'The Echoing Bruise', *London Bulletin*, 17 (15 June 1939), pp.15–16 and 17.

5 The eye of the hurricane

1. See Andrew Wilson, 'The Unconscious is Always Right', in *Sluice Gates of the Mind, the collaborative work of Pailthorpe and Mednikoff*, catalogue of an exhibition of their works, Leeds, Leeds Museums and Galleries (1998), pp.32–5. Mednikoff's letters, together with Pailthorpe's papers, have recently come to light and shed some interesting light on the internal affairs of the group. On 1 April Mednikoff had written to all surrealists, saying that at a meeting between Pailthorpe, Penrose, Hayter and himself, arrangements had been made to plan 'the reformation of the Surrealist group' 'free from political bias or activity as part of its constitution'. Apparently secret meetings were then held by Mesens, as letters to Mednikoff from Read and Colquhoun testify, before the one at the Barcelona restaurant.

2. Information drawn from Roland Penrose's archives. All quotations come from E.L.T. Mesens's draft of his declaration to the group found in Penrose's papers. Three points only are actually mentioned in the draft.

3. Among other sources for these details, see Ithell Colquhoun, intro. to *Surrealism – Paintings, Drawings, Collages 1936–76*, catalogue of the exhibition of Colquhoun's works at the Newlyn Orion Gallery, Penzance (spring 1976).

4. T. McGreevy, 'London's Liveliest Show', *The Studio*, 120 (October 1940), p.137. See also William Plomer, 'Surrealism Today', *New Statesman and Nation*, 19 (29 June 1940), p.794. Plomer praised the Surrealists' libertarian display of anti-defeatism and powerful foresight. On the texts in the *London Bulletin* 18–20, he wrote: 'These hopeful and militant sayings are a sufficient answer to the ignorant Philistines who suppose that all aesthetes are fribbles and all surrealists dilettanti, and who do not know that culture foreshadows events, sustains hopes, and invigorates the human heart.'

5. Jan Gordon, 'Art and Artists', *Observer* (23 June 1940); Eric Newton, 'Pictures for War-Time', *Sunday Times* (30 June 1940); anon., *Manchester Guardian* (15 June 1940).

6. Robert Melville, 'The Visitation 1911–17', *London Bulletin*, 18–20 (June 1940), pp.7–8; John Banting, 'The Careless Have Inherited the Earth', *ibid.*, p.2; Gordon Onslow-Ford, 'The Painter Looks Within Himself', *ibid.*, pp.30–31.

7. Conroy Maddox, 'The Object in Surrealism', *ibid.*, pp.39–45.

8. See Julian Trevelyan, *Indigo Days*, London, MacGibbon and Kee (1957), pp.116–31.

9. *Our Time*, incorporating *Poetry and the People*, ed. Beatrix Lehmann, John Banting, Ben Frankel, Birkin Howard, Randall Swingler, 1, 1 (February 1941) to 7, 7 (April 1948).

10. See *Jack Bilbo, a retrospective 1907–67*, an exhibition organized by Jane England & Co, London (22 September–8 October 1988), with an extract from a book by Owo Bilbo and Mary Kerr Woodeson.

11. Humphrey Jennings, 'I See London . . .', unpublished poem (March–April 1941) in Mary-Lou Jennings (ed.), *Humphrey Jennings, Film-Maker, Painter, Poet*, London, British Film Institute in assoc. with Riverside Studios (1982), p.37.

12. Humphrey Jennings, 'I Saw Harlequin', *ibid.*

13. An exhibition was organized around the Birmingham group, 'The Birmingham Seven', London, John Bonham, Murray Feely Fine Art (12 June–13 July 1991); texts by Michel Remy and Murray Feely.

14. John Banting, 'War Posters', *Our Time*, 1, 1 (February 1941), pp.26–7; 'Understanding Picasso', *ibid.*, 2, 1 (April 1942), pp.10–14.

15. E.L.T. Mesens, J.B. Brunius and Roland Penrose, 'Correspondence', *Horizon*, 8, 46 (October 1943), p.289.

16. All quotations from letters addressed to Conroy Maddox.

17. Toni del Renzio, 'AIA 1942', *Arson* (March 1942), p.31.

18. A surrealist anecdote is that Conroy Maddox was Toni del Renzio's best man at his wedding with Ithell Colquhoun. After del Renzio had given the aristocratic string of his names, Maddox, not to be found wanting, inserted into his name that of a plane engine then much talked about, and signed 'Conroy Griffin Booth Maddox', thus jeopardizing the legal validity of the deed.

19. Toni del Renzio, 'Correspondence', *Horizon*, 8, 48 (December 1943), pp.433–4.

20. E.L.T. Mesens and J.B. Brunius, *Idolatry and Confusion*, London Gallery Editions (March 1944). It was due to appear in *Tribune*, but was turned down. Reply to del Renzio's criticism of Eluard soon veers off on to personal attacks and insults against 'Ranci del Conno', 'Vomi du Pinceau' and other niceties.

21. *Incendiary Innocence*, an *Arson* pamphlet, ed. Toni del Renzio. The publication date was indicated as 'Lautréamont's Day, April 4, 1944'.

22. E.L.T. Mesens (ed.), *Message from Nowhere*, London, London Gallery Editions (November 1944).

23. Gordon Onslow-Ford, 'Matta Echaurren', *London Bulletin*, 18–20 (June 1940), p.29; 'Esteban Frances', *ibid.*, p.32.

24. Conroy Maddox, 'From Infiltrations of the Marvellous', *Kingdom Come*, 3, 11 (winter 1942), pp.16–18.

25. Conroy Maddox, 'Collage' (1940). First published in Silvano Levy (ed.), *Conroy Maddox, Surreal Enigmas*, Keele, Keele University Press (1995), pp.16–19. One of the most illuminating statements on collage.

26. Conroy Maddox, 'The Playgrounds of Salpêtrière' (1940). First published in the catalogue of the exhibition 'Surrealism in Britain in the Thirties', Leeds, Leeds City Art Gallery (1986), p.81.

27. Conroy Maddox, 'I Seek Only the Gestures' (c. 1939–40). First published in the catalogue of the exhibition Surrealism in England 1936 and After, Canterbury, Canterbury College of Art (1986), p.68.

28. Derek Stanford, *Inside the Forties*, London, Sidgwick and Jackson (1977), p.71.

29. Toni del Renzio, 'Can You Change a Shilling?', *View*, 3, ser. 3 (1943), p.83.

30. Ithell Colquhoun, 'Everything Found on Land is Found in the Sea', *New Road 1943*, Billericay (Essex), The Grey Walls Press (1943), pp.196–9.

31. Toni del Renzio, 'The Uncouth Invasion – The Paintings of Emmy Bridgwater', *Arson* (March 1942), p.32.

32. I am greatly indebted to Jeffrey Sherwin, a Leeds G.P., the owner of the painting, who briefly and most perceptively analysed *Brave Morning*, providing the conclusions quoted here.

33. In an interview with the author, Edith Rimmington explained that she had first painted the eight deep-sea diving suits, and had left it at that. A few weeks later, she was thumbing through a French magazine and chanced upon an article on the slaughterhouse at La Villette in Paris with a photograph of one of the rooms; on the floor, there were eight sheep's heads. The dream became compelling reality.

34. Edith Rimmington, 'Time-table' and 'Leucotomy', *Fulcrum* (July 1944), p.5.

35. Julian Trevelyan, 'John Tunnard', *London Bulletin*, 12 (15 March 1939), pp.9–10.

36. John Tunnard, in an interview with Myerscough-Walker in April 1944. Quoted in *John Tunnard 1900–1971*, catalogue of the exhibition at the Royal Academy of Arts (5 March–11 April 1977), p.22.

37. Herbert Read, 'The World of John Tunnard', *ibid.*, pp.52–4.

38. Grace W. Pailthorpe, in the broadcast 'Mirror for Women' (10 July 1944); the programme lasted only ten minutes.

39. I am greatly indebted to Yves Laroque for information on this episode. His thesis on Surrealism in English-speaking Canada is as yet unpublished.

40. J.F. Hendry and Henry Treece (eds), *The New Apocalypse*, London, Routledge (1939). Robert Melville's article on *Picasso's Anatomy of Women* is of especial significance.

41. Henry Treece, *How I See Apocalypse*, London, Lindsay Drummond (1946). The jacket carried a painting by John Tunnard.

42. See *A Paradise Lost; The Neo-Romantic Imagination in Britain 1935–55*, catalogue of an exhibition (ed. David Mellor), London, Lund Humphries in association with the Barbican Art Gallery (1987).

43. G.S. Fraser, 'Apocalypse in Poetry – General Theory of the Movement', in J.F. Hendry and Henry Treece (eds), *The White Horseman, prose and verse of the new apocalypse*, London, Routledge (1941), pp.3–4.

44. J.F. Hendry, 'Myth and Social Integration', *The White Horseman, ibid.*, pp.153–79. A very perceptive article, in which Hendry sees surrealism as 'a conglomeration of myths corresponding to the political "order" or disorder, of anarchy', while 'apocalypticism represents rather the restoration of order to myth, a pattern of myth, individual and social, which in art should correspond to the political order of planned socialism' (p.176).

45. Henry Treece, *How I See Apocalypse, ibid.*, pp.77–8.

46. Stefan Schimanski, *Knight and Devil*, Billericay, The Grey Walls Press (1942). It is through Stephan Schimanski that Maddox met Henry Treece in 1939; Treece was then broadcasting on Birmingham local radio. Just before joining the RAF, Treece wrote to Maddox to try to establish closer links with the British surrealists, suggesting contributions from Melville, Maddox and Penrose. With the same idea in mind, in 1941 Treece included Maddox among the Apocalyptic painters in an article commissioned by a Belfast magazine, and the year after, in an attempt at going 'beyond groups, and cliques and movements', invited Ithell Colquhoun to become art adviser for apocalypticism.

6 Watchman, What of the Night?

1. Herbert Read, 'Letter', *Tribune* (6 April 1945), p.12.

2. Information drawn from letters sent to Conroy Maddox (Conroy Maddox's archives).

3. *Free Unions Libres* (summer 1946), 2.

4. For further information, see George Melly, *Rum, Bum and Concertina*, London, Weidenfeld and Nicolson (1977). The poems from *Free Unions Libres* are 'Mabel's Dream' (p.12) and 'If Your Brains' (p.38).

5. Among the many newspaper reports, see 'Girl's Death from a Fall', *The Times* (4 September 1945); 'Death-fall Girl was to Have Wed This Week', *Daily Mirror* (4 September 1945); 'Girl Who Thought She was Immortal – She Dabbled in Dreams', *Daily Mail* (8 September 1945); 'Girl Artist Kept Book of Dreams', *Daily Express* (8 September 1945); 'Dabbling in Dreams Drove Girl to Death', *Daily Mirror* (8 September 1945).

6. Denis J. Jean, 'Was There an English Group in the Forties?: Two Unpublished Letters', *Twentieth Century Literature*, 45 (1975), pp.81–9.

7. Attempts were also made to launch questionnaires at these meetings. One asked the question: 'How did the war affect you sexually?' According to Conroy Maddox, 'J.B. Brunius had written a statement; Penrose stood to read it, he was the chairman, but stopped half way through and had a bit of a cough. Edith Rimmington snatched the paper and "fuck" was the word written there.' Henry Moore made a pun on his name. Robert and John Melville, Banting, Mesens, Fergar and Dylan Thomas were also present (interview with Conroy Maddox, May 1977). Another, composed by Robert Melville in 1947 focused on Magritte's painting *The Red Model* and raised the issue of the efficacy and durability of the work; but, Melville added in his letter to the group, 'the questionnaire is primarily intended as a preliminary move towards clearing the ground for closer collaboration

between English surrealists' (in Conroy Maddox's archives). Back in 1942, Toni del Renzio had devised a questionnaire asking the surrealists to define their attitude towards automatism, humour, the transformation of the mind, and coincidences, with exactly the same idea in mind, to strengthen the links between members of the group separated by the war.

8. The financing of the company that legally owned the Gallery was by a system of non-cumulative preference shares, of which Penrose owned 702 shares and Mesens 348. Technically speaking, then, Penrose could be regarded as having a two-thirds majority share in the company, but he never used this advantage to enforce any decision. On top of this, Peter Watson, probably the staunchest supporter of surrealism and similar contemporary movements, subscribed £3000, Zwemmer £2000 and Penrose another £3950 (Penrose's archives).

9. Letter by André Breton in Conroy Maddox's archives.

10. Unpublished letter from Simon Watson Taylor to Conroy Maddox, dated 18 May 1947 (Conroy Maddox's archives).

11. Unpublished letter from E.L.T. Mesens to Roland Penrose (Roland Penrose's archives).

12. E.L.T. Mesens, 'Notes', *The Cubist Spirit in Its Time*, catalogue of an exhibition The Cubist Spirit in Its Time, London, London Gallery Editions (18 March–3 May 1947), pp.10–15.

13. The so-called Carrouges-Pastoureau affair, which broke out in the ranks of the French surrealists in February 1951, had an important impact on the British group. Since Michel Carrouges had published *André Breton et les Données Fondamentales du Surréalisme*, a sympathetic book on the movement, Breton accepted him into the circle of his friends. This was put to the test when Carrouges delivered a talk on surrealism to a group of priests. Against all expectations, Breton showed no particular reaction to this and came under violent attack from other members of the group, Patrick Waldberg, Jacques Hérold, Lebel and Pastoureau. This opened an insuperable rift in the Paris group and plunged the English surrealists into some disarray.

14. See 'The Birmingham Seven', an exhibition organized at John Bonham, Murray Feely Fine Art, London (12 June–13 July 1991). The texts in the catalogue are by Michel Remy and Murray Feely.

15. Respectively, in 'Birmingham Surrealist', *Sunday Mercury* (17 February 1946); 'Surrealist', *Birmingham Mail* (15 February 1946).

16. Anon., 'Coventry Art Circle's 25th exhibition', *Coventry Standard* (17 May 1947); Robert Melville, 'Challenging Pictures at Coventry Art Circle Exhibition', *Coventry Standard* (8 November 1947).

17. Anon., 'Birmingham Art Show Breaks with Conventionality', *Birmingham Mail* (February 1949); Anon., 'The Coventry Art Circle's Display: Criticism of Attitude of Visitors', *Birmingham Post* (22 January 1951).

18. John Banting, *The Blue Book of Conversation*, London, Poetry London Editions (1946).

19. Conroy Maddox, 'The Playgrounds of the Salpêtrière' (1940), first published in Silvano Levy (ed.) *Conroy Maddox: Surreal Enigmas*, Keele, Keele University Press (1995), pp.15–16.

20. Jeanne Santerre (Conroy Maddox), 'Aesthetic Dissection' and 'Uncertainty of the Day', *Free Unions Libres* (summer 1946), pp.25 and 38.

21. Conroy Maddox, 'Notes on the Christian Myth', *Free Unions Libres* (summer 1946), pp.14–15.

22. Emmy Bridgwater, 'The Birds', *Free Unions Libres* (summer 1946), p.33.

23. Roland Penrose, 'Bulldoze Your Dead', *Message from Nowhere* (November 1944), pp.12–13.

24. Mel Gooding, 'Introduction' and 'Notes on the Selection', in *F.E. McWilliam, Sculpture 1932–89*, London, Tate Gallery (1989), p.47. See also Roland Penrose, Introduction to *Women of Belfast, New Bronzes by F.E. McWilliam, 1972–3*, Belfast, McClelland Galleries International (12–24 November 1973).

25. In the same vein, she appeared on television one day in 1948 wearing her *Ceremonial Hat for Eating Bouillabaisse*, a wide hat made of cork on which she stuck various marine elements, like urchins, starfish, seashells, thus wearing what one eats, and eating what one wears.

26. Marianne Haile, 'Recollections', in Barry Hepton (ed.) *Sam Haile, Potter and Painter 1909–1948*, London, Bellew Publishing in association with Cleveland County Council (1993), p.62.

27. Ithell Colquhoun, 'The Mantic Stain', *Enquiry*, 2, 4 (October–November 1949), then in *Athene* (June 1951).

28. Ithell Colquhoun, 'The Tarot as Colour', cyclostyled sheet published on the occasion of an exhibition of her Tarot-inspired works, Newlyn, Newlyn Gallery (26 July–13 August 1977).

Mention must be made of her Gothic novel *Goose of Hermogenes*, London, Peter Owen (1961). Structured on the eleven alchemical operations, it is a novel of initiation into alchemical and Celtic lore, unfolding in a timeless setting.

29. George Melly, *It's All Writ Out for You*, London, Thames and Hudson (1986).

30. E.L.T. Mesens, ' "Scottie" Wilson', *Horizon*, 13, 78 (June 1946), pp.400–402.

31. Roger Cardinal, 'Scottie Wilson', *Outsider Art*, London, Studio Vista (1972). To Roger Cardinal's analysis and George Melly's memories, one should add Victor Musgrave's personal support for Scottie when he was alive and his enthusiastic efforts to preserve and spread the message of Scottie's Greedies and other phantasmatic creatures. It is Victor Musgrave who first 'put into perspective the unconscious transformation of observed reality in Scottie's best work' (Melly, *ibid.*, p.34).

32. 'Scottie' Wilson quoted in George Melly, *ibid.*, p.33.

33. 'The One and the Other', an interview with Desmond Morris in Michel Remy, *The Surrealist World of Desmond Morris*, London, Jonathan Cape (1991), p.10. About Desmond Morris's work, also see *The Secret Surrealist: The Paintings of Desmond Morris*, Oxford, Phaidon (1987) with an introduction by Philip Oakes, and Silvano Levy, *Desmond Morris: Fifty Years of Surrealism*, London, Barrie and Jenkins (1997).

34. Fierce comments such as these appeared in issues of the local paper, the *Evening Advertiser* in January and September 1948. Ironically enough, the paper had been founded by Desmond Morris's grandfather.

35. 'Desmond Morris, Geoffrey Clarke and Scottie Wilson', Oxford, New Gallery, Ashmolean Museum (1952).

Postscript

1. The Enchanted Domain, Surrealist Art at Exeter City Gallery and Exe Gallery, part of Exeter Festival of Modern Arts, Exeter (24 April–20 May 1967). Of the 125 works on show, half were by British artists; among them, Mesens, Brunius, Agar, Maddox, Banting, Tunnard and Wilson, but also younger artists like Anthony Earnshaw, Patrick Hughes and Richard Humphry.

2. John Lyle, born in 1932 in Earlstown, was an indefatigable polemicist in the name of surrealism and, when a second-hand bookseller in Harpford, served as a 'resonance box' and 'central agency' for worldwide surrealism. He emigrated to France in the eighties.

3. Anon. (collective text), 'The Only Revolution that Matters', *Transformation*, n.d., n.p. First number of the magazine before its title was (slightly) modified.

4. John Welson, 'The Surrealist Proposition', in *Surrealism – The Hinge of History*, n.d., n.p., compiled by Conroy Maddox, John Welson and Pauline Drayson, and printed by Freedom Press.

5. Dada and Surrealism Reviewed, exhibition organized by David Sylvester and Dawn Ades, London, Hayward Gallery (11 January–27 March 1978); Surrealism Unlimited 1968–1978, organized by Conroy Maddox, London, Camden Arts Centre (17 January–5 March 1978); The Terrain of the Dream, organized by John Welson, Worcester, Worcester City Art Gallery (31 December 1977–21 January 1978).

6. Anthony Earnshaw, *Musrum*, London, Jonathan Cape (1968); *Wintersol*, London, Jonathan Cape (1971).

7. Conroy Maddox, introduction to the catalogue of an exhibition of John Welson's works, London, Crawshaw Gallery (25–9 April 1989).

8. For all these niceties and other reductionist comments, see *Surrealism and Women*, ed. Mary Ann Caws, Rudolf Kuenzli and Gwen Raaberg, Cambridge (Mass.), MIT Press (1991), especially Gwen Raaberg, 'The Problematics of Women and Surrealism (pp.1–10), Rudolf Kuenzli, 'Surrealism and Misogyny' (pp.17–26), Robert J. Belton, 'Speaking with Forked Tongues: "Male" discourse in "Female" Surrealism?' (pp.50–62).

9. Ithell Colquhoun, 'What Do I Need to Paint a Picture?', *London Bulletin* 17 (15 June 1939), p.13.

10. Further development of this subject will be found in Michel Remy, 'The Visual Poetics of British Surrealism', in *Surrealism, Surrealist Visuality* (ed. Silvano Levy), Keele, Keele University Press (1996), pp.157–66.

11. J.B. Brunius, 'The Goon Show', *Le Surréalisme, même*, 2 (Spring 1957), pp.86–8. See also J.H. Matthews, 'It All Depends on Where You're Standing', *TRANSFORMAcTION* 6 (1973), pp.14–24.

12. Contrariwise, Surrealism and Britain 1930–1986, organized by Ian Walker (part of the Swansea Festival 1986), Swansea, Glynn Vivian Gallery (20 September–15 November). The exhibition then travelled to Bath, Newcastle and Llandudno.

13. J.H. Matthews, 'The Spirit of Surrealism', catalogue of the exhibition Contrariwise, *ibid.*, pp.4–7.

Select bibliography

British surrealist publications and related periodicals

SURREALIST PUBLICATIONS

Arson, an ardent review. Part one of a Surrealist Manifestation, ed. Toni del Renzio (March 1942).

Bulletin International du Surréalisme / International Surrealist Bulletin 4, pub. in London by the Surrealist Group in England (September 1936).

Contemporary Poetry and Prose, ed. Roger Roughton, 1, 1 (May 1936) – 8 (December 1936 and 2, 9 (spring 1937) – 10 (autumn 1937).

Dint, Anthology of Modern Poetry, ed. Feyyaz Fergar and Sadi Cherkeshi, 1 (August 1944) – 2 (autumn 1944).

Free Unions Libres, ed. Simon Watson Taylor, London, Freedom Press (summer 1946).

Fulcrum, ed. Feyyaz Fergar (July 1944).

Idolatry and Confusion, ed. E.L.T. Mesens and J.B. Brunius, London, London Gallery Editions (March 1944).

Incendiary Innocence, an *Arson* pamphlet, ed. Toni del Renzio (April 1944).

London Bulletin, ed. E.L.T. Mesens, 1 (April 1938) – 18–20 (June 1940). Only the first issue bore the name *London Gallery Bulletin*.

London Gallery Express, an occasional news–sheet, London, London Gallery (March–April 1947).

London Gallery News, an occasional paper, London, London Gallery (December 1946).

Message from Nowhere, ed. E.L.T. Mesens, London, London Gallery Editions (November 1944).

New Road 1943, ed. Alex Comfort and John Bayliss, Billericay, Essex (The Grey Walls Press).

Salvo for Russia, and edition of etchings and engravings, in aid of the Comforts Fund for Women and Children in Soviet Russia, London, ed. Nancy Cunard and John Banting (1942).

TRANSFORMAcTION, ed. John Lyle, Sidmouth (Devon), 1 (1964) – 10 (1980).

RELATED PERIODICALS

Axis, a quarterly review of contemporary abstract painting and sculpture, ed.

Myfanwy Evans, London, 1 (January 1935) – 8 (winter 1937).

Clé, bulletin mensuel de la F.I.A.R.I., ed. Maurice Nadeau, Paris, 1 (1 January 1939) – 2 (February 1939).

Experiment, a magazine of poetry and prose, ed. G.F. Noxon, for Experiment at Trinity College, Cambridge, 1 (November 1928) – 7 (spring 1931).

Horizon, a review of literature and art, ed. Cyril Connolly, 1, 1 (January 1940).

Kingdom Come, the magazine of wartime Oxford, ed. John Waller and Kenneth Harris, 1, 1 (17 November 1939) – 3, 12 (autumn 1943).

Minotaure, ed. Albert Skira, Paris, 1 (February 1933) – 12/13 (May 1939).

New Verse, ed. Geoffrey Grigson, 1 (January 1933) – 31/2 (autumn 1938).

Phases, dir. Edouard Jaguer, 2nd series, 1 (May 1969) – 5 (November 1975).

La Révolution Surréaliste, Paris, Gallimard, 1 (1 December 1924) – 12 (15 December 1929).

Le Savoir Vivre, Brussels, Le Miroir Infidèle (1946).

Le Surréalisme au Service de la Révolution, ed. André Breton, Paris, 1 (July 1930) – 5/6 (May 1933).

This Quarter, ed. Edward W. Titus, Monte Carlo, then Paris, 1925–1932, not published between 1927 and 1929.

Transatlantic Review, ed. Ford Madox Ford, I, 1 (January 1924) – II, 6 (December 1924).

Transformation, ed. Stefan Schemanski and Henry Treece, 1 (1943) – 4 (1946).

transition, an international quarterly for creative experiment, 1–27, Paris, The Hague, New York (April 1927–April/May 1938).

Unit One, the modern movement in English architecture, painting and sculpture, ed. Herbert Read, London, Cassell (1934).

View, ed. Charles-Henri Ford, series 1 to 7 (spring 1940–October 1946).

VVV, poetry, plastic arts, sociology, psychology, ed. David Hare, New York, 1 (June 1942); 2/3 (March 1943), 4 (February 1944).

CATALOGUES OF RECENT MAJOR EXHIBITIONS

1971 *Britain's Contribution to Surrealism of the '30s and '40s*, London, Hamet Gallery (3–27 November)

1978 *Dada and Surrealism Reviewed*, ed. Dawn Ades, intr. David Sylvester, London, Arts Council Publications (11 January–27 March). Texts by Dawn Ades and Elisabeth Cowling.

1982 *La Peinture Surréaliste Anglaise 1930–1960, Les Enfants d'Alice*, Paris, Galerie 1900–2000 (14 May–30 June). Texts by Edouard Jaguer and Michel Remy.

1985 *A Salute to British Surrealism 1930–1950*, Colchester, The Minories (6 April–5 May). The exhibition then went on to Blond Fine Art in London and Ferens Art Gallery in Hull. Texts by Michel Remy and Mel Gooding.

1986 *La Planète Affolée, Surréalisme – Dispersion et Influences 1938–1947*, Marseilles, La Vieille Charité (12 April–30 June), catalogue pub. by Flammarion, Paris (1986). Texts by José Pierre, Edouard Jaguer, Michel Fauré, Sarah Wilson, José Vovelle, Peter Shield, Ragnar von Holten, Frantisek Smejkal, Vera Linhartova, Martica Sawin, Alfredo Cruz-Ramirez.

British Surrealism Fifty Years On, London, Mayor Gallery (March–April). The exhibition then went on to Middlesborough Art Gallery, Middlesborough (24 May–14 June). Text by Michel Remy.

Surrealism in England, 1936 and After, Canterbury, Herbert Read Gallery, Canterbury College of Art (19–31 May). Texts by Duncan Scott (organizer), Toni del Renzio,

Michel Remy. The exhibition then travelled to the National Museum of Wales, Cardiff (August–September) and to the Laing Gallery, Newcastle (October–November).

Surrealism in Britain in the Thirties, Angels of Anarchy and Machines for Making Clouds, Leeds, Leeds City Art Gallery (October–December). Texts by Alex Robertson, Mel Gooding and Michel Remy.

Contrariwise, Swansea, Glynn Vivian Art Gallery (20 September–15 November). Texts by Ian Walker (organizer), J.H. Matthews, George Melly. The exhibition then went on to the Victoria Art Gallery, Bath (November–January), the Polytechnic Gallery, Newcastle (January–February) and Mostyn Art Gallery, Llandudno (February–April 1987).

1987 *Surrealismi/Surrealism*, Retretti (Finland), Retretti Art Centre (16 May–13 September). Texts by Dan Sundell, Michel Remy, Irina Subotic, Jiri Kotalic, and others.

1988 *I Surrealisti* (organizer Arturo Schwartz), Milan, Palazzo Reale i Arengaria (8 June–10 September), catalogue published by Edizione Mazzotta, Milano (1988). Texts by Martica Sawin, José Vovelle, Michel Remy, Frantisek Smejkal, Ragnar von Holten, Peter Shield, Alfredo Cruz-Ramirez.

1989 *British Surrealism*, London, Blond Fine Arts (4–18 June).

1990 *Anxious Visions* (organizer Sidra Stitch) Berkeley, University Art Museum (3 October–30 December), catalogue pub. by Abbeville Press, New York (1990). Texts by Sidra Stitch, James Clifford, Tyler Stovall, Steven Kovacs and biblio. by Jeannene M. Przyblyski.

1991 *The Birmingham Seven*, London, John Bonham and Murray Feely Fine Art (12 June–13 July). Texts by Michel Remy and Murray Feely.

1992 *British Surrealism*, London, Mayor Gallery (24 March–22 May). No catalogue.

1993 *Revolution by Night*, Canberra, National Gallery of Australia (13 March–2 May); then Brisbane, Queensland Art Gallery (21 May–11 July) and Sydney, Art Gallery of New South Wales (30 July – 19 September).

1994 *British Surrealism 1935–1994*, London, England & Co. (5–27 May). No catalogue.

1995 *Real Surreal, British and European Surrealism*, ed. Lisa Rull, Wolverhampton, Wolverhampton Art Gallery and Museum (17 June–19 August).

1996 *In the Mind's Eye*, Whitworth Art Gallery, Manchester (April–June 1996); York City Art Gallery (August–September 1997); Hove Art Gallery (May–July 1998).

1998 *El Surrealismo y la Guerra Civil Espanola*, on the occasion of an exhibition organized by the Museum of Teruel (30 October–13 December), Teruel, Spain, Museo de Teruel. Texts by Emmanuel Guigon, Jean-Michel Goutier, George Sebbag, Michel Remy ('British Surrealism and the Spanish Civil War'), Nilo Palenzuela; and a testimony by Toni del Renzio.

On surrealism in Great Britain

BOOKS

Germain, Edward B., *Surrealist Poetry in English: 1929–1947*, Doctoral Thesis, University of Michigan, Ann Arbor (1969). (A shortened version was made for the introduction of *English and American Surrealist Poetry*, ed. E.B. Germain, Harmondsworth, Penguin Books, 1978.)

Jaguer, Edouard and Remy, Michel, *La Peinture Surréaliste en Angleterre 1930–1960: Les Enfants d'Alice*, catalogue of an exhibition at the Galerie 1900–2000, Paris (1982).

Ray, Paul C., *The Surrealist Movement in England*, New York, Cornell University Press (1971).

Remy, Michel, *Le Mouvement Surréaliste en Angleterre*, State Doctoral Thesis, Paris, Université de Paris VIII, 1985 (unpublished).

Remy, Michel, *Towards a Dictionary of Surrealism in England*, together with *Towards a Chronology of Surrealism in England*, Nancy, Groupe Editions Marges (1978).

ARTICLES

Blunt, Anthony, 'Superrealism', *Spectator*, 156 (19 June 1936), pp.1126–7.

Byrne, Barry, 'Surrealism Passes', *Commonweal*, 26 (2 July 1936), pp.262–3.

Coffey, Brian, 'Position Politique du Surréalisme, by André Breton – *A Short Survey of Surrealism* by David Gascoyne', 15, 60, *Criterion* (April 1936), pp.506–11.

Connolly, Cyril, 'It's Got Here, at Last!', *New Statesman*, 10, 251 (14 December 1935), pp.946.

Hoffman, F.J., 'From Surrealism to "The Apocalypse", a development in XXth century irrationalism', *English Literary History*, 15 (June 1948), pp.147–65.

Jean, Denis J., 'Was there an English Group in the Forties?: Two Unpublished Letters', *Twentieth Century Literature*, 45 (1975), pp.81–9.

Matthews, J.H., 'Surrealism and England', *Comparative Literature Studies*, 1, 1 (1964), pp.55–72.

Plomer, William, 'Extension of Reality', *Listener*, 15 (15 January 1936), p.134.

Plomer, William, 'Surrealism Today', *New Statesman*, 19 (29 June 1940), p.794.

Quennell, Peter, 'The Surrealist Exhibition', *New Statesman*, 11 (20 June 1936), pp.967–8.

Remy, Michel, 'Le Surréalisme et la Politique en Angleterre, ou l'étonnement du discours', SAES Symposium in Nantes, Paris, Didier (Coll. Etudes Anglaises), pp.185–96.

'La Vraie Nature du Surréalisme: le Surréalisme en Angleterre', SAES Symposium in St-Etienne, Paris, Didier (Coll. Etudes Anglaises), 67 (1975), pp.107–16.

'La Pittura Surrealista in Inghilterra', *Terzo Occhio*, 10, 30 (March 1984), pp.15–20.

'Le Dispositif Hystérique de John Melville, peintre, et David Gascoyne, poète', in *Du Verbe au Geste* (Mélanges offerts à M.le Professeur Danchin) Nancy, Presses Universitaires de Nancy (1986), pp.261–73.

'1936, L'Année de Tous les Dangers', *Mélusine* (Cahiers du Centre de Recherches sur le Surréalisme), 8 (winter 1986), pp.125–42.

'Samuel Haile's pursuit of theory, or the hidden face of British Surrealism', preface to the catalogue of an exhibition of Haile's works, London, Birch and Conran Gallery, 14 October–6 November 1987.

'Perspective de la Déviance: la peinture surréaliste de Conroy Maddox', *Annales du GERB*, University of Bordeaux III, 7 (1989), pp.107–34.

'La Ville Déplacée du Surréalisme Anglais', *Les Mots La Vie* (University of Nice), 5 (October 1989), pp.95–114.

'The Springs of the Firebirds: The paintings of Emmy Bridgwater', preface to the catalogue of an exhibition of Emmy Bridgwater's works, London, Blond Fine Art (July 1990).

'Les Corps Abymés d'Edith Rimmington', *Annales du GERB*, University of Bordeaux III, 12 (1994).

'The Visual Poetics of British Surrealism', in *Surrealism,* ed. Silvano Levy, Keele, Keele University Press (1995).

Short, Robert S., 'Le Surréalisme en Grande-Bretagne', *Bulletin du Centre National de la Recherche Scientifique*, Paris (9 October 1978).

Thody, Philip, 'Lewis Carroll and the Surrealists', *Twentieth Century*, 163, 975 (May 1958), pp.427–34.
Treece, Henry, 'Dylan Thomas and the Surrealists', *Seven*, 3 (winter 1938), pp.27–30.
Watson, Francis, 'Surrealism in Our Time', *Architectural Review*, 79 (June 1936), pp.251–2.
Wilson, Sarah, 'En Angleterre', catalogue of an exhibition La Planète Affolée in Marseilles, (April–June 1986), Paris, Flammarion (1986).

Works by and on British surrealists

In the following sections, primary sources precede critical studies and articles.

AGAR, EILEEN

A Look at My Life (with Andrew Lambirth), London, Thames and Hudson (1990).
'Religion and the Artistic Imagination', *The Island*, 1 (June 1931), p.102.

Ades, Dawn, 'Notes on Two Women Surrealist Painters', *Oxford Art Journal*, 3 (April 1980).
Grimes, Teresa (with Collins, Judy and Badderley, Oriana), *Five Women Painters*, London, Lennard Publishing (1989), pp.161–80.
Nash, Paul, introduction, exhibition catalogue, London, Redfern Gallery (1942).
Penrose, Roland, introduction, catalogue of exhibition 'Eileen Agar, a decade of discoveries', London, New Art Centre (30 June–24 July 1976).
Remy, Michel, 'Eileen Agar', *Ellebore*, 5 (1981), p.5.
Wilson, Andrew, 'The Spirit of Surrealism', in *Eileen Agar at 90*, on the occasion of an exhibition at Birch and Conran Gallery, London, an *Art Line Magazine* special supplement (1989).

BANTING, JOHN

The Blue Book of Conversation, London, London Poetry Editions (1946).
'The Careless Have Inherited the Earth', *London Bulletin*, 18–20 (June 1940), p.2.
'Notes on Posters of the Spanish Republican Government', *Horizon*, 9 (September 1940), p.88.
'War posters', *Our Time*, 1, 1 (February 1941), pp.26–7.
'Understanding Picasso', *Our Time*, 2, 1 (April 1942), pp.10–143.
'More Widespread Distribution of Eggs', *Message from Nowhere* (November 1944), pp.14–15.
Answer to the questionnaire of *Le Savoir Vivre*, Brussels, Le Miroir Infidèle (1946).
Causton, Bernard, 'Contemporary Foreign Writers – VII – The Surrealists', *Bookman*, 80, 478 (July 1931).
Melly, George, introduction, catalogue exhibition, London, Hamet Gallery (1–24 December 1971).
Todd, D., 'Decoration by John Banting', *Architectural Review*, 73 (April 1933), pp.164–5.
Trevelyan, Julian, 'John Banting – an English Surrealist', *Painter and Sculptor*, 1, 2 (summer 1958), pp.6–9.

BRIDGWATER, EMMY

'The Birds', *Free Unions Libres* (summer, 1946), p.33.

Answer to the questionnaire of *Le Savoir Vivre*, Brussells, Le Miroir Infidèle (1946).

Rull, Lisa Mary, *Uncovering Difference: Emmy Bridgwater and British Surrealism*, University of Wolverhampton, School of Humanities and Social Sciences (1994), unpub.

Sveinsson, Christine, *The Work of Emmy Bridgwater – an automatic thorn in the flesh of surrealism* (1994), unpub.

Deepwell, Katy (and Sugg, D.), 'Emmy Bridgwater', *Women's Art Magazine*, 37 (November–December 1990), pp.16–19.

Deepwell, Katy, *Ten decades: Careers of Ten Women Artists born 1897–1906*, exhibition catalogue, Norwich, Norwich Gallery (1992).

Del Renzio, Toni, 'The Uncouth Invasion', *Arson* (summer 1942), p.24.

Hall, Charles, 'Review: Emmy Bridgwater at Blond Fine Art', *Arts Review*, 42, 14 (13 July 1990), pp.395–6.

Remy, Michel, 'The Springs of the Firebirds', preface to the catalogue of an exhibition of Emmy Bridgwater's works, London, Blond Fine Art (July 1990).

Remy, Michel, 'Devenir et Revenir. Le Travail de deuil chez Emmy Bridgwater et Edith Rimmington, peintres surréalistes anglaises', in *La Femme S'entête: La Part du féminin dans le surréalisme*, Paris, Editions Pleine Marge, Lachenal et Ritter (1998).

Remy, Michel, 'Présentation d'Emmy Bridgwater, surréaliste anglaise', with the translation of twelve poems, *Pleine Marge*, 26 (winter 1997), pp.25–35.

COLQUHOUN, ITHELL

The Crying of the Wind: Ireland, London, Peter Owen (1955).
The Living Stones: Cornwall, London, Peter Owen (1957).
Goose of Hermogenes, London, Peter Owen (1961).
Grimoire of the Entangled Thicket, Stevenage, Ore Publications (1973).

'The Double Village', *London Bulletin*, 7 (December 1938–January 1939), p.23.
'The Moths', *London Bulletin*, 10 (February 1939), p.11.
'What Do I Need to Paint a Picture?', *London Bulletin*, 17 (15 June 1939), p.13.
'The Volcano', *London Bulletin*, 17 (15 June 1939), pp.15–16 and 17.
'The Echoing Bruise', *London Bulletin*, 17 (15 June 1939), pp.17–18.
'Everything Found on Land is Found in the Sea', *New Road 1943*, Billericay (Essex), Grey Walls Press (1943), pp.196–9.
'Aged Six', *View*, ser. 4, 2 (summer 1944), p.52.
'The Mantic Stain', *Enquiry*, 2, 4 (October–November 1949); also *Athene* (June 1951).
'Night Blossom Island', *Fantasmagie*, Brussels (1962).
'The Schooner Hesperus', *Soleils*, Paris (1963).
Preface to the catalogue *Surrealism – Paintings, Drawings, Collages 1936–1976*, Newlyn, Newlyn Orion Gallery (1976).
Answer to the questionnaire of *Le Savoir Vivre*, Brussels, Le Miroir Infidèle (1946).

Ramsden, E.H., Introduction, catalogue of exhibition of Ithell Colquhoun's work, London, Mayor Gallery (5–29 March 1947).

Young, Andrew McLaren, 'Introduction', catalogue of an exhibition, Ithell Colquhoun, Paintings, Collages and Drawings, Exeter, City of Exeter Museums and Art Gallery (Exeter Museums Publications, 69) (1972).

DAVIES, HUGH SYKES

Petron, London, Dent (1935).

'The Primitive in Modern Art', *Experiment*, 3 (May 1929), pp.29–32.
'Comment on Sir Isaac Newton Turning Mystic', 'Experiment' section in *transition*,
 19–20 (June 1930), p.117.
'Homer and Vico', *New Verse*, 8 (April 1934), pp.12–18.
'Sympathies with Surrealism', *New Verse*, 20 (April–May 1936), pp.15–21.
'Surrealism at this Time and Place', in *Surrealism* (ed. Herbert Read), London, Faber
 and Faber (1936), pp.117–68.
'Biology and Surrealism', *International Surrealist Bulletin*, 4 (September 1936), pp.13–15
 (extracts).
'In the stump of the old tree' ('Poem'), *Contemporary Poetry and Prose*, 7 (November
 1936), p.129.
'It doesn't look like . . .' ('Poem'), *London Bulletin*, 2 (May 1938), p.7.

Gascoyne, David, '*Petron*', *New Verse*, 18 (December 1935).
Heppenstall, Rayner, 'Book Reviews (on *Petron*)', *Criterion*, 15, 59 (January 1936),
 pp.332–4.
Read, Herbert, '*Petron*' (review), *New English Weekly*, 8, 5 (14 November 1935), pp.91–2
 (with exchange of letters in the issue of 28 November 1935).

DEL RENZIO, TONI

Arson, an ardent review. Part One of a surrealist manifestation, London, ed. Toni del
 Renzio (March 1942).
'Surrealist Section' (ed. del Renzio), *New Road 1943*, Billericay (Essex), Grey Walls
 Press (1943), pp.180–230.
Incendiary Innocence, London, publ. Toni del Renzio (April 1944).

'The Return to the Desolation', *Arson* (March 1942), p.22.
'The Uncouth Invasion (The Paintings of Emmy Bridgwater)', *Arson* (March 1942),
 p.24.
'Foreword', catalogue of a surrealist exhibition, London, International Art Centre
 (1942).
'Letter from London' in 'View Listens', *View*, 3 ser. 2 (October 1942), p.30.
'Can You Change a Shilling?', *View*, 3, ser. 3 (1943), p.83.
'The Light That Will Cease to Fail', *New Road 1943*, Billericay (Essex), Grey Walls Press
 (1943), pp.180–3.
'Correspondence', *Horizon*, 8, 48 (December 1943), pp.433–4.
'Surrealism . . . or else', *Tribune* (14 July 1944), p.17.
'André Breton a-t-il Dit Passe?', *Horizon*, 1, 88 (May 1947), pp.297–301.
Answer to the questionnaire of *Le Savoir Vivre*, Brussels, Le Miroir Infidèle (1946).
'The Absent Text – the Third Manifesto of Surrealism or Nothing Else' in catalogue of
 the exhibition Surrealism in England 1936 and After, Canterbury, Canterbury
 College of Art (1986), pp.58–64.
'Un Faucon et un Vrai', in *Surrealism – Surrealist Visuality* ed. Silvano Levy, Keele,
 Keele University Press (1995).
'The Exhibitionist, His Overcoat, Several Fetishes and a Phantom or So: The Life and
 Dreams of Conroy Maddox', in *Conroy Maddox: Surreal Enigmas* ed. Silvano Levy,
 Keele, Keele University Press (1995), pp.172–7.

Melville, Robert, 'Three Wooden Laths and Two Plaster Feet', *Arson* (March 1942), p.7.
Serbanne, Claude, 'Panorama – Surréalistes Etrangers', *Cahiers du Sud*, 38à (1946), p.397.

EARNSHAW, ANTHONY

Musrum (with Eric Thacker), London, Jonathan Cape (1968).
Wintersol (with Eric Thacker), London, Jonathan Cape (1971); Grove Press, New York, 1971).
Seven Secret Alphabets, London, Jonathan Cape (1972).
Flick Knives and Forks, Harpford, *TRANSFORMAcTION* (1982).
Carping and Kicking, poems and aphorisms, Paris, Hourglass Press (1987).
Aspects des Bas Quartiers, Paris, Camouflage Press (1987).
An Eighth Secret Alphabet, Oxford, Hanborough Press (1987).

A View from Back o'Town, Anthony Earnshaw's Work 1945–1987, Leeds, Leeds City Art Gallery (9 April–17 May 1987); then Middlesborough, Cleveland Gallery (4 July–15 August 1987).

EVANS, MERLYN

Catalogue of the exhibition Paintings, drawings and etchings, London, Whitechapel Art Gallery (October–November 1956). Texts by B(ryan) R(obertson) and R.H. Wilenski.
Catalogue of the exhibition The Political Paintings of Merlyn Evans, London, Tate Gallery Publications (1985). Texts by David Fraser Jenkins and Tim Green.
Catalogue of the exhibition Merlyn Evans (1910–1973), London, Mayor Gallery (1988). Text by Mel Gooding.

GASCOYNE, DAVID

Roman Balcony, London, Lincoln Williams (1932).
Opening Day, London, Cobden-Sanderson (1932).
A Short Survey of Surrealism, London, Cobden-Sanderson (1935).
Man's Life is This Meat, London, Parton Press (1936).
Hölderlin's Madness, London, J.M. Dent (1938).
Poems 1936–1942, London, Poetry London Editions, Nicholson and Watson (1942)
Collected Poems (Robin Skelton ed.), London, Oxford University Press (1965).
Collected Verse Translations (Alan Clodd and Robin Skelton eds.), London, Oxford University Press (1970).
Paris Journal 1937–1939, London, Enitharmon Press (1978), with a preface by Lawrence Durrell.
Paris Journal 1936–1937, London, Enitharmon Press (1980), with an introductory note by David Gascoyne.

'Premier Manifeste Anglais du Surréalisme (fragment)', *Cahiers d'Art*, 10 (1935), p.106.
'Answers to an Enquiry', *New Verse*, 11 (October 1934), pp.11–13.
'The Public Rose' (a review of Paul Eluard's *La Rose Publique*), *New Verse*, 13 (February 1935), p.18.
'Selected Poems by Marianne Moore (a review)', *Purpose* (October–December 1935), pp.182–4.
'Petron' (review), *New Verse*, 18 (December 1935).

'*Rimbaud Vivant*, by Robert Goffin (a review)', *Criterion*, 17, 66 (October 1937), pp.158–60.

'Sixteen Comments on Auden', *New Verse* (Auden double number), 26–7 (November 1937), pp.24–5.

Translations:

André Breton, *What is Surrealism?*, London, Faber and Faber (1936).

Benjamin Péret, *A Bunch of Carrots*, London, Contemporary Poetry and Prose Editions (1936). Translated with Humphrey Jennings.

Benjamin Péret, *Remove Your Hat*, London, Contemporary Poetry and Prose Editions (1936). The same, after censorship.

Paul Eluard, *Thorns of Thunder*, London, Europa Press and Stanley Nott Ltd (1936). Translated with George Reavey and Ruthven Todd.

Salvador Dalí, *The Conquest of the Irrational*, New York, J. Levy (1936).

Benford, Colin T., *David Gascoyne – A Bibliography (1929–1985)*, Ryde (Isle of Wight), Heritage Books (1986).

Duclos, Michèle, *David Gascoyne*, a special issue of *Cahiers sur la Poésie*, Université de Bordeaux III (GERB) (1986).

Remy, Michel, *David Gascoyne ou l'Urgence de l'Inexprimé*, Nancy, Presses Universitaires de Nancy (1984).

Cazamian, Marie-Louise, 'David Gascoyne: *A Short Survey of Surrealism*', *Revue Anglo-Américaine*, 13 (1935), p.540.

Connolly, Cyril, 'It's Got Here at Last!', *New Statesman*, 10, 251 (14 December 1935), p.946.

Cronin, Anthony, 'Poetry and Ideas: David Gascoyne', *London Magazine* (July 1957), pp.49–55.

Grigson, Geoffrey, 'A Letter from England', *Poetry* (Chicago), 49, 5 (November 1936), p.1021.

Harvey, J. Brian, 'Four Poets', *Left Review*, 2, 10 (July 1936), pp.530–31.

Hastings, Viscount, 'The Surrealists', *Left Review*, 2, 4 (January 1936), pp.186–7.

Jennings, Elizabeth, 'The Restoration of Symbols', *Twentieth Century Literature*, 165 (1959), pp.567–77.

Plomer, William, 'Extension of Reality', *Listener*, 15 (15 January 1936), pp.134.

Raine, Kathleen, 'David Gascoyne and the Prophetic Role', *Adam International*, 301 (1966), pp.41–71. Also in *Sewanee Review*, 75, 2 (1967), pp.193–229.

Stanford, Derek, 'David Gascoyne: A Spiritual Itinerary', *Month*, new series, 29, 1 (1963), pp.156–69.

Stanford, Derek, 'David Gascoyne and the Unacademics', *Meanjin*, 23 (1964), pp.70–79.

Tolley, A.T., *The Poetry of the Thirties*, London, Gollancz (1975), pp.231–40.

Walton, Geoffrey, 'Clique-Puffery', *Scrutiny*, 4 (March 1936), pp.452–4.

HAILE, THOMAS SAMUEL

'London's Loss Our Gain', *Art News* (1 March 1941).

'Of Art, the Artist and World War II', *Tomorrow* (November 1944), pp.129–31 and December 1944, pp.153–4.

Hepton, Barry (ed.), *Sam Haile, Potter and Painter 1909–1948*, catalogue of an exhibition of Haile's works, Cleveland, Cleveland County Council in collaboration with

Bellew Publishing (1993). Texts by Victor Margrie, Paul Rice, Marianne Haile and Eugene Dana.

The Surrealist Paintings and Drawings of Sam Haile, Manchester, Manchester City Art Gallery (November–December 1967). Preface by A.C. Sewter.

Anon., 'The Pottery of Sam Haile', *Architectural Forum* (March 1949).

Anon., 'T.S. Haile, Ceramist', *Craft Horizons* (summer 1949), pp.10–12.

Anon., 'People are Not Afraid of These Things Now', *Dartington Hall News*, 42nd year, 2539 (7 March 1969), pp.6–7.

Clark, Garth, 'Sam Haile 1909–1948: A Memorial', *Studio Potter*, 7, 1 (1978), pp.4–9.

Hammond, Henry, 'A Magnetic Teacher', *Craft Horizons* (May–June 1975).

Heron, Patrick, 'Round the London Art Galleries', *Listener* (13 September 1951), p.428.

Remy, Michel, 'Samuel Haile's pursuit of theory, or the hidden face of British Surrealism', a preface to the catalogue of Haile's works, London, Birch and Conran Gallery (14 October–6 November 1987).

Sewter, A.C., 'T.S. Haile, Potter and Painter', *Apollo* (December 1946), pp.160–63.

Sewter, A.C., 'T.S. Haile, Potter and Painter', *Pottery and Glass* (March 1947). Same article, but abridged.

JENNINGS, HUMPHREY

Humphrey Jennings, Film-Maker, Painter, Poet (ed. Mary-Lou Jennings), London, British Film Institute in association with Riverside Studios (1982).

'The Theatre Today', in *The Arts Today*, ed. Geoffrey Grigson, London, John Lane, The Bodley Head (1935), pp.187–216.

'Colour Film Advertising: Lubrication by Shell', *Commercial Art*, 20, 93 (March 1936).

'Surrealism', *Contemporary Poetry and Prose*, 8 (December 1936), p.167.

'In Magritte's Paintings', *London Bulletin*, 1 (April 1938), p.15.

'The Iron Horse', *London Bulletin*, 3 (June 1938), pp.22, 27-8.

'Do Not Lean Out of the Window', *London Bulletin*, 4–5 (July 1938), pp.13–14 and 43–4.

'A Determination Not to Dream', *London Bulletin*, 4–5 (July 1938), p.40.

'Who Does That Remind You Of?', *London Bulletin*, 6 (October 1938), pp.21–2.

Films:

Post Haste, GPO Film Unit, dir. John Grierson, Editor H. Jennings (1934), 10 min.

Pett and Pott, GPO Film Unit, prod. John Grierson, dir. Alberto Cavalcanti, sets H. Jennings (1934), 33 min.

Locomotives, GPO Film Unit, dir. H. Jennings (1934), 10 min.

The Story of the Wheel, GPO Film Unit, editor H. Jennings (1934), 12 min.

The Birth of the Robot, Shell-Mex and BP Ltd, prod. and dir. Len Lye, sets and prod. H. Jennings (1935–6), 6 min.

Penny Journey, GPO Film Unit, dir. H. Jennings (1938), 8 min.

Design for Spring, dir. H. Jennings (1938), 20 min.

Speaking from America, GPO Film Unit, prod. Alberto Cavalcanti, dir. H. Jennings (1939), 18 min.

Spare Time, GPO Film Unit, prod. Alberto Cavalcanti, dir. H. Jennings (1939).

The First Days, GPO Film Unit, prod. Alberto Cavalcanti, dir. H. Jennings, Harry Watt, Pat Jackson (1939), 20 min.

S.S. Ionian, GPO Film Unit, dir. H. Jennings (1939), 20 min.

Translation:

Péret, Benjamin, *A Bunch of Carrots*, London, Contemporary Poetry and Prose Editions (1936). Trans. with David Gascoyne.

Anon., *Humphrey Jennings*, London, British Film Institute (1969).

Belmans, Jacques, *Humphrey Jennings 1907–1950*, Paris, Anthologie du Cinéma, Avant-Scène du Cinéma (1970).

Bronowski, Julius, *Recollections of Humphrey Jennings*, London, British Film Institute (1950).

Grierson, John (and Kathleen Raine, Basil Wright, Dilys Powell, Ian Dalrymple, John Greenwood), *Humphrey Jennings, a Tribute*, London, Humphrey Jennings Memorial Fund Committee, n.d.

Lovell, Alan, *Humphrey Jennings*, London, British Film Institute (1969).

Powell, Dilys, et al., *Humphrey Jennings, a Tribute*, London, British Film Institute (1950).

Vas, Robert, *Heart of Britain: full transcripts of interviews used for the television documentary on Humphrey Jennings*, London, British Film Institute (1969).

LYE, LEN

No Trouble, Deya (Majorca), Seizin Press (1930).
Figures of Motion – selected writings (eds Wystan Curnow and Roger Horrocks), Auckland, Auckland University Press and Oxford University Press (1984).

'Song Time', *London Bulletin*, 18–20 (June 1940), p.33.
'Knife Apple Sheer Brush', *Tigers Eye* (New York), 7 (March 1948).
'Voice and Colour', *Life and Letters Today*, 14, 3 (spring 1936).
'Experiment in Colour', *World Film News* (December 1936).
'Notes on a Short Colour Film', *Life and Letters Today*, 15, 6 (winter 1936).
'Song Time Stuff', *Life and Letters Today*, 18, 11 (spring 1938).
'Song Time Stuff', *Life and Letters Today*, 18, 12 (summer 1938).
'Television – New Axes to Grind', *Sight and Sound*, 8, 30 (summer 1939), p.65.
'The Man Who Was Colour Blind', *Sight and Sound*, 9, 33 (spring 1940), p.6.

Films:
Tusalava, London Film Society (1929), 9 min.
Colour Box, GPO Film Unit (1935), 5 min.
Kaleidoscope, Gerald Noxon and P.W.P. Productions (1935), 4 min.
The Birth of the Robot (with H. Jennings), prod. Shell-Mex and BP Ltd (1935–6), 6 min.
Rainbow Dance, GPO Film Unit (1936), 4 min.
In Time with Industry, GPO Film Unit (1937), 5 min.
Trade Tattoo, GPO Film Unit (1937), 5 min.
North by Northwest (1937), 7 min.
Colour Flight, Imperial Airways (1937), 4 min.
Swinging the Lambeth Walk, Ministry of Information (1939), 4 min.
Musical poster n° 1, British Government (1940), 3 min.
When the Pie was Opened, British Government (1941), 10 min.
Newspaper Train (1941).
Work Party (1942).
Kill or Be Killed, Ministry of Information (1942), 15 min.
Cameramen at War, Realist Film Unit for the Ministry of Information (1943), 17 min.

Riding, Laura, *Len Lye and the Problem of Popular Films*, London, Seizin Press (1938).
Len Lye, a Personal Mythology, Paintings, Steel Motion Compositions, Films, Auckland
 (New Zealand), Auckland City Art Gallery (1980).
Len Lye – a special issue of *Art New Zealand*, 17 (1980).

Blakeston, Oswell, 'Comment and Review: Plastic Entertainment and Plastic
 Boredom', *Close-Up*, 6, 1 (January 1930), p.74.
Blakeston, Oswell, 'Sketches by Len Lye', *Close-Up*, 6, 2 (February 1930), pp.155–6.
Blakeston, Oswell, 'Teaching Music by the Abstract Film', *Close-Up*, 10, 2 (June 1933),
 pp.161–2.
Blakeston, Oswell, 'Mirror-writing: Scenario and Life: Surrealist Cinema', *Film Art*, 5
 (winter 934), pp.13–15.
Mancia, Adrienne and Van Dyke, W., 'The Artist as Film-maker: Len Lye', *Art in
 America* (July 1966), pp.89–106.
Vesselo, A., 'Rainbow Dance, Len Lye's latest film', *Sight and Sound*, 5, 19 (autumn
 1936), p.83.

MCWILLIAM, F.E.

Matle, Judith and Flanagan, T.P., *F.E. McWilliam*, Belfast, Arts Council of Northern
 Ireland and an Chomhairle Ealaion (April 1981).
Gooding, Mel, 'Introduction' (with biographical chronology) in *F.E. McWilliam*,
 catalogue of a retrospective of McWilliam's works, London, Tate Gallery (1989).
Penrose, Roland, *McWilliam Sculptor*, London, Alec Tiranti (1964).

Garrett, Albert, 'The Sculpture of McWilliam', *Studio*, 167 (November 1954).
Garrett, Albert, 'The Sculpture of F.E. McWilliam', *Art News and Review* (1956).
Nash, Paul, 'F.E. McWilliam', *London Bulletin*, 11 (March 1939), pp.11–12.
Penrose, Roland, Introduction to the catalogue of the exhibition New Bronzes, Belfast,
 McClelland Galleries International (12–24 November 1973).
Robertson, Bryan, 'The Sculpture of F.E. McWilliam', *Nimbus*, 11, 3 (1954).

MADDOX, CONROY

'Note', *London Bulletin*, 15–16 (15 May 1939), pp.35–6.
'The Object in Surrealism', *London Bulletin* 18–20 (June 1940), pp.39–45.
'from The Exhibitionist's Overcoat', *Arson* (March 1942), p.21.
'from Infiltrations of the Marvellous', *Kingdom Come*, 3, 11 (winter 1942), pp.16–18.
'from The Exhibitionist's Overcoat', *New Road 1943*, Billericay (Essex), Grey Walls
 Press (1943), pp.212–13 (same text as above).
'Note (from Some Notes on Myth and Liberty)', *Message from Nowhere* (November
 1944), p.9.
Letter, *Message from Nowhere* (November 1944), p.22.
'Notes on the Christian Myth', *Free Unions Libres* (summer 1946), pp.14–15.
Answer to the questionnaire of *Le Savoir Vivre* , Brussels, Le Miroir Infidèle (1946).
'Neuroses for Old', *Opinion* (Birmingham International Centre) (August 1950),
 pp.9–10.

Under the pseudonym Jeanne Santerre:
'Aesthetic Dissection', *Free Unions Libres* (summer 1946), p.25.
'Uncertainty of the Day', *Free Unions Libres* (summer 1946), p.38.

Levy, Silvano (ed.), *Conroy Maddox: Surreal Enigmas*, Keele, Keele University Press
(1995). Texts by Roger Cardinal, Toni del Renzio, George Melly, Desmond Morris,
Michel Remy, Robert Stuart Short, Linda Talbot and Simon Wilson.
Del Renzio, 'Note', *Arson* (March 1942), p.27.
Hendry, J.F., 'The Apocalyptic Element in Conroy Maddox', *Kingdom Come*, 3 (winter
1942), pp.14–16.
Remy, Michel, 'Perspectives de la Déviance: La Peinture Surréaliste de Conroy
Maddox', *Annales du GERB*, Bordeaux, Université de Bordeaux III, 7 (1989),
pp.107–34.

MEDNIKOFF, REUBEN

'Poem', catalogue of the exhibition *Surrealist Objects and Poems*, London, London
Gallery (November 1937).

D.L.C.(?), 'G.W. Pailthorpe and R. Mednikoff's works', *London Bulletin*, 10 (February
1939), p.23.
Catalogue of the exhibition Grace Pailthorpe 1883–1971, Reuben Mednikoff
1906–1975, London, Oliver Bradbury and James Birch Fine Art Gallery (13 April–12
May 1984).
Catalogue of the exhibition Sluicegates of the Mind, The Collaborative Work of Dr
Grace W. Pailthorpe and Reuben Mednikoff, Leeds, Leeds City Art Gallery (14
January–15 March 1998). Texts by Nigel Walsh, Andrew Wilson, David Maclagan
and Michel Remy.

MELLY, GEORGE

Rum, Bum and Concertina, London, Weidenfeld and Nicolson (1977; Futura
Publications, 1978).
Don't Tell Sybil, London, Heinemann (1997).

'Poem', *Free Unions Libres* (summer 1946), p.38.
'Mabel's Dream', *Free Unions Libres* (summer 1946), p.12.
'On the Occasion of a Birthday' (1949), in catalogue of an exhibition of the work of
E.L.T. Mesens, Brussels, Galerie Isy Brachot (30 October–7 December 1970)
reproduced in *La Peinture Surréaliste en Angleterre 1930–1960*, Paris, Galerie
1900–2000 (1982), p.69.
'What's Become of Surrealism?', *Vogue*, 122–3 (15 October 1961), p.165.
'The Pope of Surrealism', *Observer* (8 March 1970), pp.8–13.
'The W.C. Fields of Surrealism', *Sunday Times* (15 August 1971), p.23–7.

MELVILLE, JOHN

Melville, Robert, 'Note', *Arson* (March 1942), p.27.
Melville, Theo, introduction to the catalogue *John Melville: a memorial exhibition*,
London, Gothick Dream Fine Art (1987).
Melville, Theo, Introduction to the exhibition of John Melville's works, London,
Westbourne Gallery (22 May–9 June 1996).

MELVILLE, ROBERT

Picasso, Master of the Phantom, London, Oxford University Press (1939). Announced in
the *London Bulletin*, 15–16 (15 May 1939) under the title *Picasso, Master of Freedom*.

(with E.L.T. Mesens), catalogue of the exhibition The Cubist Spirit in Its Time, London, London Gallery Ltd (18 March–3 May 1947).

Henry Moore, Sculpture and Drawings, London, Thames and Hudson (1970).

'Suburban Nights (II)', *London Bulletin*, 8–9 (January–February 1939), p.49.

'Cinderella', *New Road 1943*, Billericay (Essex), Grey Walls Press (1943), pp.219–23.

'The Visitation 1911–1917', *London Bulletin*, 18–20 (June 1940), pp.7–8.

'The Temptation of Hieronymus Bosch', *Horizon*, 10 (October 1940), p.176.

'Apocalypse in painting', *The White Horseman*, London, Routledge (1941), pp.135–52.

'Picasso in the Light of Chirico', *View*, ser. 1, 11–12 (February–March 1942).

'Three Wooden Laths and Two Plaster Feet', *Arson* (March 1942), pp.7–8, 10.

'André Masson', *Arson* (March 1942), pp.25–6.

'The Evolution of the Double Head in the art of Picasso', *Horizon*, 35 (November 1942), p.343.

'The Triumph of the True God', *View*, ser. 3, 1 (April 1943), pp.12–15.

'Devil and Saint', *Transformation*, 1 (1943), pp.134–9.

'Three Moves in the Big Game', *View*, ser. 4, 3 (autumn 1944), pp.78–9, 83.

'Letter', *Message from Nowhere* (November 1944), p.22.

'The Snake on the Dining-room Table', *View*, ser. 6, 4 (May 1946), pp.9–10.

'John Layard, *The Lady of the Hare*' (review), *Free Unions Libres* (summer 1946), p.48.

'Surrealism: An Aspect of its Influence', *Listener*, 66 (21 September 1961), pp.432–3.

Answer to the questionnaire of *Le Savoir Vivre*, Brussels, Le Miroir Infidèle (1946).

MESENS, E.L.T.

(with J.B. Brunius) *Idolatry and Confusion*, London, London Gallery Editions (March 1944).

Troisième Front, war poems, together with *Pièces Détachées*, illus. by the author, London, London Gallery editions (1944).

Poèmes 1923–1958, Paris, Le Terrain Vague (1958).

'Violette Nozières', *Contemporary Poetry and Prose*, 2 (June 1936), p.28.

'The Arid Husband', catalogue of the exhibition *Surrealist Objects and Poems*, London, London Gallery (November 1937).

'Three Poems', *London Bulletin*, 4–5 (July 1938), pp.2, 8, 31.

'Le Moyen d'en Finir', *London Bulletin*, 10 (February 1939), p.19.

'Chanson Nette', *London Bulletin*, 12 (15 March 1939), pp.15–16.

'L'Etude du Langage', 'Baiser', 'Petit Poème en prose', 'Fait Divers Intraduisible, Statistique et Critique', 'Sing song', *London Bulletin*, 18–20 (June 1940).

'Goujaterie Moraliste', *Fulcrum* (July 1944), p.1.

'Le Dimanche, La Radio Annonce Toujours de Bonnes Nouvelles', *Message from Nowhere* (November 1944), pp.10–11.

'Poème', *Free Unions Libres* (summer 1946), p.32.

'Letter to the Editor of the *New Statesman*', *London Bulletin*, 18–20 (June 1940), pp.20–21.

'Correspondence', *Horizon*, 8, 46 (October 1943), p.289 (with Brunius and Penrose).

'Note', *Message from Nowhere* (November 1944), pp.21–2. In answer to Alex Comfort, editor of *New Road 1943*.

'Scottie Wilson', *Horizon*, 13, 78 (June 1946), pp.400–402.

Preface to the catalogue of the exhibition The Cubist Spirit in Its Time, London, London Gallery Ltd (1947).

'Que Faut-il Pour Faire un Collage?', *Quadrum*, 16 (1964), pp.115–22.

Answer to the questionnaire of *Le Savoir Vivre*, Brussels, Le Miroir Infidèle (1946).

Geurts-Krauss, Christiane, *E.L.T. Mesens, l'alchimiste méconnu du surréalisme*, Brussels, Editions Labor (1998).

Cavalcanti, Alberto, 'E.L.T. Mesens', *London Bulletin*, 1 (April 1938), p.19.

Jaguer, Edouard, 'Au Pays des Images Défendues', *Aujourd'hui*, 5 (June 1960), pp.18–19.

Lyle, John, 'Mesens', *Art and Artists*, 6 (September 1971), pp.50–55.

Melly, George, 'The W.C. Fields of Surrealism', *Sunday Times* (15 August 1971), pp.23–7.

TRANSFORMAcTION (ed. John Lyle), 10 (1979). Special issue in homage to Mesens. Articles by John Lyle, Louis Scutenaire, Roland Penrose, Alberto Cavalcanti, J.M. Matthews, José Pierre, Edouard Jaguer, Enrico Baj, and texts by Mesens.

MILLER, LEE

Penrose, Antony, *The Lives of Lee Miller*, London, Thames and Hudson (1985).

MOORE, HENRY

Henry Moore, Sculpture and Drawings, London, Lund Humphries (1977). Intro. by Herbert Read. Part I (1921–48), ed. David Sylvester (1957); Part II (1949–1954), ed. Alan Bowness (1965); Part III (1955–1964), ed. Alan Bowness; Part IV (1964–1973), ed. Alan Bowness.

Henry Moore: Carvings 1923–1966, London, Marlborough Fine Art Ltd (1967). Intro. by Robert Melville.

Henry Moore on Sculpture, ed. Philip James, London, Macdonald (1966).

'A View of Sculpture', *Architectural Association Journal* (English Sculptors series), London (May 1930).

'The Sculptor's Aims', *Unit One*, London (1934).

'The Sculptor Speaks', *Listener*, 18 (18 August 1937), p.449.

'Notes on Sculpture', *The Painter's Object*, ed. Myfanwy Evans, London, Gerald Howe Ltd (1937), pp.21–9.

'Quotations', *Circle*, ed. J.L. Martin, Ben Nicholson, N. Gabo, London, Faber and Faber (1937), p.118.

Digby, G.F., *Meaning and Symbol in Three Modern Artists E. Munch, H. Moore and Paul Nash*, London, Faber and Faber (1955).

Grigson, Geoffrey, *Henry Moore*, Harmondsworth, Penguin Books (1943).

Grohman, Will, *The Life and Work of a Great Sculptor: Henry Moore*, New York, Gollancz (1966).

Hedgecoe, John, *Henry Moore*, London, Nelson (1968).

Jianou, Lionel, *Henry Moore*, Paris, Arted Editions d'Art (1968).

Neumann, Erich, *The Archetypal World of Henry Moore*, London, Routledge (1959).

Read, Herbert, *Henry Moore*, London, Thames and Hudson (1965).

Russell, John, *Henry Moore*, Harmondsworth, Penguin Books (1975).

Sylvester, David, catalogue of an exhibition of Moore's works, London, Arts Council of Great Britain (17 July–22 September 1968).

Wilkinson, Alan G., *The Drawings of Henry Moore*, London, Tate Gallery, in collaboration with the Art Gallery of Toronto (1977).

Grigson, Geoffrey, 'Henry Moore and Ourselves', *Axis*, 3 (July 1935), pp.9–10.
Hendy, Philip, 'Henry Moore', *Horizon*, 21 (September 1941).
Onslow-Ford, Gordon, 'The Wooden Giantess of Henry Moore', *London Bulletin*, 18–20 (June 1940), p.10.
Read, Herbert, 'Henry Moore', *Unit One*, London, Cassel (1934), pp.29–30.

NASH, PAUL

Poet and Painter, Correspondence between Gordon Bottomley and Paul Nash 1910–46, eds C.C. Abbott and Anthony Bertram, London, Oxford University Press (1955)
Outline: An Autobiography and Other Writings, London, Faber and Faber (1949). Preface by Herbert Read.

Causey, Andrew (ed.), *Paul Nash, the Development of his Painting*, foll. by a catalogue of Nash's œuvre, London, London University (1973).
Causey, Andrew (ed.), *Paul Nash's Photographs – Document and Image*, London, Tate Gallery (1973).
Eates, Margot (ed.) *Paintings, Drawings and Illustrations*, London, Lund Humphries (1948). Texts by Herbert Read, John Rothenstein and E.H. Ramsden.
Eates, Margot (ed.), *Paul Nash, the Master of the Image 1889–1946*, London, John Murray (1973). With a text by Cecil Day Lewis.
Nash, Margaret (ed.), *Fertile Image*, London, Faber (1951). Intr. by James Laver.
Nash, Margaret (ed.), *Paul Nash's Camera*, London, Arts Council (1952).
Paul Nash 1889–1946, catalogue of the exhibition Paintings and Drawings, London, British Council (1949).

'Giorgio de Chirico', *Listener*, 5, 120 (29 April 1931), pp.720–21.
'Letter to the Editor', *The Times* (2 June 1933).
'For, but not with', *Axis*, 1 (January 1935), pp.24–6.
'The Object', *Architectural Review*, 80 (November 1936), pp.207–8.
'Surrealism and the Illustrated Book', *Signature*, 5 (March 1937), pp.1–11.
'The Life of the Inanimate Object', *Country Life*, 81, 2102 (1 May 1937), pp.496–7.
'Swanage or Seaside Surrealism', in *The Painter's Object* (ed. Myfanwy Evans), London, Gerald Howe Ltd (1937), pp.108–15.
'The Nest of Wild Stones', in *The Painter's Object* (ed. Myfanwy Evans), London, Gerald Howe Ltd (1937), pp.38–42.
'John Piper', *London Bulletin*, 2 (May 1938), p.10.
'F.E. McWilliam', *London Bulletin*, 11 (1 March 1939), p.11.
'Monster Field', *Architectural Review*, 88 (October 1940), pp.120–22.
Preface to the catalogue of the exhibition of Eileen Agar's works, London, Redfern Gallery (1942).
'Notes on a Picture', *Transformation Three* (1945), pp.133–5.

Cardinal, Roger, *The Landscape Vision of Paul Nash*, London, Reaktion Books (1989).
Digby, G.F., *Meaning and Symbol in Three Modern Artists: Edvard Munch, Henry Moore and Paul Nash*, London, Faber and Faber (1955).
Graham, Rigby A., *A Note on the Book Illustrations of Paul Nash*, Wymondham, Brewhouse Press (1965).
Read, Herbert, *Paul Nash*, Harmondsworth, Penguin (1944).
Rothenstein, John, *Paul Nash 1889–1946*, London, Beaverbrook Newspapers (1962; Parnell, 1967).

Causey, Andrew, 'Strange Encounters', *Illustrated London News*, 250 (15 April 1967), pp.30–31.

Clark, Kenneth, 'New Romanticism in British Painting', *Art News*, 45 (February 1947), pp.24–8.

Evans, Myfanwy, 'The Significance of Paul Nash', *Architectural Review*, 102, 609 (September 1947), pp.75–80.

Hendy, Philip, 'Paul Nash', *Horizon*, 42 (June 1943), p.413.

Herkens, Suzanne, 'Paul Nash', *Arts Plastiques*, 3 (1948), pp.161–3.

Ingamells, A.S., 'Unseen Landscapes', *Country Life*, 83 (21 May 1938), pp.526–7.

Mortimer, Raymond, 'Nature Imitates Art – with Photographs by Paul Nash', *Architectural Review*, 77 (January 1935), pp.27–9.

Neve, Christopher, 'The Reality beyond the Reality', *Country Life*, 150, 3878 (7 October 1971), pp.898–9.

Neve, Christopher, 'Kodak in English Surrealism: Paul Nash's Photographs', *Country Life*, 153 (17 May 1973).

Penrose, Roland, 'On Paul Nash', *London Bulletin*, 2 (May 1938), p.24.

Ramsden, E.H., 'Paul Nash: Surrealism in Landscape', *Country Life*, 91 (2 January 1942), pp.28–9.

Shand, P. Morton, 'Object and Landscape', *Country Life*, 85 (3 June 1939), pp.592–3.

Underwood, Margaret, 'Paul Nash, Painter of the Elemental', *Macandblad une Beeldende Kunsten*, 26 (February 1950), pp.39–42.

ONSLOW-FORD, GORDON

Gordon Onslow-Ford, retrospective exhibition, Oakland (California), Oakland Museum (1980). With texts and biographical notes.

'The Wooden Giantess of Henry Moore', *London Bulletin*, 18–20 (June 1940), p.10.

'Matta Echaurren' and 'Esteban Frances', *London Bulletin*, 18–20 (June 1940).

'The Painter Looks Within Himself', *London Bulletin*, 18–20 (June 1940), pp.30–31.

Breton, André, 'Gordon Onslow-Ford', *Minotaure*, 12–13 (May 1939), pp.16–17.

Breton, André, 'Des Tendances les Plus Récentes de la Peinture Surréaliste' (1939), in *Le Surréalisme et la Peinture*, Paris, Gallimard (1965), pp.146–9.

Breton, André, 'Genèse et Perspectives Artistiques du Surréalisme (1941)', in *Le Surréalisme et la Peinture*, Paris, Gallimard (1965), p.82.

Regler, Gustav, 'Four European Painters in Mexico', *Horizon*, 16, 91 (August 1947), pp.96–101. On Leonora Carrington, Alice Paalen, G. Onslow-Ford and Wolfgang Paalen).

PAILTHORPE, GRACE W.

Grace Pailthorpe 1883–1971, Reuben Mednikoff 1906–1975, London, Oliver Bradbury and James Birch Fine Art Gallery (13 April–12 May 1984).

Catalogue of the exhibition Sluicegates of the Mind, the Collaborative Work of Dr Grace W. Pailthorpe and Reuben Mednikoff, exhibition and catalogue, Leeds, Leeds City Art Galleries (15 January–8 March 1998). Texts by Nigel Walsh, Andrew Wilson, David Maclagan and Michel Remy.

Studies in the Psychology of Delinquency, London, Medical Research Council, Special Reports series, 170 (1932).

What We Put in Prison and in Preventive and Rescue Homes, London, Williams and

Norgate (1932).

'The Eye', *Transition*, 26 (1937).
'The Scientific Aspects of Surrealism', *London Bulletin*, 7 (December 1938–January 1939), pp.10–16.
'Letter to the Editor', *London Bulletin*, 17 (15 June 1939), pp.22–3.
'The Corpse' (a poem), catalogue of the exhibition Surrealist Objects and Poems, London, London Gallery (November 1937).

Alvensleben, Werner von, 'Automatic Art', *London Bulletin*, 13 (15 April 1939), pp.22–4.
D.L.C., 'G.W. Pailthorpe and R. Mednikoff's works', *London Bulletin*, 10 (February 1939), p.23.
Tyler, Parker, 'Letter from Parker Tyler to Charles Henri Ford', *London Bulletin*, 17 (15 June 1939), pp.21–2.

PENROSE, ROLAND

The Road is Wider than Long, London, London Gallery Editions (Surrealist Poetry Series, 1) (June 1939).
Home Guard Manual of Camouflage, London, Routledge and Sons (1941).
In the Service of the People, London, Heinemann (1945).
Pablo Picasso, London, Gollancz (1958).
Man Ray, London, Thames and Hudson (1975).
Scrapbook, London, Thames and Hudson (1982).

'Notes on the Ratton Exhibition of North Western American Art, Paris', *Axis*, 4 (November 1935), pp.18–19.
'David Gascoyne, *A Short Survey of Surrealism*', *Axis*, 5 (Spring 1936), pp.28–30.
'The Transparent Mirror', *London Bulletin*, 2 (May 1938), p.24.
'The Battle of Gloucester', *London Bulletin*, 4–5 (July 1938), p.40.
'Note on the exhibition of *Guernica*', *London Bulletin*, 8–9 (January–February 1939), p.59.
'Correspondence', *Horizon*, 8, 46 (October 1943), p.289 (with Mesens and Brunius).
Extracts from *The Road is Wider than Long*, *London Bulletin*, 7 (December 1938–January 1939), pp.16–22; 8–9 (January–February 1939), pp.50–56.
'Bulldoze Your Dead', *Message from Nowhere* (November 1944), pp.12–13.

Carline, Richard, 'Round the Galleries', *Our Time*, 8, 6 (June 1949), p.165.
Gascoyne, David, 'Roland Penrose', in the catalogue of the exhibition Collages Récents, Paris, Galerie Henriette Gomès (1982).
Lynton, Norbert, 'Introduction' to the catalogue of Roland Penrose retrospective exhibition, London, Institute of Contemporary Arts, London, Arts Council of Great Britain (1980).
Magritte, René and Nougé, Paul, 'Colour-colours, An Experiment by Roland Penrose', *London Bulletin*, 17 (15 June 1939), pp.9–10.

READ, HERBERT

The Meaning of Art, London, Faber and Faber (1931, 1936, 1951).
Art Now, an introduction to the theory of modern painting and sculpture, London, Faber and Faber (1933, 1936, 1948, 1960, 1963).

Form in Modern Poetry (Essays in Order, II), London, Sheed and Ward (1933).

Art and Industry, London, Faber and Faber (1934, 1944, 1953, 1956).

Essential Communism, London, Stanley Nott (pamphlets on the New Economics) (1935).

In Defence of Shelley and Other Essays, London, William Heinemann (1936).

Art and Society, London, William Heinemann (1937, 1945, 1956).

Poetry and Anarchism, London, Faber and Faber (1938).

The Philosophy of Anarchism, London, Freedom Press (1940).

Annals of Innocence and Experience, London, Faber and Faber (1940).

The Politics of the Unpolitical, essays, London, Routledge (1943).

Education through Art, London, Faber and Faber (1943, 1958, 1961).

The Education of Free Men, London, Freedom Press (1944).

Freedom. Is It a Crime? The strange case of the three anarchists jailed at the Old Bailey, April 1945, London, Freedom Press Defence Committee (1945).

The Grass Roots of Art, London, Lindsay Drummond (1947).

Poems 1914–1934, London, Faber and Faber (1935)

The Green Child, a romance, London, William Heinemann (1935; The Grey Walls Press, 1945; Eyre and Spottiswoode, 1947).

Collected Poems, London, Faber and Faber (1946).

'Romanticism in Poetry and Painting', *Listener*, 11 (28 February 1934).

'Introduction', *Unit One* (ed. H. Read), London, Cassell and Co. (1934).

'Art, Picasso and the Marxists', *London Mercury*, 31, 181 (November 1934), pp.95–6.

'Our terminology', *Axis*, 1 (April 1935), pp.6–8.

'Ben Nicholson's Recent Work', *Axis*, 1 (April 1935), pp.15–16

'Why the English Have No Taste', *Minotaure*, 7 (June 1935), pp.67–8.

'What is Revolutionary Art?', in *5 On Revolutionary Art*, ed. Betty Rea, London, Wishart and Co. (1935), pp.11–24.

'Reviews: on *Petron*', *The New English Weekly*, 8, 5 (14 November 1935).

'Abstract Art, a Note for the Uninitiated', *Axis*, 5 (spring 1936), p.3.

'Superrealism', in *Art Now*, London, Faber and Faber (1933).

'Introduction' to the catalogue of the International Surrealist Exhibition, London, New Burlington Galleries (1936).

'Censorship in India', letter to the *New Statesman* 11, 279 (27 June 1936), p.1024.

'A Primer of Dialectics', *Left Review*, 2, 10 (July 1936), pp.518–20.

'Surrealism – the Dialectic of Art' in *Surrealism*, supplement to *Left Review*, 2, 10 (July 1936), pp.ii–vii.

'Introduction', in *Surrealism*, London, Faber and Faber (1936).

'Reply to A.L. Lloyd' (with H.S. Davies), *Left Review*, 3, 1 (February 1937), pp.47–8.

'The Faculty of Abstraction', in *Circle*, ed. Ben Nicholson, Naum Gabo, London, Faber and Faber (1937), pp.61–6.

'Foreword' to the catalogue of the exhibition *Surrealist Objects and Poems*, London, London Gallery (November 1937).

'Myth, Dream and Poem', *Transition*, 27 (1938), pp.17–92.

'Magritte', *London Bulletin*, 1 (April 1938), p.2.

'The Significance of Paul Delvaux', *Listener*, 19 (23 June 1938).

'A Note on Rita Kerrn-Larsen', *London Bulletin*, 3 (June 1938), p.20.

'Picasso's Guernica', *London Bulletin*, 6 (October 1938), p.6.

'Surrealist Art', introduction to the catalogue of the Autumn Exhibition, Liverpool, Walker Art Gallery (October 1938).

'Et Vous?' *Clé*, 1 (January 1939), pp.4–5. A letter sent to *Clé*.

'In What Sense "Living"?', *London Bulletin*, 8–9 (January–February 1939), pp.9–10.

'The Development of Ben Nicholson', *London Bulletin*, 11 (1 March 1939), pp.9–10.

'An Art of Pure Form', *London Bulletin*, 14 (1 May 1939), pp. 6–9. An extract from *Art and Society*.

'The Map of Love, a review of Dylan Thomas's Verse and Prose', *Seven*, 6 (Autumn 1939), pp.19–20.

'Art in an Electric Atmosphere', *Horizon*, 3, 17 (May 1941), pp.308–13.

'Foreword', catalogue of the exhibition New Movements in Contemporary Art – English Work – Recent Paintings and Sculpture, London, London Museum (18 March–9 May 1942).

'Education Through Art', *Transformation Two* (1944), pp.65–72.

'Art and Crisis', *Horizon*, 9, 53 (May 1944), pp.336–50.

'The Universal War', *Transformation Three* (1945), pp.53–7.

'Realism and Superrealism', in *A Coat of Many Colours*, London, Routledge (1945), pp.196–9.

'The Fate of Modern Painting', *Horizon*, 16, 95 (November 1947), pp.242–54.

Herbert Read, selected writings, poetry and criticism . . ., London, Faber and Faber (1963).

Harder, Worth Travis, *A Certain Order: the Development of Sir Herbert Read's Theory of Poetry*, unpub. thesis, University of Michigan (1964).

Skelton, Robin (ed.), *A Memorial Symposium*, London, Oxford University Press (1970). Preface by Robin Skelton, articles by George Barker, Walter Gropius, Henry Moore, Kathleen Raine, Stephen Spender, Roy Fuller and others.

Wasson, Richard H., *Herbert Read: Contemporary Romantic Humanist*, unpub. thesis, University of Wisconsin (1961).

Woodcock, George, *The Stream and the Source*, London, Faber (1972).

Dahlberg, Edward, 'Herbert Read', *Texas Quarterly*, 7 (summer 1964), pp.145–8.

Grattan, C. Hartley, 'Gentlemen, I give you Herbert Read', *Harper's Magazine*, 194 (June 1947), pp.535–42.

Greene, Graham, 'Herbert Read', *Horizon*, 3, 15 (March 1941), pp.213–18.

Hausermann, H.W., 'Herbert Read's Surrealist Poetry', in *English Studies presented to R.W. Zandvoort on the Occasion of his 70th Birthday. A supplement to English Studies*, 45 (Amsterdam) (1964), pp.265–70.

Ray, Paul C., 'Sir Herbert Read and English Surrealism', *Journal of Aesthetics and Art Criticism*, 24 (1966), pp.400–413.

Roberts, Michael, 'What does Mr Read believe?', *Kingdom Come*, 3, 12 (autumn 1943), p.34.

'Symposium on Herbert Read's *Politics for the Unpolitical*', *View*, ser. 4, 2 (summer 1944), pp.60–62.

Treece, Henry, 'The Poetry of Herbert Read' in *How I See Apocalypse*, London, Lindsay Drummond (1946).

Wasson, Richard H., '*The Green Child*: Herbert Read's Ironic Fantasy', *PMLA*, 77 (December 1962), pp.645–51.

RICHARDS, CERI

Ceri Richards, retrospective exhibition, London, Marlborough Gallery (1965). Introduction to the catalogue by Robert Melville.

Homage to Ceri Richards 1903–1971, London, Fisher Fine Art (1972).

Burns, Richard, *Ceri Richards and Dylan Thomas*, London, Enitharmon Press (1981).
Robertson, Bryan, *Ceri Richards*, London, Tate Gallery (1981).
Thompson, David, *Ceri Richards*, London, Methuen (Art in Progress series) (1963).

Levy, Mervyn, 'The Celtic Urge of Ceri Richards', *Studio* (The Artist at Work series, n° 19), 165, 843 (July 1963), pp.2–7.
Williamson, H.S., 'Ceri Richards', *Horizon*, 52 (April 1944), p.266.

RIMMINGTON, EDITH

'Automatic Writing: Time-table – Leucotomy', *Fulcrum* (July 1944), p.5.
'The Growth at the Break', 'The Sea-Gull', *Free Unions Libres* (summer 1946), 28.
Answer to the questionnaire of *Le Savoir Vivre*, Brussels, Le Miroir Infidèle (1946).

Remy, Michel, 'Les Corps Abymés d'Edith Rimmington, Peintre Surréaliste Anglaise', *Annales du GERB*, Bordeaux, Université de Bordeaux III, 12 (1994).
Remy, Michel, 'Devenir et Revenir. Le Travail de Deuil chez Emmy Bridgwater et Edith Rimmington, Peintres Surréalistes Anglaises', in *La Femme S'Entête: la Part du Féminin dans le Surréalisme*, Paris, Editions Pleine Marge, Lachenal et Ritter (1998).

ROUGHTON, ROGER

'Three Poems', *Criterion*, 15, 60 (April 1936), p.455.
'Watch this space', *Contemporary Poetry and Prose*, 1 (May 1936), p.7.
'Animal Crackers in Your Croup', *Contemporary Poetry and Prose*, 2 (June 1936), p.36.
'Soluble Noughts and Crosses, or California, Here I Come. To E(ileen) A(gar)', *Contemporary Poetry and Prose*, 3 (July 1936), p.55.
'Surrealism and Communism', *Contemporary Poetry and Prose*, 4 (August–September 1936), pp.74–5.
'Fascism Murders Art', *Contemporary Poetry and Prose*, 6 (October 1936), p.106.
'Lady Windermere's Fan Dance', *Contemporary Poetry and Prose*, 6 (October 1936), p.117.
'Tomorrow Will be Difficult', *Poetry* (Chicago), 49, 1 (October 1936), p.19.
'The Journey', *Contemporary Poetry and Prose*, 8 (December 1936), pp.152–4.
'Final Night of the Bath (from the *Evening Standard*)', *Contemporary Poetry and Prose*, 8 (December 1936), p.166.
'The Largest Imaginary Ballroom in the World – A Date at the Kremlin', *Contemporary Poetry and Prose*, 10 (spring 1937), pp.33–9.
'Building Society Blues', *Contemporary Poetry and Prose*, 9 (spring 1937), p.45.
'The Foot of the Stairs', *Contemporary Poetry and Prose*, 11 (autumn 1937), pp.28–9.
'Sand Under the Door', *Criterion*, 17, 66 (October 1937), pp.67–80.
'The Human House', *Horizon*, 6, 19 (July 1941), pp.50–57.

TAYLOR, SIMON WATSON

'Afterthoughts', *Fulcrum* (July 1944), pp.10–11.
'Last reflections', *Dint* (August 1944).
Letter to *Tribune*, (18 August 1944), p.14.
'The Sailor's Return', *Message from Nowhere* (November 1944), p.19.
'Fragments from My Real Life in Exact Proportion to Those Who Cannot Read . . .',

Free Unions Libres (summer 1946), pp.18–19.

'A Shroud for Your Eyes, Madam: a Funeral Oration', *Free Unions Libres* (summer 1946), pp.39–40.

Answer to the questionnaire of *Le Savoir Vivre*, Brussels, Le Miroir Infidèle (1946).

TREVELYAN, JULIAN

Indigo Days, London, McGibbon and Kee (1957).

'Dreams', in 'Experiment', *transition*, 19–20 (June 1930), pp.121–3.

'Statement in Painting', *Experiment*, 6 (October 1930), pp.37–8.

'Mythos', in *The Painter's Object* (ed. Myfanwy Evans), London, Gerald Howe Ltd (1937), pp.59–60.

'Letter to the Editor', *London Bulletin*, 10 (February 1939), p.24.

'John Tunnard', *London Bulletin*, 12 (15 March 1939), pp.9–10.

'Art by Accident: The Technique of Camouflage', *Architectural Review*, 96 (September 1944), pp.68–70.

'Painter's Purpose', *Studio*, 154 (August 1957), pp.48–9.

TUNNARD, JOHN

John Tunnard 1900–1971, catalogue of the retrospective exhibition, London, Arts Council (1977). Articles by Rudolph Glossop, 'A Personal Appreciation', pp.8–12; Mark Glazebrook, 'Development and Influence', pp.13–16.

Canney, Michael, 'Science and the Artist', *Discovery* (December 1959).

Harriman, Virginia, 'John Tunnard's Wasteland', *Detroit Institute Bulletin*, 30 (1950–51), p.846.

Myerscough-Walker, R., 'Modern Art Explained – part II', *The Artist* (April 1944).

Read, Herbert, 'The World of John Tunnard', *Saturday Book*, 25, London, John Hadfield Hutchinson and Co. (1965).

Thwaites, John A., 'The Technological Eye', *Arts Quarterly* (Detroit Institute of Arts), 9 (spring 1946), pp.115–27.

Trevelyan, Julian, 'John Tunnard', *London Bulletin*, 12 (15 March 1939), pp.9–10.

WELSON, JOHN W.

Water Throat, the paintings, drawings and poems of John Welson, London, privately printed (1982). With an introduction by Robert Golden.

'The Surrealist Proposition', in *Surrealism, the Hinge of History*, pub. by Melmoth, London, Freedom Press (1978).

Maddox, Conroy, 'For John Welson', in the catalogue of the exhibition Drawings and Paintings, London, Crawshaw Gallery (25–29 April 1990).

Remy, Michel, 'John Welson's Slaughterhouse', *Flagrant Délit*, 4 (March 1980)

Remy, Michel, 'John Welson', in the catalogue of the exhibition Drawings and Paintings, London, Crawshaw Gallery (25–29 April 1990).

WEST, PHILIP

Philip West, el legado de un artista, catalogue of a retrospective exhibition, Santiago de

Compostela, Fundacion Granell (1998), with 16 essays, 55 colour reproductions, 200 black and white illustrations, and texts by West.
Bound Angels, Cuenca, Cuadernos Menu (1994).

Calzadilla, Juan, 'Metamorfosis de Una Vitrina del Tropico', catalogue of an exhibition of Philip West's works, Valencia, Centroarte El Parque (February 1981).
Remy, Michel, 'Al Oeste de Issenheim – sobre los Apocalipticos de Philip West', catalogue of the exhibition Axis Mundi, Zaragoza, Galeria de Arte Contemporaneo (17 January–17 February 1996).

WILSON, 'SCOTTIE'

Dubuffet, Jean, 'Scottie Wilson', in *L'Art Brut*, 4, Paris, Publications de la Compagnie de l'Art Brut (1965), pp.5–31.
Gaunt, William, ' "Scottie" Wilson', catalogue of the exhibition Old and New Images, London, Circle Gallery (June 1968).
Levy, Mervyn, 'Scottie Wilson's Kingdom in Kilburn', *Studio*, 161 (June 1962).
Mesens, E.L.T., 'Scottie Wilson', *Horizon*, 13, 78 (June 1946), pp.400–402.

Cardinal, Roger, *Outside Art*, London, Studio Vista (1972), pp.74–80.
Levy, Mervyn, *Scottie Wilson*, London (1966).
Melly, George, *It's All Writ Out for You*, London, Thames and Hudson (1986).
Schreiner, Gerald A., *Scottie Wilson*, Basel (Switzerland), G.A. Schreiner (1979).

On surrealism in general

Alexandrian, Sarane, *L'Art Surréaliste*, Paris, Hazan (1969).
Alquie, Ferdinand, *Philosophie du Surréalisme*, Paris, Flammarion (1955).
Alquie, Ferdinand (ed.), *Entretiens sur le Surréalisme*, Symposium in Cerisy-la-Salle, 10–18 July 1966, Paris, La Haye, Mouton & Co. (1968).
Aragon, Louis, *La Peinture au Défi*, Paris, José Corti (1930).
Barr, Alfred H., *Cubism and Abstract Art*, New York, Museum of Modern Art (1936).
Barr, Alfred, *Fantastic Art, Dada and Surrealism*, New York, Museum of Modern Art (1936).
Biro, Adam et Passeron, René, *Dictionnaire Général du Surréalisme et de Ses Environs*, Fribourg, Office du Livre and Paris, Presses Universitaires de France (1982).
Breton, André, *Manifeste du Surréalisme*, Paris, Gallimard (1924).
Breton, André, *Les Vases Communicants*, Paris, Editions des Cahiers Libres (1932; Gallimard, 1955).
Breton, André, *Le Surréalisme et la Peinture*, Paris, Gallimard (1965).
Cardinal, Roger and Short, Robert S., *Surrealism, Permanent Revelation*, London, Studio Vista; New York, Dutton (1970).
Carrouges, Michel, *André Breton et les Données Fondamentales du Surréalisme*, Paris, Gallimard (Coll. Idées) (1950).
Caws, Mary Ann, Kuenzli, Rudolf, Raaberg, Gwen (eds), *Surrealism and Women*, Cambridge, Mass., the MIT Press (1991), pp. 213–27.
Chadwick, Whitney, *Myth in Surrealist Painting, 1924 to 1939*, Ann Arbor, University of Michigan (1980).
Women Artists and the Surrealist Movement, London, Thames and Hudson (1985).

Chenieux-Gendron, Jacqueline, *Le Surréalisme*, Paris, Presses Universitaires de France (1984).

Europe, 'Surréalisme', 46th year, 475–476 (November–December 1968).

Gauthier, Xavière, *Surréalisme et Sexualité*, Paris, Gallimard (Coll. Idées) (1971).

Guggenheim, Peggy, *Art of This Century 1910–1942*, preface by André Breton, New York (1942).

Jaguer, Edouard, *Les Mystères de la Chambre Noire*, Paris, Flammarion (1982).

Jean, Marcel, *Histoire de la Peinture Surréaliste*, Paris, Seuil (1959) trans. Simon Watson Taylor, *History of Surrealist Painting*, London, Weidenfeld and Nicholson (1962).

Kyrou, Ado, *Le Surréalisme au Cinéma*, Paris, Arcanes (Coll. Ombres Blanches) (1953; le Terrain Vague, 1963).

Levy, Julien, *Surrealism*, New York, Black Sun Press (1936; New York, Arno, 1968).

Levy, Silvano (ed.), *Surrealism, Surrealist Visuality*, Keele, Keele University Press (1996).

Lippard, Lucy R. (ed.), *Surrealists on Art*, Englewood Cliffs, Prentice Hall Inc. (A Spectrum Book) (1970).

Matthews, J.H., *Surrealism and the Novel*, Ann Arbor, University of Michigan Press (1966).

Matthews, J.H., *Surrealism and Film*, Ann Arbor, University of Michigan (1971).

Matthews, J.H., *Towards the Poetics of Surrealism*, Syracuse University Press (1976).

Matthews, J.H., *The Imagery of Surrealism*, Syracuse University Press (1977).

Neagoe, Peter, *What is Surrealism?*, Paris, New Review Publications (1932).

Nouvelle Revue Française, 'André Breton et le Mouvement Surréaliste 1896–1966', 15th year, 172 (1 April 1967).

Obliques, 'La Femme Surréaliste', 14–15 (1977).

Opus International, 'Surréalisme International', 19–20 (October 1970).

Passeron, René, *Histoire de la Peinture Surréaliste*, Paris, Librairie Générale Française (Livre de Poche) (1968).

Pierre, José, *Position Politique de la Peinture Surréaliste*, Paris, Musée de Poche (1975).

Pierre, José, *L'Univers Surréaliste*, Paris, Somogy (1983).

Read, Herbert (ed.), *Surrealism*, London, Faber and Faber (1936). Essays by Herbert Read, André Breton, Paul Eluard, H.S. Davies and Georges Hugnet.

Rosemont, Franklin, *What is Surrealism?*, New York, Monad Press and Pathfinder Press (1978).

Rubin, W.S., *Dada and Surrealist Art*, New York, Abrams (1969).

Rubin, W.S., *Dada, Surrealism and Their Heritage*, New York, Museum of Modern Art (1968).

Virmaux, Alain et Odette, *Les Surréalistes et le Cinéma*, Paris, Seghers (1976).

Waldberg, Patrick, *Les Demeures d'Hypnos*, Paris, Editions de la Différence (1976).

Miscellaneous

Artists' International Association, *The First Five Years*, London (1938).

Artists' International Association, *Activities since 1938*, London (1942).

Blythe, Ronald, *The Age of Illusion: England in the Twenties and Thirties, 1919–1940*, London, Hamish Hamilton (1963).

Benson, Frederick R., *Writers in Arms: The Literary Impact of the Spanish War*, London, University of London Press (1968).

Cork, Richard, *Vorticism and Its Allies*, catalogue of an exhibition organized at the

Hayward Gallery 27 March–2 June 1974, London, Arts Council of Great Britain (1974).

Cunard, Nancy, *Authors Take Side on the Spanish War*, London, Left Review Editions (1937).

Cunningham, Valentine, *British Writers of the Thirties*, London, Oxford University Press (1988).

Dewar, Hugo, *Communist Politics in Britain: the C.P.G.B. from its Origins to the Second World War*, London, Pluto Press (1976).

Ford, Hugh D., *A Poet's War: British Poets and the Spanish Civil War*, Philadelphia, University of Philadelphia Press; London, Oxford University Press (1965).

Graves, Robert, and Hodge, Alan, *The Long Week End*, Harmondsworth, Penguin Books (1971).

Grierson, John, *Grierson on Documentary*, London, Faber and Faber (1966).

Grigson, Geoffrey (ed.), *The Arts Today*, London, John Lane (1935).

Grigson, Geoffrey, *The Crest on the Silver: An Autobiography*, London, Cresset Press (1950).

Groves, Reg, *The Balham Group: How British Trotskyism Began*, London, Pluto Press (1974).

Guggenheim, Peggy, *Art of This Century*, New York, Dial Press (1946).

Harrison, Charles, *English Art and Modernism 1900–1939*, Bloomington, Indiana University Press; London, Allen Lane (1981).

Hoskins, K.B., *Today the Struggle: Literature and Politics in England during the Spanish Civil War*, Austin and London, University of Texas Press (1969).

Hynes, Samuel, *The Auden Generation: Literature and Politics in England in the Thirties*, London, Bodley Head (1976).

Jennings, Humphrey and Madge, Charles (eds), *May the Twelfth: Mass Observation Day-Surveys 1937*, by over 200 observers, London, Faber (1937; repr. 1987).

Lewis, John, *The Left Book Club: An Historical Record*, London, Victor Gollancz (1970).

Madge, Charles and Harrisson, Tom, *Britain by Mass-Observation*, Harmondsworth, Penguin Books (1939).

Maxwell, D.E.S., *Poets of the Thirties*, London, Routledge (1969).

McMillan, Dougald, *Transition 1927–38, The History of a Literary Era*, London, Calder and Boyars (1975).

Mellor, David, *A Paradise Lost, The Neo-Romantic Imagination in Britain 1935–1955*, catalogue of an exhibition A Paradise Lost, London, Barbican Art Gallery (1987). Texts by Andrew Crozier, Nanette Aldred, Angela Weight and Ian Jeffrey.

Morris, L., and Radford, R., *A.I.A.: The Story of the Artists International Association 1933–1953*, Oxford, Museum of Modern Art (1983).

Muggeridge, Malcolm, *The Thirties*, London, Collins (Fontana Books) (1971; first pub. 1940 Hamish Hamilton).

Rea, Betty, *5 on Revolutionary Art* (essays by Herbert Read, F.D. Klingender, Eric Gill, A.L. Lloyd, Alick West), London, Wishart and Co. (1935).

Review (The), 11–12 (1964). Special issue on the thirties.

Robinson, Julian, *Fashion in the Thirties*, London, Oresko Books (1978).

Robson, W.A. (ed.), *Political Quarterly in the Thirties*, London, Allen Lane (1971).

Rotha, Paul, *Documentary Films*, London, Faber and Faber (1936).

Scarfe, Francis, *Auden and After: the Liberation of Poetry 1930–1941*, London, Routledge (1942).

Shermer, David, *Blackshirts: Fascism in Britain*, New York, Ballantine (1971).

Spender, Stephen, *The Destructive Element: A Study of Modern Writers and Beliefs*, London, Jonathan Cape (1935).

Spender, Stephen, *Forward from Liberalism*, London, Victor Gollancz (The Left Book Club) (1937).

Stanford, Derek, *Inside the Forties, Literary Memoirs, 1937–1957*, London, Sidgwick and Jackson (1977).

Symons, Julian, *The Thirties: A Dream Revolved*, London, Cresset Press (1960).

Tolley, A.T., *The Poetry of the Thirties*, London, Gollancz (1975).

Wees, William C., *Vorticism and the English Avant-Garde*, Toronto, University of Toronto Press (1972).

Wood, Neal, *Communism and the English Intellectuals*, New York, Columbia University Press (1959).

Index

Page references in *italic* type indicate illustrations

The Abandoned Pig (Pailthorpe, 1936), 93
abstraction
 and Agar, 64
 and Moore, 71
 and surrealism, 37, 260
 and Tunnard, 256
Abstraction–Création, 124
Académie Lhôte, and Penrose, 62
Académie Moderne, and Trevelyan, 63
Academy Cinema, 301
Ades, Dawn, 331
Adler, Alfred, 86
Adler, Jankl, 216
Agar, Eileen
 at 1936 Exhibition, 78
 at London Gallery, 148
 at one of Penrose's parties, 111
 Barcelona Restaurant, 204, 210–11
 contributes to *The Island*, 64
 displacement of objects, 140, 144
 life and work, 22, 64–6
 Living Art in England exhibition, 161, 166
 A Look at My Life, 342
 reproduced in *International Bulletin of Surrealism*, 96
 Surrealist Objects exhibition, 112–15
 surrealist postcards, 213
 war years, 260, 285, 306, 308
 and window display of Zwemmer Gallery in 1940 exhibition, 211–12
 works:
 The Angel of Anarchy (1937, 1940), 112, *114*, 115
 The Autobiography of an Embryo (1933–4), 64–5
 Bacchus and Ariadne see Battle Years, a Bullet-proof Painting
 Caliban (1945), 309, *310*
 David and Jonathan (1936), 140, *141*
 Figurehead and Ship's Wheel, Cornwall (1938), 140
 Fish Circus (1939), 140, *142*
 Food of Love (1936), 140
 Garden of Time (1947), 308, *309*
 Ladybird (1936), *143*, 144
 The Battle Years, a Bullet–proof Painting (1939), 180
 Mate in Two Moods (1936), 96, 140, *141*
 Muse of Construction (1939), 179, 179–80
 Possessed (1938), 180, *181*

 Precious Stones (1936), 140
 Quadriga (1935), 65–6, *65*
 Woman Reading (1936), 140
AIA *Newssheet*, 150, 161
alchemy
 in Colquhoun's *Dreaming Leaps*, 229–30
 in Colquhoun's work, 244–5
 and occultism in Colquhoun's work, 229–30
 part of del Renzio's renewal of surreal inspiration, 226, 227
 see also occultism
Allen, Walter, 198
Allied Artists Association, 24
Allott, Kenneth, 101
Alpine Landscape or *Mountain and Plum* (Jennings, 1938), 189, 192, *194*
Alvensleben, Werner von, 154, 207, 211
anarchism
 and Agar, 112
 at International Arts Centre, 211, 215
 Freedom Press and Friends, 271–2
 libertarianism and surrealism, 20–21
 and Melly, 275
 and post-war surrealism, 284
 Read's leanings towards, 156–7
 summary of position, 337–8
Ancestors I and *II* (Pailthorpe, 1935), 89–90, *88, 89*
And the Seventh Dream is the Dream of Isis (Gascoyne), 32, 44, 45
Andalusian Dog see Buñuel, Luis, *Un Chien Andalou*
Angel of Anarchy (Agar, 1937, 1940), 112, *114*, 115
Antheil, Georges, 66
Anthropomorphological landscapes (Maddox, 1940–70), 229, 232
anticolonialism
 and Cunard's *Negro Anthology*, 73
 and Haile, 122–3
apocalypticism, 264–70
Apollinaire, Guillaume, 17, 35, 177
Apples (Jennings, 1940), 192, *194*
Aragon, Louis, 282
 and Aragon affair, 71
 and Banting, 66
 in *Paris Peasant*, 236
 in *Transatlantic Review*, 29

Araquistain, Louis, 278
Araquistain, Sonia, suicide of, 278–80
Arcade Gallery
 'Surrealist Diversity' exhibition, 276–7
 and Wilson, 316
Archer, David, 73
Architectural Review, 102
Ariosto, Ludovico, 47
'The Ark' (barge), 57
Armchair with Seal (Jennings, c.1935), 52, 53
Armstrong, John, 41
 margin of surrealism, 36
 not a surrealist, 38
 The Open Door (1930), 38, 39
 The Philosopher (1938), 38
Arp, Jean
 in Eluard's collection, 71, 148
 and Moore, 70
 and Richards, 176
Arrabal, Fernando, 327
Arson, 225, 226, 248
Art Now, 62, 152
Art and Society, 111
Artaud, Antonin
 film by, 33
 in *transition*, 30
Artists' International Association (AIA)
 and aid to Spain, 163
 and Colquhoun, 313
 Congress exhibition (April–May 1937), 109
 and debate on realism, 123, 152
 debates in, 161
 expansion of, 103
 and Haile, 172
 headquarters, 73
 Newssheet, 150, 160
 as part of Popular Front, 108
 and Richards, 176
 surrealism's alliance with, 158
 and Tunnard, 226, 258
 war activities of, 214, 221–3
Arts and Crafts Society, and Haile, 172
Atkins, John, 227
Auden, W.H.
 Apocalypticism as antidote to, 268
 collaboration on films, 50
 in *Our Time*, 223
Auric, Georges, 99
Autobiography of an Embryo (Agar, 1933–4), 64
automatism
 in Bridgwater's writing, 252
 Colquhoun and link with occultism, 244–6
 destroys abstractions, 331–2
 and exhibition of works by Mesens, 282
 explored extensively by Colquhoun, 313
 and Lye, 56–60
 Pailthorpe and link with psychoanalysis, 86
 in Rimmington's writing, 256
Axis, 37, 123, 124
Ayrton, Michael, 267

Bacchus and Ariadne (Agar, 1939), 180
Balanchine, George, 99
Balloon Site 586 (Banting), 215
Banting, John, 331, 342
 at 1936 Exhibition, 77
 at Surrealist Exhibition in Paris (1947), 281
 and attack on forms and formality, 127–8
 Balloon Site 586 (film), 215
 and Barcelona Restaurant meeting, 176, 211
 billboard painting by, 163
 in *Free Unions Libres* (1946), 274
 in *Fulcrum* (1944), 227
 in *Le Savoir Vivre* (1946), 283, 284–7
 life and work, 52, 66–70
 in *Our Time*, 216, 222–3
 relations with AIA, 158
 in *Salvo for Russia* (1941), 224
 as satirist, 285–7
 World War II activities, 215
 in Spain, 108
 Stalinism of, 156
 and Zwemmer Gallery exhibition (1940), 212
 works: *From the Blue Book of Conversation* (1946),
 285–6, 286
 Conversation Piece (c.1935), 68, 70
 Discussing Dress (1937), 127–8
 The Funeral (1944), 215, 219
 Janus (1942), 215, 218
 Mutual Congratulations (c.1936), 128, 130
 Siamese Triplets (1932–3), 66
 Ten Guitar Faces (c.1932), 66, 67
 Two Models (1935), 69, 70
 Woman Passing between Two Musicians (1937), 128
Barcelona Restaurant
 and Melly, 209–11, 212, 224, 244, 275
 and post-war surrealism, 280
 and 'Scottie' Wilson's exhibition, 317
Bard, Joseph, 64, 111, 112, 140, 164, 338
The Bark is Worse than the Bite (Nash, 1937), 115, 118
Barker, George, 73, 271
Baron, Jacques, 29
Bartlett, Vernon, 161
The Battle Years, a Bullet-proof Painting (Agar,
 1940), 180
Baudelaire, Charles, 51, 78
Bauhaus, 125
Baxter, Glen, 343
Baxter, Robert, 340
 at Surrealist Objects and Poems exhibition
 (1937), 120
 in *Free Unions Libres* (1946), 274
 and post-war group, 280
 in 'Surrealist Diversity' exhibition (1945), 277
Bayer, Herbert, 147
Bayliss, John, 225
Beckett, Samuel
 and friendship with Banting, 66
 as translator, 30
Belgian Summer Festival (1951), 321
Bell, Clive
 criticism of vorticism, 24
 and Manet and the Post-Impressionists
 exhibition (1910/11), 23
Bell, Graham
 and debate between realists and surrealists, 161
 and Mass Observation, 103
 and United Front exhibition (1940), 163
Bell, Quentin, 109
Benayoun, Robert, and Exeter exhibition (1967),
 327
Bérard, Christain, 99

Berdiayev, Nicolas, 269
Bernhardt, Sarah, 245
Betjeman, John, 99
Beware the View (Bridgwater, c.1942), 249, 252–3
Bien Vise, see Penrose, Roland, *Good Shooting*
Bigge, J.S.
 at 1936 Exhibition, 41, 85
 on margins of surrealism, 36
 not a surrealist, 38–9
Bilbo, Jack, 216
biomorphism
 and Moore, 70–71
 and Morris, 321–6
Bird Basket (Moore, 1939), 182, *183*
Birmingham Art School, and Bridgwater, 220
Birmingham Group, as more dynamic than
 London, 198, 199, 220, 272, 284–5
 Cadavre Exquis (c.1944), 220, *221*
Birmingham Post, 199, 285
Birot, Pierre-Albert, 34
Birth of a Robot (Banting and Lye film, 1935), 51, 127
Bjerke-Petersen, and 1936 Exhibition, 74
Black Music (Penrose, 1940), 301, *301*–3, *302*
Black, Tony, 22
Blair–Stanton, Hugh, 341
Blake, William
 and The Impact of Machines exhibition, 102, 155
 Melly's interest in, 275
 and Mesens on Collins, 164
 in relation to anarchism, 271
Blakeston, Oswald, 57, 62
Blanchot, Maurice, 17
Blast, 26, 27
The Blazing Infant (Pailthorpe, 1940), 263–4, *263*
Bloomsburyism, 25, 161
Blundell, Tony, 328
Blunt, Anthony
 on Dali, 34
 in *Left Review*, 106
 on Picasso and *Guernica*, 150
 on surrealism, 161
Bogle, Andrew, interview with Lye, 58
Bomberg, David, 25
Boué, Valentine
 meets Penrose, 62
 as Penrose's model, 136
Brain Operation (Haile, 1939), 172, 173, *175*
Brancusi, Constantine
 and Agar, 64
 and Banting, 66
 and McWilliam, 192
 and Moore, 71, 124, 133
 and *Transatlantic Review*, 29
Brandt, Bill, 343
 and neo-romanticism, 267
 and surrealist competition, 102
Braque, Georges, 17, 62, 148, 177
Brauer, Gerhard, 60
Brauner, Harry, 156
Brauner, Victor, 148, 212, 334
Brave Morning (Bridgwater, 1942), *254*
Breakwell, Ian, 343
 and 1968 Manifesto, 328
Bresson, Robert, 63
Breton, André, 282, 336, 337, 342
 and *Transatlantic Review*, 29

and 1936 Exhibition, 39, 47, 56, 62, 71, 73–8
assessed by Pailthorpe, 261
and automatism, 19
and Colquhoun's meeting with, 173, 204
and Dadaism, 16, 17, 18
and declaration in Tenerife, 20
del Renzio's allegiance to, 226, 227
and discovery of Pailthorpe and Mednikoff,
 85
in exile, 172
in *Kingdom Come*, 269
letter about 1947 International Exhibition of
 Surrealism, 277, 281
letter to the British group, 156–7
in *London Bulletin*, 111, 124, 153, 155, 212
meets Onslow-Ford, 228
in *New Road 1943*, 225
on the object, 239
publishes *Surrealist Manifesto*, 18–19
quoted in Banting, 213, 223
and Rivera, 19
and *Second Manifesto of Surrealism*, 16, 19
Le Surréalism Même (1957), 342
text about Nazi threat over Freud, 160
text in *Surrealism*, 94, 97
texts in *transition* and *This Quarter*, 30
Yale speech, 272
Bridgwater, Emmy, 321, 337, 338, 340, 341, 342
 and Birmingham Group, 220
 del Renzio's poem to, 146, 242
 drawings (c.1942), *249*
 exhibition at Bilbo's gallery, 22, 216
 exhibitions in Coventry, 285
 and *Free Unions Libres*, 274
 and *Le Savoir Vivre*, 283
 libertarian sympathies, 284
 life of, 22
 and obsession with birds, 293
 and restart of group in London, 280
 poems by, 252
 poems: *Back to the First Bar* (c.1942), 252
 The Birds (1946), 293
 Closing Time (c.1942), 252
 work of, 244, 246–52, 293–6
 works, other:
 Brave Morning (c.1942), 248, *254*
 Bursting Song (1948), 293, *295*
 Remote Cause of Infinite Strife (1940), 247–8, *251*
 Transplanted (1947), 293, *294*
British Art Centre, 164, 209, 210
British Broadcasting Corporation, and Mesens
 and Brunius, 213
British Diplomacy (Dawson, 1937), 115, *119*
British Film Institute, 33, 50
Britten, Benjamin, collaboration on films, 50
broadsheets and declarations
 'And Onan Cried over his Spilt Milk . . .', 332
 Breton and Rivera's 'Manifesto Towards an
 Independent Revolutionary Art', 155–6
 'Idolatry and Confusion', 226
 'Incendiary Innocence', 226–7
 on Spain, 104–5
 'To the Workers of England', 160
 'Trajectory of Passion', 332
 We Ask Your Attention, 109–11
 'We Need You Cohn Bendit!', 328

Brockway, Fenner, 109, 222
Bronowski, Julius, 63
 as founder of *Experiment*, 28
 in *transition*, 31
Brook Green School and Agar, 64
Brown, F.J.
 and *Free Unions Libres*, 272
 and *Le Savoir Vivre*, 283
 and *Our Time*, 223
Browne, Felicia, 109
Brunius, J.B.
 and Barcelona Restaurant meeting, 210
 feud with del Renzio, 225–7
 on the Goon Show, 305, 325, 327, 343
 and ICA, 301
 and *Le Savoir Vivre*, 283
 letter to Mesens about British surrealists, 274,
 280
 and *London Bulletin*, 213
 and Trotskyism, 284
Buckland-Wright, John, 341
 and Barcelona Restaurant meeting, 210
 and camouflage, 214
 and *Salvo for Russia*, 224
 and surrealist postcards, 213
Buñuel, Luis, 60, 62, 71, 77, 185
 Un Chien Andalou (1930), 31, 62, 71, 185
 screenplay in *This Quarter*, 31
Burns, Alan, and *TRANSFORMAcTION*, 327, 328
Burra, Edward, 96, 146, 343
 and 1936 Exhibition, 85
 and Nash, 36
Bursting Song (Bridgwater, 1948), 293, *295*
Byam Shaw Art School, and Agar, 64
Bystander, 96

Cahiers d'Art, 71, 108
 and Jennings, 50
Calas, Nicholas, and *New Road*, 225
Calder, Alexander, 63, 123, 124
Caliban (Agar, 1945), 306, *310*
Cambridge Left, 29
Camden Arts Centre, 331
Camden Town Group, 24, 25
camouflage, 214
Canada, 152–3
Cant, James
 AIA and Surrealist Objects exhibition, 120
 answer to AIA *Newssheet*, 161
 joins surrealist group, 109
 and May Day 1938, 161
 relations with left-wing parties, 158
 and United Front exhibition, 164
Capa, Robert, 109
Captain Cook's Last Voyage (Penrose, 1936), 134,
 134–6, 136
Cardinal, Roger, 330, 335
Carrington, Leonora
 with Ernst in France, 111, 188
 and *New Road 1943*, 225
Carroll, Lewis, 343
 referred to by McWilliam, 31, 97, 196
Carvalho, Flavio de, 152
Carving (Moore, 1936), 71
Casson, Hugh, 100
Caudwell, Christopher, 104, 106

Cavalcanti, Guido, 51, 164
Cells of Night (Collins, 1934), 81, *83*, 84
Central School of Arts and Crafts, and Tunnard,
 258
Césaire, Aimé, 227
 and *New Road*, 225
Cézanne, Paul, 22
Chagall, Marc, 17
Chamberlain, Neville, and May Day 1938, 158,
 161–3
Chanel, Coco, 100
Chaplin, Charlie, in *transition*, 31
Char, René, 71
Charcot, J.M., 237
Chavée, Achille, 155
Chelsea College of Art, and Richards, 176
Cherkeshi, Sadi, 280
Chestov, Leon, 125
A Children That Has Gone to Cheese (Haile, 1943),
 310, 312, *314*
Chimera Costerwoman (Richards, 1939), *177*,
 178
Chirico, Giorgio de, 269
 influence on Armstrong, 38
 London Gallery exhibitions, 71, 148–9
 Nash on, 43
 surrealist postcards, 212, 214
 and *This Quarter*, 17, 31
Chomette, Henri, 33
cinema
 and avant-garde magazines, 60–62
 and Benjamin Britten, 50
 and Jennings, 51–4, 216–17
 London Film Society, 22
 and Lye, 57–8
 and Morris, 321
 situation of in 1920s, 50–52
 war films, 216–17
Circle, 124
City (Trevelyan, 1936), 137, 139
Clair, René, 33
Clark, Kenneth
 and criticism of Dali, 34
 and criticism of Ernst, 33
 on 1936 Exhibition, 74
 with Peggy Guggenheim, 166
Clayton, Frances, 147
Clé, 124–7
Clinical Examination (Haile, 1939), 173
Close-Up, 60
 and Lye, 57
Coates, Wells, and Unit One, 36
Cobra movement, 284
Cock Rock or *The Native* (Miller, 1939), 168, *170*
Cocteau, Jean, and *Le Sang d'Un Poète*, 62
Coldstream, William, 166
 and collaboration on films, 50
 and Mass Observation, 103
 and realism opposed to surrealism, 109, 161
 and United Front exhibition, 163
Coleridge, S.T., 97
Collage (house with salt shaker) (Jennings, 1935), 54
collages
 and Agar, 140
 by Jennings, 53–4
 as disruption, 54–6

and Maddox, 236, 288
as principle of composition in Banting, 66–8
and Rimmington, 253
and Trevelyan, 103
Collins, Cecil
 impression on Mesens, 164
 life and work, 22, 41, 81, 84–5
 and New Apocalypse, 214, 265
 in *Transformation*, 270
 works: *The Cells of Night* (1934), *83*, 84
 Virgin Images in the Magical Processes of Time
 (1935), 84
Colonial Administrators (Haile, 1938), 172
Colour Box (film by Lye, 1935), 57
Colquhoun, Ithell, 337, 338
 alchemical undertones, 278–80
 Barcelona Restaurant meeting, 210
 1942 exhibition, 285, 306
 first appearance at Living Art in England
 exhibition, 22, 150
 and interest in the arcane and sexuality, 227, 244–6
 interest in occultism, 226, 310, 313
 and *Le Savoir Vivre*, 283
 life and eruptive quality of work, 153, 155, 204–5
 marriage to del Renzio, 226
 and *New Road 1943*, 225
 and *Salvo for Russia*, 216, 224
 texts: *The Echoing Bruise* (1939), 205
 'Experiments' (1943), 245
 Grimoire of the Entangled Thicket (1973), 316
 The Volcano (1939), 205
 works: *Dance of the Nine Opals* (1942), 244, *246*
 Dervish (automatic drawing, c.1952), *315*
 Dreaming Leaps: in homage to Sonia Araquistain
 (1945), 278–80, *279*
 Guardian Angel (1946), 313, *314*
 The Pine Family (1941), 244–5, *247*
 Rivières Tièdes (Méditerranée) (1939), 204
 Scylla (1939), 204–5
 A Visitation (1944), 246, *250*
Coltman, Dr James B., 114
Comfort, Alex, 269, 271
 and *New Road*, 225
Communist Party, 337
 after German–Soviet pact, 19, 104, 106, 108, 150,
 158, 160, 222
Composition (Pailthorpe, 1937), 93, *95*
Composition (Tunnard, 1939), 260, *262*
Concavity of Afternoons (Melville, 1939), 200, *201*
Condensation of Games (Penrose, 1937), 119,
 119–20, *121*
Connolly, Cyril, 96
The Conquest of the Air (Penrose, 1938), 184–5, *186*
Conquest of Time (Evans, 1935), 81, *82*
Conspiracy of the Child (Maddox, 1946), 287–8, *290*
Constructivism, 123, 124, 260, 261
Contemporary Poetry and Prose, 106, 107, 160
 and Declaration on Spain, 47, 73, 101, 104
Contrariwise exhibition (1986), 343–4
Conversation Piece (Banting, c.1935), *68*, 70
Cooper, Austin, 283
Cooper, Douglas, 149
Copley, Bill, 305
Cornford, John, 73
coulage, 228
Counterpart, 265

Couple on a Ladder (Haile, 1941–43), 310–12, *311*
Coventry Art Circle, 284, 285
Cracknell, Rupert, 328
Craxton, John, 265, 283
Cresta Silks, Jennings's work on, 50
Crevel, René, and *This Quarter*, 29, 31
Cubism
 and Agar, 17, 64
 concept revisited by Mesens, 282–3
 Melville's evolution of, 284
 and Moore, 70–71
Cunard, Nancy
 and Banting, 66
 and *Negro Anthology*, 66
 and *Salvo for Russia*, 224
 and Spain, 73, 108
Cycloptomania (Onslow-Ford, 1939), 229, *231*

Dada/Dadaism
 founding of, 17, 18
 in *Transatlantic Review*, 29
Daily Express, 96
Daily Herald, 96
Daily Mirror, 96
Daily Sketch, 115
Daily Telegraph
 and criticism of Magritte, 96, 149
 and 1936 Exhibition, 76
Daily Worker, 222, 224
Dali, Gala, 77, 78
Dali, Salvador
 in collaboration with Schiaparelli, 101
 del Renzio shocked by Read's defence of, 204,
 205, 225
 in Eluard's collection, 148
 in Gascoyne's *Short Survey*, 71
 and James, 96, 99–100
 lecture at 1936 Exhibition, 77, 78
 in *London Bulletin*, 154
 meets Gascoyne, 40, 63
 in *This Quarter*, 15, 31
 and Zwemmer Gallery exhibition, 33, 34
Dalvit, Oskar, 283
Dance of the Nine Opals (Colquhoun, 1942), 244, *246*
The Dance (Penrose, 1940), 303
Dartington Hall, 164, 313
David and Jonathan (Agar, 1936), 140, *141*
Davies, Hugh Sykes, 336
 at 1936 Exhibition, 74–7
 and controversy with *Left Review*, 104–6
 debatable defence of surrealism, 145
 dislocation in writing, 44
 in *Experiment*, 29
 in *London Bulletin*, 155
 objects by, 145
 and *Our Time*, 164, 173, 223
 poems by, 47–8
 in Read's *Surrealism*, 97
 and Stalinism, 156
 in *transition*, 31
 texts: 'In the stump of an old tree' (poem, 1937), 48
 'It doesn't look like a finger . . .' (poem, 1937),
 47–8
 Petron (1935), 46–7
Dawson, Peter Norman, 115, 204
 British Diplomacy (1937), 115, *119*

Day Lewis, Cecil, 189
de la Mare, Walter, 269
death see life and death
decalcomania
 and Colquhoun, 312
 and Maddox, 229
Declaration on Spain, 104, 105, 106, 160
del Renzio, Toni
 on Bridgwater, 248
 feud with Mesens, 224–8
 his home as a meeting place, 22, 216
 and insistence on collaborative work and
 monogamy, 227
 and Le Savoir Vivre, 283
 paintings and poems, 240–44
 role of in the group, 224–8
 and suicide of Araquistain, 272, 278–80
 texts: Can You Change a Shilling? (1943), 241
 Those Pennies Were Well Spent (1942), 242
 The Uncouth Invasion (1940), 248
 works: Le Rendez-vous des Moeurs (1941), 240, 243
 Mon Père Ne Pas Reviens (1942), 241, 242
Delvaux, Paul, 148, 149, 213, 327
Dénouement (Maddox, 1946), 289, 291
Derailed Sea (West, 1987), 336, 339
Dervish (Colquhoun, 1952), 315
desire
 in Colquhoun's works, 244–5
 conflict with law in Pailthorpe's works, 264
 return to origins in Bridgwater's works, 292–6
 surrealism as liberator of, 20
Desire Caught by the Tail (Picasso), 283
Determination of Gender (Onslow-Ford, 1939), 229,
 230
The Dew Machine (Penrose, 1937), 115, 116, 341
dialectical materialism see Marxism
Digby, John, 331
Discussing Dress (Banting, 1937), 127–8
Dismorr, and Diré galleries exhibition, 27
Disney, Walt, 60
Dix, Otto, 60
Dobree, Bonamy, 149
documentary cinema, 50–51
 and relations between sound and image, 33
Dominguez, Oscar, 305
Doorway, Spain (photo by Nash, 1934), 43
Doré galleries
 second post–impressionist exhibition, 24
 Vorticist exhibition, 27
Dorner, A., 154
Dotremont, Christian, and founding of Cobra, 284
drawing (Mednikoff, 1936), 89–90, 92
dream/s
 and Colquhoun's Dreaming Leaps, 278–80
 and Rimmington's Oneiroscopist, 296
 and Trevelyan, 29
Dreaming Head (Armstrong, 1938), 38
Dreaming Leaps: in Homage to Sonia Araquistain
 (Colquhoun, 1945), 278–80, 279
Drifters (film by Grierson, 1929), 33, 50
Dubuffet, Jean, 124, 277, 305
Duchamp, Marcel, 155, 197
 and Banting, 20, 66
Dulac, Germaine
 film by, 33
 in transition, 30

Duncan, Douglas, discovered 'Scottie' Wilson,
 316
Dylan, Thomas
 as co-director of film with Banting, 147, 215
 and 1936 Exhibition, 76
 and New Apocalypse, 265
 protest against arrest of anarchists, 269, 271

Earnshaw, Anthony
 life and work, 332–4
 Homage to Jason (1985), 332, 333
 Secret Alphabets (1972–85), 333–4
 in TRANSFORMAcTION, 328
écrèmage, discovered/developed by Maddox,
 197, 229
Ede, H.S., 60, 124
Eggceptional Achievement (Miller, 1940), 171, 171
Egypt (Penrose, 1939), 188
Eight Interpreters of the Dream (Rimmington, 1940),
 253, 255
Einstein, Albert, 17
Eisenstein, Sergei, 62
Eliot, T.S., 271
 and Criterion, 31
Elliott, Sidney, 158
Ellis, Havelock, 86
Elmhirst, 164, 213
Elton, Arthur, and The Impact of Machines
 exhibition, 155
Eluard, Paul, 78, 338
 collection bought by Penrose, 97, 101, 108, 109,
 111, 148, 158
 and 1936 Exhibition, 71, 73–8
 and Gascoyne, 63
 and Jennings, 56
 in Kingdom Come, 269
 lecture at 1936 Exhibition, 78
 in London Bulletin, 155, 164, 212
 Read's questionable defence of, 225
 seen as monotonous by del Renzio, 226
 S.W. Taylor's damning letter about, 282
 and This Quarter, 31
 and Transatlantic Review, 29
 and visit of Penrose, 158
Empire Marketing Board, 50
Empson, William, 103
Endicott, Norman, discovered 'Scottie' Wilson,
 312
Endogenous Activities (Morris, 1950), 323, 324
Engels, Friedrich, 155
entoptic graphomania, 312
Entry to a Landscape (Morris, 1947), 321, 322
Epstein, Jacob, 25, 163
Ernst, Max
 in Arizona, 303–4
 designs cover of 1936 Exhibition catalogue, 94
 in Eluard's collection, 148
 as guest at one of Penrose's parties, 111
 influence on Melville, 188, 198
 in London Bulletin, 149, 154
 London Gallery retrospective of his works, 155,
 158, 161
 and Mayor Gallery exhibition (1933), 33
 meets Evans, 81
 meets Gascoyne, 63
 meets Trevelyan, 63

Penrose's collages compared to his, 184
 in post–war London Gallery, 213, 236
 and *This Quarter*, 15, 31
Esprit Nouveau, 17
Ethuin, Anne, 22
Evans, Merlyn
 life and work, 81
 on McWilliam, 196
 in *The Painter's Object*, 96, 124
 work: *Conquest of Time* (1934), 81, *82*
 Tyrannopolis (1939), 81, 84
Evans, Myfanwy *see* Piper, Myfanwy
Ewig, Isabelle, 22
exhibitions
 Contrariwise, 343–4
 Dali, first exhibition of, 34
 The Enchanted Domain, 327
 Ernst, first exhibition of, 33
 in Europe, 16
 First British Artists' Congress, 109
 Galerie 1900–2000, 15
 in Gloucester, 152
 Guernica, 149–50
 Hamet Gallery, 15
 Hayward Gallery, 15
 The Impact of Machines, 56, 155, 156, 189
 in Liverpool, 152
 Living Art in England, 150–52
 London Gallery's policy, 148
 Mayor Gallery, 16
 Miró, first exhibition of, 33
 in Northampton, 152
 in Paris, 152
 in Sao Paulo, 152
 Surrealist Diversity, 277
 Surrealist Objects and Poems, 112, *113*, 140–44
 Surrealism Unlimited, 331
 The Terrain of the Dream, 331
 in Toronto, 152
 Unit One, 36–8
Experiment, 63
 contributors to, 29
 described, 28
 distance from labels, 28
 and Jennings, 50
 in *transition*, 31
eye
 and Bridgwater, 293
 and Bridgwater's *Brave Morning*, 248
 entrapped by Nash, 43
 and Haile, 172–4
 in Nash's photographs, 31
 and Rimmington, 255–6
 and 'Scottie' Wilson, 317–20
 and 'visualness' of British surrealism, 340–42
Eye, Nose and Cheek (McWilliam, 1939), *195*, 196

5 on Revolutionary Art, 108
Family Tree (Rimmington, 1937), 120, *122*, 253
Fear of the Past (Morris, 1957), 324, *325*
Fédération Internationale pour un Art
 Révolutionnaire Indépendant (FIARI),
 158–60, 331–2
 and position of surrealists in Britain, 19, 156–8
The Female Contains all Qualities (Richards, 1938),
 178

feminine/femininity
 and Bridgwater, 245–52
 and British surreal women artists, 338–40
 and Colquhoun, 244–6
 Moore's sculptures, 132–3
 and Penrose, 184–8
 relations with feminism, 332
 in Richards's works, 176–8
 and Rimmington, 252–6
Fergar, Feyyaz, 272, 280, 282
 and *Fulcrum*, 227
Fields, W.C., 327
Figurehead and Ship's Wheel, Cornwall (Agar, 1938),
 140, 144
Film Art, 60–62
films *see* cinema; documentary cinema
Finnegans Wake (Joyce, 1939), 312
Fires Were Started (film by Jennings, 1943), 217
First Manifesto of English Surrealism (1935), 71
First View (Penrose, 1947), 304
Fish Circus (Agar, 1939), 140, *142*
Fitzroy pub, 215
Fitzroy Street Group, 24
Flanagan, Barry, 343
Flint, F.S., interview with Pound, 26
Fluchère, Henri, 31
The Flying Pig (Mednikoff, 1936), 93, *94*
Foltyn, Frantisek, and Agar, 64
Fondane, Benjamin, 125
Food of Love (Agar, 1936), 140
Ford, Charles Henri, 100, 155
Ford, Ford Madox
 and Revel Art Centre, 13
 and *Transatlantic Review*, 29
Forster, E.M., 149, 227, 271
Forsyth, James Law, and *Salvo for Russia*, 224
Four Piece Composition (Moore, 1934), 133, *134*
Frances, Esteban, 228, 229, 283, 313
 and surrealist postcards, 211, 213
Frankel, Ben, 223
Fraser, G.S., 269
 and apocalypticism, 268
Fraser, Jenny, 17
Freddie, Wilhelm, 80
 *Psychophotographic Phenomenom: Those Fallen in
 the First World War* (1936), 81
Free Unions Libres, 223, 271–5, *273*, 280, 292, 293
Freedom Press, and police raid, 271–2
Freud, Lucian, 275, 283
Freud, Sigmund/Freudianism, 17, 160, 192, 225,
 261–2
 and Mass Observation, 17, 19, 34, 86, 102–3
 see also psychoanalysis
Friedmann, Rudolf, 216
From the House Tops (Penrose, 1939), 185, 188, *188*
frottage, and Colquhoun, 312
Fry, Roger, 46
 and Manet and the Post-Impressionists
 exhibition, 23
 and 'pure form' concept-rift with Lewis, 25
 and second Post-Impressionist exhibition, 24–5
Fulcrum, 227, 253
Fulcrum (Tunnard, 1939), *259*, 260
fumage, and Colquhoun, 312
The Funeral (Banting, 1944), 215, *219*
Fuseli, Henry, 275

Futurism
 criticized by Vorticists, 28
 in London, 26
 in second Post–Impressionist exhibition, 17, 25
 and separation from Vorticism, 26–7

Gabo, Naum, 123, 124, 147, 150
Gala see Dali, Gala
Galerie Charles Ratton, 124
Garbo, Greta, 78
Garden of Time (Agar, 1947), 306, 309
Gardiner, Wrey, 269
Gascoyne, David
 on Dali's 1934 exhibition, 34
 encounter with Penrose, 63
 and exclusion from surrealist group, 145, 269, 282
 and First Manifesto of English Surrealism, 71
 and influence on Earnshaw, 332
 and Mass Observation, 101, 102
 Perseus and Andromeda (1936), 144, 145
 on Petron, 47
 and rupture as principle in writing, 44–6
 'The Symptomatic World' (1936), 127
 texts: 'And the Seventh Dream is the Dream of
 Isis' (1933), 32, 44–5
 Man's Life is This Meat (1936), 45–6, 125–7
 Opening Day (1932), 45, 63
 Roman Balcony (1930), 45
 A Short Survey of Surrealism (1935), 71, 72, 73
Gaudier-Brzeska, Henri, at Doré Galleries
 exhibition, 27
Gear, William, and post-war Birmingham group,
 284
General Post Office (GPO) Film Unit, 33, 50, 51,
 54, 111, 127
Giacometti, Alberto, 63, 71, 148
Giedion, Siegfried, 154
Gilbert, Stephen, 284, 293
Gilbert, Stuart, in transition, 30
Gimpel fils Gallery, 317
Ginner, Charles, 24
Glasgow School of Art, and Evans, 81
Gleeson, James, 283
Goldfinger, Erno['], 164, 214
Good Shooting (Penrose, 1939), 184, 187
the Goons, 342–3
Gordon, Ian, 211
Gore, Spencer, 24
gouaches, and Maddox, 228–30, 234
Goya, Francisco, 150
Grafton Galleries, 22, 24
Graham, Geoffrey (Australia, 1911–Australia,
 1986), 109, 119, 120, 223
 The Virgin Washerwoman (1937), 119, 120
Le Grand Jour (Penrose, 1938), 184, 184
Grande Chaumière
 and Hillier, 39
 and Maddox, 197
 and Trevelyan, 63
Grant, Duncan, 163
Graves, Robert, and Lye, 57
Gray, Nicolette, 123
Greedies II (Wilson, 1950), 319, 320
Gretton, Sarah, 22
Grierson, John, 124
 and Drifters (1929), 33

Grigson, Geoffrey, 124, 269
 as founder of New Verse, 32
Gris, Juan, 17, 148
Grosvenor School of Art, 134
group, 28–81, 147–8
 English specificity of, 21
 as warrant of coherence, 21
Guaranteed Fine Weather Suitcase (Penrose, 1937),
 115, 118
Guardian Angel (Colquhoun, 1946), 312–13, 314
Guernica (Picasso, 1937), 148–52, 155–6, 160, 161,
 197
Guggenheim Jeune Gallery, 149, 153, 164, 205
Guggenheim, Peggy, 66, 164–6, 210, 258, 261
Guinness, Bryan, 70

Haile, Marianne, 22, 172
Haile, Samuel Thomas, 310, 312, 314, 341
 billboard painting, 163, 165
 during the war, 215
 first appearance with surrealists, 109
 life and work, 171–6
 link with Communist Party through AIA, 120,
 124
 on Pailthorpe and Mednikoff, 94
 reaction against AIA attack on surrealism, 161
 text: unpublished notes (c.1939), 173–6
 works: Brain Operation (1939), 173, 175
 A Children That Has Gone to Cheese (1943), 312,
 314
 Clinical Examination (1939), 173
 Colonial Administrators (1938), 172
 Couple on a Ladder (1941–3), 311, 312
 Mandated Territories (1938), 172–3, 174
 Surgical Ward (1939), 173
 Torso with Severed Mamma (1938), 173
 Woman and Suspended Man (1938), 173, 178
Hamersma, Cyril, 283, 320
Hammond, Paul, 331, 334
 and concept of 'dialectical negation', 330
 and TRANSFORMAcTION, 328
Hamnett, Nina, 66
Harbour and Room (Morris, 1932–36), 129, 132
Harrisson, Tom, 102–3, 189, 269
Harper's Bazaar, 101–2
Harrison, Charles, 24
Harvinden, Ashley, 64
Hastings, Viscount, 109
Hat, Bruno, 70
Hawkes, Ken, 227
Hayter, Stanley William
 and Barcelona Restaurant meeting, 210
 and camouflage, 214
 and Evans, 81
 and Gascoyne, 22, 63
 in London Bulletin, 211, 212
 in organization of 1936 Exhibition, 74
 and Trevelyan, 63
Head in Extended Order (McWilliam, 1948), 306, 308
Headwaiter (Mednikoff, 1936), 89–90, 92
Heart of Britain (film by Jennings, 1940), 217
Heartfield, John, 150
Heath-Stubbs, John, 161
Heckroth, Hein, 164, 213, 216
Hegel, G.W.F., 335
 in one of del Renzio's letters, 225

in Welson's work, 330
Hélion, Jean, 63, 123, 124
Helmet (Moore, 1939–40), 182, *183*
Hendry, J.F., 268–70
 and *The New Apocalypse*, 265
 and *Salvo for Russia*, 224
Henein, Georges
 and *New Road 1943*, 225
 and suicide of Araquistain, 278
Henghes, 149
Hepworth, Barbara, 109, 123, 124, 128
 and disbanding of Unit One, 37
 and Unit One, 36
Heraclitus, 335
Herbert, Alan, 57
Hermes, Gertrude, and meeting with Agar, 64
Herrickx, Gordon, 303
Hess, Myra, 303
Hiller, Susan, 343
Hillier, Tristram, 41–2
 life and work, 38, 39–41
 in margin of surrealism, 36–7
 works: *Pylons* (1935), 40–41
 Surrealist Landscape (c.1932), 40, *40*
Hitchens, Ivon, 64
Hitler, Adolf, 163, 212, 217, 221, 222, 223
Hodgkins, Frances, and Unit One, 36
Hölderlin, J.C.F., 125
Holst, Gustav, 127
Homage to Jason (Earnshaw, 1985), 332, *332*
Hopkins, Gerard Manley, 265
Horizon
 and letters between Mesens and Del Renzio, 216–17
 and 'Scottie' Wilson, 226, 317
Horse's Head (Jennings, 1937–40), 189, *191*
Horseshoe pub, 216, 280
Hospice de la Bernina with Shelf and Sugar Bowl (Jennings, c.1935), 53
House in the Woods (Jennings, 1936), 56, *59*
How I See Apocalypse (Treece, 1946), 265
Howard, Charles, 211, 341
 Inscrutable Object (1937), 119, *120*, 341
 and Surrealist Objects exhibition, 81, 119–20
Hughes, Patrick, and *TRANSFORMAcTION*, 329
Hugnet, Georges, 269
 and Maddox, 71, 97, 99, 155, 158, 196–7
Hulme, T.E.
 and concept of imagism, 26
 death of, 27
Huxley, Aldous, 99, 108, 223
hysteria
 and Maddox, 237
 and Maddox in *Free Unions Libres*, 287–8

Idolatry and Confusion (Mesens, Brunius, Penrose), 226
Illusion and Reality (Caudwell, 1937), 104, 106
Imagism, 26
The Impact of Machines, exhibition, 56, 155, 156, 189
Incendiary Innocence, and Del Renzio, 226
Independent Labour Party, 104, 108, 109, 222
Indice (Canary Island paper), 337
Institute of Contemporary Art (ICA), 301, 305
Institute for the Scientific Treatment of

Delinquency (*later* Portman Clinic), 85
Interior of Wuthering Heights (Welson, 1977), 335, *335*
International Arts Centre, 216, 227
International Bulletin of Surrealism, 96
International Exhibition of Surrealism (Paris, 1947), 281, 317
International Surrealism Exhibition of 1936, 73–4, *74*, 75, 76, *76*–8, *77*, 79, 81, 84–5, 89, 90, 94, 96
Interpretation of Dreams (Freud, 1900), 17
The Island, 64

Jackson, T.A., and controversy with surrealism in *Left Review*, 104–6
Jaguer, Edouard, 22
Jakovsky, Anatole, 124
James, Edward, 99–100, 164
 and 1936 Exhibition, 77
Janus (Banting, 1942), 215, *218*
Jarry, Alfred, 62, 78
Jennings, Charlotte, 22
Jennings, Humphrey, *76*, 337, 342
 against Read, 164
 against reduction of surrealism, 97
 and automatism, 161
 Barcelona Restaurant meeting, 210–11
 collaboration with *Experiment*, 29
 collaboration with Lye on films, 111, 127
 and displacement of time, 188–92
 during the war, 216–22
 elementary images, 57, 62, 64
 and Eluard's poem for Jennings, 155
 exclusion from the surrealist group, 282
 and 1936 Exhibition, 74–7
 in *International Bulletin of Surrealism*, 96
 life and work, 50–56
 London Gallery and The Impact of Machines, 136, 154–5
 with Lye, 50
 and Mass Observation, 101, 102–3
 in *transition*, 31
 and *Our Time*, 223
 films: *Fires Were Started* (1943), 217
 Heart of Britain (1940), 217
 London Can Take It (1940), 217
 Pett and Pott (with Cavalcanti, 1934), 51
 photographs: *Portrait of Lord Byron* (c.1936), 54, *55*
 Portrait of Roger Roughton (c.1937), 54, *55*
 Woman's Head and Fireplace (c.1937), 54
 texts: in *Experiment*, 28
 The Origin of Colour, 189
 Pandemonium (with Madge, 1985), 155, 217
 Poem in *London Bulletin* (1938), 192
 'Reports', 54–6
 works, other: *Alpine Landscape* or *Mountain and Plum* (1938), 192, *194*
 Apples (1940), 192, *194*
 Armchair with Seal (c.1935), 52, *53*
 Collage (1935), 54
 Horse's Head (1937–40), 189, *191*
 Hospice de la Bernina with Shelf and Sugar Bowl (c.1935), 53
 House in the Woods (1936), 56, *59*
 Locomotive (1936–8), 189, *191*
 Mountain Inn and Swiss Roll (c.1936), 53, 54
 Tableau Parisien (1938–9), *51*, 52

Jennings, Mary Lou, 22
The Jockey (Penrose, 1930), 134
John, Augustus, 24, 164
Jolas, Eugene, as translator, 30, 31
Jones, David, and neo-Romanticism, 177, 265
Jones, Ernest, 86
Jorn, Asger, and founding of Cobra, 284
Jouve, Pierre Hean, 125, 269
Joyce, James, 265
Jung, C.G., 86

Kahn, J.P., 22
Kandinsky, Vasily, 177
Kemble, Fanny, 155
Kemp, Sophie, and *TRANSFORMAcTION*, 328
Kennington, Eric, 57
Kerrn-Larsen, Rita, 149, 155, 211
Keyes, Sidney, 269
Keynes, J.M., 164
King of the Castle (Mednikoff, 1938), 206–7, *206*
Kingdom Come, 229, 265, 269
Kirkup, James, and *Fulcrum*, 227
Kitchener, Lord, 77
Klapheck, Konrad, 334
Klee, Paul, 137, 149, 258
Klingender, F.G., 108
Knight and Devil (Schimanski, 1942), 229, 269
Knights, L.C., 31
Kokoshka, Oskar, 150, 163
Konody, P.G., criticism of surrealism, 33
Kropotkin, Peter, 271

Labour Party, 158, 161, 222, 284
 and *Guernica*, 104, 150
Ladybird (Agar, 1936), *143*, 144
L'Age d'Or (film by Bu), 58, 161, 222
Lake, John, 341
Lam, Wilfredo, 281
Lamba, Jacqueline, 204
Landsbury, George, 221
Landscape from a Dream (Nash, 1936–9), 129, *131*
language
 and Bridgwater's authority of, 295
 and Bridgwater's circling of words, 252
 and Davies's texts, 48
 'limping' of text, 56
 in Lye, 49
 and powerlessness of words, 34
 renewal of, in *transition*, 30
 and Rimmington's automatism, 253–6
 and transgression of meaning, 31
 and use of French in Colquhoun's *The Pine
 Family*, 245
 and words as active agents, 107
Laroque, Yves, 22
Laughton, Charles, 164
Lautréamont, and Dali's illustration of *Les Chants
 de Maldoror*, 34
Lawrence, D.H., and Apocalypticism, 268
Lawrence and Wishart publishers, 73
Le Corbusier, 305
Leach, Bernard, 310
Lear, Edward, 97
Leavis, F.R., and *Scrutiny*, 31
Lee, Rupert
 and 1936 Exhibition, 73–4

in *Vogue*, 78, 96, 101
Lefèvre Gallery, and Hillier, 39–40
Left Review, 161, 223
 and controversy with surrealism, 99, 104–7
 office in Parton Street, 73
Léger, Fernand
 and *Ballet Mécanique*, 33
 and Onslow-Ford, 123, 147, 149, 228
 and Trevelyan, 63
Legge, Sheila, 145
 and 1936 Exhibition, 76–7, *77*, 145
Lehmann, Beatrix, 223
Lehmann, John, 127, 215
Leiris, Michel, 305
Leite, Ruy Moreira, 22
Les Mamelles de Tirésias, 35
The Lesson (Maddox, 1938), 197, *198*
'Letter to Our Friends in London' (Breton), 156
Levy, Mervyn, and Morris, 321
Lewis, Monk, 31
Lewis, Wyndham
 and *Blast*, 26
 and rift with Fry, 24–5
 in second Post-Impressionist exhibition, 24–5
 and Vorticism, 26
Lhote, André, 39
libertarianism *see* anarchism
Lief, Stanley, 256
Lifar, Serge, 99
life and death
 and Bridgwater, 246–52
 and Colquhoun, 244–6
 and Maddox's *Dénouement*, 278–80
 and Rimmington, 252–6
Life and Letters Today, 265
Light Years (Agar, 1939), 180
L'Ile Invisible (Penrose, 1937), 136, *138*, 341
The Lily (Maddox, 1938), 229, *232*
Limbour, Georges, 305
Listener
 on Ernst's exhibition, 33
 on Miro's exhibition, 34
 Nash on de Chirico, 43
Littérature, 19
The Little Man (Mednikoff, 1944), 264, *266*
Little Nigger Boys Don't Tell Lies (Mednikoff, 1944),
 91, 93
Litvinoff, Maxim, 157
Living Art in England exhibition, 150, 152, 160,
 197, 199, 204, *205*, 260
Lloyd, A.L., 108
 and *Left Review* controversy with surrealism,
 104–6
Lockett, Enoch, 198
Locomotive (Jennings, 1936–8), 189, *191*
Lon-gom-pa (Nash, 1937), 115
London Bulletin, 228, 256, 338
 central place in Europe, 155, 156
 June 1940 triple issue, 184, 192, 196, 205, 207,
 212–13
 and Miller's photographs, 160, 161, 164, 170
 Penrose on Nash, 47, 131
 policy of, 147, 148, 149
 politics and drift from Stalinist Marxism, 156
London Can Take It (Jennings, 1940), 217
London Film Society, and 1936 Exhibition, 32–3,

62, 74
London Gallery
 difficulties of, 56, 112, 123, 147–8, 149, 150, 153,
 154, 156
 financing system, 325
 and Haile, 172
 and McWilliam, 192
 and Melly, 199, 275
 and Morris, 320
 reopening of, 276, 282, 283, 301
London Gallery Editions, 154, 227
London Gallery News, 283
London Group, 204, 258
London Museum, 260
Loos, Adolf, 64
Lorca, F.G., 160
Losch, Tilly, 99
Low, David, 147
Lunn, Augustus, 341
Lye, Len
 and 'aboriginal' automatism, 56–61
 with Jennings in films, 50
 life of, 37, 49–50
 and surrealist postcards, 127, 136, 212, 213
 films: *Birth of a Robot* (with Jennings, 1935), 51,
 127
 Colour Box (1935), 50, 57, 59
 Quicksilver (1934), 57
 Trade Tattoo (1937), 111
 Tusalava (1928), 57, 58
 text: *No Trouble* (1930), 49–50
 works, other: *Marks and Spencer in a Japanese
 Garden* (1935), 60
 Pond People (1930), 60, 61
 Snowbirds Making Snow (1936), 60, 61
Lyle, John
 radical redefinitions, 330
 and TRANSFORMAcTION, 305, 325, 327–8

Maar, Dora, 108, 188
Mabille, Pierre, 228
McBean, Angus, 343
McCaig, Norman, and Apocalypticism, 269
MacDonald, Jock, 261
Machine for Making Clouds (Trevelyan, 1937), 115,
 117
McKnight Kauffer, Edward, 74
Mackworth, Cecily, and *Salvo for Russia*, 224
McNab, Ian, and Bridgwater, 220
McWilliam, Elizabeth, 147
McWilliam, F.E., 306
 and 1937 AIA exhibition, 81, 109
 and Arcade Gallery exhibition, 277
 in *Axis*, 124
 and Lewis Carroll, 31, 97, 196
 designs Penrose's garden, 305
 and 1947 International Exhibition of Surrealism
 in Paris, 281
 in *London Bulletin*, 199, 212
 in London Gallery, 153
 and masks of Chamberlain, 159, 161, 162
 and predatory violence, 192–6
 service in RAF, 214
 supports Mesens, 163
 and Surrealist Objects exhibition, 120
 works: *Eye, Nose and Cheek* (1939), 195, 196

Head in Extended Order (1948), 306, 308
 Spanish Head (1938–9), 192, 193
Maddox, Conroy
 anthropomorphological landscapes, 228–9
 at Living Art in England exhibition, 22, 150
 attacks on religion, 287–9
 and Birmingham Group, 220
 and break with Lyle, 329
 brief link with Apocalypticists, 268–9
 and correspondence with del Renzio, 224–6
 desire in, 342
 disqualifying strategies, 231–6
 écrémages, 197, 229
 and The Enchanted Domain exhibition, 325,
 327
 and exhibition in Birmingham, 284–5
 and *Fulcrum*, 227
 gouaches, 231
 interest in hysteria, 231–6, 237, 287–8
 and 1947 International Exhibition of Surrealism
 in Paris, 272, 274, 275
 and *Le Savoir Vivre*, 282, 283–4
 libertarian leanings, 282, 283–4
 life and work, 196–7
 liminal space in, 340
 in *London Bulletin*, 155
 and Melmoth group, 330–32
 and Morris, 305, 321
 natural elements in, 334, 337
 on the object, 212, 213
 poems under pseudonym of Jeanne Santerre,
 289
 and TRANSFORMAcTION, 328
 texts: *Aesthetic Dissection* (1946), 288
 'I seek only the gestures . . .' (nd), 240
 'The Object' (1940), 213
 'The Playgrounds of Salpêtrière' (1940), 237
 Uncertainty of the Day, 288
 works: *Anthropomorphological landscapes*
 (1940–70), 229, 232
 The Conspiracy of the Child (1946), 287–8, 290
 Dénouement (1946), 289, 291
 The Lesson (1938), 197, 198
 The Lily (1944), 229, 232
 Morning Encounter (1944), 231, 234, 236
 Onanistic Typewriter (object, 1940), 239–40, 240
 Passage de l'Opéra (1940), 235, 236
 Propagation of the Species (1941), 234
 Rue de Seine (La Maison de Georges Hugnet)
 (1944), 236–7, 238
 The Strange Country (1940), 233, 236
 The Visible Man (1941), 237, 239
 Warehouses of Convulsion (1946), 287, 288
 Watchman, What of the Night? (1981), 292, 292
Madge, Charles, 155, 269
 and Mass Observation, 96, 99, 102–3
 in *New Verse*, 32
Magnetic Moths (Penrose, 1937), 184
Magritte, René, 312, 336
 and James, 99
 and McWilliam, 135, 148, 149, 155, 160, 184, 276,
 283, 306
 The Red Model, 97, 336
Malthous, Eric, and post-war Birmingham group,
 284
Manchester Evening News, on 1936 Exhibition, 76

Mandated Territories (Haile, 1938), 172–3, *174*, 341
Manifesto of Surrealism, 14
Man's Life is this Meat (Gascoyne, 1936), 45, 125
Marinetti, E.F.T., and Rebel Art Centre, 25, 26
Marks and Spencer in a Japanese Garden (Lye, 1935), 60
Martin, J.L., 124
Marxism, 328
 and dialectical materialism, 29, 71
 and *London Bulletin*'s drift from Stalinist Marxism, 155–6
 and Mass Observation, 96, 102–3
 and Mesens on proletarian revolution, 158, 160, 222–3, 225–6, 284
 see also politics
Masefield, John, 86
Mass Observation, 102–3, 111, 136, 140, 189, 217, 269
Masson, André, 283
 and *New Road*, 13, 81, 213, 225
Mate in Two Moods (Agar, 1936), 96, 140, *141*
Matisse, Henri, 39
Matta Echaurren, 229, 265, 269, 305
 and Onslow-Ford, 224, 228
 and surrealist postcards, 204, 211, 213
Matthews, J.H., 344
Maudsley Hospital, and experiment in drugs, 137
May Day demonstration (1938), 161–2
Mayor, Fred, 166
 and 1936 Exhibition, 36, 74
Mayor Gallery
 in *London Bulletin*, 37, 39, 111, 149
 Miro and Ernst exhibitions, 14, 33
 Penrose and Colquhoun exhibitions, 153
 and Unit One, 36
Medley, Robert, and 1936 Exhibition, 85
Mednikoff, Reuben, 340, 342
 and Barcelona Restaurant meeting, 111, 152, 204–8, 209, 210
 irreducible imagery, 260–64
 life and work, 85–94
 works: *drawing* (1936), 90, 92
 The Flying Pig (1936), 93, 94
 Headwaiter (drawing, 1936), 89–90, 92
 The King of the Castle (1938), 206–7, *206*
 The Little Man (1944), 246, 266
 Little Nigger Boys Don't Tell Lies (1936), *91*, 93
 Stairway to Paradise (1936), 90, *90*
Mellor, Oscar, 285, 331
 and post–war Birmingham group, 284
Melly, George
 and anarchism, 330
 arrival in the group, 22, 274, 275–6
 and 'The Enchanted Domain' exhibition, 327
 and *Free Unions Libres*, 22, 274, 275–6
 and *Trajectory of Passion*, 332
 and *TRANSFORMAcTION*, 328
Melmoth/*Melmoth*, 330–32
Melville, John, 285, 321, 337
 and Birmingham group, 220, 283
 as harbinger of surrealism, 36
 in *London Bulletin*, 155, 212
 return to Cubism, 283
 and ritual of desubstantiation, 196, 197–203
 works: *Alice* (1938), 200, *203*
 Concavity of Afternoons (1939), 200, *201*

Museum of Natural History of the Child (1939), 200, *203*
 Mushroom-headed Child or *The Font* (1939), 200, *202*
 Seated Woman with Fruit (1938), 199–200, *199*
Melville, Robert
 and Arcade Gallery, 276
 and Birmingham Group, 220
 and *Le Savoir Vivre*, 282, 283, 285
 and *London Bulletin* triple issue, 213
 and Mass Observation, 22, 103
 and New Apocalypse, 268–9
 and *New Road 1943*, 224
Melville, Roberta, 283
Meninsky, Bernard, 66
Mesens, E.L.T., *76*, *78*, 338
 at one of Penrose's parties, 78, 111
 and Barcelona Restaurant meeting, 189, 196, 204, 209–11
 in BBC programmes, 213
 and The Enchanted Domain exhibition, 325, 327–8
 feud with del Renzio, 216, 220–21
 feud with Read, 154, 155, 156, 164–5
 and *Free Unions Libres*, 244, 261, 272–5
 with Haile, 305, 310
 and hanging of 1936 Exhibition, 71, 74–6
 and ICA, 301
 intransigent spirit of, 189, 196, 204, 209–11
 and *Le Savoir Vivre*, 283
 and letter from Brunius, 280
 and *London Bulletin*, 147–9
 and London Gallery, 147–9
 and Morris, 321
 La Partition Complète Complétée (1945), 276–7, *277*
 revisits concept of Cubism, 281, 282–3
 and Surrealist Objects and Poems exhibition, 112
 and surrealist postcards, 213
 and Wilson, 317
 texts: *The Cubist Spirit in its Time* (1947), 282–3
 Idolatry and Confusion (1944), 226
 London Bulletin (1938–40), 147–9
 Message from Nowhere (1944), 227
 Third Front and other poems (1944), 227
Mesens, Sybil, 114, 283, 277
Message from Nowhere, Penrose's poem in, 227, 253, 280, 304
Mexico, 19, 100
Michelangelo, influence of *David* on McWilliam, 306
Middleton, Colin, 341
Miller, Alan, 343
Miller, Henry, 270
Miller, Lee, 338
 and birth of Antony Penrose, 168–70, 188, 211, 303, 304
 and Penrose's *The Road is Wider than Long*, 110, 136, 144, 156, 166–7
 works: *Cock Rock* or *The Native* (1939), 170, *170*
 Eggceptional Achievement (1940), 171, *171*
 photograph of Eileen Agar (1937), *142*
 Portrait of Space (1937), 169, *170*
Milligan, Spike, and the Goons, 343
Minton, John, and neo-Romanticism, 267
Miró, Joan
 and Mayor Gallery exhibition, 33
 with Morris, 123, 148, 155, 258, 305, 321, 324

object at 1936 Exhibition, 62, 63, 71, 76
 relation with Lye, 58
Mitchison, Naomi, 150
Mitford, Tom, and Bruno Hat hoax, 70
Modern Art Gallery, 216
Moholy-Nagy, László, 109, 123, 147
Mon Père Ne Pas Reviens (del Renzio, 1942), 241,
 242
Mondrian, Piet, and Living Art in England
 exhibition, 81, 123, 150
Moore, Henry, 321, 343
 attacked by Banting, 227
 and Barcelona Restaurant meeting, 210–11
 contrast with McWilliam, 109, 123, 124, 128,
 131–5, 161, 164, 179, 180–83, 184
 exclusion from group, 282
 and 1936 Exhibition, 74
 and friendship with Penrose, 305
 life and work, 64, 70–71
 and *London Bulletin* triple issue, 212
 and surrealist postcards, 213
 and Tunnard, 258
 and Unit One, 15, 33, 35–7
 works: *Bird Basket* (1939), 182, *183*
 Carving (1936), 71
 Four Piece Composition (1934), 133, *133*
 Helmet (1939–40), 182, *183*
 Reclining Figure (1936, 1937), 134, *135*
 Reclining Figure (1939), 180
Moore, Nicholas, 269, 271
Morning Encounter (Maddox, 1942), 231, 234, 236
Morris, Desmond, 331
 life and work, 285, 321, 322, 323, 324–5, *326*
 poetry by, 325
 and Birmingham Group, 22, 282, 283, 284
 texts: *Exotic Heads* (c.1949), 325
 Time Flower (film, 1952), 321
 works: *Endogenous Activities* (1950), 323, 324
 Entry to a Landscape (1947), 322, 324
 Fear of the Past (1957), 324, *326*
 Harbour and Room (1932–6), 129, 132
 The Progenitor (1950), 323, 324
Mosley, Oswald, 104
Mounier, Emmanuel, and *Transformation*, 269
Mountain Inn and Swiss Roll (Jennings, c.1936), *53*,
 54
Mountain and Plum or *Alpine Landscape* (Jennings,
 1938), 189–90, *194*
Moynihan, Rodrigo, 163
Munch, Edvard, 148
Munro, Harold, 73
Murphy, film with Léger, 33
Murray, Andrew, 22
Muse of Construction (Agar, 1939), 179–80,
 179
Museum of Natural History of the Child (Melville,
 1939), 200, *203*
Museum (Rimmington, 1951), 296–8, *297*
Mushroom-headed Child or *The Font* (Melville,
 1939), 200, *202*
music
 and Banting, 66
 and Richards, 176
 and Trevelyan, 176
Mutual Congratulations (Banting, c.1936), 128, *130*
Myerscough-Walker, Raymond, 341

Mythical Composition (Rimmington, 1950), *299*, 300
mythology
 and Agar, 65–6
 and the Bible, 82
 Celtic, 244
 and Cobra movement, 284
 Gaelic lore, 313
 Gorgon, 313
 Greek, 245
 and myth of Actaeon, 300
 and North American totems, 317–18
 paleontological inspiration, 324
 and Ys, 136

Nahum, Peter, 22
Nash, Paul, 343
 and appeal for refugee artists, 140, 163
 attacked by Banting, 227
 and *Axis*, 124
 and competition in *Architectural Review*, 102
 in defence of Ernst, 15, 33
 and 1936 Exhibition, 65, 74
 and friendship with Agar, 64
 guest at 1940 Zwemmer Gallery exhibition, 211
 influence on Morris, 321
 and James, 96, 99
 life and work, 41–4
 on McWilliam, 196
 objects by, 109, 115
 and photography, 43
 and place of nature in British surrealism, 337
 and secret life forms, 127, 128–31
 and support of Mesens against Read, 164
 and Unit One, 36–7
 works: *The Bark is Worse than the Bite* (1937), 115,
 118
 Doorway, Spain (1934), 43
 Harbour and Room (1932–6), 129, 132
 Landscape from a Dream (1936–9), 129, *131*
 Lon-gom-pa (object, 1937), 115
 Northern Adventure (1929), 43, *44*
 Woodstack and Barn (photo, 1932), 43
nature
 and Agar, 306–8
 and Bridgwater, 246–7
 and Nash, 41–2, 128–31
 synthesis, 336–7
 and Tunnard, 258–60
Neagoe, Peter, 204
Negro Anthology, 66, 73
neo-Romanticism, 73, 264–8
Nevinson, C.R.W., and Vorticism, 25–6
New Apocalypse, 73, 204–10
New Burlington Galleries
 and 1936 Exhibition, 74
 and *Guernica*, 96, 149
New Country, 29
New English Art Club, 24–5
New Road 1943, 224, 225
New Signatures, 29
New Statesman and Nation
 on Dali, 34
 and statement of aims of Mass Observation, 71
New Verse, 32
New Writing, 127
News Herald (Vancouver), 262

Newton, Eric, on Zwemmer Gallery exhibition, 211
Nicholson, Ben
 and *Circle*, 109, 123, 124
 contrast with Richards's work, 176
 in Hampstead, 128
 and Lye, 57
 with Peggy Guggenheim, 164
 and Unit One, 36, 37
 and United Front exhibition, 163
Night Mail (film by Wright and Watt, 1936), 50
Night Orchestra (Penrose, 1940), 303
No Trouble (Lye, 1930), 48–9
Noailles, Marie-Laure de, 99
Norine, and *London Bulletin*, 154
Northern Adventure (Nash, 1929), 43, 44
Norton, Mrs Clifford, 147
Nougé, Paul, 155, 184
Noxon, Gerald, and Jennings, 50

Obaldia, René de, 327
objects
 and Maddox, 239–40, 289
 in Nash's photographs, 43
 and place of drama in Jennings's works, 56
 and precipitation of vision, 43
 relation between, 22
 in Tunnard, 256–60
 in Wadsworth's marines, 41
Observer
 and criticism of Magritte, 149
 and criticism of 1940 Zwemmer Gallery
 exhibition, 211
occultism
 and Colquhoun, 226
 see also alchemy
O'Connor, Philip, 112
Octavia (Penrose, 1939), 185, *190*, 341
Olson, Charles, 328
Onanistic Typewriter (Maddox, 1940), 239, *240*, 289
The Oneiroscopist (Rimmington, 1947), 296, *298*
Onslow-Ford, Elizabeth, 211
Onslow-Ford, Gordon
 and Arcade Gallery exhibition, 277
 and Barcelona Restaurant meeting, 211
 and Colquhoun, 313
 as explorer of psychomorphology, 154, 204
 life and work in 1939, 228–9
 and link with apocalypticism, 277
 and *London Bulletin* triple issue, 212
 and surrealist postcards, 213
 and Zwemmer Gallery exhibition, 211
 works: *Cycloptomania* (1939), 229, *231*
 Determination of Gender (1939), 229, *230*
The Open Door (Armstrong, 1930), 38, *39*
Opening Day (Gascoyne, 1932), 45, 63
Orwell, George, 223, 271
Our Time, 215, 223–4
Ozenfant, Anédée, 63

Paalen, Wolfgang, 149, 260
pacifism, and Peace Pledge Union, 220–21
Pailthorpe, Grace W.
 Alvensleben's attack on article by, 207
 article in *London Bulletin*, 154–5
 and Barcelona Restaurant meeting/

countermeeting, 209–11
 Breton's fascination with, 84–94
 in Canada, 260–64
 and Guggenheim Jeune Gallery exhibition, 153
 in *International Bulletin of Surrealism*, 96
 life and work, 84–94
 and Living Art in England exhibition, 150
 poem in Surrealist Objects and Poems catalogue,
 112
 and sublimality/fluidity of imagery, 205–7
 texts: Notes (unpublished), 87–90
 'The Scientific Aspects of Surrealism' (1938),
 154–5, 207
 Studies in the Psychology of Delinquency (1932),
 85
 *What We Put in Prison and in Preventive and
 Rescue Homes* (1933), 85
 works: *The Abandoned Pig* (1936), 93
 Ancestors I and *II* (1935), 89–90, *88*, *89*
 The Blazing Infant (1940), 263–4, *263*
 Composition (1937), 93, *95*
 The Spotted Ousel (1942), 264, *267*
 Surrealist Fantasy (1938), 207
Paine, Thomas, 271
Pandemonium (Jennings/Madge), 155, 217
Paolozzi, Eduardo, 343
Parade, 35
parsemage, 312
La Partition Complète Complétée (Mesens, 1945),
 276, *277*
Parton Street bookshop, 63, 73
Passage de l'Opéra (Maddox, 1940), *235*, 236
Paulhan, Jean, 269
Paun, Paul, 282
Peace News, 222
Pedro, Antonio, 280
Penny Journal, 192
Penrose, Antony, 22, 304
Penrose, Roland, 338, 341, 343
 advocates position specific to British surrealists,
 158
 and Arcade Gallery exhibition, 277
 and *Architectural Review* holiday competition, 81,
 85, 96, 102
 and *Axis*, 124
 and Barcelona Restaurant meeting, 189, 210
 between presence and absence, 134–6
 and blending of Eros and Thanatos, 179, 184–8
 buys Eluard's collection, 148
 and camouflage, 214
 and *Daily Worker*, 224
 as editor of *London Bulletin*, 154
 and The Enchanted Domain exhibition, 327
 and 1936 Exhibition, 64, 65, 73–4
 in France, 22, 62–3
 and *Free Unions Libres*, 277
 and *Guernica*, 149–50
 as inventor of postcard collages, 111
 invites friends to parties, 111
 and journey into the Balkans, 155, 156
 and Living Art in England exhibition, 150
 London Bulletin triple issue, 211–13
 London Gallery post-war activities, 282–3
 and May Day 1938 demonstration, 161–3
 and Mayor Gallery exhibition, 153
 on Nash, 131

and organization of London Gallery, 147–50
relationship with del Renzio, 226–8
and *Salvo for Russia*, 228
and Spain, 108–9
supports Mesens in rivalry with Guggenheim,
 164–6
and 1947 surrealist exhibition in Paris, 281
and Surrealist Objects exhibition, 115, 118–19
and tension with Bretobout support to USSR,
 156–8
and United Front exhibition, 163
war/post–war painting and poetry, 284, 285,
 301–5
and Wilson, 316
and Zwemmer Gallery exhibition, 211–13
texts: 'Bulldoze Your Dead' (1944), 304
 Picasso, His Life and Work (1958), 305
 The Road is Wider than Long (1939), 54, 166–8,
 167
works: *Black Music* (1940), 301, *302*, 303
 Captain Cook's Last Voyage (1936), 134–6
 Condensation of Games (1937), 119–20, *121*
 The Conquest of the Air (1938), 184–5, *186*
 The Dance (1940), 303
 The Dew Machine (1937), 115, *116*
 Egypt (1939), 188
 First View (1947), 304
 From the House Tops (1939), 185, 188, *188*
 Good Shooting (1939), 184, *187*
 Guaranteed Fine Weather Suitcase (1937), 115, *118*
 The Jockey (1930), 134
 Le Grand Jour (1938), 184, *185*
 L'Ile Invisible (1937), 136, *138*, 341
 Magnetic Moths (collage, 1937), 184
 Night Orchestra (1940), 303
 Octavia (1939), 185, *190*
 Portrait (1939), 185
 Question and Answer (1950), 304, 305
 The Real Woman (1938), 184, *186*
 The Red Seal (1949), 304, *306*
 The Survivor (1937), 115
 Unsleeping Beauty (1946), 303, *303*
Penrose, Valentine *see* Boué, Valentine
Péret, Benjamin, 272
 and *New Road 1943*, 47, 71, 78, 155, 212, 213, 225
Peri, Peter, 161
Perse School, and Jennings, 54
Perseus and Andromeda (Gascoyne, 1936), *144*, 145
Petersen, Carl V., 78
Petron (Davies, 1935), 46–7, 337
Pett and Pott (film by Jennings and Cavalcanti,
 1934), 51
Phillips, Helen, 214
The Philosopher (Armstrong, 1938), 38
Picabia, Francis, 33, 148
Picasso, Pablo, 338
 at one of Penrose's parties, 111
 criticized by Vorticists, 17, 27
 and *Desire Caught by the Tail*, 283
 in Eluard's collection, 148
 exhibited in post-war London Gallery, 283
 and 1936 Exhibition, 78
 and friendship with Penrose, 188
 and *Guernica* (1937), 149–52, 155–6, 160, 161, 197
 influence on Melville, 198
 influence on Richards, 161, 164, 176

and London Gallery, 149
 meets Hillier, 39
 meets Trevelyan, 62, 63
 and Melville in *Kingdom Come*, 305
 and Moore, 70
 Penrose's book on, 305
 and Spain, 108
 and *Transatlantic Review*, 29
 and Trevelyan in *Our Time*, 223
Picture Post, 140
The Pine Family (Colquhoun, 1941), 244–5, 247
Piper, John
 and neo-Romanticism, 265–7
 and *Salvo for Russia*, 123, 148, 155, 215, 224
Piper, Myfanwy, and *Axis*, 37
Pissarro, Camille, 24, 109
Playfair, Onion S., 147
'The Playgrounds of Salpêtrière' (Maddox, 1940),
 237
Ploumanach, 140
Poe, E.A., 47
Poetry and Anarchism, 115, 157
Polanski, Roman, 327
politics, 337–8
 against institutionalized Marxism, 328
 and anarchism, 331–2
 artists' involvement in, 163
 and Banting, 66
 and Cunard, 66
 and influence of Bolshevik Revolution, 28
 and *Left Review*, 103–11
 and *London Bulletin*'s refusal to align, 156
 renewed leanings towards Trotskyism and
 anarchism, 285
 and Roberts's anthologies, 29
 and Spain, 103–11
 and specificity of British surrealism's politics,
 164
 surrealism and communism, 103–11
 and university magazines, 28–9
 see also Marxism
Pollitt, Henry, 158, 222
 and *Guernica*, 150
Pollock, Jackson, 228
Polymorphic Interior (Rimmington, 1950), *299*, 300
Pond People (Lye, 1930), 60, *61*
Portman Clinic *see* Institute for the Scientific
 Treatment of Delinquency
Portrait of Lord Byron (Jennings, c.1936), 54, *55*
Portrait (Penrose, 1939), refused by Royal
 Academy, 185
Portrait of Roger Roughton (Jennings, c.1937), 54, *55*
Portrait of Space (Miller, 1937), *169*, 170
Possessed (Agar, 1938), 180, *181*
postcards, surrealist, 213
pottery
 and Haile, 310
 and Penrose, 304
Potts, Paul, 271
Pound, Ezra
 and Agar, 64
 attack on surrealism, 107–8
 and conception of vortex, 25
 in defence of Vorticism, 27–8
 and imagism, 26
 and Rebel Art Centre, 26

Precious Stones (Agar, 1936), 140
primitivism
 and animism, 115
 and Cobra movement, 285
 and Lye, 56–60
 and Morris's paleontological imagery, 324
 and Onslow-Ford, 228–9
 and return to elementary images, 64
 and Surrealist Objects exhibition, 112
 in Vorticism, 25
The Progenitor (Morris, 1950), 321, *323*
Psi (Tunnard, 1938), 258, *259*, 260
psychoanalysis
 in *London bulletin*, 154–5
 and Mednikoff, 84–96, 261–4
 Melville's use of, 213
 and Moore, 184–8
 and Pailthorpe, 84–96, 261–4
 and Penrose, 134
 see also Freud, Sigmund/Freudianism
psychological morphology, 228–9
*Psychophotographic Phenomenon: Those Fallen in the
 First World War* (Freddie, 1936), 81
Pulhan, Peter Rose, 283
Pusey, Tony, 330, 332, 333, 334
 and Melmoth, 330, 333
Pylons (Hillier, 1935), 40–41

Quadriga (Agar, 1935), 64–5, *65*
Question and Answer (Penrose, 1950), 304, *305*
questionnaires
 and *Le Savoir Vivre*, 283
Quicksilver (film by Lye, 1934), 57

Radcliffe, Ann, 31
Raine, Kathleen, and *transition*, 22, 31
Rank, Otto, 86
Ratcliffe, W., 24
Ray, Man, 338
 and Banting, 60, 62
 and films, 33
 and Penrose's book, 305
 and surrealist postcards, 71, 111, 149, 188, 197,
 213
Read, Herbert, 336
 and anarchism and Trotskyism, 155, 156–7
 and attack on Socialist realism, 160, 161
 and *Axis*, 123–5
 and Barcelona Restaurant meeting, 209–11
 and committee for artist refugees, 163
 and debate with the *Left Review*, 103–6
 and Defence Committee of Freedom Press, 271
 and defence of Eluard and Dali, 225
 and defence of Ernst, 33
 and distinction between 'superrealism' and
 surrealism, 35–6
 and 1936 Exhibition, 63, 64, 73–8
 feud with Mesens, 164–6
 and *Guernica*, 149–50
 and ICA, 277, 301
 influence of *Art Now* on Gascoyne, 63
 influence on Earnshaw, 332
 and influence of his *Surrealism* on Melly, 274
 and *International Bulletin of Surrealism*, 94–9
 joint activities with AIA, 108–11
 in *Kingdom Come*, 269

and New Apocalypse, 265
and radio discussion with Jennings, 173, 189
and relative unreliability, 134, 145, 147
and *Surrealism*, 97, *98*, 99
and Surrealist Objects exhibition, 112–19
on Tunnard, 258, 260
and Unit One, 41
The Real Woman (Penrose, 1938), 184, *186*
Reavey, George, 63, 73, 78, 154
 and *transition*, 31
Rebel Art Centre, 26
Reclining Figure (Moore, 1936, 1937), 134, *134*
Reclining Figure (Moore, 1939), 180
The Red Model (Magritte), 97, 336
The Red Seal (Penrose, 1949), 304, *306*
Redfern Gallery, 306
Reed, Henry, and Birmingham Group, 198, 220
reflexivity of the gaze
 and del Renzio, 241–4
 and Haile, 176–7
 and Rimmington, 296–300
Reid, Alex, and Lefevre Gallery, 260
Reinganum, Victor, 341
Remote Cause of Infinite Strife (Bridgwater, 1940),
 247–8, *251*
Le Rendez-vous des Moeurs (Del Renzio, 1941), 241,
 243
'Reports' (Jennings), 54–6, 337
Restrepo, Pedro, 283
La Révolution Surréaliste, 63, 237
 principles, 16, 18
Reynolds News, 158
Richards, Ceri
 billboard painting, 163, *165*
 friendship with Trevelyan, 64
 life and work, 176–8
 relationships with AIA, 147, 161
 works: *Chimera Costerwoman* (1939), *177*, 178
 The Female Contains All Qualities (1938), 178
 Two Females (1937–8), 178
Richardson, Michael, and Melmoth, 330, 331
Richter, Gigi, 283
Richter, Hans, 283
Riding, Laura, 57
Rieser, Wolf, and *Salvo for Russia*, 224
Rimbaud, Arthur, 51, 62, 78, 125, 332
Rimmington, Edith, 341, 342
 and Arcade Gallery exhibition, 277
 and automatism, 244, 253–7
 and Barcelona Restaurant meeting, 210–11
 first exhibition at London Gallery, 283
 and *Free Unions Libres*, 274–5
 Free Unions Libres drawing (1946), 274, *274*
 friendship with Bridgwater, 220
 and *Fulcrum*, 227, *257*
 and Haile, 293–301, 312
 and 1947 International Surrealist Exhibition in
 Paris, 282
 and *Le Savoir Vivre*, 284
 libertarian leanings, 285
 and *London Bulletin* triple issue, 212–13
 and resumption of activities after war, 280–81
 and Surrealist Objects and Poems exhibition, 22,
 120
 and visuality based on violence, 244, 253–7
 as woman surrealist artist, 331, 337, 340

texts: 'Leucotomy' (1944), 256
 'Time–table' (1944), 256
works:
 drawing from 'Message from Nowhere' (1944),
 254
 Eight Interpreters of the Dream (1940), 253, 255
 Family Tree (photo-collage, 1937), 120, 122, 253
 Museum (1951), 296–8, 297
 Mythical Composition (1950), 299, 300
 The Oneiroscopist (1947), 296, 298
 Polymorphic Interior (1950), 299, 300
Rivera, Diego, 19, 155
Rivières Tièdes (Méditerranée) (Colquhoun, 1939),
 204
The Road is Wider than Long (Penrose, 1939), 54,
 166–8, 167
Roberts, Michael
 and New Country, 29
 New Signatures, 29
Roberts, William, 26
Robertson, Bryan, 176
Roditi, Edouard, and 'the new reality', 31
Roman Balcony (Gascoyne, 1932), 45
Romilly, Esmond, 73
Rosemont, Franklin, 331
Rosenberg, Mrs Eugene, 22
Rothenstein, William, 163
Roughton, Roger, 63, 73, 78, 101, 104, 106–8, 145
Roy, Pierre
 influence on Armstrong, 38
 in Vogue, 101
Royal College of Art
 and Haile, 171
 and Moore, 182
 and Richards, 176
Rudlin, John, 328
Rue de Seine (La Maison de Georges Hugnet)
 (Maddox, 1944), 236–7, 238
Rull, Lisa, 22
Ruskin, John, 155
Rutter, Frank
 founder of Allied Artists' Association, 24
 and second Post-Impressionist exhibition, 24

Sage, Kay, 228
St John's Wood School of Art, and Armstrong, 38
St Martin's School of Art, and Mednikoff, 86
Sale, Arthur, 112
Salisbury, C., and Salvo for Russia, 224
Salvo for Russia, 224
Sand, George, 245
Le Sang d'un Poète (Cocteau, 1933), 62
Sansom, Philip
 and Free Unions Libres, 272, 275
 and Le Savoir Vivre, 283
 and police raid on Freedom Press, 22, 271
Santerre, Jean (pseud.) see Maddox, Conroy
Sao Paulo Jornal da Mancha, 152
Sargent, John Singer, 23
Satie, Erik, 276
Le Savoir Vivre, 283
Schiaparelli, Elsa, 101
Schimanski, Stefan, 229, 269
Schlemmer, Oskar, 147
Schwabe, Randolph, 176
Schwartz, Arturo, 22

Schwitters, Kurt, 216, 283
Scotsman, 148, 269
Scrutiny, 31
sculpture
 by Moore, 132–4, 180–82
 and McWilliam, 192, 196, 306
Scutenaire, Louis, 160, 328
Scylla (Colquhoun, 1939), 204–5
Seated Woman with Fruit (Melville, 1938), 199–200,
 199
Secombe, Harry, 342–3
Second Manifesto of Surrealism, 16, 19
Seeing is Believing see Penrose, Roland, L'Ile
 Invisible
Seligmann, Kurt, and New Road 1943, 225
Sellers, Peter, 342–3
Seven and Five Society, 123
 and Lye, 37, 57
Sewter, A.C., 112, 210
Sherman, David, 340
Sherwin, Jeffrey, 22
Short Survey of Surrealism, A, 35, 63, 71, 72, 124
Siamese Triplets Singing in the Desert (Banting,
 1932–3), 66
Sickert, Walter, 23, 24, 25
Sitwell, Edith, 270
Sitwell, Osbert, 228
Slade
 and Agar, 64
 and Colquhoun, 204
 and Hammond, 332
 and Hillier, 39
Smith, Alec, and attack on del Renzio, 227
Smith, Erik, 147
Smith, Ken, and TRANSFORMAcTION, 327, 328
Snowbirds Making Snow (Lye, 1936), 60, 61
Socialist Challenge, and controversy with
 Melmoth, 331–2
Soupault, Philippe
 and automatism, 17, 19
 and Transatlantic Review, 276
Spain
 and Agar's Angel of Anarchy, 112–15
 and Araquistain's suicide, 223, 278–80
 Banting, Penrose and Gascoyne in, 104,
 108–9
 and exhibition of Guernica, 149–50
 and May Day demonstration (1938), 161–3
 and refugee artists, 163–4
Spanish Head (McWilliam, 1938), 192, 193
The Spectator
 and Blunt on surrealism, 161
 on Dali, 34
 on Guernica, 150
Spencer, Stanley, 164
Spender, Humphrey, 341
 and Mass Observation, 103
Spender, Stephen
 supports Freedom Press, 271
 in Transformation, 215, 270
The Spotted Ousel (Pailthorpe, 1942), 264, 267
Stairway to Paradise (Mednikoff, 1936), 90, 90
Stalin, Josef, 19, 157, 160, 338
Stanford, Derek, 241
Star, on 1936 Exhibition, 76
Steer, Wilson, 23

Stephenson, Cecil, 148
Stephenson, George, 102
Stephenson, Sybil see Mesens, Sybil
stillomancy, 312
Stokes, Adrian, 214
Strachey, Lytton, 70
The Strange Country (Maddox, 1940), 233, 236
Strettell, Mrs Clifford, 147
Strong, Patience, 189
Student Labour Federation, 73
Student Vanguard, 29
Studies in the Psychology of Delinquency
 (Pailthorpe, 1932), 85
Studio, on 1940 Zwemmer Gallery exhibition, 211
Sue, Eugene, 47
Summers, Luke, 102
Sunday Dispatch, on 1936 Exhibition, 76
Sunday Express, on 1936 Exhibition, 76
Sunday Referee, 96, 101
Sunday Times
 and criticism of Magritte, 149
 on 1940 Zwemmer Gallery exhibition, 211
superautomatism, 312
Surgical Ward (Haile, 1939), 173
surrealism
 and abstraction, 123–4
 and abstractionism, 36–7
 amd displacement on Agar, 140–44
 and biological primitivism, 321–4
 in Criterion, 31
 and difference with neo-Romanticism, 266–7
 diluted by Read and Davies, 97–8
 eruptive sexuality in Colquhoun, 204–5
 four main problematics, 125
 and geometricism in Trevelyan, 137
 Haile's definitions of, 172–3
 influence of abstraction on Agar, 64
 influence of abstraction on Moore, 70–71
 Jennings's growing idealism, 216–20
 and link with constructivism, 260–61
 metamorphosis and genesis in Melville, 199–200
 Moore and forms made to tremble, 182
 Nash and geometrical at service of imaginary,
 128–9
 in Scrutiny, 31
 and This Quarter, 31
 and totemic automatism in Wilson, 316–19
 and Transatlantic Review, 29
 and transition, 30–31
 and Tunnard's 'prefigurative' images, 256–60
 use/misuse of word, 35–6
 and vegetable forms in Richards, 177–8
 and Vorticism, 27–8
Surrealism – the Hinge of History (Maddox and
 Welson), 330
Surrealism (ed. Herbert Read), 81, 97–9, 98, 106,
 134, 258, 275, 332, 336
Le Surréalisme au Service de la Révolutions
 (SASDIR), 16
Surrealist Fantasy (Pailthorpe, 1938), 207
surrealist group, British, 21, 29–81, 147–8
Surrealist Objects and Poems exhibition, 112, 113,
 114–21, 145, 147, 154, 253
surrealist postcards, 40, 71, 78, 111, 149, 155, 188,
 197, 211, 213
The Survivor (Penrose, 1937), 115

Sutherland, Graham, 321, 343
 attacked by Banting, 176, 227
 erroneously mentioned, 15
 and 1936 Exhibition, 81
 and neo-Romanticism, 265
Sweeney, Michael, 22
Swift, Jonathan, 31
Swindon Arts Centre, 321
Swingler, Randall, and controversy between
 surrealism and Left Review, 104
Sylvester, David, 134, 182, 331
Symonds, Julian, 271
A Symposium (Trevelyan, 1936), 137, 139
The Symptomatic World (Gascoyne, 1936), 127

Tableau Parisien (Jennings, 1938–9), 51, 52
Tait, Mrs, quarrel with Jennings, 77
Tanguy, Yves, 228, 231
 and surrealist postcards, 40, 71, 78, 149, 155, 211,
 213
 and This Quarter, 15, 31
Tanning, Dorothea, 303, 305
Tapies, Antoni, 305
Taylor, Simon Watson
 and attack on del Renzio, 227
 and Free Unions Libres, 271–3
 and Fulcrum, 227
 and Le Savoir Vivre, 283, 284
 letters to Maddox, 275, 280, 281–2
Taylor, Sonia, 281
Tchelitchew, Pavel
 and Gascoyne, 63
 and James, 99
Ten Guitar Faces (Banting, c.1932), 66, 67
Tennyson, Alfred, Lord, 252, 265
The Terrain of the Dream exhibition, 331, 334
Thaarup, Aage, 101
Thacker, Eric, 333
Third Front, and other Poems (Mesen, 1944), 227
This Quarter, 31
Thorndike, Sybil, 164
Through the Looking Glass (Carroll, 1871), 48
Time Flower (film by Morris, 1952), 321
The Times, and Nash's letter about Unit One, 37
The Times Literary Supplement, 35, 168
Titus, Edward B., 31
Todd, Ruthven, 155, 216
Tomorrow Morning (Wadsworth, 1929–44), 41,
 42
Tooth's gallery, 36
Torso with Severed Mamma (Haile, 1938), 173
Toynbee, Philip, 220
Trade Tattoo (film by Lye, 1937), 111
Transatlantic Review, 29, 35
TRANSFORMAcTION, 325, 327–30, 329
Transformation, 265, 269–70
transition, 35, 63
 and surrealism, 30–31
Transplanted (Bridgwater, 1947), 293, 294
Treece, Henry
 and Fulcrum, 227
 and How I See Apocalypse (1946), 265
 and New Apocalypse, 265, 267–8
Trevelyan, Julian, 283
 with AIA during the war, 222
 and camouflage, 214

collaboration with *Experiment*, 22, 29
friendship with Richards, 176
and Lye, 51, 57
and Mass Observation, 103
and May Day (1938), 161–3
meets Gascoyne, 63
mythopoetic approach of, 164
and *Our Time*, 223
in 'realism and surrealism' debate, 161
and *Salvo for Russia*, 224
and Surrealist Objects and Poems exhibition,
 112–15
and *transition*, 31
on Tunnard, 256–7
United Front exhibition, 163
works: *City* (1936), 137, *139*
 Machine for Making Clouds (1937), 115, *117*
 A Symposium (1936), 137, *139*
 Underground (1933), 137
Tribune, 226–7, 271
Trotsky, Leon/Trotskyism
and *London Bulletin* drift towards, 19, 20, 107–8,
 150–52
and post-war surrealism, 160, 225, 272, 284
severance of links with, 331–2
Tunnard, John
and AIA Exhibition (1937), 109
with AIA in wartime, 223
during the war, 214
1942 exhibition, 228, 256–61, 306
and Zwemmer Gallery exhibition (1940), 120, 211
works: *Composition* (1939), 260, 262
 Fulcrum (1939), *259*, 260
 Psi (1938), 258, *259*, 260
Tusalava (film by Lye, 1928), 57, *58*
Two Females (Richards, 1937–8), 178
Two Models (Banting, 1935), *69*, 70
Tyler, Parker, 154, 160
Tyrannopolis (Evans, 1939), 81, *84*
Tzara, Tristan
and Gascoyne, 63
in *Transatlantic Review*, 18, 29

Underground (Trevelyan, 1933), 137
Underwood, Leon, and Agar, 64
Unit One, 41, 74, 96, 123
 principles of, 36–7
Unity Theatre, 154
university magazines, and use of the word
 'surrealism', 28–9, 35
Unsleeping Beauty (Penrose, 1946), 303, *303*
Untitled (Wilson, early 1950s), 318, *320*

Valéry, Paul, 17
Valois, Ninette de, 127
Van Gogh, Vincent, 23, 271
Van Hecke, P.G., 155
Van Velde, Geer, 149
Vancouver Sun, 262, 263
Vardo, Yanko, 62, 64
Venture, 28
Vidal, Jean, 272
View, 201
Vigo, Jean, 327
Virgin Images in the Magical Processes of Time
 (Collins, 1935), 84

The Virgin Washerwoman (Graham, 1937), 119, *120*,
 341
Viridiana (film by Buñuel), 327
The Visible Man (Maddox, 1941), 237, *237*–9, *239*
vision/visuality *see* eye
A Visitation (Colquhoun, 1944), 246, *250*
Vogue, 101, 221
Vorticism
anticipatory of surrealism, 27–8
criticized by Bell, 27–8
defended by Pound, 27–8
and Manifesto, 26–7
and separation from Futurism, 25–6

Wadsworth, Edward, 109
at margins of surrealism, 36
life and work, 38, 41
and Rebel Art Centre, 26
Tomorrow Morning (1929–44), 41, *42*
and Vorticism, 26
Waldberg, Patrick, 16
Walker, Fleetwood, and Bridgwater, 220
Walker, Ian, 343
Walton, William, fish at 1936 Exhibition, 76–7
Warehouses of Convulsion (Maddox, 1946), 287, *288*
Warwick Galleries (Edgbaston), 285
Watchman, What of the Night? (Maddox, 1981), 292,
 292
Watkins, Vernon, and new Romanticism, 269
Watson, Peter, and ICA, 301
Watt, Harry, 50
Watt, James, 102
Waugh, Evelyn, 70
Wells, H.G., 125
Welson, John W., 332, 334–5, 342, 343
 Interior of Wuthering Heights (1977), *335*, *335*
 and Melmoth, 331
 and recentering of principles, 22, 330
Wengraf, Paul, and Arcade Gallery, 276
West, Alick, 106, 108
West, Philip, 334, 336, 342
 and TRANSFORMAcTION, 328
 work: *Derailed Sea* (1987), *336*, *339*
Westminster College of Art, 66
*What We Put in Prison and in Preventive and Rescue
 Homes* (Pailthorpe, 1933), 85
The White Horseman (1941) ed. J. F. Hendry and
 Henry Treece, 268–9
Whitechapel Gallery, 109, 150, 163
Wilde, Oscar, 100
Wilson, Sarah, 22
Wilson, 'Scottie'
 life and work, 277, 282, 285, 316–18, 320
 works: *Greedies II* (1950), *319*, *320*
 Untitled (early 1950s), *318*, *320*
Woman Passing between Two Musicians (Banting,
 1937), 128
Woman Reading (Agar, 1936), 140
Woman and Suspended Man (Haile, 1938), 173, *178*
Woman's Head and Fireplace (Jennings, c.1937), 54
Woods, S. John, 160
Woodstack and Barn (Nash, 1932), 43
Woolf, Virginia, and exhibition of Picasso's
 Guernica, 149
Wordsworth, William, 97, 336, 337
Workers' Theatre Movement, 73

Wright, Basil, 50
Wright, Francis, and Melmoth, 331
Wykeham, Mary, 283
 and *Salvo for Russia*, 224

York Minster pub, 215
Young, Edward, 31, 97
Youngman, Nan, 109

Zadkine , Ossip, 63, 305
Zervos, Christian, 108, 109
Zwemmer, Anton, 31, 96, 164, 216
Zwemmer Gallery, 63, 211, 212, 228, 260
 and Dali, 34
Zyw, Alexander, 283